A BOOK OF BRITAIN

JOHNNY SCOTT

A BOOK OF BRITAIN

THE LORE, LANDSCAPE
AND HERITAGE OF A
TREASURED COUNTRYSIDE

PHOTOGRAPHY BY
Cristian Barnett

Collins

For
Sallioso

CONTENTS

Introduction 14

FARMING AND THE LANDSCAPE
30

WOODLAND
100

WEATHER LORE
166

WILDLIFE
240

WILD HARVEST
310

FOLKLORE & CUSTOMS
368

CRAFTS
434

COUNTRY SPORTS
500

Acknowledgements 582
Associations 583
Index 584

INTRODUCTION

I was born in February at Hamsland Holt, a farm in that lovely part of the Kent and Sussex Weald, during the great storm of 1948. Family legend has it that my father carried the midwife in through the snowdrifts on his back and that I emerged by candlelight, as the wind howled round the house and heavy flakes battered the window panes. A surviving memento of the occasion rests in my filing cabinet in the form of a large brown envelope on which my father wrote, in his beautiful copperplate handwriting: 'J. Scott, His Caul, 24 February 1948'. A child born with a caul, or amniotic sack, covering their face is believed in folklore to be protected from drowning – a superstition put to the test some years later when I fell into the Border Esk, a river notorious for its powerful undercurrent, when my father was fishing the Netherby beat.

Shortly after my birth, my parents moved to Scarletts Farm, a larger holding near Cowden with a lake and weir, four cottages, a watermill, an oast house and a beautiful Elizabethan farmhouse with a nursery wing to contain my older sister, myself and a nanny. It is here that the kaleidoscope of childhood memories really starts: the pale green of the nursery walls and the omnipresence of Nanny Pratt; my oak-beamed bedroom and the smell of my mother's scent when she came to kiss me goodnight; the faces of the people who worked on the farm: Joe Botting, the pig man and gardener; Billy Akehurst, the horseman, who always wore grey Derby tweed breeches and brown leather leggings; and Matt, the cattleman. Other faces are less distinct – Jim Akehurst's wife Betty, who cleaned, and Mrs Rogers, who cooked and lived in a cottage by the water mill with her father, a First World War veteran who had lost both feet at the Battle of the Somme and got about on leather knee pads. I remember, too, my parents' closest friends – Robert Clarke, Paul Carver, John Robson, Jimmy Waters and Kemble Watley – warming themselves in front of the big, open inglenook fireplace in the drawing room with its elaborately carved wooden surround, after a day's shooting or hunting. (The carvings were reputedly the work of Dutch drainage experts, carved in return for a night's lodging on their journey back to Holland after completing the seventeenth-century Fen drainage schemes.)

> SHORTLY AFTER MY BIRTH, MY PARENTS MOVED TO SCARLETTS FARM ... IT IS HERE THAT THE KALEIDOSCOPE OF CHILDHOOD MEMORIES REALLY STARTS: THE PALE GREEN OF THE NURSERY WALLS AND THE OMNIPRESENCE OF NANNY PRATT; MY OAK-BEAMED BEDROOM AND THE SMELL OF MY MOTHER'S SCENT WHEN SHE CAME TO KISS ME GOODNIGHT.

There were stables up at the farm yard for the cart horses, my parents' hunters and an evil-tempered grey pony called Twilight, on whom I hunted for the first time, aged four, when the Old Surrey and Burstow Foxhounds met at the house. This is a memorable occasion because I was led on foot by my perspiring father, who then contrived to be in the right place when the hounds killed and as a consequence I was 'blooded' by that marvellous huntsman, Jack Champion. A succession of great lolloping foxhound puppies spring to mind. Traditionally, all Hunts like to send puppies to 'walk' with local people for about nine months; it helps the young hound become acclimatised to humans, machinery and farm animals before returning to the discipline of Hunt kennels.

Until the centuries of hunting instinct begin to develop in them, these puppies are as enchanting as any other young animal, and I can remember names such as Outcast and Harmony, Furrier and Falcon, or Dexter and Melody with whom I romped as a child. From the whole family's perspective, walking a hound puppy is enormously satisfying and enables them to become more involved with their local Hunt. They can see their protégé being judged at the local Hunt puppy shows and it may even graduate to some of the great annual hound shows at Harrogate, Honiton or Peterborough and, of course, they have the pleasure of following its career on hunting days. I can still recall a furious argument with a small girl, both of us aged about five years old, over the relative hunting prowess of 'our' individual hounds. Many Hunts present puppy walkers with a keepsake by way of thanks at the annual puppy show, and I have a whole collection of ephemera ranging from silver spoons and cups to engraved glasses and even a snuff box presented to my grandfather engraved: 'Bolebroke Beagles. 27 April 1932. Best Couple. Bachelor and Blue Beard.'

An image of the boot room, with its gleaming rows of hunting boots and gun cabinets, leaps to mind whenever I smell boot polish or Rangoon oil. Here my father's terriers had their beds: Tweedle, Tory, Tiger and Trooper. These were all taciturn working 'stable' dogs, bred from a Sealyham belonging to Jack Champion and a bare-skinned bitch belonging to Frank Chilman, who had been my grandfather's gamekeeper at our home, Tremains. I learnt my first lesson in the treatment of animals from them; their master's son I may have been, but that didn't mean they would tolerate any liberties. I was introduced to wildlife on our afternoon walks through the ancient coppiced woods on the farm with Nanny Pratt. These were not just walks for the good of our health; rationing was still enforced and Nanny Pratt always carried with her a Sussex trug made from willow boards and, depending on the season, she filled it with flowers for the nursery, edible plants, berries or nuts. Trailing along behind her as she foraged, my sister and I quickly learnt to identify what was edible, where to find it, and why it grew there. We soon understood that some plants might look good to eat but are, in fact, deadly poisonous – such as the black or translucent berries of climbing byrony, or the dark purple ones of deadly nightshade – and we knew never to touch those we did not recognise. At the same time, any inquisitive child is bound to take an interest in the wildlife around him or her as they walk, surrounded by birdsong, darting insects and the furtive rustling of unseen little creatures. It was on these outings with Nanny Pratt, as I began to learn about the breeding seasons of animals, that the seeds of my fascination with natural history were sown.

On these afternoon walks we sometimes met others bent on the same mission as ourselves, such as womenfolk from the village or retired farm workers harvesting the hedgerows for a whole range of edible or medicinal plants. In the early

autumn there were always families of noisy Cockneys on their traditional holiday, when they came down from the East End to pick hops and apples, who would be searching for blackberries or rosehips along the lanes and in woodland. Later, on 14 September, it was the custom for bus loads of townspeople and their children to descend on the countryside to strip the hazel trees on Nutting Day. The coppiced oak, hornbeam, chestnuts and hazel woodlands were busy places through the winter, as the farm men cut and stacked the poles to dry for fencing materials. Sometimes we would see an old man cutting hazels to make into hurdles, and one winter a group of charcoal burners set up camp, living in wigwam-shaped canvas tents and building their curious earth-covered fires.

> THE COPPICED OAK, HORNBEAM, CHESTNUTS AND HAZEL WOODLANDS WERE BUSY PLACES THROUGH THE WINTER, AS THE FARM MEN CUT AND STACKED THE POLES TO DRY FOR FENCING MATERIALS. SOMETIMES WE WOULD SEE AN OLD MAN CUTTING HAZELS TO MAKE INTO HURDLES, AND ONE WINTER A GROUP OF CHARCOAL BURNERS SET UP CAMP.

In 1956 we moved from Scarletts Farm to Eckington Manor, a red-brick Queen Anne House in the village of Ripe, overlooking the long sweep of the South Downs, with better facilities to allow my father to concentrate on breeding hunters and eventers. Here the parameters of my life began to broaden. My family moved south shortly after the First World War, but kept the farms and woodland in Cumberland and Northumberland. There were other family business interests in the north, and every couple of months my father and grandfather would go up there to attend meetings and visit the tenants, sometimes taking me with them. We would travel by train to Carlisle, stay for a few days at the Crown and Mitre Hotel, then drive along the old Military Road beside Hadrian's Wall to the family farms at Wingates Moor, near Longframlington in Northumberland. My parents were keen on their fishing, and one of the greatest thrills of my young life was being carried onto the Inverness car sleeper at King's Cross at midnight, falling asleep to the hiss and chuff of the steam engine, and waking up to the grandeur of the Scottish Highlands north of Stirling. On other occasions we drove down to the West Country to stay with my grandparents at Endsleigh, in Devonshire, the stunning 'cottage orné' mansion built in 1810 for the Duchess of Bedford, when they took the fishing on the river Tamar. Before my tenth birthday I had seen much of the natural glory of Britain from the chalk downs and wooded valleys of the south, the high fells of Cumbria and Yorkshire and the magnificence of the Cheviot Hills, to the majesty of the Scottish Highlands and the open moors of Dartmoor and Exmoor.

My social perspective expanded when I went to the village school for a short while and met the children of the people who made up our community. In those days 70 per cent of the population were still employed in agriculture and the remainder were the publican, storekeeper, rector, blacksmith, carpenter, and a handful of commuters and retired people. A little later I went to a Dame school in Hailsham, which was attended by the children of the local businessmen and farmers, and then, when I was eight, I was off to boarding school.

All children of my age had one thing in common, regardless of background or whether they were rural or urban: within the code of good manners and respect

for the belongings of others, we had the freedom of the countryside and nature was our primary source of entertainment. To be outside enjoying it was considered a healthy, beneficial and profitable way for the young to spend their time. These were the philosophies around which the Scout movement, which did such exemplary work in introducing inner-city children to country lore, had been based. We made camps in the woods and spent hours being eaten alive by midges, watching a badger sett when the sow brought her piglets out at dusk, or a vixen's earth when she played with her cubs on a summer evening. We caught tadpoles in jam jars in the early spring, watching them grow into little frogs before releasing them back into the wild, and we overturned cowpats to find worms for use as bait when we fished ponds and streams for sticklebacks or eels.

Butterfly and egg collecting were still viewed as acceptable during my childhood, and although this bird nesting was officially banned in 1954 it took a few years before the hobby was finally seen as abhorrent. At one time every child would have been given a butterfly net and specimen jar, or an egg-collecting kit with the little drill for making holes in the shell and a glass 'blowing tube' for removing the yolk. The prevalent view in those days was that egg collecting was educational, an opportunity to teach the young how to watch birds returning to their nest sites with nesting material, and that if one egg was subsequently carefully taken from a nest no harm was done as a bird would always lay a replacement.

In due course, Joe Botting, our gardener, began to take me ferreting, and within a year, as with many of my contemporaries, I acquired ferrets of my own and could ferret unattended. Ferreting is a wonderful way for the young of both sexes (my daughter, Rosie, kept ferrets) to learn the responsibility of looking after an animal, and if they have listened to what they have been taught they can have enormous fun hunting with them and experiencing the thrill of bringing something home for the pot. It is also the way in which urban sportsmen have traditionally kept in touch with their rural roots; even today there are more ferrets kept in municipal environments than rural ones.

As children we learnt the seasons of birds, animals, reptiles and insects; the ones that hibernated and those that were nocturnal; the predators, the quarry they hunted and the corridors of safety, such as hedgerows, that smaller animals used as habitat, or links between woodland. We also came to understand how wildlife responded to differing weather conditions, and, most importantly, we learnt to recognise the signs of animal presence. We could all identify the narrow tracks of rabbits leading from their burrows to their feeding grounds, or the broader path of a badger, the three forward and one-heel toe of a pheasant or four-toed narrow pad of a fox crossing a muddy path through a wood. The telltale signs left by the hair of an animal passing under or over a barbed-wire fence or close to brambles would not evade us, nor the fine, soft, grey-brown fluffy hair of a rabbit, the stiff,

straight, bristly hair of deer, the long, white and grey of a badger or the short russet of a fox. So, too, could we decipher the messages in their droppings: the twisted dung of a fox, full of fur, bone fragments and seeds, and the acrid stench of his urine, where he marked his territory; the oblong dropping of rats; the long, crinkly, single black dropping of a hedgehog, glinting with remnants of undigested beetle carapaces; the tidy, open latrine of a badger or the stinking, fishy pile of otter spraints on a boulder beside a river; the oval, dark khaki droppings of roe deer or the regurgitated pellets of an owl, full of the tiny bones of shrews and voles. Above all, we learnt that every wild animal relies on sound and scent to warn them of danger, and that silence and a downwind approach were essential if we hoped to watch them.

> AS A CHILD I GREW UP AT EASE WITH COUNTRY PEOPLE OR THOSE WHO WERE URBAN BASED BUT MADE THE EFFORT TO ENJOY THEIR RURAL HERITAGE. THROUGH HUNTING, SHOOTING AND FISHING I HAD A RANGE OF CONTACTS WHICH EXTENDED FROM LAND'S END TO JOHN O'GROATS, AND IT GAVE ME A WONDERFUL SENSE OF SECURITY, KNOWING THAT I HAD CONNECTIONS WITH COUNTRYMEN THROUGHOUT BRITAIN.

My father was a man of enormous energy who took his duty of stewardship – the historic responsibilities of a landlord towards the land and its people – very seriously and he regarded it as an important part of my early education. He was a Justice of the Peace and sat on the bench every week; he was also a Deputy Lieutenant of the County, Chairman of the Parish Council and his own land agent for the farms and woodland in the north. He served on the Hunt committee, was actively involved in the Pony Club, and each year he was responsible for designing and building a hunter trials course. He bred superb hunters and eventers; hunted, shot, fished and stalked; played for the village cricket team; regenerated the bell tower in St John's Church opposite our house and rang himself every Sunday. In her own quiet way, my mother was much involved in the church, the welfare of the old people in the village and the early days of Riding for the Disabled.

As I grew older and became more involved in the adult world, I met the ghillies, stalkers, gamekeepers and Hunt servants from whom I learnt the history of mankind's benign role in managing wildlife. They explained to me how field sports had contributed to the architecture of the landscape and were responsible for creating, preserving and maintaining the habitat of the different species, whether game birds such as pheasants, partridges, grouse or wildfowl, red deer or foxes.

As a child I grew up at ease with country people or those who were urban based but made the effort to enjoy their rural heritage. Through hunting, shooting and fishing I had a range of contacts which extended from Land's End to John O' Groats, and it gave me a wonderful sense of security, knowing that I had connections with countrymen throughout Britain. I remember being utterly miserable during my first term at boarding school and consoling myself with the thought that, although I had no idea where the school was or how far away it was from my parents, were I to make a break for freedom all I needed to do was find my way to the nearest Hunt kennels, where I would be sure of a safe haven and a route home. Field sports were not seen in isolation in those days, nor had socialist politicians

allowed lobbying by a single-issue animal rights group to create an ethnic minority among country people; they were, and still are, the catalyst that binds many communities together and provides them with the folklore that defines their regional identity.

The post-war arcadia of my childhood was about to undergo dramatic changes; during the fifties, sixties and seventies the government policies of agricultural intensification created a chain reaction of loss across the spectrum of wildlife. Vast quantities of habitat were destroyed in parts of Britain, as hedgerows were bulldozed out, old pasture, heath and downland ploughed and marshes drained under devastating Ministry of Agriculture reclamation schemes. Herbicides and pesticides killed the food source of many small birds, reptiles and mammals; this in turn impacted on the larger species that depended on them. At the same time, the Forestry Commission embarked on a massive programme of planting quick-growing Sitka spruce conifers. Huge tracts of land were planted, much of it in areas of outstanding natural beauty which are totally unsuited to growing trees, the Highlands of Scotland, for example, or the moorlands of Wales and England – Kielder Forest alone sprawls over 250 square kilometres of the Northumbrian hills. Rural communities disappeared; acres of ancient natural woodlands were engulfed, and in a matter of twenty years these plantings had grown into vast blocks of sterile woodland.

> AS MACHINERY INCREASINGLY REPLACED MANPOWER, 50 PER CENT OF THE AGRICULTURAL WORKFORCE LEFT THE LAND TO FIND ALTERNATIVE EMPLOYMENT IN TOWNS. THE SELF-SUPPORTING INFRASTRUCTURE OF VILLAGES BECAME ERODED, MANY OF THE OLD CRAFTS DIED OUT AND MUCH COUNTRY LORE, HANDED DOWN FROM GENERATION TO GENERATION, WAS LOST.

As machinery increasingly replaced manpower, 50 per cent of the agricultural workforce left the land to find alternative employment in towns. The self-supporting infrastructure of villages became eroded, many of the old crafts died out and much country lore, handed down from generation to generation, was lost. As agricultural reclamations destroyed the hedgerows and small broadleaved woodlands, they took with them the urban tradition of picking nuts and berries every autumn. Gradually, the much-vaunted urban–rural divide became established.

There were great changes afoot in my own life. After I left school I travelled in South Africa, Australia and New Zealand, working my way around as a stockman on a vast sheep station in Western Australia, as a cook and miner in an iron-ore mine, a jackaroo on a sheep and cattle ranch, a lumberjack, a non-union docker – all the usual odd jobs that people of my age did to earn enough to travel on to the next place on the atlas. When I arrived home, not only was the countryside I knew undergoing enormous changes, but the family farms had gone, and with them my assumption that I would, one day, take over the running of the farms in Northumberland. Uncertain of my next career move, I was persuaded to try the City, a way of life to which I was totally unsuited and unable to settle into. The call of the hills and wide open spaces drew me back to the north, and after a year studying hill and upland sheep, and beef management at the Northumberland College

of Agriculture, I found a partnership in a hill farm on the Lammermuirs. These heather-clad hills in southern Scotland were to be my home for the next twenty-five years, and would be the place where I brought up my children.

Hill farming fascinates me; it is archaic and, despite advances in veterinary science, has remained virtually unchanged since the Cistercian monks established their great flocks on the hills in the eleventh century. The sheep are practically wild animals, and to farm them at all on the open, unfenced hills, a shepherd needs to be as much a naturalist as a stockman. I love the broad perspective, the chuckle of grouse, the comings and goings of the migratory nesting birds – the snipe, curlew, oystercatchers, plovers, redshanks and skylarks who break the long silence of winter with their exuberant birdsong in the spring. Modernity made its brutal impact even on this pastoral paradise: farm prices fell and hill communities halved as one shepherd, supplied with an all-terrain quad bike, now had to do the same job that two had previously done.

One of the strangest aspects of farming in Britain since the War has been a complete turnaround in agricultural policy. I have witnessed the farming community being paid huge subsidies in order to inflict great damage to the surface of the landscape, and in a matter of a few decades those same farmers have been paid even larger sums to put it back again. The countryside will never be quite what it was in my childhood, but then, nothing stands still, however much one may want it to. What is important now is that the nation is aware of the fragility of what we have left of our natural heritage and that it must be cherished. The countryside is now seen as a force for good, and the communities that live there, their customs and traditions, worth supporting. Technology has enabled more and more people with urban-based employment to live in rural areas and to reap the benefits of the countryside for themselves and their children. What seems so sad to me is that many of the people who seek the pastoral idyll feel alien in the midst of their natural heritage. A combination of bureaucracy, ill-advised agricultural policies and a lack of understanding have gone a long way to hide the precious secrets of our sceptred isle. It is all still there, though – the romance, antiquity and beauty – just waiting to be found.

And Nature, the old nurse, Took
The child upon her knee,
Saying, 'Here is a story book
Thy Father has written for thee.'
HENRY WADSWORTH LONGFELLOW (1807–82)

BUSH PIE HILL

CHAPTER ONE

FARMING AND THE LANDSCAPE

The British landscape is an extraordinary creation; immensely ancient and full of enchanting surprises which open little windows of our history. I cannot believe that any other country has such a diversity of interest packed into a smaller space. It is impossible to go from one parish to another without coming across some arresting reminder of the country's past, each with a story to tell – an Iron Age fort, a strangely corrugated field, a ruin, a folly, a venerable tree, a stone circle, castle, sunken lane, ancient bridlepath, right of way, old stone farm building or simply an isolated patch of nettles, indicating that humans had once settled in the immediate area. Every day on my farm here in a remote part of the Scottish Borders, I walk past the physical memorials to previous occupiers of this land going back dozens of centuries. On a bank above the Whitrope Water is a boggy area of ground called Buckstone Moss, named after the Buck Stone, a Neolithic megalith erected perhaps 3,500 years ago by dreamy prehistoric pastoralists. There are the visible remains of the earth banks that surrounded the little fields attached to the Iron Age fort on a hill called the Lady's Knowe. Below these lies the Lady's Well, a freshwater spring revered by the Celts long before the nearby chapel was dedicated to St Mary or this lovely dirge was sung about a young man murdered by the brothers of the girl he loved:

They shot him dead at the Nine-Stane Rig,
Beside the Headless Cross,
And they left him lying in his blood,
Upon the moor and moss.

They made a bier of the broken bough,
The sauch and the aspin gray,
And they bore him to the Lady Chapel,
And waked him there all day.

A lady came to that lonely bower,
And threw her robes aside,
She tore her ling [long] yellow hair,
And knelt at Barthram's side.

She bathed him in the Lady-Well,
His wounds so deep and sair,
And she plaited a garland for his breast,
And a garland for his hair.

They rowed him in a lily-sheet,
And bare him to his earth,
And the Gray Friars sung the dead man's mass,
As they pass'd the Chapel Garth.

They buried him at the mirk,
When dew fell cold and still,
When the aspen gray forgot to play,
And the mist clung to the hill.

They dug his grave but a bare foot deep,
By the edge of the Ninestone Burn,
And they covered him o'er with the heather forever,
The moss and the Lady fern.

A Gray Friar staid upon his grave,
And sang till the morning tide,
And a friar shall sing for Barthram's soul,
While the headless Cross shall bide.

Between the Lady's Well and the ruins of St Mary's Chapel are a jumble of mounds and earth banks assumed to be the remains of the motte-and-bailey castle built by Sir Nicholas de Soules, Lord of Liddesdale, in 1240. Further on, beside the Hermitage Water, on a bank above a deep pool is an oblong hump, reputedly the grave of Sir Richard Knout, Sheriff of Northumberland, who was killed by retainers of the de Soules family in 1290 when they rolled him, in his armour, '*into the frothy linn*'. Then there is the grim awesome ruin of the Hermitage Castle, the '*Gatehouse to the bloodiest valley in Britain*', where, in 1566, Mary Queen of Scots had the infamous meeting with her lover, James Hepburn, Earl of Bothwell. Back in the body of the farm, a great wall of boulders, known as the White Dyke, runs across the middle of Hermitage Hill, said to be part of the deer 'haye' or funnel into which deer from the castle deer park were driven and slaughtered. There are more stone walls or 'dykes' built in the eighteenth century during the Acts of Inclosure, when gangs of Irish labourers built mile upon mile of walling across Scotland and Northern England. At much the same time, drainers dug open drains all over the hill to improve the quality of the grazing and built 'cundies' (conduits) to carry water from one of the hill burns to power the water mill at the steading. An old drove road runs down the side of the farm's northern boundary through an area known as the Mount; at the bottom are the ruins of an old toll house and the earth banks of Mount Park, where cattle from all over south-west Scotland rested for the night on their long journeys to the trysts in the north of England. The 'old' steading, a handsome range of slate-roofed stone buildings (cattle byres, cart sheds, granary and stabling), was built in 1835; the 'new' steading, a hideous open-span erection of steel girders, asbestos and concrete, was put up in the 1970s when the government was offering subsidies for new farm buildings during a drive to increase agricultural output.

I mention all this in detail because my farm only covers 600 hectares and, although having a castle on the doorstep adds a certain amount of added historical interest, the visible traces of preceding generations are similar to those of all other farms in the country.

OUR LANDSCAPE'S HERITAGE

Virtually every corner of the British Isles, from the tip of Cornwall to remotest Hebridean Island, has been owned and tilled, cropped and grazed for at least 7,000 years. For all its wonderful areas of remote, rugged and natural beauty – the Cumbrian Fells, the Cheviot Hills, the savage grandeur of the Highlands or the moorland of the West Country – Britain is the least wild of any country on the planet. It has been estimated the there is not a metre of land that has not been utilised by someone since the arrival of Neolithic man, and the landscape we love and admire is entirely man-made. The rolling heather-clad hills of Scotland are most certainly man-made – even the Broads, the stunning network of lakes and rivers covering 300 square kilometres of Norfolk and Suffolk. Until the 1960s, when the botanist and stratigrapher Dr Joyce Lambert proved otherwise, this vast wetland area was believed to be a natural formation. In fact they are the flooded excavations created by centuries of peat extraction. The Romans first exploited the rich peat beds of this flat, treeless region for fuel, and in the Middle Ages the local monasteries began to excavate the peat as a lucrative business, selling fuel to Norwich, Great Yarmouth and the surrounding area. Norwich Cathedral, one of the most stunning ecclesiastical buildings in Britain, was built with money from 320,000 tons of peat dug out of the Benedictine lands every year, until the sea levels began to rise and the pits flooded. Despite the construction of mills and dykes, the flooding continued, resulting in the unique Broads landscape of today, with its reed beds, grazing marshes and isolated clumps of wet woodland.

> VIRTUALLY EVERY CORNER OF THE BRITISH ISLES, FROM THE TIP OF CORNWALL TO REMOTEST HEBRIDEAN ISLAND, HAS BEEN OWNED AND TILLED, CROPPED AND GRAZED FOR AT LEAST 7,000 YEARS. FOR ALL ITS WONDERFUL AREAS OF REMOTE, RUGGED AND NATURAL BEAUTY ... BRITAIN IS THE LEAST WILD OF ANY COUNTRY ON THE PLANET.

During this incredible longevity of occupancy we have developed a passion for our countryside, a bond and an affinity with the land that is uniquely British. This love affair has been expressed throughout history by an almost obsessive desire to draw attention to the landscape by affectionately adding what was considered, at the time, to be an improvement to Nature's already superlative offering. Britain is covered in decorated summits, follies, woodland plantings, individual trees, artificial lakes and monuments, all carefully sited to improve the vista and all constructed as a statement of gratitude.

MAKING A MARK IN THE HILLS

Our Bronze Age and Iron Age ancestors were among the most diligent of landscape enhancers, compulsively building henges, erecting megaliths and carving hill figures where the colour of the chalk or limestone substrata would show up in contrast with the green of the surrounding sward. Undoubtedly the most famous of these is the White Horse of Uffington, high on an escarpment of the Berkshire Downs below Whitehorse Hill, a mile and a half south of the village of Uffington, looking out over the Vale of the White Horse.

For a piece of artwork which optically stimulated luminescence dating has proved to be 3,000 years old, the highly stylised curving design is extraordinarily contemporary. It was either the late Bronze Age or early Iron Age occupants of the adjacent Uffington Castle hill fort who devoted the immense amount of time, organisation and effort required to carve the 110-metre creature into the hillside and, despite endless hypotheses, no one really knows why. From my perspective, you only have to look at it for an explanation: the horse is a thing of beauty, young, sleek and vibrant, lunging forward with neck arched and forefeet raised, a picture of health and vitality. The carving was deliberately constructed just below the summit where it would be visible to other hill-top settlements and the horse triumphantly shouts a message from his tribe across the wooded valleys: 'Look at me!' The horse rejoices, 'Am I not magnificent? See how beautiful and fertile my hill is.'

Unless the substrata was regularly kept exposed, a hill carving would disappear back into the ground within a decade and there will have been hundreds of them dotted around the uplands which are now lost to us. The two Plymouth Hoe Giants, visible until the early seventeenth century, are an example, or the Firle Corn, a nearly lost hill figure on Firle Beacon, in Sussex, now looking more like a small ear of corn or a strange weapon than a human figure, whose existence can only be seen by infrared photography. What is so remarkable about the Uffington Horse is that for over thirty centuries whenever the turf looked like growing over it the local people have always cleared it away. Long after the original architects had passed on and whatever religious, totemic or cultural significance attached to the carving had been forgotten, successive generations have preserved the carving through all vicissitudes, simply because they liked having the horse on their hill and felt it looked better with it, rather than without it.

Some hill figures have been resurrected by nineteenth- and twentieth-century archaeologists – whose enthusiasm has almost certainly changed the original outlines. The Long Man of Wilmington is one, a familiar figure to me after my father moved from Cowden to Eckington Manor, in the village of Ripe, overlooking the broad sweep of the Southdowns in Sussex. The Long Man of Wilmington, or the Wilmington Giant, is a 70-metre-high figure holding what appear to be two staves on either side of him, cut into the downland turf on the slope of Windover Hill, between two spurs of lands that face north towards the weald. He is one of the largest such representations of a man anywhere in the world, beaten only by the Attacama Giant in Chile.

The origins of the Long Man have been the subject of endless debate, ranging from a heretical image carved by a secret occult sect of the monks of Wilmington Priory during the Middle Ages; a Celtic sun god opening the dawn portals and letting the ripening light of spring flood through, a Roman standard bearer, or a deeply symbolic prehistoric fertility symbol. Adherents to this line of thought maintain the Long Man is a reversed version of the priapic Cerne Abbas Giant and that the slope on which the old boy has been carved resembles a vulva. There is also a relatively recent theory which claims the Long Man is a sixteenth-century fake, based on carbon dating chalk rubble washed down to the foot of Windover Hill. In my view, this lacks about as much credibility as some of the more ludicrous

speculation about the carving's conception. I have no doubt that the Long Man was made by the late Bronze or early Iron Age tribesmen who occupied a substantial settlement on the summit of Windover Hill. This area is a rich source of archaeological remains, with numerous impressive high-status burial sites from different ages, lynchets or earth banks created by Celtic farming and several flint mines. Although flint was of principal importance to Neolithic people, it continued to be highly valued during successive periods of history.

The earliest-known sketch of the Long Man dates from 1710 when a surveyor, John Rowley, was hired to map the Duke of Devonshire's Sussex estates. Rowley's drawing shows the Lanky Man, Lone Man or Green Man, as he was known locally then, as a faint, fizzy outline on the sward with a conical head and bulges where his ears should be. He is forward facing, with eyes, nose and mouth marked; the body is bulky and symmetrical with a posture which holds a hint of challenge or confrontation. The outline was changed and, no doubt, many of the original features lost in 1874 when the Reverend W. de St Croix of the Sussex Archaeological Society persuaded the Duke of Devonshire to fund a project to clear the turf back to the chalk and fill the trench with yellow bricks. At the time, the Duke remonstrated with de St Croix that the bricks didn't fit the original outline and very little had been achieved of the purpose of the project. The original yellow bricks have been replaced on a number of occasions, the last time in 1969, none of which have followed the previous outlines and each has altered the Long Man's shape slightly.

> THE EARLIEST-KNOWN SKETCH OF THE LONG MAN DATES FROM 1710 WHEN A SURVEYOR, JOHN ROWLEY, WAS HIRED TO MAP THE DUKE OF DEVONSHIRE'S SUSSEX ESTATES. ROWLEY'S DRAWING SHOWS THE LANKY MAN, LONE MAN OR GREEN MAN, AS HE WAS KNOWN LOCALLY THEN, AS A FAINT, FIZZY OUTLINE ON THE SWARD WITH A CONICAL HEAD AND BULGES WHERE HIS EARS SHOULD BE.

Why did the ancients carve a giant man there? I believe, as with the White Horse, they were broadcasting pride of ownership of that particular hill settlement. One thing is certain, the lovely curvature of the Downs and the uniform, slightly convex slope between the two almost identical spurs on which the Long Man has been carved would pass completely unnoticed if he wasn't there. All the hill carvings, the few ancient ones which have survived or been resurrected and the many that were created in the nineteenth century during the great era of naturalist landscape design, draw the eye to a pleasing feature of landscape.

EARLY 'LANDSCAPING'

The exertion that went into digging out hill carvings pales into insignificance when compared with some of the other creations that display an extraordinary commitment of time and effort for no apparent purpose. Silbury Hill near Avesbury, in Wiltshire, is the tallest prehistoric, human-made mound in Europe and one of the largest in the world – similar in size to some of the smaller Egyptian pyramids of the Giza Necropolis. Composed mainly of chalk and clay excavated from the surrounding area, the mound stands 40 metres high and covers about two hectares. It is an exhibition of immense technical skill and prolonged control over labour and

resources. Archaeologists calculate that Silbury Hill was built nearly 5,000 years ago and took 18 million man-hours, or 5,000 men working flat out for fifteen years to deposit and shape 250,000 cubic metres of material. This incredible structure contains absolutely nothing; no burial chamber of a great tribal chief and not one iota of treasure. It was a huge disappointment to the first Duke of Northumberland, who employed an army of Cornish miners to burrow their way through the hill in 1766, convinced they would find him some loot. There is no explanation why anyone should want to build Silbury Hill, apart from the indisputable fact that it looks jolly impressive in the middle of an otherwise flat piece of ground.

Equally peculiar are the inexplicable earthworks known variously as black-dykes, devil's dykes or Grim's dykes, found from the south of England right up into southern Scotland. These consist of a ditch and mound of varying dimensions which follow a winding course across country, often traceable for miles. The great trench and mound of the Devil's Dyke in Cambridgeshire and the long line of Offa's Dyke on the Welsh Marches are two of the most well known. The Devil's Dyke runs for 12 kilometres from the flat farmland of Reach, past Newmarket to the wooded hills around Woodditton, periodically reaching a height of 11 metres. Offa's Dyke is the massive 200-kilometre linear earthwork, 20 metres wide and about 3 high, which roughly follows part of the current border between England and Wales. There are several other remains of earth banking: Grim's Ditch in Harrow; the Black Ditches at Cavenham in Suffolk; the Brent, Bran and Fleam Ditches in Cambridge; and Woden's Dyke in Wiltshire. In southern Scotland we have the Catrail, which meanders 22 kilometres from Roberts Linn, just up from the farm, to Hoscote Burn in south-western Roxburghshire. The 8-kilometre Picts Work Ditch, from Linglie Hill to Mossilee, near Galashiels and the Celtic Dyke in Nithsdale, Dumfriesshire, runs for about 27 kilometres parallel with the River Nith between New Cumnock and Enterkinfoot.

Scottish 'black dykes' are small compared to the others, being about two and a half metres at the base. Most of these earthworks appear to have been constructed in the early Anglo-Saxon period and all, even Offa's Dyke, share one thing in common: for all the labour and energy that must have gone into building them, they serve no recognisable function. They are demonstrably not defensive; in most cases they are so short that an enemy would simply nip round the sides or, in the case of Offa's Dyke, it would be impossible to man the entire length effectively. They are obviously not boundaries, and a theory popular among nineteenth-century Scottish historians, that they were built to hinder neighbouring tribes escaping with stolen livestock, was quickly discredited. The sort of semi-wild farm animals that were around in those days would easily have been driven through the wide ditch and up the slope of the earthwork.

I find it absolutely delightful that these ancient earthworks have completely stumped the theorists and not even the silliest neo-pagan can claim them as some sort of fertility symbol. So why were they built? In the absence of any other explanation, I presume the motive was similar to that which gave us Silbury Hill; someone must simply have woken up one morning and thought a big earth dyke in this or that location would improve the look of the landscape.

THE GREAT LANDSCAPE DESIGNERS OF THE SIXTEENTH AND SEVENTEENTH CENTURIES

The Normans built their castles, cathedrals and abbeys to dominate the landscape rather than to enhance it, impressing the population with their authority and the power of the Church. Building to improve the vista didn't really start again until the sixteenth and seventeenth centuries, when the owners of deer parks began to convert verderers' observation towers into what became commonly known as 'follies'. Verderers' towers were always built on the highest ground to give them a clear view of the surrounding countryside, and as a result they were visible for miles.

Arguably the oldest folly in Britain is the six-storey, red-brick Freston Tower, just south of Ipswich, in Suffolk, in the grounds of Freston House, on a high piece of ground overlooking the River Orwell. Local folklore claims the tower was built by a 'Lord de Freston' in the fifteenth century for his daughter Ellen, to enable her to study a different subject on a different floor six days of the week. The first floor was dedicated to reception, the second to tapestry working, the third to music, the fourth to painting, the fifth to literature, and the sixth to astronomy, complete with instruments for taking observations. In fact, it was built in 1578 by Thomas Gooding, a wealthy Ipswich merchant, and apart from occasional usage as a place for picnicking, the only functional purpose this stunning piece of Elizabethan architecture has served was between 1772 and 1779, when smallpox patients were quarantined there.

Freston was quickly followed by Rushton's Lodge in Northamptonshire, which was a delightful three-sided building designed by Sir Thomas Tresham, a local landowner, and was constructed between 1593 and 1597. Built as a testament to Tresham's staunch Roman Catholicism, the number three – symbolising the Holy Trinity – is apparent everywhere; there are three floors, three chimneys, trefoil windows and three triangular gables on each side. On the entrance front is the inscription *Tres Testimonium Dant* – there are three that give witness – which is a Biblical quotation from St John's Gospel referring to the Trinity. It is also a pun on Tresham's name; his wife called him 'Good Tres' in her letters.

Farming and the Landscape

Sir Thomas had been imprisoned as a subversive Catholic for much of the previous two decades and it was during his prolonged captivity that he formulated the idea of making a covert declaration of his faith, having already smothered his cell walls with symbolic letters, dates, numbers and other religious scribbles. It was not uncommon for the Elizabethans and Jacobeans to incorporate 'messages' or allegories within their houses, but one has to admire the man who created an elaborate and complex building for no other reason than to express his religious views.

Folly building became a craze among wealthy landowners in the seventeenth century, which escalated during the eighteenth as the Grand Tour increased in popularity. Those wealthy enough to indulge in an extended expedition on the continent, particularly to Italy and Greece, returned with a passion for Classical ruins. The 'picturesque' vogue led to the creation of mock-gothic ruins and ancient temples scattered with seeming random abandon about the estates of many grand houses, designed and positioned by the great landscape designers of the day. In 1734, William Kent built among many other follies the Temple of Ancient Virtue at Stowe in Buckinghamshire for Lord Cobbold. Giacomo Leoni designed the Cage in 1737, a three-storey square tower which glows gold in the evening sunlight, on a sandstone bluff overlooking Lyme Park in Cheshire. Henry Flintcroft built the magnificent Temple of Apollo for Sir Richard Hoare at Stourhead in 1765, which

dominates the top of a hill overlooking the ornamental lake, cascades and lesser temples dotted about the grounds. He also designed the magnificent triangular King Alfred's Tower, which, at 50 metres high, looms over the landscape and can be seen from a distance of 80 kilometres.

Not everyone slavishly followed the fashion for continental ruins; in 1754, Randle Wilbraham of Rode Hall built an elaborate summerhouse resembling a medieval fortress and a round tower on a rocky outcrop above Mow Cap near Harriseahead, in Staffordshire. It was John Murray, 4th Earl of Dunmore, however, who won first prize for eccentricity in 1761 when he persuaded Sir William Chambers to build him an enormous 15-metre pineapple on the roof of an already substantial building in the grounds of Dunmore House, near Falkirk. It is undoubtedly one of the architectural wonders of Scotland and looks quite startling against the skyline, which can only explain why Murray had it built. John Hanbury, a wealthy ironmaster, had the hexagonal Folly Tower built on a ridge 300 metres above sea level at his estate near Pontypool, Monmouthshire, in 1776, on the site of a Roman watchtower.

> FOLLY BUILDING BECAME A CRAZE AMONG WEALTHY LANDOWNERS IN THE SEVENTEENTH CENTURY, WHICH ESCALATED DURING THE EIGHTEENTH AS THE GRAND TOUR INCREASED IN POPULARITY. THOSE WEALTHY ENOUGH TO INDULGE IN AN EXTENDED EXPEDITION ON THE CONTINENT, PARTICULARLY TO ITALY AND GREECE, RETURNED WITH A PASSION FOR CLASSICAL RUINS.

> *Here where the hill holds heaven in her hands,*
> *High above Monmouthshire the grey tower stands,*
> *He is weather-worn and scarred, and very wise,*
> *For rainbows, clouds and stars shine through his eyes.*
> MYFANWY HAYCOCK (1937)

At the time of Hanbury's death in 1784, his family built the Shell Hermitage further along the same ridge, employing local craftsmen to decorate the interior of the sandstone and slate-roofed grotto with thousands of shells, teeth and animal bones. It is an important local landmark commanding fantastic views south towards the Severn Estuary and is considered to be the best surviving example of a grotto in Wales. In the last year of the century, the Countess of Coventry instructed James Wyatt to design a 17-metre-high mock-Saxon castle on the summit of Broadway Hill, 312 metres above sea level at the site where beacon fires had been lit since antiquity. This fantastic edifice, visible for miles on a clear day, was built for no other reason than the Countess had often wondered whether a lit beacon could be seen from her home in Worcester 35 kilometres away.

DESIGNING THE GREAT LANDSCAPES

The seventeenth, eighteenth and nineteenth centuries were the era of the great landscape gardeners, and as Britain became a colonial power, exotic plants from all over the world were introduced to Britain. John Tradescant the Elder and his son were both gardeners to King Charles I and early plant hunters, introducing the horse chestnut tree, scarlet runner beans, larch trees, apricots, Virginia creepers, yucca plants, tulip trees, pitcher plants, bald cypress trees, magnolias, phlox and asters to Britain.

In the early part of the eighteenth century, geniuses such as John Claudius Loudon, William Kent, Stephen Switzer, Charles Bridgeman and Henry Wise created magnificent gardens and stunning landscaped parkland at Windsor and Kensington Palaces, St James's Park and Hyde Park, Chelsea Hospital, Longleat, Chatsworth, Castle Howard, Blenheim Palace, Chiswick House, Cliveden, Rousham and Stowe, to name only a few. From 1719 at Rousham, in Oxfordshire, for example, Charles Bridgeman and William Kent created a vast Neoclassical landscape in a curve of the River Cherwell to recall the glories and atmosphere of ancient Rome. Paths wound through woods and little groves, where water from the Cherwell was diverted to create small rills leading to larger ponds and formal pools. Classical statuary of Roman gods and mythological creatures was cunningly positioned to catch the eye as paths led from cascades to water gardens and on to the next temple or arcade, each set in its own valley or glade, creating a string of picturesque tableaux.

It was whilst Bridgeman and Kent were transforming the 162-hectare Baroque park at Stowe, in Buckinghamshire, that Lancelot 'Capability' Brown was taken on as a pupil. Brown was arguably the most prolific and famous British landscape

designer of his time, creating around 170 parks around some of the finest country houses, most of which have endured to this day and are open to the public. His style focused on perfecting nature in huge landscape parks carved out of the adjacent countryside. Formal gardens were replaced by great vistas of smooth undulating grass running straight to the house; serpentine lakes formed by invisibly damming small rivers and clumps, belts, groves or scattering of trees judiciously positioned to accentuate a curvature of the ground or highlight the skyline.

Humphrey Repton was the last of that generation, designing parkland and gardens for nearly fifty stately homes, most notably at Stoneleigh Abbey, Blaise Castle, Wellbeck Abbey, and Woburn Abbey, Russell Square and Endsleigh, for the Duke of Bedford. Repton specialised in creating picturesque landscapes; at Endsleigh, the Duke of Bedford's fishing lodge on the Tamar in Devon, which I remember well from the days in the sixties when my grandparents took us fishing, Repton created a fantasy world of many secret gardens. The mansion house, a magnificent *cottage orne*, resembling a romantic rustic cottage, was built to designs drawn up by Sir Francis Wyatt between 1811 and 1814 on a bluff overlooking the Tamar Valley across to the thickly wooded Cornish bank. Repton 'improved' on the breathtaking natural beauty of the position by creating rose walks and terraces that lead to summerhouses and grottoes, hidden dells or crags with viewing seats. Acres of lawns tumble down to the river, past lily ponds, cascades, a Gothic garden and fernery, a hollow filled with giant gunnera, a miniature ice-house, an octagonal dairy, a shell grotto and a holy well. Behind the house is a stunning arboretum of exotic specimen trees, chosen to create a wonderful combination of colours: Himalayan birches, Japanese cedars, weeping beeches, Persian ironwoods, tiger-tail spruces and Douglas fir.

Literally hundreds of follies were built in the eighteenth century, but this was nothing compared to the deluge of constructions that followed. Some, such as the Penshaw Monument, are truly magnificent. This 20-metre-high replica of the Temple of Hephaestus in Athens, designed by John and Benjamin Green, was built in honour of the 1st Earl of Durham on Penshaw hill between Washington and Houghton-le-Spring, Tyne and Wear, in 1844. Others, such as the Sugar Loaf near Dallington, in East Sussex, are less spectacular but equally effective in attracting the eye to a feature of the landscape.

In the early part of the nineteenth century a splendid, hard-drinking Georgian character called Mad Jack Fuller commissioned Humphrey Repton to landscape the gardens at Rosehill, his estate at Brightling, and the architect Sir Robert Smirke to design a variety of different follies positioned to draw attention to areas of natural beauty, including a mock ruined tower, a beautiful Rotunda Temple, an observatory, a 20-metre-high obelisk built on the second highest hill in East Sussex, a beautiful arched summerhouse made of Coade stone, a mausoleum in the shape of a pyramid and a conical building, similar to a dunces' hat, on a ridge in front of his mansion. Folklore insists that the Sugar Loaf was built as a result of a drunken bet made at a dinner in London, when Mad Jack claimed to be able to see the spire of Dallington Church from his drawing room. Upon returning home, he discovered he was entirely wrong and that a ridge obscured his view of the church. The wager was to be judged in a matter of days, and to win the bet Fuller employed every man on the estate to build what appeared to be, from a distance, the church spire.

> FOLKLORE INSISTS THAT THE SUGAR LOAF WAS BUILT AS A RESULT OF A DRUNKEN BET MADE AT A DINNER IN LONDON, WHEN MAD JACK CLAIMED TO BE ABLE TO SEE THE SPIRE OF DALLINGTON CHURCH FROM HIS DRAWING ROOM ... THE WAGER WAS TO BE JUDGED IN A MATTER OF DAYS, AND TO WIN THE BET FULLER EMPLOYED EVERY MAN ON THE ESTATE.

It is sad that this story is universally accepted as fact, when no Regency gentleman would have risked the social disgrace of reneging on a bet, least of all Mad Jack, who was a noted philanthropist. He was a founding member of the Royal Institution, built the Belle Touche lighthouse on the cliffs above Beachy Head and provided Eastbourne with a lifeboat, bought Bodiam Castle to save it from demolition and bestowed the nation with the Fullerian Professorship of Chemistry and, a little later, the Fullerian Professorship of Physiology.

I am sure the Sugar Loaf was built for no other reason than Mad Jack thought a mock spire would make the ridge in front of his house stand out nicely. The unusual style of the construction is easily deduced; Fuller's fortune was derived from iron foundries and sugar plantations. He had already constructed two massive pillars topped with cast-iron sculptures depicting cannons, flames and anchors, representing that side of his fortune; the Sugar Loaf represented the other side.

The last of the follies was Faringdon Folly Tower, built in 1935 on Faringdon Hill in Oxfordshire on the site of an ancient hill fort. Faringdon Hill was already a historic landmark before the superbly eccentric 14th Lord Berners, famous for dyeing fan-tailed pigeons vibrant colours and keeping a pet giraffe in the house,

decided to commission the architect Lord Gerald Wellesley to design a 43-metre-high brick monument. Asked why he was doing it Lord Berners replied, 'The great point of this tower is that it will be entirely useless.' This was the sort of *double entendre* for which he was famous. He was in effect saying, if the questioner was so blind to beauty he failed to appreciate that Folly Tower would become the focus of attention for miles (it can be seen from five different counties) highlighting the rolling hills above the Vale of White Horse, then it becomes a futile structure providing nothing more than a panoramic view to the minority who climb to the top.

Lord Berners's real feelings about the tower are revealed by the fact that he actually had it built as a birthday present for his adored companion, Robert 'Boy' Heber Percy. At the unveiling ceremony, 'Boy' appeared visibly upset and was heard muttering tearfully that all he had ever wanted for his birthday was a white pony and some pink dye.

HISTORY IN A NAME

The curious intimacy with the land which seems to me to be an exclusively British characteristic is expressed by the way every geographical feature, however insignificant, has over the long course of history been personalised with its own name. Every wood, copse, spinney, dell, dene, gully, knowe, field, meadow, stream, bog or pond has been christened after a person, a local or national event, the type of growth in the immediate area, an animal or an interesting landmark. Rural place names are the narrators of the countryside, giving it identity and a feeling of companionable familiarity.

A glance at an Ordnance Survey map of the district immediately around Wingates, in Northumberland, where we owned family farms when I was a child, is a typical example; one that is replicated in similar density across the whole of Britain. Interspersed among ancient earthworks, cairns, sites of Iron Age settlements, traces of a Roman road known as the Devil's Causeway, remnants of Cistercian monastic granges and the ruins of a sixteenth-century castle are place names which give an indication of their history. Doe Hill was presumably a piece of good, sheltered land where does calved in the spring; Heron's Close, perhaps a wood where herons nested; Harelaw, a grassy hillock frequented by hares during the rut and Haredene, the little wood adjacent to it. Garrett Lee Wood and Geordie Bell Plantation are named after people long forgotten, but whose names live on in history; Todburn is a small stream near a fox earth; Whinney Hill, where gorse would be encouraged to grow for winter feed; Linden Hill Head, the hill above a wood of lime trees; the Birks, a birch wood; and Gallows Shaw, a wood where there was once a gallows or a hanging tree. Beggars' Bush denotes a hawthorn spinney; a hawthorn was known as a beggars' bush because vagrants often slept under them, the dense branches offering some weather protection. *'Who shall never tarry with master, but trudge from post to pillar, till they take up beggars' bush for their lodging.'* The saying 'go to the beggars' bush' was subsequently usually applied to people who had brought about their own ruin. Ewesleys was a productive pasture for pregnant ewes; and Sheep Wash a field adjacent to a stream where sheep used to be washed before shearing, to remove the sulphur grease rubbed into their fleece to prevent parasites and maggot fly. The Chirm (as in charm) was a copse noted for little birdsong; Pie Hill, from its circular shape and round, flat top; and Whitham's Hole, a bog.

Place names are the windows that give us an insight into our most precious historic document; the landscape contains most of the evidence of our past and provides unparalleled revelations about our ancestors' way of life, their hopes and aspirations. The intricate pattern of farmland, woods, forestry, villages, market towns, follies, sites of ancient settlement, earthworks and chalk carvings all play their part in the complex story of these islands.

THE EVOLUTION OF THE BRITISH LANDSCAPE

The landscape today is like a complicated, multi-layered puzzle where ancient and modern places exist side by side, with natural and man-made features inextricably interwoven. It is the variety of patterns created by historic and contemporary methods of land use which gives the countryside its infinite diversity and endless fascination, and it is the analysis of the way these fit together that enables us to map its evolution.

The character of the countryside depends on a number of different factors, but geology and soil fertility are the two determining influences on the way people have interacted with nature to establish the detailed individualism of different areas. The human imprint is fundamental, either through good management practices or by ruthless and destructive exploitation. In some counties the process of change has been continuous for many centuries, escalating rapidly within living memory until the landscape became unrecognisable to those who grew up there. In others it has remained largely unchanged since the Agricultural Revolution, and in a very few places, such as our farm, the present-day surroundings would seem quite familiar to our pre-Roman forebears.

Throughout history farmers have been responsible for the shape of the countryside, gradually clearing the forests of wildwood and breaking in the land. When populations expanded, they extended farming into areas normally considered marginal and unproductive and even reclaimed land from the sea – in Norfolk and Lincolnshire, for example, or the coastal marshes of Kent and Essex. When the population was periodically in decline, as it was after the collapse of the Roman Empire, they abandoned the reclaimed land and allowed it to revert.

For many centuries this trend was cyclical and subject initially to the movements of prehistoric people across Europe to Britain, bringing improved agricultural methods. It was influenced by changing weather patterns, periodic famines, pestilence and war; particularly during the Anglo-Saxon era and later by the conflicts with Wales, Scotland and interminable hostilities with France. Since the Norman Conquest, trends in agriculture have been highly dependent on market demand for certain commodities and the investment response by landlords. Our chalk and limestone uplands were heavily farmed by early agriculturalists but reverted to grass when better land was reclaimed by the Romans and Anglo-Saxons. With the arrival of the Normans these uplands became highly valuable to landlords as sheep grazings and remained so until the twentieth century, when much of it was ploughed out for arable crop production to meet consumer demand. Similarly, the land round my farm had been occupied by Bronze and Iron Age people, was largely abandoned by the Romans and Anglo-Saxons and then became highly sought-after by the wool-producing Cistercian Abbeys. With the Dissolution of the Monasteries, the huge monastic flocks went and the land was crofted by little pockets of subsistence farmers until it became valuable again, when good-quality low-ground acres on which sheep had been grazed were needed for grain.

It is the same story with the great, medieval, open-field, strip-farming systems in the West Midlands and parts of East Anglia, which were converted from arable back to grass in the sixteenth century. An early act of enclosure enabled Elizabethan

landlords wishing to benefit from the boom in the wool price to create sheep walks by hedging and walling. By the time the wool price collapsed, the urban population had increased and the land was ploughed out for arable cultivation, removing most of the traces of ancient strip farming.

Equally, if agricultural expansion was influenced by war, famine and market growth, it in turn controlled population growth. By 1750, the population in Britain had reached nearly six million. This had happened before: in around 1350 and again in 1650. Each time, the appropriate agricultural infrastructure to support a population this high was not present, and the population fell. However, by 1750, when the population reached this level again, developments in agricultural technology and new methodology allowed the population growth to be sustained.

> OLD FARM BUILDINGS, SIMILAR TO THE EARLY NINETEENTH-CENTURY STEADING ON MY BORDERS' FARM, HAVE A SIGNIFICANT TALE TO TELL, AS DO THOSE WHICH WERE ABANDONED AT AN EARLIER TIME AND ARE NOW NO MORE THAN AN UNDULATION IN THE GROUND ... THESE TRACES OF LAND USE HELP TO INTERPRET OUR PAST AND UNDERSTAND OUR LANDSCAPE HERITAGE.

What are now recognised as historic landscape features were created by agriculturalists over this long period of fluctuations in farming methods and population growth. Heaths, of which there are 58,000 hectares in places such as Ashdown Forest in Sussex, Delamere Forest in Cheshire, Clashindarroch Forest (one of many in Scotland) or Exmoor in Somerset, were created by long-term overexploitation of poor soils by prehistoric farmers. There are 23,000 hectares of surviving wood pasture in places such as the Savernake Forest, and traces of early soil tillage can be found dotted across Britain, particularly in the Midland counties; reeves, cord rigs, lazy beds and lynchets. Old farm buildings, similar to the early nineteenth-century steading on my Borders' farm, have a significant tale to tell, as do those which were abandoned at an earlier time and are now no more than an undulation in the ground. Ancient trees are fundamental to the landscape; their presence often indicates an old parish boundary, the remains of parks and wood pasture or the existence of a field. Individually or together, all these traces of land use help to interpret our past and understand our landscape heritage.

About 6,500 years ago, the nomadic Neolithic hunter-gatherers began to establish semi-permanent settlements, clearing the native wildwood and converting the land to agriculture. Trees were killed by copying the damage done by wild animals chewing off the bark; 'ringing' with a stone axe or knife prevents sap flow and eventually the tree died, the stumps rotted away, the undercover was burnt and tillage could begin. The population at that time was probably about 80,000, made up of small farming families organised into farmsteads and hamlets along similar lines to that we see today – namely that the lowland valley of the south east of the country was best suited to the production of crops while the more upland areas elsewhere were suited to pastoral farming. The new land, cleared so laboriously, was farmed for about twenty years until fertility was exhausted and production dropped below a level sufficient to sustain the settlement, at which

point the community moved on to clear new land and start afresh. Land that was abandoned then reverted to scrub and woodland, before the cycle started again and it was cleared once more.

The climate was warm and wet, and primitive species of wheat – emmer and einkhorn – were easily grown, as were barley, beans and pulse. Neolithic man was also heavily dependent on the early spring growth of wild plants that thrive near human habitation, such as nettles, orache, fat hen and Good King Henry. Soil preparation involved scratching the ground with an ard – a primitive plough consisting of a frame mounting a nearly vertical wooden spike, dragged through the soil by human effort. Rather than cutting and turning the soil to produce furrows, it breaks up a narrow strip of soil, leaving intervening strips undisturbed. Cross-ploughing was often used, where the soil is ploughed again at right angles to the original direction. Harvested crops were stored in pits which allowed surplus produce to be used in times of need.

Storage, more than anything else, allowed the development of farming and, ultimately, civilisation. Sheep, goats and cattle were kept as well as domesticated wild pigs. Within the limitations of stone knives and axes, the wildwood conterminous with settlements was coppiced. Towards the end of the Neolithic period, settlements became permanent enough for causeway enclosures to be built as communal meeting places, for example at Coombe Hill, near Jevington in Sussex, or Flagstones in Dorset. Chambered long barrows were also constructed to house the dead, such as the one on Gussage Down in the Cranborne Chase area of Dorset, Barclodiad y Gawres in Anglesea, Belas Knap near Cheltenham, Maeshowe on Orkney, or Stoney Littleton Long Barrow. The first of the henges were painstakingly erected – testaments to Neolithic man's commitment to settling where these were built, including Ballymeanoch, in Kilmartin Glen, Scotland; King Arthur's Round Table and Mayburgh henge, near the village of Eamont Bridge, Cumbria; the Ring of Brodgar in Orkney; Thornborough Henges, near Masham in North Yorkshire; Maumbury Rings, near Dorchester in Dorset and, of course, Stonehenge in Wiltshire.

During the 1,500 years of the Bronze Age, from roughly 2100 to 750 BC, there was significant population growth as agriculture expanded throughout most of the country. Recent research suggests that the population may have exceeded a million by 2,000 BC. However, within the huge time period of this age, population growth and subsequent decline could have occurred many times as the fertility of farmland became exhausted and food production fell. In the 2,000 years since the first farmers arrived, large tracts of the wild wood had been cleared and agriculture was transforming the landscape.

For much of the Bronze Age the climate was considerably warmer than today – probably by as much as 2 degrees Centigrade. This warmth had a

significant effect on agricultural land use and farming was able to extend into the moors and uplands of Britain. Wheat and barley were the main crops, grown for flour, straw, animal feed and, for the first time, malt for alcoholic drinks. Oats, rye, peas and beans and some hay for animal feed were grown, while straw was used for bedding, thatching and winter fodder. Cattle had always been important to prehistoric farmers, but there was an increase in the importance of sheep through the Bronze Age as people had learnt the art of weaving and basic woollen clothing was becoming commonplace. Large livestock farms developed in the lowlands and appear to have contributed to economic growth and inspired increasing forest clearances. Goats and pigs both had an important place in Bronze Age communities, because they were foragers and easy to keep. Evidence shows that large areas of the countryside were laid out in unenclosed square fields, reflecting ploughing in two directions, whilst in other parts of Britain fields were enclosed by earthen banks. Traces of Bronze Age field systems and their 'reeves', or earth banks, and raised parallel boundary banks are particularly visible on Dartmoor or the Lizard and Land's End in Cornwall. Tracks and ways across the countryside allowed localised trade and some exchange of animals to prevent in-breeding. The Ridgeway, Britain's oldest road, which can be followed from Overton Hill, near Avebury, and Ivinghoe Beacon, in Buckinghamshire, is a surviving example and was almost certainly used to traverse the entire chalk escarpment that runs from Dorset to Lincolnshire.

Many famous henges that date from this period show society was well structured and able to call upon a significant population resource to build the many public monuments, where religion or ritual was an inseparable part of everyday life. Pottery was now decorated and noticeably finer and the arrival of metallurgy and the production of bronze led to new tools as well as ornaments and symbols of status. Late in the Bronze Age, around 1000 BC, the climate cooled and became wetter and many of the farming settlements of the upland areas were abandoned, not to be resettled for some 2,500 years. The Bronze Age was a peaceful and very prosperous period. Society was well structured and able to call upon a significant population resource for building projects such as enlarging Stonehenge and the erection of many other monuments: Seahenge, just off the coast of Norfolk at Holme-next-the-Sea; Achavanich, near Loch Stemster in Caithness; Beckhampton Avenue, in Witshire; Birkrigg, in Cumbria; Doll Tor and the Nine Ladies, in the Derbyshire Peak District; Rollright Stones, on the borders of Oxfordshire and Warwickshire; Tregeseal East and Mên-an-Tol, in Cornwall; Gors Fawr, Meini Gwyr, Cerrig Duon, Maen Mawr, Nant Tarw Group and Grayhill in Wales. There are hundreds and hundreds of Bronze Age megaliths across Britain, and Northern Ireland has over sixty, all indicating a cosy and settled population.

HOW FARMING ALTERED THE LANDSCAPE

The Celts started to migrate to Britain in the eighth century BC, bringing with them advanced agricultural techniques in both grain and livestock farming, and within a hundred years many parts of the country were already owned, managed and planned in much the same way that they are now. Little wildwood remained in southern Britain and the land resource was well planned with field systems in rotation, pasture and coppiced woodland. Hill forts became common and acted as local centres of administration, power and refuge.

The range of crops grown had widened considerably since the early Bronze Age and although the most important were emmer, einkorn and spelt, varieties of wheat, barley, oats, tic beans, vetch, peas, rye, flax, wode and fat hen were regularly grown. The earliest written information about Britain records that the Celts of southern and eastern Britain were skilled arable farmers. Archaeological evidence indicates that a mixture of pastoral and arable farming was practised throughout the country. Nevertheless, the balance between these farming methods in any given area would have been dependent, to some extent, upon the geographical location and trading relationships of the different tribes. As grain farmers they were surprisingly advanced; according to the Roman reporter, Pliny the Elder, British farmers invented the practice of manuring the soil with various kinds of mast, loam and chalk. He described how chalk was dug out from 'pits several hundred feet in depth, narrow at the mouth, but widening towards the bottom'. In 70 AD he wrote: 'The chalk is sought from a deep place, wells being frequently

sunk to 100 foot, narrowed at the mouth, the vein spreading out within as in mines. This is the kind most used in Britain. It lasts for eighty years and there is no instance of anyone putting it on twice in his lifetime.' There are hundreds if not thousands of the remains of 'Deneholes' in the chalk uplands of Kent, where chalk had been extracted to spread on local fields as top dressing.

Until destroyed by modern agriculture, small, irregular, squarish, Celtic fields covered thousands of square kilometres of chalk downland and other terrain which had escaped medieval and later cultivations. Although often less than half a hectare, they were surrounded by great earth banks, the product of countless man hours. The square shape expresses the custom of ploughing in two directions at right angles. On slopes, the action of the plough tended to move earth downhill, forming terraces called *lynchets*. Very good examples of these can be seen near Bishopstone and Great Wishford in Wiltshire; the Chess Valley near Rickmansworth; in among the Bronze Age reaves systems on Dartmoor, and anywhere in the vicinity of Iron Age hill forts, of which the remains of any number are still visible: Bindon Hill near Lulworth Cove, in Dorset; Tre'r Ceiri and Castell Henllys, in Wales; Castle an Dinas and Chun castle, in Cornwall; Danebury, in Hampshire; Wincobank, near Sheffield; Sutton Bank, in Yorkshire; Yeavering Bell, Traprain Law in East Lothian; and, of course, the one on my farm. Storage of crops was either in pits or in raised stores and harvest was over several months: weeds, some hay, grain and then straw.

Cattle were king in the Celtic world and a man's wealth was measured by the number of his herd. The Celts introduced the now extinct Celtic Shorthorn cattle to Britain, from whom the Dexter and Kerry are descended. There were considerable flocks of primitive dual-purpose sheep kept for milk and wool. Woollen garments such the British hooded cloak – the *birrus* – were a major export in the Iron Age. Sheep were similar to the Soay, Manx, Hebridean and Shetland breeds of today, kept for milk and wool; unlike modern breeds of sheep their wool can be pulled – 'plucked' – from their backs without shearing. Goats and pigs were important to settlements for their ease of keeping, and poultry, geese and ducks were introduced for the first time. Horses were a new arrival in the wealthier farmsteads but they were not used for work (oxen were the beasts of burden) so much as symbols of status and for driving in the Celtic war chariots.

> THERE WERE CONSIDERABLE FLOCKS OF PRIMITIVE DUAL-PURPOSE SHEEP KEPT FOR MILK AND WOOL. WOOLLEN GARMENTS SUCH THE BRITISH HOODED CLOAK – THE BIRRUS – WERE A MAJOR EXPORT IN THE IRON AGE. SHEEP WERE SIMILAR TO THE SOAY, MANX, HEBRIDEAN AND SHETLAND BREEDS OF TODAY, KEPT FOR MILK AND WOOL.

Farming typically revolved around small hamlets and farmsteads with enclosed rectilinear fields, each having areas of pasture, arable and wood. Ploughing became more efficient with the arrival of the iron 'share' plough point and a 'mould board' which turned the sod, making the cultivation of heavy, clay soils possible, and a two-field rotation was introduced: cropping one year followed by a fallow that was grazed by livestock. This led to surprisingly high yields and fuelled a growth in the population, believed to have exceeded three million.

The clearance of woodlands and opening up of areas with heavy clay soils, moreover, spread bread-wheat farming throughout much of lowland Britain – one of the reasons for the attraction of Britain to the later Roman invaders. Indeed, when Pytheas of Massilia (modern-day Marseilles) circumnavigated Britain around 330 BC, he described the people he encountered on his voyage as skilled wheat farmers. Other commentators, such as Strabo, the geographer, observed that *'Britain produces corn, cattle, gold, silver and iron. These things are exported, along with hides, slaves and dogs suitable for hunting. The Gauls, however, use both these and their own native dogs for warfare also.'*

Under the Romans, farming methods changed through a combination of technological advances and planned field systems, producing an order and regularity to the countryside that increased output and aided communication. A range of innovations in agricultural equipment, plant types and animal species were introduced, amongst which were a variety of different ploughs to suit different soil types. In particular, a symmetrical share that turned the sod simultaneously to right and left and an improved version of the existing Celtic plough with its metal share and moulding board, to which was added a coulter – a blade cutting through the soil vertically ahead of the plough which enabled previously unworkable land to be broken in. They also introduced a number of new agricultural tools: sickles, mattocks, hoe rakes, turf cutters, iron rakes, two-handed scythes, mower's anvils, forks, slip-eye axes and metal spades. The most important of these was the two-handed scythe, making close cropping of hay, other fodder crops and grain possible, and the metal spade, which had an important impact on field drainage.

> UNDER THE ROMANS, FARMING METHODS CHANGED THROUGH A COMBINATION OF TECHNOLOGICAL ADVANCES AND PLANNED FIELD SYSTEMS, PRODUCING AN ORDER AND REGULARITY TO THE COUNTRYSIDE THAT INCREASED OUTPUT AND AIDED COMMUNICATION.

Improved methods of grinding corn were brought in from the Continent along with the novel idea of drying corn in purpose-built heated granaries.

All these were of secondary importance to the development of a demand-led economy that pushed agricultural production to new peaks. Towns such as London, Bath, Colchester, Newcastle, Corbridge, York and Carmarthen, to name only a few, were a new feature in the landscape and both a catalyst for further agricultural production and consequence of it. There was also the Roman army which became a major purchaser, encouraging farmers to grow produce for sale rather than primarily for subsistence. The existing cultivated plants continued to be grown and new species of vegetable were introduced: cabbage, broad bean, parsnip, peas, radish, turnip, celery, carrot, mustard, tares and corn spurry. They also brought fruit trees and established orchards of cherry, plum, medlar, damson, bullace, apple, mulberry, figs and grapes.

There is evidence that existing sheep and cattle were improved by cross-breeding with Roman stock. I have always understood that the Romney Marsh sheep are descended from those belonging to the large Roman settlements on the fringes of the Kent and Essex salt marshes. Apart from the excellent grazing, the attraction of

marshes was the absence of liver fluke in salt water, which today still causes numerous deaths among sheep. Although wheat was the staple diet of the army, beef was the preferred ration and numerous large cattle ranches were established in the south and near places such as Hadrian's Wall and other military depots or legion bases. Livestock farmers prospered as much as grain producers; apart from meat and textiles there was a huge demand for hides to supply the army's need for leather.

The Romans introduced the revolutionary three-year or three-field system of cultivation to their arable farms, which improved soil fertility and increased productivity by rotating rye or winter wheat, followed by spring oats or barley, then leaving the field fallow during the third stage. The average size of arable farm was between 100 and 142 hectares, made up of regular-shaped oblong or square fields of around five hectares. Eastfield and three other villas near Andover, for example, North Warnborough and Stroud in Hampshire, East Grinstead and Wigginholt in East and West Sussex, and Rodmartin in Gloucestershire, were all about the same size. There were also some substantial estates and cattle ranches: Ditchley in Oxfordshire was over 400 acres; Bignor in Sussex and Cromhall in Gloucestershire were both 800 acres. Woodchester, the most magnificent of all the villas outside Rome, would have been the centre of an even more substantial hectarage. There are over a hundred major Roman sites in England, twenty in Wales and six in Scotland, plus literally hundreds of minor ones. For example, in Southern Scotland alone there are any number of farms with the name 'Chesters', indicating that there was Roman occupation and agriculture of some sort on that site.

By the fourth century AD, the population had risen to nearly five million with a substantial urban population engaged in trades and crafts, enjoying a civilised life with baths, sanitation, culture, education and entertainment. Agriculture was booming, buoyed by a money economy, efficient transport and urban markets. Unfortunately it was not to last; the Empire was overstretched and the barbarian hordes were at the gates of Rome. The legions were hurriedly recalled and within a few decades life for the population would change dramatically. The order and sophistication of the Roman period would not be seen in Britain for another thousand years.

During the fifth and sixth centuries, the endless upheaval of wars, famine, disease and political uncertainty led to a massive depopulation of Britain. By 700 AD, numbers had fallen to substantially less than two million as droves of migrants fled to north-western France, forming what is now Brittany, or Northern Spain, to create Britonia. By the beginning of the eighth century, trade that had driven the growth of agriculture in late Iron Age and Roman times had long since collapsed and farming was purely for subsistence.

Initially, the magnificent Roman villas were occupied by communities of squatters, but as the buildings collapsed through lack of repair, the majority of the population lived on small farmsteads made of wood, wattle and reed thatching. In the chaotic social structure of the time there were two classes of freemen below the king and above slaves: thanes at the upper end and ceorls (churls) at the lower. A man could only be a thane if he owned at least five hides of land – a hide being roughly fifty hectares – and a ceorls was literally 'a non-servile peasant farmer,' who farmed land under obligation to a succession of landlords, who changed according to the outcome of various territorial squabbles.

The standard cereal crops were grown but the area under arable production had fallen considerably, with much of the land previously under cultivation reverting to rough pasture, scrub and woodland. Ceorls resumed the Iron Age practice of a simple two-field rotation, typically farming one or two hides of land in small irregular-shaped fields with rough hedging or earth banks. Innovations in agriculture were non-existent and it would be some time before the open-field system was adopted, where ceorls worked co-operatively, sharing the expense of a team of oxen to plough the large common fields in narrow strips that were shared out alternately so that each farmer had an equal share of good and bad land – a change that would develop over the next two centuries and again alter the face of the countryside for generations to come.

> INNOVATIONS IN AGRICULTURE WERE NON-EXISTENT AND IT WOULD BE SOME TIME BEFORE THE OPEN-FIELD SYSTEM WAS ADOPTED ... A CHANGE THAT WOULD DEVELOP OVER THE NEXT TWO CENTURIES AND AGAIN ALTER THE FACE OF THE COUNTRYSIDE FOR GENERATIONS TO COME.

Livestock would have generally been farmed in small numbers sufficient only for the farmsteads' needs and dependent on how much could be grown to feed them through the winter. Cattle were kept primarily for milk, or as beasts of burden, and eventually for their meat and hides. Sheep were kept for milk and wool. All settlements had a few self-sufficient goats producing milk, even from the poorest diet, and large herds of pigs browsing in the adjacent woods.

When they weren't fighting, hunting was an important part of the lives of Anglo-Saxon thanes, with horses and hounds regarded as valuable status symbols, often being buried with their owners, such as the one at Lakenheath, in Suffolk. Later much of this land was consolidated into the large estates of wealthy nobles and the Church. Ceorls might work the land in return for service or produce, or they might work the lord's land a given number of days per year. As time went on, more and more of these large estates were established as integrated commercial enterprises, complete with sophisticated water mills to grind grain, such as the ones at Corbridge in Northumberland, Tamworth in Staffordshire, or Old Windsor in Berkshire.

By the end of the Anglo-Saxon period an increasing number of lords had led to a division of the landscape into smaller blocks, more akin to today's parishes, often with a single large manor and its associated church. Trade with Europe and Scandinavia in hides, wool and slaves was picking up and craftsmen were

beginning to form themselves into guilds, such as the Fellmongers, Horsemongers, Fleshmongers, Shieldwrights, Shoewrights, Turners and Salterers. A new socio-economic order was becoming established which was centred on the church and monasteries, the climate entered a warm cycle and Britain started to become prosperous again. This prosperity is reflected by the periodic discovery of rich hoards of Anglo-Saxon treasure, such as the priceless discoveries at Sutton Hoo or the 1,500 pieces of gold objects found by a metal detector in a Staffordshire field in 2009. Nor is there any shortage of archaeological sites: Spong Hill at North Elmham in Norfolk, the largest Anglo-Saxon cemetery, with associated field boundaries, enclosures and sunken huts; or West Stow, where an entire village has been excavated. There is also an extensive site at Cheddar, in Somerset, where King Edmond had his palace and settlements in the Yorkshire Wolds, such as Wharram Percy and Cottam; sites at Loughborough, Barrow and Rothley in Leicestershire; Yardley and Kings Norton near Birmingham and Langford in Oxfordshire, which formed part of a large comital estate, probably including Broadwell and Great Faringdon.

ADVANCES IN FARMING

The Normans arrived in an aggressive blizzard of super-efficiency. Within a matter of years, rebellion was quashed and the old Anglo-Saxon aristocracy eliminated. The estates of the 4,000 or so principal Anglo-Saxon landowners were confiscated and divided among just 170 Norman knights. By 1096, all Anglo-Saxon ecclesiastics had been replaced by Normans and the extensive church lands were in Duke William's hands. Fifty per cent of Britain was now owned, subject to their obligation to the King, by the 170 'tenants in chief', whilst William and the Church owned the rest. Because he was able to grant his followers vast tracts of land at little cost to himself, William's prestige increased tremendously. His awards also had a basis in consolidating his own control; with each gift of land and titles the newly created feudal lord would have to build a fortified manor or castle and subdue the local Anglo-Saxons. The social structure of the country was organised round the system of feudalism, which was built upon a relationship of obligation and mutual service between vassals and lords, with everyone owing fealty to the King. In practice the country was not governed by the King but by individual lords, or barons, who administered their own estates, dispensed their own justice, minted their own money, levied taxes and tolls, and demanded military service from vassals who held land as a grant from a lord. As the country settled down after the Conquest, small farmsteads started to nucleate, hamlets formed and the familiar landscape of villages, manor houses and churches took shape.

A typical Norman estate consisted of a manor house, one or more villages and

up to several thousand acres of land divided into meadow, pasture, forest and cultivated fields. Fields were further divided into strips: a third for the lord of the manor, less for the church, and the remainder for the peasants and serfs who worked the land. This land was shared out so that each person had equal portions of good and poor. At least half the working week was spent on the land belonging to the lord and the church. Time might also be spent doing maintenance and on special projects such as clearing land, cutting firewood, and building roads and bridges. The rest of the time the villagers were free to work their own land.

The open-field system developed by the Saxons was widely adopted by 1100 AD; land was divided into strips and allocated amongst the community on a changing basis. This gave rise to a ridge and furrow effect across the field where the soil in the strip was continually ploughed back into the centre of itself and away from adjoining strips. Ridge and furrow often survives on higher ground where the arable land was subsequently turned over to sheep walks in the fifteenth century and has never been ploughed out since by modern ploughing methods, today surviving as pasture and grazing for sheep where the effect is clearly visible, especially in certain lighting conditions. A defining feature of medieval ridge and furrow is the curved ends making the overall shape of an elongated reverse-S. This arose because of the tendency of the team of oxen ploughing with the primitive single furrow ploughs to pull to the left, in preparation for making the turn.

This shape survives in some places as curved field boundaries, even where the ridge and furrow pattern itself has long since been ploughed flat. Some of the best-preserved ridge and furrow survives in the Midlands up on high ground in the counties of Leicestershire, Nottinghamshire, Northamptonshire, Oxfordshire, Warwickshire and Gloucestershire. There are very good examples at East Leake in Nottinghamshire, Grendon in Northamptonshire and the Vale of Evesham in Warwickshire. There are many others in different parts of the country, such as Ledgers Park, near Chelsham, in Surrey; Thrislington, in Durham; Willen, near Milton Keynes; Allestree Park, in Derby; Willington Worthenbury, near Bangor Is-y-coed, North Wales; and a particularly well-preserved example at the Braid Hills golf course in Edinburgh. It has been estimated that three and a half million hectares were under cultivation, and as the more productive three-field rotation of cultivation used by the Romans became universally adopted, arable production increased by 50 per cent, helped by the continuing warm climatic cycle.

Horses started to be used for the first time to replace the slower oxen for ploughing, which helped to increase the speed of cultivation. Large numbers of cattle were kept on the un-ploughable valley slopes and, as ever, goats, fowl and pigs for personal consumption. Rabbits were farmed in a big way in purpose-built warrens, some of which covered many thousands of acres. By 1300, sheep farming had developed into the most important agricultural industry, with a national flock of twenty million breeding ewes providing a surplus of twelve million fleeces for export.

The Cistercian and Benedictine Orders were principal owners of sheep farms, establishing enormous flocks across the uplands of Northern England and Southern Scotland, and using the wealth from wool to build magnificent abbeys

at Kelso, Melrose, Jedburgh, New Abbey in Dumfriesshire or Rievaulx and Fountains in North Yorkshire, to name only a few. Wool wsa traded principally with the Italians, who had a very sophisticated economic system in those days which enabled the monks to sell wool on futures contracts in exactly the same way as some producers do today. For example, an arable producer would be offered a price to sell his grain by a merchant long before harvest, based on what the merchant thinks the world demand for grain would be; the farmer has the option of taking the money then, or waiting for harvest in the hope that the price will be better. The economy was now strongly trade- and cash-based, with over a million pounds of coins in circulation and accountants calculating profits. Taxation was also a key part of this market economy, which satisfied the King's need for revenue rather more easily than through owning land direct.

The rise of taxation also led to the rise of 'parliament', where representatives of the regions would come to London when summonsed to hear of the King's initiatives, and gradually these representatives were afforded more power. Twenty per cent of the population lived in the 800 or so towns, where craftsmen specialised in their trades under control of the various guilds. New professions developed and doctors, lawyers, administrators and clergymen all found a living in the new urban environment.

Britain was effectively a part of France and benefited from trade opportunities for cloth, leather and surplus corn. However, there was a fly in the ointment: advances in agricultural production had enabled the population to grow from two and a half million at the end of the Anglo-Saxon era to seven million by 1300. This population peak coincided with agricultural yields reaching maximum output and, as with all organic systems, the medieval farmers struggled to maintain fertility. In an effort to meet the demand for grain the three-crop system of rotating grain with fallow which provided natural fertilisation was abandoned and grain was grown in the same field year after year without a break. This merely leached all the fecundity out of the ground and harvest yields fell. Landlords attempted to ameliorate the problem by reclaiming more land in marginal areas of heath, marsh and high moorland where the effort and cost of production were often greater than the output.

The price of foodstuffs escalated for both humans and livestock, which prohibited keeping enough beasts through the winter to provide the manure desperately needed as fertiliser. Suddenly, the country was in a self-perpetuating spiral of declining fertility, collapsing harvest yields and ever-increasing prices. Added to this, the 500-year warm cycle came to an abrupt end and the weather turned cold, wet and unstable. Between 1315 and 1322, a succession of cold wet summers and freezing, sodden winters caused arable crop yields to fall dramatically – periods of prolonged rain had prevented harvest, so grain had rotted where it stood. Fodder crops were equally affected, with much hay being lost or even left uncut, leading to the premature culling of livestock.

Food prices soared, many peasants were forced to sell their oxen and became dispossessed. Prolonged cold, wet weather caused animals to lose condition and led to periodic bouts of '*murrain*', a deadly disease of cattle and sheep. Among humans,

there were many cases of the frightful effects of eating bread made from grain blighted with the deadly fungus, ergot. *Claviceps purpurea* start life in early summer as tiny, pale pink, drumstick-shaped fruit whose thread-like spores are carried by the wind to flowers of a wide variety of weed grasses, particularly black grass and rye species. By autumn, as these plants ripen, some of the kernels appear as small, elongated, black seeds, similar in shape to mouse droppings. These are the sclerotia and they contain a number of alkaloids that are massively toxic. Ever since cereal production began in Mesopotamia, 9,000 years before Christ, providing further host plants for ergot, these little sclerotia have found their way into the food chain and have been the cause of hundreds of thousands of agonising deaths.

> THE EARLY CHRISTIAN MONKS WHO FIRST RECORDED THE EPIDEMICS THAT SWEPT ACROSS EUROPE IN 857, 945 AND 1000 AD, WHEN 50,000 PEOPLE DIED OF IT IN FRANCE, REFERRED TO THE DREADFUL EFFECTS AS *IGNIS INFERNALIS* – 'HELL'S FIRE'.

Unfortunately, no one made the association between the deadly blackened seeds among rye, the principal cereal of the poor, but also to some extent wheat and barley, and its appalling consequences until the nineteenth century. Ergotomine poisoning affects both humans and livestock by paralysing the motor nerve endings and restricting the flow of blood to the extremities. Grazing animals are less at risk as ergot matures at the point grass ceases to be palatable and is usually dislodged by the movement of stock as they feed. Those that do ingest even the smallest quantity collapse with staggers and their tails, ears, lips and hooves can slough off. Humans who become infected through bread made from contaminated flour experience violent convulsions, wrenching muscle contractions which caused pregnant women to miscarry, an agonising sensation of burning, terrifying hallucinations, followed by gangrene and death.

The early Christian monks who first recorded the epidemics that swept across Europe in 857, 945 and 1000 AD, when 50,000 people died of it in France, referred to the dreadful effects as *ignis infernalis* – 'Hell's Fire'. So prevalent were outbreaks of the sickness during the medieval period that the Hospital Brothers of St Anthony established 370 hospices, painted bright red for easy identification, across Europe and Britain, with one erected as far north as Leith, Scotland, in 1430.

Ergot thrives after cold winters followed by wet springs, and the climate change of the fourteenth century provided ideal conditions for sporadic outbreaks at least every ten years, when whole rural communities were wiped out through eating infected bread. What are now believed to be mass infections of ergotism were often confused with the plague. The dancing manias synonymous with the Black Death and their associated mortalities were almost certainly hallucinogenic symptoms of ergot. The second decade of the fourteenth century was a period marked by extreme levels of crime, disease and mass death, which had consequences for Church, state, European society and future calamities to follow later in the century:

When God saw that the world was so over proud,
He sent a dearth on earth, and made it full hard.
A bushel of wheat was at four shillings or more,
Of which men might have had a quarter before ...
And then they turned pale who had laughed so loud,
And they became all docile who before were so proud.
A man's heart might bleed for to hear the cry
Of poor men who called out, 'Alas! For hunger I die ...'
POEM ON THE EVIL TIMES OF EDWARD II (C.1321)

Worse was yet to come. In the abnormally wet summer of 1348, as the wretched peasants watched another harvest rotting in the ground, the bubonic plague which had been ravaging Europe arrived in England. The disease spread throughout the country with dizzying speed and fatal consequences, particularly in towns where overcrowding and primitive sanitation aided the contagion. It reached London before Christmas, and in the following months nearly half the city's population of 70,000 inhabitants were carted off to mass graves on the outskirts of London, in what is now the East End. There would be no survivors once the plague reached isolated communities, such as villages, monasteries and hospices or Spitals.

> THE BUBONIC PLAGUE WHICH HAD BEEN RAVAGING EUROPE ARRIVED IN ENGLAND ... IT REACHED LONDON BEFORE CHRISTMAS, AND IN THE FOLLOWING MONTHS NEARLY HALF THE CITY'S POPULATION OF 70,000 INHABITANTS WERE CARTED OFF TO MASS GRAVES ON THE OUTSKIRTS OF LONDON, IN WHAT IS NOW THE EAST END.

Place names which include *Spital*, as in Spitalfields, indicate the site of a medieval leper colony and the only positive consequence of the Black Death was the virtual eradication of leprosy in Britain.

Peasants fled their fields, livestock were abandoned to fend for themselves, and crops were left to rot. Henry of Knighton, an Augustinian canon at the Abbey of St Mary of the Meadows, Leicester, who wrote a detailed eyewitness account of the Black Death, observed: *'Many villages and hamlets have now become quite desolate. No one is left in the houses, for the people are dead that once inhabited them.'* The Scots saw the pestilence ravaging England as a splendid opportunity to invade, but before they had got very far the army fell victim to the plague and the soldiers dispersed, spreading the plague deep into Scotland where 20 per cent of the population died. The cumulative effects of the famine years and Black Death reduced the population in an incredibly short period of time by 50 per cent, to below three million people. Entire communities were lost and population levels did not reach those of 1300 until some three centuries later. Many of the new villages that had been formed in the preceding centuries were deserted, soon to become ruined and disappear into the landscape. Ambion, Andreskirk, Elmesthorpe and Soby in Leicestershire are examples, or Lower Harford in the Cotswolds. Here the bumps, hollows and flat-topped banks covering about a hectare indicate a sunken medieval main street. Hovels were once strung out on the level areas and the outlines of banks and ditches mark where these villagers kept livestock and grew a few crops.

After the Black Death the much-reduced demand for grain lead to marginal arable land being converted to pasture or reverting back to scrub, woodland and moor. Although the area of arable declined, it did not shrink as much as the fall in population numbers, so food supplies increased comparatively and grain prices began to revert to affordable levels. Flax became re-established as a fibre crop, having been largely absent since Roman times, and although the cloth made was of poor quality, it eventually had a place in the growing textile industry. Sheep farming and wool production remained the main pastoral activity but patterns of taste changed and wool exports were reduced by the Hundred Years' War. Increasingly the wool clip was utilised at home in the fast-growing textile industry, largely based in towns near fast-flowing streams that ran the mills. While wool exports declined, exports of cloth increased. Out in the fields an increase in the use of the horse brought about higher ploughing work rates and assisted in the production of grain from a reduced workforce.

There was a profound change in farming systems. With a decimated population, peasants who had been bound to their lords by feudal ties suddenly found that they were able to leave for better terms elsewhere. The lords who now found it difficult to find sufficient workers gave up their role as direct producers, becoming landlords and leasing their land to tenants. These were to become a new class of yeoman farmer who provided the main driving force behind change in the countryside, typically consolidating their holdings, specialising in arable or livestock and building their own homes.

THE BIRTH OF MODERN FARMS

As the consolidation of farms began, so the practice of enclosing land was taken up by both farmers and the peasants themselves who collectively agreed to the rearrangement of their holdings in the search for efficiency. By 1400 economic activity was again picking up, and with the enclosures a new chapter in the development of the countryside began.

Enclosure, or inclosure, is the process by which common land is taken into full private ownership and use. Common land is owned by one person, but other people have certain traditional rights to it, too, such as using it for arable farming, mowing for hay or pasturage, grazing cattle, horses, sheep or other animals. There might also be piscary, the right to fish; turbary, the right to take sods of turf for fuel; common in the soil, the right to take sand and gravel; mast or pannage, the right to turn out pigs for a period in autumn to eat mast – acorns and other nuts; and estovers, the right to take sufficient wood for the commoner's house or holding (usually limited to smaller trees, bushes such as gorse and fallen branches). There are a considerable number of places in Britain where commoners' rights still exist – the Ashdown Forest and New Forest, to name but two – and these ancient rights are as fiercely defended today as they were in the Middle Ages, when common rights were of immense importance to the survival of those who held them.

Existing commons are almost all pasture, but in earlier times arable farming and haymaking were also included in the commons system, with strips of land in

the common arable fields and common hay meadows assigned annually by lot. When not in use for these purposes, such commons were also grazed. A few of them still survive, for example, common arable fields around the village of Laxton, in Nottinghamshire, and a common meadow at North Meadow, Cricklade. Under enclosure, such land is fenced – *enclosed* – and *deeded* or *entitled* to one or more private owners who then enjoy the possession and fruits of the land to the exclusion of all others.

The main thrust of the Parliamentary Enclosures was during the eighteenth and nineteenth centuries, but throughout the medieval period piecemeal enclosure took place in which adjacent strips were fenced off from the common field. From as early as the twelfth century some open fields in Britain were being enclosed into individually owned fields. This was sometimes undertaken by small landowners, but more often by large landowners and lords of the manor. Significant enclosures, or emparkments, took place to establish deer parks, particularly in the early years of Norman rule, and this was ratified in 1235 under the Statute of Merton, which gave lords of the manor the right to enclose common land, providing sufficient pasture remained for the tenants: *'setting out in what cases, and in what manner, Lords may approve part of the wastes, woods, and pastures, belonging to their Manors, against the tenants'*. There was a significant rise in the enclosure of common land during the Tudor period as surplus-to-requirement arable hectares were converted to pasture for sheep. The primary areas of enclosure were in a broad band from Yorkshire and Lincolnshire diagonally across England to the south, taking in parts of Norfolk and Suffolk, Cambridgeshire, large areas of the Midlands, and most of south-central England.

The woollen industry was the backbone of the economy and cloth exported to the continent was Britain's most important manufactured output. Flemish weavers fleeing the horrors of the Hundred Years' War with France were encouraged to emigrate to England, with many settling in Norfolk and Suffolk. Others moved to the West Country, the Cotswolds, the Yorkshire Dales and Cumberland, where weaving began to flourish in the villages and towns. Lavenham, in Suffolk, is widely acknowledged as the best example of a medieval wool town in England, its fine timber-framed buildings and beautiful church built on the success of the wool trade. In Tudor times, Lavenham was said to be the fourteenth wealthiest town in England, despite its small size. Merchants made immense fortunes from wool and gave us the magnificent and architecturally stunning 'wool' churches such as St Peter and St Paul at Northleach, St Peter at Winchcombe and St Mary's at Fairford, in the Cotswolds, Holy Trinity at Long Melford, in Suffolk, or St John's, St Martin's and All Saints' churches in Stamford.

Sheep were also seen as being essential for maintaining the soil fertility of arable ground, and periodically ploughing out sheep pasture became part of the improved rotation of cultivated land. The sheep industry was of enormous benefit to the land-owning elite, the wool merchants and the Crown, for whom it raised vast sums. It also created something of a quandary: on the one hand the economy was buoyant, on the other, enclosures led to the depopulation of villages, displacement of farm labourers and a decrease in crop production, which made England

more susceptible to famine and higher prices for domestic and foreign grain. The Tudor authorities were particularly nervous about how the villagers who had lost their homes would react. They had every reason to be worried: in Leicestershire over thirty-one villages were abandoned, and this must have run to many hundreds across the country. In Tudor Britain, a man who lost his home and his livelihood automatically became a vagrant, and vagrants were regarded as criminals. Anxious minds envisaged multitudes of vagabonds and thieves roaming the countryside as a result of continued enclosures, and Parliament began passing acts to stop them. The first such legislation was in 1489 and over the next 150 years there would be a further eleven Acts of Parliament and eight Commissions of enquiry on the subject, none of which stopped land from being enclosed.

The population in 1500 was little more than at the end of the Black Death, but it began to increase sharply. There was an urgent need for more arable land and an increase in antagonism towards graziers. Agriculture responded to the demand for food by increasing the area under the plough, reclaiming marginal upland areas again, clearing woodland for cultivations and trying to drain the fens. It was too little too late, and as social unrest grew, enclosures were seen as the cause of the problems. There were angry demands for government to remove existing enclosures and much parliamentary vacillation in the 1530s and 40s. Finally, furious peasants took matters into their own hands and started destroying the enclosures.

The first major incident was in Norfolk with Kett's Rebellion of 1549. On 6 July, the townspeople of Wymondham started ripping down enclosures in the nearby village of Morley St Botolph before moving on to Norwich, tearing out hedges from any enclosed land along the way. Robert Kett and his brother William, themselves wealthy landowners, joined the protesters in sympathy and attracted a mob of 15,000 supporters. Kett and his rebel army attacked and captured Norwich, effectively gaining control the city and major port. From here they issued a petition of twenty-six grievances to Edward VI, who responded by sending William Parr, 1st Marquess of Northampton, with 1,500 men to quash the rebellion.

This expedition was a complete failure and the rebels held Norwich until they were savagely defeated by the Earl of Warwick with an army of around 14,000, including mercenaries from Wales and the Continent. Robert Kett was hung in chains from the walls of Norwich, where his death was drawn out over several days, and his brother William from the roof of Wymondham Abbey. Ten of the other principal rebels were hung from an oak tree on Mousehold Heath, just outside Norwich, which became known as the Reformation Oak. This venerable growth can still be seen, propped, shored, and in-filled with concrete, by the roadside between Norwich and Wymondham. Despite this harsh treatment, agrarian revolts swept all over the nation, and other revolts occurred periodically throughout the century, no doubt inflamed by the Earl of Warwick persuading Parliament to ratify the Statute of Merton. This enabled landowners to enclose their land at their own discretion and was, in fact, only finally repealed in 1948.

THE STEADY MARCH OF AGRICULTURAL PROGRESS

There was a major decline in living standards as the population continued to grow, and this coupled with high unemployment meant a large proportion of the population survived through charity, Parish Poor Laws and scavenging for wild fruit and vegetables. There was a significant migration of desperate people seeking work in the towns, and by the end of the century, the State found itself both distrusted and ill equipped to deal with the social consequences of population growth and inadequate food.

> *They hang the man, and flog the woman,*
> *That steals the goose from off the common;*
> *But let the greater villain loose,*
> *That steals the common from the goose.*

Agricultural improvers were thin on the ground during the sixteenth century, and the handful that existed stand out as voices in the wilderness, including John Fitzherbert, who wrote *Master Fitzherbert's Boke of Husbandrie* in 1531, and the great Thomas Tusser, author of the instructional poem *Five Hundred Points of Good Husbandry*, published in 1557. At the end of the century, two people came up with ideas for improving soil fertility. Roland Vaughan, a Herefordshire landowner, experimented with using water from local streams to deposit silt on the fields through the winter on his estate in the Golden Valley, beside the River Dore. Vaughan is reputed to have got the idea of 'water meadows' from noticing water running from a piece of ground where a mole had tunnelled too close to a stream. This rivulet was '*one pace broad and some twenty in length*', and the grass where the water flowed over it was considerably greener than that on either side. He subsequently dug a channel, called the Royal Trench, from the River Dore across his estate and back to the Dore. Open conduits ran from the main channel to various fields and by using a system of sluices fields could be flooded either during dry periods or through the winter to both protect the grass from frost and provide fertiliser in the form of silt. Vaughan's invention was a demonstrable success, increasing the value of his land from £40 to £300 and moving his kinsman, John Davis, to verse:

> *'His royall trench (that all the rest commands*
> *And holds the Sperme of Herbage by a Spring)*
> *Infuseth in the wombe of sterile Lands,*
> *The Liquid seede that makes them Plenty bring.*
> *Here, two of the inferior Elements*
> *(Joyning in Coïtu) Water on the Leaze*
> *(Like Sperme most active in such complements)*
> *Begets the full-panche Foison of Increase:*
> *For, through Earths rifts into her hollow wombe,*
> *(Where Nature doth her Twyning-Issue frame)*
> *The water soakes, whereof doth kindly come*
> *Full Barnes, to joy the Lords that hold the same:*

For, as all Womens wombes do barren seeme,
That never had societie of Men;
So fertill Grounds we often barren deeme,
Whose Bowells, Water fills not now and then.'

Water meadows were brilliant in their simplicity and supplied the earliest hay, fed the best sheep and produced the finest milking cows. Following the publication of his seminal work in 1610, *Most Approved and Long experienced Water Workes containing The manner of Winter and Summer drowning*, Vaughan's discovery was soon widely adopted along river valleys across the country. Remains of old water meadows and their irrigation systems can be seen at Harnham Water Meadows, in Salisbury; Fordingbridge, in Hampshire; the River Kennet Meadows, near Reading; Hurst, near Dorchester on Thames, Oxfordshire; Britford, in Wiltshire; Mere, Gillingham, Blandford Forum and Shaftesbury, in Dorset; Riddlesworth and West Lexham or Appleby, Measham and Austrey in Leicestershire, to name only a fraction.

At much the same time, Sir Hugh Plat, one of Queen Elizabeth I's courtiers and a keen horticulturalist, was advocating the more scientific use of marl (calcium-carbonate-rich clay) to fertilise fields. Fertiliser, or the lack of it, was one of the most inhibiting factors in maintaining crop production, and on every farm a good dung heap was regarded as one of the most valuable assets, with anything degradable added to it. On the chalk and limestone downs, chalk was dug, crushed and scattered on the loam. Near the coast, farmers gathered the seashell-rich sand that collected along the front of a shingle beach and mixed it in with manure. When a grass pasture was being ploughed out in counties such as Sussex or Surrey, the matted turfs were first shovelled off and burnt, and the ashes scattered in with the ploughing.

> FERTILISER, OR THE LACK OF IT, WAS ONE OF THE MOST INHIBITING FACTORS IN MAINTAINING CROP PRODUCTION AND ON EVERY FARM A GOOD DUNG HEAP WAS REGARDED AS ONE OF THE MOST VALUABLE ASSETS, WITH ANYTHING DEGRADABLE ADDED TO IT.

There is evidence that lime was being burnt for fertiliser towards the end of the sixteenth century, a practice which was to become common two centuries later. The limitation with chalk, lime and seashells was transportation, and even dung was rarely seen in fields other than those immediately conterminous to the farmhouse. Marling was more feasible since it was simply a matter of digging a pit in the vicinity of the field or fields to be fertilised and extracting the clay. 'Marl' or 'Marl Pit' are common in field names across the country and many of the ponds seen where the corners of three or four fields meet are old flooded marl pits.

The problem with any fertilising in those days was that farmers did not appreciate the difference in soil types relative to the quantity of fertiliser, or the duration of effective applications before it had a detrimental effect. Barnaby Googe, the Elizabethan pastoral poet observed, *'In some counties they make their land very fruitful with laying on of Chalke ... But long use of it in the end, brings the ground to starke nought, whereby the common people have a speech, that ground enriched*

with Chalke makes a rich Father and a beggarly Sonne.' This comment is as true today when farmers force a succession of crops from the same field by increasing the application of fertiliser. Plat, who was a prolific author on such matters as making candied fruit or 'suckets' and the art of distilling scented water, wrote a detailed treatise in 1594 entitled *Diverse new sorts of soyle not yet brought into any publique use, for manuring both of pasture and arable ground*, which was the first textbook on the correct proportion of fertilisers for different soil types. The pressure to create more arable hectares led Charles I to commission Cornelius Vermuyden, the Dutch drainage engineer, to reclaim around 40,000 hectares of the Royal Forest at Hatfield Chase in the Isle of Axholme, Lincolnshire, in 1626. This was spectacularly unpopular among the local people who stood to lose their common rights and led to vigorous opposition. Dykes were destroyed and, until troops were sent to protect them, the camps of the Dutch and Walloon workmen were attacked at night, and several workmen killed.

Much more damaging to the sinking status of the King was granting the Earl of Bedford a charter in 1632 to undertake the immensely ambitious project of draining 750,000 acres of the Norfolk, Lincolnshire and Cambridgeshire fens, round the Ouse Wash, River Welland and River Nene. Bedford and thirteen 'Gentlemen Adventurers', as venture capitalists were called in those days, were promised 40,000 hectares each for funding the project, with the King taking a backhander of 5,000 hectares. Drainage was met with furious resistance from the local population, many of whom made their living from grazing the marshes or by fishing and wildfowling. 'The Powte's Complaint' (a powte being a lamprey) was a popular protest song lamenting the loss of the wild marshland landscape, sung by the 'Fen Tigers', marsh men who sabotaged the construction work whenever they could.

Come, Brethren of the water, and let us all assemble,
To treat upon this matter, which makes us quake and tremble;
For we shall rue it, if it be true, that Fens be undertaken
And where we feed in Fen and Reed, they'll feed both Beef and Bacon.
They'll sow both beans and oats, where never man yet thought it,
Where men did row in boats, ere undertakers brought it:
But, Ceres, thou, behold us now, let wild oats be their venture,
Oh let the frogs and miry bogs destroy where they do enter.
Behold the great design, which they do now determine,
Will make our bodies pine, a prey to crows and vermine:
For they do mean all Fens to drain, and waters overmaster,
All will be dry, and we must die, cause Essex calves want pasture.
Away with boats and rudder, farewell both boots and skatches,
No need of one nor th'other, men now make better matches;
Stilt-makers all and tanners, shall complain of this disaster,
For they will make each muddy lake for Essex calves a pasture.
The feather'd fowls have wings, to fly to other nations;
But we have no such things, to help our transportations;

We must give place (oh grievous case) to horned beasts and cattle,
Except that we can all agree to drive them out by battle.
Wherefore let us entreat our ancient water nurses
To show their power so great as t'help to drain their purses,
And send us good old Captain Flood to lead us out to battle,
Then Twopenny Jack with skales on's back will drive out all the cattle.

The project was seen by many people as a device for already wealthy men to benefit by dispossessing others and had much to do with hastening the Civil War. In the summer of 1637, the engineers announced that, despite all the difficulties, the work was complete. However, it proved to be a complete failure during the following winter, when the whole area flooded. Charles I went further down the route of his own destruction by stepping in to take control of a new project and appointing Vermuyden as his agent. East Anglia was a staunchly Puritan area and Cromwell was among the local farmers vociferously protesting against the drainage scheme. The King then proceeded to antagonise his own supporters by announcing to Bedford and the investors that his cut was to increase from 5,000 hectares to 20,000, effectively halving their shares.

By the time they had all stopped arguing, the Civil War had started and the project was not completed until 1653. To everyone's astonishment, the land unexpectedly started to shrink at an alarming rate as the peat soil dried out. As the level of the land dropped, water could no longer drain into the rivers, which were by now higher than the fields. Wind pumps were introduced to pump water off the land, but their reliance on adequate wind and continued shrinkage saw the task become increasingly difficult.

> BY THE TIME THEY HAD ALL STOPPED ARGUING, THE CIVIL WAR HAD STARTED AND THE PROJECT WAS NOT COMPLETED UNTIL 1653. TO EVERYONE'S ASTONISHMENT, THE LAND UNEXPECTEDLY STARTED TO SHRINK AT AN ALARMING RATE AS THE PEAT SOIL DRIED OUT.

Until steam power was introduced in the 1820s and the Fens were successfully drained (a procedure which again resulted in fierce local rioting and sabotage) the landscape was dominated by around 700 windmills, which were built in timber or brick to facilitate draining the land or milling the corn. Many have since disappeared but some still survive, including Denver Mill, near Downham Market; Haddenham, Downfield, Stevens, Wicken and Swaffham windmills south of Ely; Sibsey Trader Mill, north of Boston; and the seven-storeys-high Maud Foster Windmill in Boston itself, the tallest working windmill in Britain.

Today the fens are drained by electric pumping stations and contain over 50 per cent of the most productive land in Britain, producing vegetables, wheat, bulbs and flowers, and they are the only place where English mustard continues to be grown for Colman's of Norwich. There are still places, out on the mud flats and saltings, where a man can look out towards the grey sea, breathe the iodine-laden air and, as he listens to the cacophony of waterfowl, imagine what once it must have been.

The Restoration of King Charles II was greeted with unbridled jubilation and hope that a new era of peace and prosperity would follow the grim years of Cromwell's Commonwealth. Royalist landowners who had gone into exile with their king returned with innovative ideas for British agriculture and a determination to make farming profitable. Many of them had taken refuge in Flanders and had studied Flemish farming methods. Flanders was a densely populated country where every yard of agricultural land was utilised; the Flemish were skilled cattle and heavy horse breeders and had perfected a four-field rotation based on growing crops of wheat, turnips, barley and clover in sequence. This innovative advance on the old three-field system, where one field lay fallow and therefore unproductive for twelve months, not only meant that all the land was used throughout the year, but also that turnips and clover provided an essential product which would revolutionise British agriculture.

Legumes such as clover have nodules on their roots which contain nitrogen-fixing bacteria which replace nitrates leached out of the ground by cereal crops. They therefore provide the role of a natural fertiliser, solving one of the great problems that had beleaguered farming in Britain. Clover was also a highly nutritious fodder crop for winter feed, and this added to turnips, which ripen in the autumn and remain fresh in the ground until the spring. This meant that farmers could keep stock all year round and fatten beasts through the winter, as an alternative to the centuries-old practice of slaughtering the majority of livestock except breeding animals in the late autumn.

Farming and the Landscape

In addition to improving soil fertility, greater grain output simultaneously increased livestock production. Farmers could rear greater quantities of livestock because there was more food of higher quality and the manure provided during overwintering added to the productive cycle. Britain was at the dawn of agricultural enlightenment, and although tenant farmers were suspicious of change and reluctant to implement them for fear of incurring rent increases, the agricultural revolution was on its way.

'He that havocs may sit
He that improves must flit.'
Philosophy of seventeenth-century tenant farmers

'Anthropophagi, and men whose heads
Do grow beneath their shoulders.'
Contemporary view of tenant farmers

THE DAWN OF INDUSTRY

By the late seventeenth century, Britain had colonies in the West Indies, the western seaboard of America and a large part of Canada. The Royal African Company had established trading posts in West Africa to trade slaves in exchange for British goods, which would become the major economic mainstay for such western British cities as Bristol and Liverpool, which formed the third corner of the so-called triangular trade with Africa and the Americas. The East India Company had been in existence since 1600 and Britain acquired Bombay and Tangier in 1661, on the marriage of Charles II to Catherine de Braganza. When William of Orange ascended the English throne in 1688, bringing peace between the Netherlands and England, a deal between the two nations left the spice trade of the Indonesian archipelago to the Netherlands and the textiles industry of India to England.

One of William's first acts after his coronation was to declare war on his old enemy, France, and to impose a trade embargo on French goods which was to have a profound effect on British agriculture. In the seventeenth century very little distilling of spirits was known in Britain; the Company of Distillers made spirits under strict regulations, mainly for apothecaries who used it as a base for medicines. Some home-made alcohol was sold by street vendors, described by Daniel Defoe as *'Foul and gross, but they mixed them up with such additions as they could get, to make them palatable'*. The rich drank imported French brandy and the embargo with France left a gap in the booze market, which William promptly filled in 1690 by passing an Act of Parliament 'for encouraging the distilling of brandy and spirits from corn'.

This new industry would lead, the Act promised, to 'the greater consumption of corn and the advantage of tillage in this Kingdom'. To help things along, he withdrew the monopoly on distilling from the Company of Distillers, removed virtually all regulations and, working on the theory that if spirits were cheap, more people would drink them, lowered the tax on spirits made from malted corn to a penny a

gallon. British farmers now faced the challenge of demand created by colonisation and the new distilling industry; they had to improve production or go out of business.

The eighteenth century was a period of rapid change for every section of society, but none more so than for farmers, with landowners leading the way in agricultural improvements. The four-field rotation system was accepted as the new method of cultivation, the limitation being the hopelessly inefficient method of broadcasting seed by hand. It is obviously important that individual plants have sufficient space to grow and ripen, and there was an enormous amount of waste until Jethro Tull, a Berkshire landowner, invented a seed drill for sowing seed in rows. He also advocated the use of horses instead of oxen, which were still commonly used for farm work, and invented a horse-drawn hoe for clearing plant growth, particularly among turnip crops. The powerful Whig politician, Viscount Townsend, of Raynham Hall, in Norfolk, carried out a variety of improving experiments on his estate, mostly involving turnips. He was a fervent believer in the efficacious qualities of turnips for all agricultural improvements and became known as 'Turnip Townsend' from his habit of introducing his opinions of the plant into every conversation.

Joseph Foljambe of Rotherham, in Yorkshire, perfected a vastly superior plough which remained in use until the tractor was invented 170 years later.

DRAUGHT HORSES

In the early part of the century, the Duke of Hamilton imported six black Flemish stallions from Flanders which were crossed with local horses on his estates at Clydesdale, near Glasgow, to produce the eponymous Clydesdale horse. Clydesdales were the perfect multi-purpose work horse, which were eventually exported all over the world. At the beginning of the twentieth century there were over 140,000 Clydesdales in Scotland alone, and in 1911, 1,600 stallions were exported from Britain to various countries. By 1949, there were just eighty horses registered in Britain, and in 1975 the Rare Breeds Survival Trust listed the breed as 'vulnerable'. Clydesdales have since seen a resurgence in popularity and population, resulting in the breed's status being reclassified favourably as 'at risk', with an estimated global population of just 5,000 specimens.

At the same time, other landlords, such as the Earls of Chesterfield and Huntington, were developing regional draught horses by importing continental stallions from Zeeland. Later in the century, Robert Bakewell of Derbyshire, the famous improver of cattle and sheep, developed the Improved Black Horse, which was to become world famous as the Shire horse.

NEW ADVANCES IN GOODS TRANSPORTATION

As Britain moved into the age of industry, in the middle of the century, there was a desperate need to find some method of transporting bulky raw materials and finished products. The Toll Pike Trusts set up by Act of Parliament in 1706, with powers to collect road tolls for maintaining the principal highways in Britain, were still in their infancy. Most goods were transported by long trains of pack horses or great cumbersome wagons to the nearest port, on roads which in most places had scarcely improved since the Middle Ages. There had been some early attempts to improve inland river navigation in the seventeenth century; the government of King James established the Oxford–Burcot Commission in 1605 which began a system of locks and weirs on the River Thames and was opened between Oxford and Abingdon by 1635. Sir Richard Weston designed and built the Wey navigations in 1635, a canal running 25 kilometres from Weybridge to Guildford, allowing barges to transport heavy goods via the Thames to London. Timber, corn, flour, wood and gunpowder from the Chilworth Mills were moved up the canal to London whilst coal was brought back. The Aire & Calder Navigation, in West Yorkshire, was opened 1703, the Trent Navigation in 1712, the Kennet in 1723 and the Mersey and Irwell Navigation in 1734, which provided a navigable route to Salford and Manchester.

CARVING OUT THE CANALS

These were all improvements to existing rivers; but the first artificial canal, a waterway designed on the basis of where goods needed to go rather than where a river happened to be, was built by the Duke of Bridgewater. The Duke commissioned the engineer James Brindley to build a canal which would transport coal quickly and efficiently from his mines in Worsley to the rapidly industrialising city of Manchester. Brindley's design included an aqueduct carrying the canal over

the River Irwell, and this engineering wonder immediately attracted tourists when it opened in 1761. The Duke's canal proved to be highly successful; barges carrying thirty tonnes of coal were easily pulled by one horse walking along a tow path – more than ten times the amount of cargo per horse than was possible with a cart. Time spent moving goods was cut to a fraction and, because of the massive increase in supply, the Bridgewater canal reduced the price of coal in Manchester by nearly two-thirds within a year of its opening. It was a huge financial success, earning what had been spent on its construction within just a few years – which was a relief to the Duke, who had funded the whole venture himself.

The Bridgewater canal started a fever of canal building across the entire country until there was a nationwide network of transport communication between England and Wales, and in Scotland, from the sea ports on the east and west coasts. It was an incredible undertaking. Armies of 'navvies' (as in navigators) laboured under engineering geniuses such as Telford, Brindley, Rennie or Dadford, creating aqueducts, boat lifts, tunnels, inclined planes and caisson lifts.

> THE BRIDGEWATER CANAL STARTED A FEVER OF CANAL BUILDING ACROSS THE ENTIRE COUNTRY UNTIL THERE WAS A NATIONWIDE NETWORK OF TRANSPORT COMMUNICATION BETWEEN ENGLAND AND WALES, AND IN SCOTLAND, FROM THE SEA PORTS ON THE EAST AND WEST COASTS. IT WAS AN INCREDIBLE UNDERTAKING.

The new canal system enabled both goods and people to move around the country in a manner that must have seemed incredible compared with the methods of the recent past. Fast 'Flyboats', crewed by four men with two working while the other two slept and a system of changing horses, carried urgent cargo and passengers at relatively high speed day and night. Raw materials, fuel and produce could now be moved internally round the country with ease. Heavy cargoes for export, transported along the network linking the coastal port cities such as London, Liverpool, and Bristol, could be exchanged with sea-going ships and imported goods brought back on the return journey. The canals fell into decline as the rail network developed in the mid-nineteenth century, leaving us a legacy of 4,000 miles of waterways, both for recreational use and as a habitat for urban and rural wildlife.

CHANGING THE HIGHWAYS

Although intensely unpopular, income raised by the turnpike trusts was radically improving the condition of Britain's highways. 'Turnpike' alludes to the similarity between the gate used to control access to the road and the weapon used by infantry to deter cavalry in the wars of the Middle Ages. The turnpike consisted of a row of pikes or bars, each sharpened at one end and attached to horizontal members, secured at one end to an upright pole or axle, which could be rotated to open or close the gate. The name expressed the resentment of people who had previously used the roads freely suddenly finding them barred.

During the first three decades of the eighteenth century, sections of the main radial roads into London were put under the control of individual turnpike trusts.

The pace at which new turnpikes were created picked up in the 1750s as 150 trusts were formed to maintain the cross-routes between the Great Roads radiating from London. At this time, roads leading into provincial towns, particularly in western England, were put under single trusts and key roads in Wales were turnpiked. In South Wales, the roads of complete counties were put under single turnpike trusts by the 1760s. A further 400 were established in the 1770s, with the turnpiking of subsidiary connecting roads, routes over new bridges and new routes in the growing industrial areas in Scotland. This had doubled by 1800, and in 1825 about 1,000 trusts controlled 29,000 miles of road across the country. The trusts were required to erect milestones indicating the distance between the main towns on the road, many of which still survive as do the old toll houses, such as the one at Stanton Drew, in Somerset, or Honiton, in Devon.

The improved road system heralded the Golden Age of Coaching, with fast mail coaches and passenger stagecoaches hammering along the new highways at what were considered unbelievable speeds. The excitement of driving a coach and four fascinated members of the Regency set, who competed with professional coachmen in the skill of handling a team of 'cattle' and often bribed professionals to let them take over the 'ribbons' on one of the regular coach routes, to the alarm and discomfort of the passengers. Most notable among the amateurs were Sir St Vincent Cotton, who bought the stagecoach *The Age* with the last of a fortune he had gambled away and ran a passenger service between London and Brighton. There was also Sir John Lade, who caused a scandal by marrying the wife of the highwayman 'Sixteen String Jack' Rann shortly after he had been hanged for robbing the Royal Chaplain; Harry Stevenson, a Cambridge graduate and a genius with coach horses; Lord Worcester; Lord Sefton; Colonel Berkeley; and Lord Barrymore, known as 'Hellgate' for his outrageous behaviour. As the turnpike roads spread across the country, coaching inns became a feature of many villages as the existing ale houses were upgraded to accommodate passengers whilst the coach horses were changed. These survive as the ever-popular village pub.

A new generation of agricultural improvers emerged in the second half of the eighteenth century with ideas to meet the challenge of a population that had risen to around nine million, the rapid development of industrial towns, expanding colonisation and an army and navy on active service of about 160,000.

THE BIRTH OF NEW BREEDS

With improved feeding, livestock were growing better carcase qualities, but Robert Bakewell from Derbyshire experimented with selective breeding to standardise the best characteristic, within a breed. He started with the old Lincolnshire breed of sheep that he turned into the New Leicester. These sheep were big and delicately boned and had good-quality fleece and fatty forequarters, in keeping with the popular taste for fatty shoulder mutton. He also began the practice of hiring out his prize rams to farmers to improve their own stock.

One of the many advantages of the new communication system of roads and canals was the opportunity for farmers to exchange quality livestock amongst

each other. These sheep were exported widely, including to Australia and North America, and have contributed to numerous modern breeds, despite that fact that they fell quickly out of favour as market preferences in meat and textiles changed. Bloodlines of these original New Leicesters survive today as the English Leicester, or Leicester Longwool, which is primarily kept for wool production.

Robert Bakewell was also the first to breed cows primarily for beef. Previously, cattle were first and foremost kept for pulling ploughs as oxen. Bakewell had noticed that the Longhorn breed appeared to be the most efficient meat producers; they ate less and put on more weight than any other breed. As with the sheep, he began breeding in-and-in to enhance their characteristics and enable him to 'grow' a better carcass more efficiently. By the time he had finished, his cattle were fat, meaty and had doubled in carcass weight, and as more and more farmers followed his lead, farm animals increased dramatically in size and quality.

John Ellman then produced the stocky Sussex sheep, noted for its carcass and meat quality, which were soon being bought by improvers across Britain and exported to Russia.

Farming and the Landscape

THE DRIVE FOR CHANGE

Every department of agriculture was permeated by a new spirit of energy and enterprise. Rents rose, but profits outstripped the rise. New crops were cultivated – swedes, mangel-wurzel, kohl rabi, prickly comfrey, all were readily adopted by a new race of agriculturists. Breeders spent capital freely in improving livestock. New implements were introduced; Meikle's threshing machine (1784) began to drive out the flail by its economy of human labour. Numerous patents were taken out for drills, reaping, mowing, haymaking and winnowing machines, as well as for horse-rakes, scarifiers, chaff-cutters, turnip-slicers and other mechanical aids to agriculture.

To one degree or another, virtually every landowner and farmer was caught up in the fever for improvement, fuelled by rocketing food prices. One of the most famous was Thomas Coke of Holkham, 1st Earl of Leicester. When Coke inherited the enormous estates at Holkham, in Norfolk, not an acre of wheat was to be seen from Wells-next-the-Sea to King's Lynn. At best, the thin sandy soil produced scanty yields of rye, the poorest of the grain crops. Naturally short of fertility, it was further impoverished by a barbarous system of cropping. No manure was purchased, the ground only carried a few Norfolk sheep with backs like razors and, here and there, a few half-starved, semi-wild marsh cattle. Despite what anyone would have considered a hopeless task, Coke was determined to grow wheat. He marled and clayed the land, purchased large quantities of manure, drilled his wheat and turnips, grew sainfoin and clover, and soon trebled his livestock. He also introduced into the county the use of artificial foods like oil-cake, which, with roots, enabled Norfolk farms to carry increased stock. Under his example and advice, stall-feeding (wintering inside) was extensively practised.

> EVERY DEPARTMENT OF AGRICULTURE WAS PERMEATED BY A NEW SPIRIT OF ENERGY AND ENTERPRISE ... TO ONE DEGREE OR ANOTHER, VIRTUALLY EVERY LANDOWNER AND FARMER WAS CAUGHT UP IN THE FEVER FOR IMPROVEMENT, FUELLED BY ROCKETING FOOD PRICES.

Within nine years he was growing a vast acreage of wheat, breeding prize-winning shorthorn cattle and Southdown sheep which he used to cross with hardy Norfolk ewes to produce the Suffolk, without doubt, the most famous fat lamb-producing sheep in the world. In 1778, Coke started inviting local farmers to view his sheep at the annual sheep shearings. These gradually developed into farming seminars where new ideas were discussed and debated. By 1818 open house was kept at Holkham for a week, with hundreds of practical and theoretical agriculturists, farmers from all districts, breeders of every kind of stock, assembling from all parts of Great Britain, the Continent and America. The mornings were spent in inspecting the land and the stock, and at three o'clock as many as 600 people sat down to dinner, spending the rest of each day in discussion, comparing notes and exchanging experiences. Copying Coke's example, improving landlords in many other parts of England, such as the Duke of Bedford at Woburn, or Lord Egremont at Petworth, began holding similar meetings. These evolved into the county and regional agricultural shows held every year in Britain, of which the most famous are the Great

Yorkshire Show, the Royal Highland Show at Edinburgh, the Royal Norfolk Show near Norwich, the Royal Welsh Show at Builth Wells, the Royal Bath and West Show at Shepton Mallet and the Royal Cornwall Agricultural Show.

To accommodate the need for agricultural expansion, another wave of Parliamentary Enclosure Acts was passed in 1760 and continued almost yearly for the next century, during which three million hectares of common land, mostly heaths, moor and fen, were enclosed. Droves of small subsistence farmers and out-of-work farm labourers and their families left the land. The lucky ones stayed in rural areas and found casual jobs road building, or as navvies planting hedges or building walls for the new enclosures, whilst their wives worked in one of the cottage industries – weaving, knitting hosiery or making gloves. Many thousands gravitated to the mills and iron founaries of the industrial North or emigrated. In the North of England and southern Scotland thousands of acres of marginal upland, heath and moorland was enclosed and let to tenants as sheep-grazing dispossessed the *cottars* (peasant farmers) and small tenants, who rented a few acres to grow basic crops and had traditionally grazed their few scraggy beasts in the hill valleys. The more enlightened landlords built 'model' villages to house those that had moved off the land and established light industry to provide them with employment. The Marquess of Tweeddale built the village of Gifford to accommodate the cottars moved from their small holdings in the Lammermuir Hills. Flax was a popular crop grown in the lowlands and a weaving industry was established in the village with a sunken bleach field in which the made cloth could be steeped in a lye solution to whiten it. Lord Lynedoch built the village of Pitcairngreen for the same purpose, confidently announcing that it would become the Scottish Manchester, and the Duke of Buccleuch built the village of Newcastleton and established a handloom industry. Other dispossessed farming families made their way to the new Scottish industrial towns such as Glasgow or New Lanark.

THE INFAMOUS CLEARANCES

The 'Lowland Clearances' are scarcely remarked upon by historians compared to the highly emotive and romanticised 'Highland Clearance' that started when Highland lairds employed lowland or English agriculturalists to improve their estates. Highlanders in the often heavily overpopulated straths and glens were forced to move to make way for sheep, sometimes under conditions of considerable hardship. Many took the option of emigrating to Canada and America, whilst others were moved to crofting townships on the coast. The thin, acid soil of the Highlands – particularly on the western side proved to be too shallow to sustain large flocks of sheep for long, and numbers were already falling when the first fleeces began arriving from Australia in the 1850s, causing the bottom to fall out of the wool market. As the sheep went, the red deer population increased and stalking started to become part of the increasingly popular Highland sporting experience. This led to the establishment of deer forests as prime land use, and by the end of the nineteenth century the area of land managed as deer forest exceeded two million hectares.

Graziers who rented hill land first had to clear it of scrub and, on peat soil, old rank heather by slashing and burning, the oldest method of improving ground known to man. Because of the topography of the ground, it was never going to be possible to fence the hills, so the early graziers, appreciating the delicate nature of hill herbage and its susceptibility to over-grazing, devised a method of 'hefting' the sheep. Each area of the hill was assessed on its potential sustainable stocking rate and then the number of ewes considered safe was taught to graze on each particular area, known as hefts. The hill breeds are, by nature of the land they live on, almost wild animals and naturally very territorial. This characteristic was an enormous help in the initial process, but even so, it was enormously time consuming. Circular stone-walled enclosures called stells were built on, or near, each heft and the sheep shut in them at night. By day, a boy or an old man would stay on each heft, keeping the flocks separate.

Gradually, over several years, the sheep on each heft became acclimatised to their own ground. To maintain this territorial knowledge, every year ewes that had reached an age where they could no longer productively survive the harsh conditions were sold off the farm and a proportionate number of ewe lambs from each heft retained, thus the grazing territories became inherited knowledge, passed from mother to daughter. The sheep on the hefts at my farm are the lineal descendants of those established 250 years ago and it is not unusual to see family groups of great-grandmother, grandmother, daughter and her lamb, all grazing together in the same group. Eventually the sheep ceased to be shut in at night and reverted to the instinctive grazing pattern of wild animals. In the afternoon they make their way to the safety of high ground and rest there until dawn. As the sun comes up, they slowly graze downhill to the sweet grass in the valley bottoms and, depending on the hours of daylight, they then start making their way back to high ground.

This natural 'rake' performed by hill sheep every day of their lives is what makes the husbandry of hill farming possible. The one glaring indication that a hill sheep is in distress is if it does not follow flocking behaviour. A hill shepherd's day starts with his circuit of high ground; if a sheep is hanging back whilst the others are all grazing downhill, there is something amiss. In the afternoon, the shepherd goes round his low ground and the same principle applies. It is particularly pertinent at lambing time; ideally, as with all wild animals, a hill ewe prefers to give birth a few hours before dawn as this gives them time to recover from the birthing process, clean the offspring and see that it has suckled and is able to follow her before any danger that daylight might bring. A lesser proportion give birth during the day, after they have reached the good grazing of the lower ground and whilst there is still time for the lamb to be up and suckled before the trek back. Therefore a shepherd looks for likely problems on high ground in the early morning and on low ground at night.

The other essential piece of knowledge which is passed from generation to generation by the hefting is that if a hill farm changes hands the sheep always stay on the farm and an extra price over their market value is added for 'hefting and acclimitisation'. Were they to go, it would be virtually impossible, in this day and

age, to replicate the hefting and a new flock would simply surge round in a bunch, eating out the most palatable herbage until all the goodness had gone.

Hill farming would not be possible without the shepherd's collie: *'A single shepherd and his dog will accomplish more in gathering a stock of sheep from a highland farm than twenty shepherds could without dogs, and it is a fact that without this docile animal the pastoral life would be blank. Without the shepherd's dog, the whole of the mountainous land in Scotland would not be worth sixpence. It would require more hands to manage a stock of sheep and drive them to market than the profits of a whole stock would be capable of maintaining.'* This observation by James Hogg, the Ettrick Shepherd, is as true today as it was in 1800. A trained sheepdog in action is a wonderful sight and I consider myself privileged to have spent my farming life working with a succession of fantastic examples. Sheepdog trialling started 1873 at Bala in south Wales and there are over 400 sheepdog trials held every year in Britain, ranging from Nursery, Open, National Championship (a three-day trial held in Ireland), to the International Supreme Championship, which rotates between England, Scotland, Ireland and Wales, with each country sending a team of fifteen dogs.

Farming and the Landscape

REGENERATING THE HEATHER-CLAD HILLS

Burning heather to create fresh, palatable regrowth is as old as farming, but until the agricultural revolution it was only carried out in a very small way. The glorious carpet of purple bloom that we know today as an enchanting feature of parts of the north of England and much of Scotland was reclaimed from untamed heath by graziers as they established their flocks. By using a system of rotational burning across a hill farm and a carefully controlled stocking rate, flock-masters discovered that in place of scrub and old rank heather an even spread of palatable mixed ages could be maintained.

There was an ever-growing interest in shooting sports during the nineteenth century and an increasing demand for shooting tenancies. Landlords began to notice that moors managed by graziers carried many more coveys of grouse than those that weren't. Grouse feed on the green shoots of juvenile heather plants, and burning to give fresh food for sheep simultaneously provided grouse with the necessary food source for population expansion. This led to the successful partnership between sheep and grouse which has existed ever since, with heather burning playing a vital role in moorland management for both whilst providing a habitat for an increased number of summering bird species. If heather is not burnt, it becomes old and stemmy and lacks nutritional value for sheep or grouse and both species – and indeed all other moorland wildlife – naturally decline, including predators.

A properly managed heather moor has a mosaic pattern of different ages and lengths of heather, about 30 metres wide and up to 100 metres long, burnt rotationally every year to provide continual regrowth. This ensures that sheep graze evenly across their hefts and provides grouse and other moorland ground-nesting birds with the depth of cover to nest in safety from the increasing number of aerial predators and space for their chicks to learn to fly. Heather burning is strictly governed by legislation; below 1,500 feet it is only permissible between 1 October and 15 April and there is a fifteen-day extension for ground above that altitude. In both cases, if the weather is particularly wet a further extension may be granted. In theory, there are six months in which to burn heather; in practice, most heather is burnt in a short, hectic period from mid-March, when the heather is dry and the underlying peat wet. The most important factor is to stop burning before ground-nesting birds start to lay their eggs.

> IF HEATHER IS NOT BURNT, IT BECOMES OLD AND STEMMY AND LACKS NUTRITIONAL VALUE FOR SHEEP OR GROUSE AND BOTH SPECIES – AND INDEED ALL OTHER MOORLAND WILDLIFE – NATURALLY DECLINE, INCLUDING PREDATORS.

Heather burning has become very technical during my lifetime. It used to be done by gangs of men armed with shovels to control the fires, now there are tractor-mounted flails to cut out the shape of the area to be burnt, leaving damp mulch behind which helps control the flames and high-pressure fogging units mounted on Argocats to deal with emergencies. Today, hill farming incomes bear no resemblance to the value of the sporting increment, and although sheep and grouse continue to coexist necessarily, the preservation of moorland conservation is almost entirely funded by shooting. Without this the landscape would revert to an unsightly jungle of rank, heather, thistles and scrub.

FARMING MODERN BRITAIN

By 1850 Britain had become arguably the most powerful country in the world. The population had risen to 21 million, 50 per cent of whom were urban-based and employed, one way or another, in the booming manufacturing industries. The world map turned ever pinker as colonisation continued, requiring an army of about 400,000. The railways had out-competed all other means of transport and the rail network spread rapidly across the country; technological advances in agricultural machinery made improvements to all existing reaping and threshing machines, new ploughs and drills.

There was another surge in more efficient fertilisation when chemists discovered that guano contains high concentrations of nitrates and phosphates. In essence, guano is the sedimentary conglomerate of dung, carcasses, feathers, eggshells and sand accumulating in areas where seabirds congregate in confined spaces on small off-shore islands or rocky outcrops, which by virtue of their inaccessibility offer shelter from natural predators. Climatic and environmental conditions favouring this scenario occur on the west coasts of both South America

and Southern Africa. The discovery of rich guano deposits on the islands and coast of Chile, and Ichaboe Island, off what is now Namibia, started a series of mad rushes to acquire the precious excrement. As guano resources became exhausted towards the end of the century, they were replaced by the latest innovation in extracting goodness from the soil, chemically manufactured sulphate of ammonia and superphosphate. Agricultural productivity also rose on the back of the increase in the use of roots crops and, with an urban demand for fruit, apples became an alternative crop. In 1877, there were 9,000 hectares of eating and cider apples in Devon, Herefordshire and Somerset, 4,000 in Worcestershire, 3,500 in Gloucestershire and 2,500 in Kent.

> WOOL, WHICH FOR CENTURIES HAD BEEN THE FOUNDATION OF THE TEXTILE INDUSTRY, WAS DECLINING IN IMPORTANCE TO COTTON. HOWEVER, AS THE MARKET FOR MEAT CONTINUED TO GROW, MANY FARMERS RESPONDED BY ADAPTING THEIR BREEDING POLICY FROM WOOL TO MEAT PRODUCTION.

Wool, which for centuries had been the foundation of the textile industry, was declining in importance to cotton. However, as the market for meat continued to grow, many farmers responded by adapting their breeding policy from wool to meat production. By the end of the nineteenth century, Britain's large urban workforce provided a huge stimulus for a world economy dominated by international trade, commercialism and industrialisation. A large proportion of trade was based on import and subsequent export, supported by service industries such as banking which improved the balance of payments with invisibles. Free trade also led to an economic boom, and a significant part of the escalating population were enjoying leisure time and rising prosperity. Wage rates had increased, the birth rate fell and diets improved. Agriculture remained fundamental in the supply of foodstuffs but its influence was waning in the economy as a whole and land, once identified with power, became just another asset. In 1850, agriculture accounted for 20 per cent of national income, but by 1900 this had fallen to just 6 per cent.

In 1945, despite the agricultural changes of the previous 200 years, Britain still had a mellow, rustic air. Plump hedgerows full of wildflowers enclosed fields where cart horses still plodded ahead of the plough. Winding lanes wandered among villages and family farms, with their woodland clumps, orchards, livestock and grain systems, where a pig was fattened every year for bacon, chicken scratched for spilt grain in the stack yard and ducks paddled on the pond. As ever, a dark cloud hung over this utopian scene, and change as dramatic as any that had gone before was on its way. At the end of the war, Britain needed to maximise food production and agriculture was supported by grant funding and price support, greatly empowering a new modern era of agriculture with new technology, specialisation and improved breeding techniques. This was all very well in response to the immediate post-war food shortage, but government pressure to increase food production during the Cold War scare led to a period of intensification that dramatically altered the rural landscape.

As post-war policymakers sought for food sufficiency in the event of another war, thousands of kilometres of hedgerow planted during or before the Acts of

Enclosure were bulldozed out to create larger, more efficiently cropped arable fields. Much of our ancient woodland disappeared during the massive forestry planting, driven by the government's mania for self-sufficiency in timber products. In 1972 Britain joined the European Economic Community and, after a transitional period, agricultural policy fell within the remit of the Common Agricultural Policy, which encouraged wasteful food surpluses. With the ever-increasing drive for new technology in machinery, fertilisers, pesticides and crop production, the agricultural workforce declined and rural depopulation resulted. Only in the hills, where agricultural reclamations are virtually impossible, did farming remain much the same, but even here the effects of nylon textile were being felt as the wool price slid. The old saying, *'the wool clip pays the rent or the shepherd's wage,'* was but a happy memory and a hill farm that had once employed two shepherds could now only afford one.

During the nineties, persuaded as much by increasingly powerful conservation lobbies as the embarrassing situation of overproduction, the government began reversing the previous policies and, instead of paying farmers to intensify, they now paid them to put the countryside back the way it was. Agriculture has steadily declined as a land use, despite the rise in demand for home-grown and organic food, giving way to leisure and urban development. Patterns of ownership and management have changed, particularly with various tax incentives designed to attract non-farmers to become landowners. The complexities of the Common Agriculture Policy and fiercely competitive international food prices have led to a ridiculous situation where we have a population of 60 million and yet British agriculture provides less than 1 per cent of gross domestic products, employs only 2 per cent of the workforce and the majority of British farmers survive through a system of grants and subsidies.

> AGRICULTURE HAS STEADILY DECLINED AS A LAND USE, DESPITE THE RISE IN DEMAND FOR HOME-GROWN AND ORGANIC FOOD, GIVING WAY TO LEISURE AND URBAN DEVELOPMENT. PATTERNS OF OWNERSHIP AND MANAGEMENT HAVE CHANGED, PARTICULARLY WITH VARIOUS TAX INCENTIVES DESIGNED TO ATTRACT NON-FARMERS TO BECOME LANDOWNERS.

It is important, however, that there is never a repeat of the government follies of the sixties and seventies. The British countryside should be a place where farmers can work and earn their living and the decision makers, whether here or in Brussels, must appreciate the fragility of our historic landscape. Farmers and landowners are the stewards of our countryside heritage, and between them own many miles of historic field boundaries, thousands of traditional farm buildings and most of the ancient archaeological sites. An enormous amount was lost during the post-war period of intensification and, once gone, they can never be replaced. Changes in attitude now provide an opportunity to prevent further destruction whilst allowing farmers to fulfil their historic role of feeding the nation.

CHAPTER TWO

WOODLAND

Immediately after World War II, my father bought a farm in that lovely part of the High Weald in East Sussex, on the northern edge of the Ashdown Forest. This is a landscape of rolling hills, sandstone outcrops, little streams running through steep-sided ravines, scattered farmsteads with small, irregular-shaped medieval fields linked by sunken lanes and paths, amongst areas of ancient broadleaf woodland.

Some of my earliest memories are of my sister and me being taken on afternoon walks through the woods on the farm by our nanny, the redoubtable Nanny Pratt. The woods were a mix of coppiced ash, hornbeam and sweet chestnut, known as underwood, growing in clusters from single stools, and individual oak standards scattered about, trees allowed to grow for their timber without being coppiced. Nanny Pratt always carried a trug on our walks to put wild flowers in for the nursery or edible plants, berries and nuts. In the early spring, she would look for wild garlic plants growing in damp glades or the banks of the little streams, where the water ran reddish brown from iron ore deposits in the local clay. By May the woodland floor was a carpet of bluebells, wood anemones, woodruff, wood sorrel, and shiny-leaved Dog's Mercury, wild arum, white hellebore, little purple orchids and wood spurge. As the summer wore on, herb bennet, primroses, foxgloves, figwort, meadowsweet and purple-flowered Enchanter's Nightshade could be found.

The woods were a haven for wildlife and a constant source of delight and fascination. A stick poked among leaf litter would be guaranteed to produce something of interest: a disgruntled ground beetle, his glossy blue-black carapace glinting in the sunlight; a Longhorn beetle with waving antennae; or a thrilling, fast-moving Wolf spider. Even woodlice and millipedes had their entertainment value. There were hoverflies, brightly coloured weevils, caterpillars, and where the sun shone through the overhang, any number of beautiful woodland butterflies – White Admirals, Purple Emperors, Commas – and a whole range of woodland fritillaries. Nuthatches or tree creepers scuttled up and down the trunks of the old standard trees and we would often hear the rasping curse of a jay or the silly laugh of a green woodpecker. Cock pheasants might be seen scratching for food on one of the bridle paths and there was always a background of twittering, whistling little woodland birds such as chiffchaffs, warblers, tits, robins, wrens and blackcaps. We might see a hedgehog rootling for slugs, an adder curled up asleep on a sunny bank or find ourselves watched by a timid roe deer. In the autumn, when the leaves turned golden and the ferns began to die back, fungi would appear. Clumps of yellow honey fungus, beefsteak, velvet shank or beech tuft on old stumps; oyster mushrooms, chanterelles, boleti, Caesar's mushrooms, morels, puffballs and sometimes fly agaric and death cap. To all of these, Nanny Pratt would cry, 'Don't you go near them.' Autumn was nutting time, when the trug was filled with clusters of

hazelnuts in their little green caps, sweet chestnuts or blackberries and rose hips. Winter was my favourite time of the year. I loved the silence of the woods, the long shadows and the stark eeriness of bare trees, the red, citron, russet, black, bronze or copper of fallen leaves and the musty, mouldy smell of decay.

Sometimes, when the frost was hard on the ground, we would smell wood smoke and come across the farm men coppicing chestnut trees for fencing stobs. They would cut the poles to length and stack the 'cords' to dry until the following winter, or split dry poles from the previous year with sledge hammers and chisels, loading the split wood onto a four-wheeled box wagon, whilst the carthorses stood patiently in the shafts. The woods were coppiced on a rotational cycle and the areas to be cut were known as *coups*. Hazel was coppiced every six to eight years, chestnut every ten to fifteen years, ash every twenty, hornbeam twenty-five, and oak, around fifty years.

One winter, a family of charcoal burners set up camp in Drew's Rough, a hornbeam wood to the north of the farm, cutting and stacking the wood to dry for burning. Their arrival was an endless source of rumour and gossip among the farm men: charcoal burners lived in huts made of turfs and were worse than gypsies for thievery and poaching. They ate badgers, hedgehogs, squirrels, snails and little woodland birds which they caught with bird-lime made from fermented holly bark; were immune to the bites of adders, which they caught with their hands, skinning them and selling the fat to people who believed it cured deafness and rheumatism. I thought they sounded fascinating, and my one ambition was to be taken to visit the camp, but needless to say, as far as Nanny Pratt and indeed everyone else on the farm was concerned, Drew's Rough was a place to be avoided.

In the early spring, Nanny Pratt took her annual fortnight's holiday and she was replaced by a young woman from an agency. By then, all anxieties over the charcoal burners had been forgotten. They kept to the wood and were rarely seen; nothing had been reported stolen, nor had any of them been caught poaching. With my sister away, there was no one to contradict me when I suggested to Miss Knowles that Drew's Rough would be a pleasant place for our afternoon walk. I did not actually know where the charcoal burners were working, and I suspect that my curiosity would have been satisfied by simply watching them unobserved from the safety of the trees, if we ever found their camp.

As it happens, one moment we were ambling along the old, sunken, leaf-filled drove road that ran through Drew's Rough and the next we came round a bend to find ourselves in a clearing, where the filthiest man I had ever seen was shovelling earth onto a circular pile of logs. A horse and cart laden with cut cords was being led down a track into the clearing by another man, whilst a third loaded cords from a stack onto a wheelbarrow with four uprights rather than a body, known as a 'charcoal burners' mare'. There were the remains of a fire that had burnt down,

with a heap of hessian gunny sacks filled with charcoal beside it, partially covered by a tarpaulin. Across the clearing, where the ground rose, were several huts made of poles, turfs and canvas, shaped like wigwams. A blackened cooking pot hung on a tripod in front of them, and nearby two children played with a scruffy mongrel chained to a stake. Until now, the men had been concentrating on their work and we might have slipped away unnoticed, but the dog saw us and started to bark; two women emerged from the huts and everyone stopped and stared at us.

We couldn't leave now, so we walked across the clearing to the man with the shovel and the two women – Joe Botting, our gardener, told me later that charcoal burners' women were known as 'Motts' – came down to join him. He wore the greasy wreckage of a trilby hat, Derby tweed trousers, hobnailed boots, a collarless flannel shirt and an old waistcoat. Everything – his unshaven face, neck, arms and his clothes – was black with charcoal grime. The two women were no cleaner; one was lank and sinewy, with dirty black hair hanging in a rope down her back, wearing a threadbare jersey, a man's jacket and a thick tweed skirt, with her skinny bare legs thrust into a pair of cut-off gumboots. The other wore oily dungarees and an army greatcoat. Both of them, like the man, had dark obsidian eyes, smelt of stale wood smoke and seemed to have soot ingrained in their skin.

> A BLACKENED COOKING POT HUNG ON A TRIPOD IN FRONT OF THEM, AND NEARBY TWO CHILDREN PLAYED WITH A SCRUFFY MONGREL CHAINED TO A STAKE. UNTIL NOW, THE MEN HAD BEEN CONCENTRATING ON THEIR WORK AND WE MIGHT HAVE SLIPPED AWAY UNNOTICED, BUT THE DOG SAW US AND STARTED TO BARK.

'Good afternoon,' said Miss Knowles, 'We're from the farmhouse. This is Major Scott's son,' succinctly establishing our credentials. This was met with a stony silence, whilst the three of them stared at us unnervingly. Then the skinny one said in a high, rasping voice, 'Ooh, look at 'im. Look at his hair, innit booful?' In those days, I had a mop of blond curls which Nanny Pratt made me wear rather on the long side. I loathed them, because it made me look girlish. The skinny woman seemed to agree: 'Innit a crime for a boy to have hair like that? What I wouldn't give for curls like them.' At this, she gave what was no doubt intended to be an encouraging smile, exposing the stumps of her teeth and, stretching her hands with their long, blackened fingernails towards me, attempted to fondle my hair. At that, my nerve broke and I ran squealing out of the clearing with her horrid cackling laughter ringing in my ears, back down the old drove road towards home. For years afterwards, I was plagued with nightmares of those hands reaching out for me and the clumping footsteps that followed as I ran through the leaves.

OUR WORKING BRITISH WOODLANDS

Timber was nature's greatest gift to mankind, and coppicing is the oldest form of woodmanship, practised from the time early man discovered that the stump of a felled tree produced a self-renewing supply of timber, until well into the twentieth century. The earliest archaeological records of coppicing in Britain were discovered on the Somerset Levels in 1970, when peat diggers unearthed part of a wooden roadway, the timbers from which have been carbon dated to 3900 BC. The Sweet Track, named after its discoverer, Ray Sweet, extended across the waterlogged marshes between an island at Westhay and a ridge of high ground at Shapwick, a distance close to 2,000 metres. The track is one of a network that once crossed the Levels, connecting Neolithic island communities with each other. It is an elaborate structure, engineered from coppiced poles of ash, oak and lime driven into the swamp to support a walkway that mainly consisted of split oak planks laid end-to-end. The Sweet Track and archaeological remains of Neolithic hut construction clearly indicate that there was an existing culture of coppiced ash, oak, hornbeam and lime to provide straight poles of about 5 metres, for structural supports, with hazel rods and willow withies for wattle-and-daub walling.

There was, of course, no shortage of material; the British Isles were then almost completely covered in wildwood, except for the areas of salt marsh to the south-west and east, coastal sand dunes, wetlands and the high mountains of northern England, Wales and Scotland, where scrub gave way to heather. Gradually, during the 6,000 years since the Ice Age ended, Britain became colonised, first by the tundra tree species – birch, aspen, juniper, mountain ash and sallow – and then these were followed in more or less chronological order by pine, yew, hazel, alder, sessile and pedunculate oak, lime, wych elm, holly, ash, maple, wild cherry, crab apple, black poplar, beech and hornbeam. There was little or no hindrance to their growth; the nomadic hunter-gatherers of the Mesolithic period made less impact than the herbivores they hunted. Aurochs, elk, red deer and wild boar would have inhibited regrowth in clearings created by fallen trees and on large areas of land where poor soil type led to sparse woodland growth.

By the time of the Neolithic migration, the composition and structure of the wild wood would have varied considerably between the different regions of Britain, with a complex pattern of local variation reflecting differences in soil type and depth. Southern Britain would have been covered with oak woodland on relatively infertile soil; lime woodland probably dominated fertile, non-calcareous soil; ash woodland on calcareous soils; and alder in river valleys and wetlands. Further north, the woodland cover would have comprised pine, birch and oak; only the highest mountain peaks and most exposed areas would have remained unforested.

A Book of Britain

The Neolithic agrarian colonists arrived in Britain around 4500 BC, bringing with them sheep, goats, cattle, pigs and primitive crops such as eikhorn wheat and Hordeum barley. They established little communities on the easily drained soils of the upland hills and on the coastal plains, avoiding the thickly wooded valley bottoms. These early agriculturists were industrious people, felling areas of wildwood to create fields for their arable crops, or burning and slashing scrub in areas of poor soil to produce woodland pasture for grazing. In other parts of the wildwood adjacent to settlements, trees were coppiced for building materials, fencing and firewood. The climate was consistently warm and dry, and over a period of 2,000 years Neolithic farmers spread throughout the British Isles, clearing woodland, reclaiming land and leaving monuments to their permanence in the form of monoliths, long barrows, causeway camps and henges. The areas of heaviest settlement were the chalk hills of the south and west, the Somerset Levels, coastal Cumbria and in East Anglia, particularly the Breckland where the shallow sandy soil was ideal for basic crop production and where most of the wildwood was cut down.

> THE EARLY AGRICULTURISTS WERE INDUSTRIOUS PEOPLE, FELLING AREAS OF WILDWOOD TO CREATE FIELDS FOR THEIR ARABLE CROPS, OR BURNING AND SLASHING SCRUB IN AREAS OF POOR SOIL TO PRODUCE WOODLAND PASTURE FOR GRAZING. IN OTHER PARTS OF THE WILDWOOD ADJACENT TO SETTLEMENTS, TREES WERE COPPICED FOR BUILDING MATERIALS, FENCING AND FIREWOOD.

A new wave of settlers, known as the Beaker People from their common use of a distinctive, inverted, bell-shaped, pottery drinking cup, arrived from the Continent in about 2100 BC, bringing with them the knowledge of refining metal and how to make charcoal. Burning wood in the absence of oxygen to create carbon for fuel had been practised in Europe and the Middle East for many centuries, and initially the smiths used their skills to smelt copper that was surface mined in Devon, Cornwall, Cheshire and Wales – particularly the Great Orme mine at Llandudno in North Wales – and extensive copper mines in Ireland. Britain had large resources of tin in the West Country and lumps of cassiterite, tin oxide, were easily found in the mud of streams in places such as the Carnon Valley in Cornwall, washed downstream from outcropping lodes.

The Beaker smiths discovered that the heat generated from charcoal was capable of melting tin and that tin mixed with copper produced bronze, a much harder, more versatile material than the individual components. This was the beginning of the period of prosperity known as the Bronze Age, and by around 1600 BC the south-west of Britain was experiencing a trade boom as British tin and bronze was exported across Europe. At much the same time, the climate was deteriorating; where once the weather was warm and dry it became cooler and wetter as the Bronze Age continued, forcing the population away from easily defended sites in the hills and into the fertile wooded valleys. Bronze Age man now had the tools for large-scale forest clearance and farms of considerable size developed in the lowlands. Their wealth enabled the second and third stages of the building of Stonehenge and is reflected in the artefacts found in the richly furnished graves that have been excavated across Wiltshire.

When the Celts arrived in 800 BC, they found quite large farming communities in the fertile valleys on the edge of dense wildwood. These were predominantly cereal farms with some sheep, goats, pigs and cattle. The great lime woods of the southern half of England had been largely replaced by oak, ash, hornbeam or hazel, and areas adjacent to settlements were managed for coppicing, with newly cut coupes protected from livestock and deer by dead hedges – coppice trash woven between stakes driven into the ground. Pigs would be driven into the woods to rootle and graze by day, and cattle onto areas of wood that were common on poorer, higher ground. The Celts introduced their own improved agricultural techniques, particularly with arable farming, introducing oats, rye, millet and the more productive spelt and emmer wheat species. Fields and paddocks were laid out in regular, rectilinear patterns and fertilisation, in the form of chalk, mast, loam and marl, was used for the first time. The uplands that had been abandoned by their Bronze Age predecessors were re-occupied by pastoralists who created grazing by clearing the scrub and felling trees that had naturally reseeded.

> THE CELTS INTRODUCED THEIR OWN IMPROVED AGRICULTURAL TECHNIQUES, PARTICULARLY WITH ARABLE FARMING, INTRODUCING OATS, RYE, MILLET AND THE MORE PRODUCTIVE SPELT AND EMMER WHEAT SPECIES. FIELDS AND PADDOCKS WERE LAID OUT IN REGULAR, RECTILINEAR PATTERNS AND FERTILISATION, IN THE FORM OF CHALK, MAST, LOAM AND MARL, WAS USED FOR THE FIRST TIME.

The Celts were also skilled metallurgists, bringing with them the knowledge of making iron and mining lead, gold and silver. Lead and silver were found at Chewton Mendip in Somerset, Machen in South Wales, Pentre in the north, Shelve Hill in Shropshire and Crich in Derbyshire. Gold was panned in the stream beds around Dolaucothi, Gwynfydd and Clogan, in Wales, and dug for among the gravel washed into the valley bottoms. Copper and tin continued to be mined in Wales and the West Country, but it was iron that kept the new migrants busiest and gave its name to the era. Iron ore was surface-mined all over Britain where clay or greensand was the predominant soil type, but two of the most important areas were the Forest of Dean in Gloucestershire and part of Monmouthshire, and the Weald of Sussex and Kent, the heavily wooded area which lies between the North and South Downs. Iron nodules, easily extracted from the local greensand and sticky Wealden clay, were smelted in charcoal-fired bloomery furnaces to produce wrought iron. There was a considerable industry on the northern edge of the Ashdown Forest in iron ore smelting, coppicing and charcoal manufacture. At the time of the Roman invasion, seven hill forts and over half the thirty-three Iron Age workings in Britain were recorded in this corner of the Weald.

BRITAIN'S CHANGING LANDSCAPE

A considerable amount of the original wildwood had been cleared for farmland by the time of the Roman occupation, but there were still vast areas of dense, tangled woodland across most of Britain. The landscape would not have changed very much in the previous seven centuries or have looked very different to that which the Celts found. Most of the woodland had gone from the chalk downland and along the valleys of the great rivers, with a patchwork of managed woodland and farmland on the edges of vast areas of wildwood elsewhere. Some settlements, particularly where minerals were mined, extended deep into the great wooded areas, such as the Weald in Kent and Sussex, the Forest of Dean in Gloucestershire, Grovelly in Wiltshire, and Rockingham in Northamptonshire, to name only a few. Throughout the country there were the heaths, moorland, marshes, wetlands and bare uplands, where graziers kept their flocks.

From the moment they arrived and throughout the 400 years of their occupation, the Romans required an immense quantity of wood. In fact, had it not been for the availability of this essential raw material, it is doubtful whether the gold, silver, tin, copper, lead, iron and other commodities which Britain had to offer would have been sufficient inducement to invade. The immediate requirement of the 40,000 legionnaires and auxiliaries, when they landed in AD 43, was timber to

build new forts or to re-fortify existing ones that had been abandoned by the retreating Celts. Around ten hectares of woodland went into the construction of each fort and literally hundreds were built as the army advanced through Britain. Once the tribes had been subjugated, hectares more woodland were required in scaffolding, as permanent defences were built.

This was only the beginning; with the country becoming relatively settled, coppiced underwood was needed for all general building and mature trees for the great timber-framed urban buildings, rural villas, the numerous bridges of the road networks and ships of the navy. Fuel was necessary for basic domestic heating, brick and pottery kilns, corn dryers and for their extensive estuarine salt pans in places such as the Cooling Marshes at the mouth of the Thames or the brine springs around Northwich, Middlewich and Nantwich in Cheshire. Oak bark was in very high demand for the tanneries, and Roman mining operations were on an industrial scale not seen again until the sixteenth century. The historian Dr Oliver Rackham has estimated that charcoal from over 9,300 hectares of coppiced wood was needed to fuel the military ironworks in the Weald alone.

Considerable areas of wildwood were cleared to accommodate the large estates which now dominated the farming system, with their extensive cattle ranches, big sheep flocks and sufficiently improved cereal production to allow a surplus to be exported. Highly sophisticated methods of sylviculture were introduced, which enabled the Romans to manage the woodlands efficiently and meet the enormous demands on an inevitably limited natural resource. They were, of course, able to draw on experience acquired over centuries of woodland management elsewhere in the Empire and the knowledge of the most respected agriculturalists of the period, such as Lucius Columella, author of *De arboribus* and Rutilius Palladius, author of *Opus agriculturae*. The centuries-old system of coppicing woodland of mixed underwood and standards allowed to grow to maturity was continued, but in a much more productive manner. The Romans established a variety of cereal, vegetable, herb, fruit and tree species, the most important of which to sylviculture was sweet chestnut. Chestnut became one of the most valued coppicing timbers, and Stour Wood, an ancient chestnut wood near Harwich, is believed to grow on the site of a Roman chestnut plantation.

With the collapse of the Roman Empire and expulsion of the Roman civilian administrators around AD 410, the Romano-British were left to fend for themselves in a country besieged by barbarians from all sides. The Picts and Scots swarmed hungrily over the abandoned Hadrian's Wall; Angle, Jute and Saxon pirates harassed the coastal communities from the Tyne to the Tamar, whilst Norwegian and Irish raiders periodically amused themselves along the west coast from the Mersey to the Solway. Vortigern, the fifth-century king of the Britons, has been blamed for making matters considerably worse by employing Saxon mercenaries to fight for him and paying them with grants of land. In a relatively short space of time, the numbers of mercenaries had grown to a level where they were

powerful enough to rebel, capturing the south-east lowlands and throwing the door open to a general invasion. For the next couple of centuries, Britain was plunged into a series of wars as Britons either fled to Brittany, hence the name, or were forced into Cornwall, parts of Scotland and the hills of Wales.

There is no doubt that during the Dark Ages of early Anglo-Saxon Britain, almost every advance in civilisation introduced by the Romans was reversed. The great urban buildings, country villas, bath houses and temples were allowed to collapse, and with no central government, the industries that had once made Britain prosperous were neglected. The population, estimated at four million towards the end of the Roman occupation, rapidly fell to around two million. A natural consequence of this drop in population was a rapid expansion in woodland, which follows a simple law of nature overlooked by conservationists today, with their mania for planting: land left unused will inevitably become invaded by trees. In many areas, farms that had been laboriously reclaimed from woodland were gradually overtaken by secondary growth and intensively managed woods reverted to their natural form.

Successive waves of the invaders pushed inland, creating fortified farming communities under petty chieftains along the fertile river valleys and on the edges of immense woodland, such as the Weald and the Forest of Dean, the great woods around London and what is now Stansted airport, the Chiltern plateau, and those in Worcestershire, Warwickshire, Cheshire, Derbyshire, the Lake District and Wiltshire, in much the same way as the Celts had done before them. Saxon farming communities had the same essential requirements from woodland; they built their houses and even their principal buildings from wood. They needed wood for basic fuel, fencing, for the salt works and mines, and as the population expanded farmland was extended at the expense of trees. Woodland was coppiced in the same way as it had been by previous generations to provide a self-replenishing supply of easily handled poles, with mature trees among the underwood for beams and planks.

In the years after 1066 the woodlands provided a vital part of the whirlwind programme of castle building instigated by William the Conqueror, as he sought to suppress the populations of regional centres by creating a network of fortified power-bases. Over a period of twenty years, at least 1,000 wooden motte-and-bailey fortifications and 87 stone castles were built. Both the Crown and the Church sought to assert their authority over the populace by constructing many hundreds of imposing castles or magnificent abbeys – between 1130 and 1280 the Cistercians alone built 86. Construction on this scale required a phenomenal amount of trees, and buildings in general continued to be the single biggest use of timber for many centuries. Three-quarters of the building timber used was oak, the most common species of coppiced wood, with some ash, elm and aspen.

The majority of buildings were made from large numbers of relatively small trees, about 30 centimetres in diameter and probably no more than 6 metres in length. There were a variety of reasons for this: woodland management was designed to provide a rapid turnover of self-sustaining materials, and a standard growing amongst underwood would reach about six metres before branches or the crown developed, providing a tree that was easy to fell, extract and transport and a

trunk which did not require much carpentry and could be adzed into shape. Larger trees were expensive to move, difficult for early saws to cut through lengthwise, and were generally reserved for castles, cathedrals and great houses.

All English wood was deciduous hardwood, and from the middle of the thirteenth century the very rich began to panel the interior of their houses with softwood boards imported from the Baltic. Known as deal, there are references as early as 1250 of deal boards for panelling in the accounts for the building of Windsor Castle and of Norwegian pine scaffolding in the early 1300s during the building of Ely Cathedral's octagonal 'Lantern Tower'. During the Tudor period, an increased demand for bigger timber led to Henry VIII passing a statute which required woods to be enclosed after cutting, to prevent regrowth being damaged by browsing animals, and thirty trees to be left in each hectare, to be grown into timber.

TIMBER – NATURE'S MOST USEFUL GIFT

There was, of course, an infinite number of uses for every part of each woodland species. Oak was by far the most abundant standard tree, although other species such as ash were occasionally allowed free growth. Every soil type and region had characteristic combinations of coppice species. These included hazel and ash on the Midland clays, beech and sessile oak on Western sandstone, and lime in central Lincolnshire. Hornbeam and sweet chestnut grew widely in the south-east, while local or minor underwood species included whitebeam, wild cherry, crab apple, maple, alder and elm. Some underwood species were particularly suited to specialised uses, and there was some selection in favour of these, but most coppice woodland included a mix of trees to serve a variety of local needs.

COMMON OAK

The common oak, although widely distributed over Europe, is regarded as a peculiarly English tree. It was for many centuries the principal woodland tree in England and is intimately bound up with the history of these islands. As timber, its particular and most valued qualities are its resilience, elasticity and strength, and oak has long been a symbol that reflects the hardiness of the British people. King Edward's Chair, also sometimes known as 'St Edward's Chair' or 'The Coronation Chair', is the throne on which British monarchs sit for their coronation. It was commissioned in 1296 by King Edward I to be carved in oak and designed to contain the Stone of Destiny, the coronation stone of Scotland, below the seat. (This was returned to Scotland in 1996, on the condition that it is sent down to England whenever there is a coronation.)

In the mining areas of Britain coppiced oak was primarily cut for manufacturing charcoal, but there was also a huge demand for the hard, tight-grained, flexible timber in both house and ship-building, particularly by the navy during the Napoleonic Wars. A large ship of the line in Nelson's navy, carrying between 70 and 100 guns with a ship's company of over 1,000 officers and men, required timber from 3,500 standard oak trees. In 1805, at the time of the Battle of Trafalgar, the navy alone consisted of 128 ships of the line, 35 gun vessels, 145 frigates, 400 sloops and a host of smaller craft. Apart from fuel, charcoal, and engineering structures where strength and durability were required, or building and boat materials, oak had a mass of other uses. The best fencing was made from oak coppice which was split lengthwise and it was in constant demand by cabinetmakers, joiners, wagonmakers, wheelwrights and in particular by coopers. In the great days of pioneering rail travel, oak was as popular as ash for making railway carriages and goods wagons. Oak sawdust was used to impart a delicious flavour to York hams, and oak galls, the nodules formed where a gall wasp lays her eggs, were used for making ink and treating gonorrhoea. Blacksmiths traditionally used – and still do – the root stump of an oak for an anvil base, and the oak was universally regarded as the best of all barks for tanning.

SESSILE OR SCRUB OAK

In the uplands of the north of England and Scotland, birch and sessile oak were by far the most common species, dominating both the underwood and canopy of the coppiced woodland. Where the uplands turn into hills, and growing conditions become more difficult, standards grew too slowly and erratically to be worth fostering, so 'scrub oak' coppice without standards developed. Much of this was used for tanbark or charcoal and thousands of acres of scrub oak used to grow across the hills of the Scottish Borders, before it was cleared and the sheep inhibited further regrowth. In 1804, during the Napoleonic Wars, there was a belief that the French might attempt an invasion at Berwick-upon-Tweed, and a system of beacons was built across southern Scotland, to be fired in the event of a landing. On the night of 31 January a sergeant in the Berwickshire Volunteers on duty in Hume Castle at Greenlaw, which commands a spectacular view across the Tweed valley, mistook the twinkling of charcoal burners' fires on the distant Cheviots for the vanguard of the enemy. He promptly lit his beacon and the result was the inglorious incident known as the 'Great Alarm', in which beacons were mistakenly lit in turn right across the Borders, and several thousand volunteers rushed to repel a French army that didn't exist.

THE COOPER'S CRAFT

Coopers were once numerous and independent craftsmen, whose highly skilled craft was acquired only through years of practice. Until a century ago, virtually every village had at least one cooper, with an apprentice serving the standard seven-year apprenticeship. Their role was to supply the village with rounded watertight recipients that were able to withstand stress from rolling and weight from stacking. These ranged from buckets and pails for milk and water, to barrels, casks and kegs of every size for liquids, transporting goods or storing salt, pickled food, oil and flour. In the towns and cities, the breweries each had a cooperage making barrels that started with a 4.5 gallon polypin and then doubled in capacity through firkin, kilderkin, barrel, hogshead and butt to the mighty 216 gallon tun. With commercial whisky distilling, after the Excise Act of 1823, every highland distillery had its own cooperage and a Master Cooper who oversaw the manufacture of barrels which would remain watertight for the whisky maturing process – often for over twenty-five years. In the mid-twentieth century, stainless steel and aluminium barrels became prevalent in beer making, but some specialist real ale breweries do continue to make beer in wooden barrels. Wadworth of Devizes in Wiltshire, who employ the last remaining Master Cooper in England, is an example. In Scotland, whisky is still matured in oak barrels where the tannins in the wood play an essential role in maturation, by enabling oxidation and the creation of delicate fragrance in spirits. In the village of Craigellachie, near Aberlour, in Scotland, the Speyside Cooperage produces and repairs nearly 150,000 oak casks used by the surrounding Speyside Whisky distilleries, as well as distilleries elsewhere throughout Scotland.

It is generally accepted that the Celtish tribes of the wooded Alpine region of Germany were the first people to make barrels, in around 300 BC, and the basic structure has remained more or less unchanged. Sections of oak trunks, from trees ideally aged 100 to 150 years old, are split along the grain into staves, bent and stacked in the open for between 18 and 36 months to enable the wood to dry evenly in the air. The manufacturing process requires the use of a number of well-seasoned oak staves enclosing a circular head at either end of the cask, and then bound together with steel or copper hoops. The skill of the cooper lies in making each stave, precisely shaped and bevelled, to form the tight-fitting circle of the belly of the cask.

The staves are trimmed into oblong lengths with a double taper, traditionally called 'dressing', then joined on a jointer known as a 'colombe' and given their final shape before being fitted onto a frame and arranged around an iron 'raising up' hoop. The shaping requires heat to modify the wood's physical and chemical composition, which is provided by natural gas, steam or boiling water, or flames from burning wood chips, or a combination of these. If fire is used the barrel is assembled over a metal pot called a 'chaufferette'. The cooper hammers home temporary iron hoops whilst pressing the wood with a damp cloth. The barrel heads, comprising five or six straight staves pinned together, are shaped to fit into a groove known as the 'croze', which is cut in the inside ends of the side staves. To finish, the outside is planed smooth and the barrel is filled with steam or water: if it is watertight the bunghole is drilled and the iron hoops are replaced with steel or copper ones.

ALDER

Alder, often seen lining the banks of streams and rivers or forming small alder woods known as 'carrs' on damp ground, was an immensely useful, fast-growing, multi-purpose tree. The tightly grained wood has the quality of long endurance under both fresh and sea water, and was invaluable for pumps, troughs, sluices and water pipes. The medieval conduits bringing fresh water into London were made using alder and it was still used for piping in the eighteenth century. In fact, examples of alder water pipes from the reign of Charles II, excavated from Oxford Street in 1899, can be seen at the Powerhouse Museum in London's Chinatown.

Alder was extensively used as piling in the construction of docks, quays and landing stages – Venice was built on alder piles, and during the great era of canal building in the eighteenth century all lock gates were made of alder. It was much sought-after for lightweight, durable clogs worn by workers in the mill towns of Lancashire and the south of Scotland, and was used for cart and spinning wheels, bowls, spoons, wooden heels for shoes, herring-barrel staves and furniture.

Alder wood burns with an intense heat and so made the best charcoal for gunpowder manufacturing. Gunpowder factories were usually sited where there was a natural supply of alder trees; the Royal Gunpowder Mill, established in 1560 at Waltham Abbey in Essex, is an example of this, or the 1694 Chart Gunpowder Mill at Faversham in Kent. The bark was used for tanning, waterproofing fishermen's nets, curing sore throats and to make a reddish dye. Alder shoots, which appear in early spring, produce a brown dye, the catkins a green one, and in some rural areas the leaves, which have a clammy, glutinous surface, were strewn on the floor in rooms to catch fleas, from Neolithic times until well into the eighteenth century.

ELM

Wood from the common elm has many of the same qualities as alder; it is close-grained, free from knots, tough, flexible, and not prone to splitting. Elm does not crack once seasoned and is remarkably durable underwater, being specially adapted for any purpose which requires exposure to wet. Allowed to grow, it becomes a much more impressive tree than an alder, and can develop into a magnificent specimen, towering to a height of around 36 metres. These beautiful trees, with their haloes of reddish spring flowers and billowing summer foliage, were favourite subjects of the early landscape artists. Constable's pencil drawing of the elms at Old Hall Park in 1817 captures all the romance, vigour and majesty of a tree that was once a familiar sight silhouetted across England's skylines.

Tragically, elms are susceptible to a deadly beetle or wind-borne fungus, *Graphium ulmus,* and no one who was alive in the 1970s could possibly forget the devastation as Dutch Elm Disease ravaged elms across Britain, or the destruction of 20 million trees in an attempt to contain the epidemic. I well remember the year when miles of dead or dying hedgerows, park and city elms stood stark and haggard against the brightening colours of the growing season, giving an impression of both summer and autumn occurring simultaneously.

Elm wood had an enormous number of practical uses; its peculiar toughness and durability underwater made it ideal for keel pieces, bilge planks, jetty piles,

groyne and harbour construction, the blocks and dead eyes of ships' rigging, the bobbins of fish nets, and, since the wood shatters when struck rather than splintering, gun carriages were always made of elm. Because of the extreme toughness and weather-resistant properties, elm boards were largely used for making coffins, lining the interior of carts, wagons or wheelbarrows, and as cladding on houses and farm buildings. The inner bark is very tough and fibrous and was woven into rope or mats and, as with alder, elm wood was used in making water pipes prior to cast iron.

The dense grain of elm has one drawback which made old woodsmen wary of the tree: when the tree is in full leaf, a branch will suddenly, with no warning, snap and come crashing to the ground. This led to the superstition that, *'The elm hateth man, and waiteth.'*

Wych elm, or Scotch elm, which grows in northern England, Scotland and Wales and is the only species of elm native to Ireland, is a beautiful tree, smaller, broader and hardier than its southern cousin. It flourishes on hillsides or near the sea and the tree's ability to establish itself in remote places has enabled pockets of Wych elm to survive Dutch Elm Disease.

The word *'wych'* came from the Saxon word meaning pliable and refers to the twigs, which can be twisted and knotted without breaking, and the elasticity of the smaller branches – some of the best longbows were made of Wych elm. The wood, though more porous than that of the common elm, is tough, hardy and weather-resistant when properly seasoned, and in the north was used for similar water-based construction as common elm was in the south. The wood becomes very flexible when steamed and was much used in making small clinker-built boats. Wych elm wood is renowned for its great strength and resistance to splitting, due to the interweaving of the wood fibres which creates a cross-grained timber. The ability to resist splitting under great stress made it ideal for wheel-making, the strength of the hub being so critical that wheelwrights sourced elm from particular regions renowned for good wood. Wych elm blocks were used for pulleys, early gunstocks and the headstocks of church bells, stair treads, floorboards, table tops and the seats of chairs.

ASH

Next to oaks, ash trees were probably the most highly prized for their speed of growth and the strength and elasticity of their wood. Ash thrives on fairly damp soils, provided conditions are not too acidic and there is plenty of light. It is widespread across Britain, with ash woodland found on the steep limestone slopes of the Derbyshire Peak District, in Somerset, South Wales and south-western Scotland. In Ireland, the old forests in limestone areas were once a mixed woodland of ash and elm, and although these were cleared long ago, ash is still the most common large tree in Irish lowland hedges.

Ash wood is as tough as oak, does not splinter and is so flexible that a joist of it will bear more weight before it breaks than one of any other tree. It was used – and still is – for any implement handles that required tensile strength and shock-absorbent properties, such as axes, hammers, hoes, brooms, spades or forks. At one time ash was used for bows, arrows and spear hafts, and the name is said to derive from *Aesc*, the Saxon word for spear. Ash was coppiced for hop poles, ladder struts and for making the finest oars, whilst young ash shoots were used to make walking sticks, hoops, hurdles and crates. The Celtic war chariots were made of ash and, later, ash wood was in demand by cart and carriage makers – in 1901, the Coachbuilders' Association appealed to the President of the Board of Agriculture to try to stimulate landowners to grow more of this valuable timber. The body frames of early aircraft and railway goods carriages were made of ash, and today the chassis of Morgan sports cars are still made of seasoned ash wood. Skis were once made of ash and it is commonly used for hockey sticks, snooker cues and for the hurley bat used in the popular Irish sport of hurling. *'The clash of the ash'* is a familiar phrase used by Irish sports journalists and commentators when trying to convey the excitement of a hurling match.

HORNBEAM AND BEECH

Hornbeam is the hardest wood in Europe; the name derives from the Old English *'Horn'*, meaning hard, and *'Beam'*, a tree. It is found among oak and beech woods and is one of the few trees to survive alongside beech trees since it is very tenacious and can tolerate deep shade. Hornbeam makes ideal hedging when cut and layered, properties which were early appreciated, and the original maze at Hampton Court, planted in about 1514 by Cardinal Wolsey, was hornbeam hedging.

Hornbeam timber burns with an intense heat, and because it was too hard for early carpenters to handle it was principally coppiced and pollarded for fuel, particularly in the iron ore mining districts of the south-east. However, as the quality of tools improved, the wood began to be used to yoke pairs of oxen together for ploughing, cogs for the early flour mills, and spokes for wheels. Hornbeam wood is able to resist any amount of heavy blows and so it became commonly used for making butchers' blocks, mallet heads, balls, skittles and piano hammers.

Hornbeam is frequently mistaken for beech – Nicholas Culpepper referred to it in his *Complete Herbal* (1653) as 'the other rough sort of beech' – as they share the same habitat and have leaves of a similar shape and verdancy. Common beech is a much finer tree, though, which, when left undisturbed, can grow to forty metres in height. Coppiced beech was used as faggots for firing kilns, since the heating power of beech surpasses that of most other woods, with the timber from standard trees having a variety of appliances for articles where a short dense grain was required, including dairyware such as churns, bowls and butter tubs. Other uses included panels for carriages, carpenter's planes, stonemason's mallets, granary shovels, boot-lasts, clogs and parquet flooring.

Beech bends beautifully and is easily turned, which makes it the ideal material for furniture, particularly chairs. Until the 1970s there were still 'bodgers', itinerant wood turners, working in the beech woods of the Chilterns. Bodgers

specialised in making chair legs and stretcher poles, the horizontal structural members joining chair legs to prevent them from splaying. Traditionally, a bodger would buy a stand of trees from the woodland owner and set up a camp, consisting of a lean-to known as a 'bodger's hovel', in which to sleep, and a shelter to house his pole lathe, chisels, axes, saws and draw knives. After felling a suitable tree, the bodger would cut it into billets approximately the length of a chair leg and these would then be split with a sledgehammer and wedges, trimmed with a side axe, tidied with the drawknife and turned to shape on the pole lathe. Chair legs and stretchers would be stored in piles until the greenwood had dried and then taken to one of the large chair-making centres, the largest of which was High Wycombe, the centre of the Windsor chair industry.

In the days when there were dozens of military and civilian boot makers in London and many hundreds in the provinces, beech was extensively used by craftsmen who specialised in making boot and shoe trees. Handmade shoes and boots always had a corresponding set of wooden trees, carved to replicate the shape of the foot and leg and maintain the structure of the article. These were particularly important with riding boots, which soon lose their shape unless remoulded by boot trees after each time they are worn. Sadly, with the escalating cost of handmade boots and shoes, the art of tree making is fast disappearing and only a handful of such craftsmen remain.

> BEECH WAS EXTENSIVELY USED BY CRAFTSMEN WHO SPECIALISED IN MAKING BOOT AND SHOE TREES. HANDMADE SHOES AND BOOTS ALWAYS HAD A CORRESPONDING SET OF WOODEN TREES, CARVED TO REPLICATE THE SHAPE OF THE FOOT AND LEG AND MAINTAIN THE STRUCTURE OF THE ARTICLE.

As with hornbeam, beech is a common hedging plant and was often planted along the tops of earthbank field boundaries. The most famous and tallest beech hedge in the world is the great hedge of Meikelour, near Blairgowrie, which can be seen beside the A93 between Perth and Blairgowrie. This fantastic living sculpture, which forms part of the boundary of the Meikelour Estate owned by the Marquis of Lansdowne, is over 30 metres high and 530 metres long. It was planted in the autumn of 1745 by Jean Mercer, heiress of Meikleour and Aldie, and her husband Robert Murray Nairne, who was subsequently killed at the Battle of Culloden in 1746, while fighting for the Highland Jacobite cause against Government forces under the Duke of Cumberland. Legend has it that following the death of her husband Jean Mercer would not allow the hedge to be cut, letting it to grow towards the heavens in a tribute to her husband's memory.

BIRCHES

Our native birches, the silver birch and downy birch, are two of Britain's most lovely and graceful trees. No highland scene would be complete without these dainty masterpieces of nature growing in broken thickets on rugged hillsides and wild glens, beside thundering waterfalls and raging torrents, mountain tarns and on wind-swept moors.

These silver trees, which thrive on the light, drier soils of the eastern side of the country and the downy birches of the damp western uplands, are beautiful in

all seasons. In winter, the twigs of a birch give the impression of a purple mist hanging over the hillside which turns to a glorious haze of yellow and red when the catkins appear in the springtime. The bright freshness of its leaves and their delicate scent are not matched by any other tree, and in summer after rain, when every leaf holds an iridescent crystal at its tip, a birch really becomes the 'Lady of the Wood', the name given by the Celts. In autumn the fallen leaves give brightness and a wonderful variety of different colours to the woodland scene and alleviate any feeling of melancholy that trees in the autumn can sometimes provoke.

Hard, heavy, close-grained birch wood made superb charcoal and is among the best of firewoods, burning with a bright, steady flame and a pleasant fragrance. Hams, herrings and haddock smoked over birch twigs or 'sprays' acquire a unique flavour from the resinous wood, as did whisky when barrels were made of it. Because of its prevalence and availability in the Highlands, the uses of birch there were many and varied. It was used for all building materials, the handles of agricultural implements and for household items such as bowls, plates and spoons. Cradles were made of birch and there was a thriving cottage industry making hard-wearing bobbins, spools and reels for the Lancashire cotton industry.

The oily bark, which makes the best kindling, was used for tanning leather, and sometimes, when dried, twisted into a rope and soaked in mutton tallow to be used as a substitute for candles. Twigs or sprays were used in thatching, and birch spray, dried through the summer with the leaves on, made an acceptable alternative to heather in a mattress. Besom brooms are still made of birch sprays and the wood is suitable for veneer; birch ply is the strongest and most dimensionally stable plywood used to make skateboards, amongst other things. Birch has a natural resonance that peaks in the high and low frequencies and is the most sought-after wood in the manufacture of speaker cabinets. It is sometimes used as a tone wood for semi-acoustic and acoustic guitars and occasionally for solid-body guitars.

SCOTS PINE

A lone Scots pine tree, bent and twisted by age and ravaged by the weather, standing alone on the edge of a moor or Highland glen, personifies the harshness of the landscape and the struggle that man and beast have had to survive in this unforgiving part of Scotland. There is a recurrent theme in Highland folklore that these lone trees were used to mark burial places of warriors, heroes and chieftains. In areas further south, where the sight of a Scots pine may have been more unusual, they can be seen to mark ancient cairns, trackways or crossroads. In the Lowlands and in England, they were commonly planted to mark not only the drove roads used by the Scots cattle drovers bringing their herds south, but also the perimeters of holdings along the route where the cattle could spend the night.

Scots pine woods were a valuable source of timber; they once covered great areas of the Highlands but they are now restricted to Abernethy, Inshriach, Rothiemurchus and Glenmore Forests near Aviemore, Achnashellach in Wester Ross, Ballochbuie in upper Deeside, Einig Wood in Sutherland, Glen Affric in Invernessshire, Ordiequish in Morayshire and the Black Wood of Rannoch in Perthshire. The high resin content in the sap of Scots pines means the wood is slow

to decay, so large numbers of trees were felled for house – and ship-building materials. Straight trees were in demand as spars for the rigging on sailing boats – hence Beinn nan Sparra, Hill of Spars, in Glen Affric. The light, strong wood was ideal for fencing stobs, furniture and deal storage boxes. Later, the wood was in demand for railway sleepers and telegraph poles.

Scots pine made reasonable charcoal and was a vital source of turpentine, rosin and tar. Turpentine was made by cutting a V-shaped notch in a tree and collecting the oleo-resinous gum that ran out. When distilled, oil of turpentine was produced and used in making varnish, oil paints, polish, and as an antiseptic. Rosin, the residue from the distillation process, was used to wax the horsehair strings of violins and other bowed string instruments, for sealing wax, glue, in soap and early printing inks. More recently, powdered rosin is rubbed on the soles of shoes worn by gymnasts, dancers and boxers to improve grip. Crude tar was made from Scots pines by digging a pit on the edge of a raised piece of ground with a pipe running from the bottom to a container. A fire of dried pine cones was built in the pit, and as soon as this was burning well it was fed a supply of small pieces of freshly cut pine wood. The black fluid that trickled down the pipe was wood tar, which made the best weatherproofing for wooden buildings, boats or fishermen's nets.

Although Scots pine is quick to regenerate if left undisturbed, overcutting to meet timber demands, natural fires, overgrazing by sheep and deer, agricultural reclamations and even deliberate clearances in the Middle Ages to deter wolves have all been factors in the decline of the great woods that once covered 1,500,000 hectares.

The long history of coppicing is the reason why ancient coppice woodlands can be seen as the direct descendants of the original wildwood. It is perhaps strange that coppiced woodland, with a structure that looks least like one's perception of an ancient natural wood, is biologically closest to it. Virtually no trees were deliberately planted for commercial woodland until the late seventeenth century. There was no need to; the coppice and standard system continued to work perfectly well, and in the north of Scotland the Scots pine woodlands seemed to stretch into infinity. In most woodland, apart from some very localized transplanting of saplings to maintain the coppice crop, any improvements were made by encouraging the more valuable species to fill gaps where old stools had died, or by layering and protecting the natural regeneration.

Unwanted shrubs and invasive species, such as birch, were sometimes removed to favour more desirable trees, but by and large the general pattern of species remained very close to the original natural cover. Even in the late eighteenth century it is recorded that 'the underwood was not carefully selected and planted; the production of it, both in quantity and quality was, for the most part left to chance'.

There was, however, considerable planting of garden and orchard trees such as apple, pear, fig, sweet chestnut, common walnut and medlar, during the medieval era. Any planting of native trees was not for their timber but to enhance the landscape or to provide cover for game or as covert for foxes, with extensive planting becoming commonplace among wealthy landowners by the late Tudor period.

BRITISH FOREST LAWS

Enclosing common wood pasture to create deer parks, which had been in vogue under the Normans, suffered a decline after the Black Death devastated the country in 1350. There was a revival during the reign of Henry VIII, who created at least seven parks, the largest of which, Hampton Court Chase, enclosed 4,000 hectares of land and four villages, setting a precedent among the aristocracy and prosperous landed merchants. The owners of private deer parks tended to position small woods and clumps of trees to draw the eye to the skyline or other feature, and retained large single trees for the air of antiquity they gave to the landscape. These were practices which were later followed and improved upon by the great landscape designers of the seventeenth and eighteenth centuries.

The history of enclosing woodland areas begins further back with the Saxons, who went to considerable trouble to protect woodland by building massive 'woodbanks' round them to establish ownership and keep livestock and deer out, similar to those that survive in a number of places, such as Poundwood in Essex. Wood pastures were re-established, which combined grazing animals with widely spaced trees which had often been pollarded. (Pollarding is cutting the top out of a tree about three metres from the ground, above the height that livestock could get at the regrowth, and harvesting the rods and poles that grew from the stump in the same way as when coppicing.) There were also wooded commons or heaths, on which there were common rights for grazing cattle, sheep, goats and pigs. Pigs were an important part of the Anglo-Saxon farming system, and during the autumn and winter pigs were driven considerable distances to graze 'pannage', the beech mast or nuts, and acorns.

THE HERITAGE OF PLACE NAMES

These woodland grazing places were known as *denns*, the Saxon word for swine pasture, and this is the origin of place names ending in -*den*, such as Tenterden. Any place name with the prefix '*Swill*', as in Swilland in Suffolk, or Swillington in West Yorkshire, and '*Swin*', as in Swindon in Berkshire, Swingfield Miniss in Kent, Swinhoe in Northumbria or Swinton in North Yorkshire and Berwickshire, are all associated with keeping swine. The Saxons also left us a heritage of place names associated with woods: any word ending in '- *ley*', '- *leigh*' (from the Saxon, *leah*) was once a settlement in a clearing of substantial woodland, as in Chiddingly in Sussex, Hadleigh in Essex; those ending in '- *hurst*' (Saxon, *hyrst*) were beside a wood or large grove of trees, as in Sissinghurst in Kent. Names with '-*field*' (Saxon, *feld*) refer to an open space in sight of woodland, not a field in the modern sense. Places ending in '-*shaw*' are derived from the Saxon *sceaga*, meaning a thin strip of woodland; '- *hanger*', as in Colehanger, from *hangra*, a wood on a slope, or '-*grove*', as in Bromsgrove, from the Saxon *graf*.

A Book of Britain

There is also every reason to believe that the Saxon nobles in the late Anglo-Saxon period had started to preserve deer in wooded, fenced parks on their estates for hunting, after the manner of the French and Normans. After all, there were family ties between France and England; Eadgifu, the sister of King Edmund I, was married to Charles III of France in AD 919 and her son, Louis IV of France, spent his early life in the English court. Hunting with hounds was the favourite pasttime among the nobles in France and Normandy, and King Edmund's miraculous escape whilst entertaining envoys from East Anglia at his palace at Cheddar, described in the *Catholic Encyclopaedia* of 1913, substantiates the custom in Britain:

... the king rode out to hunt the stag in Mendip Forest. He became separated from his attendants and followed a stag at great speed in the direction of the Cheddar cliffs. The stag rushed blindly over the precipice and was followed by the hounds. Edmund endeavoured vainly to stop his horse; then, seeing death to be imminent, he remembered his harsh treatment of St Dunstan [Edmund was in the process of banishing St Dunstan from court] *and promised to make amends if his life was spared. At that moment his horse was stopped on the very edge of the cliff. Giving thanks to God, he returned forthwith to his palace, called for St Dunstan and bade him follow, then rode straight to Glastonbury. Entering the church, the king first knelt in prayer before the altar, then, taking St Dunstan by the hand, he gave him the kiss of peace, led him to the Abbot's throne and, seating him thereon, promised him all assistance in restoring Divine worship and regular observance.*

Curiously enough, the enormous value of deer and their importance to the monarchy during the Middle Ages is the reason why Britain is unique in possessing a few remaining areas of ancient and semi-natural woodland. The fact that we have a handful of national treasures such as the New Forest, Ashdown Forest, Epping Forest and the Forest of Bowland, to name only a few, is due to the formation of Royal Forests by William the Conqueror immediately after the Norman Conquest in 1066. These Royal Forests were large areas of unenclosed countryside, consisting of a highly variable mixture of woodland, heath, grass, scrub and wetland, providing the optimum habitat for various game species, particularly deer, which were reserved for the sole use of the King. The word 'forest' did not mean an area of densely wooded land as it is understood today; it was derived from the Latin *forestis silva*, which is literally translated as 'outside wood', but in the context of Royal Forests was interpreted as land outside common law.

The Forest Laws introduced by the Normans were designed to protect the habitat and certain designated species within Royal Forests. Offences under Forest Law were divided into two categories: trespass against the *vert*, the vegetation of the forest, and *venison,* the game. The first, and in many ways the most serious, was creating any disturbance to the habitat of game. Vert, from the Latin v*iridis*, meaning

green, was every tree, underwood or bush, growing in a forest and bearing green leaves which might provide cover or feed for deer. It was of two sorts: the over vert, or *haut bois*, and the nether vert, or *sous bois* – mature trees and underwood. Bracken and heather were not accounted vert. Trees which bore fruit, such as oaks and beech, were accounted as special vert, and these could not be felled in any man's freehold within the limits of a Royal Forest except by permission of the foresters and verderers. Later on, in the thirteenth century, by an Ordinance of the Forest, freeholders dwelling within a forest could not cut housebote nor haybote (firewood) within their own woods without the permission of the foresters.

The five animals of the forest protected by law were the hart, the hind of red deer, boar, hare and wolf. There were two other categories: the beasts of chase, the buck and doe, fallow deer, fox, marten and roe deer; and the beasts and fowls of warren, the hare, coney, rabbit, pheasant and partridge. The rights of chase and of warren, i.e. to hunt such beasts, were often granted to the nobility and clergy as gifts or for a fee. The King owned the game in his forests, but not necessarily the land; in some, such as the Forest of Dean, he owned the land, in others, it belonged to someone else but was subject to Forest Law.

A Royal Forest could be extended at the whim of a monarch to cover a colossal area; Waltham Forest, for example, which included Epping Forest, sprawled over 25,000 hectares and took in numerous manors, farms, hamlets, villages and the town of Waltham Abbey, all within the legal boundary of the Royal Forest. The landowners and farmers within a Royal Forest were forbidden to convert their land from pasture into arable or cut down their woods and were proscribed under Forest Law by the legal terms *assart, purpresture* and *waste*. These covered making an enclosure which would not allow the larger game to pass freely in or out of the land; causing any encroachment to the detriment of the forest, or which was hurtful to the vert or venison; spoiling and destroying the coverts or pastures of a forest by cutting down trees or lopping them, or by ploughing any meadow or grass land. All offenders who made assarts, purprestures or waste were fined, and if the land was their own freehold it was taken into the King's hands until the fine was paid. Disafforested lands on the edge of the forest were known as the *purlieu*; agriculture was permitted here, but game that strayed onto the purlieu was still the property of the King. Furthermore, inhabitants of the forest were forbidden to bear hunting weapons or keep either gaze hounds or scent hounds; mastiffs were permitted as watchdogs, but they had to be expeditated by having one of the toes of a forepaw amputated to prevent them from hunting.

> THE WORD 'FOREST' DID NOT MEAN AN AREA OF DENSELY WOODED LAND AS IT IS UNDERSTOOD TODAY; IT WAS DERIVED FROM THE LATIN *FORESTIS SILVA*, WHICH IS LITERALLY TRANSLATED AS 'OUTSIDE WOOD', BUT IN THE CONTEXT OF ROYAL FORESTS WAS INTERPRETED AS LAND OUTSIDE COMMON LAW.

As some mitigation of these hardships and disabilities, concessions were made which gave inhabitants of the forest, depending on their location, a variety of strictly controlled rights, some of which exist to this day: *estover*, the right of taking firewood; *pannage*, the right to pasture swine in the forest; *turbary*, the right to cut turf or peats for fuel; various other rights of pasturage known as *agistment*; and harvesting the products of the forest in the form of nuts and berries. Abridging the rights in the Royal Forests was an extremely useful source of income or means of guaranteeing support. Acquiring any part of one was the ultimate status symbol, with a Forest being highest. William the Conqueror established about twenty-five Royal Forests, and by the time the Domesday Book had been written in 1086 the Earl of Chester had acquired three.

> ABRIDGING THE RIGHTS IN THE ROYAL FORESTS WAS AN EXTREMELY USEFUL SOURCE OF INCOME OR MEANS OF GUARANTEEING SUPPORT. ACQUIRING ANY PART OF ONE WAS THE ULTIMATE STATUS SYMBOL, WITH A FOREST BEING HIGHEST.

Next in degree came the chase, an unenclosed hunting preserve similar to a Forest, which the great barons mostly possessed, which was subject to Common Law rather than Forest Law. After that came the smaller park, an enclosure permitted by grant of the King, which had to be fenced securely enough to stop venison entering it, otherwise it became forfeit; and, lastly, the free warren.

Law was enforced in the Royal Forests by six officers and a steward or seneschal, who was usually a noble of high rank and whose appointment by the Crown was one of great honour and authority. He in turn was supported by foresters of various classes: the foresters in fee, *Forestarii de feodo*, held hereditary office and were mostly of knightly rank; the *Forestarii equitans*, riders or rangers, were appointed by the King and held their office for life or the pleasure of the monarch. Under foresters in fee were an inferior class of forester whose duties corresponded to those of the modern gamekeeper. All these offices were ministerial and had no judicial functions. The verderer, *viridarius*, was a judicial officer of the forest chosen by the freeholders of the county in full county court in the same manner as a coroner. He was sworn to maintain the laws of the forest, and to receive and enrol the attachments and presentments of all manner of trespass within the forest, whether of vert or of venison. Reguarders were officers of the forest appointed by the King or by the Chief Justice in Eyre of the forest, and were always twelve in number. Their responsibility was to keep a roll on which was written all the ancient assarts, purprestures and wastes; and on another, all those that had been newly made since the last regard of the forest. Accompanied by the foresters, the reguarders surveyed all the old and new purprestures made within the forest, valued them, and wrote them down on their rolls; they also surveyed the King's demesne lands and woods, and the waste in them by felling of timber, or by destruction of underwood; also all fences, and whether they were constructed according to the law of the forest. The Agisters were officers of the forest who received and accounted for the money paid for the herbage and pannage of the King's demesne lands and woods within the forest. Agistment was of two kinds: firstly, the herbage of the

woods and pastures, and secondly, of the mast of trees, known as pannage. The Agisters also presented trespasses done by cattle, and, assisted by the foresters, they agisted the King's woods and lands, i.e., they made the agreements with the inhabitants of the neighbourhood, by which the number of the swine to be fed and the sums to be paid for them were settled. As regards the ordinary pasturage, no man could agist his beasts within the King's forest except one who was an inhabitant of the forest, and had common appendant or appurtenant, by reason of his land lying within the forest.

FOREST LAW

The Court of Attachment, the primary court of the forest, was held at intervals of forty days and was known as the Forty Days' Court. The object of this court was to receive the attachments or felons apprehended by the foresters and woodwards, and to enter them on the rolls of the verderers. The usual proceeding appears to have been that if the foresters found any man trespassing on the vert of the forest they might attach him by his body, and then cause him to find two pledges to appear at the next Court of Attachments. Upon his appearance at this court, he was mainprized or bailed until the next General Sessions or *Iter* of the Forest Justices. If he was found offending a second time, he had to find four pledges; if a third time, eight pledges; and if found offending a fourth time, he was detained in custody without bail or mainprize until the coming of the Justices. If a man was taken killing a deer or carrying it away, which was called being 'taken with the manner', he could be 'attached by his body', arrested, and imprisoned until delivered by the command of the King, the Chief Justice in Eyre of the Forest, or by the Chief Warden of the forest. However, no other officer of a lower degree than the Chief Warden could set him free or admit him to bail in these cases. The next stage in the chain was the Court of Swanimote; this was the court of the freeholders living within the forest, and was presided over by the Steward of the Forest. The judges were the elected verderers with a jury of *reeve*s, who were bailiffs to local landowners and four men of the townships contiguous to the scene of the trespass complained of. The Swanimote convened three times a year and the officers of the forest had to be present, including the reguarders, agisters and woodwards. Sentences were not handed at the Swanimote; evidence was recorded and passed on to be presented to the Justices in Eyre of the Forest. Eyre means circuit, and the Justices were the ultimate authority in Forest Law, moving their court between the numerous Royal Forests and presided over the *court of justice-seat*, a triennial court held to punish offenders against the Forest Law and enquire into the state of the forest and its officers. Regardless of the frightful sentence that the Justices might eventually decide on (blinding and mutilation were not unheard of), the accused would already have spent three years in custody or have been deprived of his bail surety during that period.

BRITAIN'S REGAL FORESTS

Successive monarchs increased the number of Royal Forests, and at the time of the Magna Carta, in 1215, there were 143 in England, with equally as many in Wales and slightly more in Scotland. This equated to a third of the land mass, and they were run by a vicious system which had now become intensely unpopular and much abused. The final straw came in 1204, when King John, who was desperately short of money, announced that the entire county of Devon was to become a Royal Forest and only agreed to disafforest the region, with the exception of the existing Royal Forests of Dartmoor and Exmoor, in exchange for an enormous payment. This monumental piece of land grabbing contributed to the Barons' Revolt and, ultimately, the signing of the Magna Carta in 1215 and the Carta de Foresta in 1217. Under the Carta de Foresta, much of the land that had been extended outside the royal demesnes during the reigns of King John, King Richard and Henry II was disafforested and many of the more draconian Forest Laws were relaxed. For example, all men who had been outlawed for offences against Royal Forests since the reign of Henry II were pardoned, and poaching venison ceased to be a capital or mutilating offence.

Apart from the venison and value of selling franchises, resources available to a monarch from his Royal Forests varied from region to region. He owned the mineral rights and the trees on roughly half the Royal Forests, but it must be remembered that Royal Forests were game parks, chosen for the habitat which provided cover and a diversity of grazing for venison. Some forests, such as the Forest of Dean and the New Forest, were heavily wooded, but a large proportion of the 25,000 hectares of physical Royal Forests was wood pasture, heath, hill and marsh. In the early years of Norman rule, timber from some of the forests was used for building the various royal residences that were spread across the country or donated as gifts, often to religious orders. For several centuries, efforts were made to coppice underwood and grow mature standards, in forests such as Cranborne and Grovely in Wiltshire, Wychwood in Oxfordshire, Hatfield in Essex, Rockingham in Northamptonshire and the New Forest on a commercial basis, but the Crown's interest in managing them gradually diminished and many were sold off, or reverted to ordinary common and wood pasture run by the landowner.

> SUCCESSIVE MONARCHS INCREASED THE NUMBER OF ROYAL FORESTS, AND AT THE TIME OF THE MAGNA CARTA, IN 1215, THERE WERE 143 IN ENGLAND, WITH EQUALLY AS MANY IN WALES AND SLIGHTLY MORE IN SCOTLAND. THIS EQUATED TO A THIRD OF THE LAND MASS ...

Charles I disastrously attempted to revive the Forest Laws over land belonging to others, in the hope that they would pay to have them lifted, as King John had done 400 years previously with the people of Devon. This colossal act of folly hastened the Civil War and lost him the support of many landowners. William III introduced large-scale planting schemes in the remaining Crown forests to provide a future supply of oak for the Navy, with little success as the land was generally unsuitable for trees and, in the case of the New Forest, most of the saplings were uprooted in the great storm of 1703.

Many forests were transformed out of all recognition during the Acts of Enclosure in the late eighteenth and nineteenth centuries, when landowners were empowered to reclaim wood pasture and heath for agricultural purposes, regardless of the rights of the commoners or the Crown. In the ten years between 1779 and 1789, 4,000 hectares of Sherwood Forest were lost to enclosure and, in 1779, the larger part of Epping Forest. When Enfield Chase was also enclosed in 1779, a portion was allotted to the villagers of Enfield in compensation for the loss of their common rights, and even this was reduced to a measly ten hectares in 1803. The ancient Forest of Needwood in Staffordshire was enclosed in 1802, inspiring Anna Seward, otherwise known as the 'Swan of Lichfield', to write her poem 'The Fall of Needwood Forest' in 1808:

When Poesy, the Child of Zeal,
Who soothes each Pang, that Earth can feel,
Beheld, at wounded Nature's call,
That Scene of Horror, Needwood's Fall
She said, in haste to yield Relief,
And calm the Mighty Mother's Grief:

Nature! dear Parent! Power divine!
Whose Joys and Griefs are truly mine!
To you my sympathy devotes
My cheerful, and my plaintive Notes:

With Feelings not to be supprest,
I view your lacerated Breast;
This Waste of Ravages! where flood
Your Sylvan Wealth! Your graceful Wood
I cannot from the rifled Earth
Call into sudden, second Birth.

Large parts of Windsor Forest were enclosed in 1817; in 1857 Wychwood Forest was enclosed, and within two years over 800 hectares had been converted to farmland. The Forest of Dean and the New Forest suffered from a different form of enclosure. In the Dean, 4,500 hectares were enclosed for planting in 1814, denying owners of common rights access to their historical grazings and causing extreme hardship to those whose livelihoods depended on them. The situation became nasty in 1831 when around 2,000 commoners started to tear down the enclosure and troops had to be summoned from the garrison in Doncaster to quell the riot. Resistance soon crumbled, and although their leader, Warren James, was transported to the harsh penal colony in Tasmania, the commoners' action led to their rights being ratified under the Dean Forest Act in 1838.

In Hampshire, thousands of acres of oaks and Scots pines were planted in the New Forest, from 1808 until 1877, in an attempt to develop commercial woodland. The New Forest Act 1877 put a stop to the damage that had previously been done to the forest and decreed that no more old natural woodland trees were to be felled, they regulated common rights, and reconstituted the Court of Verderers. The Court

of Swainscote and Attachment of the New Forest, better known as the Verderers' Court, meets roughly once a month at the Verderers' Hall in the Queen's House at Lyndhurst and is open to the public. The Court comprises the Official Verderer, a statutory appointment made by Her Majesty the Queen, who acts as chairman. Five elected Verderers represent the Commoners, and four appointed Verderers represent the Forestry Commission, DEFRA, the National Park Authority and Natural England. Five Agisters, who wear a livery on formal occasions of green hunting coat, breeches and boots, are employed by the Verderers; their role is to watch over the Forest and ensure, by regular inspection on foot, vehicle and horseback, that the owners of common grazing stock, and others, meet the requirements of the Verderers in respect of stock welfare and payment of making fees. In addition, they must inform the Verderers of any possible breaches of the Verderers' byelaw; attend road accidents and other incidents involving commoners' stock; deal with injured animals at the scene and humanely destroy them if necessary; arrange and manage the seasonal rounding up of ponies and cattle, and organise the construction and maintenance of stock pounds or layerages within their area.

Delightfully, court proceedings start exactly as they have done for the last 800 years, with the senior Agister rising to his feet, holding his right hand aloft and bawling: '*Oyez! Oyez! Oyez! All manner of persons who have any presentment or matter or thing to do at this Court of Swaincote let him come forward and he shall be heard! God Save the Queen!*' The Verderers of the Forest of Dean meet every forty days or so in the courtroom of the seventeenth-century Speech House. This beautiful building in the middle of the forest which was originally a hunting lodge and, later, the administrative centre for the forest is now a hotel. The Steward of the Forest and three Verderers who make up the court are appointed by the Crown, retain administrative functions and act as intermediaries between the commoners, the local public and the Forestry Commission – who manage the woodland.

The impact of Royal Forests on Anglo-Norman society and their significant place in the history of Britain has created the false impression that these islands were covered in woodland from Cornwall to Caithness. In fact, although the Saxons probably increased the area of farmland as their population increased and managed the woodland fairly intensively near settlements, the landscape remained largely unchanged during their 600 years of occupation. In 1086, about 15 per cent of England was woodland managed as mixed coppice and standards of different ages or pollarded wood pasture, 65 per cent was farmland, and the remainder was mountain, moor, heath or fen. An aerial view of Britain in the eleventh century would have shown bare mountains above the tree line, especially in the north and in Wales. There were miles of scrubby sessile oaks and birch trees, sparsely wooded heaths and wood pasture, marshes and wetlands, and coastal fishing communities and wooded river valleys with clusters of settlements and farmsteads appeared where woodland had been cleared. Across the Midlands, there was a great band of coterminous woods, sufficient, so it was said, to enable a red squirrel to cross England from the Severn to the Wash without once setting foot on the ground.

'IMPROVING' BRITAIN'S NATIVE WOODLAND

The idea of planting specifically for timber only occurred in the late seventeenth century and was largely influenced by the publication in 1664 of *Sylva, A Discourse of Forest Trees and the Propagation of Timber in His Majesty's Dominions* by John Evelyn, the diarist, keen horticulturist and founder member of the Royal Society. Evelyn had been horrified by the wanton destruction of woodland during the Civil War and the mismanagement during the years of Cromwell's Protectorate, when many Royalist landowners, such as the Reresbys of Thryberg, in the West Riding of Yorkshire, were forced to destroy extensive stands of hardwood to pay fines imposed by Cromwell. Evelyn believed, erroneously, that woodland in Britain was in terminal decline due in part to the depradations of the previous twenty years, but also from the demands of various industries, such as iron, house and ship building. *A Discourse of Forest Trees* was addressed primarily to the Lords of the Admiralty as a warning of impending timber shortages and advocated an immediate policy of woodland planting. It is surprising, considering his family fortune was based on charcoal and the manufacture of gunpowder, that Evelyn failed to recognize the historical evidence that industry had been responsible for sustaining our woodlands, rather than destroying them. Nor did he appear to appreciate that felling broadleaved trees does not kill them, and provided they are protected from browsing, areas of clear felled woodland will self-regenerate in a matter of years.

> EVELYN BELIEVED, ERRONEOUSLY, THAT WOODLAND IN BRITAIN WAS IN TERMINAL DECLINE DUE IN PART TO THE DEPRIVATIONS OF THE PREVIOUS TWENTY YEARS, BUT ALSO FROM THE DEMANDS OF VARIOUS INDUSTRIES, SUCH AS IRON, HOUSE AND SHIP BUILDING.

Throughout history, nearly all clearance of woodland has been for agriculture and, up until the industrial revolution, industries relied on coppiced woodland for fuel. The great woodlands of the Weald had already been supplying fuel for the local iron industry for a thousand years before its heyday in the sixteenth century, when over fifty blast furnaces and sixty forges were churning out cannons for the Tudor wars, and could never have survived unless they had been managed as coppice. The same was true of the other mining areas, such as the Merthyr and Ebbw valleys in Wales or the Forest of Dean. It was in the agricultural areas such as East Anglia, the Midlands, the flatlands of north Humberside, the Vale of York or the coastal lowlands of Scotland where woodlands were almost completely destroyed. To quote Dr Rackham, 'the survival of almost any large tract of woodland suggests that there has been an industry to protect it against the claims of farmers'. *A Discourse of Forest Trees* influenced many landowners, including King Charles II, and is now regarded by historians as being responsible for much of the disinformation about trees that is still current today.

In contradiction of the accepted policy of mixed woodland management, John Evelyn advised landlords to make extensive new plantations of only one or two species together. Beech was widely planted throughout Britain in the eighteenth and nineteenth centuries; the beech plantations in the Chilterns are an example of traditional coppice woodland and wood pastures being sacrificed to the needs of the

furniture industry. In other areas, landlords greatly increased their oak woods or followed the fashion for sycamore, hybrid poplar, wych elm, hornbeam or conifers.

Evelyn was a great supporter of 'exotics', as conifers were referred to, and considerable quantities of Norway spruce, silver fir and European larch were planted in the eighteenth century. The plantation movement was very active in Ireland, where plantings were ordered by statute, and in Scotland. Between 1738 and 1830, successive Dukes of Atholl – 'the planting Dukes' – planted 27 million conifers, many of them European larches grown from seed sent over from the Austrian Tyrol, in the bare hills of their estate at Blair Atholl, in Perthshire. So obsessed was the fourth Duke with plastering the countryside in trees that he is reputed to have established conifers on the inaccessible slopes of Chreag Bhearnach, a jagged mountain overlooking Dunkeld, by firing canvas bags of seed at it through a cannon. One of the original trees grown from Tyrolean seedlings has survived – the Parent Larch, planted near the west end of Dunkeld Cathedral, which is the ancestor of many of the trees seen today on the Atholl estates.

During the Parliamentary Inclosure Acts, passed between 1750 to 1860, the landscape changed out of all recognition when 21 per cent of land in Britain was enclosed, thousands of miles of stone walls were built and quick-set hedging planted as stock-proof field boundaries. It was common practice to plant saplings of oak, ash, beech, elm or other hardwood species, which were allowed to mature undisturbed among the body of hedging plants. These were deliberately left either

as a source of future timber, as boundary markers or, in some cases, to act as a pointer which ploughmen could use to make a straight furrow, and it is in old hedgerows that some of most impressive native hardwoods can still be found.

This was the era of the great agricultural improvers, such as Coke of Holkham in Norfolk, Bakewell of Dishley Grange in Leicestershire, Christie of Glynde in Sussex and Graham of Balgowan in Perthshire, all of whom had travelled extensively in Europe and studied farming practices in Holland and Flanders, the most agriculturally advanced countries on the Continent at the time. The Dutch and Flemish were experts at planting woodland to protect crops and livestock or to prevent soil erosion, particularly on exposed sandy ground. Hundreds of acres of Scots pine 'hedges' were planted in the Brecklands of East Anglia with Scots, Corsican or maritime pine woods planted around the Norfolk coast and parts of Lancashire, to consolidate the sand dunes and reduce soil erosion in the adjacent farmland. Establishing shelterbelts or small areas of mixed woodland became an additional part of the hedge-planting policy on virtually every farm in the country and there were now species which would grow at almost any altitude and soil type. Behind the steading here at our farm there is a shelterbelt, presumably planted in 1825 when the buildings were put up, containing larch, Scots pine, oak, ash, Norway spruce and beech, which is fairly typical of this part of the Borders.

During the agricultural depression which followed the end of the Napoleonic Wars, more woodland was planted as long-term investments on poor-quality arable areas. These woods and wooded strips provided an ideal habitat for a whole range of wild bird life, and pheasants in particular, where trees had been planted to protect crops. By 1830, the percussion cap – fulminate of mercury contained in a small brass cylinder – had replaced flintlock and priming powder as the ignition system in shotguns. This enabled sportsmen to shoot game on the wing for the first time and in any weather. It was only a matter of time before guns discovered that pheasants were most effectively shot when driven from one cover to another, and within ten years landowners were developing existing woodlands and sighting new ones specifically for driven shooting. In those days, woodland bare of underbrush was often planted with snowberries, laurels and rhododendrons, still seen in many old woods, to provide cover for game birds.

For a number of reasons, coppicing began a gradual decline from the early nineteenth century. One was the trend towards growing more standard trees for the production of timber, following the fashion for new plantations which had been started by Evelyn's *Discourse of Forest Trees*. Another was the demands of the industrial revolution for a more efficient fuel source, with charcoal and firewood rapidly being replaced by coal and coke. Without a market for charcoal, commercial coppicing continued, but on a reduced scale, with many woods neglected or coppiced on a much longer rotation.

> FOR A NUMBER OF REASONS, COPPICING BEGAN A GRADUAL DECLINE FROM THE EARLY NINETEENTH CENTURY. ONE WAS THE TREND TOWARDS GROWING MORE STANDARD TREES FOR THE PRODUCTION OF TIMBER ... ANOTHER WAS THE DEMANDS OF THE INDUSTRIAL REVOLUTION FOR A MORE EFFICIENT FUEL SOURCE.

The plantation movement did little to meet Britain's timber requirements, and with our industrial cities sprouting like mushrooms, we became increasingly reliant on timber supplies from overseas. By the beginning of the twentieth century about 90 per cent of all timber and forest products were imported softwoods from Scandinavia and Canada. The danger of an island depending on such a high percentage of any commodities became apparent during the First World War, when the German naval blockade prevented imports of food, fuel, timber and other necessities getting through. Over the four years, about 200,000 hectares of assorted domestic woodland had to be felled to meet the requirements of the mining industry and to supply materials for the trenches. The perceived need to rebuild and maintain a strategic timber reserve led to the Forestry Act 1919, and the establishment of a Forestry Commission responsible for woods in England, Scotland, Wales and Ireland. The Commission had wide-ranging powers to acquire land, develop afforestation and encourage private landowners to plant trees by offering grant aid. Land was cheap during the post-war agricultural depression, and by 1939 the Commission had acquired 38,000 hectares, about a third of which had been planted with blocks of fast-growing, closely packed, single-species conifers. These hideous plantations, sprawling across the landscape with no regard for variations in terrain or local features, were only the beginning of the greatest act of vandalism ever perpetrated on these islands.

Much more damaging to the landscape and remaining semi-natural woodlands of Britain were the ridiculous agricultural and forestry policies implemented immediately after World War II and in the following forty years. In 1939, the Commission forests were still too young to provide workable timber and a further 200,000 hectares of private woodland was cut down to meet demand. Much of this was hardwood which would have regrown if left to its own devices, but the overall shortage of domestic timber and the threat to 'peace in our time' posed by communism led to a blinkered policy of conifer planting on a massive scale. 'Large-scale systematic forestry,' enthused the government, 'is necessary for the welfare and safety of Britain.' Simultaneously, there was assumed to be an urgent need to increase food production and grants were directed at hedgerow and small woodland clearance to maximise agricultural land use.

With productive land at a premium, Forestry Commission planting focused on marginal upland districts, hill and moorland, most of it totally unsuitable for growing trees. Vast areas of beautiful, wild open spaces became filled with dark, regimented, forbidding conifer plantations, displacing isolated farming communities and engulfing many semi-natural woodlands. I remember being taken by my father, on one of his monthly visits to the family farms in Northumberland, to watch the planting of a big area of hill above Stannersburn and thinking how strange it looked, as a caterpillar tractor dragging a huge Cuthbertson plough gouged black lines through the green fields in front of an abandoned farmhouse. Today the Forestry Commission manages 7,720 square kilometres of land in Great Britain; 60 per cent is in the hills of Scotland, particularly the Highlands, western Borders and Galloway; 26 per cent in England, including Kielder Forest, which covers 650 square kilometres; with the remainder in Wales. Dr Rackham estimates that in the thirty years between 1945 and 1975 nearly half the remaining ancient woodlands of England, Wales and Scotland were seriously damaged or destroyed, more than in the whole of the previous 1,000 years.

Active commercial coppicing survived in a small way through the twentieth century, mainly in the sweet chestnut coppices of Kent and East Anglia, with the principal outlet being the fencing industry. In the last decade the wheel of history has turned slightly and there has been a revival of coppicing, especially of hazel in Hampshire and other southern counties, oak in the North West and beech for bodging in the Midlands. This is due to conservationists appreciating the importance of coppicing in maintaining traditional woodlands, and the growth of interest in traditional crafts. A new generation of coppice workers and woodsman have developed markets for chestnut paling, wattles, baskets, faggots for river bank stabilisation, barbecue charcoal, greenwood furniture and garden ornaments. It is encouraging to reflect that the demand for good-quality coppice now exceeds the supply.

PRESERVING OUR ANCIENT WOODLANDS

Although landlords with an interest in hunting or shooting preserved their woodlands for game cover, the overall damage to small broad-leafed woods, copses and spinneys through afforestation and agricultural reclamations inspired Kenneth Watkins, a retired farmer in Devon, to start the Woodland Trust in 1972, with the aim of preventing further loss of ancient woodland.

The early 1970s saw the beginning of conservation awareness among the general public, and by the end of the decade donations to the Trust had enabled them to acquire woodland across England. In 1980, they obtained Coed Lletywalter, a 38-hectare ancient woodland site in Wales, and in 1984, Balmacaan Wood in Scotland, overlooking the banks of Loch Ness. In 1996, they began working in Northern Ireland and by 2009 the Trust was involved in the conservation management of around 13,000 hectares of woodland. Conservation soon became part of the political agenda, and the example set by the Woodland Trust was picked up by the Nature Conservancy Council, the government department responsible for designating and managing National Nature Reserves and other nature conservation areas in Britain, between 1973 and 1991.

During the 1980s and 1990s the Nature Conservancy Council and its successors, which in 2009 were Natural England, Scottish Natural Heritage, the Countryside Council for Wales and the Northern Ireland Environment Agency, compiled inventories of ancient woodland sites in their respective regions, with the Woodland Trust providing the information for Northern Ireland.

REMARKABLY, THERE ARE STILL OVER 22,000 SITES OF ANCIENT AND SEMI-NATURAL WOODLAND IN ENGLAND, AROUND 14,570 IN SCOTLAND, 850 IN NORTHERN IRELAND AND OVER 100 FOR WALES. ONLY 3,000 SQUARE KILOMETRES OF ANCIENT SEMI-NATURAL WOODLAND SURVIVE IN BRITAIN – LESS THAN 20 PER CENT OF THE TOTAL WOODED AREA.

Remarkably, there are still over 22,000 sites of ancient and semi-natural woodland in England, around 14,570 in Scotland, 850 in Northern Ireland and over 100 for Wales. Only 3,000 square kilometres of ancient semi-natural woodland survive in Britain – less than 20 per cent of the total wooded area. More than eight out of ten ancient woodland sites in England and Wales are less than 200,000 square metres in area, only 500 exceed one square kilometre and a mere 14 are larger than three. This is a fraction of what there once was, but a great deal more than any other European country, and what we have, mainly in the remains of old Royal Forests, chases and the parkland of great estates, is now fiercely protected.

Nor are they all only in rural settings; the London Borough of Haringey contains no less than five ancient woods. Highgate Wood, Queen's Wood, Coldfall Wood, Bluebell Wood and North Wood were once part of the great Forest of Essex, and during the medieval period, the hunting estate of the Bishops of London. Here, between Muswell Hill and East Finchley, eight kilometres from St Paul's Cathedral, are 70 hectares of original pedunculate and sessile oak, hornbeam, beech and holly woods with the occasional wild service tree. There are several other ancient woodlands in the Greater London area: Dulwich and Sydenham Hill Woods, Epping Forest North, Lesnes Abbey and Bostall Woods, Ruislip Woods and Poors Field.

MYSTERIOUS AND MYTHICAL TREES

Uniquely to Britain, we have amongst our ancient woodlands, in churchyards, on village greens and parish boundaries, a number of trees of immense antiquity. When we think about preserving our ancient woodland heritage and debate the importance of doing so, it is vital to remember that since time immemorial trees and shrubs have all had religious and cultural meaning and usage.

The Celts were extraordinary people; tribal, quarrelsome and addicted to mead, but also highly organised agriculturalists, industrious miners, and successful traders in iron ore, gold, silver, lead, tin, copper, grain, skins, slaves and hunting dogs to the Continent. They were deeply religious nature worshippers, whose lives were ruled by superstition and the seasons, and it was they who bequeathed us a heritage of folklore, much of it centred round their veneration of trees.

All species were believed to have magical powers and to be inhabited by a deity or spirit, especially oak, ash, yew, crab apple and thorn, and of these the oak trees were considered the most sacred. No one has stood before the critical gaze of an ancient oak with its gnarled trunk and great twisted limbs and not felt a sense of awe. The sight of one of these majestic trees rearing up out of a glade in the underwood, or a grove of them standing alone on the edge of a heath, bare, gaunt and terrible through the winter then bursting into life again in the spring, symbolised all early man's polytheist beliefs in life, death and rebirth.

THE ANCIENT OAK

Oaks were particularly revered by the Druids, because then oak trees were the main woodland host for mistletoe. Imagine the impression on an Iron Age Celt, trudging homeward from a day's coppicing during the winter solstice, believing all plant life had ceased and suddenly glancing upwards to see a clump of green leaves and white berries glowing in a shaft of sunlight, high in the bare branches of an oak tree. This was the 'Golden Bough' of folklore and legend; an assurance that all the Druidical incantations, ritual bonfires and sacrifices were doing their stuff; that spring would come again, bringing warmth, fecundity and new life.

To the Greeks, Romans, Celts, Slavs and Teutonic tribes, the oak was foremost amongst venerated trees, and in each case associated with the supreme god in their pantheon – sacred to Zeus, Jupiter, Dagda, Perun and Thor respectively. Ancient kings presented themselves as the personifications of these gods, taking on the responsibility not only for success in battle but also the fertility of the land, which relied on rainfall. They wore crowns of oak leaves as a symbol of the god they represented as kings on Earth. Successful Roman commanders were presented with crowns of oak leaves during victory parades, and oak leaves have continued as decorative icons of military prowess to the present day. Spiritual appreciation of oaks did not cease with the advent of Christianity; although many oak groves were supplanted by early Christian churches, St Columba was said to have had a fondness and respect for oaks and was reluctant to fell them – though his chapel on Iona was constructed using timber from the nearby Mull oak woods. St Brendan was inspired to use oak boards instead of traditional hides to cover his coracle, which legend says floated him across to the Americas some thousand years before Columbus.

YEWS

Yews, being evergreen and producing red berries, were of particular significance to the ancients. Again, a splash of colour in the stark winter landscape would have been an emblem of hope and a symbol of the enigmatic power of nature. Yew trees symbolised both death and immortality, being poisonous but immensely long-lived, and able to re-root their branches to produce fresh saplings. A grove of yew trees was considered by the Druids to be particularly holy and so they preferred to make their wands from yew, rather than oak or crab apple, the other favourite wand-making woods. A rod made of yew, called a fé, was used to measure corpses for burial, and the pagan habit of placing a piece of yew foliage in a coffin persisted until the eighteenth century.

Many yews of great age have survived in churchyards because of their sacred associations, both before and after Christianity. The habit of planting yew trees in churchyards is open to dispute; one theory is that they were planted to deter graziers from turning sheep into graveyards to eat the grass. However, this lacks credulity, as the parishioners wanted the grass in graveyards to be grazed and would peg cut brambles on the actual graves to keep the sheep off them. Another, which suggests that yews were planted to provide staves for the mighty bow of the Middle Ages, is also implausible; the yews would take far too long to grow to have been of any use, and in any case, most yew staves were imported from Italy. The last theory, and the one that I subscribe to, is that early Christian churches were built on sites of pagan worship and that the habit of planting yews near churches simply persisted. This is based on the instructions given by Pope Gregory in 597 to the Benedictine monk, Augustine, as he departed on his mission to convert the pagan Britons. Gregory insisted that Augustine should not destroy the heathen temples, but only remove the idolatrous images, wash the walls with holy water, erect consecrated altars and try to convert the sites to Christian churches.

HOLLY

Holly was revered for the same reason as miseltoe-bearing yew; it was an evergreen and the fact that a crop of bright berries appeared to coincide with the winter solstice could only suggest deeply mythical connections. Furthermore, to add to the mystique, holly most commonly grows in the understorey of oak woodlands, and where few plants can survive the overhang of a mature tree, holly can be found gleefully growing in scrubby clumps around the base of big oaks. Uniquely to Britain, there were once forests of pure holly in Scotland, as it had long been an essential element in pagan winter solstice festivals, which were the most prolonged and widespread celebrations honouring

A Book of Britain

the unconquered Sun. The first recorded usage was by the Romans, who used it for decoration at Saturnalia. This festival was held in mid-December, and was a time of uninhibited celebrations. Houses and streets were decorated with holly, ivy and other evergreens, and *'Strenae'*, twigs of evergreens – laurel or holly – to which were fastened sweetmeats, were a popular gift. The Celts believed holly had the power to ward off evil spirits and to protect houses from lightning, a superstition that persisted for many centuries. Holly trees and hedges were planted around houses in some parts of the country for their evil-deterring properties, and door frames were sometimes made of holly as a protection against lightning.

The belief that plants with red berries – holly and rowan – were a defence against a malign presence was particularly strong in Scotland. The Gaelic name for holly, *Chuillin*, appears across the country from *Cruach-doire-cuilean* on Mull, where the McLeans of Duart adopted holly as their clan badge, to *Loch a' Chuillin* in Ross-shire in the north; the town of Cullen in Banffshire may also have derived its name from a local holly wood. In old Scottish myths, the Cailleach, a hag representing winter, was said to be born each year at the beginning of November. She spent her time stalking the earth during the winter time, smiting the ground with her staff to harden it and kill off growth, and calling down the snow. On May-Eve, the turning point of the Celtic year from winter to summer, she threw her staff under a holly tree and turned into a stone. The holly tree was sacred to her, and keeping a holly bough, complete with leaves and berries, in the house was believed to placate her and protect the occupants from an unwelcome visit.

> THE CELTS BELIEVED HOLLY HAD THE POWER TO WARD OFF EVIL SPIRITS AND TO PROTECT HOUSES FROM LIGHTNING, A SUPERSTITION THAT PERSISTED FOR MANY CENTURIES. HOLLY TREES AND HEDGES WERE PLANTED AROUND HOUSES IN SOME PARTS OF THE COUNTRY FOR THEIR EVIL-DETERRING PROPERTIES.

After the Battle of Dunbar in 1650, when Cromwell defeated the Scottish army commanded by Lord Newark, 5,000 prisoners were force-marched under appalling conditions to Norfolk to drain the fens. The 1,400 Scotsmen who survived the starvation and ill-treatment on the journey south were said to have stuck twigs of holly around the hovels they lived in on the marshes, as protection against any evil fen spirits.

As with several other native trees believed to have protective properties, there were taboos against cutting down a whole tree. Hollies were frequently left uncut in hedges when these were trimmed, and in 1861 the 8th Duke of Argyll even had a prospective road at Inveraray rerouted, to avoid disturbing a particularly venerable old tree. Taking boughs for decoration, however, and coppicing trees to provide winter fodder, was considered acceptable. Holly leaves proved to be particularly nutritious as winter feed for livestock, and some farmers even installed grinders to make the pricklier leaves more palatable. Folklore suggested that the wood had a mystical control over animals, especially horses, and coachmen traditionally had whips made from coppiced holly, which accounted for hundreds of thousands of holly stems during the great era of carriage driving in the eighteenth and nineteenth centuries.

Woodland

ASH

Our two native ash trees, the common ash and mountain ash, or rowan, were both held in very high regard by Iron Age man. A mature common ash tree, with its upward-reaching widely spaced branches, is a magnificent specimen. They are one of the easiest trees to recognise; it is the only one that has black buds in the spring, followed by purple florets resembling little cauliflowers. The leaves are very distinctive, having from nine to eighteen long-toothed leaflets lying opposite each other on each stem, and in the autumn the tree produces bunches of winged seeds known as Ash Keys. It grows in most soils and conditions, particularly in limestone areas, and evolved a reliable and productive seed-manufacturing system, bearing both male and female flowers on a single tree, often developing hermaphrodite flowers. When mature, the tree can reach a height of forty metres, which is reflected in its Latin name of *Excelsior*, with the bark as deeply fissured as an oak and developing an incredibly large and deep root system.

Early people across northern Europe believed that the roots of an ash tree reached deep into the underworld and that its upward-sweeping branches were stretching to the gods. It all becomes very convoluted in Norse mythology, which has a squirrel running up and down the tree carrying messages from a serpent gnawing at the roots to an eagle in the canopy; a deer feeding on ash leaves, from whose antlers flowed the great rivers of the world; and a magical goat dispensing mead from its udders to the warriors in Odin's Great Hall. All in all, the ash was generally considered a splendid tree which must have any number of magical properties, not least of which was that the wood burnt with equal intensity when either green or dry, and an old saying is, 'Burn ash wood green, 'tis fit for a queen.'

> EARLY PEOPLE ACROSS NORTHERN EUROPE BELIEVED THAT THE ROOTS OF AN ASH TREE REACHED DEEP INTO THE UNDERWORLD AND THAT ITS UPWARD-SWEEPING BRANCHES WERE STRETCHING TO THE GODS ... THE ASH WAS GENERALLY CONSIDERED A SPLENDID TREE WHICH MUST HAVE ANY NUMBER OF MAGICAL PROPERTIES.

In British folklore ash trees were also credited with a range of protective and healing properties, most frequently related to child health. Newborn babies were often given a teaspoon of ash sap, and sick children, especially those suffering from a rupture, broken limbs or rickets, would be passed naked through a cleft in an ash tree or ash sapling. The cleft was often specifically made for the purpose and bound together again after the ceremony; as the ash healed the child's health would improve. A decoction of the leaves, bark and fruits were believed to cure arthritis, rheumatism, warts and snake bites, alleviate fluid retention, improve general health and promote longevity.

Any tree with autumn berries was attributed with magical properties, and the bitter scarlet berries of the mountain ash or rowan trees were believed to be the ambrosia of the gods. Furthermore, the berries have a tiny five-pointed star opposite its stalk in the shape of the pentagram, an ancient symbol of protection. Belief in the rowan trees' ability to ward off evil was pretty well universal across Britain. A rowan tree growing near a dwelling was believed to protect the occupants from

witches, and where I farm in the Borders there are any number of ruined bothies used by shepherds centuries ago, scattered about the hills, all of which have a rowan growing nearby. Country people would invariably carry a piece of rowan bound in red thread in their pocket or sewn into the lining of a coat as a personal defence against witches. From John o'Groats to Lands End, across Wales and throughout Ireland, rowan sprigs were hung above beds as a protection against visits from the night hag and nailed above the doors of stables or cow biers to safeguard the animals. Needless to say, cutting down a rowan tree would incur the most calamitous bad luck, particularly if it grew near a house, and to this day second-home buyers in Scotland and Wales are warned of the danger.

HAWTHORN

Hawthorn is another plant that produces an abundance of red berries – haws – in the autumn and a profusion of tiny pinky-white flowers in about the middle of May. Hawthorn, quickthorn or whitethorn is an immensely hardy bush, commonly used in hedging. In the wild, the woodland variety can grow into a sturdy tree fifteen metres high. Hawthorn blossoms or 'blows' joyously regardless of the weather, particularly when a cold east wind persists, inhibiting other plant growth. On the east coast, a cold spring is known as a 'Whitethorn Spring' and the 'hungry' wind will blow as long as the flower is on the thorn. Before the calendar changed from Julian to Gregorian in the mid-eighteenth century, hawthorn flowered to coincide with the Beltane, the most important of Celtic festivals which marks the arrival of summer. Flowering boughs were part of the riotous, licentious celebrations, and the custom of cutting hawthorn continued long after the introduction of Christianity as part of the May Day celebrations.

> HAWTHORN FLOWERED TO COINCIDE WITH THE BELTAIN, THE MOST IMPORTANT OF CELTIC FESTIVALS WHICH MARKS THE ARRIVAL OF SUMMER. FLOWERING BOUGHS WERE PART OF THE RIOTOUS, LICENTIOUS CELEBRATIONS, AND THE CUSTOM OF CUTTING HAWTHORN CONTINUED LONG AFTER THE INTRODUCTION OF CHRISTIANITY AS PART OF THE MAY DAY CELEBRATIONS.

Folklore about hawthorn tends to be contradictory; in some rural areas the farm servant who brought a hawthorn bough in bloom to the farmhouse on May Day was rewarded with a dish of cream. This was made into a garland and hung in the kitchen for a year and then taken into a grain field and burnt to protect the crop from malevolent spirits and disease. In other regions there was an absolute conviction that bringing hawthorn flowers into a house was extremely unlucky and would inevitably be followed by sickness and death. This belief stemmed from the sickly-sweet scent of the flowers, which is not unlike the stench of decomposing flesh – an all-too-familiar smell in the age when corpses were laid out at home for several days prior to burial. Scientists later discovered that the flowers contain trimethylamine, a product of decomposition responsible for the odour when body tissue starts to decay. A curious custom, which endured into the early twentieth century, was hanging the fresh placenta of a cow or mare on a hawthorn bush. This was believed to protect the mother from postnatal illness and bring good luck to the calf or foal.

Britain's most famous hawthorn is the Glastonbury Thorn, which miraculously flowers at Christmas and was reputedly grown from a staff belonging to Joseph of Aramathea, uncle of the Virgin Mary. The original tree was cut down and burnt by Cromwell's soldiers during the Civil War, but by then there were plenty of other trees across Britain grown from cuttings of the original, and a sapling from one of these was replanted outside St John's Church. A sprig of Holy Thorn is traditionally sent to the monarch each Christmas by the vicar and Mayor of Glastonbury, a custom started by the Bishop of Bath and Wells in the reign of James I. 'Thorn', or derivatives of the word, are the most common tree-related place names in Britain after ash and grove.

CRAB TREES

Crab trees – crab from the Norse word *skrab,* meaning scrubby – is a familiar sight in hedgerows, but was traditionally a woodland tree often found growing among oaks. They produce fragile, sweet-scented, pink-tipped flowers in the spring and bitter, rock-hard little apples – the ancient mother of all apples – in late September.

As a spring-flowering, autumn-fruiting tree, crab apples were venerated by pagans across Europe, with many beliefs and legends connected to them. Most were centred around the fruit being a symbol of love, fertility, wisdom and plenty. Crab apples are one of the hosts for mistletoe and the Druids are believed to have planted them near oak groves to ensure the sacred trees would have their 'Golden Bough'. The little fruit were highly prized as the essential ingredient in the highly alcoholic drink cyser, or melomel – a potent cider and mead mixture drunk during the various winter festivals.

During the period of the Roman occupation, domesticated apple varieties were introduced and apple orchards became established, often run by army veterans who were persuaded to stay in Britain by being given land on which to plant apple trees. The Vikings brought with them the habit of 'wassailing', in mid-January. Wassail is derived from the Norse *ves heill*, meaning 'be healthy', and wassailing was the equivalent of our New Year's Eve partying, at which the centrepiece was the wassail bowl, containing strong ale mixed with pulped roasted crab apples. During the Middle Ages, wassailing the apple orchards became a popular event in the cider-making counties, and it is still carried on in parts of the West Country.

One of the strangest customs in Britain is the Egremont Crab Fair, which has been held every September almost continually since the Cumbrian town was granted a Royal Charter in 1267 by Henry III. A principal feature of the fair is the World Gurning Championships, where contestants compete to pull the ugliest face whilst their head is stuck through a horse collar. This extraordinary practice, where competitors have been known to devote a lifetime to achieving exceptional ugliness, was inadvertently started by Thomas de Multon, Lord of the Barony of Egremont. After harvest, de Multon was in the generous habit of rewarding his serfs by riding through the town and tossing each a crab apple; the bitter taste of the apples caused the peasants' faces to contort and thus began the tradition. Giving away crab apples continues to this day with the 'Parade of the Apple Cart', where apples are thrown to the people who line the main street.

HAZEL

The importance of hazel trees to our ancestors cannot be overestimated. Hazels grow throughout Britain except on very poor or waterlogged ground and are the most prolific tree or shrub to cultivate beneath the canopy of other woodland trees, particularly oak and ash. They grow most frequently in the form of a multi-stemmed bush of slender trunks, and the pliable rods and whips, which can be bent, twisted, woven and even knotted, provided Mesolithic nomads with the materials to make their fishing creels, baskets, hoops to spread skins over for shelter and an infinity of other uses. As communities became settled and early man discovered coppicing, hazel rods were split and woven into wattle hurdles for fencing or as panelling for house walls when daubed with clay. Hazel leaves, which are usually the earliest to appear in spring and often the last to fall in autumn, were fed to cattle as fodder. Hazel catkins, which appear in February, are among the first plant food for bees – an important consideration for the mead-dependent Bronze or Iron Age man – and the autumn crop of hazelnuts provided a plentiful and easily stored source of protein.

The significance of hazel is reflected in the wands and nuts found in virtually every Neolithic, Bronze Age or Iron Age burial site across Britain. Hazel nuts also appear to have been among the votive offerings at holy wells; during the excavations of an Iron Age well shaft at Ashill in Norfolk, quantities of hazel nuts were among the artefacts discovered within the walls of the shaft.

Many of the myths attached to hazel are connected to water, especially in Ireland, where the magical hazel trees surrounding Connla's Well and the Well of Segais, the legendary sources of the Boyne and Shannon, flowered and produced nuts at the same time. Nuts from these miraculous hazel trees were believed to be 'the Nuts of Wisdom', and many stories tell how the nuts fell into the waters of the wells, imbuing them with special qualities and causing bubbles of mystic inspiration to form. The nuts were eaten by salmon – the Silver Goddesses, revered by the Druids – who gained great wisdom and the number of spots on their backs corresponded to the number of nuts consumed. Hazel rods have been the diviners' or dowsers' wood of choice to detect water and mineral veins since antiquity and are still favoured today. As late as the seventeenth century, hazel divining rods were believed capable of finding buried treasure and to identify murders. John Evelyn, the famous diarist, observed that hazel divining rods were:

> *'Very wonderful by whatever occult virtue, the forked stick (so cut and skilfully held) becomes impregnated with those invisible steams and exhalations, as by its spontaneous bending from a horizontal posture to discover not only mines and subterranean treasure and springs of water, but criminals guilty of murder etc.'*

158 ✂ *A Book of Britain*

The Gaelic word for hazel is *cuil, coll, cal* or even *cow,* as in Cowglen. It appears frequently in place names in the west of Scotland, such as the Isle of Coll and Bar Calltuin in Appin, both in Argyllshire, where the tree and its eponymous names are most common. It also appears in the name of Clan Colquhoun, whose clan badge is the hazel, and the Roman name for Scotland, Caledonia, comes from Cal-Dun, which means 'Hill of Hazel'. Until relatively recently, it was the custom of Scots lovers to each place a hazel nut among the embers of a fire on Hallowe'en. If the nuts burnt together, it was a sign of eternal true love; if, however, one or other exploded, as hazel nuts are prone to do, it was a clear indication that the relationship was doomed and that the person who had chosen the nut was being unfaithful.

> *'Two hazel nuts I threw into the flame,*
> *And to each nut I gave a sweetheart's name*
> *This, with the loudest bounce me sore amazed*
> *That, with a flame of brightest colour blazed.*
> *As blazed the nut, so may thy passion grow,*
> *For t'was thy nut that did so brightly glow.'*
> THOMAS GRAY (1716–71)

In Wales, to be given a hazel twig was a sign of love rejected and, conversely, to wear a hazel twig in one's cap was said to bring good luck, as was carrying a double nut in one's pocket. Hazel whips were often buried with a coffin to protect the dead from malign spirits, and belief in the protective powers of hazel seems to have been widespread. Sailors along the east coast of England would wear a hazel nut on a string round their neck to protect them from drowning, and houses in East Anglia commonly had hazel twigs pinned to window frames as a safeguard against lightning. In the West Country, hazel was thought to cure adder bites; a cross made from hazel twigs was placed over the injury and the following words recited by someone with, hopefully, a good memory:

> *Underneath this hazelin mote,*
> *There's a braggoty worn with a speckled throat;*
> *Nine double is he.*
> *Now from eight double to seven double,*
> *And from seven double to six double,*
> *And from six double to five double,*
> *And from five double to four double,*
> *And from four double to three double,*
> *And from three double to two double*
> *And from two double to one double,*
> *And from one double to no double,*
> *No double hath he*

Somewhere along the passage of time, the association between hazel nuts and wisdom died away and the nut became seen as signifying fertility and fecundity. A very old custom which continued in England for many centuries was giving or throwing hazel nuts at the bride as she leaves the church on her wedding day, to ensure that the nuptial occasion would prove fruitful. The nut part of this old tradition has been replaced by rice or confetti, except in rural parts of Europe where nuts remain the popular missile. 14 September, Holy Cross Day, was traditionally Nutting Day, when everyone would disappear into the woods to harvest hazel nuts. It appears to have acquired the same sexual connotations and reputation for naughtiness as May Eve, with various inferences to licentious behaviour. 'Plenty of catkins, plenty of babes,' was one and: 'She bore a Devil's baby,' another. (This latter would refer to a wretched girl giving birth in June, with the assumption being that she had been taken advantage of on Nutting Day, when the Devil was believed to lurk in hazel groves, dressed as a gentleman.) To substantiate the goings on, we have documentary evidence in the form of an outraged missive written in 1826 by Archer Houblon, the owner of Hatfield Forest, to his benefactor.

> *'As soon as the nuts begin to get ripe, the idle and disorderly Men and Women of bad character from Stortford ... come ... in large parties to gather the Nuts, or under pretence of gathering the Nuts to loiter about in Crowds ... and in the Evening ... take Beer and Spirits and Drink in the Forest which affords them opportunity for all sorts of Debauchery ...'*

As Britain became an industrial nation, with a shift in population from rural to urban areas, Nutting Day evolved into an immensely popular family day out with children being given the day off school up until the First World War.

A NATION OF REMARKABLE TREES

Since 2004, the Woodland Trust, the Tree Register of the British Isles and the Ancient Tree Forum have been compiling a register of heritage trees. Known as the Ancient Tree Hunt, volunteers are encouraged to find and map all ancient trees across Britain so that a comprehensive living database is created, enabling these remarkable specimens to be protected and preserved.

The oldest living thing in Europe is the enormous yew tree which grows in the graveyard at Fortingall in Glen Lyon, Perthshire. It stands near a Bronze Age tumulus and is believed to be between 2,000 and 5,000 years old. Yew was considered a symbol of death and rebirth due to its poisonous berries and the curious manner of growing shoots or branches which root themselves in the ground and produce new trunks, and because the trunk of the Fortingall Yew is divided into three and has a girth of 36 metres, at one time it was common practice at local funerals to pass the coffin through a gap in the trunk.

There are any number of historical oaks – Windsor Park has several, amongst which is the William the Conqueror Oak, reputedly one of many planted by the Duke's own fair hand. Sherwood Forest has the famous Major Oak, named after Major Hayman Rooke, a local antiquarian, who described it in his book *Remarkable Oaks in the Park at Welbeck* (1790). The tree was originally pollarded and has a girth of 20 metres, with a hollow interior large enough to hold fifteen men or thirty small children. It was previously known as the 'Cockpen Tree', from being used to store fighting cocks in their wicker baskets for the cock fights that were held nearby. The Victorian legend that Robin Hood and his Merry Men used to shelter in the hollow interior made the Major Oak internationally famous, and by 1900 the volume of visitors required the daily presence of a guardian employed by the landlords, the Thoresby Estate, to deter souvenir hunters. Barely a stone's throw away is the Parliament Oak, under which either King John in 1212, or King Edward I in 1282, is believed to have held an emergency council whilst hunting in the forest. This venerable tree is a classic example of the urgent need to protect heritage specimens; in 2004 the immediate vicinity had been turned into an illegal rubbish tip and it is a miracle that some of the rubber car tyres lying about were not set alight by vandals and the tree burnt down.

The Royal Remedy Oak of Woodlands, a small hamlet between Wimborne and Cranborne in Dorset, is another legendary tree of almost incalculable antiquity. It was fully grown when the Boy King, Edward VI (1537–53), who came to the throne at the age of nine, is believed to have sat beneath the canopy of its branches and 'touched for Kings Evil'. Kings Evil was any of a variety of skin diseases, in particular a form of tuberculosis affecting the lymph nodes of the neck, which the touch

of the monarch was believed to cure. Sovereigns were thought to be divine and to have acquired their power through descent from Edward the Confessor, who, according to legend, received it from St Remigius. The practice continued in England until the early eighteenth century and one of the last supplicants to be 'touched', before King George I put an end to the practice as being too Catholic, was the infant Samuel Johnson, touched by Queen Anne in 1712. The Royal Remedy Oak may not be with us for much longer, though, as half its trunk has rotted away and although sap still struggles along the great gaunt branches every spring, it is held upright by a network of poles and steel cables. There are many more wonderful historic specimen trees, including the great limes of Holker Hall in Cumbria, the Maryculter sweet chestnut on the banks of the River Dee in Aberdeen, near the ruins of St Mary's chapel (built by the Knights Templar in the thirteenth century), the great plane tree which towers over the grounds of the twelfth-century Mottisfont Abbey, near Romsey in Hampshire, the splendidly gnarled and ancient wild cherry tree in the grounds of Studley Royal in North Yorkshire, or the Belvoir Oak, Ireland's oldest tree, in Belvoir Forest Park, Belfast.

※ ※ ※

Broad-leafed woods are quiet places in winter; havens of peace and tranquillity. There is an old oak and ash wood near here where I go and sit sometimes, and listen to the wind sighing through the tree tops or rustling the leaves on the ground. If I let my mind drift, I can see the wood when it throbbed with the sounds of woodsmen working; the rasp of a two-handed saw as sawyers drew it back and forth, laboriously sawing a big standard into planks in a saw pit especially dug for the purpose.

> *Now saw out thy timber, for board and for pale,*
> *To have it unshaken and ready for sale;*
> *Save slap of thy timber for stable and sty,*
> *For horse and for hog, the more cleanly to lye.*

There is the 'tock' of axes, the clink of hammers striking wedges and the scrape of a bodger's wheel, the snorts of a carthorse leaning into its traces and the creak of wagon wheels. Beside the sunken track, worn by centuries of timber wagons, are piles of different-sized firing food for brick kilns or for making charcoal, faggots, billets and bavins or stackwood, cutting blocks, cordwood, roots, long ash poles, whips, twigs and bark. The broad-leafed woodlands of Britain are among our greatest national treasures and, as such, they must be cherished.

CHAPTER THREE

WEATHER LORE

What is it moulds the life of man?
The weather.
What makes some black, others tan?
The weather.
What makes Zulus live in trees,
The Congo natives dress in leaves,
While others go in furs and freeze?
The weather.
W.J. HUMPHREYS (1862–1949)

Anticipating the weather has been a principal concern of mankind since the dawn of time and will, no doubt, continue to be an obsession until the world ends. The very existence of nomadic Stone Age hunter-gatherers depended on their ability to accurately interpret changes in the rhythm of seasons by observing the patterns of nature: the colour of sky at dusk or dawn; the shape of clouds or direction of the wind; the behaviour of animals and the migration of birds; the activity of insects and mammals; or a dearth or abundance of wild plant growth. Communities that got it right were the ones that survived, passing this vital knowledge on from generation to generation.

Our Neolithic ancestors, the first agriculturalists, increased their understanding of the weather by a detailed study of the cycle of the sun and moon (see pages 170-73) and erecting stone circles, henges and monoliths (the ultimate symbols of prehistoric achievement), which were aligned to the winter and summer solstices, the equinoxes and lunar phenomena. Gradually, as a primitive calendar evolved, it became apparent that the weather conditions on certain days influenced the elements during the following few weeks. These observations became of enormous consequence in the Celtic year and were added to the existing seasonal pagan festivals of Beltane (1 May), Samhain (1 November), Imbolc (1 February) and Lugnasadh (1 August) as occasions for worship to the sun gods or relevant sky deity for that particular day.

Meteorological patterns and abnormalities were also sanctified by the Romans, and considerable syncretism of Roman and Celtic beliefs occurred during the Roman occupation. When Christian missionaries reached these islands in the first few centuries AD, they were faced with the almost impossible task of transforming deep-rooted heathen practices into Christian dedications. Appreciating the significance of weather worship for the pagan population, the Church began to attach saints' names to each day of Celtic weather prophecy in order to align the two beliefs. The saints' days of prediction became a calendar around which agriculture was planned, and as the river of history flowed through the centuries, generations of observant country people, sailors and fishermen added a mass of weather beliefs, sayings and adages. To help remember them, the majority were in the form of rhyming couplets, which produced some of the most evocative prose and poetry in the English language. They became part of culture and education, and together they constitute a priceless treasury of folklore that is a unique part of our national heritage.

THE LOST ART OF WEATHER WATCHING?

The science of meteorology has taken huge leaps forward since NASA launched the first weather satellite in 1960. We now have supercomputers correlating data on hourly global climate change from meteorological spaceships, ground stations, polar-orbiting and geostationary satellites. Bi-static Doppler radars rapidly assimilate the speed and direction of wind vector fields. Radiosondes, carried high into the atmosphere every twelve hours by helium or hydrogen balloons, record upper air conditions for warmth and humidity. Weather ships and meteorological buoys monitor sea-surface temperature, wave height, currents and ocean oscillation. Teams of climate scientists and meteorologists study minute changes in the environment of the North Atlantic in an attempt to predict a long-range forecast for northern Europe.

The statistics supplied by this technology are essential to the aviation and marine industries, the armed forces, utility companies and to assist large private-sector businesses, such as supermarkets, in anticipating seasonal consumer spending. They also provide the general public with round-the-clock weather bulletins via the media and internet. We are, in fact, swamped with information about our weather.

> WE ARE, IN FACT, SWAMPED WITH INFORMATION ABOUT OUR WEATHER. HAS SOPHISTICATED MODERN FORECASTING DESTROYED THE CREDIBILITY OF CENTURIES OF PERCEIVED WEATHER WISDOM? IN THE SHORT TERM, TRADITIONAL WEATHER LORE REMAINS A RELIABLE GUIDE TO DAILY CHANGES IN THE CLIMATE.

Has sophisticated modern forecasting destroyed the credibility of centuries of perceived weather wisdom? In the short term, traditional weather lore remains a reliable guide to daily changes in the climate. Probably the most well-known phrase: *Red sky at night, a shepherd's delight. Red sky in the morning, a shepherd's warning,* continues to be as consistently accurate as it was when Jesus is reported to have observed: 'When it is evening, ye say, it will be fair weather for the sky is red. And in the morning, it will be foul weather today for the sky is red and lowering'. (Matthew XVI, 2–3). In the longer term, some of the monthly and saints' days prophecies lack credulity. This is largely because we are undergoing a period of cyclical climate change and, as the Met Office is the first to admit, our weather is so chaotic at the best of times that making any forecasts beyond about a week is highly speculative. Nevertheless, the saints' days and monthly prophecies still have their place, if only because they are part of our literary history and, not so long ago, formed the basis of the calendar of rural life.

THE LUNAR CYCLE

The 29-day cycle of moon phase was the earliest form of measuring time, and the present months are roughly equal to the lunar cycle. Each of the farming seasons – spring, summer, autumn and winter – lasts three months or three moon cycles, thus a year was made up of twelve full moons, the cycle of each following the same pattern. A New Moon is completely black; over the next four nights the moon 'waxes' or becomes more visible until a quarter, known as a Waxing Crescent, can be seen on the right side. Four nights later, half the moon, known as the First Quarter Moon, is visible. A couple of nights later, this has enlarged to become a Waxing Gibbous Moon, and two nights later, a Full Moon. It then 'wanes' in similar time intervals on the left side, through Waning Gibbous, Last Quarter and Waning Crescent until it becomes a Darkened or New Moon.

Each full moon had its own significance. The full moon at the end of March had various names: it is known as the Worm Moon, because the ground has warmed up sufficiently for earthworms to become active; the Crow Moon, from the vocal mating of crows, or the Lenten Moon, since it was the last full moon of Lent, or Sap Moon, from the appearance of the first buds on trees. This full moon was of particular importance in the farming calendar as it was officially the last full moon of winter and heralded the start of the three-month vernal equinox. (The name 'equinox' is derived from the Latin *aequus* (equal) and *nox* (night), because around the equinox, night and day are approximately equally long.) It was an important time for sowing seed; the ancients were aware of the moon's influence on the tides and always endeavoured to plant with a waxing moon, believing, as many do today, that just as the moon pulls the tides it also causes moisture to rise in the earth, encouraging growth. The later stages of a waxing moon are also favoured for harvesting plants that need to be rich in moisture content, such as grapes, tomatoes, strawberries and wild mushrooms.

> *When the moon is at the full,*
> *Mushrooms you may freely pull*
> *But when the moon is on the wane,*
> *Wait 'ere you think to pluck again.*

Root plants, such as potatoes, turnips and carrots, are best planted during the 'dark of the Moon'. The waning moon is the time for killing weeds, cutting back dead growth, harvesting root vegetables, drying herbs, flowers and fruit, and planting beans.

> *Sowe peason and beanes, in the wane of the moone,*
> *Who soweth them sooner, he soweth too soone*
> *That they with the planet may rest and arise,*
> *And flourish, with bearing most plentiful wise.*

The next three moons all have names associated with growth and fertility. April has the Egg Moon or Hare Moon (both symbols of fertility), Grass Moon or Seed Moon. May has the Milk Moon from the first flush of grass providing milk, and June has the Flower or Honey Moon. The longest day of the year and the start of the Summer Solstice is 21 June and these often coincide with the Full Moon. The days now become imperceptibly shorter and folklore insists the birds start singing later in the mornings.

July, August and September, the three months of the Summer Solstice, are the ripening months of the farming year. July has the Hay Moon, when the hay is cut. August has the Grain Moon, when 'grain ripens as much by day as by night' under the Full Moon, and September has the Harvest Moon, the Full Moon nearest the autumnal equinox. This has a wonderful hazy, orange colour and appears bigger than other moons, caused by light from the moon passing through a greater amount of atmospheric particles than when the moon is overhead.

Weatherlore

The Hunter's Moon in October is the first Full Moon after the start of the equinox and is so called because the moonlight enables sportsmen to shoot migratory geese arriving from their Arctic summer grazings. November has the Frost Moon and December the Long Night Moon; this occurs around 21 December, the shortest day and the longest night, and the start of the Winter Solstice when the position of the sun is lowest in the sky. The following two full moons are the Ice Moon or the Moon after Yule in January and the Wolf Moon in February, from the long-gone days when wolf packs roamed the countryside howling at the paucity of available food.

In addition to these twelve full lunar cycles, each solar calendar year contains an excess of roughly eleven days compared to the lunar year of twelve lunations. The extra days accumulate and every two or three years there is an extra full moon in one of the months. These phenomena are called Blue Moons and no one quite knows how they became named 'blue', since they look no different to other moons, although a credible hypothesis is put forward by the *Oxford English Dictionary,* which claims the first reference to a blue moon comes from a nonsensical proverb recorded in 1528:

> **EACH SOLAR CALENDAR CONTAINS AN EXCESS OF ROUGHLY ELEVEN DAYS COMPARED TO THE LUNAR YEAR OF TWELVE LUNATIONS. THE EXTRA DAYS ACCUMULATE AND EVERY TWO OR THREE YEARS THERE IS AN EXTRA FULL MOON IN ONE OF THE MONTHS. THESE PHENOMENA ARE CALLED BLUE MOONS.**

'If they say the moon is blue,
We must believe that it is true.'

This is as meaningless as saying the moon is made of cheese, but a connection between the rarity of two full moons in one month and the absurdity of the proverb seems to have stuck. For early people, who recognised the effect of the moon on tides, the natural assumption at the appearance of two full moons in one month was to expect massive flooding and sea surges.

There are an immense number of myths and folklore attached to the power of rays from a full moon, the most obvious of which is lunacy. Moon madness was taken very seriously: *'Lunacy grows worse at full and new Moon,'* proclaimed the famous fifteenth-century Swiss physician, Paracelsus, referring to a disease that had been recognised since Classical times, and which became official under British law in the mid-nineteenth century. The 1842 Lunacy Act defined as a Lunatic: *'A demented person enjoying lucid intervals during the first two phases of the Moon and afflicted with a period of fatuity in the period following after the full Moon.'*

It was considered extremely detrimental to sleep in a room with the curtains open during the full moon and an absolute disaster to be born exposed to moonlight. Although the cottars pig was always killed just after the November full moon, when it would be especially fat from gorging on acorns by moonlight, enormous care was taken to ensure that the carcass was not exposed to the malefic rays of a waning moon, less they corrupt the flesh. On the other hand, woodsmen avoided felling trees around the period of the full moon in the belief that the timber would contain too much water and quickly rot.

Weatherlore

HOW SAINTS' DAYS PROPHESY THE WEATHER

When I was a child in the 1950s, my father still used heavy shire horses on the farm. His horseman, Jim Akehurst, was typical of the older generation of countryman who could recite all the saints' days of weather prophecy and monthly predictions off by heart. He also knew a surprising amount about the saints' lives and how the martyrs met their fate.

In Jim's cottage were three framed samplers, painstakingly stitched by his grandmother; two catalogued all the days of prediction and their respective rhymes, the third listed the quarter and cross-quarter days in England, Ireland and Wales and their relevant weather prophecies. Since the Middle Ages, the quarter days were the four dates in each year when servants were hired and rents and rates became due for payment. They were also the dates when magistrates visited remote areas to adjudicate outstanding cases and suits. Quarter days fell on four religious festivals, three months apart, close to the two solstices and two equinoxes which marked the start of the seasons: *Lady Day*, 25 March – The Feast of the Annunciation; *Midsummer's Day*, 24 June – The Feast of St John the Baptist; *Michaelmas Day*, 29 September – The Feast of St Michael; and *Christmas Day*, 25 December.

> JIM AKEHURST WAS TYPICAL OF THE OLDER GENERATION OF COUNTRYMAN WHO COULD RECITE ALL THE SAINTS' DAYS OF WEATHER PROPHECY AND MONTHLY PREDICTIONS OFF BY HEART ... JIM'S LIFE WAS PLANNED AROUND THE QUARTER DAYS, CROSS-QUARTER DAYS AND SAINTS' DAYS OF WEATHER PREDICTION, AND THIS WAS THE WAY IN WHICH HE KEPT IN MIND KEY EVENTS.

The cross-quarter days were holidays in between quarter days: *Candlemas*, 2 February – The Purification of the Virgin; *May Day*, 1 May; *Lammas*, 1 August – The Feast of the First Fruits (also known as St Peter in Fetter's Day); *All Hallows Day*, 1 November – All Saint's Day. In Scotland the traditional quarter days fell on different dates and were referred to as 'term days': *Candlemas*, 2 February – The Feast of the Purification; *Whitsunday*, 15 May – Pentecost; *Lammas*, 1 August – Long Mass; *Martinmas*, 11 November – The Feast of St Martin. All these dates have their origins in pagan festivals of weather worships, subsequently appropriated by the Christian church.

Jim's life was planned around the quarter days, cross-quarter days and saints' days of weather prediction, and this was the way in which he kept in mind key events. If a mare foaled on 11 June, for example, he would remember the foal as being born on St Barnabas' Day, which, according to weather lore, is always fine and, traditionally, marks the start of haymaking. Similarly, if a notable incident occurred on 3 August, it would be lodged in his memory as happening two days after Lammas, one of the quarter days, when corn is supposed to ripen as much by day as by night, or St Chad's Day, for no other reason than he was an early English saint.

For Jim, the annual farming calendar followed these red-letter days:

✻ OCTOBER ✻

For a month packed with weather lore, there are, surprisingly, only two saints' days:

18 October, St Luke's Day

Imprisoned with St Paul, Luke was the author of St Luke's Gospel and the Acts of the Apostles. Somehow he managed to avoid martyrdom and died of old age in AD 84. Until 1830, St Luke's Day was known as *Dog-Whip Day,* because on that day in the thirteenth century a hungry cur crept into York Minster and ate the communion wafers. Stray dogs were subsequently whipped from the streets of York every year on 18 October. The practice of driving strays out of urban areas at the beginning of winter soon became universal.

Often four or five days of unseasonably mild weather occurs around St Luke's Day, known as '*St Luke's little summer'*. Traditionally, the four Evangelists are symbolised by a man for Matthew, a lion for Mark, an eagle for John and an ox for Luke, representing the sacrificial aspects of Christ's life so stressed in Luke's Gospel. As a consequence, oxen were never worked on 18 October:

> *On St Luke's Day,*
> *Oxen have leave to play.*

28 October, St Simon and St Jude's Day

Simon the Zealot and Jude the Apostle did much of their preaching as a team in Judea, Syria and Mesopotamia. They were bludgeoned to death together by a horde of pagans in Beirut in AD 65. The traditional forecast for this day is rain:

> *As well I know,*
> *It will rain on St Simon and St Jude's Day.*
> And:
> *Now a continual Simon and Jude's rain,*
> *Beat all your feathers as flat down as pancakes.*
> THOMAS MIDDLETON, *The Roaring Girl* (1611)

31 October, All Hallows Eve

> *Hark! Hark to the wind! 'Tis the night they say,*
> *When all souls come back from the far away ...*
> *The dead, forgotten this many a day.*
> VIRNA SHEARD (1865–1943)

All Hallows Eve was the night when country people stayed firmly inside, particularly if there was a full moon. In the Celtic calendar, 31 October was the festival of Samhain, marking the end of the 'light' or growing half of the year and the beginning of the 'dark' or dead half. The Celts believed the spirits of their ancestors became active with nightfall, a superstition substantiated by the ghostly movement of migratory wildfowl such as woodcock and geese flying by moonlight. The early Christian Church was quick to impose its own interpretation of Samhain, creating All Souls Night for rural people – on Hallowe'en the dead were abroad.

NOVEMBER

Country people call November the black month but, like poor mad John Clare, the 'peasant poet', I love November's stark beauty.

> *Sybil of months and worshipper of winds,*
> *I love thee, rude and boisterous as thou art:*
> *And scraps of joy my wanderings ever find*
> *'Mid thy uproarious madness.*
> 'November', JOHN CLARE (1793–1864)

November has always been a portentous month and as such has acquired a number of prophecies. It marked the beginning of the dark half of the year to the Celts, who celebrated the start of the month with the three-day festival of Samhain. Livestock were slaughtered, some as sacrifices but most to keep communities alive through the winter. Because of this, the Celts called November the 'blood month', a name which lasted until the late nineteenth century. Samhain, like other Celtic festivals, became incorporated into the Christian calendar and was re-invented as All Saints' Day.

1 November, All Saints' Day or All Hallows Day (a cross-quarter day)

> *On first November if weather is clear*
> *'Tis the end of the sowing you'll do for the year.*

With shortening hours of daylight and lowering ground temperature, a clear day at this time of year indicates frost is on its way.

11 November, Martinmas

> *If the wind is in the south-west at Martinmas, it will stay 'til Candlemas.*

This predicts that a mild winter can be expected. Equally, cold north winds tend to presage a period of continued cold weather:

> *Wind north-west at Martinmas, a severe winter to come.*

A freeze in November was often followed by a thaw if this next saying rang true:

> *If ducks do slide at Martinmas*
> *At Christmas they will swim;*
> *If ducks do swim at Martinmas*
> *At Christmas they will slide.*
> And:
> *Ice before Martinmas,*
> *enough to bear a duck.*
> *The rest of the winter,*
> *is sure to be but muck.*

Similarly, very mild weather will turn hard eventually:

If leaves fall not by Martinmas Day, a cruel winter's on its way.

For many centuries, it was the custom to kill oxen on Martinmas Day and dry the beef in the chimney in the same way as bacon.

Dried flitches of some smoked beeve,
Hang'd on a wirthen wythe since Martinmas.
 Also:
Martinmas beefe do beare good tacke
When country folk do dainties lack.

23 November, St Clement's Day

Clement was the fourth Christian pope (AD 53–117). He was banished to the Crimea by the Emperor Trajan where, against all expectations, Clement converted the heathen inhabitants to Christianity and built 75 churches. As a consequence, Trajan had him thrown into the Black Sea, attached by the neck to a heavy anchor.

Clement is the patron saint of blacksmiths. For several centuries, the apprentice blacksmiths working in the armouries of the naval dockyard at Woolwich, the 'Gentleman Vulcans', held an annual ritual on St Clement's Day. A procession of apprentices in elaborate costumes carrying all the accoutrements of war were led by a band of fifes and drums round Woolwich. Money was collected from door to door, which was later spent on a dinner in St Clement's honour.

St Clement gives the winter.

In the Middle Ages, 23 November was considered the beginning of winter.

25 November, St Catherine's Day

Catherine famously attempted to dissuade the Emperor Maxentius (AD 278–310) from persecuting Christians. She was condemned to be broken on the wheel, which collapsed when Catherine touched it, so she was subsequently beheaded. The Catherine Wheel firework is named after her.

Catherine is the patron saint of spinsters, and in Ireland unmarried women and girls would fast on St Catherine's Day in the hope of finding a husband. Conversely, in England young unmarried women met and made merry on this day. This seventeenth-century equivalent of a ladettes' day out was called Cathar'ning.

As St Catherine, foul or fair,
So t'will be next Febryair.

St Catherine's Day marked a turn in the seasons; from then on the weather was no longer dependable.

✳ DECEMBER ✳

The Church was so busy cramming this month with saints' days, in an effort to quash any residue of the pagan Roman festival of Saturnalia and the Norse festival of Yule, that there seems to be little room for Christian days of weather prediction.

21 December, St Thomas Didymus' Day

Thomas was said to have carried Christianity to India in about AD 45. He later converted the wife of King Misdai of Syria, for which he was speared to death.

St Thomas grey, St Thomas grey,
The longest night and the shortest day.

If it freeze on St Thomas' Day, the price of corn will fall;
If it be mild, the price will rise.

A good summer was believed to follow a bad winter, meaning a glut of grain, and a bad summer followed a mild winter, meaning scarce and expensive grain. In the Midlands the poor went *Corning* or *Thomasing* on this day, begging for corn.

25 December, Christmas Day (a quarter day)

If the sun shines through the apple trees on Christmas Day,
When autumn comes they will a load of fruit display.
 And:
Snow on Christmas Day means Easter will be green.

Again, this is the pious hope that hard weather in the winter would be compensated by good in the spring, when it was most needed. The opposite being:

A dull Christmas Day with no sun bodes ill for the harvest.
 And the chilling:
A black Christmas brings a full graveyard.

Black meaning no snow, ice or frost. We all know and dread those periods of heavy, damp, windless days when the nation goes down with colds and 'flu. If this was followed by a period of hard weather, the very young and old were particularly vulnerable.

31 December, New Year's Eve

Wind direction is of immense significance to country people; the first thing they do in the morning is glance up at the clouds to see which way the wind is blowing them. The direction on New Year's Eve was said to set the pattern for the year.

If New Year's Eve the wind blows South
It betokeneth warmth and growth.
If West, much milk and fish in the sea.
If North, cold and storms there will be.
If East, the trees will bear much fruit.
If North East, then flee it, man and brute.

JANUARY

A disturbing month; the hours of daylight are imperceptibly getting longer, but winter still stretches away into the distance. The gradual change in climate is more noticeable in January than any other month. Twenty years ago in southern Scotland snow in January was pretty well guaranteed, but now the month is mild and damp. On 17 January 2001, my beloved terrier, Tug, was bitten by an adder which had emerged from hibernation thinking it was spring.

22 January, St Vincent's Day

Vincent of Saragossa was the deacon to St Valerius, Bishop of Saragossa. He was flayed and burnt to death on a gridiron by the Emperor Diocletian, a notorious persecutor of Christians, in AD 304.

> *If on St Vincent Day the sky is clear,*
> *More wine than water will crown the year.*
> And:
> *Remember St Vincent Day,*
> *If the sun his beams display;*
> *Be sure to mark the transient beam,*
> *For 'tis a token, bright and clear,*
> *Of prosperous weather all the year.*

Both of these are comforting predictions for the future, before we entered the current period of cyclical climate change and winters were proper winters.

25 January, St Ananias' Day

A disciple of Jesus and the Bishop of Damascus, Ananias baptised the Apostle Paul and cured him of blindness. He was tortured and stoned to death on the orders of Lucianus, Governor of Damascus, in AD 40.

> *If St Ananias' Day be fair and clear,*
> *It betokeneth a happy year.*
> *But if it chance to snow or rain*
> *Dear will be all sorts of grain.*
> *If clouds or mist do dark the sky*
> *Great store of birds and beasts will die.*
> *And if the winds do fly aloft*
> *Then wars shall vex the kingdom oft.*

The origins of this gloomy little piece of prose have been lost in antiquity, but it serves to illustrate how terrifying the winters were to superstitious rural communities.

FEBRUARY

The Celts celebrated the beginning of this month with the festival of Imbolc, one of the cornerstones of the pagan calendar, which marked the first day of spring. The word comes from the Old Irish, meaning 'in the belly', referring to the pregnancy of livestock, and possibly humans as well. It was an occasion for lighting bonfires to the goddess Brigid in a plea for favourable weather.

The Saxons called February *Sprout-Kele, kele* meaning cabbage. Our ancestors, starved of vitamins and minerals for the previous months, longed for the first health-giving green sprouts of cabbages, nettles and ransoms (wild garlic). As these began to appear in early February, they were eagerly picked and made into medicinal soups and purées.

1 February, St Bride's Day

Bride of Kildare was one of the patron saints of Ireland who founded Kildare Abbey and made her cell among the roots of a large oak tree. She reputedly died around 525 and was buried under the high altar of the abbey she founded. Later, she was disinterred and her skull was extracted and taken to the Cathedral of John the Baptist in Lisbon. Some historians maintain that St Bride is fictional, a creation by early Christian missionaries based on the pagan goddess in their efforts to convert the Irish Celts.

> *The serpent will come from his hole,*
> *On the brown Day of St Bride,*
> *Though there should be three foot of snow*
> *On the flat surface of the ground.*

This very old Scottish proverb implies that the ground temperature is warm enough for adders to come out of hibernation and that a fall of snow would not last long. It also confirms that winters in the Middle Ages were harder but shorter.

2 February, Candlemas Day,
The Purification of the Virgin (a cross-quarter day)

On this day all the candles to be used in the church during the coming year were blessed, but it was also a significant day for farmers. The weather on Candlemas Day was considered a marker for the progress of winter. A fair start (if a badger can see its shadow) means there is more winter ahead than behind; a bright day predicted more frost and hard weather; a wet one suggested a continued gradual improvement into spring.

> *If Candlemas be fair and clear*
> *We'll have two winters in one year.*
> *When Candlemas be fine and clear*
> *A shepherd would rather see his wife on a bier.*
> *If Candlemas Day be fair and bright,*
> *Winter will have another flight:*

If on Candlemas Day it be shower and rain,
Winter is gone and will not come again.
If Candlemas be wet with rain,
Winter's gone and won't come again.
If Candlemas be bright and fair,
You've half the winter to come and mair.

Like the proverb for St Bride's Day, snow in February does not last long.

When Candlemas Day is come and gone
The snow lieth on a hot stone.

Snowdrops used to be known as Candlemas Bells because they tend to appear around this time of year:

The snowdrop, in purest white array,
First rears her head on Candlemas day.

Finally, this day marked a warning to farmers that grass growth could still be a long way off:

A farmer should, on Candlemas Day,
Have half his corn and half his hay.

14 February, St Valentine's Day

There would appear to have been two St Valentines and it has never been entirely clarified which saint is remembered on this day. The more likely contender is a priest beheaded in about 270, for continuing to perform marriages after the Emperor Claudius II had issued a decree forbidding young soldiers to marry. The other was the Bishop of Terni, also beheaded by Claudius, after being apprehended whilst assisting Christians to escape imprisonment.

The Roman fertility festival of Luprecalia took place in the middle of February and the date of St Valentine's Day was indubitably chosen by the church to Christianise an event to which pagans looked forward with eager anticipation. In 1836 St Valentine's mortal remains were given to a Carmelite priest, Father John Spratt, by Pope Gregory XVI. The relics, in their black and gold casket, were taken to the Carmelite Church in Whitefriar's Street, Dublin, and can be seen there every Valentine's Day.

Since the Middle Ages, St Valentine's Day is traditionally the date when birds start to pair and make nests. Typically, there is a 'fool's spring' in the middle of the month and the temperature rises for a few days. Birds start nesting and the summer migrants – oystercatchers, snipe and plover – begin moving into the uplands from their coastal wintering. As soon as the temperature drops all activity ceases and the migrants disappear.

If she be a good goose, her dame well to pay,
She will lay two eggs before St Valentine's Day.

If the goose doesn't lay on or about the middle of February, the implications are that it knows something about the weather. This date was also a reminder to farmers that the sowing of spring crops will start soon and they need to see that seed barrows are in working order:

On St Valentine's Day
Set thy hopper by mine.

24 February, St Matthias' Day

St Matthias was the Apostle chosen to replace Judas Iscariot. He preached the gospel in Judea and Ethiopia and was martyred either by crucifixion, a lance, or a double-headed axe at Colchis, in what is now modern Georgia, in AD 68.

St Mathee sends the sap up a tree.

The first faint green haze of budding is generally seen at the end of February.

On St Mattio,
Take thy hopper and sow.

Shrove Tuesday often falls at the end of February, but the weather on that day foretells the weather for the next forty days:

As the weather is on Shrove Tuesday,
So t'will be till the end of Lent.

✤ MARCH ✤

This is considered by farmers to be the vital month for spring sowing, and is one they hope will be mainly dry with a little light rain to help germination.

1 March, St David's Day

The patron saint of Wales and a general aesthete, David founded various monastic orders in Wales. He was renowned for his Monastic Rule, which prescribed that monks should pull the plough themselves without draught animals, and refrain from eating meat or drinking beer – instead adopting a diet of water and bread, flavoured on special occasions with a little salt or herbs. By sticking to this regime himself, St David is believed to have been over 100 years old when he died in 590.

Upon St David's Day
Put oats and barley in the clay.

Indicating that the ground would have warmed sufficiently for seeds to germinate.

2 March, St Chad's Day

Chad was the Abbot of Lastingham, in north Yorkshire, and the Bishop of Lichfield and was noted for his extreme piety. He died of natural causes in AD 672.

Before St Chad every goose lays,
Either good or bad.

Geese were an important animal to cottagers with common grazing; they were fattened for the Michaelmas markets and provided a little extra income. Like all birds, geese lay their eggs to coincide with rising temperature. If a goose hadn't laid an egg by St Chad's Day, they obviously weren't going to and would be fattened for the pot.

12 March, St Gregory the Great's Day

Pope Gregory I (AD 540–604) was a most notable figure in ecclesiastic history. He exercised a momentous influence on the doctrine, discipline and organisation of the early Catholic Church, despite suffering from chronic indigestion and 'slow fevers' brought on by a lifetime of prolonged fasting. During the last years of his pontificate, he was a martyr to gout.

St Gregory's Day used to be remembered as 'Farmer's Day', when the clergy went into the fields to bless spring crops.

21 March, St Benedict's Day

Benedict was the founder of at least twelve monasteries, the best known of which, his first, is Monte Cassino in southern Italy. St Benedict is remembered for the precepts he wrote for his monks, The Rule of St Benedict, which was adopted by most monastic orders in the Middle Ages. In later life he retired to a cave but, when overcome with ill health, he was removed to Monte Cassino, where he died in 547.

The vernal equinox is around this date and signifies the changing seasons.

As the wind is on St Benedict's Day
So it will bide 'til St Barnabas Night.

This predicted the wind would remain the same until just before 23 June, Midsummer's Eve. St Benedict's Day also served as a reminder to farmers that peas sown after this date are unlikely to germinate:

Sow thy peas or keep them in the rick.

25 March, Lady Day, The Feast of the Annunciation (first quarter day)
Lady Day was a traditional day on which year-long contracts between landowners and tenant farmers would begin and end in England. Farmers time of 'entry' into new farms and onto new fields was often on this day. As a result, farming families who were changing farms would travel from the old farm to the new one on 25 March. Lady Day also marked the start of the vernal equinox and the beginning of spring growth.

✸ APRIL ✸

April is a happy, optimistic month. Birds are nesting, swallows arrive from Africa, the cuckoo and the nightingale announce that spring has really come, and the long silence of winter is over. It is a glorious month of growth and new birth. Lambs and calves fill the fields, and in the hills, snipe make that beautiful droning sound with their tail feathers as they mark mating territories. Cock grouse grumble and curlews mew.

Easter falls on the first Sunday following the fourteenth day of the full moon, which happens on or after St Benedict's Day. Like so many Christian festivals, Easter was originally pagan and involved a three-day orgy of worship to the fertility goddess Eostre, which started on the first full moon after the equinox. This event was so deep rooted that the Church did not even bother to change the name.

Palm Sunday (the sunday before Easter Sunday)

If on Palm Sunday there be rain,
That betokeneth to goodness.
If it thunder on that day,
Then it signifieth a merrie year.

Thunder and rain would mean a productive year well worth celebrating.

Good Friday and Easter Sunday

Rain on Good Friday and Easter Day,
A good year for grass and a bad year for hay.

This infers that if rain falls over Easter weekend it will still be raining in June, when hay-making starts. Similarly, the Easter weather was believed to foretell the weather on Whitsunday, which falls forty-nine days after Easter:

The weather on Easter Day foretells the harvest.
If the sun shine on Easter Day,
So it will shine on Whitsunday.

If the weather is warm enough at Easter for greenfly to hatch, June will be an exceptionally hot month:

Greenfly at Easter, June will blister.

23 April, St George's Day

The most revered saint in the Eastern and Oriental Orthodox Churches, George is the patron saint of England and twelve other countries, too.

In AD 303 George was a tribune and a member of the Emperor Diocletian's personal guard. When Diocletian ordered the persecution of Christians across the Roman Empire, George confessed to being one. Diocletian had George subjected to various barbaric tortures in an effort to make him recant, before having him beheaded.

The legend of St George and the dragon grew during the crusades, with St George representing the forces of Christian good fighting the dragon of Islam.

St George to borrow.

By now, spring-sown crops should be showing and a farmer could calculate his potential yield. This would enable him to assess what he could borrow with a degree of confidence that he could repay the loan. Equally, a lender could quantify his liability.

✺ MAY ✺

May must be the poet's month; the wild flower growth is quite breathtaking. The verges of every country lane gleam white with wild parsley, stitchwort and hawthorn blossom, while gorse, buttercups, celandine, dandelions and bird's foot trefoil throw a golden sheen across the landscape and the woodland is carpeted with bluebells, clusters of purple-flowered bittersweet and lilac blossom, yellow laburnum flowers and pink horse chestnuts. Sometimes, on a May evening, a sudden warm gust of air will be filled with the most exquisite scent, a combination of all the day's blossom fragrances. It lasts only for a second, then the evening chill closes in again and one of the wonders of nature is completely gone.

The Saxon name for May was 'Tri Milchi', from the abundance of new grass growth which allowed them to milk lactating cows three times a day.

Beltane, at the beginning of May, was the heathen festival of purification that marked the beginning of summer, when twin bonfires were lit on hilltops in a plea to the gods for a good harvest. It was one of the most important occasions in a ceremony-packed Celtic calendar. Each community, and all their livestock, were 'purified' by passing between the two fires whilst the Druids chanted. Every tribal village endeavoured to make the occasion special, by having a prisoner handy for a human sacrifice. Beltane later became the May Day celebrations, but Christianised bonfire or 'need' fire ceremonies persisted in parts of Ireland and Scotland well into the twentieth century.

I have often wondered why the Church did not adopt the day for their own use, in the same way that other heathen events were shanghaied. As it is, the nearest saint's day falls at the end of the month.

15 May, Whitsunday (a cross-quarter day)
Cross-quarter days were significant in the farming year because they fell between a solstice, where the sun's apparent position in the sky reaches its northernmost or southernmost extreme, and an equinox, the point at which the sun is vertically above a point on the equator.

25 May, St Urban's Day
Little of any accuracy is known about Pope Urban I, who was in office from AD 222 until his death in 230. He may have died of natural causes during the reign of the Emperor Carus, or by having a nail driven into his head for causing a heathen idol to fall over through the power of prayer.

Rogation Sunday, the fifth Sunday after Easter, usually falls in May and it was the custom for the clergy to go into the fields to bless the crops on this day.

St Urban gives the summer.

The most succinct of all the saints' day prophecies!

❖ JUNE ❖

The sixth month of the year was named *Weyd-monat* by the Saxons – *weyd* meaning pasture. June is the month when grass growth is at its best, either for grazing beasts or for making hay.

11 June, St Barnabas' Day

The apostle and companion of St Paul, Barnabas is the patron saint of Cyprus. In about AD 50 Barnabas was unwisely attempting to attract potential converts to Christianity by preaching the gospel in the synagogue at Salamis, in Cyprus. He had hardly begun when the fanatically Jewish congregation dragged him outside and, after various inhuman tortures, stoned him to death.

> *Barnabas bright, Barnabas bright,*
> *The longest day and the shortest night.*
> *When St Barnabas smiles both night and day*
> *Poor ragged robin blooms in the hay.*

Ragged Robin *(Lychnis flos-cuculi)*, otherwise known as Cuckoo Flower, Meadow Spink, Polly Baker, Shaggy Jacks or Batchelor's Buttons, is a thin-stemmed member of the carnation family with red flowers. It used to grow wild in old, damp, hay meadows and the reference here is to June being such a good month for weed growth. St Barnabas' Day itself marks the start of hay-making:

> *On St Barnabus,*
> *Put the scythe to the grass.*

15 June, St Vitus' Day

Born in AD 291 into a noble, pagan, Sicilian family, Vitus was brought up by Modestus and Crescentia, a Christian couple who had him baptised.

His father was furious when the boy returned to him, at the age of twelve, a devout Christian. Every inducement, from brutality to the offer of a 'corrupt woman', was tried in an effort to persuade Vitus to renounce his faith. Finally, Vitus, Modestus and Crescentia fled to Naples where their success as Christian missionaries drew the attention of the Emperor Diocletian. All three were subjected to a variety of tortures, including being boiled in oil, before eventually succumbing on the rack.

In the Middle Ages, St Vitus became a cult figure in the northern Germanic countries and across eastern Europe. His followers celebrated St Vitus' Day by dancing themselves into a state of religious ecstasy, giving the name 'St Vitus' Dance' to the spasmodic jerking and involuntary muscular movements which are symptoms of the nervous disorder, Sydenham's Chorea.

> *If St Vitus' Day be rainy weather,*
> *It will rain for forty days together.*

Rain on St Vitus' Day predicted more rain.

21 June, the Summer Solstice and the longest day

In the northern hemisphere, the Summer Solstice is the longest day of the year, when the sun rises farthest in the north-eastern horizon, rises highest in the sky at noon, and sets farthest along the north-western horizon of any day in the year. The Summer Solstice marks the first day of the summer and the ripening period for grain. For early agriculturalists, it was an occasion for much celebration.

24 June, St John's Day

John the Baptist, or John the Precursor, was a Hebrew prophet and preacher who foretold the coming of a Messiah; it was he who recognised Jesus as the Son of God and baptised him. Imprisoned and beheaded by Herod at the insistence of his step-daughter, Salome, in AD 30, his body was buried at Sebaste, Samaria, and later moved to Jerusalem, then Alexandria. The actual whereabouts of his severed head remains a mystery; in the Middle Ages the Knights Templar were believed to have it, and today religious houses in at least four different countries claim possession.

St John gave his name to St John's Wort, another medieval cure-all. The tiny yellow flower of this plant, when crushed, exudes a red, oily droplet which early Christians believed was the blood of the saint. St John's Wort is prescribed for depression in holistic medicine.

Midsummer's Eve and Midsummer's Day

Originally this was a five-day pagan festival. At this time (around 21–25 June) the Sun Gods were at the pinnacle of their power and huge sacrificial bonfires were lit on hilltops to give thanks for the warmth and life of the summer months. The popular tradition of lighting bonfires and partying, from St John's Eve to St Peter's Eve, five nights later, persisted until Cromwell's Commonwealth of 1648. As ever, the Puritans, suspecting that the midsummer frolics were simply an excuse for drunkenness, gluttony and licentious behaviour, put a stop to them. The partying started again after the Restoration, but petered out in the late nineteenth century.

> *St Johnsmas fires should be lit at the moment the sun sets.*
> *Before St John we pray for rain,*
> *Afterward we get it anyway.*
> *Cut your thistles before St John*
> *You will have two instead of one.*

Thistles are incredibly hardy weeds and capable of regenerating if cut in June.

> *If it rains on Midsummer's day, the filberts will be spoilt.*

In this context, filberts is another name for hazel nuts. Hazel bushes were credited with supernatural powers in folklore. In Scotland, a double hazel nut, known as a St John's nut, was considered especially efficacious when thrown at a witch.

> *If Midsummer Day be ever so little rainy, the hazel and walnut will be scarce*
> *and corn smitten in many places: but apples and plums will not be hurt.*

Rain would damage the nut and corn harvest, but not fruit.

Weatherlore

JULY

Then came hot July, boiling like to fire.

July is the month of heat, verdancy and the sweet smell of soft fruit ripening – strawberries, raspberries, gooseberries, and black-, white- and redcurrants.

15 July, St Swithin's Day

The Anglo-Saxon Bishop of Winchester from 852 until his death in 861, Swithin's dying request was to be buried outside his church so that he might feel the footsteps of the devoted and the 'sweet rain of heaven'. In 971 it was decided to move his body to a new, purpose-built shrine inside the cathedral. The ceremony of reinterment was delayed for forty days due to torrential rain and this was interpreted as the saint's expression of displeasure at being disturbed.

St Swithin's Day gives us undoubtedly the best-known and, after St Vitus' prophecy, the most demonstrably inaccurate of all weather lore:

> *St Swithin's day if thou dost rain,*
> *Full forty days it will remain.*
> *St Swithin's Day, if thou art fair,*
> *Full forty days t'will rain nae mair.*
> *How, if on St Swithin's feast the Welkin lours*
> *And every penthouse streams with hasty showers,*
> *Twice twenty days shall clouds their fleeces drain*
> *And wash the pavements with incessant rain.*
> *If it rains on St Swithin's Day, the saint is christening the apples*
> *and they will be sweet and plentiful.*

25 July, St James's Day

James the Apostle preached in Samaria, Judea and Spain before returning to Jerusalem where he became the first Apostle to be martyred when Herod Agrippa had him stabbed to death in AD 44. His relics were taken to Campostela in Spain, which became a famous destination for pilgrims during the Middle Ages.

> *Till St James is past and gone,*
> *There may be hops or there may be none.*
> *If it be fair three Sundays before St James,*
> *Corn will be good, but wet corn will wither.*

St James's Day was the day on which the clergy traditionally blessed apple orchards, particularly in the counties of Kent and Gloucestershire.

> *July to whom the Dog Star in her train,*
> *St James gives oysters and St Swithin rain.*

This date in July is traditionally also the last day of the close season for oysters. The weekend nearest to St James's Day marks the start of the famous Whitstable Oyster Festival.

✳ AUGUST ✳

The harvest month. In the Celtic calendar, 31 July was the eve of Lugnasadh, the pagan festival of the 'First Fruits', when ritual bonfires were lit to add strength to the waning powers of the sun. Tribes sacrificed a portion of crops, livestock or, best of all, a prisoner, to thank the deities for the 'First Fruits' of the agricultural year and as an entreaty for an abundant harvest. Lugnasadh became the Christian ceremony of Lammas, or Loaf-Mass, and the holy day of St Peter in Fetters, and the celebrations moved to 1 August.

1 August, Lammas Day and St Peter in Fetters Day (a cross-quarter day)

Peter was Christ's right-hand man and spokesman for the Apostles. He denied any association with Jesus at his arrest, as Christ had prophesied at the Last Supper, but was forgiven by a three fold affirmation of his love for Jesus. He worked as a missionary until he was crucified, head down, by the Emperor Nero in AD 64.

On Lammas Day, we moor men
Cut hay.

Hill farmers in the uplands of Britain made hay from 'bentgrass', a thin moorland grass which would not be ready to cut in the higher altitudes before August. After Lammas the ambient temperature ripens corn as much by night as by day.

After Lammas, corn ripens as much by day as by night.

6 August, Day of the Transfiguration

The Transfiguration of Jesus was an event covered in the gospels of Matthew, Mark and Luke, when Christ experienced a miraculous meeting with Elijah and Moses. Traditionally, the first fruits of the year are brought into churches to be blessed.

As the weather is on the day of the transfiguration
So it will be for the rest of the year.

24 August, St Bartholomew's Day

Another of the original Apostles, Bartholomew preached in Mesopotamia, Persia, Egypt and Armenia. Finally, some time in the first century, he was flayed and crucified by Astyages, King of Armenia, and it was the method of his martyrdom that led to Bartholomew being adopted as patron saint of tanners.

If St Bartholomew be fine and clear
Then hope for a prosperous autumn that year.

This only applied if St Swithin's Day was dry; if wet, the following would apply:

All the tears St Swithin can cry,
St Bartholomew's mantle can wipe dry.
St Bartholomew brings the cold dew.

The evenings become noticeably chilly at this time of year, and in the mornings, the first dew may be seen on spiders' webs.

SEPTEMBER

The exuberance of harvest is mostly over by the end of the month. The temperature begins to drop; grass stops growing and insect activity diminishes. Soft-billed insect eaters – swallows, house martins and swifts – line up, shoulder to shoulder, on telegraph wires in preparation for the long journey home. Apple trees hang heavy with ripening fruit, leaves begin to turn, fungi appear, oak and beech trees shed their nuts. Winter is not far away.

1 September, St Giles' Day

An enchanting hermit, Giles (AD 650–710) lived in solitude deep in a forest near Nimes, sustained by the milk of a tame red deer hind. He was accidentally wounded by a huntsman pursuing the hind and so became known as the patron saint of cripples. He was also known as the patron saint of lepers and of the city of Edinburgh, where St Giles' Cathedral is a prominent landmark.

> *Fair on September first,*
> *Fair for the month.*

This prediction seems hardly likely, given the storms associated with the equinox later in the month (21 September).

14 September, Holy-Rood or Holy-Cross Day

Many churches in Britain were dedicted to the Holy Cross during the Middle Ages, but the one in Edinburgh is particularly well known because it became the nucleus of the palace of Scottish Kings.

> *If dry be the buck's horn on Holyrood morn,*
> *'Tis worth a kist of gold.*
> *But if wet it be seen by Holyrood e'en,*
> *Bad harvest is foretold.*
> *If the hart and the hind meet dry and part dry on Rood Day Fair,*
> *For six weeks, there'll be nae maen.*

These two predictions are obviously unique to Scotland, where the harvest takes place that much later in the month.

A tradition which persisted well into the eighteenth century was for the monarch to allow his huntsmen a deer each from the herds in Richmond Park. The fallow deer were in 'pride of grease' or fat from their summer grazing. The traditional period of the 'time of grease' was from Midsummer's Day until Holyrood Day.

> An entry from *The Gentleman's Magazine*, Tuesday 14 September 1731:
> 'It being Holy Rood Day, the king's huntsmen hunted their free buck
> in Richmond New Park with bloodhounds, according to custom.'

On the same day, 14 September, it was also traditional to start harvesting hazel nuts.

> *This day, they say, is called nutting day*
> *And all the youths are now a-nutting gone.*

The Devil goes a-nutting on Holyrood Day.

Nutting Day was one of the occasions, like May Day, when teenagers could escape the watchful eye of their parents. Unwanted pregnancies were the inevitable consequences and among the many myths and legends associated with the hazel bush was a superstition that the devil was abroad in the hazel groves on Nutting Day, particularly if it was a Sunday. On Sundays, he disguised himself as a charming and irresistible gentleman, who was entirely responsible for any accident that might occur among careless adolescents.

21 September, St Matthew's Day and the Autumn Equinox

Matthew the Evangelist (1 BC–AD 34) preached the gospel in Parthia and Ethiopia. He was martyred in the city of Nadabah by being beheaded with a halberd on the instructions of the King of Ethiopia.

By now the temperature will be dropping, the bees will have stopped working and the hours of daylight have become noticeably shorter:

St Matthew brings cold rain and dew.
St Matthew shuts up the bees.
St Matthew, get candle new,
St Matthew, lay candlestick by.

29 September, Michaelmas Day,
Feast of St Michael and St John (a quarter day)

According to legend, the Archangel Michael bore the banner of the celestial host that drove the angel Lucifer and his followers from heaven into hell, where they shall remain until Judgement Day.

Michaelmas Day was traditionally the day on which landlords entertained their tenants and, as a quarter day, held the annual rent audit. It also marked the termination of the year's service for the men and women engaged at hiring fairs the previous year, so the following day they would present themselves in the local market town to be hired for the next year.

As the wind is on St Michael's Day
So 'twill be for three months.

A fine Michaelmas sets all in a tune.

On Michaelmas Day, the Devil puts his foot on blackberries.

Blackberries are considered past their best by this time.

September, when by custom (right divine)
Geese are ordained to bleed at Michael's shrine.

This reference is to geese, having fattened off harvest gleanings, being ready to eat, for goose was traditionally eaten on Michaelmas Day. Elizabeth I was said to have been dining on a Michaelmas goose when she received news of the total defeat of the Spanish Armada.

THE CALENDAR OF WEATHER LORE

By the traditional calendar, the agricultural year started on the first of October. The harvest was over, the quarterly rent paid, harvest thanksgiving had been celebrated and now farmers looked onward to winter's challenge and the next year's harvest. Most of the weather lore for the following months was mainly long-term predictions and therefore pretty unreliable, but there are occasions when they prove to be accurate and it is fun trying to forecast the weather in the same way as our ancestors.

OCTOBER

A good October and a good blast,
To blow the hog, acorn and mast.

Fresh October brings the pheasant,
Then to gather nuts is pleasant.

Pheasants love beech mast (nuts) and acorns. A strong wind at this time of year would bring down a fall of nuts and acorns, drawing pheasants into woodland.

In October dung your field
And your land it's wealth will yield.

The quicker dung is spread, the longer it has to fertilise the ground.

If there is snow and frost in October,
January will be mild.

If the deer's coat is grey in October,
there will be a severe winter.

If the hare wears a thick coat in October,
then lay in a good stock of fuel.

If foxes bark much in October,
there will be a severe winter.

(This is more likely to be young dog foxes barking to establish individual territories than anything to do with the weather.)

In October, put on thy woollen smock.

NOVEMBER

No leaves, no birds – November.

If the November goose wishbone be thick,
so will the winter weather be;
If thin, likewise the winter weather.

Geese were fattened on harvest gleanings: a thick wishbone suggested the bird had fed well and a hard winter often follows a good summer. The reverse was true of a lean summer, which would be followed by a mild winter. There was also a belief that both domestic and wild animals could anticipate a bad winter and would feed hard through the summer months.

DECEMBER

December was an important month for divining weather for the rest of the year.

A green December fills the graveyard.

A warm December is invariably followed by a cold snap, which often catches the elderly unawares.

Snow at Christmas means a green Easter.
 And the opposite:
A green Christmas; snow at Easter.
 And, based on a warm summer
 following a hard winter:
A starry sky on Christmas Eve; good summer crops.

JANUARY

General weather predictions for the beginning of the month centre around mild weather and their consequences.

*If Janiveer's calends be summerly gay,
'Twill be winterly weather to the calends of May.*

*The grass that grows in Janiveer
Grows no more all year.*

*Janivier spring,
Worth nothing.*

These last two have stood the test of time because the earlier grass starts to grow, the poorer it will be later on.

FEBRUARY

Clear, mild weather at the beginning of February is a bad sign, as it presages more winter ahead.

*When a cat lies in the sun in February
She will creep behind the stove in March.*
 Or:
*Of all the months of the year
Curse a fair Fevrier.*

MARCH

Among general weather lore for the month are such sayings as:

A windy March foretells a fine May.

*A peck of March dust and a shower in May
Makes the corn green and the meadows all gay.*

*March dust to be sold
Worth a ransom in gold.*

A dry, cold March never begs its bread.

*March wind and April showers
Bring forth May flowers.*

*A March without water
Dowers the hind's daughter.*

This ancient saying refers to red deer hinds giving birth. Wild red deer tend to calve in May and a dry March foretells good weather.

*If March comes in with an adder's head
It goes out with a peacock's tail.*

Another old saying which means that if the month starts as cold and bare as an adder's head it will end with the colours of a peacock's tail, a variation on the famous assumption that if the month starts with weather roaring like a lion it will end as docile as a lamb:

*If March comes in like a lion
It goes out like a lamb.*
 The bad news is:
A wet March makes a sad harvest.

*So many mists in March,
So many frosts in May.*

*Better bitten by a snake
Than feel the sun in March.*

A final word from John Clare who, when he wasn't on the bottle or binned up in Nottingham Asylum for the Insane, wrote some lovely poetry:

*March, month of many weathers, wildly comes
In hail and snow and threatening floods and hums.*

Weatherlore 203

APRIL

April can be a splendidly contrary month, with weather ranging from sunshine to thunder and heavy rain; snow, fog and frost to mild, muggy and drizzly days. There is a host of weather lore pertinent to the many variables.

April wet, good wheat.

April and May, key to the whole year.

April cold and wet,
Fills barns yet.

April rain makes large sheaves.

A wet April brings both bread and wine.

All these imply that rain is wanted to germinate seed. However:

An April flood carries away the frog and her brood.

Frogs and their spawn being washed away.

And the cautionary:
'Til April's dead
Cast not a thread.

Advising people not to be fooled into packing away their winter clothes by warm weather – the month can easily turn cold again.

MAY

Optimistic weather lore begins in May:

Up merry Spring and up the merry ring,
For the summer is come unto day.
How happy are those little birds that merrily do sing
On the merry morning of May.
A swarm of bees in May makes a load of hay.

If the weather is warm enough for bees to swarm, there will be lots of honey. Until the eighteenth century, honey was, for many people, the only available sweetener and was considered a very valuable commodity.

Flowers in May,
Good cocks of hay.

When the mulberry tree begins to shoot,
The last frost has gone.

Mist in May, heat in June,
Makes the harvest come right soon.

A leaky May and a dry June,
Puts the harvest all in a tune.

Rain in May makes bread for the whole year.

He who would live for aye,
Must eat sage in May.

Sage, *Salvia officinalis,* was the medieval cure-all; it was particularly recommended as a general tonic and to help barren women conceive. New growth of this herb appears in early May.

Less optimistic weather lore includes:

Be sure of hay 'til the end of May.

Cast not a clout 'til May is out.

Who doffs his coat on a winter's day,
Will gladly put it on in May.

Shear your sheep in May,
Shear them all away.

Button the chin till May be in.

204 ✕ *A Book of Britain*

JUNE

*A swarm of bees in June
Is worth a silver spoon.*

Bees in June are still valuable in terms of honey production, but less so than a swarm in May.

June damp does the farmer no harm.

*If there are thunderstorms in June,
There will be a plump harvest.*

Thunder would indicate that a period of hot dry weather was going to be broken and rain would follow.

A good summer brings a hard winter.

If the cuckoo delays changing his tune until mid June, St Swithin's Day will be wet.

*June; half-prinked with spring,
With summer half embrowned.*

JULY

*If the first of July be rainy weather
'Twill rain for full four weeks together.*

*A shower in July when the corn begins to fill
Is worth a plough of oxen and all that belongs there still.*

*A swarm of bees in July
Is not worth a fly.*

*If the dog days be clear,
It will be fine all year.*

*If ant hills are high in July
Winter will be snowy.*

AUGUST

August often has some of the hottest days of the summer and is the most important month for grain ripening. Until Henry VIII broke with the Church of Rome in 1540, farmers made bread from the first wheat crop on Lammas Day to be used at a special communion service of thanksgiving.

A dry autumn and warm doth the harvest no harm.

*If the first week of August be warm,
the winter will be white and long.*

SEPTEMBER

*If acorns abound in September,
Snow will be deep in December.*

This promotes the misconception that a profusion of nuts and berries indicate a hard winter. In actuality, a glut is likely to have been the result of an early spring and a dry summer rather than foretelling future weather.

September dries up wells and breaks down bridges.

*September blow soft,
'Til the fruit is in the loft.*

This comes from an old prayer that the Equinoxal gales will not arrive before the orchards have been picked.

THE ANCIENT ART OF READING THE WEATHER

If Jim Akehurst and his generation of countryman used the saints' days of prediction and the old proverbs as a calendar around which to build the fabric of their lives, they relied upon nature to provide them with immediate, localised weather forecasts on a day-to-day basis. When Jim left his home in the early morning, he would instinctively look upwards and 'read the sky' in exactly the same way as his Neolithic ancestor would have done.

Weather indicators, such as the colour of the sky, cloud formation, wind direction, scent, trees, plants, behaviour of animals, birds and insects, are as consistently trustworthy today as they have been for countless generations. This information is depended upon by farmers, fishermen, gamekeepers, stalkers, hunt servants – in fact anyone whose lives are spent close to nature – but it is, of course, available to everyone. All they have to do is be observant and read the signs.

WINDS

The direction in which the wind is blowing is one of the first signs a countryman looks for in the morning; he may deduce this from the movement of clouds, by pulling up a little grass and throwing it up into the air, or from the way the tree tops are bending. Jim would look towards the weather vane, shaped like a running fox, on the clock tower of the stable block, or to the weathercock on the church spire.

An indication of how important the knowledge of wind direction was in the Middle Ages is reflected in one of the images in the eleventh-century Bayeux Tapestry, which depicts an artisan erecting a weathercock on the spire of Westminster Abbey.

WEATHER VANES

Weather vanes – the word comes from the Saxon *fane,* meaning flag – have been in use since antiquity. Perhaps the earliest recorded is the one that adorned the Tower of Winds in Athens, built in the 1 BC. As Christianity spread across Europe, weather vanes began to be erected on the top of church spires for the benefit of the community. Cockerels became the universal motif after a ninth-century papal edict commanded that every church in Christendom must be adorned with a cockerel, to remind Christians of their duty of worship and not to betray Christ as St Peter had done. (From Christ's prediction at the Last Supper: 'I tell thee, Peter, the cock shall not crow this day, before that thou shall thrice deny that thou knowest me.') Although not originally intended as weather vanes, cockerels soon replaced those that already existed.

A Book of Britain

The first poem about wind to be printed in Britain was written by the farmer-poet, Thomas Tusser, published by Richard Tottel in 1557.

North Winds send hail, South Winds bring rain
East Winds bewail, West Winds blow amain
North-East is too cold, South-East not too warm,
North-West is too bold, South-West doth no harm.

The North is a noyer to grass of all suites,
The East is a destroyer to herd and all fruits;
The South, with his showers, refreshes all corn,
The West, to all flowers may not be foreborne.

The West, as a father, all goodness doth bring,
The East, a forebearer no manner of thing;
The South, as unkind, draweth sickness too near,
The North, as a friend, maketh all again clear.

With temperate wind, we be blessed of God,
With tempest we find we are beat with his rod;
All power, we know, to remain in his hand,
However wind blow, by sea or by land.

Though winds do rage, as winds were wood,
And cause spring tide to raise great flood,
And lofty ships leave anchor in mud,
Bereaving many of life and of blood;
Yet true it is as cow chews the cud,
And trees, at Spring to yield forth bud,
Except wind stands, as never it stood,
It is an ill wind turns none to good.

THOMAS TUSSER, 'Description of the Properties of Winds at All Times of the Year'

The vagaries of wind and its consequences are as significant today as they were to Tusser in sixteenth-century England. As a general rule, the prevailing wind in this country is from the west, and westerly winds usually predict temperate weather. This fisherman's proverb covers all permutations of wind direction and their predictions:

When the wind is blowing in the North,
No fisherman should set forth,
When the wind is blowing in the East,
'Tis not fit for man nor beast,
When the wind is blowing in the South
It brings the food over the fish's mouth,
When the wind is blowing in the West,
That is when the fishing's best!

Northerly and easterly winds are associated with low atmospheric pressure and signify bad weather. Wind circulates clockwise round a high-pressure cell and counter-clockwise round a low one. If the wind is out of the east, it indicates that a 'high' front from the west has just moved on or is passing to the north. Low pressure follows high with the same monotony as night following day, since highs and lows invariably alternate in progression. With the approach of a low weather front, the east wind picks up and becomes gusty. Known as the 'lazy wind', because it blows straight through you, easterlies are unpleasantly hot, dry and dusty in summer, and bitterly cold in winter. The north winds, which follow a low weather front, are cold, blustery and, from a sailor's point of view, always produce heavy, possibly dangerous seas. Westerly winds generally suggest milder weather, while a southerly in summer often brings humidity and rain: *'A wind from the south, has rain in her mouth.'* This would explain the allusion to fish feeding in the proverb above, as insects would fly closer to the surface of the water in warm, damp weather.

No weather is ill, if the wind be still.

Still, cloudless summer days are a sign of a dominant high-pressure cell; they can also signify the approach of a thunderstorm – the calm before the storm – as high pressure in the west sucks up surface wind before it can arrive locally. This type of storm, with its army of great towering clouds, threatening thunder, lightning and heavy rain, can easily be seen banking up to the west.

When the wind backs and the weather glass falls,
Prepare yourself for gales and squalls.

A backing wind is one that starts in the west and changes direction counter-clockwise to the east or south-east, heralding the approach of a low-pressure cell and lousy weather.

THE IMPACT OF ATMOSPHERIC PRESSURE

When the glass falls low, prepare for the low.
When it rises high, let your kite fly.

A 'weather glass', sometimes known as a 'thunder glass', was an early form of barometer for measuring atmospheric pressure. Variations in air pressure can predict short-term changes in the weather: 'Decreasing atmospheric pressure predicts stormy weather.'

Mercury barometers have been used in weather forecasting since the seventeenth century, and at one time nearly every household had one. I remember the barometer made by Negretti and Zambra, instrument-makers to HM Queen Victoria, which stood in our hall when I was a child. It was a long glass tube containing a reservoir of mercury at the bottom, set in a tall wooden case. High pressure forced the mercury up the tube and low pressure reduced it. Weather predictions corresponding to the height of the mercury were engraved into the wooden casing beside the glass tube. Whenever my father left the house he would tap the tube to check that the mercury had adjusted correctly; Jim, lacking anything so sophisticated, would rely on his nose to tell him whether pressure was high or low, as many country people still do today.

When ditch and pond affect the nose,
Look out for rain and stormy blows.

High pressure, and the associated good weather, tends to hold scent and smells to the ground or their source, whereas low atmospheric pressure releases them, so previously suppressed odours become very apparent. Walking across marshy ground is a classic example of this theory at work: the reek of rotting vegetation is very apparent just before a shower, and so too is the reek from a cesspit or a piggery. By way of compensation, until it disappears as the temperature drops with the approach of rain, the summer scent of blossom or new mown grass is gloriously enhanced by warm, humid air.

Weatherlore ⚹ 211

A coming storm your shooting corns presage,
And aches will throb; your hollow tooth will rage.
 And:
The approaching storm makes an old man's back ache.

This is all too painfully true. Historic injuries, such as broken bones, become sensitive as a low pressure approaches; toothache will become more acute, and those with rheumatism suffer more than usual. Like many country people in the fifties, Joe Botting, our gardener, was a victim of the 'screws', as he called rheumatism. Years of working outside in all weathers without adequate protective clothing caught up with him in middle age and winters were a misery. A warm summer brought some relief, but only served to make the 'screws' all the more excruciating when they returned with a low-pressure front.

Medical research undertaken to discover a possible explanation as to why some people experience pain during low atmospheric pressure suggests that tissue expands and blood vessels become dilated, exacerbating already sensitive nerve ends near old injuries, sore teeth or arthritic joints. The same will be true for those, like me, who suffer from headaches, dizziness and a ringing in the ears before thunder or a fall of snow.

When birds fly low,
Expect rain and a blow.

When the atmospheric pressure is low, signifying bad weather, birds find flying requires more effort because the air is thinner. During a high-pressure cell, when air is denser, it is much easier for them to fly at a higher altitude, and in summer there are also likely to be warm thermals on which they can soar.

NATURE'S WEATHER MESSAGES

In by day, out by night.

This pragmatic little statement refers to the diurnal change between sea breezes blowing inland during the day and land breezes blowing out to sea through the night.

Fog, humidity, the colour of the sky and cloud formation all play a large part in reading Nature's weather signs.

A summer fog for fair,
A winter fog for rain,
A fact most everywhere,
In valley or in plain.

In summer, fog is caused by temperatures falling to what is known as the 'dew point' – when humidity rises to 100 per cent. This occurs on clear, calm summer nights when excess heat is dissipated into the sky. A cloudy sky acts like a blanket, holding in the heat of the day, and so the dew point won't be reached. If the sky is clear and cool enough for there to be an early morning mist or dew on the ground, a clear sunny day will inevitably follow.

When dew is on the grass,
Rain will never come to pass.
When grass is dry at morning light,
Look for rain before the night.

If grass is dry in the morning it means there is either a strong breeze or an overcast sky, both of which could signify approaching rain.

Evening red and morning grey,
Two sure signs of one fine day.

A red sunset may be the result of sun shining through dust particles in a clear western sky. A grey morning might mean an early fog, which would clear away as the sun rose, or be because weather systems move from west to east, and because clouds have already passed by overnight and are now in the east.

An evening grey and a morning red
Will send the shepherd wet to bed.

This means that rain clouds seen building up on the western horizon in the evening have yet to reach you.

Winter fog, on the other hand, is caused by warm, moisture-laden air being blown over a cold surface. Air is more humid above the sea or a large body of water than above land. Ice-fog, so treacherous to drivers, forms when the temperature falls substantially below freezing. The Tweed Valley near my farm is spectacularly beautiful under these conditions, when freezing mist from the River Tweed smothers trees, hedgerows and telegraph wires, leaving them sparkling in the winter sunlight. In urban areas, freezing fog is thickened by vapour from traffic emissions, household fires and factory pollutants.

When sound travels far and wide,
A stormy day will betide.

Moisture-laden air is a better conductor of sound than dry air, and moist, summer air carries sound further. In winter, however, temperature contradicts this saying. Mild, damp winter air will carry sound in the same way as it does in summer, but a very cold, frosty day will carry sound better than either, as air becomes dense in extreme cold weather.

Red sky at night, a shepherd's delight,
Red sky in the morning, a shepherd's warning.

The sky appears blue on a clear day when the sun is high because it has only a short distance to travel through the atmosphere. At sunset and dawn, rays from a low sun have much further to travel, encountering dense atmosphere and many more particles of dust. These fragment and scatter the longer-wavelength red end of the light spectrum, creating a glorious pageantry of crimson colours as the sun sets. This suggests that the western sky is clear for hundreds of miles over the western horizon and that there is no immediate risk of an approaching frontal system bringing rain.

Fine weather often falls between two low weather systems, particularly in summer. Because the sun rises in the east, a red sky at daybreak often suggests that the high is moving away eastwards and that sunlight is illuminating the undersides of rain clouds moving in from the west.

Like a red morn that ever yet betokened
Wreck to the seaman, tempest to the field,
Sorrow to the shepherds, woe unto the birds,
Gusts and foul flaws to herdmen and to herds.

Rainbows always occur in the part of the sky that is opposite the sun. A rainbow in the morning is caused by rays from the sun rising in the east, then striking and refracting (bending) through moisture droplets in westerly rain clouds. Most rain comes from the west, so a rainbow in that direction means rain is on the way. Equally, a rainbow arching across an easterly evening sky indicates that rain has passed through.

Rainbow in the morning, shepherds take warning,
Rainbow at night, shepherds delight.

Halos around the sun or moon are created by light refracting through the crystals that form high-level cirrus and cirrostratus ice clouds – distant fibrous wisps or gossamer-thin smears of cloud. These clouds do not physically produce bad weather themselves, but they are often the harbingers of a storm system, with cold weather to follow.

If a circle forms around the moon,
'Twill rain soon.
 And:
When halo rings the moon or sun,
Rain's approaching on the run.

The colour and height of clouds are strong weather indicators; the mood of the weather is clearly visible across the sky and the ever-changing picture that clouds create is one of the wonders of nature. Low-level cumulus clouds, looking like balls of cotton wool moving lazily across a clear blue summer sky, are the epitome of benign weather. Dirty grey, medium-level nimbostratus clouds, streaked with black and trailing in places down towards the ground, are the exact opposite.

Trace in the sky the painter's brush,
The winds around you will soon rush.

When clouds look like black smoke,
A wise man puts on his cloak.
 And:
When we see cloud rise out of the west,
Straightway ye say: There cometh shower
And so it is.
Luke, Chapter 12

Clouds are created when air rises to a level where moisture in the air condenses. The higher air rises before condensation starts to take place, the drier it was to start with.

The higher the clouds, the finer the weather.

Clouds that form into a massive area, towering high into the sky like a great jumble of rocks, brilliantly white where sunlight strikes the tops and black along their ragged base, are known as cumulonimbus clouds. These are the vehicles for thunder, lightning and very heavy rain showers after a period of hot summer days. In the winter, they can bring rain, hail or snow.

When clouds appear like rocks and towers,
The earth will be washed by frequent showers.

I love the fury and pageantry of thunder and lightning, and can well imagine the effect on superstitious minds, such as the image of the Celtic god, Thor, raging across the night sky and lashing about in a fury with his hammer. It is, of course, dangerous to shelter near tall trees in a thunderstorm, particularly oaks; oak and ash trees grow well where there is a seam of iron ore, and this seems to draw lightning.

Beware the oak,
It draws the stroke;
Avoid the ash,
It draws the flash;
But under the thorn
You'll come to no harm.

Wisps of cirrus ice cloud, trailing high in the sky, sometimes resemble horses' tails or manes. Although they do not carry bad weather themselves, they are the precursor of an approaching storm front that will arrive in about a day and a half.

Horses' manes and mares' tails,
Sailors soon shall shorten sails.

Medium-level altocumulus clouds sprawling across the sky, like a mass of broken sheep's wool or the silver scales of a mackerel, are an impressive sight, particularly when blue sky shows through the gaps and the edges glow iridescent yellow in the thin evening light. As with cirrus clouds, altocumuli do not bring a storm, but act as a warning that one will follow in about 36 hours. Cirrus and altocumulus clouds are often seen close together.

> *Mares' tails and mackerel scales*
> *Make tall ships carry small sails.*
> And:
> *A dappled sky, like a painted woman,*
> *Soon changes its face.*

Jets leaving long white plumes, known as contrails or distrails, indicate rain or snow if they hang in the sky. The trail is caused by the aircraft sucking in moisture-laden air, then expelling it as a hot vapour that freezes. If a jet trail lasts only a short time, the air at that level is dry and good weather can be expected.

The sky at night can often be a gauge of what the weather will hold the following day. If the first thing Jim did in the morning was to look to the sky, it was also the last thing he did at night. Light from the sun, moon and stars is reddened or dimmed by moisture in the atmosphere. Moisture and cloud cover hold in the earth's heat like a blanket: less moisture in the atmosphere makes the moon and stars more visible and the temperature colder. A clear, starry, cloudless sky means the next day will be fine.

> *Clear moon, frost soon*
> And:
> *Clear is the night, when the stars shine bright.*

When the atmosphere is loaded with dust particles, moonlight shining through them makes the moon appear pale yellow or a reddish colour, like the Fruit, Grain or Harvest Moons at the end of a hot summer. If the atmosphere is clear, the moon appears white. Raindrops cannot take on a shape unless they have a condensation nucleus to form around, such as an ice crystal or a dust particle. The more dust there is in the atmosphere, the greater the likelihood of moisture-forming raindrops.

> *Therefore the moon, the governor of the floods;*
> *Pale in her anger, washes all the air,*
> *that rheumatic fevers do abound.*
> SHAKESPEARE, *A Midsummer Night's Dream (Act II, Scene I)*
> And:
> *Pale moon rains: red moon blows.*
> *White moon neither rains or snows.*
> And:
> *If the moon's face is red,*
> *There's water ahead.*

If the old moon can be seen as a faint golden outline behind a new moon, a phenomenon caused by light from earth being reflected back to the moon – 'earthshine' – bad weather can be expected.

> *Late, late, yester ev'n I saw the new Moon*
> *Wi' the old Moon on her arm,*
> *And I fear, I fear, my dear master*
> *That we shall come to harm.*

UNRAVELLING CLUES TO THE WEATHER

Interpreting the effect of atmospheric pressure on a variety of objects is another way of anticipating short-term movements in weather patterns. Jim Akehurst always kept a pinecone in the harness room; in dry weather the pinecone opened and most of the scales stood out at right angles; as humidity rose, and the likelihood of rain increased, the pinecone absorbed the moisture and re-formed into its original, tightly packed shape. Human hair, particularly if it is curly or has been curled, is affected by low atmospheric pressure and the attendant rise in humidity. My grandmother used to go to London once a month and have her hair set in what were known as Marcel Waves, a laborious process which seemed to take most of the day. The whole effect could be ruined by a low-pressure cell:

> *I know ladies by the score*
> *Whose hair foretells a storm;*
> *Long before it begins to pour*
> *Their curls take a drooping form.*

Wooden chairs that squeak when they are sat on, salt and sugar clogging, doors and windows that suddenly swell and become difficult to open or close; these are all signs of moisture being absorbed as low atmospheric pressure and high humidity presage rain.

> *If chairs squeak*
> *It is of rain they speak.*
> And:
> *If salt is sticky and gains in weight*
> *It will rain before too late.*
> And:
> *When windows won't open,*
> *And salt clogs the shaker,*
> *The weather will favour*
> *The umbrella maker.*

The way in which smoke disperses is also a precursor of rain. Sometimes, smoke from the village a few miles below the farm rises almost straight into the sky. At other times it lies like mist all along the valley and the acrid smell of coal fires hangs in the air. Smoke particles absorb humidity and heavy, moisture-laden smoke cannot disperse in the same way that it would if the atmosphere were dry.

> *If smoke lies near to the ground,*
> *Rain will soon abound.*

Animals, birds, insects and certain plants, collectively or individually, give considerable information about the weather to those of us who have been shown how to recognise changes in their behaviour. They are all very sensitive to subtle movements in atmospheric pressure, which cause some degree of discomfort or stress anxiety.

Weatherlore

As a hill farmer I 'look' my sheep twice a day and easily notice any variation in normal flocking behaviour. Hill sheep always move to high ground in the afternoon, spending the night on the tops. By day, they graze slowly down to the more palatable herbage on lower ground, before starting their return journey. This is known as a sheep's natural 'rake', and in the mornings I go round all the high ground, and in the afternoon all the bottoms. A ewe hanging back when all the others are moving either up or down immediately tells me that there is something amiss: either she is ill or perhaps has lost her lamb. If the whole flock move quickly down to the low ground on a winter's morning, or are reluctant to move to high ground in the afternoon, I know there is a snow storm on its way, long before the bands of grey-black nimbostratus clouds with their sinister, ragged green edges start covering the sky.

> IF THE WHOLE FLOCK MOVE QUICKLY DOWN TO LOW GROUND ON A WINTER'S MORNING, OR ARE RELUCTANT TO MOVE TO HIGH GROUND IN THE AFTERNOON, I KNOW THERE IS A SNOW STORM ON ITS WAY, LONG BEFORE THE BANDS OF GREY-BLACK NIMBOSTRATUS CLOUDS START COVERING THE SKY.

A hill sheep's primary interest is food intake for survival and to maintain the body condition necessary to produce and rear a lamb. Their grazing pattern, as they move up and down hill, follows a fairly sedate, matronly routine. From time to time they lie down to digest what they have eaten, calling out a grumpy warning to their lambs not to play too far away. When a low-pressure front is approaching, they become flighty and distracted, shifting about in a manner that is clearly unsettled.

In the spring and summer, lambs and other young animals – calves, colts and piglets – seem particularly sensitive to climatic change, often performing a series of jumps or rolling on their backs, as if they were trying to shake off an irritating sensation. All animals, whether wild or domesticated, respond badly to low pressure and the threat implied by the change in atmosphere: cattle bellow and gambol about when they would otherwise be grazing; donkeys shake their ears and bray more than usual; horses become restless and easily spooked. If the carthorses were difficult to handle, Jim would say, 'there's a change a-coming'.

At one time, most agricultural workers kept a pig. A piglet was bought in the autumn and fattened until the following winter, when it would be killed and made into bacon, the staple rural diet. The baconer's well-being was of enormous concern to its owner; a contented pig was a pig putting on weight, and growth progress was carefully monitored. When a pig lies happily in its wallow, no rain can be expected, but if the pig starts carrying more bedding into its sty, it is a certain sign of an impending drop in temperature. Animals hate wind and pigs, with their huge ears, especially dislike it. When a pig runs about, throwing up its head with a peculiar jerking motion and squealing, strong winds are on the way. Hence the West-country proverb, 'Pigs can see the wind.'

When pigs carry sticks,
the clouds will play tricks;
When they lie in the mud,
No fears of a flood.

Wild animals always feed with their backs to the wind, an inherent form of self-preservation that is shared by domestic stock. If a predator approaches from behind, the wind will carry their scent to the grazing animal, immediately alerting it to danger. Good weather generally approaches from the west and bad from the east, therefore:

> *A cow with its tail to the west*
> *Makes weather the best.*
> *A cow with its tail to the east*
> *Makes weather the least.*

Household cats, because of their proximity to humans, are good weather meters. As humidity lowers with the approach of dry weather, static electricity builds up on their fur. Many cats dislike being stroked when air humidity is low, as this can create small, irritating electric discharges. When a cat assiduously licks itself, it is moistening its fur to make it more conductive and allow static electricity to 'leak' away, preventing build-up. To a lesser degree, cattle and horses do the same thing.

> *If a cat washes itself o'er it's ear,*
> *'Tis a sign the weather will be fine and clear.*

Dogs and cats become torpid and dull as a low-pressure system approaches. Cats become fractious and restless, often chasing their tails and dashing around in an irrational manner. It is a well-known fact that both cats and dogs eat grass to make themselves vomit when they are suffering from gastrointestinal distress. I don't keep a cat, but my experience of working dogs over many years has led me to believe that dogs also eat grass as a low-pressure front looms. They seem to do this as soon as they are let out of kennels and I have always assumed that this induced vomiting is a means of shaking off the lethargy associated with heavy atmospheric pressure.

Mole catchers will tell you that moles abandoning fields and moving into damp woodland, where worms will be working nearer the surface, warns of a drought. As spring and the breeding season approaches, moles extend their underground galleries: when they start pushing earth through frozen ground in February, a thaw can be expected, because grubs and worms start moving towards the surface as ground temperature rises.

Domestic fowl become very disturbed when the weather is about to change for the worse. Cockerels, which normally crow at midnight, at about three in the morning and at dawn, will instead crow distractedly at intervals throughout the day. Ducks and geese become unusually vocal and frequently beat their wings. Chickens loathe rain, working themselves into a state of agitation as it approaches, shaking their pinions and flocking together. Hence the expression, 'As mad as a wet hen', and when they roost early, rain is imminent.

A couple of years ago, a peahen appeared in our garden, blown to us during a storm, from I know not where. This magnificent but lonely creature becomes excessively noisy and retreats shrieking to its perch in an oak tree just before a fall of rain.

When the peacock loudly bawls,
Soon we'll have both rain and squalls.
 And:
If the cock goes a crowing to bed,
He will rise with a watery head.
 And:
When chickens go to roost by day,
Expect the wet is on its way.
 And:
When chickens scratch together,
There's sure to be foul weather.

LEARNING FROM WILDLIFE

It is the manner in which wildlife reacts to fluctuations in our climate and the clues to weather forecasting which Nature, in her generosity, provides to the observant, that have always fascinated me.

Birds can teach us an enormous amount about the weather throughout the year is and the arrival of spring migrants – cuckoos, swallows, swifts, house martins and nightingales – is always eagerly awaited. In the days when the rural economy and people's survival were much more directly connected to the seasons, the coming of spring and timing of new growth were of vital importance. Early people believed cuckoos brought the spring, and once the first mating call had been heard, everything would burst into life. Even today, the arrival of the cuckoo has lost none of its significance and the date and place where the cock bird's song is heard is religiously reported annually in *The Times*.

Summer is icumen in,
Llude sing, cuccu!
Groweth sede and bloweth med
And springth the wude nu.
Sing, cuccu.

Summer is a-coming in,
Loudly sing, cuckoo!
Grows the seed and blooms the meadow
And the woods spring new.
Sing, cuckoo! (Chorus)

This was a very popular ditty in the early thirteenth century. During the Middle Ages it was the custom in various parts of Britain to give workers the day off when the first cuckoo of the year was heard. Cuckoo Day was celebrated by the drinking of 'cuckoo ale', accompanied by many renderings of this little sonnet.

The cuckoo's summer migration from Africa and up through Europe is carefully recorded. Traditionally, the bird is first heard in the south of France in the middle of March and reaches Sussex and Kent on 14 April. Cuckoos should then spread quickly across Britain, reaching Yorkshire by 21 April and the Scottish Borders by 24 April, where I am listening anxiously. In actuality, cuckoos can arrive as early as March, predicting a warm spring, or as late as May, by which time we are all aware that spring has been a disaster. Swallows, martins and nightingales all follow cuckoos in a matter of days, with swifts making their appearance a week or two later. The date that any of these birds turn up depends, crucially, on confidence that the temperature at their destination will be consistently warm enough to provide the source of insects on which they all feed. As swallows, swifts and house martins nest on buildings, their spectacular, aerobatic flight is very visible and their response to changing weather patterns easily noticeable.

When swallows fly high,
The weather will be dry.

Swallows swooping and twittering round tree tops or the roofs of buildings on sunny days are feeding on insects carried there by thermals. When they fly high in the evening it is likely that the following day will be fair. This is also true of bats.

Low fly the swallow,
Rain will follow.

As high pressure moves on and bad weather approaches, air density decreases and humidity builds up. Humidity has a mass that is less than dry air, and as it increases the mixture of air and water vapour becomes thinner. Birds can cope with this but insects, without the benefit of thermals to help them aloft and with the added weight of moisture on their wings, are forced to fly lower. Pied wagtails, those dainty, delicate little birds with their rapid, undulating flight, are said to be beckoning in the rain when seen on the ground with their long tails frenetically dipping backwards and forwards. Pied wagtails are ground feeders anyway, but when they are particularly active they occasionally flutter into the air to grab at insects flying near the ground, which suggests an approaching low-pressure front.

Flying insects of all sorts, particularly biting ones such as gnats, mosquitoes and horse flies, become more of an irritation before rain. Humans become a convenient target on humid days when insects find flying difficult: heat makes us sweat and odours are released when atmospheric pressure on the body lowers, creating a combination that flies and other insects find irresistible. When the dreaded midge dances up and down vortices in the beams of a setting sun, it will be sunny the following day. If they gather under trees and bite more than usual, it will surely rain.

Lazy fly,
Rain is nigh.
 And:
When eager bites the thirsty flea,
Clouds and rain you'll surely see.

Birds flying high is generally a pretty dependable sign of good weather. When ravens (once a bird of the north-west and the Highlands and now spreading rapidly throughout Britain) circle at a great height in the morning, croaking, a fine day is guaranteed. The further rooks and jackdaws fly from their roosts and the longer they are returning, the finer the next day, and likewise if skylarks are particularly vocal, the weather will stay good. Seagulls flying inland, though, were once considered a sure sign that a storm was on its way. Sea birds are particularly sensitive to barometric pressure, and for creatures that prefer to roost on water, the advent of high winds and broken seas is deeply distressing. With the development of reservoirs and sewage works, thousands of black-headed gulls are now breeding inland and this piece of weather lore only holds true if you live near the coast.

Seagull, seagull, sit on the sand,
There's never fine weather when you're on land.

When kestrels, sometimes known as the windhovers or mouse falcons, hover near the ground in the afternoon, it is an indication of impending rain, as they will be fretfully hunting for voles and mice before the weather breaks. Kestrels rely on absolute stealth to hunt small mammals for whom, being endowed with exceptional hearing, the rustling of damp feathers is more than enough to alert their prey to danger.

The same is true of barn owls. A barn owl's plumage has the exquisite texture of silk, which enables them to hunt at night in complete silence. Once this becomes wet, however, the camouflage is completely negated. After a period of prolonged rain, barn owls can be seen hunting by day, indicating their desperation for food and confirming a break in the weather. Occasionally, one might be seen by day before the arrival of bad weather, signifying that when rain does come it is likely to last for some time. Assuming nothing else has disturbed them, a heavy shower can be expected if a flock of feeding pigeons suddenly take to the air and fly back to their roosts. Pheasants are equally dependable when they roost late and come down early; it foretells that it will be a fine day. If they go noisily to perch early in the afternoon or are late down, it indicates that low pressure is building up.

Garden and park birds are good at advertising a change in the weather: mistle thrushes or storm cocks become positively energised at the approach of really foul weather. If they sing defiantly 'more rain, more rain' when facing into the wind, a severe low front is coming from that direction. Mistle thrushes are the only birds that will sing happily through a raging winter storm.

When the storm cock sings,
Facing the wind,
Harsh weather he'll surely bring.

Our national bird, the cock robin, who sings his plaintive, warbling song vociferously throughout the year (except when he moults in July), is a faithful little weather forecaster. If he sings from the top of a bush it is a good sign, but if he sings from within the bush, prepare for rain. The same may be said for a number of birds, particularly blackbirds.

Jim Akehurst believed that when an ouzel cock (as he called blackbirds) sang with its tail pointing straight down inside a bush, it would soon rain.

If the ouzel sing with its tail down,
'Tis waiting to shed rain, soon to abound.

The maniacal laughing cry of a green woodpecker, or 'yaffle', has been associated with approaching rain since antiquity. The Druids revered yaffles because they fed on sacred oaks, and they held them in high regard as weather prophets. This belief was still popular many hundreds of years later when John Aubrey, the eighteenth-century diarist, observed: 'The country people doe divine of raine by their cry.' Low atmospheric pressure, indicative of rain, would certainly make the woodpecker's call much more audible.

When the woodpecker cries, rain will follow.

Beautiful great spotted woodpeckers, with their grey and red plumage, were nearly extinct in northern England and Scotland a hundred years ago, but they are now the most widespread of British woodpeckers, regularly seen in city parks and suburban gardens. Great spotted woodpeckers communicate by tapping on a dead branch, making a far louder, more resonant sound than the one made when they are feeding. This hollow drumming sound is sometimes heard during the 'false spring' of mid-winter and proclaims good weather, if only for a short time.

When the woodpecker pecks low on the tree
Expect fine weather.

A bird table in the winter, when natural food is in short supply, can be a fascinating medium for forecasting the weather. When common garden birds – robins, house sparrows, blue tits, great tits, green finches and chaffinches – are joined at the bird table by farm or woodland birds – bullfinches, goldfinches, siskins, greater spotted woodpeckers and nuthatches – in a frenzy of feeding, very cold weather is not far off.

The departure of summer migrants does not foretell a hard winter; adult cuckoos tend to leave for home towards the end of July or beginning of August, nightingales and swifts follow in the middle of the month, young cuckoos start the long flight to Africa in the middle of September, and martins and swallows start clustering in pre-migration roosts at the end of the month and are gone by the first week of October – the early or late timing of their going depends on the degree of remaining insect activity.

The early or late arrival of the first winter migrants from northern Europe, the Baltic, Scandinavia and the sub-Arctic is indicative of a good or bad winter. Skeins of pink-footed geese from Greenland, Iceland and Spitzbergen start appearing in the north of Scotland in the middle of September, gradually moving down to the Wash. If great armadas of them arrive early and move quickly to East Anglia, conditions will have been very harsh on the Arctic fringe and must be assumed to be moving south. The same is true of the other migrant geese – brents, bean, barnacle, greylag and whitefronts. Snipe, woodcock and other long-billed migrant waders move south with the October moon as soon as the temperature in their summer homes makes the ground too hard to probe for food. When rafts of wigeon, shoveller, pochard, pintail, goldeneye and teal materialise early on our estuaries in large numbers, they are leaving dirty weather behind.

Arctic thrushes – fieldfares and redwings – are heralds of a cold winter. As the temperature drops, flocks of both these migrants from Scandinavia and northern Russia can be seen squabbling for feed on rough pasture, heaths, marshes and open woodlands. If cold persists and hunger increases they move to arable farmland, parks and even large gardens.

> *... flocking fieldfares, speckled like the thrush,*
> *Picking the berry from the hawthorn bush;*
> *That come and go on Winter's chilling wing*
> *And seem to share no sympathy with Spring.*
> JOHN CLARE, 'The Shepherd's Calendar' (1793–1864)

Every few years, a mass invasion of waxwings descend on us from Siberia. A 'waxwing winter' occurs when freezing conditions cause the 'snowbird's' favourite food source of rowan berries to become exhausted, forcing them to venture further afield for food. By the time they arrive, our winter will be fairly advanced and most hedgerow berries have already been eaten. Very often, the first warning we have of impending bitter weather is flocks of these little birds appearing in urban parks and gardens, hungrily stripping berries from ornamental trees and bushes.

LEARNING FROM OUR INSIGHTFUL INSECTS

Old weather lore claims that frogs croak before rain, but this only holds true in the spring when they are mating. There is also a belief that frogs foretell a wet spring by laying spawn near the edge of a pond, and a dry one by spawning near the middle. When toads are seen hunting on a summer's evening, low atmospheric pressure and increased humidity have brought an abundance of insect life within range of their long, sticky tongues and rain is on its way.

At dusk, the squalid toad was seen,
Hopping and crawling o'er the green.

Bees, ants and spiders are our most intelligent insects and their behaviour is absolutely dependable in forecasting the weather: when ants or pismires, as they were once called, bustle about in a state of agitation, rain is on the way. Introducing moisture and humidity into a colony would be catastrophic and you will never see an ant out of its nest during rain. The entrances to anthills are worth noticing; if they are open, the weather will be fine; if closed, expect rain. Ants on the move, lugging their eggs and bits of leaf with them, are relocating from low to high ground ahead of floodwater.

Swift moves the ant as the mercury rises.

Bees will only swarm if they are entirely confident the weather is going to remain settled and dry, or will leave their hive if it is going to rain.

When bees to distance wing their flight,
Days are warm and skies are bright.
But when their flight ends near their home,
Stormy weather is sure to come.

The banks of streams are favourite places for wasp and hornet nests. If they build their nest low on a bank it indicates a dry summer; if high, floods are to be expected through the season. Observing how and when spiders weave their webs can be a useful weather barometer: high winds can destroy a web, and before a gale spiders can be seen shortening and strengthening their webs. When the frame lines are short and stout, a spider's instinct has warned it that blustery weather is fast approaching, whilst long slender frame lines are a very reliable sign of a calm, clear day. A web needs constant attention and is often replaced every twenty-four hours. If a spider is seen working on its web on a summer's evening, there will be no rain that night and one seen at work in the early morning means the rest of the day will be fine.

When spiders weave their webs by noon,
Fine weather is coming soon.

On hot summer evenings in the south, hedgerows come alive with the cheerful, chirping, mating song of male crickets. The hotter the day, the more frequent the chirp and the greater the likelihood of continued warm weather. When we were children, my sister and I would amuse ourselves trying to calculate the temperature

by timing the number of chirps a cricket made in fifteen seconds and adding thirty-seven to the number. The total of the two should, theoretically, produce an accurate reading in Fahrenheit.

This formula for calculating the ambient temperature based on the number of cricket chirps is known as Dolbear's Law; it was discovered in 1897 by Amos Dolbear, an American inventor and physicist. Dolbear, who devoted many years to the study of cricket chirps before presenting his opus to an astonished world, appears to have overlooked certain variables that might affect the rate of chirp, such as the age and well-being of individual crickets, so no two calculations were ever the same. This, of course, only added to the fun, and for several years hot childhood summers became synonymous with taking it in turns to be the eccentric scientist.

Ladybirds are another friend from summers long ago. These beautiful little red and black spotted beetles have consistently been viewed as omens of good luck by farmers. Legend has it that the name originates from the Middle Ages when a plague of aphids was in the process of destroying all spring crops. Prayers of a distraught populace to the Virgin Mary were answered when swarms of ladybirds appeared and ate the aphids. Originally known as Our Lady's Beetles, Lady Beetles or Lady Bugs, farmers still believe their early appearance from hibernation indicates a hot summer.

In this children's rhyme of great antiquity, a farmer warns the beetles to leave his fields before he begins burning stubbles and harvest aftermaths:

Ladybird, ladybird, fly away home.
Your home is on fire, your children will burn.

From a child's point of view, ladybirds are obligingly easy to catch and there are many folklores relating to the direction the beetle takes when it leaves the hand. Most of these divine future husbands:

This lady-fly I take from off the grass,
Whose spotted back might scarlet red surpass,
Fly ladybird, fly, north, south, east or west,
Fly where the man is found I love best.

One, at least, is directly connected with weather forecasting. A ladybird is placed on the palm of an outstretched hand and the person who holds it chants:

Ladybird, ladybird tell to me
What the weather is going to be;
If fair, then fly in the air,
If foul, then fall to the ground.

When the first two lines have been said, the beetle is thrown into the air. Like other insects, beetles of all sorts become active during high atmospheric pressure and sluggish at the approach of a low one, so if a ladybird comes into the house, expect a drop in temperature.

Collective animal and insect weather portents are summed up succinctly in this piece of prose from *The New Book of Knowledge*:

If ducks and drakes their wings do flutter high,
Or tender colts upon their backs do lie;
If sheep do bleat or play and skip about
Or swine hie by straw bearing on their snout;
If oxen lick themselves against the hair,
Or grazing kine to feed apace appear;
If cattle bellow, gazing from bellow,
Or if dogs, entrails rumble to and fro;
If doves and pigeons in the evening come
Later than usual to their dove house home;
If crows and daws do oft themselves be wet,
Or ants or pissmires home apace do get;
If in the dust hens do their pinions shake,
Or by their flocking a great number make;
If swallows fly upon the waterlow,
Or woodlice seem in armies for to go;
If flies or gnats or fleas infest or bite,
Or sting more than their wont by day or night;
If toads hie home or frogs do croak amain,
Or peacocks cry – soon after, look for rain.

THE PRESCIENCE OF PLANTS

Observing the behaviour of certain plants as a prediction of imminent changes in the weather has been depended on by countrymen since time immemorial. Many flowers close their petals to protect pollen at the approach of rain: little white wood anenomes, which flower at the end of March or the beginning of April, are one of the earliest. The flowers of dandelions are protected by coarse-toothed leaves – hence the name, *dent de lion* – which fold around them prior to rain. When clover leaves are folded and pointing to the sky or if 'goats' beard', the pretty yellow weed that grows along roadsides and in old pastures, closes its leaves over the flower before midday, it will rain that afternoon. Chickweed, bindweed, wild indigo and tulips all close as a low front approaches. The same is true of Welsh poppies, often seen growing along stream banks, when they hang their head. Scarlet Pimpernel, the enchanting, tiny star-shaped flower known as 'the shepherd's weather glass', is always entirely reliable. When the petals begin to close and are shut by noon, a shower is in the offing; if they remain open, the day will stay fine.

> *And scarlet, starry points of flowers,*
> *Pimpernel, dreading nights and showers,*
> *Oft called the shepherd's weatherglass,*
> *That sleeps till suns have dried the grass,*
> *Then wakes and spreads its creeping bloom*
> *Till clouds with threatening shadows come –*
> *Then close it shuts to sleep again;*
> *Which weeders see and talk of rain,*
> *And boys, that mark them shut so soon*
> *Call: 'John that goes to bed at noon'.*
> JOHN CLARE, 'The Shepherd's Calendar' (1793–1864)

A false spring in late February is often followed by a 'blackthorn winter'. When bitter winds blow from the north-east this hardy thorn-covered bush of hedgerows and heaths becomes covered in clouds of minuscule, snow-white flowers that appear before the leaves. To the ancients, this abundance of blossom that seemed to defy the tyranny of winter was one of nature's more impressive miracles: a message to the despairing that warm weather would come, eventually, and that spring cultivations should not be delayed.

> *When the slae tree is as white as a sheet* (*slae* = sloe)
> *Sow your barley wither it be dry or wet.*

Jim Akehurst always used to say that the 'snag bush' – because of its vicious thorns – would bloom as long as the 'hungry' wind lasted. When the wind changes to the west, rain inevitably follows and the fragile blossom is destroyed.

WHEN WILDLIFE PREPARES FOR WINTER

There is a popular mistaken belief that a profusion of autumn berries – holly, hawthorn, rowans – presage a hard winter. Country people believed it was Nature's way of providing wildlife with the extra food they would need to cope with the rigours to come. In actuality, an abundance merely indicates a mild, frost-free spring which has encouraged unrestricted pollination and fertilisation. The same is true of the condition of animals as winter approaches. When Frank Chilman, who had been my grandfather's keeper, took me ferreting, the kidney fat of rabbits was always closely studied. If there was a lot of fat when we skinned them, Frank would say rabbits knew a hard winter was definitely coming and were laying on fat to see them through. Realistically, if rabbits are fat in late autumn it is because there has been plenty of food for them throughout the year so far.

Creatures that go into a dormant or semi-dormant state through the winter – hedgehogs, newts, adders, grass snakes, toads and certain insects, such as bees – do so in late September and October. Hibernation is influenced by a diminishing food supply and shortening hours of daylight: once the temperature drops below 10 degrees Centigrade they should all be safely tucked up in their respective hibernacula, emerging groggily as soon as it reaches a sustained 10 degrees. Early hibernation suggests the beginning of winter will be hard and the timing of their reappearance heralds the start of spring.

NATURE'S WILD WEATHER WARNINGS

There is no doubt that animals have a sixth sense which can warn us of impending natural disasters on a national scale. We are lucky that they rarely happen in this country: there was the Great Storm of October 1987, which the Met Office got so catastrophically wrong when they failed to identify the direction of a hurricane that killed eighteen people and caused £1 billion worth of damage, but that was a mere nothing compared to the North Sea flood of 1953.

A combination of an abnormally high spring tide, a tidal surge from the North Sea and a severe European wind storm created the worst natural disaster ever recorded in the UK. A massive sea breached coastal defences from the river Tees in the north to Medway in the south, in some places surging inland over two miles. 30,000 people had to be evacuated from their homes; 24,000 properties were swamped and 1,000 square kilometres of land saturated in salt water; 307 people lost their lives in the flood and a further 224 were drowned at sea.

> THERE IS NO DOUBT THAT ANIMALS HAVE A SIXTH SENSE WHICH CAN WARN US OF IMPENDING DISASTERS ON A NATIONAL SCALE. WE ARE LUCKY THAT THEY RARELY HAPPEN IN THIS COUNTRY.

Among the many areas that were devastated was the Hoo Peninsula, a neck of land in North Kent poking out into the English Channel, with the Thames estuary on one side and the Medway on the other. This isthmus is predominantly low-lying marshland, with a ridge through the middle on which the villages of Cliffe, High Halstow, Hoo St Werburgh and All Hallows perch, surrounded by orchards

and market gardens. In the 1970s I farmed part of the Cooling Marshes, an eerie place of dykes, mists and waterfowl that ran from the moated ruins of Cooling Castle out to the Thames sea wall. I inherited a shepherd with the farm, Bill Dockwray, who had looked after the sheep and cattle on the marshes all his life, bicycling to work from his home in Cliffe every day. He told me that on 30 January 1953, the sky was full of shrieking, swirling birds of every description, and he had never known stock so agitated. Sheep were milling about calling urgently to each other and all the cattle were huddled together, bellowing. Hundreds of seaside riding donkeys, which overwintered on the marshes, could be heard braying fretfully all around him on neighbouring land. It was a sinister cacophany of anxiety that made the hair stand up on the nape of his neck.

Every morning, before he set off to work, Bill would study the marshes from his back garden through an enormous pair of ex-Naval binoculars. At dawn on 31 January, he could see the stock not only on his own marshes at Cooling but those on the Buckland, Halstow and St Mary's marshes, right along past Egypt Bay to Dagnam Saltings. Thousands of sheep, cattle and donkeys were standing motionless with their heads up, staring at the sea wall. Then, with one accord, the whole lot turned and poured inland. A great multitude of frantic panicking animals leapt through dykes and crashed through gates and hedges until they reached the safety of the orchards and market gardens. Half an hour later, a massive surge seemed to lift the whole Thames up above the sea wall, and within moments the marshes disappeared under a tidal wave of grey water.

THE CHANGING CLIMATE

Up until 1990, the weather in Britain was fairly predictable. The summers (with some exceptions) were reasonably hot and the winters cold, with snow on high ground after Christmas. We then seemed to enter one of the cyclical changes in the weather pattern that afflicts us only every few hundred years, and now the weather pattern bounces about all over the place. Early spring is cold and wet, followed by a period of sun and warmth. Summers are repetitively damp with very heavy rain in late August. The winters are mild, wet and unhealthy, with occasional short periods of hard frost when you least expect them and occasionally a fall of snow. Politicians and environmentalists worldwide have capitalized on what has become an international phobia – Global Warming – conveniently ignoring the historical evidence of previous climate changes.

This absence of hard winters has, to some extent, upset the balance of nature. Rabbits breed all year round, birds begin nesting earlier and reptiles drifted in and

out of hibernation whenever the temperature rose above 10 degrees Centigrade. Old and sickly wildlife, which would normally have died in a hard winter, linger on and invasive plant and animal species, of which there are now many hundreds, thrive.

From a hill farmer's perspective, the succession of mild winters has had a curiously detrimental effect on the sheep. As previously described, the essence of hill farming is the territorial knowledge passed from one generation of sheep to the next. Before the weather pattern changed, the high ground of Britain invariably experienced a degree of snow cover in January or February. Hill farmers prepared for this eventuality by storing hay at emergency feed points strategically placed out on the farm, in sheltered places where sheep would move to in the event of a storm. Unless there is a complete covering of snow, hill sheep will not eat hay, preferring their normal diet of poor-quality moorland grasses and heather. With no appreciable snowfall over a succession of years, we stopped stocking the emergency hay sheds, and now, on the rare occasions when nature surprises us with a blizzard, the sheep no longer recognize the feeding points as places of safety. They continue to be weather indicators by moving down from high ground as they have always done, but the generational knowledge which was once part of the whole flock has been lost and small groups tend to seek shelter in cleughs and gullies, often becoming trapped as snow drifts across the entrance. Frustratingly, until the weather pattern reverts very little can be done about this situation.

> DESPITE ALL THE AVAILABLE SCIENTIFIC EQUIPMENT, DECIPHERING CLIMATE PATTERNS AND FORECASTING LONG-RANGE WEATHER VARIATIONS HAS BECOME A NIGHTMARE FOR METEOROLOGISTS ... IT IS NOT SURPRISING THE WEATHERMEN GET IT WRONG; THE ENVIRONMENT HAS GIVEN BIRTH TO A NEW CYCLE AND, AS WITH ANYTHING YOUNG, ITS BEHAVIOUR IS IMPULSIVE AND CAPRICIOUS.

Despite all the available scientific equipment, deciphering climate patterns and forecasting long-range weather variations is a nightmare for meteorologists. In early 2009, they confidently predicted a 'barbecue summer' followed by an unprecedentedly mild winter. The summer was memorable for floods and the winter experienced the heaviest snow nationwide in fifty years. It is not surprising the weathermen get it wrong; the environment has given birth to a new cycle and, as with anything young, its behaviour is impulsive and capricious. For this reason as much as any, I ignore the wisdom of scientists and make my own daily weather predictions based entirely on the information nature provides me with – and I am rarely wrong.

Weatherlore

CHAPTER FOUR

WILDLIFE

Most cultures sentimentalise wildlife, but none anthropomorphise them in anything like the way we British do. The origins of our love and fascination with wildlife must lie in the animistic beliefs of Neolithic hunter-gatherers, who viewed themselves on roughly an equal footing to the animals they depended on for survival. The Celts deified almost every aspect of nature, and animals in particular, with whom they developed a deep respect and intimate relationships, creating gods of some. Notable ones included Cernunnos, the horned god of fertility, who is most frequently associated with red deer stags; Bran, god of prophecy and war, represented by ravens; Ban, the salmon and the silver goddess of wisdom (hence the River Ban in Northern Ireland); Eostre, the hare goddess of spring and rebirth; and Moccus, the boar god of war and hunting (the last vestige of the pagan boar cult is our tradition of buying a ham at Christmas). There was also Epona, the horse goddess; horses had been revered since the Bronze Age, as indicated by the figure carved into the chalk downs in about 1500 BC at Uffington, in Wiltshire. This longevity of veneration probably accounts for our aversion to eating horsemeat.

> THE ORIGINS OF OUR LOVE AND FASCINATION WITH WILDLIFE MUST LIE IN THE ANIMISTIC BELIEFS OF NEOLITHIC HUNTER-GATHERERS, WHO VIEWED THEMSELVES ON ROUGHLY AN EQUAL FOOTING TO THE ANIMALS THEY DEPENDED ON FOR SURVIVAL.

There were hundreds of other creatures around which the Celts built myths, folklore and superstitions, or to whom they attributed human characteristics. Foxes and wolves were appreciated for their cunning and intelligence, bats and owls were associated with the underworld, and beavers and otters were held in great awe for being able to run on land and swim underwater; a cloak made of otter or beaver skins was believed to make the wearer invisible. Bees were greatly admired for their discipline, energy and as providers of honey – the essential ingredient in mead, without which no Celtic party was complete. Weasels, stoats, pine martens and polecats were believed to be the familiars of various deities. Weasels and stoats were considered magical for being able to change the colour of their coats from russet to gold in winter and, to add to their mystique, weasels were believed to conceive through the ear and give birth via the mouth. Butterflies were thought to be the souls of the dead.

All the hibernators, toads, frogs, lizards, newts, slow worms, grass snakes and adders, were a source of wonder. Adders were held in high esteem by the Druids, who believed the snake's ability to shed its skin indicated the power of reincarnation. Entwined adders were one of the Celtic symbols, and Druids often carried 'snake stones', stones with a natural perforation, which they believed had been created by an adder's tongue. Snake stones later became known as 'hag stones' and were carried by country people to ward off evil, hung above beds to protect against nightmares or in stables to prevent horses from being stolen and ridden at night by witches.

Birds were a source of fascination and were generally regarded as messengers from the deities. The migration of birds was as much a mystery to the Celts as it was to following generations, and many of the myths which persisted until the nineteenth century (such as geese and woodcock flying to the moon, or cuckoos changing

into kestrels) originated during the Iron Age. Bird song was believed to impart mystic messages, and our tiniest bird, the wren, was the sacred bird of prophecy to the Druids, who used the musical notes of its long, complex song as divination.

Successive pagan invaders, particularly the Vikings, added more myths and elaborated on existing ones. Goats were very popular with the Vikings: as the first animals to produce young in the spring, they were seen as a symbol of fertility. Odin had a she-goat that produced mead from her udder, and Thor, the god of war and thunder, travelled in a chariot drawn by billy goats. Dogs, which had been essential to the survival of communities since pre-history and were already well established as heroic figures in Celtic mythology, now appeared in numerous guises, not least of which was Garm, the four-eyed guardian of the underworld. Red squirrels were messengers, scuttling up and down trees carrying gossip from the birds to ground creatures. In Norse mythology, the squirrel Ratatoskr carries messages from an eagle perched in the uppermost branches of Yggdrasi, the tree of life, to Nithogg, a malevolent serpent which lives among the roots.

Ratatosk is the squirrel who there shall run
On the ash-tree Yggdrasil;
From above the words of the eagle he bears
And tells them to Nithhogg beneath.
Translated from Poetic Edda (Tenth Century)
by Henry Adams Bellows (1810–1900)

Swans were mystical creatures. Odin's valkyries, originally hideous hags who scavenged battlefields, became beautiful women in later Norse mythology who came down to the realm of man disguised as swans. Cats and sows were associated with Freyja, a principal Norse fertility goddess. Fish, an early fertility icon, were her sacred creatures and are said to be the reason we eat fish on Friday or Freyja's day.

CHRISTIANISING PAGAN ICONS

In AD 595, Pope Gregory sent a mission of forty monks led by a Benedictine called Augustine, prior of the abbey of St Anthony in Rome and later the first Archbishop of Canterbury, from Rome to England, with instructions to convert the pagan inhabitants to Christianity. Augustine was advised to allow the outward forms of the old religious festivals and beliefs to remain intact, but wherever possible to superimpose Christian ceremonies and philosophy on them. The sheer scale of the task confronting the missionaries was so colossal that halfway from Rome they got cold feet and decided to turn back. They were only too well aware, leaving the innumerable festivals aside, that every tree, spring, stream, hill and animal had, since antiquity, its own guardian deity. Before a tree could be cut down, a stream dammed, a well drunk from or an animal disturbed, the individual guardian spirit had to be placated. Pleas for papal permission to allow the mission to return were refused and two years later the anxious group arrived in Canterbury, where they achieved immediate success with the baptism of King Aethelbert, but converting the wider population was to take many centuries.

Pope Gregory's mandate of conversion through coercion was followed by the missionaries and their successors for many hundreds of years. It was brilliant in its simplicity; Gregory surmised, accurately, that the easygoing Saxon peasant population would not object if the seasonal festivals of the pagan calendar were Christianised, as long as no one stopped them celebrating. Gradually, the principal heathen feasts became days honouring Christ himself or one of the Christian martyrs, and the Church had plenty of saints in hand, ready for any eventuality that might arise. It is sometimes claimed that the Church substituted a cult of saints for both the polytheism (the belief in multiple deities), and animism (the principle that animals, plants and inanimate objects had souls) which had existed for several millennia.

This may have been true in most cases, but not where our deep-rooted respect for and affinity with wildlife was concerned. Here the Church had a challenge they were unable to win, despite concerted efforts to manipulate naive and superstitious minds by demonising the old deities and animals associated with them. The Church attempted to classify animals as good or bad; goats, which had been fertility symbols associated with Tor, now became representative of Satan, and a common superstition put about in the Middle Ages was that goats whispered lewd suggestions in the ears of the female saints. Witches replaced the old goddesses, and cats or hares (previously the animal form of Freyja and Eostre) now became perceived as impish assistants in devil worship. Reptiles; snakes, toads, lizards and frogs fell into the same category, as did bats, crows and ravens. Sheep, on the other hand, were good, as was anything white – the symbol of chastity and purity – including stoats and weasels when in their winter pelage.

Where our love of animals was fostered, rather than suppressed, was after 1066. The Normans introduced a feudal doctrine where all land and wildlife belonged to the King. The right to hunt and harvest the enormous variety of wildlife that formed a major part of the food chain could be gifted by the King to his nobles and the clergy, subject to Forest Laws.

WILDLIFE HIERARCHY

Forest Laws codified as virtually divine a social stratification of animals which, when applied to hunting, produced a distinction between high and low game – of Forest, Chase and Warren. Broadly speaking, the 'noble' beasts of venery were red deer, boars, wolves and hares, prized and admired for their bravery and the challenge they presented to a huntsman. The lesser beasts of Chase were roe deer, fallow, hares (if hunted differently), badgers, foxes and martens. Warrens were artificial animal parks in which rabbits, hares, pheasants, partridges, bustards and rails were bred. Added to these were wildfowl and the fish of the inland waterways, each with its own place in piscine hierarchy, and as early as 1175 King Henry II appointed one Roger Follo to the rank of King's Otter Hunter.

OUR HUNTING HERITAGE

'A man cannot be a true sportsman who is not also a true naturalist,' is as accurate an observation now as it was in the Middle Ages. Venery has always meant the chase of a wild animal in its natural haunts and it cannot be performed efficiently unless the huntsman has learnt everything about the habitat of his quarry and the other wildlife that live there. The successful outcome depends on interpreting the behaviour of other animals and birds: the sudden alarm call of a jay, rooks rising clamorously from their roosts, rabbits bolting into their burrows or a hare starting from its form.

The young noviciates of the Middle Ages were expected to recognise the footprints of all wildlife, from the tiny imprint of a shrew or the pad mark of a fox to the trod of a hare. Some animals, red deer and fallow, were classified as being of 'sweet foot'. Others – otters, badgers, roe deer, foxes, polecats, stoats and so on – were of 'stinking foot' because of the scent they left. Dung – fuants, fewmets, lesses or croteys, depending on the animal – was closely studied to determine species, age and what it had been feeding on.

COMPANIES OF BEASTS

The chapter on hunting in the *Boke of St Albans* concludes with a list of instructions in the correct terms for the 'companies of beasts and fowls'; many of which are still used in natural history and zoology, or are part of the language of our everyday lives, such as a gaggle of geese, a pride of lions, a brood of hens, a flight or piteousness of doves, an army of ants, a swarm of bees, a litter of pups, a herd of swans, a sounder of swine.

Most of these collective nouns are delightfully illustrative, immediately conjuring up the animals' habits and behaviour: a raft or paddling of ducks, a spring of teal, a wisp of snipe, a charm of finches, a murmuration of starlings, a labour of moles, a parliament of owls, a tribe of goats, a colony of badgers, a glint of goldfish, a barren of mules, a knot of toads, a vindictiveness of ravens, an exultation of larks, a covey of partridges, grouse or ptarmigan, a nye of pheasants on the ground, or a bouquet of them when flushed.

There were literally hundreds of them and the author thoughtfully mixed among them the proper terms for companies of people, too: a melody of harpists, an eloquence of lawyers, a wandering of tinkers, a worship of writers, a rage of maidens, a tabernacle of bakers, a herd of harlots, a blush or rascal of boys, an obeisance of servants, a fighting of beggars, a prudence of vicars, a superfluity of nuns, a dampening of jurors, a diligence of messengers, and so on.

WILDLIFE IN LITERATURE

In the Middle Ages, the essential reading for those who had recently become gentrified was the *Boke of St Albans*, which was a treatise on the terminology of hunting, hawking and heraldry, rather than technique. The various species of hawk were classified into the different ranks and positions which existed in society: an eagle for an emperor, for example, a gyrfalcon for a king, a peregrine for a prince, a rock falcon for a duke, a tierce for an earl, a bastard hawk for a baron, a saker for a knight, a lanner for a squire, a merlin for a lady, a hobby for a young squire, a goshawk for a yeoman, a female sparrow hawk for a priest, a male for a clerk of holy water, and kestrels for children or knaves. The *Boke of St Albans* was so popular that there were twenty-two reprints between 1486 and 1616 – more than any other work during the same period, except the Bible – and was much plagiarised by subsequent authors, such as Gervase Markham.

BEDTIME STORIES FOR CHILDREN

In 1695, the French author, Charles Perrault, laid the foundation for a new literary genre: the fairy tale. His best-known works, indubitably derived from existing folk tales, were *Puss in Boots, Little Red Riding Hood, Toads and Diamonds, Cinderella, Sleeping Beauty, Bluebeard* and *Donkeyskin* – a remarkable creature whose droppings were pure gold. Perrault's fairy tales were then translated into English and published in 1729 by Robert Samber, as *Histories* or *Tales of Past Times, Told by Mother Goose*. In the following year, Thomas Boreman published *A Description of Three Hundred Animals,* and in 1736, *A Description of a Great Variety of Animals*, to which was added in 1739, *Curious and Uncommon Creatures.*

The first books for children involved anamorphic animals and were the translations of *Aesop's Fables* and *Reynard the Fox*, both published by Caxton in 1484. Although these moral tales for the young were immensely popular among the educated, they remained the only printed matter available for next 250 years. Children's books, particularly featuring animals, later became big business. John Newberry, the patron saint of children's books, published *Mother Goose's Melody*, or *Sonnets for the Cradle*, in 1744, a compilation of old rhymes such as *Baa, Baa Black Sheep; Goosey, Goosey, Gander; Old Mother Hubbard; Three Blind Mice; The Cat the Rat and Lovell the Dog.*

At least fifty publications based around natural history had been specifically printed for a juvenile readership by the end of the eighteenth century. Amongst these were *The Natural History of Birds* by T. Teltruth, published in 1770, and the ponderously titled *An Easy Introduction to the Knowledge of Nature and Reading the Holy Scriptures, Adapted to the Capacity of Children,* written in 1780 by the formidable Christian educationalist, Sarah Trimmer. In the text, a mother and her two small children are taken on a series of nature walks during which the mother introduces them to the wonders of God's creation. This book was so popular that by 1850 it had sold 750,000 copies.

250 ✳ *A Book of Britain*

Equally successful was *Fabulous Histories or The History of Robins*, published in 1786, which remained in print until the early years of the twentieth century. Robins are everyone's favourite bird, and Trimmer's story involved two families, a robin family and a human one, learning to live together in congenial harmony. Most importantly for the moral storyline, to achieve this state of bliss the children and the young robins must develop virtue and shun vice. *Fabulous Histories* was an exhortation to children to be kind to animals, in the hope that these Christian merits acquired during childhood would naturally lead to universal benevolence as an adult.

The late nineteenth century saw the publication of *Black Beauty* (1877), the heartrending novel based round the central character of a horse, written by Anna Sewell. Originally intended as a treatise aimed at inducing kindness, sympathy and understanding among people working with horses, and not as fiction for the young, it soon became a children's classic, breaking all publishing records. By telling the story of Black Beauty's life in the form of an autobiography and describing the world through the eyes of the horse, Anna Sewell pioneered new literary ground, introducing a style of writing that was adopted by future generations of authors such as Beatrix Potter, creator of *Peter Rabbit*, *Squirrel Nutkin* and *Little Pig Robinson*, and Kenneth Grahame, who wrote *Wind in the Willows*.

FEEDING THE THIRST FOR KNOWLEDGE

A natural consequence of the desire to see and learn more about the animal kingdom, and British wildlife in particular, was a flood of natural history books. In 1789, Dr Gilbert White published his enchanting and atmospheric *Natural History of Selborne*, possibly the most enduring book on British wildlife, which in 2009 had been in continual print for 220 years. This was followed by a series of bestsellers by the Rev. J. G. Wood, written in an endearingly breathy style, including: *The Illustrated Natural History* (1851), *Common Objects of the Seashore* (1856) and *Common Objects of the Country* (1857), which sold more than 100,000 copies in a week, *Animal Traits and Characteristics* (1860), *Out of Doors* (1874), *Field Naturalists Hand Book* (1879) and many more.

Another author who had an enormous following for his sensitive writing on natural history, rural life and agriculture was Richard Jeffries. Jeffries grew up in the village of Coate, in north Wiltshire, and famously wrote *A Gamekeeper at Home* (1878), having acquired his knowledge of natural history from a gamekeeper he befriended, who worked for the Calleys of Burderop Park. There were literally hundreds of books and articles on field sports written during the nineteenth century, by sporting naturalists such as Colonel Peter Hawker, Charles St John, Lord Walsingham, William Scrope, Sir Ralph Payne-Gallwey and Dr John Henry Walsh, editor of *The Field* magazine, to name only a few. These tended to be advice on shooting technique, whereas Jeffries's book was a fascinating insight into the life and work of a Victorian gamekeeper. The text included sensitive descriptions of the gamekeeper's personal appearance, his family, cottage and home life, the conservation of game birds and the benefits to all wildlife from man's role in maintaining the balance of nature by controlling predators. This was followed by *An Amateur Poacher* (1879), *Wildlife in a Southern County* (1879) and *Round about a Great*

Estate (1880). Jeffries then wrote two enchanting children's books: *Wood Magic* and *Bevis*, published in 1881 and 1882, both about the adventures of a young boy, Bevis, who wanders into a world of talking nature, where the wind, streams and creatures of the fields and woods all have their stories to tell.

Later, whilst living in Surbiton he wrote *Nature near London* (1883), *The Life of the Fields* (1884) and *The Open Air* (1885). He died of tuberculosis in 1887 and his last work, *Field and Hedgerow*, was published after his death. Jefferies remains unsurpassed as a descriptive writer on the landscape, natural history and characters of Victorian rural life. He possessed the ability to convey a sense of never-ending discovery which is part of the beauty of nature's gift to us, when we take the trouble to look for it, whether we live in urban or rural surroundings.

CHANGING ATTITUDES TOWARDS WILDLIFE

Wildlife, and their role as respected quarry species, continued to be a principal literary subject throughout the seventeenth century; however, the hierarchy was changing. Wild red deer were still the noblest of all wild animals, but their forest habitat was fast disappearing and they were seen increasingly as agricultural pests. The very wealthy hunted them in huge deer parks and their numbers were controlled with hounds on Exmoor and the wild open parts of Devon, much as they are today. Wolves had been exterminated in England by the end of the fifteenth century, although a few survived in Scotland for another hundred years. The last wild boar was killed by James I in the Royal Park at Windsor in 1617; beaver were extinct, and bustards scarce and localised. Towards the end of the sixteenth-century foxes, admired as cunning rogues, were becoming fashionable as quarry species.

The Agricultural Revolution of the eighteenth century had a profound effect on the British landscape and its wildlife population. Our remaining natural forests were disappearing at an alarming rate, and with it the habitat of many woodland creatures. Red deer in particular vanished from most parts of England, except the West Country and Cumberland, whilst in Scotland the deer found new homes in the remote, treeless Highlands. New habitat was provided for a whole biodiversity of smaller wildlife by the thousands of miles of hedgerows planted during the Acts of Enclosure. With agricultural improvements in lowland grain-producing areas and as more land came under the plough, flock masters looked to the barren uplands for new pastures, burning great swathes of old, rank herbage to create better grazing. The British Isles became renowned for the excellence of their agricultural produce, and, where livestock and grain production benefited from innovative landowners in England and Scotland, wildlife flourished.

Little caged song birds, canaries, finches, larks and siskins, some with their feathers dyed bright colours, became all the rage, with hundreds sold every week in London's Leadenhall Market. So too were hedgehogs, bought to kill cockroaches in cellars, larders and food stores. Landowners such as the Earls of Hertford and Rochford, or the Dukes of Leeds and Northumberland, were among those who began importing large numbers of red-legged partridges to put down as game birds on their various estates.

The observation by Dr Caius that '*we Englishe men are marvailous greedy gaping gluttons after novelties, and covetous cormourantes of things that be seldom, rare, straunge, and hard to get*' was to prove increasingly true of British landowners during the nineteenth century, as more alien species were imported and turned loose in the countryside. Mongolian, Reeves, Silver, Japanese and Lady Amherst pheasants arrived from the Far East on tea clippers and adapted well to their new environment. Green parakeets were successfully established in the park at Northrepps Hall, near Cromer, in Norfolk, by J.H. Gurney. Little owls were imported from Europe by a certain Colonel Meade-Waldo of Stonewall Park, Edenbridge, Kent, to 'Rid the belfries of sparrows and bats, and fields of mice'. Little owls were easily tamed and became popular pets; Florence Night-ingale brought one, christened Athena, home from a trip to Greece and carried it everywhere in her pocket. To Florence's great distress, the little creature died on the eve of her departure for the Crimea and she left instructions that it should be stuffed and taken to her family home, Lea Hurst, in Derbyshire. In 2007, when Lea Hurst and its contents were sold, the Florence Nightingale Museum at St Thomas' Hospital acquired the 150-year-old owl, where it now has pride of place.

Japanese Sika deer were introduced to a number of large estates, as well as Lundy and Brownsea islands, many of which promptly escaped to form feral herds. North American grey squirrels were first recorded in the wild in Montgomeryshire prior to 1830 and there were subsequent releases later in the century at Henbury Park in Cheshire, Woburn Abbey in Bedfordshire, Regent's Park and in Ireland. In 1909, a dozen grey squirrels, a gift from the Duke of Bedford, were released on the lawns of Castle Forbes, County Longford, for the entertainment of the guests at the wedding of Lord Granard to the American heiress, Beatrice Mills. Zander pike-perch, Wels catfish, Orfe carp, American brook charr and Rainbow trout were all released at various times. Midwife toads were accidently introduced to Bedfordshire in a consignment of ferns and water plants from southern France by the nurserymen Horton and Smart. Several thousand edible frogs were distributed among the Foulden fens in Norfolk by George Berney of Morton Hall, who found their distinctive, rasping croak attractive. Over time, many of these exotic adornments to the estates of eccentric landowners, of which grey squirrels are a classic example, were to become environmentally damaging as they bred and their numbers multiplied.

It is difficult to imagine the impact of the Industrial Revolution. Britain emerged from the Napoleonic Wars as the only European nation not ravaged by financial plunder and economic collapse. A world market for its seemingly limitless supply of natural resources in coal, iron, tin, copper and lead, and a boom in textiles manufacturing, provided jobs for those affected by the post-war

agricultural depression, resulting in thousands of families leaving the countryside for new industrial towns. Within decades, the railways made it possible to reach parts of the country in hours, not days, and the diverse beauty of our different landscapes became accessible with relative ease. The comparison between the splendour of the West Country, the Welsh mountains, the Lake District or the Highlands of Scotland and the belching smoke of the sprawling Black Country towns fuelled the Age of Romanticism. A movement was started in Britain by the poets William Wordsworth, Samuel Taylor Coleridge, William Blake, Percy Bysshe Shelley, Lord Byron and John Keats, who used the magnificent freedom of animals in their natural wild state as subject matter, emphasising the potential for humans to find creativity by emulating their independence. British artists such as John Constable, James Ward, Joseph William Mallard Turner, Edwin Henry Landseer and John Martin found inspiration from the powerful images created by nature.

> THE COMPARISON BETWEEN THE SPLENDOUR OF THE WEST COUNTRY, THE WELSH MOUNTAINS, THE LAKE DISTRICT OR THE HIGHLANDS OF SCOTLAND AND THE BELCHING SMOKE OF THE SPRAWLING BLACK COUNTRY TOWNS FUELLED THE AGE OF ROMANTICISM.

The stark contrast illuminated by the prosperity of the escalating middle classes and the wretched, exploited lives of those who scraped a living in the foundries, coal mines, sweatshops and textile mills led to a growing social conscience. It is indicative of our love of the natural world that this humanitarian unease was centred, not round human inequality, but animal welfare.

Since the majority of transport was dependent on animals, any ill-treatment of them, particularly in towns and cities, was very visible. Markets and slaughterhouses were urban based, and on butchering days the roars of the beasts and shouts of the slaughtermen were audible to all. Bear, bull and badger baiting, cock fighting and dog fighting were very popular, publicly conducted, spectator betting sports, on which truly frightening sums of money were won and lost. Leaving aside these vicious pastimes, I do not believe cruelty to farm and transport animals was as endemic as social historians have suggested. Britain was, and still is, renowned worldwide for the quality of its meat products and, as every livestock producer knows, this can never be achieved unless farm animals are properly fed and reared in stress-free conditions. Overworked and neglected transport animals will quickly cease to provide the functions expected of them, and meat from beasts damaged by rough handling at the slaughterhouses is worth considerably less to the butchers.

Ill-treatment of animals had been recognised as counter-productive for many, many centuries, but there were enough incidents to create a wave of public outrage and for an Act to Prevent the Cruel and Improper Treatment of Cattle to be passed through Parliament in 1822. The Martin's Act, named after the charismatic MP for Galway, Colonel Richard Martin, known as 'Humanity Dick' or 'Hair trigger Dick', from the numerous duels he fought, made it an offence to 'beat, abuse or ill-treat any horse, mare, gelding, mule, ass, ox, cow, heifer, steer, sheep or other cattle'.

*'If I had a donkey wot wouldn't go,
Do you think I'd wollop him? No,no,no!
But gentle means I'd try d'ye see,
Because I hate all cruelty.
If all had been like me, infact,
There'd ha' been no need for the Martin's Act.*

This from a lampooning music-hall ditty of the time, but people took a different view when Martin himself triumphantly brought about the first prosecution under the Act. Any citizen was entitled to bring charges of ill-treating an animal and Martin had a costermonger, named Bill Burns, arrested for beating his donkey. The case made history when Martin dragged the donkey into court and paraded its injuries before the judge. As a result, Burns became the first person in the world to be convicted of cruelty to an animal, and a painting of this event hangs in the headquarters of the RSPCA.

> THE MARTIN'S ACT WAS ... ALL THE MORE REMARKABLE WHEN ONE CONSIDERS THAT IT BECAME LAW AT A TIME WHEN A PERSON COULD BE TRANSPORTED TO PENAL SERVITUDE IN AUSTRALIA FOR A PETTY OFFENCE, FLOGGING WAS STILL PREVALENT IN THE ARMED FORCES ... HANGINGS WERE A PUBLIC SPECTACLE AND SLAVERY WAS YET TO BE ABOLISHED.

The Martin's Act was an outstanding achievement which in many ways reflected the unique attitude which Britons have towards animals, whether wild or domestic. It was all the more remarkable when one considers that it became law at a time when a person could be transported to penal servitude in Australia for merely a petty offence, flogging was still prevalent in the armed forces and frequently meted out as punishment by the courts, children and women were forced to work sixteen hours a day in the mills and ironworks or below ground in the mines, hangings were a public spectacle and slavery was yet to be abolished.

In 1824, Martin and a group of fellow MPs, doubting that magistrates were likely to take the Act seriously, formed the Society for the Prevention of Cruelty to Animals, with the aim of sending inspectors into slaughterhouses and livestock markets and to monitor the treatment of horses by coachmen. In the same year, Catherine Smithies, an anti-slavery activist, formed youth clubs associated with the Society, known as Bands of Mercy, using the members to encourage other children to be kind to animals. Lobbying by the Society saw the Martin's Act extended in 1835, to specifically prohibit bear, bull and badger baiting, cock fighting and dog fighting. Queen Victoria granted the society a Royal Charter in 1840 and from that date it became known as the Royal Society for the Prevention of Cruelty to Animals. It was not until forty-four years later, in 1884, that a similar society, the London Society for the Prevention of Cruelty to Children, was founded by the social reformer, Benjamin Waugh. It took five years of determined lobbying by its members before the first law to protect children in Britain from abuse and neglect was passed through Parliament. From 1889, children were to have the benefit of the same legal protection enjoyed by animals for the previous sixty-seven years, and to mark the occasion the London Society became renamed as the National Society.

BRINGING THE EXOTIC TO BRITAIN

Fascination with the natural world grew as the Empire expanded. Sir Stamford Raffles established the London Zoological Society in 1826, acquiring land in Regent's Park to establish a zoo, originally intended to house exotic animals purely for scientific study. In 1847, the zoo opened to the public and was phenomenally popular. For the first time Londoners and those who travelled from the provinces could gaze in wonder at the lions, tigers, leopards and Tasmanian Devils; Nile crocodile and hippopotami; bears from India, Asia, Syria, Canada and the Arctic; Oryx, Kudu, Agouti, Quagga, Reindeer, Sambur, Muntjac, Zebras and Giraffes; apes and monkeys of every description. There was soon to be an aquarium, a reptile house built with proceeds of the sale of Jumbo the elephant to Barnum's Circus, and an immense aviary. One of the great attractions in the summer of 1851 was an exhibition of twenty-four glass cases, each containing between five and fifteen stuffed hummingbirds, the creations of John Gould, the taxidermist, bird illustrator and official Preserver to the Zoological Society. Gould's display was described by the reporter for the *Atheneum* as one of the gems of natural history collections and the little hummingbirds, with their brilliantly coloured, iridescent plumage surpassed anything that anyone had ever conceived possible in creation. In the first year, 75,000 people visited Gould's exhibition and made him a fortune.

For about 100 years from the early nineteenth century there was a golden age of collecting animals, and in particular taxidermy. During the initial era of great scientific exploration and discovery, animals, birds and reptiles from all over the world were killed, skinned, pickled and sent home to be stuffed and displayed in natural history museums. This was followed by the passion for trophies from the big game safaris enjoyed by wealthy Victorians, and a general mania among everyone else for stuffed animals as household decorations.

Many famous taxidermy businesses flourished over this period; one of the earliest was owned by John Edmonstone of Edinburgh. Edmonstone had originally been a black slave from Demerara, in Guayana, who had been granted freedom by his owner and subsequently returned to Scotland with him, setting up a business teaching taxidermy to the students of Edinburgh Univerity – one of whom was Charles Darwin. Other well-known taxidermists included Kirk in Glasgow, Cullingford of Durham, Williams and Sheals in Dublin, Betteridge and Montagu Brown in Birmingham, Hutchinson in Derby, Shopland in Torquay, Jeffries in Carmarthen, and many others. London had several thriving taxidermy businesses: Gould, Gardner, Cooper, Leadbetter and Rowland Ward, who became world famous for mounting big game trophies.

Nor was the craze restricted to exotic species; if anything, perhaps because they were easily accessible and therefore less expensive, mounted specimens of British wildlife were even more popular. Rare birds, such as Cornish choughs, avocets, egrets,

bitterns, ruffs and water rails, black-tailed godwits and all the birds-of-prey species were much in demand, but so too were any sort of commonplace bird and animal. Robins, tits, gulls, rabbits, field mice, foxes, wrens, shrews – virtually each and every species was quarry to dealers who made their living supplying the taxidermists.

As the century wore on, the various taxidermy firms began producing tableaux of groups of animals in their natural setting with realistic background habitats. A pair of hen-harriers feeding on a mole, for example; Peregrine falcons with nest, chicks and a dead grouse, among rocks; stoats in their winter pelage, feeding on a white hare in a winter snowscape; a cameo of different waders, with a background of mud, rushes and a distant sea; a vixen with her cubs, playing among bracken; or a badger sow and piglets, outside a sett. The possible permutations for different species and settings were endless, and there was a ready market for all of them. Inevitably, any sort of deformity, freak or oddity, such as an albino mole or a kitten with five legs, became very highly prized and I daresay some taxidermists were not above creating what could not be found naturally. The taxidermists were highly skilled creative craftsmen, and surviving examples of nineteenth-century taxidermy are now recognised as works of art, which fetch high prices at auction.

> INEVITABLY, ANY SORT OF DEFORMITY, FREAK OR ODDITY, SUCH AS AN ALBINO MOLE OR A KITTEN WITH FIVE LEGS, BECAME VERY HIGHLY PRIZED AND I DARESAY SOME TAXIDERMISTS WERE NOT ABOVE CREATING WHAT COULD NOT BE FOUND NATURALLY.

The Victorian obsession with wildlife, dead or alive, was to spread to butterfly and bird's egg collecting. At one level both of these were seen as healthy, educational, wholesome pastimes for the young and were featured in publications such as Beeton's *Boy's Own Magazine* (1855), Kingston's *Magazine for Boys* (1859), Brett's *Boys of England* (1866) and the long-running *Boy's Own Paper* (1878), edited by Macauley and published by the Religious Tract Society.

At another level, there were those who became phobic about acquiring an egg or butterfly from as many species from all over the world as was humanly possible, buying them from professional egg or butterfly hunters, who often took incredible risks to obtain rare specimens. Some of these 'field collectors' were explorers in their own right or became recognised as such: Captain Samuel White, for example, F.W. Andrews, Alexander Shields or Albert Meek. There were a number of notable private collectors: Lord Walsingham, the famous shot, amassed 260,000 specimens of small moths, but the most prolific was undoubtedly Walter, the second Baron Rothschild. This delightful eccentric, who once drove himself to Buckingham Palace in a gig drawn by a pair of zebras, managed to accumulate over 200,0000 sets of eggs, 300,000 beetles, a similar number of bird skins and 2,500,000 moths and butterflies. These were painstakingly catalogued and exhibited in a purpose-built museum at the family home at Tring, in Hertfordshire, but they were a mere fraction of the largest collection of natural history specimens – alive and dead – ever put together by one man. Many private collections, including parts of Walter's, were eventually gifted to the Natural History Museum, forming the basis for invaluable ornithological and lepidopteral scientific research.

THE LOST ART OF CONNECTING WITH NATURE

For the first three decades of the twentieth century, rural Britain remained virtually unchanged since the improvements implemented during the agricultural revolution. Apart from the Black Country of the West Midlands conurbation and sprawling manufacturing towns such as Manchester, Liverpool, Glasgow, Bristol, Leeds and Newcastle, Britain was still a green and pleasant land. In the lowlands, the traditional family farms with their small field-hedge boundaries and combination of arable, winter root crops, livestock, old pasture, orchards and woodland, provided ideal sanctuaries for a whole biodiversity of plants and wildlife. Moorland birdlife and grouse in particular became enormously more plentiful as the heather uplands were farmed for hill sheep and cattle. The red deer population in Scotland blossomed as deer forests managed by professional stalkers became prime land use in the Highlands. Landlords across the country continued to plant and conserve woodland for field sports, and by so doing provided a habitat for a wide range of woodland fauna. Despite the drainage schemes of the previous century, there were still huge areas of wetland supporting vast numbers of estuarine birds and attracting hosts of migrant wildfowl through the winter.

> THE NATION AS A WHOLE PROBABLY KNEW MORE ABOUT THEIR ENVIRONMENT THROUGHOUT THE LONG YEARS OF RATIONING DURING AND AFTER THE SECOND WORLD WAR THAN AT ANY OTHER TIME, SIMPLY BECAUSE SO MUCH TIME WAS SPENT IN THE COUNTRYSIDE HARVESTING NATURAL RESOURCES.

Britain's wealth lay in industry, and as the population became predominantly urban, links to the countryside became increasingly important. Small boys and girls explored canal banks with fishing rods and butterfly nets or bicycled miles from towns and cities to enjoy the life of their rural cousins. Meanwhile, their mothers harvested hedgerows on the urban fringes and their fathers kept racing pigeons, ferrets, and small lurchers or Bedlington terriers.

The nation as a whole probably knew more about their environment throughout the long years of rationing during and after the Second World War than at any other time, simply because so much time was spent in the countryside harvesting natural resources. Children like myself, who were born a couple of years after the war ended, acquired an enormous amount of wildlife knowledge by accompanying adults on the daily or weekly foraging trips which were part of everyone's life until rationing ended in 1954. These essential outings to search for extra food taught us to be observant and a degree of intuition. The adult you were with had to know not just where to source a whole range of different wild animal and plant foods, but how to find them in places where others on the same mission were unlikely to have been.

As a result of the need to stay alert, country lore was quickly learnt by rural and urban children alike. We knew seasons of birds, animals, reptiles and insects; the ones that hibernated and those that were nocturnal. The predators, the quarry they hunted and the corridors of safety, such as hedgerows that smaller animals used as habitat or links between woodland, how wildlife responded to differing weather conditions, and, most importantly, we learnt to recognise the signs of animal presence: the narrow tracks of rabbits leading from their burrows to their

feeding grounds, or the broader path of a badger; the three forward and one heel toe of a pheasant or four-toed narrow pad of a fox crossing a muddy path through a wood; the tell-tale signs left by the hair of an animal passing under or over a barbed wire fence or close to brambles; the fine, soft, grey-brown, fluffy hair of a rabbit; the stiff, straight, bristly hair of deer; the long white and grey of a badger or the short russet of a fox. So, too, the messages in their droppings; the twisted dung of a fox, full of fur, bone fragments and seeds, and the acrid stench of his urine, where he marked his territory; the oblong dropping of rats; the long, crinkly, single black dropping of a hedgehog, glinting with remnants of undigested beetle carapaces; the tidy, open latrine of a badger; the stinking, fishy pile of otter spraints on a boulder beside a river; the oval, dark khaki droppings of roe deer or the regurgitated pellets of an owl, full of the tiny bones of shrews and voles. Above all, we learnt that every wild animal relies on sound and scent to warn them of danger, and that silence and a downwind approach were essential if we hoped to watch them.

> WE LEARNT TO RECOGNISE THE SIGNS OF ANIMAL PRESENCE: THE NARROW TRACKS OF RABBITS LEADING FROM THEIR BURROWS TO THEIR FEEDING GROUNDS, OR THE BROADER PATH OF A BADGER; THE THREE FORWARD AND ONE HEEL TOE OF A PHEASANT OR FOUR-TOED NARROW PAD OF A FOX CROSSING A MUDDY PATH THROUGH A WOOD.

It was not sufficient to identify wildlife from these signs; their distinctive footprints and whether they were walking or running was also learnt, particularly in relation to determining the age or sex of an animal. For example, the toes of the slot or cloven hoof of a stag or buck are larger than those of a hind or doe and the slots are closed if deer are moving fast and become widespread as they tire; also, the male deer species walk more evenly and have a deeper 'trace' than the female.

The prints of a hare and rabbit are similar, with the hare's being larger; the hind legs leave a long, narrow print – the entire shin of the animal touches the ground – while the forefeet leave an oval mark, though without much detail because the sole of the foot is very furry. When a rabbit or hare is running fast the hind prints are in front of the fore prints; when they are sitting or hopping slowly, the fore prints are in front.

A badger has five pads and five claws, almost level with each other at the tips. When walking, as opposed to running, the prints of the hind feet fall almost on top of those of the fore feet. Otter prints are distinctive as they have no heel, but rather a round ball under the sole of their pad, by which their track, known as a 'seal', is easily distinguished. In soft mud, the 'pole' or 'rudder', as an otters tail is called, also leaves a distinctive mark.

These skills became so much a part of our lives as we grew a little older and more independent. Nature was our prime source of entertainment and to be outside enjoying it was considered a healthy, beneficial and profitable way for the young to spend their time. This was the philosophy that the Boy Scout movement, which did such exemplary work in introducing inner-city children to country lore, had been based around. We made camps in the woods and spent hours being eaten alive by midges, watching a badger sett when the sow brought her piglets out at dusk, or a

vixen's earth when she played with her cubs on a summer evening. We caught tadpoles in jam jars in the early spring, watching them grow into little frogs before releasing them back into the wild, and we overturned cowpats to find worms for use as bait when we fished ponds for sticklebacks or eels.

I, and all my contemporaries, kept a succession of wild animals that had been injured or abandoned by their parents. During the course of my childhood I was variously the proud possessor of a hedgehog piglet, a grass snake, a pet toad I fed on dried ants a jackdaw which I taught to say 'good morning', a leveret, a young barn owl with a broken wing and, until it escaped, a weasel kit. Butterfly and egg collecting were still viewed as acceptable then, and although bird nesting was officially banned in 1954 it took a few years before the hobby was finally seen as abhorrent. At one time, every child would have been given a butterfly net and specimen jar, or an egg-collecting kit with the little drill for making holes in the shell and a glass 'blowing tube', for removing the yoke. The prevalent view in those days was that egg collecting was educational; an opportunity to teach the young how to watch birds returning to their nest sites with nesting material, and that if one egg was subsequently carefully taken from a nest no harm was done as a bird would always lay a replacement. Rare species were scarcely at risk, since their nesting sites tend to be the most difficult to find or reach and, in any case, as a hobby, egg collecting was always fairly short-lived. However, there were, and still are – despite successively more draconian amendments to the 1954 Protection of Birds Act – the occasional individual who obsessively collects rare birds' eggs.

THE IMPACT OF MODERN LANDSCAPING POLICIES

The post-war arcadia of my childhood, so evocatively illustrated in the Collins *New Naturalist* series, which started in 1945, was about to undergo dramatic changes. During the fifties, sixties and seventies the Forestry Commission, set up in 1919 to implement a national reafforestation scheme designed to meet the shortage in home-grown timber, embarked on a massive programme of planting quick-growing Sitka spruce conifers. Huge tracts of land were planted, much of it in areas of outstanding natural beauty totally unsuited to growing trees, the Highlands of Scotland, for example, or the moorlands of Wales and England. Kielder Forest alone sprawls over 250 square kilometres of the Northumbrian hills. Rural communities disappeared; acres of ancient natural woodlands were engulfed, and in a matter of twenty years these plantings had grown into vast blocks of sterile woodland. Trees in commercial softwood forestry are planted too close together to allow the undergrowth to become established, which would support a whole range of wildlife. It does, however, provide an almost impenetrably safe habitat for predators – foxes and raptor species – to predate into adjacent areas.

> AT THE SAME TIME, THE GOVERNMENT POLICY OF AGRICULTURAL INTENSIFICATION CREATED A CHAIN REACTION OF LOSS ACROSS THE SPECTRUM OF WILDLIFE. VAST QUANTITIES OF HABITAT WERE DESTROYED IN PARTS OF BRITAIN, AS HEDGEROWS WERE BULLDOZED OUT, OLD PASTURE, HEATH AND DOWNLAND PLOUGHED AND MARSHES DRAINED.

Ground-nesting moorland birds are particularly vulnerable as prey, and the extensive post-war forestry planting that has taken place in Wales has been the cause of the decline in all birdlife on the once-famous Denbighshire grouse moors.

At the same time, the government policy of agricultural intensification created a chain reaction of loss across the spectrum of wildlife. Vast quantities of habitat were destroyed in parts of Britain, as hedgerows were bulldozed out, old pasture, heath and downland ploughed and marshes drained under devastating Ministry of Agriculture reclamation schemes. Herbicides and pesticides killed the food source of many small birds, reptiles and mammals; this in turn impacted on the larger species which depended on them.

By the mid-1980s a ludicrous situation of agricultural overproduction had evolved, with excess produce being bought by the government and stored in butter, milk, grain and meat 'mountains'. This, as much as the desperate lobbying on behalf of wildlife by conservation bodies and environmentalists, persuaded government that existing agricultural policies had to change. Initially, farmers were paid to take land out of production under 'Set Aside' schemes or to reduce livestock under 'Extensification' schemes. These were followed by a whole variety of landscape-enhancing, agri-environmental schemes, designed to redress some of the damage previously done. Grants became available to replant hedges and small woodlands; repair and replace stone walls; allow drained marshes and wetland areas to revert to their origins; or to encourage traditional farming by converting to organic. Although these did much to bring wildlife back into areas where the population had fallen, it has meant that the stewardship of the countryside and the

benign management of nature, which since time immemorial has been the responsibility of farmers and landowners, is increasingly in the hands of government departments.

Today we seem to suffer from a surfeit of conservation bodies, what with governmental departments such as Department for Environment, Food and Rural Affairs (Defra), the Department of Energy and Climate Change and the Scottish Executive Environment Directorate and governmental Executive Agencies, such as the Forestry Commission, the Joint Nature Conservation Committee, English Heritage, Natural England and the Environment Agency. Since devolution, Scotland, Wales and Northern Ireland each have their own governmental Executive Agencies: Scottish Natural Heritage, the Scottish Environment Protection Agency and Historic Scotland. Wales has CADW, the department of cultural and built heritage, the Countryside Council for Wales, and their own Environment Agency. So far, (2010) Northern Ireland only has an Environment and Heritage Service and a Forest Service. Needless to say, each of these agencies is divided into myriad different departments employing armies of bureaucrats, very few of whom have any rural background. In addition, there are literally scores of non-governmental conservation organisations, trusts, partnerships, schemes, associations, groups, societies, corps and committees, devoted to conserving everything from bugs to barn owls.

Conservation has become something of a twenty-first century obsession and was quickly picked up by New Labour as a populist cause. One of the more rebarbative laws to be passed through Parliament was the Countryside and Rights of Way Act 2000, otherwise known as the 'Right to Roam'. Heralded as a socialist dream come true, giving the public a legal right of access to the British countryside, all this piece of legislation achieved, it seems to me, was to ratify at enormous cost the existing National Parks and Access to the Countryside Act of 1949. The National Parks and Areas of Outstanding Natural Beauty initiatives have been splendid in protecting the landscape, but access to the countryside has been available to everyone for centuries. There has never been any law of trespass in Scotland; and England and Wales are criss-crossed with public footpaths, bridlepaths, green lanes and old drove roads. In the old days, very few farmers or landlords objected to anyone crossing their land, other than by one of the existing access routes, provided they were asked first and the normal courtesies observed. CRoW 2000 is actually riddled with restrictions and the countryside is now plastered with signs telling people where they can or cannot go.

WHILING AWAY THE HOURS WITH WILDLIFE

Spring is a wonderful time to watch wildlife: the creatures with a short gestation, such as birds, the smaller mammals and reptiles are engrossed with the need to procreate and the urge to mate overcomes their normal timidity. The larger mammals, with longer gestation - foxes, badgers, deer and so on, will be giving birth, and in either case they are all preoccupied by the calls of nature and, with care, are much more approachable.

It is a glorious period of the year here at my home in the uplands; a warm day or two and suddenly everything comes to life. The long silence of winter is broken by an enervating bustle of energy and birdsong, as summer-nesting migrants start arriving from the coast: the wild, ululating, territorial call of cock lapwings, as they perform tumbling, aerobatic display flights; curlews hang like crescent moons as they circle breeding areas, their soporific whistling rising to a crescendo that fades away to a strange burbling sound when they dive. At the same time, oystercatchers patrol up and down the Hermitage Water, which runs through our farm, yapping hysterically; red shanks yodel; skylarks warble; little stonechats and whinchats hiss and tick; cock grouse grumble and snipe, plunging through the air with their tail feathers extended, creating a weird, mournful bleating sound; while above them, high in the sky, ravens cough and buzzards mew. Rabbits gambol, hares box, the few remaining red squirrels chase each other up and down trees and bees buzz:

> *In fact, it is the season for billing and cooing,*
> *Amorous flying and fond pursuing,*
> R. BUCHANAN, 'The Undertones', (1866)

BIRD WATCHING

On a knoll behind our farm buildings is a small stand of old Scotch pines, larches, birch, ash and oak trees. The nesting bird life here is different, but no less frenetic and noisy. Tiny, pugnacious goldcrests (Britain's smallest bird) flicker among the tops of conifers building intricate, expanding nests of spiders' webs, moss and feathers. Tree creepers scuttle up and down like feathered mice, uttering high-pitched squeaks. Siskins announce their mating territory with a sweet, fluting twitter. Coal tits trill plaintively. Long-tailed tits splutter shrilly and goldfinches tinkle. Periodically, above this cacophony of exuberant small birdsong, the protracted drumming of a greater spotted woodpecker can be heard, or the silly laugh of a green one.

Strangely enough, it is familiar garden birds that have learnt to live in the proximity of humans whose peculiar nesting habits prove the most interesting, particularly to children. The old steading at the back of our house, with its cattle byres, granary and stabling, provides ideal breeding sites for a variety of birds – most of whom gladly utilise man-made objects as part of their home building. Last year, a pair of barn owls made their nest – a disgusting mess of disgorged pellets – on a ledge in the granary, using a section of clay drainage pipe that must have lain there for decades, as a retaining wall to stop the owlets falling off. Further along

the same ledge, a hen blackbird built a tidy nest of dry grass, leaves and mud in a rusty tin half-filled with nuts and bolts, whilst swallows blithely fly in and out with tiny particles of mud, constructing nests under the eaves. In the tack room below, where the terriers have their kennels, a pair of dainty pied wagtails reared their brood in a nest of hair and wool in a corner of the wall head.

It would seem that the smaller, more pugnacious and territorial the bird, the more indiscriminate the nest site. Blue tits, the comic little tit mice of poetry, will nest in practically any cavity away from the ground, hissing with fury at any intruders; the only requirement is an unimpeded flight path and enough room to rear their clutch of between seven and twelve eggs. Holes in a wall or tree are favourite places, but I have known nests in drainpipes, flowerpots, a milk bottle stuck in a hedge and the tool box of a derelict tractor. For several years in succession, a pair nested inside a narrow-necked stoneware jug, deep in a bramble bush growing out of an old rubbish dump. Little skulking wrens with their piercing, rattling song are notorious for choosing strange nesting sites. The cock makes a series of bell-shaped nests for the hen to choose from and will site them in any situation round the house or farmyard where there is any semblance of an entry hole. Proximity to humans doesn't bother them and I have found wrens nesting in a broken carriage lamp among the ivy beside our front door, the coils of a garden hose hanging from a nail, an old gym shoe on a shelf in the summerhouse and a crash helmet in the garage. Wrens build their nests with astonishing speed; years ago, the gardener put his trilby down in the greenhouse one morning and found a partially constructed wren's nest in the crown that evening.

MAKING BIRD NESTS

Providing nesting sites for little birds is enormous fun and can be done anywhere, in urban as well as rural areas. When my children were small we always had an annual nest-creating day in early March. They and their little friends scoured the farm for suitable receptacles: every farm has a junk heap of considerable antiquity, with its ubiquitous elder tree growing nearby, and the children would return triumphantly with all manner of pots, tins, jars, old kettles, teapots and the occasional hob-nailed boot. With this treasure trove piled into a wheelbarrow, we would set off round the farm pushing his or her find into wall cavities and hedges or fixing them to the branches of trees. How these were positioned was crucial to their eventual occupation; they had to be rigidly secured, with enough shade, cover and height to give a sense of safety. The next step was to scatter the contents of an old feather pillow in places protected from the wind and watch little birds take them away. When the nest sites were checked at beginning of April, at least half had a blue tit, great tit, hedge sparrow, wren or robin in situ.

However, it is robins that claim the most unusual recorded nesting site. The corpses of two highwaymen, Thomas Brown and James Price, executed in 1796 for robbing a mail coach, were hung in gibbets on the green at Mickle Trafford, not far from Chester racecourse. When these were finally taken down in 1820, a robin's nest of moss, wool and hair was found in Price's skull.

Our national bird can always be relied upon to provide entertainment in the spring, vociferously establishing mating territories and fighting off all comers. Hens will cling to a nest under circumstances that would be unthinkable for any other bird. Some years ago I moved an enormous quantity of lumber which had accumulated in a loft in one of the old buildings: armchairs with the horsehair stuffing bulging through the material and vast, ungainly dressers; rusting iron bedsteads; piles of trunks and suitcases filled with moth-eaten clothes; tea chests full of toys and those treasured infant-school projects – drawings and little plaster or papier mâché figures. One whole corner was taken up by an enormous heap of plastic bin liners containing decades of annual farm accounts. Over several days, much of what had gone up with relative ease was lowered down by a rope with considerable difficulty. Except the black bin liners; these were hurled off the loft with rapturous shouts of 'look out below', landing in a cloud of dust with a satisfying thud. When the job was finally finished, I went to move a tea chest containing a broken wicker bottle basket on top of a pile of toys. This had been among the first to come down, and as I approached, something stirred in one of the bottle compartments. A hen robin, her tail feathers bristling erect, was glaring at me from a newly constructed nest.

Some birds are closer to my heart than others; in particular snipe, with their beautiful, throbbing wind music. I hear them here first in late February – that strange, unsettling month with its imperceptibly lengthening days, which is more burdened with myths and folklore than any other. The Saxons called February '*Sprote-cal*' (sprout kale) and the initial signs of growth in the valley below us start to appear in the middle of the month: a faint green haze of buds on alder, hazel and willow, with wild garlic and aconites pushing through along the river banks. In the hills, the first harbinger of spring is often the eerie melody of a cock snipe, announcing his arrival by performing a territorial display flight.

This hauntingly lovely sound puzzled naturalists for several centuries. One school of thought believed it was vocal; the other maintained it was produced by motion of the wings. The matter was not resolved until the 1950s, when the great ornithologists, Sir P. Manson-Bahr, R.A. Carr-Lewty and the then editor of *The Field*, Eric Parker, proved under laboratory conditions that 'drumming' is created by the two extended primary tail feathers vibrating in the air stream at a certain speed. The beautiful humming, which rises to a fluting crescendo, becomes audible when snipe, diving from a considerable height at an angle of 45 degrees, reach a speed of between 25 mph and 45 mph. It only lasts for a few seconds and has extraordinary carrying and ventriloqual properties, with the bird, disconcertingly, always some distance from where the noise is heard. The soft bleating or whinny-ing which has given snipe a variety of colloquial names – 'heather beater', 'horse gowk' and 'mire kid' – seems to serve a number of purposes: it declares the cock bird's territorial boundaries and announces his presence to hens. Once one has been attracted, it forms part of the courtship display, and during nesting, or after the fledglings are born, I believe the ventriloqual effect is used to distract predators.

Cock birds arrive from low-lying marshes and wet fields at their moorland breeding grounds towards the end of February, with the hens appearing a week or two later. The main period of drumming activity is during mating and nesting, from mid-March until the beginning of July. Only the cocks drum, and courtship is a wonderful exhibition of aerobatics as the two birds chase each other or preen and posture on the ground with tail feathers erect and spread like a black cock's. Apart from their harsh scraping alarm call when disturbed, mating is the only other occasion when they become vocal, uttering soft, eager cheeps.

The nest is a well-hidden shallow scrape lined with dry grass in which the hen lays an average of four greenish eggs with brown blotches. Incubation lasts about three weeks, and whilst the hen sits the cock stays in the vicinity, displaying from time to time. The eggs hatch over a period of thirty-six hours and the first few chicks, which are active within a very short time, are hurried away by the cock to a nearby place of safety to protect the rest of the nest from predators. Both parents feed the young, which can fly at three weeks and are able to feed themselves by the time they are a month or five weeks old. Snipe remain in the uplands until the first frosts drive them to lower ground. Common snipe, *Gallinago gallinago,* are mysterious little creatures of bogs and damp, empty spaces, of mists, water margins and rushes. The name of a quantity in flight, a wisp, is so descriptive; seen briefly above a reed bed, they soon melt away into a grey winter sky. A number of them on the ground is

called a 'walk'. Their striped plumage, the varying shades of yellow and brown and the long green legs are all the autumn colours of their marsh and estuary feeding grounds. They weigh no more than six ounces and measure between ten and twelve inches, of which a quarter is beak. This disproportionately long proboscis, with its pliable tip that enables them to locate their diet of worms, larvae and water snails, was once thought to be the means by which they launched themselves airborne.

Snipe are highly respected as a game bird for their exquisite flavour and the almost impossibly difficult shooting challenge they present. Apart from being the smallest target of any game bird, snipe jinx unpredictably from side to side into the wind, with the same aerial dexterity of a wasp. They have an extensive distribution, provided suitable wetland conditions are available, which includes north and central Eurasia from Iceland to the Bering Strait, most of Africa, outside desert regions and North and South America. Britain has a breeding population of around 70,000, augmented from August onwards by waves of migrants moving south from Iceland, the Baltic and northern Europe as soon as the ground becomes too hard for the soft tip of their beak to penetrate. Large numbers of migrants often appear with the September and October moons along west coast estuaries and in Northern Ireland – particularly Lough Neagh and Upper Lough Erne, with its hundreds of little wooded islands – before dispersing across country in search of suitable habitat.

The ideal wintering conditions are a combination of moist, frost-free soil and mud containing their food source of worms, larvae, invertebrates, water snails and tiny molluscs. Some adjacent cover is required as protection from strong winds, as is a bit of open water, free from human disturbance, which need be no more than the damp corner of a field where a blocked drain has flooded.

Enormous areas of snipe habitat were lost during post-war monoculture, which are now being replaced under environmental schemes, but the presence or absence of birds in any particular area is entirely dependent on the their capricious response to the weather. Apart from hard frost, which will drive snipe from their damp inland haunts back to the coast, their movement is governed by laws about which we know little or nothing. In some weather conditions they lie so tight you can practically tread on them, in others they consistently spring and jink away just out of range. In one season there will be any number at a certain marsh; the next year not one will visit the same spot. I have been down at the Solway in late October on a day of blustery wind and heavy showers with wisps of snipe everywhere; so many of them they looked from a distance like clouds of midges. The following day I hurried back laden with cartridges and there was not one to be seen.

Woodcock are another weather indicator, and every year I always expect to see one in the same place at the end of October, after the full moon. On the edge of the moor, the ruins of a shepherd's bothy nestle in a sheltered south-facing valley where a small burn meets a bigger one. It is protected from the north by a windbreak of old Scots pines and contorted larches, and on the other three sides by the steeply rising slopes of the surrounding hills. If I climb the steep sheep path above the ruin during the first week of November, a woodcock invariably materializes out of a patch of dead bracken where it had been dozing in the sunshine and, after jinxing from side to side, silently curves away to 'fall' among the trees.

The first 'falls' of these magical birds, whom the French so eloquently call *'La Mordorée'* – the Golden Queen of the Woods – arrive from northern Europe around Hallow'een, 31 October, when they are driven south, like snipe, as the ground becomes too hard for the pliable tip of their beak to penetrate, lolloping like great moths under the Hunter's Moon. Exhausted birds are often seen with their feathers puffed up, recuperating in the bent grass among the sand dunes of the east coast. It is extraordinary that a bird completely unsuited for prolonged flight, whose digestion is so rapid and whose food intake normally so frequent, should undertake a long sea crossing. Success depends on the north-easterly wind and disaster lies in being caught in an offshore blow that prevents them landing – sometimes forcing them to alight on fishing boats. The extremes in condition between birds that have had an easy or difficult crossing led to a theory there were two distinct species. With plentiful food, their voracious appetite leads to a rapid recovery, and in open weather in early November woodcock stick to high ground as they move across country to winter in mixed woodland with decent undercover and open glades.

For sheer fascination, woodcock stand shoulder to shoulder with brown hares and, on the rare occasions when they can be watched undisturbed, always provide a thrilling and memorable experience: the silent, ghostly movement along a woodland ride as one makes its lazy journey to a favourite feeding ground at dawn or dusk; the way the dumpy little creature stands four square on the edge of a damp clearing, probing the ground with its long delicate beak, occasionally performing a rapid, stamping dance to bring worms closer to the surface. A survey by the Game and Wildlife Conservation Trust in 2008 recorded 79,000 resident breeding pairs in Britain, with 750,000 migrants arriving from Scandinavia and northern Europe. Spring migration starts in February or the beginning of March, depending on the weather, with woodcock filling the woods along our east coast, waiting for the right wind for the return journey.

Our otherwise mute resident cock birds become vocal from March until June as they perform a territorial mating flight, known as roding. Flying at tree-canopy height they quarter their territory, periodically uttering far-carrying frog-like croaks ending in a high-pitched squeak, to which the silent female responds by exposing the white underside of her wing. Unlike most birds, woodcock are philanderers, staying with the hen for only a few days before searching for another. Roding can continue until August as immature and less-experienced males search for females. Nests are rarely seen, with the hen relying on the camouflage of her plumage – all the colours of autumn leaves, yellow, black, chestnut, russet, citron, gold and copper – which integrates into her preferred habitat among brambly woodland of mixed ash and sycamore. She raises her four chicks single-handed, and if disturbed or threatened will relocate them, transporting each chick clutched between her thighs.

WINTER MIGRATION

Up until the nineteenth century, when the mystery of migration was finally accepted, there had been several theories about where seasonal visitors spent their periods of absence. Swallows and house martins were believed to hibernate in ponds, because they build nests of mud and are often seen skimming the surface of small inland waters to drink. Cuckoos either turned into a kestrel or hibernated in hollow trees. Geese are often heard or seen travelling by the light of an autumn moon ('the Gabriel hounds'), and it was not unreasonable for people to assume that the various migrant goose species lived there for part of the year. Some believed the same about woodcock, whose ghostly movements under the Hunter's Moon helped fuel the belief that witches were abroad at Hallowe'en. Others insisted that they hibernated in sand below the tide line, which explained why bedraggled birds were sometimes found on the sea shore or floating in the surf.

A bird of passage gone as soon as found,
Now in the moon perhaps, now underground.
ALEXANDER POPE, 'An Epistle to Cobham' (1733)

I always think of nightingales when spring has arrived in the south of England and winter is still reluctant to release its grip north of the Border. I heard my first one as a very small child staying with my grandparents in the Ashdown Forest. I had been fast asleep when my sister woke me with an excited whisper, 'A nightingale. You must listen to the nightingale sing.' Together we sat on the window seat, gazing across moonlit lawns towards the Forest, with the tall pine trees that were Winnie the Pooh's camel standing out against the skyline. Just as I began to wish I was back in bed, a warm gust of air laden with the most exquisite scent, a combination of all the day's blossom fragrances, wafted past. It lasted for a second, then the evening chill closed in again and it was completely gone. At that moment, as if nature had not already done enough to impress, the most wonderful sound I had ever heard filled the silence, as a nightingale started to sing. A rapid succession of varied, gushing, unconstructed notes, some harsh, some liquid, sung with great urgency, exuberance and vigour, which changed to a long, slow, pleading song that rose in volume to a sudden piteous crescendo, before reverting to a tune of jollity and mirth. Nothing but a phoenix could be capable of such music, and in my mind's eye I saw it erect and glowing, somewhere in the darkness among the oak trees, but no amount of searching that morning produced a single golden feather.

It is a paradox of nature that a bird capable of a song so loud and intensely lovely that Isaac Walton described it as making *'mankind to think miracles are not ceased'* is a dowdy little thing, only slightly larger than a robin, to whom it is related as part of the enormous thrush family. Nightingales have none of a robin's pride or arrogance and are rarely seen. Hiding deep in the undergrowth of deciduous woodland, heaths and thorn thickets (there was a belief at one time that nightingales

only achieved the more plaintive notes by pressing their breasts against thorns) camouflaged by their dun-coloured body, buff chest and belly. They feed on worms, spiders, ground-living woodland insects and, occasionally, small berries. Rare sightings of them are usually the flicker of their chestnut tail feathers as they bolt for cover when their feeding is disturbed.

> *'How subtle is the bird she started out*
> *And raised a plaintive note of danger nigh*
> *Ere we were past the brambles and now near*
> *Her nest she sudden stops – as choaking fear*
> *That might betray her home so even now*
> *We'll leave it as we found it – safety's guard*
> *Of pathless solitude shall keep it still*
> *See there she's sitting on an old oak bough*
> *Mute in her fears our presence doth retard*
> *Her Joys and doubts turns all her rapture chill*
> *Sing on sweet bird may no worse hap befall*
> *Thy visions than the fear that now decieves.'*
> JOHN CLARE, 'The Nightingale's Nest' (1835)

Nightingales winter in West Africa, north of the equator, and have a very wide breeding distribution, ranging east through Asia Minor to the Pamirs and west from Morocco, the Mediterranean countries, to Holland, central Germany, Denmark, Poland and the Ukraine. Cock birds arrive in Britain towards the end of April, establishing mating territories in the south and east. They are rarely seen north of the Humber, in Wales, the south-west or Ireland. Why they avoid the West Country, which has such an abundance of perfect habitat, has never been adequately explained. Gilbert White (1720–93) had a theory, supported by the great ornithologist, the Rev. C.A. Johns, in *British Birds in their Haunts*, that nightingales avoid long sea crossings, entering Britain at the narrowest point and only spreading across those counties nearest the direction of its migration.

Cock nightingales migrate ahead of the hens and when they arrive their singing is competitive, the volume and range of song marking their breeding ground. Nightingales often return year after year to the same place, and until about sixty years ago bird catchers would be waiting for them, as tired, distracted birds were easily caught. Experience had shown that cocks caught before hens arrived would continue to sing if caged, but pined and died in silence if confined after they pair. Hens appear about ten days later, at the beginning of May, and through this period cocks sing frantically day and night, as the hens can arrive at any time. The cock vocalises to attract a female and the volume of his song increases. His courtship display, conducted from a perch on the edge of his favourite bush, includes spreading his russet tail feathers and flicking them up and down, fluttering his wings and bending forward with his beak below the level of his perch, presumably to suck air into his lungs as he throws his body back and fills the air with his love song.

Once paired, the hen makes a little cup-shaped nest deep in a bramble or blackthorn bush and other dense vegetation, out of dead leaves lined with grass or animal

hair. Sometimes nests are made on the ground, hidden and protected inside a thick patch of nettles. The hen bird incubates her four or five olive-brown eggs single-handed, whilst the cock continues to sing his glorious song, with an added lilt of triumph and exuberance. Incubation takes a fortnight and as soon as the eggs hatch and the cock starts to share the role of feeding the chicks his singing stops. Milton's *'sweet bird that shunn'st the noise of folly, most musical, most melancholy'* can now only manage a frog-like croak or a grating, irritable 'tchaaa', when alarmed. Most birds have ceased to sing by the beginning of June, with only the occasional straggler crooning on to the end of the month, usually when an early hatch has been lost. Young birds leave the nest after about twelve days and, unless you notice their coppery tail feathers, are often mistaken for juvenile robins. Nightingales start migrating back to West Africa towards the end of July and are gone by mid-August.

There are between 3 and 5 million nesting pairs across Europe, with France, Italy and Spain having the largest populations. Numbers in Britain dropped away during the 1970s and 80s due to habitat damage caused by a decline in deciduous woodland management and the loss of coppicing. Subsidised hardwood planting and alternatives to farming in the form of Countryside Premium and Rural Stewardship schemes have done much to bring back a population, now estimated at between 5,000 and 6,000. A local Wildlife Trust or the RSPB will usually supply information on where nightingales can be heard.

HIBERNATING WILDLIFE

There are a whole range of animals – hedgehogs, dormice, toads, bats, newts, frogs and adders, to name only some – which go into hibernation when the temperature drops below around 10 degrees Centigrade, emerging groggily again when it rises. With the mild winters we have experienced for the last decade, this happens fairly frequently. Hibernators store just enough body fat to see them through the winter in a torpid state, and emerging at the wrong time due to a rise in temperature, when there is no available food source, must account for a number of deaths and failed pregnancies.

BATS

Bats are one species that manages to hibernate throughout the winter and I consider myself fortunate to have a colony on the farm. Above my workshop, in what was once the feed room for the carthorses, is a pathetic little garret reached by a ladder, where a succession of bachelor farm workers lived. In 1923, one of them painted his name on the door and, more in hope than expectation, the word 'Welcome'. Behind the crumbling plaster and lathe walls, with their shreds of flower-patterned wallpaper, a colony of tiny pipistrelle bats – the smallest in Britain – have established a nursery colony.

From late August, until the drop in temperature forces them into hibernation, male pipistrelles, gorged on the insects they have eaten through the summer, parade outside their breeding sites. This might be a crack in a wall, a hole in a tree or the gap under a roof tile, which the male vigorously defends against other would-be

suitors. A love song, inaudible to human ears, and wafts of pheromones attract a succession of females which are lured into the male's den for mating. Female bats have developed a system of delayed fertilization, retaining the male's sperm separate from their eggs, allowing them to avoid ovulating until they emerge from hibernation in the spring. Bats hibernate from October until March, or whenever the temperature drops below 10 degrees Centigrade in the autumn and rises above it in the spring. In May or June, when their condition has improved through feeding, pregnancy kicks in and female bats create maternity roosts in traditional sites, whilst males and barren females roost elsewhere. Gestation is around five to seven weeks and is controlled by the weather; warmth is essential to young bat pups and gestation can be arrested if there is a prolonged period of cold and wet conditions.

Bats roost hanging upside down by their toes, but to give birth the female hangs by her thumbs. She draws her legs up to create a pouch of her tail membrane into which the bald, blind pup is born in June or July. The tiny infant, with its disproportionately large head and feet, crawls up the fur on the dam's chest, latching onto her breast with its teeth, and for the first week, or until the pup becomes too heavy, the dam continues to hunt with her infant clinging to a nipple. A bat's hooked teeth are thought to be specifically designed to provide the young with a secure attachment whilst the mother is in flight. Once the pup's weight affects her flying ability it is detached, placed in a crêche of other infants and fed every couple of hours until it is old enough to fly, at about three weeks. After six to eight weeks, they are fully weaned and able to forage for themselves. This is the period I love. A stream of adult and juvenile bats, dropping like leaves out of a crack in the wall below the garret roof, just as the light fades, perform their spectacular aerial ballet, swooping and diving around the square formed by the farm buildings.

Our part of the Borders has a high rainfall, and the boggy, misty countryside with its big areas of woodland is ideally suited to the night-active insect life on which bats feed, such as midges, mosquitoes, lacewings, moths and beetles. Our farm is particularly well situated for a variety of bat species – the stand of old larches, ash trees and Scots pines on the knoll behind the farm buildings provide roosts for Noctule bats (one of Britain's largest, with a wing span of 400mm), which skim like swallows above the treetops. As dusk turns to darkness, common long-eared bats, Natterers and Whiskered bats flicker through the nearby ruins of Bothwell's gaunt castle, whilst scores of Daubenton's bats circle among the alder trees to dive for midges above the surface of the Hermitage Water. Not everyone is as lucky; the sixteen species of bat found in Britain are among our most endangered mammals. Some, such as the Bechstein, Barbastelle, Serotine and Greater Horseshoe, are considered under threat and are now only found in the south and west. The heavy, slow-moving, Mouse-eared bat is probably extinct, and any rare sightings in Kent and Sussex are almost certainly vagrants from France.

The bat population had been in gradual decline since the 1900s and this accelerated during the 1960s and 70s as intensive farming destroyed much of the habitat that provided their food and shelter. Thousands of acres of insect-rich permanent pasture were ploughed out and wetlands drained. Pesticides further reduced the available food source and created health problems through bats eating contaminated insects. Hundreds of miles of hedgerows were grubbed out under field expansion schemes and acres of old deciduous woodland cut down, to be replaced by close-planted conifers. Many bats relocated from woodland to old traditional farm buildings, only to be dislodged as these became popular for conversion. Increasingly, bats sought new roosts in the roofs of houses and there are an estimated 50,000 homes today providing accommodation to a colony of bats.

All bats became protected under the Wildlife and Countryside Act of 1981, and it is now an offence to kill, injure or disturb them. At about this time, county bat conservation organizations, known as Bat Groups, started to be formed to increase knowledge, understanding and acceptance of these unique creatures. In 1992, the Bat Conservation Trust was created to act as an umbrella organization to the growing number of county Bat Groups. There is now a network of nearly 100 Bat Groups throughout Britain, with some 1,500 bat workers who provide rescue centres for injured bats, survey roosts, monitor hibernation sites and advise householders, builders, farmers and foresters on how to preserve bat habitats. One of their most important roles is raising public awareness by organizing monthly events and bat walks to visit known roosts from May to September.

BAT DETECTORS

Since bat activity takes place in rapidly fading light, the principal tool on these occasions is the bat detector. A bat detector is to the *chiroptologist* (as we bat aficionados are known) what binoculars are to the bird watcher and is the ideal present for the person who has everything. Bats are able to fly and locate prey by echo location: sounds emitted through the mouth or nose at incredible speed – up to thirty a second – are reflected back from objects, enabling bats to build up sound pictures in their brain of their immediate surroundings and to hunt, even in complete darkness. Bats burn an enormous amount of energy flying and their consumption of insects is prodigious – a tiny pipistrelle will eat 3,000 midges a night. Bat detectors convert these ultrasonic calls into sounds audible to humans, allowing us to plot movements and identify species through a fascinating series of clicks, ticks and smacks, which rise to a crescendo as they home in for the kill. Added to these are extraordinary little bird-like chirrups and squeaks detected during the breeding season.

The annual European Bat Weekend, held every year at the end of August, is a celebration of bats and bat conservation, organized by the Bat Conservation Trust. A whole range of walks, talks and public events are arranged across Britain and throughout Europe, as those countries on the Continent who, like the UK, are part of the conservation group, Eurobats, set up light traps to draw in insects and bat detectors to record their resident bats as they swoop in to feed. It is a wonderful opportunity for anyone interested to join in the fun and learn something about the world's only true flying mammal.

HEDGEHOGS

Towards the end of autumn, hedgehogs start searching for suitable sites to construct individual hibernacula, a thick nest of leaves and grass. These may be inside compost heaps, under brushwood, deep among the roots of a hedge, old rabbit burrows or wasps' nests and beneath garden sheds. When there is a sustained period of low temperature in November, December or January and the food source of invertebrates becomes more difficult to find, hedgehogs retreat to their hibernacula. Then they become torpid, their bodies cool from 35 degrees to 10, their heartbeats drop from around 190 per minute to a scarcely perceptible 20, respiration is reduced to once every few minutes and they survive on energy from body fat built up over the summer. Fluctuations in temperature cause them to wake up, particularly extreme cold. If the glass on a barometer falls below freezing, the hedgehog's metabolism switches back on again, body temperature rises and rather than improve insulation in their existing hibernacula they look for an alternative site.

Hibernation lasts until late March or April, and sufficient body weight in early winter is vital: a young hedgehog under 500g or an adult weighing less than a kilogram is unlikely to survive. Mating begins as soon as they have recovered from hibernation and lasts until July, with the boar travelling up to 3 km a night in search of a sow. Apart from a snuffling sound when quartering the ground in search of food and a mewing sound, which the young make when frightened, mating is a rare occasion when the creatures become vocal. During the witch scene in Macbeth, *'thrice and once the hedge-pig whin'd'* refers to the hedgehog boar calling for a sow. Courtship is protracted and involves much circling, snorting and bumping as the boar encourages the sow to flatten her spines and protrude her hindquarters, allowing him to mate without injury. As soon as mating is over, the boar abandons the sow and sets off in search of another.

Gestation is between four and five weeks, with the sow usually giving birth to five piglets. The young are born blind with a coat of soft white spines which are beneath the skin to protect the mother during birth, emerging after a few hours. These are replaced by a second coat of stronger spines after thirty-six hours,

followed by a third and darker adult set, which develops into a protective layer of between 5,000 and 6,000 spines 25mm long. Each lasts about a year before dropping off and being replaced by a fresh one. The face and belly are covered in coarse hair and, being unable to groom themselves, their coats are usually full of fleas and mites. Young hedgehogs' eyes open at ten days; they can curl into a defensive ball at a fortnight; are weaned after four weeks and learn to forage at night with their mother. At six weeks they become independent. A sow disturbed with a litter of newborn young often kills or abandons them, but will transport older ones by the scruff to a safer place. A sow that has lost a litter may come in season again and have another, which will be unlikely to gain enough body weight to last the winter.

Hedgehogs spend all day asleep in a secluded nest, emerging to feed after dark and covering 90,000 square metres hunting for the hundred or so invertebrates required to satisfy their appetite. They are only seen in daylight when food is scarce or if their body weight is low as winter approaches. A hedgehog's diet consists mainly of worms, beetles and caterpillars, but it will also eat berries, fallen fruit, slugs, snails, eggs and fledglings of small ground-nesting birds, mice, frogs, lizards and carrion. In a dry summer I have often seen them at night feeding on road kill. They are immune to adder bites and are reputed to eat them, having first provoked the adder into exhausting itself attacking their impenetrable wall of spines. Hedgehogs have notoriously feeble eyesight, relying on acute senses of smell and hearing to locate prey above ground, and up to 3cm below soil. They can swim, climb and are capable of reaching astonishing speeds for short periods.

Furze pigs, urchins or hedge pigs, as they still are known by some country people, are incredibly ancient in evolutionary terms and have been foraging across Britain and Europe, from Scandinavia to Romania, for over 10 million years. For much of their association with humans they have been victims of prejudice and either killed for food and quack medicine, or treated as vermin. The Romans were partial to hedgehog and the easily digested boiled flesh was a popular invalid food in the middle ages. Hedgehog meat was frequently eaten by country people well into the last century and the fat was reputed to cure all manner of ills – from boils to baldness. There was a widely held and persistent belief that they stole milk from cows and spread the dreaded *murrain* among cattle. In 1566 they were declared vermin under the Act for the Preservation of Grain, and a bounty was paid by church wardens for the snout of every hedgehog killed in their parish. This Act was only repealed in 1863, but by then they were being persecuted by gamekeepers for stealing game bird eggs and there was a brisk trade in live hedgehogs at London's Leadenhall market, where they were bought to control cockroaches and other insects in cellars, larders and food stores.

Under the UK Biodiversity Action Plan, hedgehogs are currently listed as a species of conservation concern, a status I suspect will soon become a priority.

> HEDGEHOGS HAVE NOTORIOUSLY FEEBLE EYESIGHT, RELYING ON ACUTE SENSES OF SMELL AND HEARING TO LOCATE PREY ABOVE GROUND, AND UP TO 3CM BELOW SOIL. THEY CAN SWIM, CLIMB AND ARE CAPABLE OF REACHING ASTONISHING SPEEDS FOR SHORT PERIODS.

A phenomenal number of these animals die on the roads; others are killed by garden pesticides, mowing machines and man-made pitfalls such as swimming pools, cattle grids, steep-sided drains or becoming entangled in rubbish or plastic netting, but their single greatest threat is badgers. Badgers and hedgehogs share the same woodland habitat and as badger numbers escalate every year and competition for their natural food source of slugs, worms, berries, baby rabbits, ground nesting bird's eggs and the occasional adder or grass snake increases, hedgehogs have become part of the diet.

BADGERS

It is a tragedy that badgers, once our most respected woodland creature and the principal character in many works of fiction such as *The Tale of Mr Todd* by Beatrix Potter, *Wind in the Willows* by Kenneth Grahame, *Prince Caspian* by C.S. Lewis and *The Fantastic Mr Fox* by Roald Dahl, to name only a few, have become an object of odium to many people. Over the last twenty years or so, the poor old brocks have found themselves at the centre of a controversy over bovine tuberculosis, which they are believed to carry and transmit to cattle. Under the Badger Protection Act 1992 the species was given complete immunity from disturbance or persecution, apart from exceptional circumstances, such as a new housing development or motorway, where a licence may be obtained for their removal from a statutory authority. As a consequence, the badger population has rocketed to around 250,000 and cases of bovine TB among cattle have escalated, as has damage to crops and gardens across the country.

> OVER THE LAST TWENTY YEARS OR SO, THE POOR OLD BROCKS HAVE FOUND THEMSELVES AT THE CENTRE OF A CONTROVERSY OVER BOVINE TUBERCULOSIS, WHICH THEY ARE BELIEVED TO CARRY AND TRANSMIT TO CATTLE.

At the same time, badgers have been forced to change their eating habits, due to pressure on their normal food source, and will now eat carrion, take young lambs or break into chicken houses – the local mole catcher was telling me the other day that badgers even dig up and eat the moles caught in his traps. Old or sick badgers that have been expelled from the family sett linger on due to the mild winters, and every year 50,000 badgers are run over, particularly at night when they are feeding on road kill. Moreover, as is always the case with over-population, the species is becoming smaller and weaker. The plight of the badger today is another instance of bureaucracy interfering with man's management of wildlife. Even the eminent pathologist, the late Professor M.E. Kay, who served for ten years on the National Badger Advisory Panel, observed: 'What we need is a healthy population of badgers, but not too many of them. The key word is "balance".'

The behaviour of badgers differs by family, but all shelter underground, living in burrows called setts. Some family units are solitary, while others are known to form clans, colonies or cetes of up to fifteen individual families, living together in deep, extensive setts of immense antiquity. Unlike foxes, badgers are phenomenally clean animals and one simple way of identifying a badger sett is by the piles of old bedding – leaves, grass or bracken – which are regularly dragged out of their

sleeping chambers. A sow badger gives birth to one, two or occasionally three cubs in around mid-February, although the sow can mate at any time of the year after weaning, keeping the eggs in the womb in a state of suspended development until they implant, usually at the end of December. This serves a dual purpose: the sow and boar mate when both are in good condition, but if the sow subsequently loses weight in a hard winter her metabolism determines if and when the eggs become implanted.

Badger cubs are fascinating to watch in late May or early June, playing outside their sett, exuberantly chasing each other round a tree stump or playing 'king of the castle', and there is no shortage of Badger Groups offering advice on where to see them. A hand-reared orphan cub makes an enchanting and easily house-trained pet. A friend of my father's had one which lived in the house and followed him around like a dog. Churchill, who had the capacity to completely switch off from a crisis, heard of the badger and asked to borrow it one afternoon during the crucial stages of the Battle of Britain. When my father's friend arrived at Chartwell to collect the badger, Churchill's private secretary told him that there might be some delay. 'We didn't like to disturb the Prime Minister,' he said, 'but if you follow me, you will see something to remember for the rest of your life.' In a deck chair at the far end of the lawn, Churchill lay fast asleep with the badger cradled in his arms. Whilst the RAF fought the most significant battle of the war in the skies above him, the great man had played with the badger until they were both exhausted.

ADDERS

A few days of consistent April sunshine and I start to keep an eye out for adders basking on patches of bare south-facing ground above likely hibernation sites – a heap of rocks, and old section of dry stone wall or a disused rabbit burrow. *Vipera berus*, Britain's only venomous reptile, are short stocky creatures with disproportionately small heads, easily identifiable by the dark zigzag pattern that runs the length of their back. The male is 60–70cm long and bears varying colours of grey and khaki, whilst the larger, stouter female is more brown or red. In both cases the belly is grey and the throat cream. Melanistic variants are not uncommon.

Adders have the widest distribution of any snake and are found throughout Europe, Scandinavia, across Russia and Asia to northern China and are the only species found inside the Arctic circle. They occur in a range of habitats from open heathland, woodland glades and moors to grassy cliff tops, sand dunes and railway embankments. Their principal requirement seems to be an open, sunny environment with enough rough cover to escape into when disturbed, free of urban populations.

Male adders begin to stir in their hibernation dens – a pile of stones, the burrow of another animal or a deep, dry crevice – which they may share communally and occasionally with other reptiles, such as toads, frogs and lizards when the temperature reaches around 10 degrees Centigrade. They emerge several weeks before the females and spend most of the day absorbing warmth and vitamin D from sunlight as their sperm develops. They do not feed during this period and continue to live off remaining body fats stored the previous summer. In due course, as the females start appearing, they become more active. Last year's dusty skin is shed and

the male, gleaming brightly, sets off following a female's scent trail with his tongue, which acts as the olfactory organ. Once a female has been located, the male begins a courtship display which involves writhing over and round her, flicking his tongue along her body and tapping her with his head. This behaviour becomes more frantic as the female begins to release pheromones. If another male appears the first will defend his position aggressively and an 'adder dance' ensues, taking the form of a wrestling match which continues until one concedes defeat and the victor returns to the female. Once male and female have joined together they may remained locked for up to an hour. If disturbed during this period, the female will glide away, dragging the male behind her. Sexual maturity is reached by males at 3–4 years, and females a season later.

Female adders who have bred are generally desperately undernourished when they enter hibernation and only reproduce, at most, every other year. Female adders give birth to live young, and with gestation lasting around twelve weeks she needs to feed hard as soon as mating is over, to build up fat before pregnancy reduces her ability to hunt. Normally, between five and fifteen brick-red young, 20cm long, are born towards the end of August and early September. These are fully active and, although they may hide beneath their mother during the first twenty-four hours, they receive no parental attention and soon disperse to search for juvenile invertebrates. Adders seek hibernation sites when the glass drops in October, emerging from time to time if the temperature rises above 10 degrees Centigrade.

An adder's prey consists of small mammals such as shrews, voles, field mice, lizards, frogs, toads and, during the nesting season, fledglings of ground-nesting birds. They hunt using their tongue to follow scent and heat sensors located on their slightly upturned snout, which detects the prey's body warmth. The quarry is killed with a bite from hollow, hinged fangs through which venom is injected from glands in the upper jaw. The fangs fold back and the wide-opening upper and lower jaws move independently to allow an adder to swallow its victim whole, head first, whilst enzymes in their digestive tracts break down all bones and tissue except fur.

Although poisonous, adders are not aggressive and their danger is largely exaggerated. They are more anxious to avoid people than to attack, and usually move into cover as soon as they detect the ground vibration of an approaching human. Bites happen through accident or stupidity and are rarely fatal – the last death was in 1975 – but the effect varies from localised discomfort and swelling to vomiting and diarrhoea. Dogs and children are particularly at risk in the spring when the haemotoxic venom is more potent. I have lost the use of two sheepdogs to adder bites and my beloved terrier, Tug, very nearly died from being bitten by an adder which had come out of hibernation during a warm spell in the middle of January, some years ago.

Adders have few predators. A hungry brock will take the odd one; a fox with nothing better to do might torment an adder until it is exhausted and kill it. Hedgehogs occasionally eat them, and basking adders run the risk of being spotted by buzzards. They have, however, suffered a drastic loss of habitat in the last fifty years through intensified farming, agricultural reclamations, motorways and urban spread. Although not threatened with extinction in Britain or considered a priority species under the UK Biodiversity Action Plan, adders are endangered in certain areas. Since 1981, adders have been protected under the Wildlife and Countryside Act from being killed, injured or sold. Assessing the adder population is now of considerable importance, and the Herpetological Conservation Trust are always grateful for information on adder sightings.

ADDER CATCHERS

Until the twentieth century, ointment made from adder fat was the universal cure for bruises, migraine, rheumatism or snake bite, and in parts of Europe it still is. Adder catchers in various parts of the country made a decent living catching and selling adders to quack doctors. Perhaps the most famous snake catcher was Harry Mills, who died in 1905. During his lifetime, 'Brusher' Mills is reputed to have caught over 20,000 snakes in the New Forest. He was a habitué of the Railway Inn at Brockenhurst (subsequently renamed the Snake Catcher, after he was found dead in one of the outbuildings) where he sponged drinks off tourists by releasing live adders in the bar and catching them again with his hands.

TOADS

On summer evenings, the cobbled courtyard at the back of our farmhouse becomes the hunting ground for a large, khaki-black female toad. I often see her in the light of my torch when I let the terriers out for their late-night run, creeping ponderously along the base of the buildings, searching for slugs, worms, centipedes and woodlice or squatting as she waits for insects to come within range of her long, sticky tongue. Like all toads she is an opportunist feeder and will eat anything she can fit into her mouth, from spiders to field mice, or even the dry warty skin which she sheds frequently through the summer. Sometimes, if we leave the back door open on hot nights, she comes into the passage leading to the boot room and sits under the light, in the hope that moths will drop down to her. When approached, she inflates her body and crouches with arms and legs akimbo, gazing belligerently through bulging golden eyes.

A toad's prehistoric appearance, nocturnal habits and reputed association with witches have always made them much maligned. Even during the Age of Enlightenment, the eighteenth-century naturalist, Thomas Pennant, described them as '*the most deformed and hideous of all animals – objects of detestation*'. People believed toads were poisonous and carried a magical stone, the '*crapaudina*' or toadstone in their skulls, which was an antidote for any poisonous bites, stings or toothache. Quack doctors sold rings and amulets made from a type of dark, spotted basalt found in Derbyshire, which is now called toadstone. They perpetuated the myth that toads were poisonous by using live ones at country fairs to demonstrate the efficacy of their poison-curing potions. The quack's assistant would appear to swallow one, collapse and be revived – hence the word 'toady'. Female toads are considerably larger than the male; ours is about 15cm from her snout to her tail and is superbly gross, bloated and warty. She is presumably the epitome of womanly desirability to a male toad, with her grotesque body supported by long, powerful hind legs and surprisingly slim, elegant forearms. I estimate her to be about ten years old and her longevity suggests that her traditional breeding site is not far away. Even so, it is remarkable she has survived so long.

> FEMALE TOADS ARE CONSIDERABLY LARGER THAN THE MALE; OURS IS ABOUT 15CM FROM HER SNOUT TO HER TAIL AND IS SUPERBLY GROSS, BLOATED AND WARTY. SHE IS PRESUMABLY THE EPITOME OF WOMANLY DESIRABILITY TO A MALE TOAD, WITH HER GROTESQUE BODY SUPPORTED BY LONG, POWERFUL HIND LEGS AND SURPRISINGLY SLIM, ELEGANT FOREARMS.

Toads can live for twenty years in the wild or up to forty in captivity, but the casualty rate is phenomenal. Their only defence against predators – foxes, stoats and weasels – is the parotid glands that project in the form of lumps at the back of the neck. These contain cardiac glycosides potentially strong enough to stop the heartbeat of a human and a disgusting-tasting toxic substance, which hyperactivates the salivary glands of anything that tries to bite them. Experienced predators learn to flip them onto their back and eat them without touching the poisonous upper body skin. Hedgehogs, grass snakes and adders appear to be immune to the toxins.

Common toads are our oldest reptiles and for a creature so ancient their reproduction is astonishingly chaotic. Except during the breeding season, both sexes are

solitary, living in damp secluded burrows under logs, rocks or deep in old leaf mould – our one has a lair under a stone water trough. They hibernate in these, or occasionally in large groups, sharing a den with snakes and newts, from October to the end of February or whenever the ground temperature reaches a consistent 9 degrees Centigrade. In March they experience an urge to return to their birth pond to breed and set off on nocturnal journeys which may take as little as a couple of nights or as long as a month, bypassing suitable locations and surmounting obstacles like walls with un-toad-like agility, in their determination to reach the ancestral breeding sites.

Unfortunately, many of the hereditary migration routes are now intersected by busy main roads, and so thousands of toads are squashed by motorists as they lumber across them. Since the mid-1980s, when the volume of toads killed on the road from Marlow to Henley-on-Thames created a serious traffic hazard, several hundred toad tunnels have been built under highways across the country, with flanking walls to guide the convoys of migrants into them. In other areas, volunteers from the Wildlife Trust and the charity, Frogline, monitor likely crossing places, erecting traffic warning signs and transporting bucketfuls of toads to safety. Despite these efforts, an estimated 20 tonnes of toad are killed annually and all too often the survivor's journey ends in disappointment, when they discover their breeding site has been drained or built over.

Male toads become sexually active at three years, and females a year later. Consequently, there is a massive disparity between males congregating at the ponds, canals or slow-moving rivers and available females. Older, experienced male toads lie in wait and ambush females along their route, arriving at the competitive shambles of the mating areas, clinging to her back – an embrace known as amplexus – by the nuptial pads on the inside of their thumbs and fingers. These nuptial pads become more pronounced during the breeding season and provide the grip which enables a male toad to remain in position for hours and possibly days, whilst his sperm fertilizes the female's eggs as it is released. They are also used by competing males to drag each other away from a female or to clamber onto the back of a male already in situ. Mating balls (the animal group name is a 'knot'), or multiple amplexi, regularly occur, when several males pile on top of a female, crushing or drowning her. Frustrated, inexperienced young toads frequently mount each other, frogs and even small fish, and the most commonly heard croak through the breeding season is the high-pitched staccato release call of an outraged male.

A female toad will lay as many as 2,000 eggs during a successful spawning, which settle in two strings between two and three metres long, round the stems of water plants. Once spawning is over, the adults leave the water and begin the weary, hazardous trudge back to their burrows, no doubt wondering whether it was all worth it. The tadpoles hatch after ten days and, although distasteful to most fish, they are prey to water beetles, water boatmen and newts. The tiny golden toadlets metamorphose from tadpoles at between twelve and sixteen weeks, depending on the water temperature. They leave their birth sites in July and August, dispersing into the countryside to find their own feeding territories. At this age their parotid glands are little protection and the young are vulnerable to all ground predators, as well as herons, crows and gulls. The survival rate is about one in twenty.

THE HUNTERS AND THE HUNTED IN WINTER

Hard winter weather is the time to see both the hunter and the hunted, as the creatures that don't hibernate struggle for survival. Nature is at her most cruel after a long frost, when the ground is iron hard and gravelly ice glints on the hedgerows. Predators find easy pickings as their prey becomes weak and distracted through cold and lack of food. This is the time when I expect to see stoats, nature's little nightmares, hunting by day when rabbits are out of their burrows and scratching for grass in the thin winter sunlight.

STOATS

Part of the mustelidae family, which includes otters, badgers, pine martens, polecats and weasels, stoats are the most perfect, utterly fearless, opportunist killing machines, the embodiment of sinuous agility and determination who, in the words of *The Irish Sportsman,* 'runs like a fox, dives like an otter, climbs like a cat, doubles like a hare and will stand before hounds for hours and beat them'. Their diet is sufficiently varied for them to have survived the loss of their principal food source through myxamotosis during the 1950s. They will hunt anything from shrews to hares, including reptiles, amphibians, fish and even, *in extremis*, will eat berries, earthworms and insects. They are deadly to ground-nesting birds or in a hen run; can shin up and down trees head first like a squirrel and cover the ground in an effortless lolloping gallop at a speed of 20 km. Such is their reputation in the

animal world for relentlessly holding to scent that rabbits and hares become paralysed with fear when they know they are being hunted by one, pathetically waiting for death. They will also mesmerise prey by performing a whirling dance, resembling a leaf spinning in the wind. I once saw a stoat spiralling on its hind legs in front of a ring of sparrows, which drew closer and closer until it struck and seized one.

At the far end of the farm there is an old wooden railway goods wagon, used as an emergency hay shed when snow blocks the track from the farm, and nearby are the tumbled remains of a stone sheep stell. Hay seeds trodden in over many decades have created an improved sward relished by the rabbit population from a warren on a bank 100 yards away. The hayshed and stones of the old sheep stell have provided a habitat to generations of stoats and it is one of the mysteries of the natural world that predator and prey can live in harmonious proximity with each other until, of course, a stoat feels hungry. To watch one kill is a truly primeval experience; the darting circuitous downwind stalk and vicious leap as the stoat launches an attack, entwining itself round a rabbit's head as it seeks to bury its teeth into the base of the skull. When satisfied the rabbit is dead, the stoat peers rapidly in every direction, muzzle lifted and ears pricked, before darting off into a clump of rushes. Within moments it returns to the carcass and performs a little victory dance, before pulling it backwards in a series of frantic tugs towards the hay shed, his body coiling and uncoiling in spasms of effort. Periodically he stops, not to rest but to sit upright on his haunches, nostrils twitching for scent, before continuing his journey. At the goods wagon, he slides through a gap where a plank has come loose and in a series of heaving jerks drags the rabbit through. Once inside, he hauls the rabbit three and a half metres to the upper layer of bales. The whole exercise is an incredible feat of strength, when you consider that a dog stoat is only 10cm long, a bitch about half that size, and their prey weighs at least six times as much as either of them. I try to remember this when I struggle out to feed the sheep after a heavy fall of snow and find the top bales covered in a disgusting mess of digested rabbit.

> TO WATCH ONE KILL IS A TRULY PRIMEVAL EXPERIENCE; THE DARTING CIRCUITOUS DOWNWIND STALK AND VICIOUS LEAP AS THE STOAT LAUNCHES AN ATTACK, ENTWINING ITSELF ROUND A RABBIT'S HEAD AS IT SEEKS TO BURY ITS TEETH INTO THE BASE OF THE SKULL.

Bitch stoats mate in July or August, often with multiple partners, and have a gestation period of eleven months, the longest delayed implantation of any mammal. She rears up to twelve kittens single-handed, which are born blind and are covered in white fur with a thicker patch at the nape, used by the mother if she needs to carry them. The kittens open their eyes after a month, are weaned at five weeks and the distinctive black tip to the tail, which identifies them from weasels, appears at six. It is not unusual for an adult dog stoat to force his way into the family group and inseminate a juvenile bitch at this age. After weaning, the family stays together for some time and I have occasionally watched a 'pack' of young stoats in the vicinity of the goods wagon being taught to hunt small mammals by their mother, and once saw a young rabbit with a bitch stoat and six young clinging to it.

Wildlife

Like all mustelids, stoats are inquisitive, playful and natural comics. A family at play, chasing each other at terrific speed, deliberately running to the top of a bank and tumbling down or collapsed in an exhausted family heap, is one of the great sights of nature. The other is an army of stoats on the move. As many as fifty, complete with scouts questing ahead of the main body, will swarm across the country with deadly intent, chittering and squealing among themselves. Although rarely seen in the flesh, stories of this terrifying phenonema were common in country tales, and as children we were warned to be wary in a long hot summer or a prolonged period of very cold weather, which seems to be the causal motivation for the stoats' behaviour.

In late autumn the young disperse to find their own territories, establishing several dens in abandoned burrows, rock crevices or among a pile of stones. They now become solitary, meeting only when the bitches are in oestrus. Both sexes fiercely defend their hunting grounds, which range from 2,000 to 6,000 square metres, depending on the type of habitat and food source. These are marked with pungent scent from the glands on either side of their anus. Like polecats, pine martens, ferrets and mink, stoats will use their scent glands as a powerful deterrent if attacked by a large animal that knows no better. Many a foolish young dog has undergone the indignity of repeated bathing until the appalling stink wears off.

Except for the glossy black tip to their tail, stoats turn white in winter. The rich copper colour of their summer coat disappears over a couple of days as the creamy belly fur spreads upwards over the back. Unlike blue hares, which turn white seasonally regardless of temperature, a stoat's pelage changes colour climatically. Some stoats seem more inclined to adopt winter clothing than others, with white stoats being seen during a temperate winter in the south; whereas in parts of the Highlands they remain white all year round. During the Middle Ages, ermine, as the white fur is called, became an extremely valuable commodity, and wearing it was restricted under medieval sumptuary laws to the highest ranks of nobility. Ermine imported from Russia, and later Canada, became the official mantling of Coronation and Parliamentary robes worn by Peers. It took up to thirty skins to create the heraldic white field flecked with black tails. To ensure that the Peers were properly turned out, 50,000 ermine skins were imported from Canada in 1937, for the coronation of King George VI. Curiously for an animal so merciless, a white stoat was once considered to be a symbol of purity and chastity which would rather die than get its coat dirty. Leonardo Da Vinci's famous painting, 'Lady with the Ermine' (1483) which hangs in the Czartoryski Museum, Cracow, is an ironic play on this belief. His subject, Cecilia Gallerami, depicted cradling a stoat in its winter pelage, was the seventeen-year-old mistress of the Duke of Milan, whose heraldic design was an ermine.

HARES

The chasing, boxing and posturing of brown hares in the early spring is a fascinating spectacle to watch.

> *'The March Hare will be much the most interesting, and perhaps as this is May it won't be raving mad – at least not so mad as it was in March'*
> LEWIS CARROLL, *Alice's Adventures in Wonderland* (1865)

Sometimes only a brace of hares are seen performing, and on these occasions it will be a buck and doe engaged in their courtship display, with the doe feigning reluctance to mate by fighting off the attentions of the buck. At other times, as many as six – a 'company' – will be seen, with two bucks rushing backwards and forwards, shadow boxing on their hind legs, leaping over each other or squatting nose to nose on their haunches like Sumo wrestlers, whilst the others follow their every move. This may be some form of competitive rutting display, but as hares breed from March until September, or longer now that our winters are so mild, I believe that this exuberant lunacy among otherwise solitary creatures is more their reaction to the start of spring growth, and certainty of summer's warmth, than any urge to rut.

There are three species of hare in the British Isles: the Blue or mountain hare, which is indigenous, turns from chocolate-brown to white in winter and lives on high moorland; the larger, lowland brown hare, which was an introduced breed; and the Irish hare. This last is a recognised species in its own right, exclusive to Ireland, which combines some of the characteristics of the other two, being larger than a mountain hare and with a coat that turns partially white in winter. Blue hares can be found on high ground across northern Europe and the Arctic regions. Brown hares have a natural distribution that extends across the whole of Europe to central Asia and were introduced during the 1800s for sport, to North and South America, Australia and New Zealand.

No other animal is more surrounded by myths and legends or commands such respect among sportsmen than the hare. Most of it is attached to brown hares, partly because they are bigger, faster, more extreme in every way and infinitely better eating than their mountain cousins, but also I suspect it is because they played such an important role in Celtic religion. Paradoxically, this, the wildest of all animals, can be easily tamed, if caught young enough, and the Celtic ruling classes liked to keep them in their houses as a sort of living connection to the gods. Boadicea is reputed to have careered into battle with the family pet stuffed inside her blouse, which suggests that brown hares were first introduced by the Celts and not by the Romans, as has been suggested. Performing hares were often used by travelling medieval jongleurs, in much the same way that monkeys were, by Victorian street entertainers. T.B Johnson, in the *Sportsman's Cyclopedia* (1831), refers to a hare appearing on the stage at Sadler's Wells, beating a drum with its forefeet.

Solitary and normally crepuscular, brown hares are the fastest, most agile European animal, capable of speeds of 40 km per hour. They can turn on a sixpence in full flight and jump 7 metres with ease. This in itself was enough to command respect from early people, but their behaviour, which sometimes appears almost humanly irrational, and a hideously childlike scream when caught or injured, convinced them that hares were more than simply animals. As surface dwellers relying on speed, eyesight and acute hearing for protection, they developed elaborate defensive tactics to disguise their scent from predators and protect their young. Hares live in 'forms' or 'seats' – shallow hollows scraped out of the ground in a position that gives them a clear view of the surrounding countryside. Hares feed at dusk and dawn, lying up by day and eating any trace of the soft faeces from the previous night's feed. When leaving or approaching their form, they double back and forth, making sudden leaps and 90 degree turns to break up the scent line. They are extraordinarily fastidious in their habits and loathe getting dirty or wet, although they will cross water to find a new food source, a mate, or to avoid pursuit. Hares will avoid entering a field where cattle are, or have been grazing, and dislike feeding anywhere near rabbits or sheep.

For centuries, there was a common belief that hares were hermaphrodite and that both sexes bred. This was disproved in the nineteenth century, but what is almost unique is their ability to be pregnant and conceive at the same time. Does can have four litters of between two and four leverets a year and, unlike most young animals that are born blind, bald and defenceless, these have fur and can see immediately. Once the birthing process is over, the doe scrupulously cleans each one and moves them to separate hiding places where they wait, silent and immobile, for their daily feed. About an hour after sunset, breaking her scent trail in the usual way, the doe suckles each leveret in turn. Once fed, she rolls the little animal on its back and stimulates the urinary area with her tongue, ingesting any discharge to ensure it remains scent free for the next twenty-four hours before moving them to new sites. Leverets become independent of their mothers after a month.

Under Norman Forest Law, hares were elevated to one of the five Noble Beasts of Venery, joining the hart, hind, boar and wolf. The Normans were great hound

men and loved hunting. Deer, boar and wolves provided speed and drama but for the complicated science of hound work there is still nothing to beat a hare. They remained fiercely protected by successive game laws, until suddenly demoted to vermin by the Ground Game Act of 1880. Nearly 200 years of agricultural improvements and the small-field mixed farming policy of the time, providing an ideal habitat and food range, had led to a dramatic increase in hare numbers – a conservative estimate of the winter population exceeded 4 million. With the right to take game restricted to landlords, tenant farmers struggling to survive decades of agricultural depression lobbied Parliament to be allowed to protect their crops at any time and by whatever means. Hare numbers dropped so alarmingly in the decade following the Act that a feeble effort to stop the decline, the Hare Preservation Act – which simply banned the sale of hares between March and July – was passed in 1892. It has been left to the sporting community to give hares the courtesy of a closed season.

Brown hares suffered another blow during the 1970s and 80s from modern farming. The traditional crop rotation of roots, grass leys and cereals, which had previously provided hares with a consistent food source, was replaced by arable monoculture. Pesticides removed weed plant varieties essential to their diet, and silage, cut so much earlier than hay, destroyed breeding habitat and killed leverets born just before cutting. The population dropped to 400,000 and the only areas hares could be seen in any number were those where landlords, who supported coursing under National Coursing Club rules, farmed for hare conservation. From 1995, when the EU introduced arable set-aside rules which subsidised farmers for land taken out of production, and a later provision, allowing this allocation to be used to create broad headlands, much lost habitat was replaced. As a consequence, brown hare numbers more than doubled and the population began to thrive. However, the greatest risk to the future of brown hares in the twenty-first century came from the 2004 Hunting Act, which took their conservation out of the hands of those who love and respect them.

> NO OTHER ANIMAL IS MORE SURROUNDED BY MYTHS AND LEGENDS OR COMMANDS SUCH RESPECT AMONG SPORTSMEN THAN THE HARE. MOST OF IT IS ATTACHED TO BROWN HARES, PARTLY BECAUSE THEY ARE BIGGER, FASTER, MORE EXTREME IN EVERY WAY AND INFINITELY BETTER EATING THAN THEIR MOUNTAIN COUSINS.

SHREWS

One of our smallest and most abundant mammals is the long-nosed common shrew – the Mammal Society estimates that there are nearly 42 million of them – and although rarely seen, their thin, angry squealing can sometimes be heard, particularly during the spring. Except when mating, both sexes are solitary and extremely aggressive, belligerently defending territories of about 400 square metres in woodland and half that in pasture. Should two strangers of either sex chance to meet out of the breeding season, they freeze momentarily in outraged disbelief, before rearing onto their hind legs, shrieking with anger. A brief but ferocious battle ensues with much scratching and snapping of teeth, generally ending with the trespasser being driven off and neither protagonist badly injured.

It is a very different matter during the breeding season, April to September, when male shrews roam outside their territories hunting for a mate. Now the sheer savagery and determination of their testosterone-fuelled encounter becomes a fight to the death.

Cousins of the minuscule pygmy shrew, Britain's smallest mammal, and the beautiful water shrew, common shrews are well distributed all over Britain except in Ireland and on high, peaty moorland in the north of Scotland. They live among long tussocky grass in pasture or moorland fringes, roadside verges, hedge bottoms and in deciduous woodland; foliage in the urban parks of any city provides ideal shrew habitat. The little creatures have a very high metabolic rate and expend so much energy in their craving for food that a shrew would starve to death if it did not eat every three hours. This forces them to hunt by day and night, moving in jerky runs, twittering and muttering as they poke their long noses into cracks and crevasses, under logs, among leaf litter or standing on their hind legs to snatch at passing insects. Shrews will eat any invertebrate – pouncing on slugs, snails, spiders, beetles, centipedes and scratching into dead wood for woodlice. Such is a shrews' need for food, they will, if desperate, eat carrion and even other shrews. Their favourite diet is earthworms, which they hunt along tiny burrows they dig just below the surface, relying on their acute sense of smell and bristling whiskers, which enables them to travel along tunnels in the dark, to guide them towards prey. Every couple of hours they collapse through exhaustion and snatch a few moments of deep sleep before continuing hunting. All British shrews are known as 'red-toothed', from the iron deposited in the enamel of their crowns, which makes the teeth more resistant to wear and tear. Nature has also given them another advantage in the form of a toxin in their saliva which stupefies their prey.

> THE LITTLE CREATURES HAVE A VERY HIGH METABOLIC RATE AND EXPEND SO MUCH ENERGY IN THEIR CRAVING FOR FOOD THAT A SHREW WOULD STARVE TO DEATH IF IT DID NOT EAT EVERY THREE HOURS. THIS FORCES THEM TO HUNT BY DAY AND NIGHT.

Almost black in their winter coat, which becomes lighter after the spring moult, the two sexes are only distinguishable by a patch of white hairs on the back of the female's neck where fur has been torn out by males during mating. Female shrews have between two and four litters of up to ten young, between April and September. The kits are born bald, blind and defenceless, and she rears them totally without help from the male, in a well-hidden nest of grass and leaves, until they become independent at about a month. During that time she must find twice the normal amount of food, a task which seems almost impossible. If the nest becomes threatened in any way, the mother shrew will lead her young to safety in a caravan fashion, with each using their mouth to hold onto the tail of the one in front.

There is a very high mortality rate among young shrews, probably due to competition for food at the end of summer when the population expands significantly. For a creature so aggressive, they are susceptible to stress and can die of shock. Country people believed shrews could be killed by thunder. They are vulnerable to a large number of predators, weasels, stoats, foxes, domestic cats and dogs. Although these

will kill shrews they rarely eat them, due to the foul-smelling scent gland contained in their thighs, used to mark out their territories. Birds of prey, which have a poor sense of taste, and owls in particular, eat shrews, and in some parts of the country badgers are so desperate for food they will scavenge for them.

For centuries, shrews suffered from completely unjustified persecution. Their Latin name, *araneus,* means spider, referring to the old belief that they were poisonous. No doubt this was based on the disproportionately painful bite these little creatures are capable of inflicting and was to lead to dire consequences for shrews. The warmth from cattle and sheep lying down to chew the cud attracts a variety of flies and insects; these in turn are a magnet for hungry shrews and hedgehogs. Where hedgehogs were accused of stealing milk, 'poisonous' shrews were believed to cause mass outbreaks of lameness, one of the dreaded murrains that periodically devastated livestock. Gilbert White, in his *Natural History and Antiquities of Selbourne* (1789), describes the common superstitious cure of the time: A hole was bored into an ash tree and a live shrew forced in. The hole was blocked up and a twig or branch cut from the 'shrew ash' applied to afflicted limbs.

OUR ISLANDS' INSECT LIFE

There are literally thousands of different insects that are common to the British Isles, including flies, fleas, midges, mosquitoes wasps, bees, worms, slugs, snails, beetles, earwigs, cockroaches, myriapods, spiders, ticks, lice and mites. By and large, people have an antipathy to most insects, and yet they are among our most fascinating wildlife. Those that repel because they bite or sting are balanced in equal measure by those that are beautiful, such as moths, butterflies and dragonflies, or immensely useful, such as ladybirds, which eat plant-destroying aphids, and bees, which pollinate flowers and without whom humans would not exist.

BEES

With the first spring sunshine, young queen bumblebees fertilised the previous summer emerge from winter hibernation and drowsily forage for plant nectar. After a couple of weeks they start actively searching for a nest site – depending on the species, the abandoned nests of mice or voles, tussocks or leaves at the base of hedges. Once a suitable place has been found, the bee makes a circular chamber of fine grass and plant debris. Inside, she constructs a cup with wax secreted from her abdomen, partially filled with pollen, on which to lay her eggs. At the same time another wax vessel is made to store a reserve of honey in case the weather turns cold and she is unable to forage. When the eggs are laid, the bee closes the cup with wax, incubates them like a broody hen and nourishes the grubs with honey and

pollen once they hatch. Within a month, these emerge as fully fledged, sterile, female worker bees who feed the queen and new broods of grubs as she produces them. As summer wears on the queen lays fewer eggs, and with the increase in food provided by the workers some of the larvae develop into queens, whilst others become drones (male bumblebees). These mate; the little colony disintegrates and all except new queens die as autumn approaches.

There are about 200 species of bumblebee worldwide and around nineteen in Britain. Six are familiar to most of us: Buff-tailed, Carder, White-tailed, Red-tailed, the Early Nesting bee with orange tail, and the yellow-banded Garden bee. Some, like the Red Shanked, Great Yellow, Shrill Carder and Blaeberry bumblebees are increasingly rare. There are also six species of cuckoo bumblebee which, like their avian namesake, are parasites. Emerging from hibernation later than normal bumblebees and invading an established nest to lay their eggs, cuckoo bees resemble the species they intend to use as a host, entering the nest, stinging the sitting queen to death and relying on the existing worker bees to bring up their broods. Her progeny are either all fertile females or drones – there are no workers – and their presence defeats the purpose of the original colony, as cuckoo grubs use up resources whilst contributing nothing to

> BEES – AND BUMBLEBEES IN PARTICULAR – ARE ESSENTIAL TO OUR SURVIVAL AS POLLINATORS OF CROPS, FLOWERS AND TREES ... BUMBLEBEES ARE THE CHIEF POLLINATORS OF THE ORCHARDS AND SOFT FRUIT MARKET GARDENS OF NORTHERN EUROPE AND SCANDINAVIA.

the nest. The other major parasite affecting the success of a nest is canopid flies. These horrid insects lurk in the vicinity of flowers which attract bumblebees; when a bee is occupied feeding, it leaps out of hiding and thrusts an egg into the bee's body. The egg feeds inside the bee, killing it within a fortnight. A bumblebee colony is also at risk from hungry badgers.

Bees – and bumblebees in particular – are essential to our survival as pollinators of crops, flowers and trees. The thick hair covering and ability to dislocate and vibrate their wing muscles to generate body heat enables them to be active earlier in the growing season when temperatures are below 10 degrees Centigrade, in wind or when there is cloud cover. Bumblebees are the chief pollinators of the orchards and soft fruit market gardens of northern Europe and Scandinavia. They are much stronger, more aggressive foragers than honey bees, forcing open flowers such as antirrhinum to get at nectar and pollen, which is transferred from plant to plant on their body hairs.

Agriculturalists have been aware of the bumblebee's essential role in pollination since the eighteenth century. Long-tongued species – Carder, White-tailed, Garden and Ruderal bumblebees – which can reach into the long narrow corollas of certain plants, were all imported to New Zealand in 1885 to pollinate red clover and alfa alfa forage crops. Bumblebees are now bred commercially for pollinating a whole range of fruit and vegetables cultivated in large-scale greenhouses. Around half a million colonies are reared annually and used in over thirty countries to cultivate everything from strawberries and kiwi fruit to cranberries, blueberries, aubergines, sweet peppers and cabbages. They are especially important in pollinating tomato plants:

tomato flowers are among flora that release pollen through vibration and bumblebees are one of the few species to 'buzz pollinate' – they seize hold of pollen-bearing anthers in the flower's centre and release pollen by vibrating their flight muscles without moving their wings. Bumblebees have now almost entirely replaced the labour-intensive artificial pollination previously used by commercial tomato growers.

Part of the fascination of bumblebees is how, with fat, hairy bodies completely out of proportion to their wings, they defy accepted theories of aerodynamics to become airborne. Bumblebee aeronautics studied at Göttingen University in the 1930s proved that, theoretically, they could not generate enough power for lift-off. 'The Bumblebee Paradox' puzzled and infuriated the world of science until 1996, when the Zoology Department at Cambridge University built robotic models of bumblebees to monitor airflow round moving wing tips. Over the last decade researchers have discovered that the flexible wings of a bumblebee, when forced through air at an acute angle, create a powerful vortex. Vortices – swirling masses of air – caused by rapid wing beats, produce sufficient up-draught for take-off and not only keep the bee airborne, but enable them to fly with surprising dexterity.

Large tracts of the British countryside have altered dramatically since the 1950s and bumblebees have suffered badly from habitat destruction. Three species are already extinct – the Apple, Cullems and Short-haired bumblebee – and many others have become scarce or localised. Bumblebees are active from spring until late summer and require a variety of different nectar and pollen sources during this period to keep the nest provisioned. Worker bees have a foraging range of under a mile and the loss of a particular flower species within their radius at a crucial time – through pesticides, forestry planting, urban development or changes in farming practice – can spell doom for the colony.

MOTHS

Of all our wildlife species, probably none have been more affected by climate change and habitat loss than moths. According to Butterfly Conservation, many of the 900 macro-moths and 1,600 micro-moths that occur in Britain and Ireland have undergone a drastic decline in both numbers and distribution over the last fifty years. Although the current network of county moth recorders produces invaluable records of what may be flying around in their different counties, there had been no national record of moth activity on a given night until 1999. *Atropos*, the journal for butterfly, moth and dragonfly enthusiasts, and Insectline, a telephone service for collating information on lepidoptera, launched National Moth Night. Becoming increasingly popular, it has taken place annually, on a differing night through the months of moth activity – April to September – with lepidopterists from all over Britain and Ireland setting up light traps and lures in a variety of different locations across the country and recording a wealth of moth species information. From 2004, National Moth Night was extended to include moths that are active by day, of which there are any number of species, some very scarce.

The beauty of National Moth Night is that anyone can join in, particularly children, and it has become something of a nationwide sporting event, with

enthusiasts gathering at lunch parties or evening barbecues. To add competitive spice to the occasion, there are always a number of prizes to be won for a variety of entries. In previous years these have included a very desirable, professionally made collapsible moth trap, complete with electrics and waterproof control panel; books on Lepidoptera, such as *The Aurelian Legacy: British Butterflies and their Collectors,* by M.A. Salmon, or *Pyraloidea of Europe* by Franti Sek Slamka; a set of binoculars; book tokens: or cash.

LURING MOTHS

To make a wine rope:
In a large pan, dissolve 1kg of white sugar in 1 litre of cheap red plonk. Bring to the boil and stir. Insert half a dozen one-metre lengths of light hemp rope or strips of material. Leave them in the syrupy liquid until it has cooled and become well absorbed. To ensure the best results, drape the wine ropes over low branches, bushes or fences just before dusk a few evenings in advance of the National Moth Night. Moths feeding on the ropes will be drowsy, to say the least, and easily manipulated into a jar or photographed.

To make moth 'sugar':
In a large pan, dissolve 1kg of Barbados sugar in 1 litre of brown ale. Simmer for 5 minutes. Add 50g black treacle. Simmer and stir the mixture vigorously for a further 5 minutes. Decant into an open-necked container, adding a dollop of Navy rum. Using a stiff paintbrush, smear the mixture at about head height on tree trunks, branches or the tops of fence posts.

Apart from a camera and a decent book on identifying moths (T*he Colour Identification Guide to Moths of the British Isles,* by Bernard Skinner, is recommended) very little is required for an evening's moth hunting. If there is sallow or ivy blossom nearby, red campion, night-scented stock, honeysuckle, buddleia, hebe and red valerian in the garden, moths can be found feeding by the light of a torch. To localise them for catching or photographing, use either a wine rope, or moth 'sugar'. Light trapping is the single most effective way of seeing moths, and an ultraviolet bulb rigged up to a post on an extension lead, with a white sheet below it, will draw in any number of them. Among moths certain to turn up in most gardens are Buff Arches, their wings marked with distinctive white and orange arcs; brilliantly coloured Large Emeralds, more like a butterfly than a moth; Yellowy Scalloped Oaks, with the wing divided by a brown central band; Swallowtails; lovely, dove-grey Peppered moths; a range of little yellow and grey Footmen; zebra-patterned Garden Tigers with blue dappled red under wings; and blood-red Ruby Tigers. There is likely to be no shortage of wretched Large Yellow Underwings either, one of the many drab, paisley-patterned *Noctuid* species whose larvae, known as cut worms, are so destructive to lettuces and brassicas. Everyone loves Hawkmoths and there is every chance of seeing the greyish-pink Poplar, green-camouflaged Lime, the exquisite pink-and-yellow-striped Elephant or the stunning Eyed Hawkmoth, with its pink underwing and blue-ringed eye spot markings, designed to deter owls and nightjars. Those in the south might see foreign vagrants that have come across the channel on pockets of warm air, such as the mighty Convolvulus Hawkmoth or, best of all and a contender for the rare immigrant specie prize, the Death's Head Hawkmoth. Of the micro-moths, White Pearls, Green Oak Rollers, Purple and Gold Pyralids, a range of small ermines with the tiny black dots on their wings or the almost translucent White pearls, may appear under the light.

There is terrific scope for those attracted to the idea of a lunchtime moth hunt, not least because organisers are keen for recordings of daylight-feeding Clearwing moths. The best way to see these delicate creatures involves luring them with artificial sex pheromones, which have been developed to control pest species. (A form irresistible to Clearwings is available from Anglian Lepidopterist Supplies of Hindolveston, in Norfolk.) Remove the top from a vial and suspend it in a pair of tights hung from a branch and watch the Clearwings home in over lunch. If there are sufficient larval food plants in the area, such as willow, poplar, birch or currant bushes, a variety of species may gather: Red-tipped, Six-belted, Orange-tailed, White-barred or Currant Clearwings. Target species are the Dusky Clearwing, last seen in 1924, and the Welsh Clearwing (if you are lunching in Wales) identified by the two narrow yellow bands round its black abdomen and an orange tail fan. If anyone feels up to a post-prandial wander in the surrounding countryside, brilliantly coloured Burnet and Forester moths could be sighted, or russet Fox moths, dun Oak Eggars, Emperors, red-winged Cinnabars or the most beautiful of daytime moths and harbinger of good tidings, the Hummingbird Hawkmoth. Moths can be watched in any location, no matter how urban. A few moth-friendly plants in the windowbox of an inner-city flat, particularly one near a park, from April until September, will encourage a fascinating variety of nighttime visitors.

WILDLIFE MEETS THE CITY

It is surprising just how much wildlife exists in the parks, cemeteries, graveyards, canals, derelict building sites and railway embankments of our towns and cities. It is equally surprising how quickly wild animals become acclimatised to an urban environment, the close proximity of humans and the noise of a modern city – even rare and temperamental species have adapted to surroundings which must seem completely alien to them. Peregrine falcons, those beautiful and iconic creatures of remote rocky valleys and sea cliffs, have discovered that tall city buildings offer height, safety, ambient warmth and illumination which allow them to hunt at night and an easily accessible food source in the surrounding urban green spaces. The world's fastest and most savage bird of prey now nests insouciantly on Birmingham's Fort Dunlop, the Tate Modern in London, Lincoln and Chester cathedrals, Cardiff Clock Tower, St Michael's Church in Exeter and Manchester's Arndale shopping centre. Research (2008) into the prey of urban peregrines found that feral pigeons made up 40 per cent of peregrine kills, with the rest consisting of an eclectic variety of species ranging from little song birds, bats and rats, to mallard, teal moorhen and nocturnal migrants, such as snipe, woodcock, water rail and corncrake.

Deer, roe deer and muntjac in particular have become urban pests, predating into suburban gardens. Muntjac were one of a number of species introduced to Woburn Abbey during the previous two centuries, which have subsequently escaped and become feral. They are the smallest deer species – about 50cm at the shoulder – and since the original break-out in the 1920s the wild population has expanded quite alarmingly, becoming a pest to gardeners. Muntjac are now a familiar sight in the London suburbs, where their favourite diet of garden flowers and vegetables is readily available. These funny-looking little creatures, with their protruding upper canines, have spread as far north as the Scottish Borders and are frequently seen on the outskirts of many large cities. Otters, which were nearly extinct in the 1970s due to poisoning by agricultural pesticides, have become established on waterways in over thirteen major towns and cities, including Bristol, London, Manchester and Birmingham, with sightings of them in more than 100 other urban settings. The water quality of the old polluted canals and city waterways has improved dramatically in the last twenty years and these have become wildlife havens, supporting a whole range of aquatic bird life, amphibians and fish, such as roach, bream, gudgeon, carp, tench and eels – an otter's favourite food. Seals can sometimes be seen lolling in the Thames at Westminster or Waterloo Bridges and as far west as Richmond; porpoises have been sighted at Gravesend and Greenwich, and even dolphins at the Isle of Dogs in London's Docklands.

Less rare species, such as foxes, are a common sight and although they are only occasionally seen, one is never more than a metre away from a brown rat at any time in a city centre. The universally loathed brown rat is the most widespread and numerous terrestrial mammal. It originates from China and worked its way gradually westward over many centuries, periodically hitching a lift on ships. Brown rats were recognized as a destructive, disease-carrying pest species in Britain by the early eighteenth century, at about the time of the accession of George I, becoming

known as the 'Hanoverian' rat. Loyal Jacobites used to drink a toast to 'The King over the sea and the expulsion of the Hanoverian rat'. The damage they inflict upon the food chain runs to millions every year, but their prolificacy makes control almost impossible. Foxes have become mange-ridden urban vermin, predating into city centres, digging up gardens, making parks foul where they mark their territories with pungent urine or evil-smelling faeces and terrifying people on late winter nights with their eerie, shrieking mating calls. It grieves me to see them at night, slinking down mean city streets or standing on hind legs to push open a dustbin lid in some sordid back alley.

Foxes began to be an urban pest after the First World War; improved transport systems which enabled people to work in one place and live in another led to a massive increase of suburban building in rural areas. The urbanisation of the animal most associated with the British countryside has been more a case of us invading his habitat, than he finding our suburban gardens a comfortable place to live, or the contents of our dustbins an easy food source. Nevertheless, they quickly adapted to their new surroundings; there was no form of control, and although the quality of their diet became degraded, the population thrived. Successive generations of foxes evolved into a scavenging subspecies of their rural cousins, driven inwards towards city centres as their population expanded. They are opportunist feeders but the instinct to hunt is determined by the amount of food waste in their diet; it is obviously greater for an inner-city fox than for a suburban one with access to the prey which form part of their normal food.

Hedgehogs, which are declining in other parts of the country to the extent they are classified as a National Priority Species, actually do rather well in a suburban or a large, urban, green-space environment, probably because they are less vulnerable to predators. Bats thrive in cities, establishing roosts in the roofs of private houses, public buildings and churches. The City of London is particularly rich in bat species, and on warm summer nights, long-eared, Daubentons, Leisler's, serotine or tiny pipistrelle bats can be seen flickering over areas where midges congregate, suburban gardens, the edges of inner-city parkland water features, canals and along tree-lined avenues. The London Bat Group hold fascinating bat-watching events throughout the season and are one of the many similar organisations devoted to wildlife conservation in our cities and making urban dwellers aware of the natural heritage on their doorsteps.

The enormously popular Federation of City Farms and Community Gardens, which has put thousands of urban people – particularly children – in touch with the basic facts of food production and given them a taste of pastoral life, has also increased the wildlife population of the area near the farm, garden or allotment. Who would have thought that sparrows would be seen scratching among chickens in the middle of Bradford, starlings nesting on a pigsty in Edinburgh's Gorgie Road or a robin, our national bird, perched on a spade handle watching a sheep-shearing demonstration at Spitalfields City Farm in the centre of London?

OUR BRITISH RAVENS

If robins are our national bird, the fate of the country and the kingdom rests on the continued presence of an 'Unkindess of Ravens' at the Tower of London. An ancient myth insists that unless there are six ravens in continued presence, the White Tower, the monarchy and the nation will fall. The origins of this legend are lost in the mists of antiquity, but in 1675, when John Flamsteed, the Royal Astronomer, complained that the ravens were interfering with his observations, Charles II had the Royal Observatory moved from the Tower to Greenwich, rather than disturb the birds. During the Second World War, the Tower ravens were considered of such national importance that Winston Churchill ordered young ravens to be caught in Wales and brought to London as a matter of urgency during the Blitz, when the Tower population dropped to one bird. Ravens are fascinatingly awesome creatures and their derisive double croak is a sound that never ceases to thrill me. Much of this has to do with their prominence as harbingers of ill omen in mythology and early cultures of the northern hemisphere, which gave such enormous scope to childhood fantasies. As a raven I could sail with the Norsemen in their war galleys to sack the East coast of Yorkshire or discover Greenland, skim across the centuries observing an endless succession of battles, or simply perch on the White Tower to watch the headsman at work.

> *The sad presaging raven, that tolls*
> *The sick man's passport in her hollow beak*
> *And in the shadow of the silent night*
> *Doth shake contagion from her sable wing*
> CHRISTOPHER MARLOWE, *The Jew of Malta* (c.1589–90)

By indulging a favourite pastime, I learnt that this powerful bird, insouciantly sharing the same air space as golden eagles, is the largest of the corvidae (crow) family with a wing span of a metre and a half and with such an acute sense of smell that it can scent sickness in animals and will keep them under observation until they die. Where food is concerned, ravens are voracious and opportunist feeders, eating anything from carrion to berries. They have been known to pursue baby rabbits into their burrows, eat hedgehogs and in hard winters to dig through snow to reach the bodies of dead animals. They prefer to let other predators kill for them but are equally determined and fearless hunters. They are the most intelligent of the crow family, have been trained to hawk and are easily taught to speak. They mate for life and live to a great age – Jim Crow, one of the Tower ravens, was 44 years old when he died.

More than anything else, my affection for ravens stems from their presence in remote, wild places in circumstances that

hold particular memories for me: the spectacular aerobatics of two ravens that entertained me as a child when my parents fished on the Spey; the raven who congratulated me as I gralloched my first stag in a Highland corrie; and the croak of a raven that fills the silence when hounds check on a Cumbrian Fell.

Ravens once bred throughout the whole of Britain, with flocks of them feeding on filth in the streets, middens and around slaughterhouses in every town and village. Their role as scavengers was recognized as so important that they became protected during the Middle Ages, a status which lasted until sanitation improved and their food source became increasingly scarce. The urban population diminished, with the last pair of nesting ravens in London finally vacating Hyde Park in 1826. Over the centuries, they were gradually driven to the west and north as their habitat in our natural forest was destroyed and sheep grazings came under the plough, removing one of their carrion sources. By the end of the nineteenth century they had disappeared from the Home Counties and virtually the whole middle and eastern side of Britain. Ravens briefly began to spread back during the war years and retreated to the mountains, moorland and coastal cliffs of the west. In 1970, the UK breeding population was estimated at 5,000 pairs, mainly in Wales and the western Highlands.

Since ravens became protected under the 1981 Wildlife and Countryside Act, the population has exploded and they are moving inexorably eastward into their former habitat. In the last few years breeding pairs have become established across the Midlands and south into the Home Counties. According to the National Game Keepers Organisation, ravens can be seen in Bedfordshire, Buckinghamshire and Hertfodshire and, except for a pair that bred during the war, they have returned to Sussex for the first time since 1895. Nor are they confining themselves to the countryside: *'The devil in black feathers'* is back nesting on Chester Cathedral after an absence of several centuries; a pair have taken up residence on a lighting gantry in the Liverpool docks; and the *Highbury and Islington Express* reported a raven flying above Tufnell Park and Primrose Hill in 2006.

A hen raven lays between four and six eggs in February or early March and is fed by her mate, who shares the incubation when she leaves the nest through necessity. The eggs hatch after three weeks and the young are flying six weeks later. They do not mate before their third season, and until they pair up, young birds congregate in rookeries in ever-increasing numbers. It is these juvenile birds hunting in packs which have recently created an ecological nightmare for every moorland gamekeeper and ornithologist I have spoken to. One who keepers in west Aberdeenshire described sixty or seventy ravens at a time systematically quartering the ground on foot during the nesting season, eating the eggs and fledgelings from every ground-nesting moorland bird they can find. Keepers in that part of north-eastern Scotland spend days trying to drive the ravens off, but on a big moor they just move round them or onto their neighbour's ground. It is a similar story in Peebleshire, Northumberland, Lancashire, the Peak District and across the Scottish Borders, where there were none a few years ago. The situation is even more horrific for those lambing in the hills; ravens kill by first blinding their prey, and a ewe in the process of lambing, or a newborn lamb, are easy victims.

WILDLIFE PROTECTION VERSUS STEWARDSHIP

There has been a massive increase in all raptor species over the last twenty years and it is interesting how the ever-expanding raven population is adapting to co-exist with them. Keepers tell me that ravens watch from a great height until another aerial predator species, such as a peregrine, makes a kill and then dives in to steal the prey. The result, of course, is the peregrine must kill again, doubling the death toll of moorland bird species. Stories of ravens harassing various raptor species have been reported up and down the country, highlighting one of the consequences created by government intervention in man's management of wildlife.

Under the 1954 Protection of Birds Act and the Wildlife and Countryside Act 1981, it is an offence to intentionally kill, injure or take any wild bird, their eggs or nests. There are some game bird and wildfowl exceptions which are allowed to be shot outside the closed-breeding seasons, but the vast majority of birds are covered by the Act and fiercely protected by the Royal Society for the Protection of Birds. This charitable organization was founded in 1889, in protest against the trade in rare bird plumes which were the fashionable decoration on women's hats in the Victorian era. The campaign caught the attention of various prominent women in society, such as Lady Margaret Brooke, the Ranee of Sarawak and the Duchess of Portman, who became the first president. The original protest group received a Royal Charter in 1903; joining the nascent RSPB was soon seen as very fashionable and the membership grew rapidly. Since then, the organization has developed into an immensely influential lobby group, able to dictate government policy on conservation and the environment. Over the years it has acquired one of the largest land holdings in the country and has an annual income (2009) of £100 million.

> THE RSPB IS A CLASSIC EXAMPLE OF WHERE THE AMBITIONS OF AN INCREASINGLY POWERFUL CONSERVATION GROUP CAN CONFLICT WITH STEWARDSHIP, THE INTERESTS OF AGRICULTURAL COMMUNITIES AND THE HISTORIC ACTIVITIES OF RURAL PEOPLE.

The RSPB is a classic example of where the ambitions of an increasingly powerful conservation group can conflict with stewardship, the interests of agricultural communities and the historic activities of rural people. There are a number of predator bird species, such as mergansers, goosanders and cormorants, which predate on salmon and trout smoults, whose numbers have expanded since they became protected under the ban. This is of enormous anxiety to those who are struggling to preserve stocks of Atlantic salmon. Similarly, high densities of protected raptor species seriously impact on the effective management of grouse moors and lowland shoots. The numbers of certain protected geese have increased to the level that they now cause agricultural damage and create grazing pressure on other wildlife. Magpies, believed in Scotland to presage death and to carry a droplet of Satan's blood under their tongue, are now the major threat to songbird survival in urban areas; the catalogue goes on and on. The 1981 Act does make allowance for certain species, ravens for example, to be controlled on individual licence – if the government considers it to be appropriate. However, the performance involved in applying to Defra for a licence, waiting for a government representative to assess

the validity of the situation and the strict limitations imposed on the numbers allowed to be culled rarely make the application worthwhile.

There is also considerable concern over the attitude of some major government conservation agencies towards non-native plants and animals. Over 100 alien species have become established in Britain, all of which have had, or will have, a detrimental impact on the indigenous flora and fauna. Many of these – grey squirrels, a number of deer species, Laughing frogs or the Rose-ringed parakeets which are expected to exceed 100,000 by 2010 – were originally introduced on the whim of wealthy landowners in the nineteenth century. Some came by accident – brown rats, Japanese knotweed, New Zealand burrs or Zebra mussels, to name only a few; others were introduced commercially – mink, coypu, wild boar, Signal crayfish and Chinese mitten crabs – and either escaped to become feral or, in the case of mink and wild boar, were deliberately released by single-issue animal rights groups. As we enter a cyclical period of climate warmth, invasion by alien species represents a greater threat to our biodiversity than habitat destruction. In addition to affecting eco-systems and contributing to the rapid demise of vulnerable native species, invasive aliens have the potential to cause major socio-economic damage.

> THERE IS ALSO CONSIDERABLE CONCERN OVER THE ATTITUDE OF SOME MAJOR GOVERNMENT CONSERVATION AGENCIES TOWARDS NON-NATIVE PLANTS AND ANIMALS. OVER ONE HUNDRED ALIEN SPECIES HAVE BECOME ESTABLISHED IN BRITAIN, ALL OF WHOM HAVE HAD, OR WILL HAVE, A DETRIMENTAL IMPACT ON THE INDIGENOUS FLORA AND FAUNA.

Species control is a dirty word to the majority of conservation organiszations, particular those which have become influential lobby groups, and the government's response to the problem of wildlife management has been increasingly supine. Grey squirrels are a classic example; since they were introduced in the nineteenth century, grey squirrels have colonised Britain and most of Ireland; they have virtually wiped out the indigenous red squirrel through competitive exclusion and by being the carriers of parapox virus, a disease deadly to reds. In 2003, the British Trust for Ornithology provided conclusive evidence on the decline of woodland songbirds – tits, song thrushes, tree pipits and finches – which is directly due to grey squirrel predation. In the same year, the European Squirrel Initiative, a voluntary group of concerned environmentalists, woodland owners and conservationists, commissioned *The Grey Squirrel Review*. Included in this report were the impacts, costs, scale and long-term implications of the tree damage incurred by grey squirrels. Both species strip bark, but it is the degree of damage by the larger greys as their numbers increase that has such environmental implications. Bark-stripping degrades the value of timber and also inhibits growth, particularly among broadleaves, to the extent that planting hardwoods cannot be recommended in areas of high grey squirrel density. This deprivation will inevitably lead to a landscape either vacant of broadleaf trees or containing stunted specimens, devoid of the high canopy associated with beech, oak and sycamore in glorious maturity. In 2009, despite all the apocalyptic evidence and the virtual eradication of an iconic indigenous species, the government was still only paying lip service to any

suggestion of control, let alone considering the necessity for an immediate programme of immuno-contraception.

Compare this situation to the one created by feral coypu in the 1950s. Coypu are large South American rodents which were imported for fur farming in the 1920s, mainly to Southern England and East Anglia. Inevitably some escaped and by 1950 there were over 200,000 coypu living wild, destroying crops – particularly sugar beet – undermining river banks, creating flood hazards and damaging the local biodiversity by eating out native plant species. In the early 1960s, the Conservative government of the day responded by ordering a cull which reduced the population by 100,000. This was followed up in the early 1980s by a full-scale eradication programme under a Ministry of Agriculture directive, which successfully averted a conservation disaster. In the light of the recent past, it beggars belief that in 2009 Scottish Natural Heritage, the public body and agent for the government in conservation matters, was supporting a scheme to release beavers into the wild. It would have been very much more worthwhile to have done something about the water vole, the 'Rattie' of *Wind in the Willows,* which has been virtually wiped out by American mink.

* * *

Britain is a tiny island, and urban pressure is making our natural environment smaller all the time. The increasingly fragile ecosystem has been damaged all too often in the past, and to preserve our remaining rural heritage we must learn from the mistakes of previous generations. Above all, we have a historic duty to our wildlife, and man's involvement in the balance of nature is unavoidable. These responsibilities were best described by George VI, shortly before World War II, when he observed: 'The wildlife of today is not ours to dispose of as we please. We have it in trust. We must account for it to those that come after.'

CHAPTER FIVE

WILD HARVEST

February is a wretched month in the Borders of Scotland, best described by that marvellously onomatapoeic Scots word, 'dreich'. A dreich situation is one that has become dreary, unpleasant and drawn out. A dreich day is a miserable one; foggy, chilly and damp. By now the winter has become detestable, hanging on for far too long. Everything around is dead; the hills of Liddesdale are grey and lifeless; the trees gaunt and leafless; sunlight is thin and watery; the ground cold and wet. Towards the end of the month a change occurs, and under the alder trees that grow along the banks of the Hermitage Water a beautiful green living carpet of spear-shaped leaves emerges. These are wild garlic, *Allium ursinum,* and their appearance is greeted by us with the same enthusiasm and excitement as that felt by generations of our predecessors, long before the Novantae Celts built a fortified village overlooking the valley.

Ramsoms, buckrams, wood or wild garlic (as they are also known) are the first wild growth of spring and were once a longed-for source of fresh food, minerals, trace elements and vitamins after months of eating salt meat and dried vegetables. The plant produces a profusion of brilliant white, star-shaped flowers in late April or early May and could be mistaken for Lily of the Valley but for the overpowering, pungent, garlicky scent which on a warm day can be unmistakably recognised from yards away. Cattle find them irresistible and the milk from dairy cows grazed on old pasture where wild garlic grows immediately becomes tainted by it. For centuries, the leaves were made into soups and purées or used as flavouring for stews and sauces. John Gerard, in his *Great Herball* of 1597, mentions the use of buckram leaves in a sauce for fish and observed, 'they may very well be eaten in April and May with butter, by such as are of strong constitution, and labouring men'. We sometimes eat them like this to accompany steak, softened in a pan with butter and the meat juices.

There are literally hundreds of different wild plant species in Britain and virtually all of them, even the poisonous varieties, were once extensively used by both rural and urban populations. An enormous number were edible, either fresh or preserved, and were depended on by isolated rustic communities in times of drought or famine. Others were harvested for their curative properties and for many centuries constituted the only known source of available medicine. Many plants were dual purpose, being edible and containing remedial properties at the same time. Still more had an infinity of practical uses: reeds, rushes and marram grass for baskets, bee skips and thatching; bracken for bedding stock or packing breakables for transport. A cottager in the eighteenth century, whether living on sea coast or estuary, mountain, moorland, flat or fen, would have an encyclopaedic understanding of the wild plants and herbs that grew in his district.

WILD PLANTS – NATURE'S PRECIOUS HARVEST

Even after the enclosures and agricultural improvements of the 1800s, which brought prosperity and an abundance of available produce to most areas, wild foods were still assiduously harvested. This was especially so in early spring, when winter stores were running short and cultivated crops were yet to grow, or during periods of localised failed harvests. It was on occasions like this that wild foods came into their own; hardy, resilient and able to thrive on the poorest soils, our indigenous plant life has always been there in times of need. Dependence on nature's bounty of plants and herbs gradually diminished as industrialisation drew people away from the land and when medical science made great strides forward in the development of mineral-drug-based pharmaceuticals. Although herbal remedies were still used in rural areas to treat all but the most serious illnesses, their efficacy was sneered at elsewhere as ignorant folklore. Rudyard Kipling's poem, 'Our Fathers of Old', reflects the view of the intelligentsia in 1910:

Excellent herbs had our fathers of old –
Excellent herbs to ease their pain –
Alexanders and Marigold,
Eyebright, Orris, and Elecampane –
Basil, Rocket, Valerian, Rue,
(Almost singing themselves they run)
Vervain, Dittany, Call-me-to-you-
Cowslip, Melilot, Rose of the Sun,
Anything green that grew out of the mould
Was an excellent herb to our fathers of old.
Wonderful tales had our fathers of old –
Wonderful tales of the herbs and the stars –
The Sun was Lord of the Marigold,
Basil and Rocket belonged to Mars.
Pat as a sum in division it goes –
(Every herb had a planet bespoke) –
Who but Venus should govern the Rose?
Who but Jupiter own the Oak?
Simply and gravely the facts are told
In the wonderful books of our fathers of old.
Wonderful little when all is said,
Wonderful little our fathers knew.
Half their remedies cured you dead –
Most of their teaching was quite untrue –
'Look at the stars when a patient is ill
(Dirt has nothing to do with disease),
Bleed and blister as much as you will,
Blister and bleed him as oft as you please.'
Whence enormous and manifold
Errors were made by our fathers of old.

Yet when the sickness was sore in the land,
And neither planets nor herbs assuaged
They took their lives in their lancet-hand
And, oh, what a wonderful war they waged!
Yes, when the crosses were chalked on the door –
(Yes when the terrible death-cart rolled!),
Excellent courage our fathers bore –
Excellent heart had our fathers of old.
None too learned but nobly bold
Into the fight went our fathers of old.
If it be certain, as Galen says –
And sage Hippocrates holds as much –
'That those afflicted by doubts and dismays
Are mightily helped by a dead man's touch,'
Then be good to us, stars above!
Then be good to us, herbs below!
We are afflicted by what we can prove,
We are distracted by what we know.
So – ah, so!
Down from your heaven or up from your mould,
Send us the hearts of our fathers of old!

Four years later, Kipling's generation were desperately grateful for the excellent herbs of their forefathers. When urgently needed drugs ran short during World War I, the continued supply of medicines in Britain relied on the use of native plants and age-old natural remedies. Volunteers from all over Britain were organised to gather herbs such as field marigold (*Calendula arvensis*) whose antibacterial properties made it a vital medicine in the treatment of wounds and amputations. Marigolds were considered so important that Gertrude Jekyll, the famous garden designer, donated a field at Munstead Wood, her home in Surrey, purely for growing them. Wild garlic bulbs were dug up and used as an antiseptic. The acidity in sphagnum moss had long been known as an anti-bacterium and vast quantities were gathered from peat bogs and made into wound dressings. Irish moss, a red algae containing carageenans (a gelatinous substance used in ice cream), was picked all round the coast of Britain and Ireland and used to treat throat damage caused by mustard gas. Shepherd's purse (*Capsella bursa-pastoris*) was used on the battlefield to help control haemorrhaging. The little daisies of the traditional medicinal plant feverfew (*Tanacetum parthenium*) were used to reduce temperatures, and the purple flowers and leaves of marsh or hedge woundwort *(Stachys sylvatica)* to staunch bleeding. Comfrey (S*ymphytum uplandica* x), which contains allantoin, was used in fracture injuries. The sedative properties of valerian root had been known for centuries and was now used to treat shell shock and to calm the nerves of Londoners during the Zeppelin bombing raids. As the war ground on and commodities became scarce, the civilian population relied increasingly on wild plants to supplement vegetable and fruit shortages. Towards the end of the

war, a crisis occurred when the UK fruit harvest failed and the army ran out of jam. The High Command believed jam was a vital anti-scorbutic and the British forces consumed 1.5 million pots of it per day. To avert disaster, the Ministry of Food called upon every man, woman and child to strip hedgerows across Britain of blackberries and deliver the fruit to jam-making collection points organised by the War Women's Association.

Twenty-one years after the 'war to end all wars', wild plants were in even greater demand as the German submarine blockades tried to starve Britain into submission during World War II. The first emergency to be dealt with was crucial medical supplies, which had virtually run out by late 1940. The Vegetable Drugs Committee was immediately set up, with the task of galvanising the people of Britain to collect and dry medicinal wild herbs. With the assistance of the National Federation of Women's Institutes, the Scottish Women's Rural Institutes and the Women's Voluntary Service for Civil Defence, herb-gathering organisations were set up in every town and village. These were made up of every able-bodied civilian, of school children, Boy Scouts and Girl Guides, who scoured hedgerows, waste ground, canal banks, woods, heaths and moorland for the complex variety of herbs required. To assist herb gatherers, the Ministry of Health, in conjunction with botanical herb merchants such as Brome and Schimmer, provided pamphlets for identification and, more importantly, instructions on how to dry the herbs. In the first year, an amazing 1,000 tons of herbs were collected and delivered to drug

manufacturers, an achievement all the more remarkable when one considers that 80 per cent of a plant's weight is lost in drying.

At the end of the war, 4,000 tons of the forty or so different essential herbs were being gathered every year, ranging from those that had been used in the First World War to skull cap (*Scutellaria galericulata*) for treating spasms and nervous disorders; black horehound (*Ballota nigra*) for the expulsion of intestinal worms; the root of meadowsweet, as a diluent for fevers; and agrimony (*Agrimonia eupatoria*) for its anti-inflammatory and blood-staunching properties. Children in the Highlands picked blaeberries (*Vaccinium myrtillus*), which the RAF believed improved the night vision of pilots, whilst in the south, conkers from horse chestnut trees (*Aesculus hippocastanum*) provided the glucose in Lucozade. By 1941, doctors were reporting that British infants were showing symptoms of severe vitamin C deficiency and an emphasis was placed on gathering rose hips when they ripened in the autumn. Known since long before Culpepper's day for their anti-scorbutic properties, hundreds of tons of rose hips were picked and made into a syrup which was provided free to all British children.

In 1939, domestic food production was only sufficient to support one in three of the population, and every year Britain imported over 70 per cent of consumer commodities, such as meat, cheese, sugar, fruit and cereals. Only a trickle of these got past the Nazi blockades and the Ministry of Food was obliged to impose stringent food rationing within the first months of the war. Suddenly the Home Front, as the civilian population became known, had to learn to become almost entirely self-sufficient. The government distributed a whole series of advisory pamphlets on thrift and improvisation: flower gardens, lawns and urban parks across the country were dug out and converted into vegetable allotments under the Ministry of Agriculture 'Dig for Victory' scheme. Authors, such as the doyenne of wartime cookery writers, Marguerite Patten, provided inventive and nutritious recipes consisting largely of vegetables and leftovers, which were broadcast by the BBC on their daily wireless programme *Kitchen Front*. Even the Savoy Hotel made a contribution – Woolton Pie, a sort of turnip and cheese hotpot named after Lord Woolton, the Minister for Food.

Wild-food plants, historically always the fallback when a failed harvest meant scarcity and hunger, were now collected on a national scale. Most country people and the herb gatherers knew what to look for and how to make use of them, but for those who lacked the benefit of inherited knowledge there was an enchanting book of advice and recipes written in early 1940 by the Vicomte de Mauduit, entitled *They Can't Ration These*. De Mauduit, who had been brought up in England and whose previous publications included *Reminiscences of a Wandering Nobleman* and *A Vicomte in the Kitchen*, covered every aspect of Nature's larder from nettle cakes and clover purée to snail consommé and starling stew. There were instructions on how to clean teeth with sage leaves, make port wine from beetroot or ink from oak galls. By following the Vicomte's recommendations, everyone, even the most urban, would be able to eat and eat well. If all else failed, he actually had a recipe for grass.

At the time, *They Can't Ration These* was considered of such importance that Lloyd George was persuaded to write the foreword. Sadly, de Mauduit was never to

know how successful his book would become. Shortly after publication he returned to France, arriving just as the country was overrun by the German Army. What happened next is something of a mystery, but it is believed he was captured and transported to Germany, where he subsequently died in a prison camp. The benedictory epilogue on the final page of the book makes a very fitting epithet for the author: 'Before closing this book let us remember The Giver and offer our thanksgiving for all the good things of existence.'

> IT IS INCREDIBLE TO REFLECT THAT, IN THIS AGE OF WASTE AND PLENTY, A WHOLE GENERATION HAD GROWN UP KNOWING NOTHING BUT SELF-SUFFICIENCY AND PRIVATION. FORAGING FOR WILD FOOD … GAVE PEOPLE OF ALL AGES AND WALKS OF LIFE A DEEPER UNDERSTANDING OF THE COUNTRYSIDE AND ITS WILDLIFE THAN AT ANY TIME IN THE PRECEDING CENTURY.

Food shortages in Britain became even more chronic after the hostilities ceased and the Allies found themselves burdened with providing food for European countries devastated by the fighting. Herb gathering for medical supplies finished in 1946 as stocks of vegetable drugs began to be imported from India and New Zealand, but food rationing lasted another nine long, grinding years, eventually ending officially in 1954. It is incredible to reflect that, in this age of waste and plenty, a whole generation had grown up knowing nothing but self-sufficiency and privation. Foraging for wild food, whether along canal banks, hedgerows, waste ground or woodland, gave people of all ages and walks of life a deeper understanding of the countryside and its wildlife than at any time in the preceding century. The nation was, as a result, much closer to and had a greater respect, appreciation and gratitude for their natural environment. After all, at some point during the previous fifteen years everyone, rural or urban, civilian or armed forces, had to a greater lesser degree depended on nature in a time of need.

I was six years old when rationing ended and I remember my sister and me being taken by our nanny, Nanny Pratt, on daily walks along the lanes and through the fields and woods near my parents' home. On these afternoon excursions Nanny Pratt always took her trug, and whichever wild food was in season at the time was picked and taken back. Wild garlic leaves which carpeted the local woods or mustard garlic from hedge banks, in the early spring; goosefoot, dandelion and chickweed, all full of iron, vitamin B and calcium; the grey-green leaves of common orache, fat hen, shepherd's purse and, later, watercress that grew where a stream broadened as it flowed through a meadow. As nursery food, these were always eaten well boiled, particularly the watercress, which acts as a host to liver fluke. In the summer, when the countryside was a riot of blossom and sweet scent, the trug was filled with flowers for the nursery or wild strawberries and raspberries. As autumn came and the leaves began to turn, we picked blackberries and elderberries for jam; rosehips and sweet haws for the syrup we were given every day and little yellow, rock-hard crab apples for pickling. October was the month for hazelnuts and early November, windblown sweet chestnuts, lying in their spiny green shells among the golds, russets, bronze and ochre of fallen leaves.

We were rarely alone on these trips, as others would often be out gathering wild food at the same time: the gardener's wife, perhaps, picking nettle leaves to

make into nettle beer for her husband, or gathering wild hop buds which she made into a pillow to help him sleep when his rheumatism was particularly painful. Sometimes we would see the two elderly brothers who lived in the village picking golden dandelion heads, cowslips, meadowsweet and elderberries to make into wine or carefully picking blackthorn leaves. When dried, these were used as a substitute for tea or smoked in their pipes when tobacco was scarce. On other occasions we would pass places where the broken stems of ground elder and hogweed or fat hen indicated that someone had recently been harvesting. In the autumn, people bicycled for miles from local towns or came by bus from the cities to pick the hedgerow harvest of blackberries, rosehips or crab apples, returning a month later for the nutting season. For young children of any generation, trailing behind adults as they forage is the beginning of an education in natural history and country lore. They learn to identify what is edible, where to find it and why it grows there, and that some plants might look good to eat but are, in fact, deadly poisonous – such as the black or translucent berries of climbing byrony, or the dark purple ones of deadly nightshade – and never to touch those they do not recognise. At the same time, inquisitive children took an interest in the wildlife around them: the birdsong, darting insects and furtive rustling of unseen little creatures. It was on the outings with Nanny Pratt, as I began to learn about the breeding seasons of animals, that the seeds of my fascination with natural history were sown.

After the end of the war, tension mounted between America and Russia and their allies, with both sides building arsenals of nuclear weaponry. When Fidel Castro established formal ties with Russia and began developing nuclear missiles, US president John Kennedy promptly ordered the US navy to blockade the island, which was interpreted by the Kremlin as an act of aggression. For three terrifying days at the end of October 1962, the world teetered on the brink of nuclear war. Although this disaster was averted at the eleventh hour when Russia agreed to dismantle the missile bases, a very real threat remained. The British government responded by implementing a policy of massively increasing agricultural production to avoid a dependence on imported food and prevent a repeat of the shortages experienced in World War II. Much of the old pastoral landscape was destroyed as thousands of kilometres of hedgerows and small woodlands were bulldozed out to create huge arable field units. Vast tracts of permanent pasture, moorland and heath went under the plough, and great swathes of marshes and bogs were drained and reclaimed. Headlands disappeared as field margins were maximised and wild plants, now condemned as weeds, were annihilated by toxic clouds of powerful agricultural herbicides. At the same time, insect life was indiscriminately obliterated by Dieldrin, the deadliest of pesticides. The wildlife population diminished as their habitat

and food source was taken away, and with advances in agricultural technology machinery rapidly replaced manpower; in ten years between 1962 and 1972, over 50 per cent of the rural workforce left the land to seek new lives in cities.

There were still many places where wild plants thrived, unaffected by modern agriculture, but they were less accessible than before. Lifestyles changed, and to meet economic needs for heightened expectations and improved living standards both adults in a family were required to work. Supermarkets began to appear on the outskirts of every town, and as global transport improved out-of-season fruit and vegetables became readily available at an affordable price. There was less necessity to bottle and preserve as virtually everyone now owned a refrigerator and freezer. 'Pick your Own' fruit farms started popping up all over the country, offering an easier alternative to hunting for berries along hedgerows and being eaten alive by midges. Despite publications such as Richard Mabey's *Food for Free*, published in 1972, and Roger Philips's *Wild Food*, ten years later, foraging for food gradually died away. Only aficionados, older country people, rural romanticists, New Age Travellers and followers of Lady Eve Balfour, an early pioneer of organic farming, remained loyal to the ancient tradition of gathering wild plants.

A LONG-AWAITED RETURN TO WILD FOODS

A resurgence of interest in wild foods started in the late 1980s, when food heroes such as Carlo Petrini created the Slow Food Movement, dedicated to the protection of traditional foods and agricultural biodiversity. Henrietta Green, the author of *British Food Finds* (1987) and *Food Lovers' Guide to Britain* (1993), championed the cause of small British food producers against supermarket domination and started the Food Lovers' Fairs. At the same time, the government became aware that intensified farming, coupled with a policy of cheap food imports, had created a situation where Britain was massively over-producing. It was lobbying by increasingly powerful conservation groups, as much as an escalating food surplus, that forced the first agri-environmental scheme designed to reduce agricultural output, to be introduced in 1987. Having spent billions subsidising environmentally damaging reclamation programmes, the government now started to spend more billions subsidising farmers to take land out of production and put it back the way it had originally been. Wild plants, dormant under cultivated land since the original reclamation schemes, started to appear again.

The popularity of wild foods and herbs has grown worldwide with the increased interest in alternative medicine, coupled with consumer demands for natural ingredients, organic produce and traceability in agricultural commodities. It is the new global culinary craze, with wild-food festivals of one sort or another in most European countries, Britain, America, Australia and New Zealand (which actually has one of the oldest: the Hokitika Wild Food Festival, started in 1990 and attracting annual attendances of 25,000). There are any number of courses on harvesting nature's larder in Britain, offering tuition on plant identification and how best to prepare them for the table. Camping holidays for foragers are very popular with the intrepid, and Cornwall has its own wild-food school at Lostwithiel, on the

River Fowey. In the last five years, foraging has hit the media spotlight as the subject of several celebrity chef TV programmes and has become the 'must-have' ingredient in smart restaurants. Chic London foodies hunt for dandelions, nettles, elderflowers and blackberries along canal paths and railway embankments. Chickweed, wild garlic and ground ivy are picked in Hyde Park, Hampstead Heath, Wandsworth Common, Kensal Green and Highgate cemeteries. Those who know what they are looking for can even impress their friends with edible fungi, collected in the early mornings from Wimbledon Common. Foraging has become fashionable and fun.

USING NATURE'S BOUNTY

I consider myself lucky to have always had nature's bounty growing on my doorstep. It is as much a part of my life as the animals that graze on the land, and the start and end of the wild-plant growth cycle sharpens my sense of the changing seasons. When my children were small we foraged quite industriously; it was educational for them and fun to do as a family. Nowadays, my foraging is more periodic than structured, and during the spring and summer I tend to pick as the fancy takes me, whether edible plants, herbs or flowers. In the autumn I am slightly more dedicated, as pickled or preserved gatherings provide an important range of winter delicacies.

The one thing I particularly love about wild plants is the clues they give to the social history of the landscape. The places where they are found can sometimes indicate that a community once lived there and the plants had become semi-domesticated through regular use. Horseradish mixed with fat was an embrocation for saddle or girth sores and will still grow in an area where horses were stabled. Nettles, an essential ingredient in rennet for making cheese, can indicate the location of an old dairy. Elder trees were frequently planted near houses and grow on the sites of ancient middens, as does the aptly named but very nutritious dung weed or fat hen. The healing herbs, comfrey, horehound, meadowsweet, yarrow and agrimony might be growing where a religious hostel once stood on a long-forgotten pilgrims' path, or an inn beside a drove road. Gorse, which is now an invasive weed species, was once deliberately cultivated as cattle, horse and sheep feed. Even our hedgerows, which provide the forager with such a rich harvest, have their history in the Acts of Enclosure, when 200,000 miles of hedgerow were planted between 1603 and 1850, to enclose seven million acres of common land.

There are an enormous number of different wild plant species, flowers and herbs that have been either part of the food chain, utilised medicinally or for their fragrances – many more than I could possibly list. I therefore only include here those that were commonly used and are easily found today.

Scurvy, the painful symptom of vitamin C deficiency caused by lack of fresh vegetables through the winter, was endemic for centuries, and among the most valuable to early communities as an anti-scorbutic was fat hen (*Chenopodium album*). Fat hen (also known as pigweed, lamb's quarter, midden Myles, dirty Dick or white goosefoot – from the shape of its, grey succulent leaves) is among the first wild

plants to appear at the end of winter. It contains more protein, iron, vitamins A, B and C, calcium, potassium and phosphorus than any cultivated vegetable. It is a prolific coloniser of newly disturbed soil, and remains of the plant have been found by archaeologists in Neolithic settlements all over Britain, Europe and Scandinavia. The whole plant went into the health-giving gruels that were made in early spring and the leaves provided a wholesome vegetable through the summer. It produces thousands of tiny black seeds which were roasted and made into flour or simply added to the pot and boiled – the stomach contents of the Tollund Man and Grauballe Man, the perfectly preserved 2,000-year-old corpses discovered in a Danish peat bog, both contained traces of fat hen seeds.

In the Middle Ages, fat hen was one of the ingredients that went into 'porry', a thick broth stewed in a cauldron overnight on the embers of a kitchen fire. The word is derived from *Allium porrum,* the botanical name for leek, but medieval porry was principally made from any available edible wild pot herbs and anything else that might be on hand to thicken it up – stale bread, bacon, bones or meat leftovers. Fat hen was cultivated during the Tudor and Elizabethan periods and cooked as a vegetable or made into a purée. 'Boil Myles in water and chop them in butter and you will have a good dish,' was an old saying of the time. The introduction of spinach gradually supplanted cultivated fat hen, although it continued to be harvested from the wild by country people. As the name suggests, the seeds were used as poultry food at one time and the seed heads are a magnet to small songbirds in the autumn. For this reason, fat hen and other plants of the same genus are often included in game crop mixtures.

Fat hen is easily found along verges, canal banks, building sites and around farm buildings, especially in the vicinity of a dung hill or slurry pit. It is the first weed to appear when ground is disturbed by construction work, often becoming established in phenomenal quantity. It is a drab, greyish-green plant growing to about 90cm high with ragged spear-shaped leaves. The whole plant can be used in the early spring, when the young leaves and stems make a delicious alternative to spinach. As the plant grows, the leaves are used as a green vegetable, for soups and in stews, or added to beans as the carmative properties of fat hen help to suppress flatulence. The stalks and flowerbud tips are edible cooked as asparagus, until they reach the height of 20cm, after which they become too coarse and woody. The little black seeds, when dried and ground in a pestle and mortar, can be used as a flavoursome thickener.

Another species of goosefoot that is found growing abundantly near human habitation, urban waste ground, roadsides and canal banks, is Good King Henry (*Chenopodium bonus-henricus*). Also known as poor man's asparagus, Lincolnshire spinach, allgood or smearwort, it is a slighter smaller, finer plant than fat hen with bright green waxy leaves, introduced by the Romans and cultivated during the 400 years of their occupation. It then became a feral plant, and since Tudor times it has periodically enjoyed bursts of popularity among gardeners. A hundred years ago it was still grown regularly as a garden vegetable in parts of East Anglia and as far north as the Humber.

Good King Henry is exceptionally high in protein, vitamin B, calcium and iron. As with other wild plants that appear in the spring, it was added to broth and porry and made into purées or boiled as a vegetable in its own right, when cookery became more refined. The leaves were an ingredient of Elizabethan sallets, when salads became popular among the intelligentsia, although 100 years later the diarist, John Evelyn, described them as insipid in *Acetaria: A Discourse of Sallets* (1699). The plant was, nevertheless, regarded as being excellent for the digestion; poultices made of the leaves were used to heal chronic sores and weeping ulcers (hence the name smearwort) and the roots were given to sheep as a remedy for coughs. Despite Evelyn's opinion, one of the nicest ways of eating Good King Henry is as a base leaf in salads. Otherwise, the plant is used in the same manner as fat hen, although it should be remembered that Good King Henry is a mild laxative.

Two other species of Chenopodiae which are easily found and have been used as food plants since antiquity are common, wild or spreading orache (*Atriplex patula*) and spear or halberd-leaved orache (*Atriplex hastata*). Both are widespread throughout Britain, except in the far north of Scotland. As with other plants of this genus, they are quick to colonise soil that has been disturbed or waste ground, often growing in large clumps. They can tolerate some salinity and are frequently found in coastal regions. Spear-leaved orache, in particular, thrives on shingle banks above the tide line and on roadside verges where road salting during the winter deters the growth of other plants. Tolerance to salt made orache a popular food source for the Neolithic hunter-gatherers, whose settlements were always coastal, and traces of it have been found during archaeological excavations on the site of first-century BC dwellings, discovered at the Iron Age lake villages of Glastonbury and Meare.

Common orache is a sprawling plant growing to a metre in length with greeny-grey, mealy leaves which often have a reddish tinge. Spear-leafed orache is smaller and more upright with greener, waxy leaves. The leaves and shoots of both these plants have an excellent tangy flavour and make a wonderful alternative to spinach, in stews or as a soup. As with other goosefoots, the seeds were used as a thickener for gruel, or made into flour. The plants are high in protein, vitamins, iron and calcium and the name 'orache', a corruption of the Latin for gold, *aurum,* was given because a concoction made from the seeds was reputed to cure 'yellow jaundice'.

Stinging nettles (*Urtica dioica*) thrive wherever man has left his mark on the landscape. They subsist on sites of the earliest settlements, wherever a bonfire has burnt, or on roadsides, canal banks, railway embankments, waste ground, urban parks, rubbish tips and building sites. An isolated patch of nettles is often the only indicator of long-forgotten human occupation, and when I farmed in the Lammermuirs a lonely clump of them grew in the middle of the heather moorland where an RAF plane had crashed in World War II. They are the commonest of all edible wild foods and once had a wide range of different uses. Fibres from mature plants were used by early man for thread and twine for fishing nets. Before the introduction of flax for making linen, cloth was made of nettle fibre – a practice still popular in Scotland and Ireland well into the seventeenth century. During the First and Second World Wars, when Germany ran short of raw materials, colossal quantities of nettles were harvested as cotton substitutes, whilst in Britain the herb gatherers collected hundreds of tons for the extraction of khaki dye and chlorophyll. More recently, the agricultural scientist, Dr Matthew Horne, has been researching, with a team from Leicester University, the commercial feasibility of making a variety of textiles and upholstery fabrics from nettle fibre.

> AN ISOLATED PATCH OF NETTLES IS OFTEN THE ONLY INDICATOR OF LONG-FORGOTTEN HUMAN OCCUPATION, AND WHEN I FARMED IN THE LAMMERMUIRS A LONELY CLUMP OF THEM GREW IN THE MIDDLE OF THE HEATHER MOORLAND WHERE AN RAF PLANE HAD CRASHED IN WORLD WAR II.

Since nettles establish themselves with alacrity in the presence of humans and are one of the first plants to appear in the spring, their food history is diverse and ancient. Until June, when they become too coarse, the young tops and shoots were made into a variety of broths or added to other wild plants in the ubiquitous porries of old. Nettle pudding, made from oatmeal and nettles, was a staple spring and early summer dish among crofters on the highlands and islands of Scotland and the poor of Ireland, until the middle of the twentieth century. In more refined households, young nettles were puréed and eaten with poached eggs or mixed in equal quantities of thick cream.

Nettles contain an amazing cocktail of health-giving properties: they are rich in protein, vitamins, phosphate and iron but also contain formic and silicon acids, ammonia and histamine: chemicals which increase haemoglobin, lower blood pressure, increase circulation and relieve the discomfort of rheumatism. Urtication, or flogging with nettles, is an ancient folk remedy used for rheumatism. Joe

Botting, our gardener when I was a child, was a martyr to rheumatism and on cold days he regularly rubbed his swollen hands with a bunch of nettles. He also brewed litres of nettle beer in the early summer to ease the winter nights and often brought a flask of tea made from dried leaves to work with him. Nettles contain more of the proteins keratin and collagen than linseed and have been used as animal fodder in the past, particularly with horses that have gone poor. I have often mixed nettle seed in with a feed ration to give a horse a glossy coat.

When picking nettles, remember the old adage:

Tender handed stroke a nettle,
And it stings you for your pains;
Grasp it like a man of mettle,
And it soft as silk remains.

Sorrel (*Rumex acetosa*) is widespread across Britain and is a food that merits looking for. It can be found on roadside verges and woods; in the uplands, rough grassland, heaths and moorland fringes. The broad, arrow-shaped leaves start appearing in late January, then the plant produces clusters of small red and green flowers along narrow stems 15–60cm high from May to August. The leaves have a wonderfully cool citrus taste when raw – chewing a leaf is a favourite among country children. It was extensively cultivated during the Tudor and Elizabethan ages as a pot herb, with the leaves cooked as a vegetable or mixed with vinegar and honey as a cold condiment – which gave the plant its folk name: Green Sauce. It was equally popular hot as a sauce for fish and meat (particularly veal and lamb) and as a rich soup or purée. Sweetened sorrel purée was sometimes eaten with roast pork or goose, when apples were in short supply, or made into desserts. Cooked as spinach, it is good with poached eggs; in quiches and tarts, or with onions or anchovies. Sorrel is rich in vitamins, minerals and trace elements with a considerable potash content. It was highly prized as an anti-scorbutic to treat scurvy, and the leaves, root and flowers were used for reducing fever, curing ringworm, scrofulous abscesses or stomach ulcers.

> URTICATION, OR FLOGGING WITH NETTLES, IS AN ANCIENT FOLK REMEDY USED FOR RHEUMATISM. JOE BOTTING, OUR GARDENER WHEN I WAS A CHILD, WAS A MARTYR TO RHEUMATISM AND ON COLD DAYS HE REGULARLY RUBBED HIS SWOLLEN HANDS WITH A BUNCH OF NETTLES. HE ALSO BREWED LITRES OF NETTLE BEER IN THE EARLY SUMMER TO EASE THE WINTER NIGHTS.

Wood sorrel (*Oxalis acetosella*) is an attractive plant and worth looking for in conifer woods. It is often the only splash of colour in spring, appearing in fragile clumps among the pine needles of dark forbidding forests. The delicate-stemmed plants grow to about 5–10cm with lime green, shamrock-shaped leaves and delicate pink-veined white flowers which blossom between April and May. The leaves contain oxalates, which gives them the pleasantly sharp taste that made it popular with medieval cooks. It too was cultivated during the fifteenth century and much used as a salad ingredient and sharpening agent for sauce.

One of the most prolific British weeds, which brings colour to roadsides, pastures, waste ground, urban parks and lawns in early spring, is the dandelion

(*Taraxacum officinale*). The name *officinale* derives from '*officina*', the dispensary in a monastery adjacent to the hospice, where medicinal herbs were kept. (The word office comes from the same source.) The therapeutic properties of dandelions as blood cleanser were known long before early Christian monks elevated the plant to the rank of '*officinale*'. Dandelions contain an arsenal of chemicals, vitamins, protein and minerals. During World War II, Dr Charles Hill, the radio doctor, advised the civilian population to eat them whenever possible. One important component found in the leaves and root is teraxicin, a powerful diuretic and remedy for water retention caused by liver or heart disease: hence its other folk names, Pissabed and Wetweed. The other is inulin, which strengthens the function of the kidneys and pancreas whilst stimulating the immune system. The milky latex which exudes from the stem has a reputation for removing warts and repelling mosquitoes.

Dandelions are astonishingly hardy plants, producing flowers and green leaves all year round except during periods of very cold weather, which makes them an important plant for bees. As with other wild food, the leaves were once additions to a communal hotpot but were to become appreciated as a plant food in their own right. Young leaves have the best flavour – the more mature ones are too bitter – and these were stripped from the plant and cooked as a vegetable, puréed or made into soup. At one time they were cultivated as a pot herb or salad green and the leaves induced to grow to a huge size by covering the plants with flower pots or earthing them up over the winter. Growing the leaves in the dark not only produced a bigger leaf, it removed much of the bitterness. Flower heads were traditionally picked on St George's Day, 23 April, to make a delicious wine known as Christmas wine, because it was considered mature enough to be drunk by the end of December. The

plant's ability to flourish on any patch of urban waste ground meant dandelion stout was a popular homebrew among factory workers during the industrial revolution. The roots of mature plants were added to stews, cooked as a vegetable and later, when coffee became fashionable, roasted and used as a substitute. Coffee made from dandelion root, acorns, chicory and asparagus buds was among the substitutes drunk during the rationing years. Dandelion juice, extracted from fresh roots, was sold as a tonic by chemists, and in the late Victorian era Dandelion and Burdock became a popular health drink.

With the current revival of interest in wild foods, this versatile plant is enjoying the spotlight in worldwide contemporary cuisine. It is particularly popular as a salad green, often served with the freshly chopped root or tiny, unopened flower buds. The French have a famous recipe, *Pissenlit au lard (*fried bacon or pork on a bed of dandelion leaves, lightly dressed with the bacon fat or olive oil and vinegar) which, in the Ardennes region of France, is served with roast haunch of fallow deer on 3 November to celebrate the feast of St Hubert, the patron saint of hunting. Cutting-edge restaurants serve dandelion, steamed, boiled, stir-fried, sautéed or as a stuffing, and demand for dandelions in America is such that a considerable hectareage is now cultivated. Vinelands, a town in New Jersey, has over seventeen local farmers growing more dandelions than anywhere else on the planet and claims the title of Dandelion Capital of the World. A Dandelion dinner, consisting of seven courses, is held each year prior to the Vinelands Dandelion Festival, with the plant served differently with each course.

> DANDELIONS ARE ASTONISHINGLY HARDY PLANTS, PRODUCING FLOWERS AND GREEN LEAVES ALL YEAR ROUND EXCEPT DURING PERIODS OF VERY COLD WEATHER, WHICH MAKES THEM AN IMPORTANT PLANT FOR BEES ... WITH THE CURRENT REVIVAL OF INTEREST IN WILD FOODS, THIS VERSATILE PLANT IS ENJOYING THE SPOTLIGHT IN WORLDWIDE CONTEMPORARY CUISINE.

Chickweed (*Stellaria media*), the gardener's nightmare, is another wild plant that is easy to find, sprawling along the ground beside hedgerows, field headlands, urban wasteland, ground that has been disturbed for whatever reason and, of course, gardens. Chickweed is very resilient and grows pretty well all year round, particularly now that the winters are so mild. There are two times in the year when it is particularly good to eat: in early spring, when the first tender young leaves appear, and in late autumn. During the height of summer the unchecked straggling growth becomes dusty and tired, so the leaves and stems should be stripped in handfuls off the main stalks and can be made into a delicious purée, soup or as an early spring salad, either on its own or mixed with other early spring wild growth, such as dandelion, Good King Henry, ramsoms (wild garlic) or hedge garlic.

Chickweed has had a long history as a food and was once hawked round London by itinerant vegetable hawkers, who picked wild plants on the outskirts and sold them door to door. There is an etching of a ragged chickweed hawker by J.T. Smith in John Bowyer Nichols and Sons' publication of the *Cries of London*, 1839. Chickweed had an ancient reputation as a healing herb, particularly for sores, open wounds, burns and stings. A handful of chickweed rubbed on nettle stings is more

effective than dock leaves. The mucilage content, demulcent, was thought to heal stomach ulcers and inflamed bowels when taken orally. Dried herbs scattered in a hot bath were a sovereign cure for stiff joints and sore muscles, and a poultice of fresh crushed chickweed was used to reduce breast inflammation during lactation. As an anti-scorbutic, chickweed was second to none: the plant is full of iron, copper, manganese, phosphorus, zinc, potassium, sodium and calcium, vitamins A, B, C and D. The potassium content was believed to reduce food cravings and the water in which chickweed had been cooked was prescribed three times a day to people suffering from obesity. It was also recommended as a cure for constipation and an inhibitor of flatulence.

Ground elder (*Aegopodium podagraria*) is another plant now considered an extremely irritating invasive weed species, but it was once highly appreciated as a pot herb and for its assumed medicinal properties. Ground elder is believed to have been introduced by the Romans as a culinary plant and would have quickly reverted to the wild as they left Britain. It was cultivated by the early Norman monks, both as a vegetable in monastic kitchen gardens and as a medicinal herb, in herb garths and beside pilgrim hostels. The roots and leaves of ground elder made into infusions or poultices were used to treat all manner of muscle, nerve and joint pains, in particular, sciatica and gout. Hence the generic names Goutweed, Bishopsweed and Herb Gerard, after St Gerard, the saint most frequently invoked by chronic sufferers.

Ground elder is widespread across Britain, under hedges, along roadsides and in waste ground. It is also found near the ruins of religious settlements, and an isolated clump of ground elder near a ford could indicate the site of an old inn or pilgrim hostel. Ground elder leaves are worth picking before the plant flowers in June and cooking as spinach or including in salads.

Hogweed (*Heracleum sphondylium*) is one of the more prevalent, easily found and under-appreciated of all our edible wild food. Hogweed or cow parsnip is the most visible of roadside plants during the summer, towering 180cm over other foliage, with their cluster of white flower heads. The young shoots and leaves, picked in the spring before the leaves uncurl, and cooked until tender, are among the very best of what nature has to offer. They have been eaten for centuries in Eastern European countries and parts of Russia. They were the original vegetable used to make Borscht (*borshchevik* is the Slovak word for hogweed) and in some recipes hogweed is still used as the base vegetable to which beetroot is subsequently added.

Wild garlic (*Allium ursinum*), buckrams or ramsoms are widespread across Britain, growing in abundance along canal and stream banks, at the base of hedgerows and in dense drifts in damp woodland. Their colloquial name comes from

the Anglo-Saxon *Hramsa*, meaning rank, a reference to their distinctive smell. Place names with the prefix *'Ram'* – Ramsdale, Ramsden, Ramsgill, Ramsbottom, etc. – indicate that profusions of wild garlic once grew there and in many cases probably still do. It is another wild plant which has erupted into the limelight after centuries of obscurity. A few years ago you would never have seen it on a menu; nowadays wild garlic seems to be the vegetable of choice among international contemporary restaurants. The broad, dark green leaves start thrusting through leaf litter in early February and are ready to pick by the end of the month. The raw leaves have the sharp tang of chives with a mild aftertaste of garlic and this unique flavour has inspired modern chefs to create an infinity of exciting new recipes. There are now wild garlic raviolis, risottos and omelettes, pestos and vinaigrettes. The leaves are used to wrap chicken breasts and to stuff veal, are added to cream cheese and mayonnaise, soups and stews, or can be deep-fried, sautéed, puréed and steamed, made into sauces for fish and included in salads with other wild greens. I have even seen a recipe for wild garlic bubble and squeak, topped with a poached egg and hollandaise sauce. The flowers, which have an intense flavour, can be used as a salad garnish, and the bulbs, although tiny, are worth digging up to use in the same way as cultivated garlic.

> WILD GARLIC IS ANOTHER WILD PLANT WHICH HAS ERUPTED INTO THE LIMELIGHT AFTER CENTURIES OF OBSCURITY. A FEW YEARS AGO YOU WOULD NEVER HAVE SEEN IT ON A MENU; NOWADAYS WILD GARLIC SEEMS TO BE THE VEGETABLE OF CHOICE AMONG INTERNATIONAL CONTEMPORARY RESTAURANTS.

Wild garlic has been prized for centuries as a general blood cleanser, antiseptic and tonic. It is also used for shifting intestinal worms in humans and dogs, relieving fermentative dyspepsia and repelling moths. It is rich in vitamins, and recent scientific research has shown that it contains much higher levels of iron, manganese, magnesium and sulphur than ordinary garlic, properties that are particularly effective in reducing high blood pressure and cholesterol levels, for which wild garlic was declared the Medicinal Plant of the Year in 1992 by the Association for the Preservation and Research of European Medicinal Plants.

Equally as good, but less well known, is garlic mustard (*Alliaria petiolata*), or Jack-the Hedge and Sauce Alone. It is an early-flowering upright plant with broad, bright green, ragged-edged leaves growing from a central stem, closely resembling white dead nettle. Garlic mustard is widespread and plentiful on the edges of woods, hedgerows and field margins. In the current phase of mild winters, the first green leaves will often be seen at the beginning of February and the upper leaves are ready to pick when the flowers are in bud, from mid-March. The leaves become rather bitter when the attractive, snow-white flowers appear from April to June, but this is compensated by the fact that they can also be eaten. If the autumn and early winter is frost free there is another edible growth on the flowerless shoots.

Garlic mustard is actually no relation to garlic at all but a *brassicaceae* – part of the same family as cabbage. Nevertheless, it has a delicate garlicky flavour and was very popular as a salad green during the sixteenth and seventeenth centuries. John Evelyn observes in his *Acetaria*: 'Jack-by-the-Hedge ... is eaten as other Saletts,

especially by Country People, growing wild under their Banks and Hedges'. It was also much used in sauces for fresh and salt fish, boiled mutton and ham or chopped up in vinegar-based condiments. The tap root was peeled and chopped to make a sauce similar to horseradish. Evelyn also mentions that garlic mustard 'has many Medicinal Properties', amongst which were its use as an antiseptic in cleaning wounds and as dressings for ulcers and gangrenous sores. The juice of the crushed tap root and leaves mixed with honey was taken to ease bronchitis and dispel excess fluid by inducing heavy sweating. The plant contains higher than average levels of vitamin C, plus vitamins A, B, E, K, calcium, potassium and sulphur.

Horseradish (*Armorica rusticana*), found all over Britain except in the far north, is another plant that happily colonises any ground that has been disturbed by man. Roadsides, construction sites, railway embankments or the gardens of derelict buildings are all ideal habitat for horseradish – we even have some that grows among the rubble of a wagon shed that fell down decades ago. At one time it was made into an embrocation for horses and is invariably found near old stables and farm buildings, although the prefix 'horse' is actually used adjectively, to mean coarse or strong. The leaves and root were extensively used in Britain during the Middle Ages as a medicine for both humans and animals, for ailments ranging from stiff joints and torn tendons to chilblains, gout and partial paralysis. It was mixed with honey to treat whooping cough or internal parasites in children; sliced up in milk to make a cosmetic to brighten dull skin; and infused in wine to stimulate the nervous system and induce perspiration. Horseradish was eaten as a relish in Eastern Europe for many centuries but doesn't seem to have caught on here much before the beginning of the seventeenth century. An early reference is by Shakespeare, who mentions Tewkesbury Mustard in *Henry IV*: mustard seeds milled into flour and mixed with grated horseradish, formed into dry balls for preservation and reconstituted when needed, by moistening with vinegar or cider.

> HORSERADISH, FOUND ALL OVER BRITAIN EXCEPT IN THE FAR NORTH, IS ANOTHER PLANT THAT HAPPILY COLONISES ANY GROUND THAT HAS BEEN DISTURBED BY MAN ... AT ONE TIME IT WAS MADE INTO AN EMBROCATION FOR HORSES AND IS INVARIABLY FOUND NEAR OLD STABLES AND FARM BUILDINGS, ALTHOUGH THE PREFIX 'HORSE' IS ACTUALLY USED ADJECTIVELY, TO MEAN COARSE OR STRONG.

Horseradish has large, dark green shiny leaves, similar in shape to a dock, and produces a spray of white blossom on a long thin stem from May to September. It is easy to identify by late summer, as the plant will have grown to 90cm and be dominating other herbage. The root, which can be up to 45cm long and have numerous branches, is at its best in November or December, after the leaf has died back. When digging up horseradish it is prudent to break off one of the branches and replant it in the ground for next year's growth. Once cleaned of dirt the skin must be peeled, and this is best done out of doors; horseradish root is odourless until cutting or bruising releases the blindingly pungent fumes. The chunks of white peeled root should be used immediately or preserved in pickle, as they turn brown and lose their flavour in a few days. Although horseradish has traditionally

and almost exclusively been eaten in Britain with roast beef, it has a much wider culinary range in Eastern and Northern Europe; in Slovenia in particular grated horseradish is mixed with chopped apples, hard-boiled eggs and cream as a traditional Easter food. We make something similar using pickled peaches, which we eat with our Christmas ham.

Hops (*Humulus lupulus*) were eaten as a wild food in Britain long before they were first cultivated for brewing in the fifteenth century. Wild hops are a perennial climbing plant that can be found in all countries of the northern hemisphere. New stems emerge from root stock in early spring and twine their way up host plants in hedgerows, fence posts, saplings in damp thickets or the edges of woodland, reaching 8 metres by the end of the summer. Young hop shoots were a great favourite with the Romans; Pliny the Elder (AD 61–113) gave them the name *Lupus salictartius*, meaning wolf among scrubland, from the mistaken believe that hop tendrils strangled the plants they grew on. The generic word *Humulus* possibly derives from the old Germanic *Humel*, meaning fruit bearing.

> HOPS WERE EATEN AS A WILD FOOD IN BRITAIN LONG BEFORE THEY WERE FIRST CULTIVATED FOR BREWING IN THE FIFTEENTH CENTURY ... HOPS WERE ONE OF THE MEDIEVAL WONDER DRUGS, BELIEVED BE EFFICACIOUS FOR HEART DISEASE, FITS, NEURALGIA, JAUNDICE, BLADDER AND UTERINE COMPLAINTS, STOMACH ULCERS AND TO IMPROVE POST-NATAL LACTATION.

Hops were one of the medieval wonder drugs, believed to be efficacious for heart disease, fits, neuralgia, jaundice, bladder and uterine complaints, stomach ulcers and to improve post-natal lactation. It was used in poultices to draw boils, treat severe bruising and ease rheumatism. The most abiding herbal use has been as a soporific to induce slumber; hops are a relative of the cannabis plant and contain the mildly sedative drug lupulin. An infusion of hop flowers drunk at night or a pillow stuffed with them was relied on by people who suffered from insomnia, the nagging pain of rheumatism, or toothache.

Wild hop plants are widespread across Britain and are a real delicacy. Picked before they become too stemmy in May, the young shoots are delicious cooked as asparagus with salted butter, or raw with a vinaigrette sauce; in omelettes and risottos; lightly fried in batter or made into soup.

Elder (*Sambucas nigra*) is a common sight in hedgerows, woodland edges, waste ground and the sites of previous habitation. From late October, the emaciated branches of an elder tree are the epitome of winter's starkness: bare, gaunt, brittle and lifeless. In spring it comes alive with new growth, and from June, when the plant is covered in profusions of creamy white, sweet-smelling blossom, it is more synonymous of the British summer than any other vegetation. *'Summer is not here until the elder flowers and it is gone when the berries ripen,'* is an old country saying with a lot of truth to it.

Elder has an enormous number of medicinal, culinary and domestic uses as well as a wealth of folklore and mysticism attached to it. One of its names, Judas tree, refers to a belief that Judas hanged himself from the branches of an elder tree. Another myth was that the cross on which Christ was crucified had been made of

elder wood and it was considered bad luck to use elder branches on a fire. Neither is very likely; elder is technically a bush, with fragile pithy branches which would never provide enough wood for a cross or be strong enough to bear the weight of a hanged man. The deeply entrenched belief that the elder had the power of protection against evil (in some parts of Britain a corpse would be buried with a piece of elder wood and the driver of the hearse carried a symbolic whip made of elder) predates Christianity and is descended from pagan plant worship. It was frequently planted near houses both to ward off witches and warlocks and so that the leaves, flowers and berries could be picked and used. Digging near elder trees is often rewarding as ash and household rubbish was spread on the ground to fertilise and nurture it. I have found all sorts of treasures near the one that grows by the farmhouse – bits of plate, old bottles, coins, earthenware pots and, once, a child's tiny hob-nailed boot with a turned-up toe.

In the spring the young leaves can be made into a purée, eaten as spinach or, with the addition of flower buds, as a delicious salad. But it is in June when the shrub is in blossom that it really comes into its own. There are probably more uses for elder blossom than any other species of flowering plant. A refreshing summer drink, reminiscent of vanilla soda, can be made, simply by putting some flower heads in a jug and pouring boiling water over them. Add yeast and sugar to make a pleasantly alcoholic elderflower 'champagne'. Boil flower heads with water and sugar to make a cordial for bottling; capture the sweet scent in custard, compotes, jellies, sorbets and ice cream, pancakes and doughnuts; mix with honey, wine and a little garlic as a glaze for roast lamb. Elder flowers are even wonderful on their own, in a sandwich of thinly sliced brown bread. My absolute favourite pudding is elderflower fritters; whole flower heads dipped in light batter and deep fried. After a hot, tiring day, elderflower heads are as good in a bath as meadowsweet.

At the end of August, the flower heads die back to be replaced in a few weeks by clusters of brilliantly versatile reddish-black berries. These can be used as a fruit in soufflés, tarts, pies, jellies and sorbets, cakes and muffins or as an exquisite sauce for game, particularly venison or duck. They can also be simmered with stock to make an incredibly rich soup, boiled with sugar to make jam or a syrupy cordial similar to crème de cassis, or pickled with vinegar to make a sweet and sour sauce for cold meat or roast lamb. We sometimes make spicy Pontack sauce, which was popular among the nineteenth-century hunting set, who based themselves at Melton in Leicestershire. A pint of elderberries is boiled in a pint of claret (hence the name) and left to stew overnight in the bottom drawer of the Aga. The liquid is drained off and boiled with mace, shallots, peppercorns, cloves and ginger, bottled and stored in the cellar for a year. It is absolutely terrific with cold meat, game, steak or liver, and the longer you leave it, the better it be.

Wine has been made from elderberries since time immemorial; it is very easy to make and similar to good burgundy or port, depending on the recipe. My first alcoholic drink, when I was ten years old, was elderberry wine, made by a German ex-prisoner-of-war called Paul Richter. Paul lived by the ruins of Laughton Castle out on the Laughton Marshes, where my father had the shooting rights. One freezing November we went into Paul's cottage after duck flighting and he gave me a

glass of the deep purple wine to warm me up. I remember it being the most exquisite thing I had ever tasted.

During the eighteenth and nineteenth centuries, acres of elders were cultivated in Kent to make wine, spuriously sold as French clarets and burgundies or as port. A basket of elderberries, water, yeast and sugar is all that is needed for a basic wine, and I thoroughly recommend it. Another marvellous drink which knocks sloe gin into a cocked hat is elderberry schnapps. Simply fill a Kilner jar with elderberries and pour in a bottle of vodka. Stand in sunlight for a day or two, giving it a good shake every so often, and leave in a cellar or dark storeroom for a few months. Strain and bottle the schnapps and use the vodka-infused elderberries as a stuffing for wild duck, sauces for game, mousses, sorbets or pies.

Elder has been called 'nature's medicine chest', and the range of medicinal uses for it is quite staggering. Elderflower water, made from boiled water and elder flowers, was once the universal skin softener. The flowers were mixed with clarified lard as an early form of face cream and as a soothing lotion for scalds, stings, chilblains and scar tissue. During World War I, the Blue Cross appealed for elder flowers to make into unguents to treat injured artillery and troop horses. Elderflower teas, possets and syrups were recommended as a blood purifier and in escalating doses for colds, influenza, asthma, bronchitis and pneumonia. The berries, bark and leaves contain viburnic acid and were used to induce perspiration to sweat out fevers, for rheumatism and syphilis, or made into an ointment to treat haemorrhoids or mixed with fennel to relieve sciatica.

> MY FIRST ALCOHOLIC DRINK, WHEN I WAS TEN YEARS OLD, WAS ELDERBERRY WINE, MADE BY AN GERMAN EX-PRISONER-OF-WAR CALLED PAUL RICHTER. ONE FREEZING NOVEMBER WE WENT INTO PAUL'S COTTAGE AFTER DUCK FLIGHTING AND HE GAVE ME A GLASS OF THE DEEP PURPLE WINE TO WARM ME UP. I REMEMBER IT BEING THE MOST EXQUISITE THING I HAD EVER TASTED.

A TASTE OF THE SEA

Some of the most distinctive-tasting edible wild plants grow round our coastline, drawing their flavour from salinity in the soil.

Marsh samphire (*Salicornia europaea*), that succulent plant of estuaries and mudflats, has gained tremendous popularity in recent years, appearing on the menus of smart London restaurants during its short two-month season from the middle of June to the middle of August. Marsh samphire can be found in estuaries all round Britain and Ireland, particularly the tidal salt marshes of Norfolk and Lincolnshire. It resembles a small, hairless, jointed cactus and is picked at low tide, when the muddy creeks and gutters of the mudflats where it grows become accessible. Sometimes a bed of samphire will cover several acres, at other times they are found in isolated clumps. Picking samphire is a labour of love; chest waders are recommended, a board to kneel on and a basket for your pickings. It is hot, muddy work, but the pleasure of being out in one of the few unspoilt places in Britain, with the smell of the sea, the distant sound of the surf and the cries of the wildfowl, makes it an outing to remember. And it all comes back to you again in the salty, slightly fishy taste of the samphire. Curiously enough, until recently, marsh samphire was only appreciated by those that lived near the estuaries. Rock samphire (*Crithmum maritimum*), an entirely different plant altogether, was the great Tudor and Elizabethan delicacy, a flowering plant of shingle beeches and sea cliffs that was once in such demand for its unique flavour that people would risk their lives scrambling along rock faces or being lowered over cliffs on ropes to pick it. Shakespeare mentions it in *King Lear: 'Half way down, hangs one that gathers samphire – dreadful calling.'* It is now protected under the Wildlife and Countryside Act.

The common name for marsh samphire is Glasswort, which the plant acquired in the sixteenth century when Venetian emigrants introduced a method of making glass using soda ash. Marsh samphire is high in sodium, and until synthesised sodium carbonate was invented in the mid-nineteenth century vast quantities were harvested, dried and burnt for the alkali in the ashes. As a palatable and highly nutritious spring green, the plant would probably have been exclusively eaten by the wildfowlers, fishermen, reed cutters, shepherds and wort burners who made their living on the marshes. The humanist scholar and martyr Sir Thomas More (1478–1535) describes marsh samphire as improving 'many a poor knaves pottage'. It was also traditionally preserved for winter consumption by pickling in vinegar. When I first went wildfowling on the north coast of Norfolk, you could buy pickled samphire from cottages beside the road that follows the shoreline from Hunstanton to Cromer.

Only 5 per cent of samphire eaten in fashionable restaurants or sold by trendy fishmongers is harvested in Britain; the rest is imported from the Continent.

Sea purslane (*Halimione portulacoides*) also grows out on the mudflats below the high-tide mark. The plant grows in dense clumps on the edges of muddy creeks and gutters, which makes picking the succulent, oval leaves something of an adventure. It is well worth the effort as sea purslane, like other salt marsh plants, absorb all the vitamins, minerals and trace elements washed from the uplands down to estuaries and has a superb tangy, salty flavour. It makes a wonderful addition to a salad; can be steamed, puréed or pickled to eat with cold meat.

MARSH SAMPHIRE (*SALICORNIA EUROPAEA*), THAT SUCCULENT PLANT OF ESTUARIES AND MUDFLATS, HAS GAINED TREMENDOUS POPULARITY IN RECENT YEARS, APPEARING ON THE MENUS OF SMART LONDON RESTAURANTS DURING ITS SHORT TWO-MONTH SEASON FROM THE MIDDLE OF JUNE TO THE MIDDLE OF AUGUST.

Sea beet (*Beta vulgaris* subsp. *maritima*) is common, except in the north of Scotland, at the base of sand dunes, shingle beaches well above the high-water mark and beside paths leading down to the sea. The plant grows to about 90cm with large, fleshy, shiny green leaves and is believed to be the ancestor of all cultivate varieties of beet – sugar beet, beetroot, mangel-wurzels and, of course, spinach. The leaves can be picked from May to December and were undoubtedly eaten by prehistoric coastal communities. Because of the plant's extended growing season and high protein content, it was greatly prized during the sixteenth and seventeenth centuries as animal fodder. It is rich in all essential minerals, vitamins and trace elements and has a vastly superior flavour to cultivated spinach. Sea beet adapts to any contemporary recipe for spinach.

There are a number of seaweeds that can be eaten in one form or another – the algae, Irish moss (*Chondrus crispus*), for example, used to be made into flavoured blancmanges, jellies and custards – but the only ones I mention here are purple laver (*Porphyra umbilicalis*) and green laver (*Ulva lactuca*). Both these seaweeds are found all round the coasts of Britain and Ireland, clinging to rocks and stones, their soft, irregular-shaped fronds moving gently at the water's edge. A dark green, almost black purée of the seaweed, known as laverbread, is a traditional Welsh delicacy and I became very fond of it when I was an agricultural student on a hill farm in Carmarthenshire. A fishmonger in Llandeilo, the local market town, sold laverbread and we ate it for breakfast. Eggs and home-cured bacon were cooked in a pan, and slices of bread fried in the fat. The laverbread was heated in the remaining fat for a few minutes and spread on the fried bread with the eggs on top. An alternative method was to roll dollops of laverbread in oatmeal and fry them. Either way, those breakfasts, after a cold morning lambing out on the hill, stick in my memory as the most delicious I have ever eaten. Laverbread is also full of iron, potassium, calcium iodine and magnesium, plus vitamins A, B, C and D.

Alexanders (*Smyrnium olusatrum*) grow above the tide mark on the dry marshes where sea aster, centaury, campion and thrift add a little colour to the pale coastal grasses. Alexanders are bushy plants that grow to about 120cm, with sturdy stems

similar to cow parsnip. It produces umbels of yellowy green flowers from April to June and has trios of glossy leaves on the end of leaf stalks. Alexanders originate from the Mediterranean and were among the many vegetables introduced by the Romans, who were fond of the plant's cloying, resinous, myrrh-like flavour. It became naturalised and then reintroduced by the Norman monks, who grew it in the kitchen gardens of their religious houses; Alexanders can sometimes be found growing wild in the vicinity of old abbeys and monasteries. The plant continued to be widely cultivated as a garden pot herb until the middle of the eighteenth century, when it was gradually displaced by celery. The best time to pick Alexanders is just before they flower in April. The first 15–20cm of the stem is the edible part and should be peeled like rhubarb and cooked as asparagus. The leftover green leaves make an interesting addition to salads.

> FENNEL IS ANOTHER TREASURE INTRODUCED BY THE ROMANS ... FENNEL WAS BELIEVED TO HAVE AN INCREDIBLE RANGE OF CURATIVE AND MYSTICAL PROPERTIES THAT RANGED FROM ACTING AS A PROTECTION AGAINST WITCHES (BUNCHES OF IT WERE HUNG ABOVE DOORS ON MIDSUMMER'S EVE) TO RESTORING SIGHT.

Fennel (*Foeniculum vulgare*) is another treasure introduced by the Romans and is quite commonly found (except in the far north) along roadsides, paths and waste ground near the sea. The whole plant, leaves, seeds, flowers, and root, has been highly prized since antiquity for its sweet, aromatic flavour and purported medicinal properties. Wild fennel, which grows to about 150cm, is an attractive, elegant plant of delicate stems and narrow, wispy leaves, which produces clusters of yellow flowers from June to the beginning of October. Rub a bunch of the leaves between your hands and the wonderful, rich scent of aniseed is released. It was traditionally cultivated to eat with fish, particularly during the Middle Ages, when the early Roman Catholic Church imposed endless fast days; fennel sauce with salt fish was a typical medieval Lenten dish. As with Alexanders, fennel was grown in the kitchen gardens and herb garths of the Norman monasteries and can still be found growing wild in the vicinity of those built near the coast.

Fennel was believed to have an incredible range of curative and mystical properties that ranged from acting as a protection against witches (bunches of it were hung above doors on Midsummer's Eve) to restoring sight. It was a medieval cure-all, reputed to be efficacious for everything from swellings of the spleen and stoppages of the lungs, to gout, hiccoughs and wind. (A belief in the last of these persists to this day.) Since the early nineteenth century, fennel has been a principal component of Gripe Water, sometimes known as baby's bliss, a mixture of fennel, alcohol, bicarbonate of soda and syrup, given to infants suffering from wind. Fennel is also a natural breath freshener, and the better sort of Indian restaurants provide fennel seeds to chew at the end of a meal to act as a palate cleanser and to stimulate digestion.

The plant is endlessly versatile and is best picked before the flowers appear in June. The fresh-cut fronds and stems give a unique flavour to fish and meat sauces, soups, stews, pastas, risottos and salads. They are delicious chopped small, mixed

with egg, Parmesan cheese and breadcrumbs, formed into flat cakes and fried. It is the dominant flavour in the marinade used to make gravadlax (pickled salmon) and they add a certain nimbus to homemade sausages. Bunches of stems and fronds can be dried for winter use and the seeds, harvested in late autumn, are an early winter addition to a variety of meat dishes.

Common mallow (*Malva sylvestris*) is found growing on roadsides and rough ground leading down to the coast, and is worth picking. The plant is rather bushy with straggly, tough stems and a beautiful mauve flower with purple veins, which flowers from June to October. The ivy-shaped leaves, which are rather moist to touch, are best picked before the flowers open and are an interesting addition to salad or can be made into a rather gelatinous purée. Children love to chew the small round seeds (mallow cheeses) which are satisfyingly crunchy and have a nutty, cheesy flavour.

Marsh mallow (*Althaea officinalis*), as the name suggests, grows out on the salt marshes, on the banks of river estuaries and inland, beside ditches or in damp meadows near the sea. The plant grows to about 1.5 metres and produces a pink flower in August when the leaves are at their best. Marsh mallow has a high content of starch, mucilage, pectin, oil, sugar and cellulose. Although the leaves can be eaten sparingly in salads and in stews and soups, the plant's principal value has always been medicinal, the natural mucus proving particularly helpful in soothing coughs and sore throats, kidney and urinary infections, or when used as a poultice to reduce inflammation. The flowers boiled in water with alum and honey were used as gargle for sore throats or mouth ulcers and the dried, powdered root was mixed with honey and sucked as a throat lozenge. The French popularised marsh mallow as a confection in the mid-eighteenth century, by mixing the root with egg white, sugar and rose water to create *pâté de guimauve*. Modern commercial marshmallow does not contain any of the wild plant.

WILD FOOD FROM THE HILLSIDES

Bistort (*Polygonum bistorta*) is common on the edges of damp marginal hill pastures throughout Britain. The broad, spear-shaped ribbed leaves appear early in spring, and as the summer progresses the plant grows to about 60cm, producing a cluster of tiny pink flowers from June to August. The leaves have been eaten since antiquity and were the principal ingredient in Easter Ledge Pudding (a corruption of Easter *mangeant),* a plant to be eaten at Easter. These puddings were traditional Easter fare in Yorkshire, Northumberland, Cumberland and Lancashire, hence one of its other names: Passion Dock, from Passion tide – the last fortnight in Lent. They were made of young bistort leaves and any other edible pot herb that might be growing locally at that time: nettle tops, dandelion leaves, Good King Henry, fat hen, orache, and so on. The leaves were chopped small and mixed with onions, barley or oatmeal. Beaten eggs were folded into the mixture and the whole thing wrapped in a cloth and stewed in a pudding basin. Sometimes bacon or other meat, salted for winter consumption, would be added. Recipes varied slightly from county to county, and in 1971 the village of Mytholmroyd, in the Calder Valley of West Yorkshire, started hosting the annual World Championship Dock Pudding Contest. This very popular and well-attended event normally has as many as thirty different variations of the pudding entered for judging.

Broom (*Cytisus scoparius*) has a very noble heritage. Geoffrey of Anjou (1113–51), Duke of Normandy, wore a sprig of the distinctive bright yellow flowers attached to his helmet, to help his knights identify him in the heat of battle. His son, Henry II, took it as his personal cognizance, and the Plantagenet Kings adapted their family name from *planta genista,* the medieval words for broom. It first appeared as the official heraldic device of England on the Great Seal of Richard I.

> BROOM ... HAS A VERY NOBLE HERITAGE. GEOFFREY OF ANJOU, DUKE OF NORMANDY, WORE A SPRIG OF THE DISTINCTIVE BRIGHT YELLOW FLOWERS ATTACHED TO HIS HELMET, TO HELP HIS KNIGHTS IDENTIFY HIM IN THE HEAT OF BATTLE. HIS SON, HENRY II, TOOK IT AS HIS PERSONAL COGNIZANCE, AND THE PLANTAGENET KINGS ADAPTED THEIR FAMILY NAME FROM *PLANTA GENISTA.*

The buds of this densely growing shrub, found on heaths and waste ground across Britain, were once considered a great delicacy. Broom is one of the earliest flowering plants, producing blossom from March to June, and the buds were picked in late April and May. These were either preserved in brine or pickled in a mixture of salt and vinegar and eaten as an appetiser. At the feast following the coronation of James II, pickled broom buds were among the delicacies provided for the nobles on the three principal tables. Broom flowers and pickled broom buds were one of the ingredients in *salmagundi,* a presentation dish popular in the seventeenth century, containing a whole variety of different tastes, colours and textures on the same plate. Minced veal, ham, chicken or rabbit, pickled herrings and anchovies, eggs in calves' foot jelly, cold squab, little birds and oysters, were all arranged in patterns on a bed of wild and cultivated pot herbs. Garnishing these were rock samphire, broom flowers and pickled buds, sweet violets, almonds, raisins, figs, chopped onions, sliced oranges, peas and redcurrants, dressed with oil and vinegar.

The plant contains sparteine and scoparin, chemicals which are the reason broom tops and broom flowers were renowned for their diuretic and carmative properties. Decoctions of broom were known to triple kidney output, and this miraculous voiding of fluid was believed to be beneficial to almost all internal ills. Henry VIII was convinced he lost weight by drinking infusions of broom flowers, and broom tops were on the herb gatherers' list during World War II to be synthesised into diuretics.

Broom is a classic multi-purpose plant which once had a variety of different uses – apart from medicinal or culinary. The long, slender, stiff branches were used for sweeping floors (hence the English common name), making baskets and for thatching in areas where reeds were not available. It was planted along newly formed banks and on sand dunes to prevent erosion, in plantations to protect young trees from the wind, and as cover for game. The bark and twigs when macerated in water produced fibres similar to flax, and tannin was extracted from the bark for tanning leather. The black seedpods of broom ripen in July, and on hot summer days burst with a sharp report, flinging the seeds up to 7 metres. When picked just before the pods ripen, the seeds have been used to make a bitter coffee substitute.

Common gorse (*Ulex europaeus*) is generally distributed across Britain, particularly on heaths and moorland fringes. The flowers of this dense, prickly evergreen shrub manages to retain a few blossoms all year round, adding a little colour to drab winter landscapes. Hence the saying:

When gorse is out of season,
Kissing is out of bloom.

An allusion to this used to be found in rural areas of the north of England and Scotland, where a sprig of gorse would always be included in a bridal bouquet. New blossom starts to appear in February, and from May until August, whilst the flowers are in full bloom, the plants are a riot of golden colour. On hot days, the warm coconut scent, busy hum of bumble bees and 'pop' of bursting seedpods epitomises summer in this part of Scotland.

Over the last 100 years, common gorse has gone from being a valuable plant cultivated for a number of uses to classification as an invasive agricultural pest

species. Like broom, the buds were pickled as delicacies and the flowers made into a delicious refreshing wine, but its principal value was as a winter stock feed. Gorse had been cultivated and harvested since before the Roman occupation, a practice that continued until the early twentieth century. Seeds broadcast on free-draining soil would be ready for grazing by sheep in two years or cropping in four by coppicing. Branches were cut with long-handled loppers and taken back to the farm for crushing to break up the woody stems and sharp spines. Depending on the quantity required, this was done with a wooden mallet, by spreading gorse branches on flagstones and dragging a stone roller over them, or by mangling in a purpose-built gorse mill. Gorse needed to be broken down to the consistency of moss before sheep and cattle could eat it, but horses will happily pick away at a bundle of gorse hung up in their stall. With a protein content equivalent to half that of oats (12 per cent), six acres of gorse would feed four cows or six horses and dairy cows fed on gorse were said to produce the sweetest milk. The importance of gorse as a crop is reflected in the frequency of place names prefixed by one of its other appellations – *Whin*: 'Whin Bank', 'Whinny Knowe', 'The Whins' are all common place or farm names in northern England and Scotland. As machinery replaced manpower, harvesting gorse died out and the plant spread uncontrolled through natural regeneration every summer as the seedpods burst, scattering seed over a distance of up to 7 metres.

Gorse was planted as hedging and also cultivated as fuel. The resinous wood has a high heat content and was used in bakeries, brick and lime kilns. The alkaline-rich ash was used as a fertiliser, al ye for washing cloth and a component in soap making. Flowers were picked to make a beautiful yellow dye and their sulphur content was said to be good for acne when mixed with goose fat and used as a face cream. For years the Benedictine monks of Caldey Island, off the coast of Wales, have made a lovely scent from the sweet-smelling blossom. Gorse is one of the few plants that appear to be credited with very little medicinal folklore. An infusion of blossom was used to treat scarlet fever and an effluent of chopped gorse steeped in water was believed to have insecticidal properties which killed fleas in the house.

Even in its unmanaged state, gorse does have a place in creating valuable habitat for a whole range of biodiversity. The extended flowering season attracts a mass of insect life, particularly rare butterflies and moths. The Sinnington Hunt in North Yorkshire manages and conserves a stand of gorse at Hutton Common, one of the few places where the Pearl-bordered fritillary butterfly and common dog violet on which the caterpillar feeds can be found. The dense thorny cover provides nesting shelter to a number of little birds: stonechats, linnets, wrens, rare Dartford warblers and yellowhammers. The Welsh for yellowhammer is *'melyn yr eithin'* – yellow bird of the gorse.

Bracken (*Pteridium*) is another multi-purpose plant which once had an enormous number of different uses and has become an aggressively invasive weed species. Bracken grows vigorously worldwide, except in arctic or desert areas, and covers nearly 4,000 square miles of England and Wales and half as much again in Scotland. Most of it is in hill stock rearing and heather moorland, where it reduces potential grazing areas, colonises ground-nesting bird habitat and blankets out competing vegetation, particularly environmentally important plants such as heather. During the summer growing period it is poisonous to all livestock. Various species of disease-carrying ticks hibernate and breed in the mulch at the base of plants. The spores, released when the fronds open in July, cause blindness in animals and are recognised as carcinogenic. Forestry Commission workers are now required to wear face masks when working near bracken, and the Scouts Association advises members to 'refrain from walking through bracken patches and from using bracken to construct backs wood shelters'. Despite efforts to control the plant with herbicides, the total area in Britain continues to expand at the rate of 3 per cent per annum.

The reason bracken has been able to invade such enormous areas during the last 100 years has been the loss of its value as a natural resource. Bracken was once harvested annually for thatching, deep litter bedding for livestock, and as a base for straw and hay stacks. Root crops were covered in bracken to protect them from frost, either in the ground or in clamps. A tanning solution called 'brake water' was made from the rhizomes for colouring wool and leather (particularly kid and chamois) yellow and silk grey. As a quick-burning, rapid heat fuel, it was used in bread ovens, brick and lime kilns. During the eighteenth and nineteenth centuries, enormous acreages were cut to be burnt for the alkali and potash used in glass and soap making. Potassium-rich bracken ash was much sought after as a fertilizer for root crops. Anything breakable, such as slates, pottery, earthenware troughs and sinks, was always packed in bracken for transport. Even in the fifties and sixties, Irish bracken cutters were a regular sight on the hills of northern England and Scotland, cutting bracken with scythes in July and August, and stacking it in heaps to dry.

> THE REASON BRACKEN HAS BEEN ABLE TO INVADE SUCH ENORMOUS AREAS DURING THE LAST 100 YEARS HAS BEEN THE LOSS OF ITS VALUE AS A NATURAL RESOURCE. BRACKEN WAS ONCE HARVESTED ANNUALLY FOR THATCHING, DEEP LITTER BEDDING FOR LIVESTOCK, AND AS A BASE FOR STRAW AND HAY STACKS. ROOT CROPS WERE COVERED IN BRACKEN TO PROTECT THEM FROM FROST.

The plant was also valued for its medicinal properties; a decoction made from the extensive roots, or rhizomes, was efficacious in expelling stomach worms and for easing bronchitis. Early colonists to America, New Zealand and Australia were slightly nonplussed to find not only bracken growing in these countries, but the natives using the plant for the same purpose. A powder made from dried, powdered stalks and roots was used as a coagulant in wounds and dusted on cuts and ulcers. Fronds were cooked up in grease as an ointment for severe bruising or made into poultices for boils. Sap squeezed from the stalks relieved wasp stings,

inflammation left by tick bites, and mouth ulcers and toothache. Smoke inhaled from burning bracken was recommended to relieve headaches and repel mosquitoes. Gardeners watered plants with a solution made from boiled fronds to kill aphids, the hopeful rubbed it into their scalp to promote hair growth, and in Russia and Scandinavian countries mature fronds are added to malt to make a type of beer.

In certain parts of the world, bracken rhizomes and the tightly curled, emergent fronds, known as 'fiddleheads', have been eaten for centuries. Rhizomes are high in starch and were made into a form of flour by aboriginal people across North and South America, and from the Canary Isles to the Far East. Until recently, they were never really eaten here, probably because the plant was so valuable for other uses. Fiddleheads have now become popular with contemporary chefs, appearing in a variety of guises on menus in trendy restaurants and gastro pubs. There is so much bracken across the country that even the most sedentary forager should be able to find some, but as a last resort fiddlehead greens can be bought frozen or canned from gourmet and Asian food stores.

Having arrived, metaphorically speaking, on the heathery uplands, I must mention bilberries (*Vaccinium myrtillus*). Bilberries, whortleberries, whinberries or blaeberries are delicious little fruits that grow on a small creeping shrub with wiry, angular branches on heaths, moors and mountains across Britain. The berries appear from July to September and are initially a reddish yellow, turning to black as they ripen. When fully ripe they acquire a faint white bloom which rubs off on the fingers. Bilberries sometimes cover a considerable area, at other times they have to be searched for among the heather, but the effort is always well rewarded. Eaten raw, they have a fresh, slightly acid taste and are superb with sugar and cream. The rich flavour comes to the fore when they are made into jams and syrups or used in pies, puddings (a pint of bilberries transforms summer pudding), fillings for pastries, either on their own or mixed with apples. At one time, considerable quantities were picked by gypsy families, who camped out on the moors and sold the berries in local towns. In Yorkshire, a bilberry pie was part of the traditional tea following a funeral and the berries were sometimes added to the batter mix for Yorkshire pud.

BEYOND THE KITCHEN

There are a multitude of wild plants that are not necessarily edible but were used as medicinal herbs, for flavouring, making wine, tisanes, to perfume cosmetics and 'sweet waters', or simply to disguise unpleasant smells. Our ancestors were aware that ill health was associated with the appalling stench from middens and open sewage drains that were part of everyday life until the late nineteenth century. They believed that diseases carried by foul air could be avoided by superimposing a pleasant, and therefore healthy, smell over an obnoxious one.

The universal floor covering until the eighteenth century (and in poor households for even longer) was rushes. Rushes cushioned the feet on stone, wood or packed earth floors, absorbed spilt food and rain, mud or snow brought into houses. There was a considerable industry in supplying a town such as London, with rush cutters harvesting Common rush, Bulrush and an agreeably smelling rush called Sweet Flag, from the marshes along the Thames estuary and delivering them in barges. Once rushes had been laid, they were sprinkled with 'strewing herbs', each containing important properties that were aromatic, disinfectant or insect and rodent repellent.

> ONCE RUSHES HAD BEEN LAID, THEY WERE SPRINKLED WITH 'STREWING HERBS' ... LAVENDER WAS STILL BEING STREWN ON THE FLOORS OF HOSPITALS IN THE REIGN OF QUEEN VICTORIA, AND AT ONE TIME IT WAS EXTENSIVELY CULTIVATED, WITH LARGE PLANTATIONS IN KENT, SURREY, SUFFOLK, HERTFORDSHIRE AND NORTH LONDON – HENCE LAVENDER HILL...

Thomas Tusser, in his *Five Hundred Pointes of Good Husbandrie* of 1557, lists twenty-one strewing herbs. Among those used at the time were: tansy, a disinfectant and insect repellent with a powerful scent; sage, an anti-bacterial; thyme, an aromatic antiseptic; meadowsweet, a favourite of Queen Elizabeth I for its beautiful perfume; wormwood, catnip, the pungent-smelling pennyroyal, rue and fleabane as insect and rodent repellents; rosemary, marjoram, fennel, basil, burnet, mint, sweet gale, feverfew, and lavender for aromatic, antibacterial and antiseptic purposes. Lavender was still being strewn on the floors of hospitals in the reign of Queen Victoria, and at one time it was extensively cultivated, with large plantations in Kent, Surrey, Suffolk, Hertfordshire and North London – hence Lavender Hill. The essential oils of these herbs were released as they were walked on, and larger households employed an Herb Strewer, whose role was to ensure that the right mixture of fresh herbs and flowers was strewn to keep the household healthy and free of vermin.

> *'But those herbs which perfume the air most delightfully, not passed by all the rest, but, being trodden upon and crushed, are three; that is, burnet, wild-thyme and water mints. Therefore, you are to set whole alleys of them to have the pleasure when you walk or tread.'*
> FRANCIS BACON, *Essays, Civil and Moral* (1601)

Britain still has a hereditary Royal Herb Strewer, an ancient title recreated in 1660 by Charles II, when he returned from exile in France to find the dreadful smell from the Thames, which was little more than open sewer, permeating St James's Palace. Bridget Rumney was engaged at £12 per annum as '*garnisher and trimmer of the Chapel, Presence and Privy lodgings*'. Bridget received a further £12 for performing the same duty in Queen Catherine's chambers. As sanitation improved, the office became more ceremonial, with the historic importance of the post reflected by a Royal Herb Strewer, in scarlet livery, leading the coronation parade for a succession of monarchs. The last Royal Herb Strewer to officiate at one such was Anne Fellowes, a close friend of George IV. In 1820, she and six attendants scattered flowers and herbs through Westminster Abbey ahead of his coronation procession. Subsequent monarchs have dispensed with the services of a Royal Herb Strewer, although the Fellowes family still claim the title for their eldest unmarried daughter in each generation.

Of the plants mentioned by Francis Bacon, wild thyme (*Thymus drucei*) grows on sandy heaths, dunes, the screes on the side of a steep, grassy hill, or on limestone cliffs. It is a little creeping plant and easiest found when the pretty clusters of pink flowers appear between June and August. This is also the best time to pick the herb so that you have the benefit of the honey-scented flower as well as the oblong leaves. As with many wild herbs, thyme has a milder flavour than the cultivated variety and it pays to be liberal with it to get the full benefit of the glorious natural taste. The whole plant, leaves, stem and flowers can be made into a delicious stuffing for chicken, added to omelettes, used as a bouquet garni for casseroles or to flavour roast lamb. The flowering tops, if macerated in salt water and placed in direct sunlight for a couple of days, make an enchanting 'sweet water' for adding to a bath. The dried plant will hold its flavour for winter use, and a hot infusion of dried thyme makes a soothing night-time drink.

Burnet, lesser or salad burnet (*Poterium sanguisorba*), is common in England on limestone and chalk downs, but rare in Scotland. The plant grows in clumps between 40 and 90cm high and produces globular red flower heads with tufted stigmas on reddish-brown erect stalks between April and October. The leaves are short, deeply toothed and grow in pairs of up to ten on either side of a thin stem. When crushed the leaves exude a fresh smell similar to cucumber, which would have been the attraction as a strewing herb. Picked young, before they become too bitter, they are an uplifting addition to salads, and in Roman times they were much used as a cooling addition to wine. Salad burnet leaves are a delicious inclusion among the fruit and mint in Pimm's or in a white-wine cup on a hot day. It was credited with considerable medicinal properties as a styptic and astringent, a cure for gout, rheumatism and nervous trembling. It was one of the herbs taken to America by the early settlers.

The water mint (*Mentha aquatica*) referred to by Bacon is a glorious plant and one of my favourites. It can be found all over Britain growing in masses along the edges of streams and bogs, damp meadows and wet woodland glades. The plant grows to about 60cm with bushy, lilac flower heads between June and September. The purple-tinged leaves can be used exactly as cultivated mint and have a sharper,

more intense minty flavour, which some people find requires a lot of sweetening. It is superb as a mint sauce, in chutneys, relishes and as a mint tea. When crushed, the volatile oils in water mint release a powerful aroma which relieves headaches and nasal congestion. The plant was much used as a strewing herb at feasts or in churches. Folklore recommended water mint mixed with honey as a cure for earache and a decoction of the leaves as a remedy for difficult menstruation, flatulent colic and blood vomiting.

Water mint is one of a number of mints found in Britain. Sadly, pennyroyal, peppermint and apple mint are now rare and localised. Corn mint (*Mentha arvensis*) and whorled mint (*Mentha* x *verticillata*) are common and easily found in damp places. Both are worth picking. Catnip (*Nepeta cataria*), another species of mint, is a plant of hedgerows, waste ground and field margins, growing to about 90cm. It is easily recognised by the grey, mealy leaves, covered in soft down that resemble rabbit ears, and the pale pink flowers. Although infusions of the leaves were recommended in treating hysterics and cases of temporary insanity, the principal use was as a strewing herb to repel rodents, cockroaches, fleas and flies. The smell released by bruising or crushing catnip induces bizarre, euphoric behaviour in cats – hence the name. Cats will roll on the plant, chew it, salivate copiously and purr or growl. Scientific research has identified that nepetaclone, the chemical that causes this reaction, also acts as the repellent to insects and rodents.

The bitter herbs rue (*Ruta graveolens*), fleabane (*Inula dysenterica*) and wormwood (*Artemesia absinthium*) are highly effective insect repellents. A few sprigs of rue, a stemmy plant with blueish-green leaves, greeny yellow flowers which bloom from June to September, hung from a window will keep flies out of a room. The plant has a strong acrid smell, and so assize judges, when presiding in court, used to surround their bench with sprigs of rue to keep the jail fleas of the accused away. The ancients credited rue with all manner of curative properties, from blindness and epilepsy to chronic bronchitis and nervous spasms. It was also once used to induce abortions.

Fleabane, a plant of damp meadows, ditches and riverbanks, grows to about 90cm and produces flat yellow flowers from July to September. Bunches hung in an open window will also deter flies, and an effluent made from fleabane soaked in water is an effective wash to rid dogs of fleas. In the Middle Ages it was burnt to rid houses infested with them and used as a cure for dysentery and diarrhoea.

Wormwood is a bushy plant of roadsides and waste ground, with profusions of little grey-green leaves and small, drooping white flowers which bloom from July to October. It was cultivated as an insect repellent in houses, particularly clothes moths, to keep slugs and snails from eating vegetables and to produce a

liquid to spray against aphids. Wormwood is aromatic and incredibly bitter; it was employed medicinally to remove intestinal worms and as an enervating, if nauseous, tonic which, if taken to excess, could lead to giddiness and convulsions. During the nineteenth century wormwood was used on the continent to flavour the alcoholic drink absinthe, and was believed to be the reason habitual drinkers became easily addicted.

Bog myrtle (*Myrica gale*) is a deciduous shrub that thrives beside bogs, on acidic peaty soil, moorland, marshes and wet heaths. It grows to about 120cm with grey-green toothed leaves on red twigs and orange-brown catkins. The leaves of bog myrtle or sweet gale, as it was known in the Middle Ages, have a powerful resinous scent and taste similar to cloves. They were used fresh as a strewing herb and dried to perfume linen and repel moths. Long before hops were introduced in the sixteenth century, gale was used to flavour ale and mead. Gale mead is a very refreshing drink, which is easy to make and has the advantage of being ready in about a week. Some microbreweries are now making ales flavoured with gale or 'gruit', a combination of gale, yarrow, mugwort or heather, using recipes dating back to the Bronze Age. Bog myrtle is best known to stalkers, fishermen and tourists to Scotland as a midge repellent. A handful of freshly picked bog myrtle leaves rubbed between the hands and spread over the face and neck is more effective than any commercial product. Scientific research has discovered that bog myrtle has essential oils that are extremely beneficial in treating acne and contains anti-ageing properties. Boots the chemists have launched a product range, Botanics Sensitive Skin, and anticipate the development of 5,000 hectares of gale plantations across Britain which will supply ten tons of gale oil by 2016.

Meadowsweet (*Filipendula ulmaria*), so loved by Elizabeth I, is a truly wonderful plant. It is widespread throughout Britain along roadsides, by running water, ditches, boggy ground, meadows and damp woodland. Banks of it grow near here, and between June and October, when the plants produce foaming clusters of creamy white flower heads, warm summer days are full of their glorious, sweet, honey and almond scent. The aroma is so exuberant and heady that it is easy to appreciate why meadowsweet was one of the plants held most sacred by the Druids. It has been used as a flavouring since antiquity – the Druids flavoured mead with it and the Romans used it to sweeten sour wine. The flower heads can be used to make sweet waters or bath oil, and for sheer luxury tip a basket of flower heads into a hot bath and clamber in. They will sweeten virtually all summer drinks and make a delicious cordial or white wine. Meadowsweet also endows rice pudding with a radiance that catapults it from a wholesome nursery food into the realms of haute cuisine. For once it really is ambrosial. For a plant so celebrated by the ancients, it appears to have surprisingly few medicinal properties in folklore, other than as an invalid tonic and a specific in children's diarrhoea.

Tansy (*Chrysanthemum vulgare*) is the forgotten flavouring. Tansy is an erect plant that grows to about 150cm when mature, with fern-like leaves and clusters of round, flat, bright yellow flowers, which appear in late summer from July to September. The plant has a powerful scent similar to camphor and the young leaves were much used in the medieval, Elizabethan and Stuart periods as a flavouring for

cakes, biscuits, custards, milk puddings and omelettes or mixed with vinegar as a cold sauce for mutton and as a hot sauce for fish. Tansy was a powerful repellent to rodents and most insects – ants will never nest near plants. It was used to induce abortions and in milder doses as a powerful anthelmintic. As such, it was customarily eaten during Lent, to expel the intestinal worms which fish were thought to carry. Over the course of time, the original medicinal use of tansy was lost and tansy cakes, biscuits, puddings and sauces became part of traditional Easter foods. The volume of medieval and sixteenth-century recipes for Easter dishes using tansy leaves raises an interesting observation on climate change. Until recently, tansy did not produce leaves until May, but as spring weather has become milder over the last decade, leaves are appearing earlier and nearer to the medieval date of Easter.

Tansy fell from grace as a flavour when cloves and cinnamon became readily available, although the name lived on as descriptive of a certain type of pudding, using fruit, cream and egg white – except in Ireland. A delicacy of County Cork is *drisheens*, a sausage made of sheep's blood, milk and mutton suet, flavoured with chopped tansy leaves. The plant's hot, piquant flavour is now appearing again in contemporary dishes. It is well worth trying as a stuffing for herrings and mustard sauce, mixed with cream cheese as a filling for crepes, as a flavouring for pancakes and, when used sparingly, in omelettes.

> THE VOLUME OF MEDIEVAL AND SIXTEENTH-CENTURY RECIPES FOR EASTER DISHES USING TANSY LEAVES RAISES AN INTERESTING OBSERVATION ON CLIMATE CHANGE. UNTIL RECENTLY, TANSY DID NOT PRODUCE LEAVES UNTIL MAY, BUT AS SPRING WEATHER HAS BECOME MILDER OVER THE LAST DECADE, LEAVES ARE APPEARING EARLIER AND NEARER TO THE MEDIEVAL DATE OF EASTER.

Wild basil (*Clinopodium vulgare*) is common in England, less so in Scotland, and rare in Ireland. It is a straggling plant with thin, hairy, erect stems, egg-shaped leaves and pink flowers which bloom from July to September. Wild basil, or hedge basil, grows beside hedges and waste ground, particularly on limestone and chalk (old chalk quarries are good places to find it). Wild basil is delicious freshly picked in salads, sauces, soups or made into a pesto, and can be dried for winter use. The bruised young leaves, steeped in olive oil and placed in direct sunlight for a few days, impart a delicate fragrance to dressings. As with other wild herbs, basil is mild and a liberal quantity is required to get the benefit of its flavour.

Marjoram (*Origanum vulgare*) is another plant common on chalk and limestone cliffs and sandy heaths. It is a thin-stemmed plant growing to about 90cm, with slender branching stalks which support bunches of pink flowers from July to October. The oval leaves and flowers, stripped from the rather wiry stalk, make a spicy addition to salads; the leaves give a piquancy to soups, roast lamb and rich stews. The curious, warm balsamic flavour becomes sweeter when the plant is dried for winter use. Dried marjoram in muslin bags was kept in linen cupboards at one time, to make sheets smell pleasant in the same way as lavender bags are today, and the juice squeezed from the plant was rubbed into furniture for the same reason. Marjoram was used to cure toothache, measles and as a liniment by farriers.

THE AUTUMN HARVEST

In late August and September, when the nights begin to draw in and the swallows start gathering for their migration home, nature provides another harvest of berries, nuts and fungi. Blackberries (*Rubus fructicosus*) flower from May to September and produce their delicious purple berries from late August until early November. Blackberries can be found all over Britain in bramble bushes along hedgerows, railway embankments, inner-city canal banks, waste ground and woodland fringes. The lowest berry of each cluster is the first to ripen and has the best flavour. Fat and juicy, these were the ones we looked for as children and would endure any amount of scratches to get hold of. The secondary berries are picked for preserving, jams, puddings, ice cream, jellies, blackberry wine and for flavouring vinegar. Traditionally, blackberries were over by the end of the first week in October and an old country saying, 'The Devil pisses on blackberries in October,' was a reference to the surviving berries turning soft with the first frosts of winter. Nowadays, with milder winters, the smaller berries can still be picked for several weeks more, although they tend to have a higher proportion of pips and are best used in pies with other fruit.

Not so long ago, blackberry picking in September was a significant event in the lives of urban people. It was one of the ways in which they kept in touch with their rural background, and every weekend whole families, armed with baskets and buckets, would descend on the countryside by bicycle, train, motorcycle and

356 ✂ *A Book of Britain*

sidecar or buses especially booked for the occasion. Sadly, the custom died out in the 1960s and 70s, as hedgerows that some families had visited every year were bulldozed out to create large field units. Preserving blackberries for winter consumption was a valuable source of vitamin C, and the leaves, bark and root, which contain a high proportion of tannin, were made into a decoction during the sixteenth and seventeenth centuries for treating dysentery.

Wild roses (*Rosa canina*) or Dog rose (from dag or dagger – a reference to the wickedly sharp thorns) – are common on waste ground, woodland margins and hedgerows. It is one of the traditional hedging plants, and millions were planted with hawthorn, holly, hazel, beech and blackthorn during the Acts of Enclosures, when 200,000 miles of hedging were established between 1603 and 1850. The rambling tendrils of wild roses produce fine pink or white blossom from June to July. Towards the end of the flowering period, the petals become loose and can be plucked off for use in salads or as a flavouring for sweet water, vinegar, jellies and sorbets. They can be made into wine, jam, crystallised, or used to add a delicate fragrance to puddings – they are particularly good with rhubarb. Rose hips, the bright red fruit which appear from late August until November, contain twenty times as much vitamin C as oranges. In medieval times they were boiled into a purée with honey as a pudding, but rose hips have been principally used for the last century in the form of a syrup as a vitamin C supplement through the winter. Rose hips can also be made into wine or a rich soup using fresh or dried hips.

> BLACKBERRY PICKING IN SEPTEMBER WAS A SIGNIFICANT EVENT IN THE LIVES OF URBAN PEOPLE. IT WAS ONE OF THE WAYS IN WHICH THEY KEPT IN TOUCH WITH THEIR RURAL BACKGROUND, AND EVERY WEEKEND WHOLE FAMILIES, ARMED WITH BASKETS AND BUCKETS, WOULD DESCEND ON THE COUNTRYSIDE BY BICYCLE, TRAIN, MOTORCYCLE AND SIDECAR OR BUSES.

Blackthorn *(Prunus spinosa),* the hardy thorn bush found all over Britain on heaths and in hedgerows, produces bitter blue-black sloes in September and October. Traditionally, sloes were never picked before the first frosts, which softened the fruit and removed some of the unpalatable acidity. Now the same thing can be achieved by putting them in the deep freeze for a couple of days. Most sloes are used to make the ever-popular sloe gin, a liqueur easily made by filling a 2-litre Kilner jar half-full of frozen sloes that have been pricked with a fork. Add 50g of crushed barley sugar and a bottle of gin. Leave in a warm place for at least three months, giving it a good shake from time to time. Strain through muslin into bottles, but keep the gin-infused sloes for stuffing duck or for a rich sauce to accompany any game. Sloes also make a superb wine similar to port, and in the eighteenth century gallons of sloe wine were sold by fraudulent wine merchants as genuine port. Sloe jelly is vastly superior to redcurrant with lamb or venison.

Another marvellous fruit of hedgerows, scrub woodland and heaths is little, rock-hard, yellow crab apples *(Malus sylvestris).* Wild apple trees, with their gnarled, twisted limbs, produce a beautifully scented flower in May and fruit from August to November, which are at their best from early September until the middle of October. Crab apples were highly prized by ancient Britons both as a food and as

an ingredient in a very potent, cider-based mead made from fermented apples and honey. All manner of myths and folklore became attached to crab apples, the most abiding of which was the Twelfth Night ceremony of Wassail. Originally part of a pagan fertility rite intended to hasten spring, wassail involved drinking toasts to fruit-bearing trees. It later became part of the Christian ritual of goodwill to mankind with honey-sweetened hot spiced ale, in which roasted crab apples floated, drunk from beautifully carved wassail 'Loving Cups' . Although the wassailing revels have died out in most parts of the country, orchard-visiting wassails continue in the West Country with Whimple in Devon and Carshalton in Somerset holding particularly famous ones on Old Twelfth Night, 17 January. On this night, villagers caper round the largest apple tree in a local orchard, drinking mulled cider and yodelling the wassail song:

Old Apple tree, old apple tree;
We've come to wassail thee;
To bear and to bow apples enow;
Hatsfull, capsfull, threebushel bags full
Barn floors full and a little heap under the stairs.

Shotguns are fired to frighten away evil spirits and pieces of cider-soaked toast are hung from the branches for robins, which are considered to represent the good spirits of the tree.

Crab apples are too bitter to eat raw (the name comes from the old English word meaning sour, bitter or twisted, and in Scotland the word 'crabbet' is often used to describe an evil-tempered woman), but are very good in their cooked form, especially when mixed with a sweeter fruit, such as blackberries. Crab-apple jelly has an exquisite flavour which is particularly good with hot scones or toast. Crab-apple cheese, made with cloves, cinnamon and nutmeg is delicious as a pudding or served as a sauce with goose, pork or boiled ham. Crab-apple wine, a medium-sweet modern version of the brew drunk by the ancient Britons, is easy to make. We pickle crab apples in cider vinegar and Barbados sugar every autumn, to eat with our Bradenham ham at Christmas – their tart flavour offsets the fattiness of the ham. We also make verjuice by roughly mashing them in a food processor, letting the mash ferment with a little water for four days; straining through muslin and bottling. It is a terrific alternative in all dishes where vinegar or lemon juice might otherwise have been used.

Rowan or mountain ash (*Sorbus aucuparia*), whose profusion of pale pink, early summer flowers and clusters of brilliant orange autumn berries has made it a favourite with municipal landscape planners, is common on dry heaths and woodland, moorland fringes and rocky valleys. There is much superstition and folklore connected to rowan trees, particularly as a ward against witchcraft (see page 153). Rowans were one of the Celtic sacred trees, and the berries were used by them to flavour mead or ale. I have known several hill shepherds who made wine from rowan berries and a retired naval commander who used the juice instead of Angostura bitters to make pink gin. For many centuries, rowan berries, sometimes mixed with crab apples, have been used to make a rather sharp-tasting jelly, which is the

traditional accompaniment for venison or roast mutton. They make an excellent stuffing, fresh or dried, for old grouse or wild duck.

Hazel (*Corylus avellana*) was one of the traditional hedging plants and can be found in old hedgerows, scrubland and as understorey woods across Britain. Hazels produce male 'lamb's tail' catkins and buds with little red protruding flowers from January to April. The nuts, encased in their thick frilled green husk (the name is from the Anglo-Saxon word *haesel*, meaning cap or hood) appear from late August to early November. Hazelnuts are high in protein and carbohydrates, and nutting for hazelnuts was another important custom involving the whole family which has died out – up until the 1930s, it was common practice for the schools of villages and market towns to close on Holy Rood Day, 14 September, to allow children to spend the day nutting with their parents. Once picked, the nuts must be kept in their shells in a warm dry place for eating through the winter, simply as a nut or used in an infinite variety of pudding dishes: tortes, macaroons, pies, meringue, ice cream biscuits or as paste fillings for cakes.

Sweet chestnuts (*Castanea sativa*), described as the most magnificent trees in Europe, are widespread throughout England, particularly where such a tree would enhance the immediate locality, such as parks, Royal Forests, near villages or in woods. They produce flowers in June and July which take the form of upright catkins, with the male flower on the upper part and the female on the lower. The female parts develop into fruit-bearing spiny cupules in the autumn, which ripen and fall with the leaves in October and November. I love hunting for prickly chestnut husks among the golden leaf carpet of a wood in the chill of a late October afternoon, with the musty smell of damp earth, an evening mist beginning to creep into the hollows and every so often the skittering sound of an animal hurrying through the leaves. Sweet chestnuts are tremendously versatile and were considered a delicacy by the Romans; it is generally assumed that it was they who introduced the tree to Britain. The nuts can be pickled, cooked with cabbage or Brussels sprouts or made into soup, puréed or used as a stuffing for pheasant, chicken and, of course, turkey. If there are any really big ones they can be lightly boiled and repeatedly dipped in hot syrup to make my favourite Christmas treat – marron glacé. Or they can be simply roasted in the embers of a hot fire as part of the tradition of Christmas. John Evelyn succinctly described sweet chestnuts as 'delicacies for princes and a lusty and masculine food for rusticks, and able to make women well-complexioned'.

WILD FUNGI

Nothing is more synonymous with this period of mists and mellow fruitfulness than the mushrooms, toadstools and other fungi that appear in our woods and old pastures. They are fantastical organisms that sprout up among leaf litter, decaying stumps, the trunks of trees or simply emerge as jelly, oozing out of the ground – prehistoric parasitic growths which, lacking the ability to produce their own food, absorb sustenance from living or dead plant matter, creating a nutrient recycling process without which crops, trees and grass would not survive. What we see at this time of the year are the fruiting bodies of fungi, a device for distributing spores. The fungus itself is a mass of filamentous growths, or *hyphea*, extending beneath the soil or whatever happens to be the host matter. There are something in the region of one and a half million different species of fungi worldwide, which include moulds, rusts, smuts, yeasts, mildews, lichens, mushrooms and toadstools, with perhaps as many as 20,000 in Britain.

Of these, half a dozen are pretty deadly, about the same number contain hallucinogenic properties and several are very good to eat: field and horse mushrooms; little stumpy *Boletus edulis* or ceps that grow in coniferous forests; chanterelles, which appear in carpets of eggshell yellow among mosses in deciduous woodland; the darker horns of plenty, clustering among leaf litter; shaggy ink caps of compost and dung heaps; puff balls; parasol and oyster mushrooms; wood and field blewits; wrinkled, pale-skinned morels; delicate, silver-grey oyster mushrooms; and sulphur polypore, or chicken of the woods, bulging in gibbous tiered groups from the trunks of oak, cherry or sweet chestnut trees.

Despite the vibrant food culture of the last couple of decades, the prevalence of cultivated fungi in supermarkets, dried fungi in every aspiring foodie's larder, or the educational fungus-identifying forays organised by conservation groups, we as a nation (except for dedicated aficionados, who really know what to look for) have a deep-rooted antipathy to picking fungi in the wild. Why this should be, when all our Continental neighbours have a historical culture of harvesting edible fungi, I have never quite understood. None of the explanations – that the early Christian Church anathematised fungi because hallucinogenic Liberty Cap and Fly Agaric had been part of Druidical ceremonies, or that in Roman Catholic countries fungi were acceptable Friday fare – carry much substance. I think the answer lies in a thoroughly British suspicion of anything unusual in the food line, mixed with inherent, basic common sense.

Requiring no light, most fungi emerge in dank, dark, sinister places where no healthy plant would be expected to survive. Many, like jew's ear, yellow brain and tripe fungus, resemble discarded body parts, so succinctly described by Shelley as *'pale, fleshy, as if the decaying dead with a spirit of growth had been animated'*. Some, stinkhorn and witch's egg, have the sickly sweet smell of carrion. Others, known to be edible, bore too close a resemblance to those that were deadly poisonous: delicious little chanterelles resemble the aptly named deadly webcap. Common morel could be mistaken for the toxic false morel, with fatal consequences to the liver and kidneys. Confusing common field and horse mushrooms with death caps or destroying angels was far too big a risk to take. Most boletus, which appear very

similar, could be eaten with safety, but by no means all. Shaggy ink cap, which grows on lawns, roadsides and garden rubbish heaps, has an almost identical nasty cousin: common ink cap – the medieval source of ink – which contains the toxin coprine. Coprine becomes activated if the fungus is ingested with alcohol and the effect, although not necessarily terminal, is enough put someone off any sort of mushroom for life. In the sixteenth century, John Gerard, an apothecary to James I and author of the famous *Herbal*, summed up the prevailing view of fungi with the warning that, 'most of them do strangle and suffocate the eater'.

None of these inhibitions affect wildlife, and fungi play an essential role in the food chain. Fungi provide specialist habitats for a huge number of mini beasts and their larvae, which in turn assist the fungi by distributing their spores. They are a host for flies such as fungus gnats, phorids, thrips and minute cecids, bluebottles, green bottles and flesh flies; any number of beetles, including dor beetles that hollow out bracket fungi, ambrosia beetles and the elm bark beetle that carry the spores of fungi from tree to tree. The great black, ash-grey and tree slugs are all voracious fungi eaters, and so too, are rabbits, badgers, hedgehogs, deer and red squirrels. Both deer and hedgehogs have fungi named after them: the little chunky hedgehog fungus, much prized by European epicures; *Pluteus cervinus*, an umber-coloured mushroom of deciduous woodland, much favoured by fallow deer; and the descriptively named deer balls – a globular yellowish toadstool, once used medicinally to encourage lactation. Our few remaining red squirrels supplement their winter supplies with a variety of the boletus species that grow in coniferous forests, carrying them up into the overmantle and fastening them to twigs or among conifer needles.

If fear of poisoning led to fungi being shunned as food, there were many other practical uses for them. Birch polypore or razor-strop fungus, the rubbery white bracket fungus which grows at right angles on birch trees, was harvested in large numbers and sold to barbers and wood carvers to put a fine edge on cutting tools. Birch polypore contains antiseptic properties and was used by Highlanders to pad their targes (shields) against impact and, if necessary, as wound dressings. Another birch polypore, the hoof or tinder fungus, was, as the name suggests, an essential component of a tinder box. Later on, it was used in the manufacture of fusees, an early form of match sold under the name of Amadou. The hard, corky fungi were beaten flat, cut into thin strips and the ends dipped in saltpetre. Hoof fungi were also used medicinally as a styptic to control haemorrhages. Green wood-cup colonises the fallen branches of oak trees, staining the wood a beautiful verdigris colour. Spores of this fungus were deliberately introduced to timber planking by eighteenth-century cabinet makers to create a curious colouring known as 'green oak' used in Tunbridge ware, a unique form of marquetry. The wood of oak trees infected by ox tongue fungi was found to have a darker colour and was much sought after by furniture makers. Jew's ear, the slimy brown growths often seen on elder trees, soothed and healed ophthalmic complaints. Powder from dried giant puffballs had a variety of applications: it made good tinder; bee keepers used it (and still do) when smoking bees; surgeons treated septic wounds with it to draw foreign matter; and it could be made into an invigorating

tonic. Fly agaric, the highly toxic scarlet mushroom found in birch woods, was pulped, mixed with water and painted round doors and windows to kill flies.

For those expert enough to distinguish between edible species and their poisonous look-alikes, there are some wonderful delicacies to be found in the autumn. But, having known someone who made a simple mistake and spent the rest of her life on a kidney dialysis machine, I cannot overemphasise the importance of studying fungi with a professional mycologist before contemplating foraging. Following the resurgence of interest in wild food, there is now no shortage of expertise available through fungi-identifying courses and workshops run by local fungus recording groups, the British Mycological Society, the Field Studies Council or Natural History associations. A number of cookery schools and fine-food outlets also run courses. and some of the most enjoyable are those offered by Valvona and Crolla, the famous Edinburgh delicatessens. During September and October, Valvona and Crolla organise tutored fungi-identifying expeditions led by Professor Roy Watling MBE, the consultant mycologist at Edinburgh's Royal Botanic Gardens. Parties are taken by bus to woodland locations likely to provide a wide variety of fungi. They then disperse among the trees, collecting any fungus they come across, meeting up again at lunchtime for a terrific picnic and selection of Italian wines provided by the delicatessen, whilst the professor identifies their findings.

FLY AGARIC

Curious stuff, fly agaric. A powerful hallucinogenic, it was used for centuries as an inebriant by the nomadic reindeer-herding tribes of northern Scandinavia and Russia. The habit started, apparently, when the tribesmen noticed the effect of the hallucinogen on reindeer, who find the mushroom palatable. The popular method of ingesting the drug was to tether the inebriated beast and drink its urine. Muscimol, the psychoactive element, remains active in urine, and revelling tribespeople were able to recycle the drug among themselves, for as many as seven reingestions. Maddeningly, history fails to tell us how this fascinatingly economical way of holding a party was ever discovered, but it is indubitably the origin of the expression 'to get pissed'.

The most delicious fungi are often among the easiest to find. One of my all-time favourites is giant puffball (*Langermannia gigantea*). They are not uncommon in woodland glades, the corners of fields and under hedgerows, emerging from August to October. Puffballs are usually between 10 and 30cm in size, but can sometimes be found much larger, and it is a real bonanza to stumble across one of these gross white globules glinting in the autumn sunlight. One of their advantages is being unmistakable for anything else; as long as it is pure white and more or less spherical, it's a puffball. If the skin has a yellowish tinge, they are past their best and will soon turn brown, exuding a cloud of dust spores when kicked. The best way to eat one is to cut 1cm slices from top to bottom and fry them in bacon fat until golden brown. Pink-gilled field mushrooms (*Agaricus campestris*) and the larger horse mushrooms (*Agaricus arvensis*) are usually easy to find from August to November in pastures and old meadows, particularly where horses are kept. The wonderful flavour of horse and field mushrooms is best appreciated if simply simmered in a little butter or milk. Unfortunately, yellow-staining mushroom is almost identical, except for the stem, which turns bright yellow when cut and can cause acute digestive upset.

> PUFFBALLS ARE USUALLY BETWEEN 10 AND 30CM IN SIZE ... AND IT IS A REAL BONANZA TO STUMBLE ACROSS ONE OF THESE GROSS WHITE GLOBULES GLINTING IN THE AUTUMN SUNLIGHT. ONE OF THEIR ADVANTAGES IS BEING UNMISTAKEABLE FOR ANYTHING ELSE; AS LONG AS IT IS PURE WHITE AND MORE OR LESS SPHERICAL IT'S A PUFFBALL.

The scaly-brown parasol mushroom (*Lepiota procera*) is unmistakable in wood margins, on stubble edges and along roadsides. It rises, closed, like an old-fashioned sun shade, the top held by a loose ring of tissue which moves up the slender stem as it opens. This eventually breaks free and can be moved up and down the stem. Parasol mushrooms are about 18cm when fully open and are good cooked as field mushrooms or sliced, dipped in batter and fried. Another edible species, shaggy parasol (*Lepiota rhacodes*), is similar, but with a scalier cap.

Ceps (*Boletus edulis*) are common in the open spaces of deciduous woodland, particularly beech. They have rounded, shiny brown caps supported by a spongy mass of pores, which represent the gills found in other mushrooms, and short, stubby, stems. Their country name is 'penny bun', which they resemble to some extent, and a sweep of ceps, growing among fallen beech leaves, is a joy to find. Ceps have a wonderful nutty, earthy taste – '*L'eau de terre*' – and are one of the most popular fungus on the Continent. There are a prodigious number of recipes for them: They can be grilled, baked, sautéed, stewed and fried; added to casseroles or soups; dried for winter consumption and made into flour. Boletus come into a number of species, all of which are very good to eat, except *Boletus satanas*. Satan's boletus looks very similar to all the others; it is easily recognisable to those who know what they are doing but is potentially an extremely unpleasant mistake for those who don't.

Chanterelles or girolles (*Cantharellus cibarius*) are beautiful little trumpet-shaped fungi of pine, oak, birch and beech woodland and appear in yellow carpets from July until the first winter frosts kill them off. They are the most

sought-after fungi on the Continent and have an exquisite flavour – a handful of freshly picked chanterelles has the aroma of fresh apricots. They are superb sautéed in butter with diced potatoes and bacon; fried with a little oil and garlic or in an omelette. Deadly webcap have been mistaken for chanterelles, with devastating results; one positive way of telling the difference is that the gills of chanterelles run down the stem. However, always remember the maxim of even the most experienced fungus forager: 'If in doubt, leave well alone.'

Oyster mushrooms (*Pleurotus ostreatus*) sprout in grey clusters from the dead or dying branches of beech or ash trees during the autumn. As with many fungi that grow on trees, they tend to be rather tough, but young specimens, sliced, dipped in egg and breadcrumbs and deep fried, are very good. They can also be added to stews, casseroles or soups, or grilled or dried for winter consumption. Chicken of the woods (*Laetiporos sulphureus*) can be found at any time of the year, except late winter, in gibbous yellow layers on old oaks, yew, sweet chestnut or willow. This fungus should be cut while it still has the yellow vibrancy of youth. This is a meaty fungus, and when chopped into cubes its texture and rich flavour are a delicious addition to casseroles.

Shaggy ink caps (*Coprinus comatus*) or lawyer's wig are often found in clusters in fields, road verges, canal banks, garden rubbish tips – virtually anywhere that humans have disturbed the ground. They emerge like white guardsmen's busbies, covered in light brown scales. As the slender stem grows, the fungus partially opens like an umberella, with pink gills that turn black and liquid as the fungus matures. Eventually it dissolves into an inky goo. Picked young, when the gills are still pink, and eaten almost immediately, they are delicious sautéed in butter or baked with eggs and a little cream. I find the flavour rather elusive and prefer to make them into ketchup by packing layers of the fungi with salt in an earthenware crock. The resulted fluid is strained, seasoned with pepper and nutmeg, brought to the boil and bottled. Shaggy ink cap is similar to common ink cap (*Coprinus atramentarius*), a mushroom which reacts badly with alcohol. It is distinguishable by being more slender than shaggy ink cap, a lack of scales and a dingy grey colour.

✳ ✳ ✳

Searching for nature's bounty and being rewarded with some delicacy, fragrance or even, if one knows what one is looking for, a palliative, is a cathartic experience which gives the forager a greater understanding of the land and the changing seasons. For this reason, among many others, it is vital that the wild places where these treasures grow must be preserved and cherished.

CHAPTER SIX

FOLKLORE & CUSTOMS

No country can have as many folk customs, festivals, feasts, privileges and traditions as the British Isles. Other nations use their folklore to define a single patriotic identity; ours define regional communities. Each county, every city, town, village and hamlet has its own unique variation. There are festivals with pagan origins which were subsequently adopted by the Church for every month of the year; strange ceremonies, such as Beating the Boundaries or Riding the Commons; wakes, fairs and winter fire festivals; odd sports, games and dances which have remained unchanged since the early Middle Ages; obscure medieval, civic and manorial courts.

Some customs, such as the ancient Doles and Charities, still have a practical application. Others are so old that they have long since lost their original point and are still practised simply because they have become embedded in the calendar of the locality. Blowing the Wakeman's curfew horn every evening in Ripon, for example, is a custom said to have originated in AD 700. The equally ancient Pig Bell is rung every night at 8 p.m. from St Peter's Church in Sandwich to signal that pigs may now be released into the streets to eat the rubbish.

It is remarkable that the hundreds of different folk customs – some highly publicised, others scarcely known – have defied the swings and roundabouts of history, to survive more or less intact into the twenty-first century. Henry VIII disrupted many of the quaint, semi-religious customs during the Reformation, then Cromwell and the Puritans put a stop to all festivities through the Commonwealth – until these were encouraged back again at the time of the Restoration. The later Agricultural Revolution saw landlords and farmers discouraging the old seasonal feasts and customs on the grounds that they had the potential to compromise efficiency and waste man hours. The infrastructure of many rural communities was then destroyed by the eighteenth-century Acts of Enclosure, when displaced farm workers were forced to seek work in the growing industrial towns, and the coming of the railways was believed to herald the death knell of the pastoral way of life. Villagers freed from their protective isolation would abandon themselves to urban vices, claimed the social moralists, whilst depraved townspeople, hearing of some simple rustic festival, would descend in train loads and transform it into 'a pandemonium of vice and drunkenness', according to the nineteenth-century British writer, James Greenwood. Two world wars were followed by rapid advances in agricultural technology, which were responsible for removing whole generations of village people as machinery replaced manpower. Successive socialist governments sneered at our heritage of customs and traditions, claiming they were archaic relics of the class system.

At one time or another our customs have been adversely affected by political, religious or social influences. Some disappear altogether in one generation, only to be revived in the next. Today, with the revival of interest in our rural heritage, these customs are stronger than ever. The reason for their popularity remains the same as it was a millennium ago: customs and traditions are essential to any community. They engender a feeling of individuality, collective pride and the sense of historic security which continuity has always provided. There is also another important sentiment in this age of high-speed modernity: only when something is in danger of being lost do we appreciate its value.

CELEBRATING THE START OF SUMMER

On 1 May, May Day, the date that traditionally marks the start of British summer, my mother always opened our gardens to the public and, as an added attraction, girls from the village school wearing long white dresses were dragooned in to perform ribbon dances round a flower-decked pole erected on one of the lawns. Under the direction of Mrs Lister, the Sunday School teacher, they executed increasingly complicated steps whilst the red, white and blue ribbons formed patterns up and down the pole. Starting with Single Plait and moving through the intricacies of Double Plait, Barber's Pole, Jacob's Ladder and Spider's Web to finish with Gypsy's Tent, the most difficult of all the dances, their faces creased with concentration.

This enchanting rural scene, which is still repeated in towns and villages all over Britain at the beginning of May, is a relatively modern interpretation of a much more ancient festival. Ribbon dancing became a popular stage act during the eighteenth century, particularly in London's famous pleasure gardens – the Cremorne and Ranelagh. In 1881 it was introduced to Whitelands College, London, the teachers' training college for women, by the Victorian philanthropist and art critic John Ruskin as part of their May Day celebrations. The enthusiasm of the Whitelands graduates spread the idea to schools throughout Britain and much of the English-speaking world with such success that ribbon dancing round the maypole became accepted as a May Day tradition.

MAY DAY MERRIMENT

Celebrating the start of real summer growth is as old as antiquity. On a summit not far from our farm in the Borders is a megalithic standing stone, one of many thousands erected across Europe. At this time of year, I like to think of dreamy Bronze Age herdsmen capering round it as dawn broke and the sun rose. Beltane became the most significant festival in the Celtic calendar, with Druids lighting great ritual bonfires on hill tops at sundown before May Day; a tradition which has experienced a revival among neo-pagans in recent decades. The Romans celebrated the start of the new life cycle with a six-day orgy dedicated to Flora, the goddess of flowers, regrowth and prostitutes. It was a time of great rejoicing, dancing and merriment. Houses, public buildings and temples were decked with flowers and greenery collected the previous day, and hares, a symbol of fertility, were released into the streets. This festival spread across Europe to Britain as the Roman Empire expanded, becoming entwined with Beltane and, eventually, Walpurgis Night – the fertility celebration of subsequent Norse invaders.

May Day revelries reached their height in the Middle Ages, and the enthusiasm for them was to last for several centuries. The custom of going into the woods 'A-Maying' – to gather flowers, greenery and branches of hawthorn blossom the night before – became synonymous with licentious behaviour that was enjoyed by all levels of society, including the clergy. A 'green wood marriage' or 'to wear a green gown' were well-known metaphors for what went on under cover of darkness. Having washed their faces in the morning dew, the returning foragers brought back tall saplings and erected them on village greens as focal points for dancing, games, ceremonies and the selection of May Queens.

Maypoles became the emblem of May Day and were equally popular in urban communities as in rural ones, with some erecting permanent poles. Two of the most famous were at Cornhill and the Strand. The Cornhill maypole was so tall that the adjacent church became known as St Andrews Undershaft. This pole was cut down in 1517 after the riots of 'Evil May Day', when the London apprentices used it as a rallying point for their attacks on the homes of immigrant workers in the East End.

May Day had long been a target for the zealous reforming Protestant Church and the voices of opposition had become more strident year by year. Philip Stubbes, the sour Puritan author of the *Anatomie of Abuses* (1583), was vociferous in his attack on May Day celebrations. This was no harmless folk festival; everything about it was pagan, ungodly and, according to Stubbes, presided over by Satan, Prince of Hell. The origins lay in ancient fertility rites. Maypoles smacked of tree worship, were possibly phallic in connotation and certainly idolatrous. The abandoned dancing and raucous merrymaking were a threat to public order; the custom of going 'a-maying' and associated promiscuity was a revolting moral disgrace. Stubbes claimed that scarcely a third of the maids who were lured into spending a night in the woods returned home undefiled. As Puritanism became the dominant religion through the latter years of the reign of Charles I, May Day was seen as a symbol that personified the evils of social liberalism that were encouraged by a Roman Catholic monarchy. May Day – and many other traditional customs, including Christmas – were outlawed in 1644 during Cromwell's Commonwealth. Indeed, the maypole in the Strand, erected during the reign of Elizabeth I, came down in 1644 as a victim of a Parliamentary Ordnance which instructed the constables of parishes that 'all and singular maypoles that are or shall be erected to be taken down and removed'.

MAY DEW

The dew on the first morning of May was, for centuries, believed to contain all manner of curative and beauty-enhancing properties. May dew was thought to improve the complexion, remove freckles and cure acne. Queen Catherine of Aragon is recorded to have gathered dew at daybreak on 1 May 1551, followed by a retinue of twenty-five ladies-in-waiting. Pepys makes several entries in his diaries of being woken by his wife in the early hours of a May morning as she called her maid to 'go abroad to gather May dew'.

May dew was also believed to cure consumption, goiters, ophthalmic problems, gout and paralysis. Gout sufferers were a common sight hobbling barefoot through dew-covered grass at dawn on May Day; those who had lost the use of their limbs were wrapped in blankets left out overnight to absorb the precious moisture. Edinburgh had a long tradition of the townspeople flocking to Holyrood Park to first visit Arthur's Seat and wash their faces in the dew before making another ablution at the nearby St Anthony's Well, where the infirm were bathed in the holy waters.

On 1 May 1660, Parliament invited Charles II to return to Britain from exile as King, and as a sign of the good times to come maypoles were re-erected all over the country. To replace the Strand's maypole, a massive limb 40 metres long was floated up the Thames and hauled upright by a team of sailors under the direction of the Duke of York. Painted with gilt and covered with coloured balls and flags, this symbol of rejoicing remained in place for over fifty years before being removed to provide a site for the church of St Mary le Strand. The redundant pole was subsequently bought by Isaac Newton and taken to Wanstead, where the base was used to support Huygens' enormous telescope.

The Restoration also saw a return of the old uninhibited May Day behaviour. London's fifteen-day May Fair, held on the site of what is now Curzon Street and Shepherd Market, became so notorious for drunkenness and bad behaviour that it was suppressed in 1708. Revived by popular demand a few years later, the fair was banned altogether in the 1770s. May Day festivities lost their impetus in rural districts during the Industrial Revolution, when country people left their villages to find work in towns, but were revived again by the Victorians with their passion for 'Merry England' in a more genteel and romanticised form.

Nowadays May Day is all things to all men: it is a public holiday that commemorates the struggle of the international workers to achieve an eight-hour working day; it is a neo-pagan festival; a commercialised celebration of the start of summer; and an excuse for demonstration and political protest. Few of the children dancing round the maypole in my mother's garden would have been aware they were perpetuating a rite that started with the dawn of time.

MAY DAY CELEBRATIONS ACROSS THE COUNTRY

The West Country has its own variations of the May Day celebrations. Helston, in Cornwall, for example, dedicates 8 May, the Feast of the Apparition of St Michael, patron saint of Helston and Cornwall, to a day of revelry and dancing. Originally called 'Faddy Day' or 'Furry Day' (from the Celtic word *feur*, meaning a festival), it was renamed 'Flora Day' by the Victorians in their enthusiasm for classic origins, under the mistaken belief that the custom of decorating the town with hawthorn boughs and wild flowers was a survival of the Roman Floralia.

Today the celebration is known as the 'Helston Furry Dance' and attracts visitors from all over the world. Young people start the dancing at 7 a.m. in what used to be called the Servants' Dance, touring the town accompanied by figures dressed as Robin Hood and some of his outlaws, a Roman soldier, and St George and St Michael. Periodically, the dancers stop to recite a folksong of Elizabethan origins called the Hal-an-Tow:

Hal-an-Tow, jolly rumble, O,
For we are up as soon as any day, O,
And for to fetch the summer home,
The summer and the May, O,
For the summer is a-come, O,
And the winter is a-gone, O ...

At 10 a.m., over 1,000 children dressed in white and wearing lily-of-the-valley buttonholes, the emblem of Helston, perform their dance, and at noon the principal dance of the day is led off by the Mayor in his mayoral robes and golden chain of office. For this dance, performed by adults only, the men wear morning dress, complete with top hats, and the women, ball dresses. The dancers weave their way around the streets of Helston, passing in through the front doors of shops and houses and leaving out of the back – an intrusion which is supposed to bring good luck to the household. This is followed by a mystery play of the same name as the Elizabethan folksong, featuring various historical incidents, particularly the Spanish attack on Newlyn and Penzance in 1595. The final dance of the day, at 5 p.m., is a cider-fuelled free-for-all that carries on until the small hours.

Padstow, in Cornwall, and Minehead, in Somerset, both greet May Day with Hobby Horse celebrations that begin at midnight on 31 April. The origins of these West Country May Day celebrations, and other festivals featuring hobby horses that occur across Britain during the year, undoubtedly have their origins in ancient fertility rites. In Padstow the streets and boats in the harbour are decorated with flags and flowers, and on the stroke of midnight the procession, gathered outside the Golden Lion Inn, sing the Night Song:

Unite and unite, and let us all unite,
For the summer is a-come unto day,
And wither we are going we will all unite,
In the merry morning of May.

There is no sleep for the good citizens of Padstow on this night, as the parade moves around the town bellowing raucously outside each house:

Arise up Mr – and joy you betide,
 For the summer is a-come unto day,
 And bright is your bride that lies by your side,
 In the merry morning of May.

In the morning, two groups of dancers progress through the town, one of each team wearing a hobby horse. The two horses are known as the 'Old' and the 'Blue Ribbon' horses. During the day a number of 'Junior' horses appear, operated by children. Accompanied by drums and accordions and led by acolytes known as 'Teasers', each horse is adorned with a gruesome mask and black frame-hung cape, under which they try to catch young

Folklore & Customs

girls as they pass through the town. In the old days, the men inside the horse would attempt to drag the girl inside where she would be smeared with black lead to indicate that she had already been 'ravaged' by the teaser. The Blue Ribbon horse is of more recent origin; in the late nineteenth century this horse was supported by members of the Temperance Movement, who were trying to discourage the consumption of alcohol that was associated with the 'Old' horse followers. After World War I, any idea of temperance was lost and the horse became known as the Peace horse. Each horse has a 'stable'; in the case of the Old horse it was the Golden Lion Inn, and for the Blue Ribbon or Peace horse it was the old Temperance Institute. It is from these stables that the horses emerge at the start of the day's proceedings, and to which they weave their way back at the end.

During the day, the Day Song is repeatedly sung. This has around seventeen rollicking verses, but at the eighth the tempo of the music changes and becomes solemn, as the horse collapses to the ground whilst the company sing:

> *O! Where is St George,*
> *O! Where is he, O,*
> *He is out in his long boat on the salt sea, O.*
> *Up flies the kite and down tails the lark, O.*
> *Aunt Ursula Birdhood she had an old ewe*
> *And she died in her own Park, O.*

On the last drawn-out 'O' the drummers beat a sharp tattoo, the horse leaps to its feet and the music and verses resume the original jolly rhythm. The climax comes in the late afternoon when the horses and their followers, most of whom will by now be tired and emotional, meet and dance together round the maypole.

The Minehead May Day celebrations also start on the evening of 30 April, but there the festival manages to keep going pretty well non-stop for the next three days, earning this period the title of Minehead's May Day Mayhem.

Each day starts at dawn with two hobby horses, the Sailor's Horse and the Town Horse, parading through the town with their attendant supporters and musicians, accosting spectators for money. Those that are slow to produce their cash are pinned against a wall or whipped with the horse's rope tail. The cavalcade makes its way to nearby Dunster Castle where, in the days when the estate was owned by the Luttrell family, it would collect its dues before returning to the town. Every evening there are dances and street parties, culminating in Booty Night, when onlookers are grabbed by two of the Horse's attendants, held face down under the front of the Horse and 'Booted' – struck ten times by the frame of the Horse. The reason for this part of the tradition is obscure, although it may have been a way to extort some kind of payment from the victims. Having been booted, the victim is made to dance with the horse, trying to avoid being lashed by its tail.

In present times, the two horses dance together and have mock fights, but not too long ago there were often violent drunken clashes on Booty Night. In 1880, the Church unsuccessfully attempted to ban the festival after a man was killed for failing to produce his dues to the horse.

OAK APPLE DAY

There are a number of other May customs celebrated at the end of the month, one of which is Oak Apple Day on 29 May. Once an occasion for national rejoicing and now, sadly, scarcely recognised as a cause for celebration, Oak Apple Day marked the birthday of King Charles II and the date on which he made his triumphant return to London in 1660. The event symbolised the return of the monarchy to Britain and the end of nine dreary and repressive years of Cromwell's Republic, during which anything enjoyable, including Christmas, had been banned.

The populace were ecstatic, and soon afterwards Parliament commanded that this 'Happy Restoration' should forever be observed as a day of thanksgiving for redemption from tyranny; to be marked with church services – a special blessing was included in the Book of Common Prayer, bell ringing, Morris dancing, bonfires, plum pudding and beer. It was party time and the crucial ingredient of these celebrations was sprigs of oak leaves, preferably with oak apples still attached. These sprigs were used to commemorate the day in 1651 when King Charles and his cavalry commander, William Carless, evaded capture after the Royalist defeat at the Battle of Worcester by hiding in the thick foliage of a pollarded oak tree near Boscabel House, in Shropshire.

The nation had much to be grateful for. A patron of the arts, science and the turf, the Merry Monarch was a man of taste, vision and foresight. Cavaliers returning from the Continent brought back innovative ideas for agricultural improvements and King Charles dreamt up a brilliant scheme to regenerate the moribund sheep industry: he instigated an Act of Parliament in 1666 that decreed no one could be buried in 'any shirt, sheet, shift or shroud' except of wool, nor the coffin lined in any other material. The country prospered, and until the late nineteenth century churches, civic buildings, houses, carriage and farm horses – even railway engines – were all garlanded with symbolic oak boughs, sometimes with the leaves and oak apples gilded. Church bells rang; bonfires sent showers of sparks into the summer night and anyone not sporting the symbol of Royalist support on their lapel or hat was likely to be beaten up, or at least pelted with rotten eggs and manure.

In 1859, the service of blessing was removed from prayer books, the spray of oak leaves which had long adorned one side of our sixpences and shillings was replaced with the British lion, and the custom gradually lost popularity.

Vestiges of Oak Apple Day were still active in the 1950s, and I remember one such occasion as the highlight of the summer term at my prep school. In those days it was known as 'Pinch Bum Day', when anyone not wearing an oak leaf in their buttonhole could expect to have their bum pinched. There was always a frantic scramble through the

Folklore & Customs

woods in the school grounds on 28 May to secure sprigs of the protective leaf for the following day. Most sought after were those with the yellowish, irregular-shaped oak apples or shick-shacks, as these were more durable than leaves during the inevitable roughhousing on 29 May, and provided considerable entertainment in their own right later on. The unsuspecting could be persuaded they were edible, as oak apples have little smell but are incredibly astringent; they were also quite hard when thrown and were the source of endless speculation when dissected, revealing a series of tiny chambers containing miniscule grubs.

Few people still recognise 29 May as a historic occasion. In Worcester, the 'Faithful City', the Guildhall is garlanded with oak boughs and on its steps a pageant is held where enthusiasts in period costume are met by the Lord Mayor and civic dignitaries. A look-alike impersonates King Charles, thanks the people of Worcester for their monarchist support, and the procession moves off to spend the rest of the day entertaining the public at the medieval Commanderie, which had been the Royalist headquarters during the battle. At Northampton, to which the King gave 1,000 tons of oak after the town was virtually destroyed by fire in 1685, a service of thanksgiving is held at All Saints Church and the royal effigy above the portico is dressed with oak leaves. The Chelsea Pensioners of the Royal Hospital cover the statue of their founder with oak garlands and parade in his honour, wearing their scarlet dress uniforms and tricorn hats, before tottering off for their traditional blow-out of beer and plum pud – but even this significant ceremony has to wait until Chelsea Flower Show week is over.

The oak was a symbol of British stoicism and independence long before the Restoration; history has a habit of repeating itself, and something tells me that Oak Apple Day could well be reinstated in the not too distant future.

MAKING MERRY THROUGHOUT THE MONTH OF MAY

There are three other notable customs on Oak Apple Day that are not directly connected with the Restoration. Castleton in Derbyshire has a charming Garland Day on 29 May, where a Garland King, dressed in Stuart costume, rides through the village enclosed inside a bell-shaped wooden frame which is completely covered in flowers and foliage. After touring the village pubs, accompanied by his Queen, a procession of dancers and a band, the King rides to St Edmund's Church and is relieved of his Garland. This is then hoisted to one of the eight pinnacles of the tower, the other seven of which have been dressed with sprays of oak leaves, where it is left to wither. The rest of the day is spent in dancing. This ceremony, supposedly commemorating the Restoration, is of pagan origin and was revived by the Reverend Samuel Cryer in the late 1600s, in the well-established tradition of the Church putting a new interpretation on an old custom.

Arbor Day, held in the Shropshire Village of Aston-on-Clun, is another local celebration held on 29 May, when a black poplar tree at the crossroads in the centre of the village is dressed with coloured flags. As with many customs, Arbor Day has undergone several interpretations over the centuries. The festival obviously has its

origins in pagan nature worship, which formed the basis for an early summer village festival at the beginning of May, with the ancient poplar tree offering a convenient alternative to a maypole.

May Day celebrations were banned in 1644, and Arbor Day was recreated as part of the Oak Apple Day celebrations following the Restoration. Where many local customs became forgotten, Arbor persisted thanks to a legacy from Mary Carter, a local heiress. Mary Carter of Sibdon married Squire John Marston of the Oaker Estate on 29 May 1786, and she was so charmed at the sight of the villagers dancing round the poplar tree that she left a legacy for the custom to be perpetuated and the tree cared for.

Arbor Day continued as a low-key village custom until the 1950s, when the simple ceremonies of previous centuries expanded into an elaborate pageant made up of characters associated with Aston-on-Clun's past. These included the goddess of nature and fertility, a pastoral shepherd with his bride, a Roman soldier, St George of England and St George of Abyssinia, the Puritan St Brigit and Charles II, and Mary Carter and John Marston. The tree's reputed association with ancient fertility rites attracted worldwide attention and the pageant was stopped in 1959, in response to local concern that it was becoming too large for the village to cope with and the poplar – believed to be at least 300 years old – was in danger of being damaged by souvenir hunters. The pageant was revived as part of the Jubilee Celebrations in 1977, and although the village tree collapsed through old age in 1995, Arbor Day is fêted with unabated enthusiasm around a new black poplar, grown from a cutting taken from the original one.

> MAY DAY CELEBRATIONS WERE BANNED IN 1644, AND ARBOR DAY WAS RECREATED AS PART OF THE OAK APPLE DAY CELEBRATIONS FOLLOWING THE RESTORATION. WHERE MANY LOCAL CUSTOMS BECAME FORGOTTEN, ARBOR PERSISTED THANKS TO A LEGACY FROM MARY CARTER, A LOCAL HEIRESS.

At the same time of year, in Wishford Magna in Wiltshire, just north of Salisbury, the villagers celebrate their ancient, eleventh-century Right of Estovers – the right to gather fallen wood in nearby Grovely Woods. Various attempts by landlords to restrict these rights were fought off through the courts in 1292, 1318, 1332, and again in 1603, when the villagers' right was regularised and set down in a charter which begins: *'The right has been since time out of mind'*. The charter stipulates that in order to maintain their right, the villagers must go to Groveley Woods at dawn on the Tuesday after Whitsun and cut boughs of oak, preferably ones with oak apples attached (although this celebration is not an Oak Apple Day one), and stand the boughs outside their houses for the whole of that day. The inhabitants should then *'go in a daunce to the Cathedral Church of our blessed Ladie in the Cittie of new Sarum (Salisbury) on Whit Tuesdaie in the said countie of Wiltes, and there make theire clayme to their custome in the Forrest of Grovely in theis wordes: Groveley Groveley and all Groveley'*.

The date was moved from the Tuesday following Whitsun to 29 May after the Reformation, and although the villagers no longer dance in the Cathedral Square the ceremony has otherwise remained more or less unchanged, despite numerous attempts

to stop it. In 1809 the owners of the woods, the Earls of Pembroke, enclosed the area, and in 1825 four women who had gone to collect firewood were arrested and imprisoned for trespassing. The courts found in favour of the defendants and upheld the right of the inhabitants of Wishford to collect wood at will. In 1892, the Oak Apple Club, which adopted the Socialist slogan 'Unity is Strength', was formed to ensure the continuance of local rights and to ward off any further attempts to remove them.

Even now, the villagers still rise at dawn and set out for Groveley Woods to cut branches to decorate their houses or to carry in the procession later in the day. A party led by the rector then travels by coach to Salisbury Cathedral, where four women in nineteenth-century costume, carrying bundles of wood symbolising those arrested in 1825, dance in the Cathedral close. On the steps to the high altar, parts of the charter are read out and those present shout 'Grovely, Grovely, Grovely and All Grovely', to assert their rights for another year.

Back in Wishford, there is a fancy dress procession through the village led by a brass band and two men supporting a banner embroidered with 'Grovely, Grovely, Grovely and All Grovely. Unity Is Strength.' The procession is concluded by a luncheon in the Royal Oak public house and the afternoon is given over to dancing, sports and hoisting a large oak bough, decorated with coloured ribbons, to the top of the parish church tower. This is called the Marriage Bough, and it is believed to bring good luck to those married in the church in the coming year.

FESTIVALS ON HORSEBACK

From the beginning of June until the first week in August, a series of unique, spectacular riding festivals takes place across the Scottish Borders. These are the ancient and famous Common Ridings, celebrated at Hawick, Selkirk, Lauder and Langholm, with similar mounted pageants held at Jedburgh, Kelso, Duns, Galashiels, Melrose, Coldstream, Peebles and West Linton. The origins of the Common Ridings can be traced back to the thirteenth and fourteenth centuries, when the Border lands were in constant upheaval during the long wars with England, and later, from the perpetual raids and counter-raids of the reivers.

For 300 years, until James I stamped it out in the early seventeenth century, reiving (an ancient word for robbing) was the principal occupation of families such as Scott, Elliot, Armstrong, Douglas, Ker and Turnbull on the Scottish side of the border, and Dacre, Charlton, Robson, Dodd and Milburn on the English side. These reiver families plundered each other's lands, pillaging back and forth across the length of the border on their light, fast Galloway horses, rustling each other's livestock, stealing what they could carry, burning farmsteads and attacking towns and villages. In such chaotic, menacing times, the men of the border towns needed to be constantly alert, riding the boundaries or marches of their common grazing lands to protect them from marauders and prevent encroachment by neighbouring landlords. Long after the danger was past and peace had descended on the Borders, the ridings continued in commemoration of local legend, history and tradition.

HARING AROUND AT THE HAWICK COMMON RIDING

Hawick is the nearest town to our farm and for years I have stood among the cheering crowds, watching the cavalcade of horsemen as they pass through the streets on their way to ride the Common boundaries. It had never occurred to me to ride with them, until Walter Jeffrey, the legendary ex-Master of the Jedforest Foxhounds, suggested that it was an experience not to be missed.

The Hawick Common Riding is the first of these Border festivals and celebrates the ancient custom of a young man, the Cornet, riding the boundaries of the parish, bearing a banner which represents the capture of an English flag by the 'callants' or young men of the town, in 1514. The Scots army under James IV had been defeated at the battle of Flodden Field in 1513, and for many months the Tweed valley lay under a pall of smoke as English soldiers enjoyed the fruits of victory by laying waste to the Borders. Among the king, an Archbishop, four abbots, twelve earls, seventeen barons, 400 knights and 17,000 soldiers who lost their lives during the battle were most of the adult male population of Hawick. The town was defenceless but for a handful of teenagers, and it was with deep anxiety, in the early summer of 1514, that the women and old men watched smoke drifting closer, as the marauders worked their way towards them through Teviotdale, destroying everything in their path. An unknown number of English soldiers, bent on rape, pillage and slaughter, were spotted camping beside Hornshole, a deep pool where the River Teviot narrows, about two miles from Hawick. In a desperate effort to save the town, the youths of Hawick gathered together what weapons they could find and

A Book of Britain

attacked the camp, driving the English off and capturing their blue and gold flag. This was borne defiantly at the Ridings for many years, until it was replaced by a series of purpose-made replicas, similar to the one carried today. Blue and gold were adopted as the town colours of Hawick, and during the Common Ridings the shops and streets are hung with blue and gold flags.

Over the years, the build-up to the Common Ridings has become increasingly elaborate, developing into immensely significant civic occasions, and involving the whole community over several weeks. At Hawick, the principal characters are the Cornet, an unmarried young man of blameless character, and his Lass, a young woman of equally spotless reputation, who is usually the current girlfriend. The Cornets from the previous two years, known as Right and Left Hand Men, plus their Lasses, have the role of supporting the new Cornet and his Lass during the trying times ahead. The Honorary Provost and Bailies are the guardians of the town, and they must oversee activities to ensure that the proper procedures involved in the Common Riding week are followed to the letter. The Acting Father and Mother are a more mature couple who are there to offer wise counsel to the Cornet and entourage, should they need it. The Acting Father has a further role as Acting Senior Magistrate, who must witness the Cornet carrying out his official duties correctly. The Halberdier carries his halberd – a replica of the two-handed, spiked pole-axe favoured by fourteenth-century Scots infantrymen, at all the ceremonies – and is the Provost's aide. A Master of Ceremonies is responsible for the elaborate ceremonial elements of the Ridings, and an Official Song Singer leads the singing

at the official functions. There is also the town's brass band and a band of the fifes and drums, which are kept busy playing at the various ceremonies.

The new Cornet is elected at the beginning of May, when the Provost's and Bailies' Council, acting on the recommendation of the two previous Cornets, invite him to accept the post. This event is known as 'Picking Night', when the Halberdier, accompanied by the drums and fifes and followed by a crowd of townspeople, carries an official letter of invitation to the home of the nominated Cornet, who is waiting with his entourage and female principals. This is, of course, accepted; the halberdier is rewarded with a new 'shilling' and is asked to carry the Cornet's letter of acceptance back to the waiting Council. Afterwards, the Cornet, his two predecessors and the Acting Father greet the townspeople as they walk round the older parts of the town to the Town Hall. On the steps of the Town Hall, they lead a sing-song before entering to attend a ceremony of speeches known as the 'Congratulatory Smoker', where the Cornet receives his official Badge of office. At a separate ceremony, the Cornet's Lass and the Acting Mother receive their Association Badges at the Lasses' Dinner.

> ON EVERY TUESDAY AND SATURDAY FOR THE REST OF MAY, MOUNTED CAVALCADES OF BOTH SEXES AND ALL AGES, LED BY THE CORNET AND HIS ATTENDANTS, LEAVE HAWICK TO THE CHEERS OF THE ASSEMBLED CROWDS, ON 'RIDE-OUTS' TO NEIGHBOURING FARMS AND VILLAGES ... TODAY THESE RIDE-OUTS HAVE A DEVOTED FOLLOWING.

On every Tuesday and Saturday for the rest of May, mounted cavalcades of both sexes and all ages, led by the Cornet and his attendants, leave Hawick to the cheers of the assembled crowds, on 'ride-outs' to neighbouring farms and villages. In the old days, the ride-outs were an opportunity for remote rural communities to meet and welcome the new Cornet and to be reminded that the main event, the Common Riding itself, was only a few weeks away. Today these ride-outs have a devoted following, including some who do not own horses and save all year to hire one at around £150 a day (2009), for all the ride-outs and the Common Ridings throughout the riding festivals.

The ridings pass through some of the most beautiful parts of the rolling Scottish Borders and are followed by supporters in cars laden with refreshments. Once the destination is reached, the riders dismount and picnic for an hour or two before mounting for the return journey. At this point on the Hawick ride-outs, the Cornet, his Right- and Left-hand Men and the Acting Father doff their hats and take it in turn to sing a verse from 'Teribus'. 'Teribus' could be described as Hawick's national anthem, with words written by James Hogg in 1819 to a much older tune. It is based around 'Teribus Ye Teri Odin', the war cry of the Hawick men who died at Flodden Field, and runs to twenty-four verses which chronicle the history of Hawick. The words are deeply emotive and 'Teries', as the people of Hawick are called, are frequently reduced to tears on hearing it.

Scotia felt thine ire, O Odin;
On the bloody field of Flodden;
There our fathers fell with honour,
Round their King and Country's banner.

Chorus:

Teribus ye Teri-Odin,
Sons of heroes slain at Flodden,
Imitating Border bowmen,
Aye defend your rights and Common.

The riders are greeted back into the town and the evening ends with a communal sing-song, which is rewarded by the Cornet with a 'strive', when he and his entourage scatter handfuls of coins for the children.

The tempo really starts to pick up on the Thursday evening before the start of the Common Riding week, with the first of the 'Chases' and the ceremony of the Ordering of the Curds and Cream. The pipes and drums lead the mounted cavalcade through the town; the riders proceed past the golf course, where a series of male-only gallops or 'chases' are performed along the tarmac road leading into the countryside from a point known as Auld Man's Seat, up a hill to the top of Nipknowes. The Acting Father leads the first, or Married Men's, chase, which represents the Bailies chasing intruders off Hawick's Common land in the bad old days. This is followed by the Cornet Chase, with the Cornet galloping ahead of his Right- and Left-hand Men, and behind them, the unmarried men. This chase represents the youths of Hawick returning victorious from Hornshole in 1514. Crowds line the roadsides to watch this spectacle, made all the more thrilling by the noise of the horses' hooves thundering on the tarmac.

With the 'chases' over, the riders proceed to St Leonards Farm, one of the farms belonging to the town. Here they dismount and enter a large wooden shed situated among the farm buildings, affectionately known as The Hut. Essentially, The Hut is a sheltered refuge for the riders where they are served refreshments before riding the Marches and where speeches are made and songs sung – but this simple building is far more than that. The Hut has become a sort of shrine, the spiritual epicentre of Teviotdale and a symbol of all the centuries of Hawick's traditions and history. Exiled Teries in the far-flung corners of the Empire yearn for The Hut; Hawick men serving in the heat and misery of Iraq or Afghanistan dream, not of home fires burning, but of The Hut; dying men whisper 'The Hut' as they slip into eternity and go to join old comrades. It would be a national calamity if anything untoward were to happen to it.

On the occasion of the first 'chase', the Acting Father is presented with his Badge of office; there are then some fourteen speeches, songs and toasts which are broadcast by microphone to the crowds outside. The curds and cream, which will sustain the riders for the next week, are formerly ordered and then the Principals stand in front of St Leonards Farmhouse, where the Official Song Singer sings 'Teribus'. The Cornet and his entourage have another 'strive' for the children,

before the cavalcade mounts and rides back to Hawick, where they are met by the brass band which plays them through the town.

Sunday is a big day for all concerned; the Cornet and his attendant, attired in top hats and tails, the Provost and Bailies, in their ermine robes, and the ex-Cornets and Acting Fathers, followed by the men and lads of the town dressed in suits and ties, parade through the streets to the church, where they are met by the Lasses in their Sunday best. A service of blessing is performed and new bibles are presented to the Cornet and his Lass. This is followed by a formal luncheon, the laying of a wreath at the monument at Hornshole and an 'exhibition' at the local racecourse where the Cornet, his Principals and their Lasses walk the course in their finery.

At 6.30 a.m. on Monday, Tuesday and Wednesday, the riders repeat the chases to St Leonards Farm, but on Wednesday the Cornet practises riding with a replica of the heavy official flag. On Tuesday afternoon the Cornet, his entourage and their Lasses visit all the hospitals and nursing homes to give the elderly and infirm the opportunity to meet them. On Wednesday evening, exiled Teries who have returned to Hawick for the Common ridings are entertained to a reception, dinner and evening of song, speeches, toasts and music. A dress rehearsal takes place early on Thursday morning, when the Cornet carries the Flag, the famous 'Banner Blue', up to St Leonards Farm. There the riders repair to The Hut for a mere ten speeches, toasts and songs. When these are over, another rendition of 'Teribus' is sung in front of the farmhouse and the riders go back to Hawick, where the Flag is returned

to the Council Chambers. After a quick breakfast – it is still only 9 a.m. – the Cornet and Principals visit all the schools in Hawick to formally request that the pupils are given the rest of Thursday and Friday off. Speeches are made, songs sung and prizes and gifts presented. That evening is the biggest night in a week of big nights – Colour Bussing Night, when all eyes are on the Cornet's Lass.

The drums and fifes lead the Provost, Acting Senior Magistrate and Bailies, dressed in their ermine robes, into a packed town hall. Next comes the Cornet's Lass carrying the 'Banner Blue', followed by her female attendants and Maids of Honour. On a dais in the front of the hall, the Right-hand and Left-hand Lasses hold the Flag whilst the Cornet's Lass 'busses' it, by tying long blue and gold ribbons to the top. She then hands it to the Provost, solemnly intoning: 'I very much appreciate the great honour conferred upon me in being allowed to present this ancient banner, and trust you will find it well and truly bussed.' The Provost replies with equal gravitas: 'May I congratulate you on the dignity and poise with which you bussed our ancient banner. I do indeed find it well and truly bussed. May I present you with your Lass's badge as a memento.' Whilst this is pinned to her bosom, who should appear but the Cornet, escorted by his Left and Right Hand, dressed in their green riding tailcoats and top hats. The Cornet's Lass now drapes a silk sash over his shoulder and the Provost hands him the Flag, reminding him that it is 'the embodiment of all the traditions that are our glorious heritage'. The Cornet is charged to ride the Marches of the Commonty of Hawick and return the Flag 'unsullied and unstained'. The halberdier then calls on the burgesses to 'ride the Meiths and Marches of the Commonty'. This is followed by a considerable number of speeches, songs, the reading of telegrams from exiled Teries unable to return for the Ridings and, of course, a few verses of 'Teribus'.

> THE HUT IS A SHELTERED REFUGE FOR THE RIDERS WHERE THEY ARE SERVED REFRESHMENTS BEFORE RIDING THE MARCHES AND WHERE SPEECHES ARE MADE AND SONGS SUNG – BUT THIS SIMPLE BUILDING IS FAR MORE THAN THAT. THE HUT HAS BECOME A SORT OF SHRINE; THE SPIRITUAL EPICENTRE OF TEVIOTDALE AND A SYMBOL OF ALL THE CENTURIES OF HAWICK'S TRADITIONS AND HISTORY.

The whole lot, led by the brass band, walk through the town to a large bronze statue of a mounted Callant holding a flag aloft, at the top of the main street. Here the Cornet gingerly climbs up a long ladder and ties the gold and blue ribbons to the flagpole. The evening ends with a dinner, speeches, songs, toasts and a rendering of 'Teribus'.

Friday is the big day, and at 5.30 a.m., Walter Jeffrey and I joined one of the small groups of people to be seen loitering in the vicinity of Hawick's Auld Brig. Some of these are thirstily waiting for the pubs to open at 6 a.m., others are listening for the sound of the drums and fifes, as the band, led by the halberdiers, 'rouses the town'. As this party crosses the Auld Brig at about 6 a.m., the Official Song Singer appears holding an ancient snuff mull – a whole ram's horn full – for the Snuffin' Ceremony. This ritual is so old that no one can remember what it is supposed to represent, which is a shame, as it is utterly bizarre. First, the Official Song Singer is surrounded by five or six burly protectors, who link arms and form a circle round

him, facing inwards. Then onlookers attempt to climb over the backs of the human wall and grab a pinch of snuff. This is known as the 'Maul' and the struggling, sneezing mass of humanity surges backwards and forwards, eventually arriving at the steps of Drumlanrig Tower. The Official Song Singer is now released and enters the Tower, and throws packets of snuff from an upper window to the crowd below.

After these exhilarating early morning excitements, myself and Walter retired to Brydon's tea-shop for breakfast. Here the Cornet and his guests, the principal riders from other towns, such as the Braw Lad of Galashiels, the Callant of Jedburgh, the Whipman of West Linton, the Standard Bearer of Selkirk, the Duns Reiver, the Kelso Laddie or the Langholm Cornet, meet before the start of the ride.

Shortly after 8 a.m., Walter and I went to look for our mounts among the horseboxes. I had originally thought I would bring the two Fell ponies that we use on the farm up to Hawick, but Walter arranged for his brother, Willy, a noted horse breeder, to lend us two of his superb eventers. More than 300 horses from all over southern Scotland were being unloaded – every conceivable type of hunter, cob, pony, half-breed, thoroughbred, eventer and any number of riding-school hacks. Whilst this confusion was being sorted out, the Cornet, his entourage and the Official Song Singer took turns to sing verses from the 'Old Song' on the steps of Drumlanrig Tower:

'We'll all hie to the muir a riding,
Drumlanrig gave it for providing
Our ancestor of martial order
To drive the English of our Border.'

Chorus

'Up wi' Hawick it's rights and Common,
Up wi' a' the Boder Bowmen!
Teribus ye Teri-Odin,
We are up to guard our Common.'

The Cornet, bearing the 'Banner Blue' and followed by his Right- and Left-hand Men and the Acting Father, then leads probably the largest body of mounted men to be seen in Europe twice round the town, through streets lined with cheering crowds. It is an interesting experience, riding five deep and nose to tail in this cavalcade. By the second circuit, the pace had increased to a fast trot and the horses were beginning to react to the atmosphere, the noise of the crowd and the crash of hooves on the tarmac. Several thoroughbreds in my immediate vicinity were beginning to rear and skitter sideways, and even the riding-school hacks were throwing their heads about. Suddenly we were at the Auld Man's Seat; the marshals let the unmarried men through to the front and the next moment the 'chase' was on and we were galloping flat out up the road towards St Lawrence Farm.

On arrival there, the riders frantically look for someone to hold their horses, so they can run for The Hut as quickly as possible. Access to The Hut on Common Riding Day is the ambition of every Hawick man, and around 600 people somehow manage to squidge themselves into this hallowed building. The atmosphere inside is absolutely euphoric and the heat incredible. Already seated at the top table, of course, are the Cornet, his Right- and Left-hand Men, the Provost and Bailies in their robes, the Acting Father, guests, past Cornets and Principals – some of whom are very old men. Those of us lucky enough to find a seat sat virtually in each others' laps at tables laden with bottles of rum, milk, beer, and dishes of curds and cream. The curds and cream represent 'sour dook', a sort of buttermilk carried in flasks by the reivers when they were off a-reiving, and later by hill shepherds when they were out with their flocks all day. Rum and milk is the 'purely medicinal' traditional breakfast drink served at the Common Ridings and it is urgently needed by some of those who have been at it non-stop for about a week and must, by now, be hallucinating through lack of sleep.

We were gathered to hear toasts, songs and speeches – and indeed we did. The Queen, the Cornet, the Common Riding guests and the Principals were all toasted to thunderous applause. Some of the finest amateur singers in the world gave us renderings of beautiful ballads such as 'Up wi' old Hawick', 'The Banner Blue', 'Bonnie Teviotdale' and 'Pawkie Paterson'. We roared each chorus and showed our appreciation for the singer by hammering on the tables with empty bottles.

My God, it was thirsty work, and waiters, threading their way through the scrum standing three deep round the walls, were kept busy replenishing the rum,

milk and beer. There were speeches galore: past principals eulogised current ones, current principals eulogised past ones, guests spoke, the Acting Father spoke, and the place went wild when the Cornet rose to speak. I remember one speaker in particular; during his peroration about the beauties of Teviotdale, the bravery of Hawick men and the glory of the Common Riding, he would periodically interject: 'London has Buckingham Palace; Delhi has the Taj Mahal; Galashiels has the Volunteer Hall, but we ...' – and here his voice rose to a shout – '... have The Hut,' or 'Edinburgh has a castle. Paris has the Eiffel Tower. Galashiels has the Volunteer Hall, but we ... have The Hut'. To which we responded by hammering on the tables and bellowing at the top of our lungs, 'The Hut, The Hut'. It was all deeply moving.

> FINALLY, THE SPEECHES, TOASTS AND SINGING CAME TO AN END. DRENCHED IN SWEAT AND WEAK WITH EMOTION, WE STAGGERED OUT OF THE STEAM TO TRY AND FIND OUR HORSES, WHILST IN FRONT OF ST LEONARDS FARMHOUSE, THE OFFICIAL SONG SINGER SANG THE 'TERIBUS' ONCE MORE.

Finally, the speeches, toasts and singing came to an end. Drenched in sweat and weak with emotion, we staggered out of the steam to try and find our horses, whilst in front of St Leonards Farmhouse the Official Song Singer sang the 'Teribus' once more.

By comparison, the next stage, the Common Riding itself, was relatively tame, as the Cornet led the procession round the Marches. It was a lovely sunny day, and but for the occasional unpremeditated burst of activity, when the cavalcade broke into a high-spirited gallop for some reason, the ride was a pleasant, gentle jog through stunning countryside. At the southernmost boundary, the Cornet dismounted and marked this extremity of the Marches by cutting a symbolic sod of turf. We rode on towards the racecourse, known as the Mair, where in the distance we could hear the cheers of all Hawick, who had gathered to greet us. The Cornet and his entourage then performed a sort of victory gallop round the racecourse, pursued, after a suitable interval, by the rest of the procession. This is the moment in the event when all caution is thrown to the wind and over 300 riders, some of them awash with rum and milk, feel the urge to demonstrate their horsemanship. The effect on the horses when the marshals release the cavalcade is similar to that moment during the Light Brigade's progress down the Valley of Death when Lord Cardigan gave the order to charge: they drop their heads, take the bit between their teeth and go for it. Careering along in that mass of bolting, competing horse flesh, with the crowd yelling encouragement, was an unbelievably alarming experience, and as I hurtled down the last furlong, desperately trying to control my mount, I heard a voice shouting, not: 'There goes bold Sir John,' as I might have hoped, but, 'Don't be so wet, Scotty. Drop your reins and let him go.' Once the racecourse had been cleared of enthusiasts determined to ride the circuit again, the afternoon was spent picnicking and watching the official races.

Anyone would be forgiven for thinking that more than enough had been done for one day, but the fun had only just begun. At around 4 p.m., the Cornet and his party left the racecourse and returned to Hawick, followed by those riders still capable of riding. On the way, they stopped at a pool on the river Teviot, known as the Cobble Pool, into which the Cornet dipped the staff of his banner. This is the

ceremony of the Dipping, and it marks another of the Marches. Back in town they were met by the band and any hope of a hot bath or cup of tea can be forgotten, as there are speeches to be made, proclamations to be read, crowds to be waved at and, yes, the 'Teribus' to be sung. Then there is the Common Riding Dinner, and then the Common Riding Ball. At dawn, the Cornet, the Principals and a remaining handful of stalwarts sing 'Teribus' to the rising sun at the town moat, before the Cornet, the Acting Father and the Right- and Left-hand Men dance a reel in the centre of town.

To bed, perchance to dream? No such luck. At 8 a.m. the fifes and drums are at it again, waking the town. The Cornet drags his weary body into the saddle and leads his entourage to the war memorial, stopping on the way to sing 'Teribus'. At the war memorial, they dismount and lay wreaths to honour the Hawick men and women who have died serving their country. The Cornet leads a diminished calvalcade to the racecourse at the Mair and gallops round the track. As before, the day is spent picnicking and watching the races until the Cornet leads them back to Hawick, to be met by the band. With moving ceremony, the Banner Blue is returned, 'unsullied and unsustained', to the council offices for another year, and then it's party time, as the Cornet and his principals don funny hats and dance with the crowd in the streets.

Folklore & Customs

WATCHING AND WAKING – WAKES DAY FESTIVALS

Many village communities, particularly in the North of England, have revived the ancient rush-bearing ceremonies that were once performed as part of the Wakes festivals from the end of June through July, August and the early part of September. Wakes were originally Patronal or Titular feasts of dedication to the patron saint after whom the local parish church had been named. The wake itself was a vigil or watch-night devotional of 'waking', or watching inside the church for all or part of the night before a holy day.

Churches in those days had packed earthen floors which were covered in rushes and sweet-smelling sedges, such as Sweet Flag, to absorb the mud and rain brought into the church on the feet of worshippers. In some areas, fresh meadow hay, bracken and even heather were used if rushes were scarce. On the morning of the holy day, following the wake, villagers would arrive at the church with decorated hay wanes carrying piles of elaborately thatched, freshly cut rushes. Behind them came a procession of young women dressed in white, carrying bundles of rushes bound with flowers on their heads. The old flooring was swept out and the new one ceremoniously brought in to the peal of church bells.

The rest of the day was a holiday, and it is curious to note how many churches are dedicated to saints who have their feast days in the summer months. Many churches were deliberately constructed on sites of pagan worship, and although any building work would have been immeasurably easier during the spring,

summer and autumn, I suspect many churches were completed to coincide with the old heathen summer festivals.

Wakes Day developed into the highlight of the village year; with sports, dancing, feasting, and entertainments such as a cock fighting, bull and bear baiting. In some places the revelry was extended over two or three days, or even a week, attracting itinerant musicians and entertainers, as well as hawkers and pedlars, who lined the village streets with stalls selling gingerbread, coloured ribbons, beads, buttons, pins and other wares. Occasionally these unofficial temporary markets developed into large annual fairs.

During the sixteenth and seventeenth centuries the Wakes holidays came under religious persecution from Puritan supporters in the same way as May Day and many other community festivals. The Puritans managed to ban the Wakes in some areas of Lancashire and Yorkshire, an interference that so infuriated Charles I that he issued the following decree in 1633:

> *'Of late, in some counties of our kingdom, we find that, under the pretence of taking away abuses, there hath been a general forbidding ... of the feasts of the dedication of churches, commonly called Wakes. Now our express will and pleasure is, that these feasts, with others, shall be observed ...'*

This edict provided a short-lived reprieve. Within ten years the country was locked in civil war, and by the end of it Charles I had been executed and all festivals, fairs and public holidays were banned under Cromwell's Commonwealth. When the monarchy was restored in 1660, the Wakes and rush-bearing celebrations, and all other secular or religious festivals, were started up again with unbridled enthusiasm. After years of sour Puritan despotism, the country wanted to party and the Wakes holidays became notorious for licentiousness and bad behaviour. The eighteenth century was a jolly, rollicking, drunken period, and by the end of it social reformers were making their presence felt. Dr Richard Hind, the vicar of Rochdale in Lancashire, for example, became so appalled by the behaviour of his parishioners during the Wakes holiday that he banned the rush-bearing ceremony in 1780. No one need have worried; the industrial revolution was beginning to fragment rural communities, and by the early 1800s virtually every church in Britain had its earth floor covered with wooden boards or flagstones, so rush-bearing became redundant.

Wakes holidays survived in the industrial towns of north-west Britain for the simple reason that, despite the harsh discipline in the cotton mills and manufacturers' sweat shops, workers would continually fail to turn up during the period of any of their traditional holidays. Rather than become involved in an annual fracas with workers and its inevitable time-consuming aftermath, mill owners found it easier to accept this, close their factories for a few days and use the time to service machinery. During the Victorian era, whole towns, such as Preston, Burnley, Blackburn or Darwen, would grind to a halt and an army of pallid-skinned factory workers with the manic gaze of people determined to have a good time would arrive by train at coastal towns such as Blackpool, Morecambe or Grange-over-Sands. These seaside resorts could never cope with all the mill workers and their

families descending on them at the same time, so different towns developed the habit of staggering the dates of the summer school holidays, a custom which persisted long after Wakes week had ceased to be a conventional holiday.

The Victorians, with their vision of a rural idyll, were responsible for resurrecting the rush-bearing customs in many villages, and for a period the old Wakes fair-day atmosphere returned. Music was often provided by German bands, which travelled all over the country from late spring through to the early autumn specifically to play at different rural festivals, right up until World War I. The popularity of rush bearing dwindled away during the 1950s, when the population of rural communities was reduced as machinery replaced much of the agricultural workforce.

However, the increasing popularity of country living and the resurgence of interest in rural folk customs and traditions has fuelled the renaissance of rush-bearing ceremonies and some of the old Wakes festivals. Villages such as Grasmere and Ambleside in Cumbria, Sowerby Bridge in West Yorkshire, Littleborough in Lancashire and Lymm in Cheshire are among the many that now have delightful rush-bearing festivals.

At Sowerby Bridge, the focal point of the two-day event is a beautifully decorated two-wheeled cart, piled five metres high with elaborately thatched rushes. This is drawn by sixty local men dressed in Panama hats, white shirts, black trousers and clogs, accompanied by musicians, no less than five or six teams of Morris dancers and group of mummers, actors who perform traditional medieval folk plays. A relay of young ladies, known as Cart Maidens, take turns to ride on top of the rushes, a position that becomes increasingly precarious as this colourful procession winds its way through several villages. The cart stops to allow the Maidens to dance outside every pub en route and deliver symbolic rushes to the local churches. There is a craft fair and entertainers performing in Sowerby Bridge during the afternoon and, as you might expect with five or six teams of Morris dancers, an awful lot of dancing in the evening. The following day the procession sets off again in the general direction of nearby Ripponden, where a village fête is held, stopping here and there along the way to dance and refresh themselves at local pubs. The arrival of the procession is eagerly awaited and considered to be the climax of the day – if not the entire year.

DANCING THE ABBOTS BROMLEY HORN DANCE

Probably the most ancient and primitive dance in Europe is performed during the early part of September, on the Monday of the local Wakes Week in the Staffordshire village of Abbots Bromley. No one knows the age of the Abbots Bromley Horn Dance, a ritual performed by men wearing antler headdresses, since its origins are uncertain. That it has been danced almost continually for many, many centuries is beyond dispute, as is the fact that prior to the Civil War it was performed at Christmas, New Year and on Twelfth Day, with the date being moved to coincide with the Wakes celebrations only after the Reformation. This indicates that the custom was originally connected with the Celtic god Cernunnos and the fertility rites of the winter solstice, but anthropologists have argued that the dances, which mimic a bowman killing a reindeer, were performed as a ritual to ensure a successful hunt. The Bushmen of the Kalahari and other aboriginal peoples have almost identical ritual dances miming a warrior killing its prey, whilst the 20,000-year-old Paleolithic cave paintings of Lascaux, in France, depict men wearing antler headdresses being stalked by bowmen.

There are twelve male performers in the dance company who all wear the Tudor costume of loose breeches, doublet, hose and the floppy woollen cap which, from 1571, everyone over the age of six was obliged by law to wear on high days and holidays, in order to help England's wool trade. Six 'stags' carry antlers mounted on carved wooden deer heads, to which short shafts are attached for ease of transport. One man wears a Hobby Horse costume, another is dressed as Maid Marion, while a Jester, or Fool, capers in multi-coloured motley. There is a bowman, who is often a boy, and two musicians – one used to play a violin and now plays a melodeon, or accordion, while the other plays a triangle. The 'horns' themselves are a mystery. They are undoubtedly reindeer antlers and are of considerable size – the largest pair, always carried by the dance leader, weighs over 11 kilogrammes and has a span of 1 metre. The others vary in size and weight, downwards to a span of 80 centimetres and 7.5 kilogrammes. In the 1970s, a fragment of an Abbots Bromley antler was carbon dated as being over 1,000 years old, proving they are of Scandinavian origin as reindeer have been extinct in Britain for several millennia. Whether these replaced earlier sets, as has been suggested, thus dating the ritual back to the Iron Age or before, or the dance and antlers arrived with Norse invaders, continues to remain a mystery.

To add to the general air of antiquity surrounding the Abbots Bromley Horn Dance, the dancers themselves have, since time immemorial, always derived from two Abbots Bromley families. Until the end of the nineteenth century, the dancers were all members of the Bentley family. The dance then passed to their cousins, the Fowells, with whom it remains to this day, although rising house prices have meant that none of them have homes in the village, and are forced to live in nearby towns. As a result of the media attention and increasing spectator popularity of the dance, the Fowells have been known to allow visitors to 'dance in', if they ask politely, and will sometimes invite other musicians and onlookers to take part.

The festivities begin at 7.30 a.m. on Wakes Monday with a service of Blessing at St Nicholas Church, where the horns are housed for the rest of the year. The dance begins on the village green and proceeds out of the village, perambulating

the district within the parish boundaries, which takes most of the day. On their way they visit houses, pubs and farms, and it is considered to be an omen of bad luck for anyone who is missed. With the horn bearers leading the little procession, they arrive silently in gardens, pub forecourts or farmyards and begin the ritual by forming a circle. The leader breaks the ring by turning and passing between the second and third dancers, with the rest following to form a loop. Then the six horn bearers fall into two lines and dance towards each other, lowering their horns as if to fight; this is repeated several times before they cross, passing left shoulder to left shoulder to turn and begin again from the opposite side. Meanwhile, the Hobby Horse weaves about snapping its jaws, the Fool capers and the musicians play.

When the dance is over, the performers quietly follow their leader to the next port of call until they reach Blithfield Hall, the ancestral residence of the Bagot family and home to the Bagot goat – a unique breed of black-necked, semi-feral goats brought to Britain by returning crusaders. These goats have been in the park at Blithfield Hall ever since the original herd was gifted to Sir John Bagot by King Richard II, in 1383, to commemorate a splendid day's hunting on Sir John's land. With the goats and the Bagots entertained, the performers continue round the parish until they reach Abbots Bromley. They dance through the streets and give demonstrations to the crowds on the village green, before returning the antlers to the church and taking part in Compline service to hear prayers to end the day.

SEEKING SWANS ON A SUMMER'S DAY

At the end of July the annual custom of Swan Upping is performed, and it is one of the oldest traditions to survive virtually unchanged over the centuries. Swan Upping involves Mute swans and their cygnets being caught, after which the ownership of the adult birds is identified and the cygnets are marked accordingly.

Mute swans are the most beautiful and graceful of birds and are endowed with all the qualities that inspired reverence, folklore and mythology among the ancients and the works of artists, poets, writers, musicians and composers of later generations. For much of their early history in Britain, swans were protected by their association with one or other of the pagan deities. However, despite their prominence in ancient European mythology, swans were considered a great delicacy by the Romans and were a highly prized part of the food culture during their 400 years of occupation. There is evidence that Mute swans were also eaten at Anglo-Saxon feasts and that they became the property of the monarch and a bird 'Royal' in the twelfth century. Thereafter a herd or quantity of Mute swans became known as a Royalty of a Game of Swans.

From the Middle Ages, and for many subsequent centuries, swans were considered extremely valuable as a much-sought-after bird with which to impress guests at ceremonial banquets; so much so that ownership of a Royalty of a Game of Swans was sometimes given by the monarchy to nobles and the clergy as a special favour. In 1274, the price of a swan was fixed by the *'Statuta Poletrice'* of the City of London, a sort of early form of trading standards, at three shillings – ten times the price of a goose or pheasant and twenty times that of a large roasting fowl. The status of these birds increased when Edward I chose a swan as his personal badge and two swans *'gorgeously caparisoned, their beaks gilt'* were paraded as part of the ceremony in Westminster Abbey at the investiture of knighthood on his heir. By the late Tudor period, successive monarchs had given hereditary rights for 'Games' of swans to as many as 900 individuals, institutions and corporations, including the London Livery Companies, Colleges and the Church, each of whom identified their birds by cutting individual Swan Marks into the beaks. All unmarked swans belonged to the Crown, except those on a stretch of the River Cam at Cambridge, which belonged to the Fellows of St John's College. Swan herding had developed into a highly sophisticated form of husbandry by the middle of the sixteenth century, with the swan wardens of the various different swan herds scouring rivers across Britain by boat every July to catch and mark the new broods. Cygnets are easily handled at this time of year, whilst the adult swans are in moult and unable to fly, which made it the perfect date for the custom of Swan Upping.

Traditionally, once the birds had been corralled, their ownership established and the cygnets marked, some were left on the rivers as future breeding stock, while the rest were taken away to be fattened for four months in purpose-built swan 'pits' or ponds, when they would be ready for the table. One of the most famous was the St Helen's swan pit, attached to the St Giles Hospital in Norwich, home to the cygnets belonging to the City Corporation. These birds had a reputation for superb flavour and excellent carcass quality, and swans from the St Helen's pit were sent every year to Buckingham Palace and the crowned heads of Europe.

The right to a Royalty of a Game of Swans was, at one time, the source of considerable income; for most of the year the swans were self-supporting. Labour was cheap and plentiful during the busy period of Swan Upping and demand always exceeded supply. Gradually, though, the swan population diminished through the loss of bankside grazing and nesting sites to urban development and disturbance from increased river traffic and pollution. At the same time, domestic geese and poultry became more common, the value of swans plummeted and they were usurped as the festive Christmas bird by turkeys. By the 1850s, few people bothered to retain their Royalties and the last monarch to eat swan was Edward VII.

To this day the Crown retains the right to ownership of all unmarked Mute swans in open water, but the Queen only exercises her prerogative on certain stretches of the Thames and its surrounding tributaries. Apart from the Crown, only three bodies have maintained their rights to a Royalty of a Game of Swans: these are the Ilchester Estate and two of the ancient London livery companies, the Worshipful Company of Vintners and the Worshipful Company of Dyers, both of whom were granted rights in 1473. The Ilchester Estate maintains the magnificent Swannery at Abbotsford in Dorset, originally established by the Benedictine monks of Abbotsbury Abbey in 1040, and supply the plumes for the helmets worn by the Queen's Gentlemen at Arms and for the quill pen used to update the Loss Book at the close of business each day in Lloyds, the London insurance market.

> THE ANNUAL SWAN UPPING PROCEEDS SLOWLY DOWN THE THAMES OVER A PERIOD OF FIVE DAYS, CREATING A VALUABLE CENSUS OF THE SWAN POPULATION, REMOVING SICK OR INJURED BIRDS TO ONE OF THE RESCUE ORGANISATIONS SUPPORTED BY THE DYERS AND VINTNERS COMPANIES, AND GIVING BANK-SIDE EDUCATIONAL TALKS TO SCHOOL CHILDREN. AS THEY DRAW LEVEL WITH WINDSOR CASTLE, THE CREWS ALL STAND TO FACE THE OFFICIAL RESIDENCE AND DRINK A TOAST TO 'HER MAJESTY THE QUEEN, SEIGNEUR OF THE SWANS'.

The Crown, the Dyers and Vintners companies maintain the tradition of Swan Upping on the 79-mile stretch of the Thames between Sunbury and Abingdon, although swans are no longer eaten and their role is partly ceremonial with an emphasis on conservation, swan welfare and public education.

In the third week of July, a flotilla of Thames skiffs leaves Sunbury, rowed by the Swan Uppers of the Queen in scarlet blazers, the Dyers in blue and the Vintners in dark green. The Queen's boats fly the Royal Cipher and have at their helm the Sovereign's Swan Marker and the Sovereign's Swan Warden, resplendent in gold-trimmed blazers and yachting caps with a swan feather horizontally behind the Royal cap badges. The livery companies fly the company banners with their coats of arms and carry the Swan Master of the Vintners' Company and the Bargemaster of the Dyers – which is the same role under a different title. Nowadays they are followed by a motor launch, which acts as the support vessel and can take the skiffs in tow, if necessary.

Once the opening parade is over, the Swan Uppers discard their official blazers and row off in their red, white or blue jerseys. When a family of swans, the pen, cob

and their cygnets, is spotted, the Uppers cry 'All Up' and the skiffs converge on the brood, surrounding them and pushing them to the bank. The Uppers then have to seize the male birds, which is an extremely skilled job as the pen can be a ferocious brute and it is essential to gently but firmly hold the cob's wings tight to the body. Ownership of the parent birds is identified and recorded by the Queen's Swan Marker, and cygnets belonging to the livery companies have identifying rings fitted on their legs. The Dyers' are ringed on one leg, and those caught by the Vintners are ringed on both, whilst the Royal birds are left unmarked. Until 1996, the age-old custom of nicking the beaks was still practised; in the case of the Dyers, this was one nick, with two for the Vintners. Behind this double mark of the Vintners Company lies the origin of London public houses having the name the Swan with Two Necks. The Queen's Swan Warden then checks the adult birds and cygnets for signs of injury or ill health, the cygnets are weighed and the brood is returned to the water.

The annual Swan Upping proceeds slowly down the Thames over a period of five days, creating a valuable census of the swan population, removing sick or injured birds to one of the rescue organisations supported by the Dyers and Vintners companies, and giving bank-side educational talks to school children. As they draw level with Windsor Castle, the crews all stand to face the Official Residence and drink a toast to 'Her Majesty the Queen, Seigneur of the Swans'.

VENERATING OUR VITAL RESOURCES

Throughout the spring and summer months, towns and villages across the Peak District of Derbyshire, and some in the neighbouring counties, celebrate the ancient custom of well dressing. Springs and natural wells have been venerated since antiquity; water is a basic necessity of life and to our forefathers the purest and most miraculous water was that which bubbled out of the ground. In an age when all the various wonders of nature were deified, a lively spring that brought fertility to the land, upon which the survival of a settlement depended, was universally accepted as being the dwelling place of a powerful and benign spirit to whom sacrifice was due.

> SPRINGS AND NATURAL WELLS HAVE BEEN VENERATED SINCE ANTIQUITY; WATER IS A BASIC NECESSITY OF LIFE AND TO OUR FOREFATHERS THE PUREST AND MOST MIRACULOUS WATER WAS THAT WHICH BUBBLED OUT OF THE GROUND ... A LIVELY SPRING BROUGHT FERTILITY TO THE LAND.

Water is most precious during the dry summer months, so this was when the ancients chose to worship at springs and wells, decorating them with flowers and greenery and holding religious ceremonies dedicated to them. Wilweorthunga, the practice of dressing springs and wells or tying coloured cloths to nearby bushes and trees in the hope that a wish would be granted by the water spirit, was banned by King Edgar under early Christian Canon Law in the middle of the tenth century. This edict was largely ignored, though, so instead the Church adopted the policy of dedicating springs and wells to the Virgin Mary or one of the many Christian saints. Well dressing continues as part of a Saint's feast day and no longer,

on the surface at any rate, has anything to do with pagan water-spirit worship. Holy wells proliferated all over Britain and Ireland in the eleventh and twelfth centuries, and many of them, such as St Winifred's Well at Holywell in Flintshire, or St Drostan's Well in Angus – one of 600 holy wells in Scotland – were believed to have miraculous curative properties and became places of pilgrimage. However, by the thirteenth century the well-dressing ceremonies seem to have lapsed, only to be revived again in 1350, at the Derbyshire village of Tissington. This would appear to have been as a reaction to the Black Death epidemic of 1349, when hundreds of people died and whole villages were wiped out as a result of the bubonic plague sweeping across the Derbyshire Peak District, yet Tissington remained unscathed. This was due, so people believed, to the purity of the water in its five wells, so as a result services of thanksgiving were subsequently held in the church on Ascension Day. Afterwards, the congregation and choir followed the clergy to a blessing at each flower-decked well. The custom briefly enjoyed a revival in the neighbouring towns and villages until it was suppressed, either by the Reformation during the reign of Henry VIII or by Cromwell's Commonwealth.

St Anne's Well at Buxton, which was of Roman origin and had a miraculous reputation, was filled in during the Restoration, and the nearby chapel that had been built for the benefit of the pilgrims who flocked there was destroyed. However, there was a considerable resurgence of interest in the mid-nineteenth century, both at existing wells and at the communal pumps and taps, when piped tap water was laid on for the towns and villages. The pretty garlands and greenery were now replaced by elaborate collages, made using every conceivable sort of natural material to create a large picture that featured a historical or religious event as the subject. A large wooden board cut to the required shape would be covered in damp clay, into which was pressed tightly packed flower heads, leaves, berries, pine cones, teasels, berries, nuts, pebbles, sand gravel, seashells, bark, mosses or lichens. The materials differed from village to village and were largely dependent on seasonal availability, the only proviso

being that nothing manufactured was allowed in the composition. The custom lapsed again as a result of the effect on village populations from two world wars and an exodus of the agricultural workers during the 1950s, only to be resurrected again in the 1970s. Today, over fifty towns and villages across Derbyshire, Staffordshire, Cheshire, Shropshire and South Yorkshire now hold well-dressing ceremonies, usually as part of a general summer festival which includes a church service and well blessing, followed by a fête or fair and all the usual music, dancing and entertainments.

The designs of the large floral decorations, whilst following a triptych form, have become increasing detailed and artistic. They begin with someone in the community drawing the chosen subject for that year's well-dressing ceremony on paper, then tracing it onto soft clay. The whole village becomes involved in the laborious process of gathering the necessary flowers and other materials and the complicated process of creating the picture. The finished article is then carefully erected behind the well or water source, where the flowers and other plant materials remain fresh for about a week until the clay dries.

There is one holy well I know of, where the worship of the local water god has remained unchanged since long before Christianity. On the shore of Loch Neagh, near the ruins of Cranston Church, is St Olcan's Well. It is a small, unattractive, algae-covered pool that is partially obscured by overhanging scrub and reached by a well-worn, muddy track. The bushes all around are covered in fragments of rags, as a testimony to the persisting belief that a sick person can be cured by dipping a piece of cloth in the scummy waters and rubbing the area of sickness with it. The rag is then hung on one of the bushes and as it decays the affliction will miraculously disappear. Furthermore, some mineral content in the water, or perhaps the micro-organisms that create the algae, cause the pebbles in the pool to turn an amber colour. The person who wears one of these stones, so local belief has it, will never die by drowning, and there isn't a fisherman on Lough Neagh who doesn't carry one of St Olcan's amber stones in his pocket.

FESTIVALS OF GIVING – DOLES AND CHARITIES

Some of our more archaic and eccentric customs are the surviving relics of the ancient tradition of distributing Doles and Charities. The notion of unequivocal charity in caring for the poor, the elderly or the infirm, did not exist in pagan society, nor was it encouraged by their religion. Pity and mercy were considered weaknesses of character to be avoided by all men, and compassion was contrary to their interpretation of justice. Plato, the father of philosophy, took the pragmatic view that, 'a poor man who was no longer able to work because of sickness should be left to die'. Plautus, the Roman playwright, was equally hard-nosed, observing, 'You do a beggar bad service by giving him food and drink; you lose what you give and prolong his life for misery.'

It was the early Christian missionaries to Britain who brought with them the concept of a single, all-powerful but merciful God, who required humans to reciprocate his love by showing compassion to each other. Potential converts would not please God, the missionaries warned, unless they accepted the basic principle that Christian brotherly love must extend beyond the boundaries of family and tribe to include 'all those who in every place call on the name of our Lord Jesus Christ'. It took several centuries before Christianity became established, but care of 'God's deserving poor' was quickly accepted as a collective responsibility, with the poor being succoured at the early monasteries and religious houses. Here, the monks performed the custom of 'Maundy', washing the feet of the poor in remembrance of Christ washing his disciples' feet at the Last Supper and his command – Maundy comes the Latin, *mandatum,* an order – to love one another.

Early in the tenth century, King Alfred's grandson, King Athelstan, founded the first almshouse at Tickhill, in York, to provide charitable shelter to the destitute, elderly and infirm. Throughout the Middle Ages, and for many centuries thereafter, royalty, nobles, senior clergy, yeoman and merchants all left bequests to establish similar almshouses, hospices, leprosaria or schools, or left sums of money in trust to pay for 'doles' of food or clothing to be dispensed to the poor. The motive of these benefactors was not entirely altruistic; occupants of the almshouses and beneficiaries of the dole were expected to pray for the souls of these patrons, increasing their chance of getting into heaven. Over the centuries, hundreds of almshouses were founded and thousands of bequests of money were bequeathed to provide Doles for the poor. From the thirteenth century until well into the nineteenth, the poor in the Staffordshire town of Lichfield alone were provided with shelter in seven different almshouses and received dole and clothing from over sixty charities. The doles were usually handed out with due ceremony at the church door, after the beneficiaries had attended a service of thanksgiving to the patron. Others were distributed at the graveside of the benefactor, and some from the home of the original donor.

> SOME OF OUR MORE ARCHAIC AND ECCENTRIC CUSTOMS ARE THE SURVIVING RELICS OF THE ANCIENT TRADITION OF DISTRIBUTING DOLES AND CHARITIES ... THE EARLY CHRISTIAN MISSIONARIES TO BRITAIN BROUGHT WITH THEM THE CONCEPT OF A SINGLE, ALL-POWERFUL BUT MERCIFUL GOD, WHO REQUIRED HUMANS TO RECIPROCATE HIS LOVE BY SHOWING COMPASSION

As the care of the needy gradually became the responsibility of the state, many of these charities ceased to exist, but there are still 30,000 almshouses across Britain and some of the old Dole ceremonies have been preserved as part of our heritage. One such is the distribution of Maundy money by the Queen. This is an ancient tradition that has its origin in the monarch washing the feet of the poor on the Thursday before Easter. Today, purses of specially minted coins are distributed to selected pensioners with great pomp and ceremony, at a service held in a different cathedral each year. The amount is determined by the age of the monarch at the time of the ceremony; thus in 2009 each recipient was given two purses – a red purse containing a £5 coin celebrating the 500th anniversary of the Accession of Henry VIII and a 50p coin to mark the founding of Kew Gardens, and a white purse containing 83p in Maundy coins, because the Queen was 83 years old.

> AS THE CARE OF THE NEEDY GRADUALLY BECAME THE RESPONSIBILITY OF THE STATE, MANY OF THESE CHARITIES CEASED TO EXIST, BUT THERE ARE STILL 30,000 ALMSHOUSES ACROSS BRITAIN AND SOME OF THE OLD DOLE CEREMONIES HAVE BEEN PRESERVED AS PART OF OUR HERITAGE.

At Ufton Court, a beautiful Elizabethan manor house near the Berkshire village of Ufton Nervet, bread and cloth are still handed out to the 'poor of Ufton' from the hall window. This follows instructions under the will of Lady Elizabeth Marvin, who died in 1581. According to local history, Lady Elizabeth, the owner of Upton Court, managed to get herself lost in one of the vast tracts of woodland near her home, and after wandering about in a state of considerable agitation for a couple of days she was rescued by local villagers. In gratitude, 164 loaves of bread, 12 ells of canvas and 12 yards of calico were donated to the poor every Maundy Thursday during her lifetime. Ufton Court passed out of Lady Elizabeth's family in 1769, but the present owners continue the tradition, although the canvas and calico have been replaced by sheets and duvet covers.

The Biddenden Dole of bread, cheese, butter and rock-hard biscuits is distributed every Easter Monday at this charming village near Ashford, in Kent. Correctly known as the Chulkhurst Charity and administered by the Consolidated Charities of Biddenden, the Biddenden Dole has a fascinating history. The earliest records of the Dole stem from the beginning of the sixteenth century, when twenty acres of land were bequeathed to All Saints Church by Eliza and Mary Chulkhurst, or Chalkers, with instructions that money from the rent of what became known as the Bread and Cheese Land should be used to fund the Dole. However, a much-publicised legend, believed by many to be fact, insists that the Dole dates from the twelfth century and that Eliza and Mary were Siamese twins. This piece of folklore has grown around the design on the Dole biscuits, which were traditionally made with the imprint of two women standing shoulder to shoulder and what appeared to be the number 11, supposedly representing the date 1100. Regardless of the truth of the matter, the charity has become immensely wealthy following the sale of the Bread and Cheese Lands for building and is now able to help the pensioners in much more practical ways, such as assisting with heating bills through the winter.

A Book of Britain

There are many others, too. Under the terms of the Butterworth Charity in 1686, twenty-one sixpences were bequeathed annually to twenty-one poor widows of the parish of St Bartholomew's the Great, Smithfield. Following a service of remembrance, the sixpences were placed on the tomb of the donor and the widows knelt to pick them up, then walked over the gravestone to be rewarded with a hot cross bun and a half crown. The ceremony continues today outside the Priory Church in Smithfield on Good Friday, following the service of Remembrance, although the money element has been dropped and the congregation now simply share the hot cross buns.

Under the will of William Glanville, the nephew of John Evelyn, the diarist, who died in 1717, five boys under the age of sixteen who have retentive memories and are willing to brave a cold churchyard on 2 February can earn themselves 40 shillings each. To do so, they have to stand with both hands on Glanville's tombstone in the graveyard of the church of St John the Evangelist in the village of Wotton, near Dorking, in Surrey. Here they must recite the Lord's Prayer, the Apostles' Creed and the Ten Commandments. Next, they have to read aloud the fifteenth chapter of the First Epistle of St Paul to the Corinthians, and follow this by writing two verses of the Epistle in a clear and legible hand. Despite being postponed on some occasions, due to inclement weather, or the event having to take place inside a makeshift tent erected over the grave, there is no shortage of local scholars willing to have a go.

THE CURSE ON THE TICHBORNE DOLE

Two of the oldest Doles are the Wayfarer's Dole, which dates from 1136 and offers a glass of beer and a piece of bread on request throughout the year from the gatehouse of the Hospital of St Cross in Winchester, and the Tichborne Dole.

The latter has been distributed to the parishioners of Tichborne, Cheriton and Lane End in Hampshire since the twelfth century. According to family history passed down through successive generations of Tichbornes, the Dole was a bequest of Lady Mabella, the wife of Sir Roger de Tichborne, a knight in the service of Henry II. Sir Roger was away from home being knightly for much of their married life, and during his long absences Lady Mabella consoled herself with good works. When she was dying of a wasting disease, she begged her husband to ensure that after her death the poor would be provided with a Dole of bread on Lady Day, 25 March. Sir Roger appears to have nurtured a resentment at his wife's devotion to the poor and told her, with a nasty laugh, that he would give as much land to provide grain for the Dole as she was able to walk round holding a lighted torch. Considering her condition, this amounted to a refusal of help, but Lady Mabella was made of stern stuff. Ordering her servants to carry her outside, she managed to crawl round twenty-three acres, known to this day as The Crawls, before the torch flickered out. Her dying words were to warn Sir Roger that she had made a curse that if he or any of his descendants failed to deliver the yield from this acreage to the poor on Lady Day, the ancient line of the Tichbornes would die out and the ancestral home collapse round their ears. As a precursor to this event, a generation of seven sons would be born, followed by seven daughters.

The Tichborne Dole became very famous. The event was painted in 1671 by the Flemish artist Gillis Van Tilborgh, and until 1796 the Dole was religiously handed out in front of Tichborne House, with The Crawls providing grain for the bread. By now, the Dole was being thoroughly abused, with paupers flocking to Tichborne and turning the occasion into an excuse for a riotous drunken party. On the instructions of the local magistrate, the Dole was stopped and the revenues from The Crawls diverted to the Church. The head of the family at the time, Sir Henry Tichborne, had seven sons; his heir, sure enough, produced seven daughters, and in 1802 part of the house collapsed around their ears.

The Dole was revived in 1835 by Sir Edward Tichborne and has been distributed with unfailing regularity ever since, despite a costly hiatus when his grandson was lost at sea in 1854 and an Australian butcher called Arthur Orton claimed the estate. The case of the Tichborne Claimant was one of the longest and most expensive in legal history, dragging on for two years before Orton was finally proved to be an impostor. There was an anxious moment in 1948, during the most stringent period of post-war food rationing, when the Ministry of Food agreed to supply the necessary bread coupons to allow the ceremony to take place and then promptly reneged. This received nationwide publicity and the consequences to the Tichbornes if they failed in their historic obligations were reported in virtually every newspaper. The Ministry of Food collapsed under the weight of public opinion, allocated the necessary coupons and misfortune was avoided. Today, the Dole – a gallon of flour per adult and half a gallon per child – no longer comes from grain grown on The Crawls, but the soul of Lady Mabella is still blessed by a local Roman Catholic priest and the Dole distributed as it has always been, except for that one disastrous period.

CHARITY THAT DEFIES DEATH

Another Dole, but one with a macabre twist to it, is the strange story of Old Man's Day. On 2 October 1571, the bell of St Mary's Church in the Hertfordshire village of Braughing solemnly tolled as a funeral procession made its doleful journey from Quilter's Farm along tree-lined Fleece Lane. Six pallbearers carried on their shoulders a coffin containing the mortal remains of Matthew Wall, a young farmer, and among the mourners was his grief-stricken fiancée whom he had been about to marry. Near the end of Fleece Lane, one of the leading pallbearers slipped on the damp autumn leaves and fell backwards into the man behind him. The coffin twisted from the grasp of the other pallbearers, toppling to the ground with a ghastly thud. It was everyone's worst nightmare, and as the pallbearers scrabbled to lift their burden again, the mourners heard a hollow thumping and muffled screams from inside the coffin. When the lid was prised off, the corpse of Matthew Wall sat up, struggling to remove his burial shroud.

The jolt from the fall had woken the farmer from a coma induced by an epileptic fit and saved him from the dreadful fate of being buried alive. Matthew went on to marry his fiancée and lived for a further twenty-four years, leaving provisions in his will to commemorate his remarkable escape. Under his will of 1595, Matthew bequeathed the village a piece of land with the instructions that the income should be used to ensure that on 2 October every year Fleece Lane should be swept clear of leaves – an odd request, considering he owed his life to autumn leaves – the bell of St Mary's should then ring a funeral toll whilst the villagers walk to the churchyard. A service of remembrance should follow, ending with the joyous quarter peal from the bell ringers that is normally rung at a wedding. To ensure his grave was properly maintained, Wall left instructions that the sexton should peg brambles on it to keep the sheep off. So 2 October became known as Old Man's Day in Braughing, and for more than four centuries Matthew Wall's testimonial instructions have been observed almost to the letter. However, today, sheep are no longer used to keep the grass down in graveyards and there is no need for the sexton to cut brambles to peg on Matthew's grave.

> NEAR THE END OF FLEECE LANE, ONE OF THE LEADING PALLBEARERS SLIPPED ON THE DAMP AUTUMN LEAVES AND FELL BACKWARDS INTO THE MAN BEHIND HIM. THE COFFIN TWISTED FROM THE GRASP OF THE OTHER PALLBEARERS, TOPPLING TO THE GROUND WITH A GHASTLY THUD.

Old Man's Day has become an important community event in Braughing; seventy school children sweep Fleece Lane, the bells peal as instructed, the villagers all gather at his graveside for a memorial and service of blessing and the continuity of this ancient tradition is assured. The original field bequeathed to the village was sold for housing and the money received for it is managed by Braughing Parish Charities.

REMEMBER, REMEMBER...

Guy Fawkes night, with its bonfires and fireworks, is an event enjoyed by all ages, although few children are aware of the religious significance of the occasion when they happily chant,

> *Remember, remember, the fifth of November,*
> *Gunpowder, treason and plot.*
> *I see no reason why gunpowder, treason should ever be forgot ...*

For 900 years since AD 600 (when the Benedictine monk, Augustine, became the first Archbishop of Canterbury) Roman Catholicism had been the dominant religion in Britain and each successive Pope had been accepted as Christ's representative on earth as the head of the Church. In 1534, Parliament passed the Act of Supremacy declaring that Henry VIII 'was the only supreme head of the Church of England and on earth', and breaking the ancient ties with the Church of Rome. The actual purpose behind the Act was to enable Henry to annul his marriage to Catherine of Aragon and marry Anne Boleyn, but it led to many decades of religious strife. From the early sixteenth century, theologians such as Martin Luther, who initiated the Protestant Reformation, challenged the authority of the Roman Catholic Church by rejecting the centuries-old belief that Popes were Christ's representatives on earth, whose teachings were infallible and binding upon all Christians.

A Book of Britain

Instead, they preached that no human is infallible and that Christ was the only head of the Church. The Act of Supremacy played straight into the hands of the religious reformers, particularly when this was followed by the Treason Act, which invoked the death penalty for anyone who disavowed Henry's position as Head of the Church. During the brief and brutal reign of Queen Mary, a staunch Roman Catholic, the Act of Supremacy was repealed and Protestants were savagely persecuted. Mary was succeeded by her Protestant half-sister, Elizabeth I, who promptly reintroduced the Act, expanding it to include the Act of Elizabethan Religious Settlement, which required anyone appointed to public or church office and all those attending universities to swear an oath of allegiance to the monarch as head of Church and state. Cripplingly heavy fines, imprisonment or death were the penalties for those who refused, and during Elizabeth's long, 44-year reign, Catholics had every reason to feel embittered and marginalised.

> A SMALL HANDFUL OF DESPERATE MEN, LED BY ROBERT CATESBY ... DECIDED TO KILL KING JAMES AND MOST OF THE ARISTOCRACY BY BLOWING UP THE HOUSE OF LORDS DURING THE STATE OPENING OF PARLIAMENT. CATESBY ENGAGED GUY FAWKES ... TO HANDLE THE DETONATION.

The hopes of Roman Catholics in Britain were raised in 1603, when Mary Queen of Scots' son, James, became King. He was known to take a tolerant attitude towards their faith and promised that he would not 'prosecute any that will be quiet and give an outward obedience to the law'. This was to change dramatically in 1604, when he became convinced, presciently, that he was about to become the victim of a Catholic assassination plot. He immediately denounced the Catholic Church, ordered all Roman Catholic priests to leave the country and imposed punitive fines on Catholics who refused to attend Church of England services. This was the final straw for a small handful of desperate men, led by Robert Catesby, a prominent Catholic embittered at losing his estates after a failed Catholic plot to remove Queen Elizabeth in 1601. These disaffected Catholics decided to kill King James and most of the aristocracy by blowing up the House of Lords during the State Opening of Parliament. Catesby engaged Guy Fawkes, a soldier and explosives expert, to handle the detonation. By March 1605, Guy Fawkes had stored thirty-six barrels of gunpowder in a cellar the conspirators had rented beneath the House of Lords, ready for the big day. However, as every child knows, the conspirators were betrayed, Guy Fawkes was arrested in the cellar on 5 November, tortured, and, along with several other members of the plot, subsequently hung, drawn and quartered.

News of the attempted assassination quickly spread through the streets of London and, to assure everyone that he and his parliament were safe, King James encouraged Londoners to light bonfires across the city to celebrate the failure of the plot, *'always provided that this testemonye of joy be carefull done without any danger or disorder'*. The following year, a grateful and relieved Parliament ordered that 5 November should henceforth be observed as a holiday which should be celebrated with bonfires, the firing of cannon and the pealing of bells, and a special service – which remained in the English Prayer Book until 1859 – should be held in every church in the land, amidst universal rejoicing.

The majority of the population were ecstatic – partly through loyal outrage and partly because Parliament had fulfilled their hearts' desire. The Catholic minority could now be tormented with impunity and a wave of anti-Papist fury swept the country, particularly in areas where the Catholic persecutions were still a bitter memory. The Puritans were gaining influence and trying to suppress historic festivals, and a new official holiday, where unbridled jollification was clearly a royal command, put them firmly in their place. Traditionalists were delighted that the old Hallowtide custom of lighting bonfires in early November had been replaced, albeit under another name, and everyone, except Papists and Puritans, believed that celebrating 5 November was striking a blow for freedom.

A penny loaf to feed the Pope
A farthing o' cheese to choke him.
A pint of beer to rinse it down.
A fagot of sticks to burn him.
Burn him in a tub of tar.
Burn him like a blazing star.
Burn his body from his head.
Then we'll say ol' Pope is dead.
Hip hip hoorah!
Hip hip hoorah hoorah!

Never had there been such national rejoicing as on the day of this decree; across Britain bells pealed throughout the day and services of thanksgiving were conducted in every church – a special one was held in St Paul's Cathedral, attended by the Lord Mayor and Aldermen of London. Cannons boomed and at night the sky glowed orange from the flames of bonfires in every city, town, village and hamlet as effigies of Guy Fawkes or the Pope were gleefully burnt.

Nowhere celebrated 5 November with greater enthusiasm, or expressed more extreme anti-Catholic feeling, than the town of Lewes in Sussex. They had good reason; within living memory, between 1555 and 1557, seventeen Protestant martyrs had been burnt at the stake in the middle of the town – ten of them in one go. These unfortunates were victims of Roman Catholic persecutions during the appalling five-year reign of Queen Mary I, when over 300 people were condemned to public execution by burning. The Bonfire Night festivities in other parts of the country were relatively harmless jollies compared with the vehement anti-Catholic demonstrations that took place in Lewes. These verged on virtual riots and explain why 5 November was only celebrated intermittently in this otherwise unremarkable market town, whilst it became an established part of the calendar in the rest of Britain.

Bonfire Night was banned, of course, under Cromwell's Commonwealth, but it was revived throughout the kingdom after the Restoration, except in Lewes. Here, the authorities only allowed the event to occur occasionally, but when it did take place, the old religious fury was re-ignited and sober citizens cowered in their beds as competing gangs of 'Bonfire Boys' ran amok. In 1847, magistrates attempted to ban the Lewes Bonfire Night with the result that police forces from

neighbouring counties, and even from London, had to be drafted in to quell the riot and break up the fights.

The problem facing the authorities in Lewes tended to be the very high risk of property damage, rather than public disturbance from the torchlight processions, anti-Papist chanting, drunkenness or riotous behaviour. In many towns, a feature of the Bonfire Night festivities was rolling flaming barrels of tar through the streets, and in the Devonshire town of Ottery St Mary it still is. In Lewes, blazing barrels were released from the top of a steep hill in the middle of town where the Lewes martyrs had met their fate. The barrels careered down the High Street, gathering speed and scattering gobbets of burning tar until they either leapt the bridge over the River Ouse at the bottom, exploding on impact in an area of town called Cliffe, or hurtled into the river in a cloud of steam. Unfortunately, it is very difficult to get a barrel to roll straight and the houses on either side of the High Street were in an extremely vulnerable position. Metal railings designed to deflect a runaway tar barrel can still be seen on some of the older buildings.

> IN LEWES, BLAZING BARRELS WERE RELEASED FROM THE TOP OF A STEEP HILL IN THE MIDDLE OF TOWN WHERE THE LEWES MARTYRS MET THEIR FATE. THE BARRELS CAREERED DOWN THE HIGH STREET, GATHERING SPEED AND SCATTERING GOBBETS OF BURNING TAR... EXPLODING ON IMPACT IN AN AREA OF TOWN CALLED CLIFFE.

After the 1847 riots, during which a considerable amount of property was damaged, several people seriously injured and the magistrates thrown into the Ouse, it looked as if the Lewes Bonfire Night would be banned for good. However, representatives of the gangs of Bonfire Boys from the different areas of the town persuaded the authorities that they would form properly organised Bonfire Societies and take on the responsibility of keeping order, if the event was allowed to continue on an annual basis. This arrangement has worked successfully ever since and Lewes Bonfire Night has become the largest and most famous in the world, attracting crowds of over 100,000.

Indeed, it is an amazing spectacle; on the night of 5 November the members of the seven Bonfire Societies parade through the town in fancy dress from their different districts, carrying banners, musical instruments, torches and flaming crosses to represent the Lewes Martyrs, each with an elaborately constructed effigy. This is always a reviled contemporary public figure such as Osama bin Laden, for example, or the recent socialist prime ministers, Blair and Brown. In the past, President Kruger, the Kaiser, the Sultan of Turkey, Hitler and President Mugabe have all featured. In addition, one or other of the Societies will always carry an effigy of Guy Fawkes or the Pope, dressed in full canonicals. The processions eventually converge and make their way through the town to a field on the outskirts, where each has a separate bonfire and a stunning firework display.

THE TURNING OF THE DEVIL'S STONE

At around the same time of year as the rest of the country are lighting bonfires and letting off fireworks, the village of Shebbear, in north Devon, has its own unique annual ritual which has nothing to do with Guy Fawkes. At 8 p.m. on the night of 8 November, the village bell ringers enter the church of St Michael and All Angels and ring a series of violent, jangling, discordant peals. Once this has been completed, they move to a point just east of the churchyard where, in front of an ancient oak tree said to be at least 1,000 years old, lies a large oblong stone known as the Devil's Stone. Here, the bell ringers take a crowbar each and, with considerable difficulty since it weighs over a ton, turn the stone. After these not inconsiderable exertions, the villagers repair to the nearby pub, The Devil's Stone, secure in the knowledge that their village is protected for another year.

No one knows when this quaint ceremony was first performed, since it pre-dates village history, but local tradition insists that if the bells are not rung in the prescribed manner and the stone turned, serious misfortune will overtake the village. The stone is formed from a type of granite that is unknown in the area and there are innumerable legends attached to how it got there, most of them centred round the Devil, who is said to have accidentally dropped it on his way to hell. Preventing him from returning to claim it and harming the village can only be achieved by creating a clamour of noise once a year and by turning the stone. In reality, the granite boulder, being a Sarsen stone or erratic, was most likely to have been carried to the area by glacial movement during the ice age, and its shape suggests that it may once have been a Neolithic standing stone, probably pushed over by Saxon monks when St Michael's church was built.

SEEING OUT THE YEAR – NEW YEAR'S EVE FESTIVITIES

Survivals of the ancient and once widespread practice of lighting bonfires on or near the winter solstice, to hasten the spring and drive out old evils, are still performed in parts of the north of England and Scotland at the end of December.

Burning the Old Year Out is a major event in the charming Scottish town of Biggar, Strathclyde. For most of December, an enormous pyre is built near the old Mercat Cross, then at 9.30 p.m. on 31 December a pipe band leads a torchlight procession down the High Street and a local resident, specially chosen for the honour, lights the fire. For the next two and a half hours, whilst the fire burns furiously, fireworks are let off and the pubs do a roaring trade. At midnight, the church bells ring in the New Year and everybody forms a gigantic human circle to sing Auld Lang Syne.

In most other parts of the world, people would begin to think of trickling off to bed at this point, but not here in Scotland – and certainly not in Biggar. Mischief Night now begins, when all manner of petty bad behaviour takes place and practical jokes are played, including the infuriating practice of lifting garden gates off their hinges and hiding them. When these silly games cease to amuse, the revellers set about the time-honoured Scots' custom of 'First-footing'. Traditionally, this involves calling on friends and neighbours to wish them Happy New Year and to give them

a small gift. In Biggar, first-footing after Burning the Old Year Out is a determined house-to-house search for alcohol, which goes on for most of the next day.

The unique Fireball Ceremony in the fishing town of Stonehaven, Kincardineshire, is an astonishing sight that attracts people from all over the world. As the clock on the Old Town House chimes midnight on 31 December, all the lights in the town are switched off and a pipe band leads a procession of forty-five men whirling fire balls on the end of chains into the High Street. The fireballers, who are all local men, proceed through the town, creating intricate, synchronised patterns as they swing the blazing balls round their heads, until they reach the harbour where the balls are ceremoniously hurled into the sea. This is followed by a firework display and the usual Scottish New Year partying.

The towns of Wick in Caithness and Comrie in Perthshire have similar fire festivals, and one of the oldest must be the curious ritual which takes place in Burghead, a fishing village on the Murray Firth.

Burning the Clavie is an ancient Scottish custom that is still performed at Burghead on 11 January, which was New Year's Eve under the old Julian calendar. Basically, a Clavie is a large herring or whisky barrel cut in two, but its preparation for this festival must follow certain time-honoured rules. A group of young men, who are all members of long-standing local families, led by the Clavie King, are the only ones permitted to be involved in constructing the Clavie. No stranger is allowed to take part or touch any of the tools or materials. These must either be lent or given and dreadful bad luck would follow if anything new or bought were to be used.

> BURNING THE CLAVIE IS AN ANCIENT SCOTTISH CUSTOM THAT IS STILL PERFORMED AT BURGHEAD ON 11 JANUARY, WHICH WAS NEW YEAR'S EVE UNDER THE OLD JULIAN CALENDAR ... THE PREPARATION FOR THIS FESTIVAL MUST FOLLOW CERTAIN TIME-HONOURED RULES.

The barrel is sawn into two equal parts and one half is fixed to a stake, known as the Spoke, by a large single nail – the Clavie, from the Latin *clavus,* nail – which is especially forged for the occasion. The Clavie has to be hammered into place with a large stone, as the use of a metal hammer is strictly forbidden. The barrel is filled with tar and wood shavings, to which the staves from the other half are added. At 6 p.m., the Clavie is lit with burning peat and the Clavie King hoists it up amid loud cheers and sets off round the old part of the town, followed by a procession.

The Clavie is too heavy for one man to carry along the whole route, so the team who made it relieve each other at points along the way. Periodically, burning faggots are handed to householders as good-luck charms for the coming year. The procession makes its way up a rocky headland called Doorie Hill, where the Spoke is fixed upright among the stones of an old fort, believed to be of Roman origin. More fuel is added until the whole headland is lit by a beacon of flame, and whilst the Clavie is still burning the Clavie King and his men begin smashing it to pieces. Spectators scrabble for the pieces of burning wood, which are treasured for the rest of the year and even sent to people from Burghead who are living abroad.

Allendale, an old lead-mining town in Northumberland, has an interesting fire festival that takes place at midnight on New Year's Eve. The origins of the

Allendale Tar Barrel Ceremony are open to doubt; some believe it lies in pagan fire worship; others claim it was started in 1858 when the town was still involved in lead mining and on New Year's Eve, the town's silver band paraded through the town, their music sheets lit by candles. These were forever blowing out, and someone had the idea of the town's strongest men lighting the band's progress with barrels of flaming tar. The truth is slightly incidental; the Tar Barrel Ceremony is spectacular and highly unusual. It gives enormous pride and pleasure to the whole community, and the party afterwards is always memorable.

The ceremony begins with forty-five 'Guisers', wearing fancy dress and a flat-cushioned hat and asbestos gloves, parading through the town behind a band, carrying blazing half-barrels filled with tar on their heads. When they reach the town centre, each Guiser heaves his flaming headgear onto a bonfire and the crowd of spectators all shout, 'Be damned to he who throws last.' The right to carry the 15kg barrels is considered a great honour and is passed from generation to generation of the same families. Once all the Guisers have flung their barrels into the fire, there is much dancing and revelry, fuelled no doubt by a collective feeling of relief that another Tar Barrel Celebration has been got through without anyone being hideously burnt. In the past, the townspeople kept open house for all and sundry for the remainder of the night and much of the following day, a practice which has stopped due to the volume of outsiders who come to watch the spectacle.

MARKING THE FESTIVE SEASON

Across Wales, a custom used to take place between Christmas and Twelfth Night, or even later, in the form of surprise visits from Mari Lwyd, or the Grey Mare, and his motley attendants. Mari Lwyd was, to all intents and purposes, a hobby horse similar to those used in the old mumming plays, the Abbots Bromley Horn Dance and many other seasonal festivals. As such it was a decorated horse skull with a hinged jaw, mounted on a wooden pole. A long, white cloth attached to the skull completely enveloped the man holding the pole who was led about by a set of reins covered in little bells. Mari Lwyd's five or six attendants wore rosettes, sashes, coloured ribbons and hats with bells on, and blackened their faces or wore masks. Sometimes two of them would be dressed as Punch and Judy, and one of them was always 'Merryman', who played the fiddle or an accordian.

Throughout the festive season, as darkness fell, the leader of this little group, dragging Mari Lwyd by the reins, would arrive outside a house and beat on the door with a stick shouting 'Permission to sing'. Without waiting for a reply, the group would burst into song or start reciting verse. Through the closed door, the householder would enquire, also in verse, how many people were outside, who they were and what they wanted. The exchange of rhyming questions and answers would continue with both sides making up impromptu verses which became increasingly noisy, nonsensical and uncomplimentary, as each side struggled to keep the repartee going. Eventually, inspiration would fail and if it was the Mari Lwyd party that stopped first, they were supposed to move on to annoy someone else. However, if it was the

householder who ran out of steam – and this was usually done deliberately, as a visit from Mari Lwyd brought good luck – the Mari Lwyd party were invited in. Once inside, the Mari Lwyd cavorted round the house, snapping its jaws, whilst the leader of the group pretended to restrain it by dragging on the reins. Punch capered about groping at any women and girls; Judy, who carried a broom, chased Punch, and the Merryman added to the din with his fiddle or squeeze box. For a short while, until food and drink was produced, it was orchestrated chaos, with dogs barking and children screaming. When the time to leave came, the Mari Lwyd party would sing one of the traditional Welsh good luck songs, before setting off for their next victim.

As with the Abbots Bromley Horn Dance and any other festivals involving the costume of an animal, particularly around the time of the winter solstice, the origins of Mari Lwyd lie in pagan fertility worship. During the nineteenth century, the powerful influence of Methodists and Nonconformists on Welsh rural communities suppressed many of the old customs, amongst them the Mari Lwyd. A very toned-down version survived in parts of Glamorganshire and Camarthenshire, which lacked much of the old *joie de vivre*, but with the resurgence of interest in traditional folk customs the clicking of the Mari Lwyd's teeth has once again become a familiar sound in the valleys.

In the old agricultural communities, the farm workers' Christmas holidays lasted until the first Monday after Epiphany. This was known as Plough Monday, and instead of returning to work the farm men turned the day into one of the most important semi-religious festivals of the agricultural year. The principal

feature of the day was a church service during which a decorated plough was blessed. This was then dragged through the village by bands of young farm workers, variously called 'plough-bullocks' or 'plough-jags', wearing fancy dress, covered in ribbons, horse brasses, rosettes, little bells and pieces of coloured glass. The plough, dubbed the 'Fool Plough', would be pulled from house to house where gifts of money, food or drink were demanded. If this was forthcoming, and it generally was, the bullocks all shouted 'Largesse', and danced round the plough; in the unlikely event of it being refused, they cried 'Hunger and Starvation' and the ground in front of the house was ploughed up.

From the Middle Ages and up until the Reformation, the money collected on Plough Monday went to support the Plough Light – candles that burnt night and day in front of the Plough Guild in the church. Blessing the plough and the ploughmen, and praying for a good harvest, was a deeply significant religious service in the Middle Ages, as indicated by the words carved into one of the beams of Holy Cross Church in Caston, Norfolk:

God spede the plow
And send us all corne enow
Our purpose for to mak
At crow of cok
Of the plwlete of Sygate
Be mery and glade
Wat Goodale this work mad.

Guilds were banned from churches after the Reformation and the Plough Lights disappeared. The money raised from the Plough Money was diverted in smaller and smaller amounts to the Churchwardens for parish expenses, with the larger portion of it, and eventually the whole of it, going to fund the communal Plough Monday party. The festival was then banned during the Commonwealth, but, like many other customs, was revived with renewed vigour at the Restoration.

With the agricultural improvements of the eighteenth and nineteenth centuries, the Plough Monday festivals in the big grain-producing areas such as East Anglia, Lincolnshire, South Yorkshire, Nottinghamshire and Cambridgeshire developed into very elaborate occasions. There would be musicians, mummers, fools, jesters and molly dancers – the latter were traditionally out-of-work ploughboys who performed an East Anglian variation of Morris dancing. The cavalcade would be led by a man dressed as a woman wearing a bullock's tail, who carried the collection box, and the day would end with the usual dancing and feasting.

Although the custom pretty well died out as machinery did away with manpower and rural communities broke up, in recent years the Plough Monday festivals have become immensely popular again, with villages and towns such as Ramsey in Cambridgeshire, Northwold in Norfolk, Hinckley in Leicestershire, Goathland in Yorkshire, Middleton in Suffolk and Wisbech in Lincolnshire putting on displays to revive the old customs at the height of their popularity.

RIOTOUS DINING

For sheer dotty eccentricity, it would be hard to beat the astonishing custom of Hunting the Mallard, which is performed by the Fellows of All Souls College, Oxford, after their Gaudy, or Feast, on 14 January. The college, whose full nomenclature is All Souls of the Faithful Departed, was founded in 1438 by Henry VI and Archbishop Henry Chichele as a centre of prayer and learning. Traditionally, All Souls has no undergraduates and its Fellows are considered to be among the finest minds in the world. Legend has it that when the foundations of the College were being laid, an enormous mallard was disturbed, which took flight and avoided capture. Hence, on Mallard Night, after the feasting had ended, a search was made for it by all the Fellows, led by an elected Lord Mallard and six officers carrying white staffs. Some time after midnight, the whole company of Fellows, armed with sticks and lanterns, stumbled forth in riotous procession, preceded by a man with a live mallard attached to a long pole. Every room, closet, passage, cellar, attic, and even the roofs, had to be inspected in a search which required frequent breaks for refreshment, and lasted until well after daybreak. Whilst the hunt for the mythical bird was in progress, it was obligatory for the company to sing the Mallard Song with great gusto:

The Griffine, Bustard, Turkey & Capon
Lett other hungry Mortalls gape on
And on theire bones with Stomacks fall hard,
But lett All Souls' Men have ye Mallard.

 Chorus
Hough the bloud of King Edward,
By ye bloud of King Edward,
It was a swapping, swapping mallard!

Some storys strange are told I trow
By Baker, Holinshead & Stow
Of Cocks & Bulls, & other queire things
That happen'd in ye Reignes of theire Kings.

 Hough the bloud, etc.

The Romans once admir'd a gander
More than they did theire best Commander,
Because hee saved, if some don't foolle us,
The place named from ye Scull of Tolus.

 Hough the bloud, etc.

Folklore & Customs

The Poets fain'd Jove turn'd a Swan,
But lett them prove it if they can.
To mak't appeare it's not att all hard:
Hee was a swapping, swapping mallard.

 Hough the bloud, etc.

Hee was swapping all from bill to eye,
Hee was swapping all from wing to thigh;
His swapping tool of generation
Oute swapped all ye wingged Nation.

 Hough the bloud, etc.

Then lett us drink and dance a Galliard
In ye Remembrance of ye Mallard,
And as ye Mallard doth in Poole,
Lett's dabble, dive & duck in Boule.

 Hough the bloud, etc

At the end of the Hunt, the mallard was decapitated and those still standing drank a final bumper of wine into which the duck's blood was mixed.

College tradition says the custom is as old as the building itself, but there are no records of it before an angry letter of 1632, from George Abbot, Archbishop of Canterbury, who happened to have been staying in Oxford the previous year, complaining bitterly of the '*great outrage ... last year committed in your college, where, tho' matters had been formerly conducted with some distemper, yet men did never before break forth into such intolerable liberty as to tear down doors and gates, and disquiet their neighbours as if it had been a camp or town at war. Civil men should never so far forget themselves under pretext of a foolish mallard, as to do things barbarously unbecoming.*' Poor Dr Abbot, he was known to suffer from melancholia after accidentally shooting one of Lord Zouch's keepers with his crossbow whilst hunting in Bramshill Park, but even so, that was no way to address the elite of the seventeehth-century academic world.

Another account comes from the nineteenth-century student diaries of Reginald Heber as he observed the spectacle from his rooms in Brasenose College (Heber was later a Fellow of All Souls and subsequently Bishop of Calcutta). He describes forty or fifty people staggering about on the roof of All Souls in the early hours of 15 January 1802 waving lighted torches and that, 'All who had the gift of hearing within half a mile, must have been awakened by the manner in which they thundered their chorus, "Oh, by the blood of King Edward".'

Shortly after this particularly riotous Mallard Hunt, a decision was taken that the ceremony should cease to be an annual occasion and henceforth become centennial. The menu for the Gaudy of 14 January 1901, for which each course had an appropriate vintage, was as follows:

Potâge des Tourterelles du Siècle Nouveau
Tourbot, Sauce du Warden
Éperlans à la Custodes Jocalium
Vol-au-Vent du Ris de Veau à la Sub-warden
Filets de Boeuf de L'Estates Bursar
Châpons Rotis à la Roi Edouard
Jambon d'Yorck
Selle du Mouton
Mallard Swapping Sauce
Pouding d'All Souls
Gâteau de Chichele
Sardines de Chichele
Merluches Salade des Junior Fellows
Dessert de Common Room

On this occasion, Cosmo Lang, the future Archbishop of Canterbury, was Lord Mallard and apparently sang every verse and chorus of the Mallard Song beautifully, whilst clinging to a spire on the roof of All Souls' chapel. This event, in 1901, was the first time that the old, symbolic practice of carrying a live mallard on a pole, cutting off the head and drinking wine mixed with its blood, was discontinued. Thereafter it was replicated by mixing Madeira with port. Under normal circumstances this would be considered sacrilege, but by the time it was served I don't suppose any of the thirty-six diners at the 1901 Gaudy either knew or cared what they were drinking.

The 2001 feast was no less magnificent in the number of courses or antiquity of the vintages. One hundred and eighteen Fellows and Quondam Fellows sat down to dinner, amongst them William Waldegrave and John Redwood, once members of the Conservative cabinet, Lord Neill of Bladen, former chairman of the Committee for Standards in Public Life and one-time warden of All Souls, and for the first time there were women Fellows in attendance, too. Dr Martin West, the internationally recognised scholar in classics, classical antiquity and philology, Emeritus Scholar of All Souls and Kenyon Medallist for Classical Studies, was the Lord Mallard, bellowing the Mallard Song in true tradition, as he was carried round the college on the shoulders of his elected officers. For this historic event, the revels ended with an enormous firework display as dawn broke.

It seems sad that the Mallard Hunt is now so rarely celebrated, but it gives an insight into something unique about the British psyche; there is every expectation that in 100 years' time the cream of academia, judges, bishops and elder statesmen will stumble forth again, after a fourteen-course dinner and enough vintage port to sink a battleship, to perpetuate a tradition which began in 1438. The menu for 2101 has probably already been chosen.

> THIS EVENT, IN 1901, WAS THE FIRST TIME THAT THE OLD, SYMBOLIC PRACTICE OF CARRYING A LIVE MALLARD ON A POLE, CUTTING OFF THE HEAD AND DRINKING WINE MIXED WITH ITS BLOOD, WAS DISCONTINUED. THEREAFTER IT WAS REPLICATED BY MIXING MADEIRA WITH PORT.

BEATING THE BORDERS

On the morning of Shrove Tuesday, when most people are tossing pancakes and wondering what to give up for Lent, the shopkeepers and townspeople of Jedburgh are frantically boarding up their windows. Every year, at this small town in the Scottish Borders, celebrated for its royal associations, exquisite twelfth-century ruined abbey and medieval reputation for rough justice – *'Where in the morn men are hung and drawn, And sit in judgment after'* – an extraordinary ball game is played.

> ON THE MORNING OF SHROVE TUESDAY, WHEN MOST PEOPLE ARE TOSSING PANCAKES AND WONDERING WHAT TO GIVE UP FOR LENT, THE SHOPKEEPERS AND TOWNSPEOPLE OF JEDBURGH ARE FRANTICALLY BOARDING UP THEIR WINDOWS.

The Jethart Ba' consists of two teams – the Uppies, men born above the Mercat Cross; and the Downies, those born below it – competing for possession of a leather handball. There are no rules, other than that the ball must not be kicked, or any sort of defined playing area. The Uppies endeavour to get the ball to their 'Hail' on Castle Hill, and the Downies to theirs at the bottom of town. Anyone can join in and an enormous struggling, cursing, scrum of men surges up and down the streets and alleys of Jedburgh; in and out of gardens; over the A68 into the River Jed and back into town again, leaving a trail of minor injuries and property damage in its wake.

Local legend insists that the origins of the game started in the fifteenth century, when some of the Jedburgh callants, or young men, returned from one of the interminable cross-Border scuffles that were a feature of the period, triumphantly clutching an English soldier's head. This was thrown down in the Market Square for all to see; someone gave it a kick, someone else kicked it back, and all of a sudden a grisly game of football started. Everyone had such fun that the townspeople decided this should become an annual event, with the Englishman's head replaced by a leather ball stuffed with straw.

By 1704, the game had become so violent that the town council forbade *'the tossing and throwing up of the football at Fastern's E'en within the streets of the Burgh'* because this had *'many times tended to the great prejudice of the inhabitants there have been sometymes both old and young near lost their lives thereby'*. By now, though, the annual ball game was deeply embedded in the consciousness of Jedburgh's male population and it was unthinkable that it should be stopped. A compromise was reached by substituting a handball for the football, and the game continued with unabated enthusiasm until 1849, when a more than usual amount of property damage and personal injury occurred. The Burgh authorities decided that enough was enough and banned the game altogether, imposing ruinous fines on any one found playing it. They little realised how much the people of Jedburgh enjoyed wrecking their town once a year, or that anyone damaged in the game wore the injuries with immense pride. Jedburgh would not be Jedburgh without its traditional Shrovetide Ba' and so the matter was put before the High Court in Edinburgh. A ruling was secured where the rights to play the game through the streets of the town were sanctioned by *'Immemorial Usage'*.

※ ※ ※

Since the 1960s a number of new customs have become established: the Great Spitalfields Pancake Race, held on 16 February, or the World Coal Carrying Competition, which takes place in Wakefield on Easter Monday. There is the Stilton Cheese Rolling Competition – actually round blocks of wood – at Stilton, near Peterborough, in early May, and the Nettle Eating Contest at Marsham in Dorset. Since 1994, the World Toe Wrestling Competition has been held every July in the Derbyshire village of Bentley, and since 1998 the Yorkshire village of Kettlewell has held an annual Scarecrow Festival every August. The Bog Snorkelling Championships take place every August Bank Holiday at the Waen Rhydd peat bog, near Llantwrtyd Wells in Wales, and in Brighton 21 December is the annual Burning the Clocks winter solstice festival and parade. It seems unlikely that any of these will become part of our folklore heritage, but who knows? I don't suppose that the first people to pull funny faces at the Egremont Crab Fair in 1297 imagined that it would still be enormously popular over 700 years later.

CHAPTER SEVEN

CRAFTS

Sixty years ago, despite the march of progress in the interbellum years between the First and Second World Wars, rural populations were still largely self-supporting and dependent on local crafts and tradesmen. Seventy per cent of the male population in the village of Ripe and the adjoining hamlet of Chalvington in East Sussex, where I grew up, worked on the land. The other 30 per cent were made up of the vicar and two storekeepers (one in Ripe and one in Chalvington), two publicans (one of whom was also the local builder, plumber, electrician and carpenter), a butcher, baker, seamstress, blacksmith, schoolmistress, a rabbit catcher and a dairy farmer, who provided fresh milk for the village. There were also, I think, three businessmen who worked in London during the week: a retired tea planter, the novelist Malcolm Lowry, and Major Horace Ridler, a heavily tattooed ex-circus performer with teeth filed to points and a bone through his nose. Horace had served with distinction throughout the First World War but, despairing of finding employment after the armistice and in deep financial difficulties, he had persuaded a tattooist to cover him from head to toe in broad zebra stripes. Turning his back on society, he spent the rest of his life as an exhibit in various circuses and freak shows, billed as the 'Great Omi, Zebra Man, or the Barbaric Beauty'. He was quite the most terrifying person I had ever seen, but the brown eyes that smiled from the hideously tattooed face were, disconcertingly, full of kindness and understanding.

> SIXTY YEARS AGO ... RURAL POPULATIONS WERE STILL LARGELY SELF-SUPPORTING AND DEPENDENT ON LOCAL CRAFT, AND TRADESMEN. SEVENTY PER CENT OF THE MALE POPULATION IN THE VILLAGE OF RIPE AND THE ADJOINING HAMLET OF CHALVINGTON IN EAST SUSSEX, WHERE I GREW UP, WORKED ON THE LAND.

In those days few people owned cars and, except for a bus that came once a week, most people got about on foot or by bicycle. The farm men worked a six-and-a-half-day week, rarely travelling to the neighbouring town of Hailsham, 10 kilometres away, preferring to spend their free time working in their gardens. Many kept beehives, a few chickens or a pig, and a general barter system operated among the cottagers. The rabbit catcher exchanged rabbits for vegetables, honey, bacon or eggs. There was someone who cut hair in exchange for produce, another who mended boots. Someone's wife took in washing, others knitted and mended. The local hedger provided ash sticks for broom handles, bean poles and hammer handles or withies and hazel rods for baskets. Everyone harvested wild plants, nuts, berries and mushrooms, and pickled and preserved for the winter months.

Great changes were to come with mechanisation. I can remember a salesman arriving in the village with a bright orange, three-wheeled Allis Chalmers tractor on the back of a Bedford lorry. This was ceremoniously unloaded on the village green in front of an admiring crowd and remained there for a week, whilst the salesman stayed in the village pub, entertaining the farmers who flocked to inspect it. When I think of the excitement this vehicle created, I wonder how many people realised what it represented for the future of the village. Within a decade, half the agricultural workforce had left to find urban-based employment, the village school mistress, the blacksmith, baker and butcher were all gone, and families who had

lived there for generations became fragmented. Many of the old skills and their connection with the land were in danger of being lost as the village ceased to be a principally agrarian community, and when cottages were bought by commuters and weekenders. This, of course, was happening all over Britain wherever villages were within reasonable commuting distance of large towns and when urban-based businesses relocated to rural areas. It is these newcomers to rural Britain who, wishing to learn about the natural heritage of their surroundings, have been responsible for fuelling the growth of interest in self-sufficiency and old country crafts.

KEEPING HONEY BEES

A colony of wild honey bees lived in the roof of my parents' old home; they were probably descendants of those that once lived in straw skeps which were kept in alcoves, or bee boles, along the south face of the walled garden. Generations of bees had lived there for so long that the tiles below their entry hole were stained black from tiny fragments of pollen trodden in over successive generations. Their continued presence was believed to bring the family good luck, as the Arms of the Scotts of Beauclerc are: *'Per chevron azure and or, in chief two bees volant, and in base a crescent all counterchanged'*, and our crest, *'Between the hornes of a crescent sable a bee volant proper'*.

A Christmas Eve tradition, when my sister and I were children, was being taken up into the attics of the house just before bedtime. We tiptoed by torchlight, past ghostly piles of leather trunks and old furniture hanging with cobwebs, to a place where we could hear a faint murmuring behind the panelling that covered the eaves. This, we were assured, was our bees – God's little servants – joyously humming the 100th psalm, which convinced us of the truth in the folklore that farm animals were granted the power of speech on this hallowed night and knelt in memory of those that attended the nativity at Bethlehem.

AN ANCIENT ART

Apiculture, the art of breeding and keeping honey bees, has been practised in Asia, South America and Europe since before recorded history. Probably no other creature is more deserving of the innumerable myths and legends attached to it than the honey bee – the one insect capable of being harnessed for man's use. They were divine beings to many early cultures, who believed they originated in paradise and that honey was the ambrosia of the gods. The Egyptians, Minoans, Mayans, Greeks and Romans all had bee goddesses who symbolized fertility, purity, the soul and universal life force. In the 1611 King James' version of the Bible, honey or bees are mentioned no fewer than sixty-one times and there is even a record in Genesis of honey being a product of export. Arguably the most famous reference to bees is in the Old Testament, Exodus 33:3, where the Canaan valley is described as a 'land flowing with milk and honey', signifying that it was fertile and rich in plant life.

The Bronze Age Beaker people had been using honey to make mead for centuries before the Celts arrived and named Britain the Island of Honey, indicating that a country with plenty of bees was a healthy place. The Celts were accomplished

beekeepers, using the honey as a sweetener, preservative and for making mead, the ritual drink of the Druids. Hives, or skeps, were small conical baskets of woven withies with a waterproof finish of wool, moss or a clay and cow dung daub. Little hives encouraged bee colonies to split in two during the early summer when the hive became overcrowded, which ensured the survival of the colony. As a beehive swarms, the old queen bee takes half the colony out of the overcrowded hive in search of a new home. A beekeeper would follow the swarm, and, when it settled, shake them into a basket and establish them in a new hive. In this manner he increased his apiary and the amount of honey he was able to produce. This method was known as 'swarm beekeeping' and depended on bees swarming early and producing additional honey later in the summer.

At the end of the summer honey would be taken from the lightest hives, as those bees would starve during the winter anyway, and also the heaviest, as they had produced the most honey. Medium-weight hives were kept intact, as these bees needed the honey for winter survival in order to provide brood stock the following year. Bees in the selected hives would be smoked to death, then the comb was taken out, broken into pieces and hung up in cloth to allow the honey to drip through. Later, the cloth would be pressed to extract the last of the honey and the wax retained for weatherproofing, softening leather, as a lubricant, or for waxing thread and bowstrings.

Apart from a period in which the Romans introduced improved beekeeping methods (which were forgotten as soon as the Empire collapsed), apiculture remained unchanged for hundreds of years. By the time of the Norman Conquest, the only significant advances were in hive construction. Lightweight, heat-retentive skeps were now being made from coils of twisted reed or straw, but beekeeping was still wasteful and a great number of hives were needed to produce any quantity of honey.

Under the Normans, bee husbandry and the production of honey and wax became extremely efficient. Beekeepers had an official roll in the feudal hierarchy as *Apes custodus*, and all noble or ecclesiastical establishments had extensive apiaries. The church was fascinated by the similarity of monastic discipline to the ordered structure of a hive – the industry, service, obedience, devotion and celibacy of the worker bees. Bees were once believed to be parthenogenetic or formed from unfertilized eggs, and so became icons of chastity, moral purity and virginity. Since bees supposedly had thousands of 'virgin births', they became symbols of the Virgin Mary and, by association, represented immortality and the resurrection.

Benedictine monks and, later, the Cistercians, were particularly skilful beekeepers and every monastic herb garth would have an apiary, sometimes containing several hundred hives. Although the honey was used as a sweetener, an ungent and a base for medicines, monastic bees were kept principally for their wax.

The alleged sexual purity of bees made their wax suitable for making the canonical candles which were burnt in every place of worship.

During the medieval period, most people kept bees; the cottager might have just one or two hives, whilst a manor house would have an apiary and a bee master to look after it. There were commercial beekeepers as well, who sold their honey and wax at the autumn honey fairs held across Britain, such as the one at Conwy in North Wales, which has been held every September for over 700 years. By now, wax had infinite different uses; as furniture polish, and for mould making and metal casting. Melted into cloth it was used as we would employ greaseproof paper, or as an airtight sealant for bottles, pots and jars. Eggs were preserved for long keeping in wax and cerecloths, shrouds steeped in wax, were used to transport corpses. Sailors, saddlers and leather workers all used waxed thread; archers relied on wax to keep their bowstrings lubricated, and the great houses were lit with beeswax candles. Honey was, of course, essential for cooking the heavily spiced, elaborate dishes of the time, but was also used for preserving fruit and for curing meat. Covering meat in a coating of honey or using it as an ingredient in immersion pickles helps to extract tissue fluid, allowing salt to penetrate more swiftly. The propolis, or bee glue, which bees use to sanitise the hive, was applied as an antiseptic or mixed with honey and yarrow as a wound dressing.

Sugar was first introduced by returning Crusaders in the twelfth century, but remained an extremely expensive luxury even after Britain established sugar plantations in the West Indies in 1655. The price of sugar was prohibitive for all except the very rich, until the sugar tax was removed in 1874, and only really became nationally affordable when sugar beet started to be grown extensively after the First World War. For most people, honey continued to be the only sweetener, with straw skeps kept in bee boles built into the walls of mansion house gardens, castles, churches, farm buildings and cottage outhouses. The eighteenth and nineteenth centuries were the heyday of bee bole construction, especially on large country house estates. Many of these were of great architectural merit, such as the ornate examples set into a wall at Kersland House at Stewarton, in Ayrshire; Brodick Castle, on the Isle of Arran; or those of the Lost Gardens of Heligan, in Cornwall.

The first major breakthrough in beekeeping for many centuries came in 1851, when an American beekeeper, the Reverend Lorenzo Langstroth, succeeded in achieving what had eluded beekeepers for hundreds of years – a method of harvesting honey without destroying all or part of the colony. The advantage of the Langstroth hive over any previous inventions was in the design of the frames in which bees built their honeycomb. Langstroth's frames fitted into hives in such a way that bees were unable to build honeycomb anywhere other than inside them. This meant that individual comb-bearing frames could be easily removed for the first time. Langstroth's invention came at an opportune moment; the old, easy-care

straw or reed skeps produced honey that was full of foreign bodies and consumers were now demanding jars of clear, clean honey.

For the next fifty years, commercial beekeepers and enthusiastic apiculturists in America, Europe and Britain, such as Baron Von Berlepsch, Thomas Woodbury, Johannes Mehring, Abbe Collin, William Broughton Carr, T.W. Cowan and Moses Quinby, added their own inventions and refinements until two hives became standard worldwide. One was the Improved Langstroth, popular in Europe and America; the other was the British Standard National hive, commonly used in this country. Both contained a lower chamber where the queen lived with her brood, and an upper chamber in which sheets of wax hung inside removable wooden frames. The two sections were separated by a board with holes in it big enough to allow worker bees through, but not the queen. Worker bees carrying nectar arrived at the entry port at the bottom of the hive, then worked their way through the brood chamber to store honey in the wax frames above. A little smoke puffed into the hive entrance drew the workers from the upper chamber into the lower one and allowed a beekeeper access to the honey-filled frames without disturbing the queen. These were lifted out and the little wax caps that seal the tops of honeycombs were removed with a sharp knife and heated in boiling water. The uncapped frames were then placed in a honey extractor (a rotating stainless steel drum) which removed the honey by centrifugal force. The empty frames were then returned to the hive so the worker bees could start filling them again.

For the first fifty years of the twentieth century, beekeeping remained as much a part of the self-sufficient lifestyle of both rural and urban people as keeping chickens or growing vegetables, with thousands of hives kept in suburban gardens and on allotments. The countryside, which foamed with wild flowers, was a paradise for bees. Every farm had its orchard and there were mile upon mile of hedgerows full of blackthorn, hawthorn, hazel, brambles, mountain ash, and crab apples, all providing nectar through the spring and summer. The small woodlands that were such a feature of the landscape, with their diversity of flowering deciduous trees – limes, sweet chestnut, alder, sycamore, whitebeam and hollies – were all valuable sources of plant food to bees. After the First World War sugar became relatively cheap, as sugar beet production was developed in East Anglia, reducing the price of imported cane sugar and largely replacing honey as the principal sweetener. This was fairly short-lived, however, as sugar was one of the commodities stringently rationed from the start of World War II until rationing ended in 1954. Throughout those fifteen years, more bees were kept through necessity than ever before.

> THE SIMPLEST, BEST AND MOST NATURAL FORM OF BEESWAX POLISH IS MADE BY PUTTING EQUAL QUANTITIES OF BEESWAX SHAVINGS AND PURE TURPENTINE IN A JAR WITH THE LID ON, TO AVOID EVAPORATION AND PLACING IT IN HOT SUNSHINE OR AN AIRING CUPBOARD UNTIL THE TWO EMULSIFY. ALTERNATIVELY, HEAT BEESWAX UNTIL IT MELTS; REMOVE FROM THE HEAT AND MIX IN THE TURPENTINE, THEN STIR WELL AND ALLOW TO SET.

The period of intensive farming during the sixties, seventies and eighties was a terrible time for bees. Hedgerows, orchards and small woodland areas were grubbed out to create large arable field units. To maximise acreages, headlands that had previously been fertile areas of wild flowers, were ploughed out and many bee-friendly plants destroyed with agricultural herbicides. The social structure of rural areas changed dramatically, as advances in technology led to the agricultural workforce being reduced by 50 per cent as machinery replaced manpower. The old-fashioned, self-supporting family farms with their geese, ducks, chickens, a fattening pig, a house cow and beehives became a thing of the past. For the majority of consumers honey was now represented by the runny, pasteurised version sold in supermarkets. This was made from bees fed a diet of sugar and water on huge commercial apiaries in South America or Australasia and bore no resemblance to 'wild', home-grown honey.

Thankfully, there were dedicated commercial and amateur beekeepers in Britain who continued producing honey and improving bee strains. Probably the most famous beekeeper of the post-war period was the Benedictine monk, Brother Adam Kehrle of Buckfast Abbey, in Devon. The community at Buckfast maintain the medieval tradition of monastic beekeeping and Brother Adam travelled thousands of miles through Europe, Africa and the near East searching for breeding stock to improve the indigenous British bee. After many years of patient experiment, Brother Adam created the Buckfast bee, world famous for being hardy, hardworking, productive, easy to handle and resistant to disease.

A RENEWED PASSION FOR BEEKEEPING

Consumer demand for traceable, natural, home-grown commodities has created a tremendous resurgence of interest in beekeeping, with the British Beekeepers Association (founded in 1874) reporting a 30 per cent increase in membership since the millennium. This coincided with new environmental policies directed towards landscape enhancement and reducing agricultural output. Subsidies became available to take land out of production, replant hedges and small woodland areas, and to protect and encourage wild plants. The British countryside became a bee-friendly place again and rural beekeepers made the most of it. Beekeeping also became increasingly popular with urban dwellers, and by 2008 over 2,000 people were keeping bees within the M25 corridor. Nor were these hives restricted to suburban gardens or allotments; apiculture provides the ideal opportunity for people with limited space (a hive requires no more than two square feet) to become closer to nature, whilst ensuring a supply of pure, organic honey. Bees thrive on the diversity of flowers and flowering trees provided by inner-city parks and gardens. Many hives are kept on the roofs of buildings and courtyards of houses in central London: famously on top of the Bank of England, Fortnum & Mason and the Royal Festival Hall, and in Lambeth Palace's gardens and the Natural History Museum.

The wonderful thing about starting out as a beekeeper, as I discovered years ago, is that there is no shortage of kindly, enthusiastic people willing to share their knowledge. In 2008, there were 260 regional beekeeping associations in Britain, many of which, such as the London Beekeepers Association, run beginners' courses, workshops, demonstrations, lectures and summer apiary site meetings. Information on how to contact local associations is available through the British Beekeepers' Association, the representative body for Britain's 45,000 beekeepers, based at the National Beekeeping Centre in Warwickshire. A basic start-up kit of hive, a nucleus of bees, protective clothing, hive tool and smoker costs about £500, but second-hand equipment can be bought through the associations. In a decent summer, one hive of bees should provide around 25 kilogrammes of honey, and cappings from the frames will eventually provide enough beeswax to make into furniture polish.

Few occupations are as magical or soothingly pastoral as beekeeping. There is something deeply therapeutic about the sound of a hive or two, gently humming with activity at the bottom of the garden. It is mesmerising to watch the constant bustle on a sunny day, as hundreds of bees leave a hive in search of nectar and hurry back, their honey stomachs bulging. Nothing gives the same sense of achievement as harvesting your own supply of honey, rich with goodness gleaned from the local flora, from a hive you have tended and nurtured yourself. Working with bees is an extraordinarily cathartic experience: they will only respond without aggression to the most gentle and considerate handling. A beekeeper must get to know his bees and earn their trust, and old beekeepers laid great store by talking to their bees. Scientists have now established that bees can't actually hear sounds but are sensitive to vibration, and the gentle voice of a beekeeper is reassuring to them. Equally, they are very susceptible to emotion in humans and to certain smells; a hive should never be handled by someone who is depressed or who reeks of alcohol or petrol.

BEE-FRIENDLY GARDENING

There is also enormous satisfaction in creating a bee-friendly garden. This can be made from a few of the right type of bee-friendly plants, as suggested by Phillippa O'Brien and Melanie Whitlock, who created a Bee Garden for Townies for the 2007 RHS Chelsea Flower Show, or as many as you like depending on the size of your garden. Garden plants that attract bees are annuals such as asters, sunflowers and zinnia. Among the perennials are roses, foxgloves, hyacinths, geraniums, hollyhocks and climbing plants such as wisteria, honeysuckle and ivy. Many herbs are bee-friendly, including tansy, woundwort, rue, horehound, lavender, borage, all the mints, bergamot, rosemary and thyme. In the kitchen garden good bee plants include all the berry shrubs, cucumbers, strawberries, garlic, chives and, of course, apple, plum and pear trees.

Beyond the garden fence, God's little messengers have a much greater role to play in the wider ecosystem and the survival of mankind. Plant life provides us with the oxygen we need in order to live, and bees are the principal pollinator of some 250,000 species of flowering plants. They are responsible for pollinating 80 per cent of our flowering food crops across the globe, and in Britain alone it is estimated that the economic value of crops grown commercially that benefit bee pollination is between £150 million and £200 million per annum. Bees are, however, vulnerable to deadly fungi, stress disorders, the bacterium 'foul brood' and a number of contagious parasite-borne viruses, any of which can wipe out whole colonies. Between 2006 and 2008, 50 per cent of all domestic bees in America were lost to a disease known as Colony Collapse Disorder. CCD is thought to have been caused by pesticides, GM crops, signals from cellphones, or a combination of all three, creating a level of stress that makes bees susceptible to disease. This is a warning to us that we must cherish and look after our bees, otherwise, to quote the words attributed to Albert Einstein: 'If the bee disappeared off the surface of the globe, man would only have four years left to live. No more bees, no more pollination, no more plants, no more animals, no more human beings.'

TRADITIONAL CRAFTS WITH STRAW

Every year, towards the end of September or the beginning of October, churches up and down the country hold services of Thanksgiving, to rejoice in the end of the harvest. Congregations contribute produce from their farms, gardens, allotments or wild foods from woods and hedgerows to decorate their church and bedeck the nave and altar with baskets of grain, flowers, fruit and vegetables. Sometimes there is a large loaf of bread shaped to resemble a sheaf of wheat, oats, barley or rye, and very often little corn dollies made from intricately plaited straw. These will be lovingly woven to celebrate God's gifts, in traditional harvest designs; a Horn of Plenty, a Harvest Cross, the Countryman's Favour, Harvest Wreath, Corn Maiden or Glory Braid.

The tradition of celebrating Harvest Festival in churches began in 1843, when the Reverend Robert Hawker invited parishioners to a special thanksgiving service at his church at Morwenstow in Cornwall. The Victorians sentimentalized rural Britain and hymns such as 'We plough the fields and scatter', 'Come ye thankful people, come' and 'All things bright and beautiful' helped to popularise Harvest Festival services. The custom of venerating the harvest, however, and the origin of symbols made from plaited straw, predates Christianity by thousands of years.

The Iron Age Celts who migrated to Britain from northern Europe in 500 BC were skilled farmers and introduced many new farming practices, in particular the two-field rotational system for growing crops: ground would be sown with grain one year and rested the next, whilst being grazed and fertilised by livestock. Surprisingly high yields were achieved and the improvement in food quantity, especially through the winter, fuelled population growth. The Celts were fervent nature worshippers and their religion was based on the adulation of multiple deities who were almost entirely connected to nature and the seasons. The sun, moon and stars, daylight and darkness were all powerful divinities, but there were hundreds of others: trees, woods, rocks, mountains, streams, rivers, wells and springs. Wind, rain, thunder, lightning, the different stages of plant growth and every animal were all peopled with gods and goddesses; some were exclusive to families or local clan areas, others, such as Brigit, the goddess of healing, or Cernunnos, the god of nature and horned animals, were popular enough to be universal.

The ancient craft of plaiting figurines from straw to celebrate the harvest probably dates from the period when Neolithic man ceased to be a nomadic hunter and became an agriculturalist. The earliest records are from the Iron Age period when there were four major seasonal festivals during the Celtic calendar, all of which involved ritual bonfires, gallons of mead, hallucinogenic mushrooms and, if possible, a human sacrifice or two. Samhain, at the beginning of November, celebrated the end of summer and the start of the 'dark' half of the year; Imbolc, the milk month, in early February, marked the first signs of spring growth; Beltane, in May, glorified the arrival of summer and the 'light' half of the year; and Lughnusadh, in August, was when the ripening of the first fruits and arrival of the new harvest season were worshipped.

Lughnusadh increased in importance as the survival of early people became more dependent on crops, and at the end of the harvest each community would

ceremoniously cut the last few remaining stalks of corn standing in a field and plait them into the crude figurine of a woman. This represented the corn spirit, or Cerridwen, the goddess of grain, known to pagans in southern Europe as Ceres (hence the word cereal) who was believed to live among the crop and whom the harvest would make homeless. As the harvest progressed, the domain of the goddess shrank as each sheaf was cut, until she resided in the last few cornstalks. By plaiting these into the required shape, the goddess was saved, joyously taken home and cherished through the winter. In the spring, the figurine was ploughed into the first furrow of the season to symbolise the corn spirit returning to the ground to ensure fertility and abundance for the next harvest. This followed the pagan concept of the 'circle of life', where everything was born, died, and reborn.

Lughnusadh continued to be a major pagan festival until Pope Gregory I sent a mission under St Augustine to convert the Anglo-Saxons to Christianity in AD 597. Part of Augustine's mandate included instructions to consecrate pagan temples for Christian use and, if possible, to impose days celebrating Christian martyrs on the numerous occasions for heathen feasting. Among the first to be adapted was Lughnusadh, which became Lammas – Loaf Mass. Bread made from new grain was given to the church and used at Communion Mass during a special service of thanksgiving for the beginning of harvest. Astonishingly, although every other tradition connected to the old Celtic religions was eventually Christianised, the custom of making effigies representing the grain goddess remained untouched until the middle of the nineteenth century, when Harvest Festival services became popular. Even then, the style of the figurines was only altered to resemble a cross, as a concession to their inclusion amongst the farm produce decorating churches.

> ASTONISHINGLY, ALTHOUGH EVERY OTHER TRADITION CONNECTED TO THE OLD CELTIC RELIGIONS WAS EVENTUALLY CHRISTIANISED, THE CUSTOM OF MAKING EFFIGIES REPRESENTING THE GRAIN GODDESS REMAINED UNTOUCHED UNTIL THE MIDDLE OF THE NINETEENTH CENTURY, WHEN HARVEST FESTIVAL SERVICES BECAME POPULAR.

Over the centuries, there are many historical references to these harvest figures, under a variety of different names, all of them feminine – Kern or Kim baby, Mell dolls, Maidens, Brides, Dames, Queens, Hags, Mares, Old Mothers or Ivy Girls. Some, such as those made in the North of England and parts of Scotland, were large enough to be carried home in triumph on a pole, or in pride of place on top of the last harvested load. After 1536, when Henry VIII broke with the Church of Rome and Holy Communion was banned, celebrating the harvest moved from the beginning of the season to the end. With more straw available, larger figurines appeared, decorated with coloured ribbons or wearing a dress at harvest suppers, seated at the head of the table as the principal guest. Some were very simple and only used on one occasion, whilst others were more decorative, involving complex plaiting techniques, to be kept in the barn or above the fireplace over the winter.

Not all corn dollies took the shape of a corn maiden, and various regional ceremonies developed around cutting the final sheaf. In some parts of East Anglia and the Midlands the last remaining corn stalks growing in the harvest field were

plaited or tied together and reapers took turns trying to cut the sheaf by throwing their sickles at it. The plait was known as a corn 'neck' and the reaper who succeeded in cutting it down took the neck back to the farmhouse and hung it in the hall where the harvest supper was held.

> IN TIME, EACH DISTRICT DEVELOPED THEIR OWN UNIQUE ORNAMENTAL STYLE, WHICH EVOLVED FROM LONG LOCAL USAGE: HANDBELLS IN CAMBRIDGESHIRE, HORSESHOES IN SUFFOLK, BOWKNOTS IN STAFFORDSHIRE, LANTERNS IN NORFOLK, SPIRALS IN YORKSHIRE, RATTLES IN ANGLESEA, MAIDENS IN KINCARDINESHIRE, FANS IN WALES AND TERRETS IN ESSEX.

There were similar customs in other parts of the country, where reapers tried to cut the neck blindfold or facing backwards. In the West Country, where they always do things slightly differently, the ancient, cider-fuelled tradition of 'Crying the Neck' was always religiously observed. After the field had been cut and a neck fashioned to represent a narrow-waisted, broad-hipped woman, the reapers and binders formed a circle round the person who had made it. He knelt and held the neck to the ground, whilst the circle took off their hats and copied him. Then, with a long cry of 'The Neck, The Neck', they all stretched upright, with hats and the neck held high above their heads. This was repeated three times and then the cry was changed to 'Way Yen, Way yen', also repeated three times. Finally, they threw their hats in the air and capered about shouting and laughing. At which point one of the reapers grabbed the neck and rushed back to the farmhouse where a dairy maid or one of the serving women waited with a bucket of water. If he was able to enter into the house undetected, his reward was to kiss the maid; if caught, he was soaked. The neck then became the entre piece of the harvest dinner. However, whatever the rest of the regional custom, the figurines were always ceremoniously returned to the ground when ploughing began.

In time, each district developed its own unique ornamental style, which evolved from long local usage: handbells in Cambridgeshire, horseshoes in Suffolk, bowknots in Staffordshire, lanterns in Norfolk, spirals in Yorkshire, rattles in Anglesea, maidens in Kincardineshire, fans in Wales, and terrets – the metal loops on a carthorse neck collar – in Essex. Others, known as Countrymen's Favours, were plaits resembling hearts, which were made by young farm workers and given to girls they fancied. There were many other general designs: glory braids, cornucopias, harvest wreaths and corn maidens.

Many of these complex designs originated as a result of the burgeoning cottage industry in straw plaiting which started in the early 1600s. Straw is a wonderfully versatile material which once had any number of uses: as roofing for houses, barns, hay stacks, straw stacks, and to pile over root crops to protect them over winter. Twisted into ropes it was made into bee skeps, baskets, tubs, chairs, truckle beds (which were marvellously warm in winter) and the straw hassocks used in churches, cathedrals and other ecclesiastical buildings. The main straw work industry was centred round delicate weaving and plaiting to make fine baskets (we have an old sewing basket made of straw), hats and bonnets, straw mosaic table mats, rugs and artificial flowers.

Wheat straw was cut in the normal way and dried in the sun, which gave it a glorious golden colour. The straw was then dampened and worked into patterned strips by the plaiters, which were sold to the manufacturers of hats, baskets and other goods. At the height of the straw working industry, in the middle of the nineteenth century, over 30,000 women and children were employed in villages across the Home Counties alone. By the turn of the century, the domestic market had been virtually killed off by cheap imports from Italy and, later, China and Japan.

The tradition of making straw figurines and ornaments died out in the 1930s with the advent of combine harvesters, and as hollow, long-stemmed straw varieties were replaced by shorter species that produced more grain. Luckily, when there was a revival of interest in straw work after World War II, enough old-fashioned types of wheat, such as Maris Wigeon and Maris Huntsman, were being grown for the thatching industry to supply the heritage craft enthusiast with the right material. Harvest figurines were now known by the generic term of 'corn dollies', and making them became one of the most popular rural crafts. As all country children know, straw is an incredibly flexible substance, which can be bent or twisted into any shape, and working with it is enormously satisfying. Modern copies of the old traditional designs are works of art, requiring creative talent and technical expertise, and these are the most sought-after and collectable rural ornaments. There is no shortage of courses available to those who want to learn how to make these, and the Guild of Straw Craftsmen has a very comprehensive website which gives information on all aspects of straw work, including publications, events, demonstrations and courses. I often reflect, when I see corn dollies in someone's home or at craft fairs, that much of the attraction in reviving this ancient practice lies in our inherent desire to believe in the old religions – the deities, the spirits, the supernatural, the sacred and transcendent.

THATCHING

A thatched cottage on a sunny day, its garden overflowing with hollyhocks, sunflowers, phlox and dog roses, is everyone's imagery of the quintessentially English rural idyll. It was a favourite subject for artists of the early Victorian pastoral romanticist style of painting, often featuring in the foreground a sleepy looking carthorse and a rustic chewing a straw.

Thatching is the oldest form of roofing and, except in slate mining areas such as Wales and Cumbria, thatch was the only roofing material available to the majority of the population in cities, towns and villages. Even after the commercial slate industries developed in 1820 and building materials could be more easily moved via the canal system and then the railways, thatch remained the principal form of roofing in most rural areas for much of the nineteenth century.

Thatching is the traditional and ancient method of building a roof using dried vegetation such as heather, bracken, reeds, rushes and straw, by layering the material to create a barrier against rain that will deflect water. Depending on the

vegetation used, thatching material is fastened together in bundles with, in the case of straw, a diameter of about 70 centimetres. These are then laid on the roof with the butt end facing outwards and pegged in place with wooden rods. Layers are added on top of each other, finishing with one, often decorated, which secures the ridgeline of the roof.

Different districts used whichever materials were readily harvestable; in the coastal regions reeds were cut for thatch; the Norfolk Broads and the northern bank of the River Tay were two areas noted for their thatching reed. In much of the highlands of Scotland and the hill country of the north of England, bracken or heather was used. Where grain grew, thatch was made from straw with new thatch added to the old every thirty years, or once it became weathered, a process known as 'spar coating'. On some old houses 'spar coating' has created an accumulation of thatch to a depth of 2.2 metres. There are over 200 houses in southern England which still retain base thatch first laid in the fifteenth century, providing archaeologists with direct evidence of the types of wheat, oats and rye grown in the medieval period.

In 1800 there were roughly one million thatched buildings of all sorts – houses, churches, barns, stables, and so on. This had dwindled away to around 35,000 by 1960 as modern, short-stemmed corn varieties replaced traditional grain types and the availability of commercial slate and tiles out-competed thatch on ease of use. Since the 1980s, thatch has become popular again following the resurgence of interest in using more sustainable materials and preserving historic buildings. Specialist growers are now providing the old, tall-stemmed, 'heritage' varieties of wheat grown in low-input or organic conditions. Long straw, combed wheat reed and water reed are the three most commonly used thatching materials of these water reed is the most durable, and although a small quantity is still cut in Norfolk most water reed is imported from China, Turkey and Eastern Europe.

A THATCHED COTTAGE ON A SUNNY DAY, ITS GARDEN OVERFLOWING WITH HOLLYHOCKS, SUNFLOWERS, PHLOX AND DOG ROSES, IS EVERYONE'S IMAGERY OF THE QUINTESSENTIALLY ENGLISH RURAL IDYLL. IT WAS A FAVOURITE SUBJECT FOR ARTISTS OF THE EARLY VICTORIAN PASTORAL ROMANTICIST STYLE OF PAINTING.

Today, there are 24,000 listed thatched buildings in Britain, about 5 per cent thatched new builds and around 1,500 thatchers, who learn the ancient art during a four-year apprenticeship while apprenticed to a Master Thatcher, who will be associated with the National Council of Master Thatchers Association. Expertly applied and properly looked after, thatch is cool in summer and hot in winter. Its excellent insulation properties and the consequent conservation of energy represent considerable savings in fuel costs. Apart from these qualities, thatched roofs are often more in keeping with the overall look of the traditional British countryside.

WORKING WITH WILLOW

In this day and age, when the vast majority of receptacles in daily use are made of plastic, it is hard to imagine the importance to our forefathers of plants that were fibrous, pliable and durable enough to be made into baskets. Reeds, rushes, straw and certain types of coarse grass such as marram grass, which grows in coastal regions, were woven or plaited to make the equivalent of today's plastic bags. For something more substantial, the reeds, rushes, straw or grass would be twisted into ropes and stitched in coils. The strongest basketry was made of intertwined light hazel rods, stripped bramble and oak spelks (thin strips of wood riven from a billet of oak), but by far the oldest and most frequently used was willow.

Willow grows vigorously in heavy, damp soil near water, and at one time about a quarter of Britain was marsh or wetland of one sort or another. Wherever rivers entered the sea there were marshes stretching back until the ground began to rise and drainage took place naturally. Inland, there were innumerable wetland areas and, except in areas of high ground, Scotland and Ireland were virtually all bog. The first inhabitants of Britain, 4,000 years ago, established themselves in the coastal marshes, building on areas of dry land using the reeds and willow that grew all over. The earliest records of the use of willow came from archaeological research on the site of the Glastonbury Lake Village, built in about 300 BC. It transpired that the lake village, a 'crannog' or man-made island, was constructed on a foundation of willow trunks and contained huts and barns built of willow and reeds. Among the miscellaneous artefacts preserved by the peaty soil and recovered by archaeologists were baskets woven from willow rods. Excavations at Bronze Age bog villages in Scotland, Ireland, Wales and the Hebrides confirm that willow was extensively used as a building material for fish traps, crude furniture and household containers. There are also indications that the uniformly straight rods had been cut from managed woodland, and that pollarding (cutting down trees to a 1.5-metre stump to encourage the multiple regrowth which produced straight rods or 'withies') was common practice among prehistoric people.

> THE EARLIEST RECORDS OF THE USE OF WILLOW CAME FROM ARCHAEOLOGICAL RESEARCH ON THE SITE OF THE GLASTONBURY LAKE VILLAGE, BUILT IN ABOUT 300 BC. IT TRANSPIRED THAT THE LAKE VILLAGE, A 'CRANNOG' OR MAN-MADE ISLAND, WAS CONSTRUCTED ON A FOUNDATION OF WILLOW TRUNKS AND CONTAINED HUTS AND BARNS BUILT OF WILLOW AND REEDS.

Every village, manor and ecclesiastical community, even those in the hills or mountains, had a pond, stream or wet area where willow grew naturally or could be encouraged to grow. As the population increased, 'wicker', woven withies, was used to make an incredible range of essential products, so much so that cultivating willow, or osier beds, and harvesting pollarded willows was considered to be one of the most important rural activities. Withies were needed by builders for wattle and daub work, for the creels to carry mortar and sand, and for the scaffolding. The first monastery of Iona, founded in Scotland in 563 by St Columba, was made of wickerwork, and the early chronicles record that St Columba 'sent forth the monks to gather twigs to build their hospice'.

Until the 1950s, when willow was finally superseded by plastic, there were over 200 specialised types of basket and hamper in daily use: bakers, butchers, grocers, cheesemongers, washerwomen, laundry men and cloth manufacturers were a few of the many tradesmen who each had their own design of wicker basket. The importance of basket making was recognised in 1569 when the Worshipful Company of Basket Makers, one of the ancient London Livery Companies, was constituted by the Court of Aldermen. Farmers made wicker grain baskets, vegetable and apple skeps, panniers for pack ponies and cages to transport small livestock, and also hurdle fencing. Fishermen used withies to make their fishing equipment and in the framework for coracles or willow canoes. Coach builders and cart makers built on wicker superstructures, and the light, one- or two-horse 'chaises' continued to be made with wickerwork bodies until the beginning of the last century. Beautiful lightweight furniture was fashioned from willow, as were cradles, coffins and, later, the gondolas for hot-air balloons. The bearskin 'caps' worn by the Foot Guards of the Her Majesty's Household Division were constructed on a wicker frame, and during World War I the seats in early RAF aeroplanes and thousands of shell carriers were made from wicker.

To meet the increased demand for withies, by the late eighteenth century substantial commercial osier beds had become established in Norfolk, Cheshire, the Tweed Merse, County Antrim, London's Pimlico, the marshes of the Vale of Berkeley and the Somerset Levels. Withies which had been harvested through the late autumn and winter were now being treated to suit different customer requirements. Buff willow rods – smooth pinkish-brown withies – were made by boiling the wood for several hours until it absorbed the tannin from the bark, which was then removed by stripping. These buffs were mostly used for making furniture, picnic hampers and the enormous variety of tradesmen's and indoor basket work. Green is the natural colour of most willow when it has the bark on, and these withies, which remain alive for a long time in water, were used by fishermen to make their lobster and crab pots, eel traps, cran baskets, cockle flats, fish kiddles (fish traps set into sluices), fishing net frames and baskets for carrying their catch. Brown willow, withies that had been allowed to dry naturally, were used for agricultural baskets, creels, panniers, hurdles or wattle and daub work. White willow is created when withy rods are left standing in tubs of water until the early spring, when the sap begins to rise and they can be easily stripped of their bark. These beautiful ivory-coloured rods were considered to be more hygienic than other willows, and so they were used to make cradles, all manner of baskets for the catering industry, laundry baskets, washing baskets and any of the many wickerwork containers that were used in hospitals, or by dentists, doctors and veterinarians.

UNTIL THE 1950S, WHEN WILLOW WAS FINALLY SUPERSEDED BY PLASTIC, THERE WERE OVER 200 SPECIALISED TYPES OF BASKET AND HAMPER IN DAILY USE: BAKERS, BUTCHERS, GROCERS, CHEESEMONGERS, WASHERWOMEN, LAUNDRY MEN AND CLOTH MANUFACTURERS WERE A FEW OF THE MANY TRADESMEN WHO EACH HAD THEIR OWN DESIGN OF WICKER BASKET.

Commercial willow growing was still booming in the 1930s, with 400 hectares of osier beds on the Somerset Levels, about 1,500 hectares in the Norfolk Fens, and probably the same hectareage in Gloucestershire. The industry collapsed in the early 1950s when willow products were unable to compete with the sheer range and volume of colourful, shiny, modern, injection-moulded thermoplastic and laminate household items. During the sixties, seventies and eighties, as much of Britain's remaining marsh and wetland areas were reclaimed for agricultural use, the hectareage of commercial osier beds and the number of people employed in a once-burgeoning rural trade dwindled to a fraction. An ancient craft was saved when fashions changed and natural products became desirable and chic, creating a resurgence of interest in rural crafts, particularly articles made of willow. By 2008, there were a considerable number of craftsmen growing withies, manufacturing most of the old willow designs and holding courses in basketry, hurdle making and the increasingly popular living willow garden features. An example of one is P. H. Coate & Son, who have been willow growers since 1819 and run the Willows and Wetlands Visitor Centre at Stoke St Gregory, near Taunton, on the edge of the Somerset Levels. The Coate family grow and harvest their willow to make indoor and outdoor furniture, screens, hurdles and garden structures, coffins, charcoal for artists and every conceivable sort of basket, hamper, bin, tub and box. They sell the whole range of colour and size of withy, hold courses in living willow garden design and all aspects of willow work.

MAKING BASKETS

Basketry has become so popular with hobbyists as a recreational craft that The Basketmakers' Association, which started in a small way in the late seventies, has grown into a substantial organisation, promoting classes, courses, exhibitions, lectures and demonstrations throughout Britain, whilst setting standards of teaching, quality of workmanship and encouraging original design. The Basketmakers' Association provides a comprehensive list of regional organisations plus the dates, venues and contacts of courses or events during each year. They sell a considerable range of educational literature and videos and can provide successful applicants from within their membership with bursaries for further study, both at formal courses and for periods of travel.

WALKING STICKS

In the corner of my hall is an old leather Horse Artillery shell bucket which is overflowing with walking sticks. Some have marvellous metal attachments for swatting thistles or digging out docks; others are beautiful, elegant 'dress' sticks with ebony or *lignum vitae* shanks and ivory, silver, agate or gold tops. There are three 'System' sticks, a leather-bound sword stick, a Malacca cane with a hidden spirit flask, one with a snuff box concealed in the top and another with a nineteenth-century surveyor's measuring rod inside it. Amongst those are a selection of hazel, ash and holly sticks with handles carved in the heads of various animals – a terrier, foxhound, greyhound, salmon, pheasant and one made of ivy with a snake entwined around its length. Leaning beside them are half a dozen ram's horn crooks, which I use virtually every day on the farm, and lastly an old, battered thumb stick with a hazel shank and hand piece made from the forked top of a stag antler. I am deeply attached to the last stick; it has helped me out of the ooze of tidal mudflats when I have been wildfowling, in and out of rivers when fishing, or up and down steep and craggy mountains, stalking or fell hunting, and it has held me more or less vertical at countless game fairs, point-to-points and coursing meetings – but what makes my silent, dependable companion so very special is that I made it myself.

There is something extraordinarily personal about a walking stick; it is, after all, an extension of the body and will share many an adventure with its owner. They are enormously popular with both sexes, and stick makers sell armfuls of their craft every year at game fairs and country shows. There are sticks with carved and fancy handles of every kind on sweet chestnut, cherry, holly or blackthorn shanks; sturdy, agricultural ash roots; traditional neck crooks in rams horn or glossy black buffalo, and sticks with heads made from sika, fallow or whole roe buck antlers. The most popular, though, is undoubtedly the traditional thumb stick, with a hazel shank and stag-antler top.

WHITTLING WALKING STICKS

A stag-antler thumb stick is relatively simple to make and the materials can be easily found. All the component parts for making sticks – different types of shank, horn and antler – can be bought online or from the stick-making stands that are a feature of every country show, but it is immeasurably more satisfying to source all the ingredients oneself and make the whole thing from start to finish.

Hazel grows throughout Britain in deciduous woodland; it is naturally an under-storey plant and is often found in oak and ash woodland, in hedgerows and on stream banks. Thousands of acres of hazel woodland was once coppiced to provide fencing stobs, hurdles, barrel hoops, fishing rods, whip handles, pegs, ties for fastening thatch, fuel for ovens, faggots and charcoal for gunpowder, domestic fires and ovens. The most attractive hazel for stick making, with beautiful silvery bark, is found on rocky soil through the west of the country and up into Scotland.

Shanks should be cut whilst the sap is down and the bark still hard, from the beginning of November to before catkins start appearing towards the end of February. Look for a stave that will give you a shank of between 1.38 and 1.52 metres,

with a diameter no greater than 4 centimetres at the bottom and 2.5 centimetres at the top. Balance along the length of the stick (stick makers call a well-balanced stick 'clever') is all important, but don't worry if the stave is not completely straight, as hazel is very pliable and can be straightened whilst it dries. This will take a year – giving you plenty of time to find a suitable antler – by attaching it to a beam and hanging a heavy weight off the bottom.

Finding the right piece of antler is the next key step. If you stalk, you might have a head that is not worth mounting, or know a friendly stalker who will let you pick through the pile at the back of a deer larder until you find what you want. Realistically, the best option for most people is to buy what you need; either way, you are looking for a piece of antler with the top tines reasonably level, a stem 10 centimetres long and 2.5 centimetres in diameter to fit the top of your shank. It is important that this feels comfortable in the hand, with the thumb hooked through the V.

There are two methods for fitting the hand piece to the shank. First, square off the ends of both with a fine blade fretsaw or file so that they meet flush and marry in diameter, then drill out the marrow inside the antler with a hand drill using a five-eighths flat bit to a depth of 8 centimetres. The old-fashioned way is to shape an 8-centimetre dowel at the end of your shank and glue it into the corresponding hole; the more modern and stronger method is to fashion a wooden plug with a sharp penknife to fit the drilled cavity exactly and glue it in with araldite. When the glue has dried, cut off any protruding wood flush with the antler. Drill a hole through the centre of the plug, 8 centimetres deep, with a two-eighths flat bit and glue in a 16-centimetre threaded metal rod of the same diameter. Keeping the drill absolutely level, make a hole 8 centimetres deep down the centre of your shank, using the same two-eighths flat bit. If the glue has dried in the hand piece, fit it to the shank. Hopefully, both will fit together flush; if they don't, the angle of the drill may have been slightly out. This is where the metal rod beats the dowel. Remove the hand piece and gently bend the rod until you have a perfect marriage. Once you are satisfied, apply glue to the rod and fit them together.

> MY STICK ... HAS HELPED ME OUT OF THE OOZE OF TIDAL MUDFLATS WHEN I HAVE BEEN WILDFOWLING; IN AND OUT OF RIVERS WHEN FISHING, OR UP AND DOWN STEEP AND CRAGGY MOUNTAINS, STALKING OR FELL HUNTING, AND IT HAS HELD ME MORE OR LESS VERTICAL AT COUNTLESS GAME FAIRS, POINT-TO-POINTS AND COURSING MEETINGS – BUT WHAT MAKES MY SILENT, DEPENDABLE COMPANION SO VERY SPECIAL IS THAT I MADE IT MYSELF.

The next step, and probably the most important one, is cutting the shank to length. A rule of thumb is to hold your arm straight out from the shoulder, clench your fist, then measure the distance from your thumb to the ground and add 10 centimetres. It is then a matter of gradually sawing off little bits until you have the height to suit, bearing in mind a thumb stick's two essential roles: one is to propel you forward over rough ground; the other, to take the weight off the body when standing for any length of time.

I have noticed that thumb-stick aficionados fall into two distinct groups: Leaners and Loungers, and fine-tuning shank length is determined by which of

these you happen to be. Leaners favour the slightly shorter shank and can be seen with arms folded, propped upright, with their stick wedged into the fleshy part of the forearm, leaning nonchalantly. Loungers, like myself, place our sticks under the oxter and lounge. A few centimetres can be crucial to one's future comfort, so greater care needs to be taken over shank length than any of the other operations.

Finally, you need to protect the point of your stick. To make a fancy job of it, 4 centimetres of antler or buffalo horn of the right diameter would be very smart. Simply drill a hole 5 centimetres into the shank and 2 centimetres into the antler or buffalo horn using a one-eighths flat bit, insert a threaded metal rod of the same diameter and glue in place. If you anticipate that your stick is going to get a lot of hard usage there are several options: an empty 12-bore cartridge with a plastic case is one (it looks pretty scruffy but it does the job); or a steel ferrule, obtainable from any stick maker. However, I find these too hard and intrusively noisy when trying to watch wildlife. and furthermore I had a misfortune while mink hunting some years ago when a steel-ferruled stick slid off a submerged rock, just as I was lounging comfortably in midstream. Ever since, I have always made tips from a piece of copper piping: cut a 4-centimetre section of a one-eighth copper pipe the same diameter as the end of your stick, then trim it to fit, glue it and tap it in place. The shank's wooden tip is now protected by the copper outer casing, but, more importantly, it has grip and is barely audible on rocky ground.

STICK-MAKING BY THE EXPERTS
The popularity of stick making among hobbyists led to the formation of the British Stickmakers Guild in 1984, with the Dowager Duchess of Devonshire as Patron and Lords Aylesford and Carnarvon as President and Vice-President. The object of the Guild is to cultivate and promote the art of making walking sticks, canes, staffs and shepherd's crooks, by setting standards of excellence and organizing shows and competitions during the year. By 2008 there were regional and local stick-making groups, with courses, events and demonstrations throughout Britain. Part of the attraction of this craft, which appeals to all ages and gender, is the facility to create something to be cherished, at any level of competence. The beginner's ash plant, cut from a hedge, with a handle bent to shape by simple steaming, is as satisfying to make as a stick with an animal head that has taken hours of laborious carving.

In the North of England and Scotland, the interest in stick making as a recreational leisure pursuit has been largely responsible for saving an ancient heritage craft. In remote areas of Northumberland, Cumberland and much of Scotland, where the mountain sheep are predominantly horned, hill shepherds traditionally whiled away the long winter nights 'dressing' ram's horns into crook heads. The horns of rams that had died during the year were sawn from the head, dried, and arduously cut, heated and filed into the desired shape. Most of the designs were 'neck' crooks, similar to a Bishop's crozier, for catching sheep by the neck. Others were smaller leg 'cleeks' for catching sheep by the hock. Many of these were basic tools of the trade, but every shepherd would make at least one that would be his pride and joy, over which he would spend hours of patient work. This was his 'fancy' or 'market' stick; a work of art that would only be brought out on special occasions,

such as market days, the annual ram sales or agricultural shows. It would have the owner's name incorporated on the side of the horn and, frequently, the curved 'nose' of the crook would be carved into scroll work, or the head of a moorland creature such as a cock grouse, golden plover or hare. Sometimes the carving would be of a favourite collie dog, and in Scotland the thistle was a popular choice.

For hundreds of years, the number of ewes a hill shepherd looked after was twenty-five score (500). Although life in the hills was harsh, isolated and often lonely, shepherds contrived to meet every so often and spend a winter's evening dressing sticks together. After World War II man-made fibres caused the UK wool price to collapse and falling farm incomes led to severe cutbacks in the numbers of shepherds employed. The average hill herding doubled to fifty-score ewes (1,000) and as a consequence the population in the rural uplands halved. Shepherds now had even less social contact with each other and many of the old customs died out.

Fortunately, there were those who, anticipating that the knowledge of stick dressing was in danger of being lost, formed organisations with the object of promoting crook making as a personal craft by providing help and expertise to those who were interested. Two pioneer organizations, both of which started in the late 1950s, take the credit for keeping this ancient art alive until it became a popular pasttime. One was the Border Stick Dressers Association in Northumberland, whose Royal Patron is HRH the Prince of Wales; the other, the Scottish Crookmakers Association, who have as their Patron the Duke of Buccleuch and Queensberry.

WONDERFUL WOOL

Wool is nature's most versatile fibre; it has such a complex combination of properties that no other material, natural or man-made, can match it. Sheep have evolved a covering that allows them to live in extreme climates, including heat, cold and wet, and that has properties so that they remain cool in heat, warm in low temperatures and can soak up damp without feeling wet. Every strand of wool that makes up a fleece contains outer cells that repel water, while inner cells absorb humidity from the air. It is also versatile as a material; depending on the breed, sheep can produce wool rugged enough to be made into carpets or fine enough for baby's clothes. Wool's capacity to retain moisture enables it to take on deeper, richer, purer colour dyes than vegetable or man-made fibres. It is also used to create a fabric that clothes astronauts and polar scientists, highland stalkers and the clientele of world-famous fashion designers.

> WOOL IS NATURE'S MOST VERSATILE FIBRE; IT HAS SUCH A COMPLEX COMBINATION OF PROPERTIES THAT NO OTHER MATERIAL, NATURAL OR MANMADE, CAN MATCH IT ... IT IS ALSO VERSATILE AS A MATERIAL; DEPENDING ON THE BREED, SHEEP CAN PRODUCE WOOL RUGGED ENOUGH TO BE MADE INTO CARPETS OR FINE ENOUGH FOR BABY'S CLOTHES.

Wool was being woven into cloth by the tribes of northern Europe at least as far back as 10,000 years ago, and there was already an established Celtic woollen industry in Britain when the Romans invaded. Wool production and textile manufacture were sufficiently developed in the Saxon period for a percentage of goods to be exported to France, according to historical documents from the Emperor Charlemagne to the King of Mercia. At the time of the Norman Conquest, sheep were more numerous than any other livestock, but it was the Normans who organised wool production to be our greatest national asset.

Among the first to establish large-scale sheep farming were the Cistercian, Benedictine and Augustinian monks. By the early part of the twelfth century, great religious houses and beautiful abbeys were soon under construction – particularly in the north of England and across the Scottish Borders. The monks were superb agriculturalists, and these monasteries built up enormous flocks; at one point Melrose Abbey alone had 25,000 sheep grazing the Cheviot hills. During the early Middle Ages, the Border monastic manors at Kelso, Jedburgh, Dryburgh, Melrose and Sweetheart Abbey, in Dumfriesshire, became some of the biggest wool producers in the Western world, bringing prosperity to the region. Raw wool was exported from Berwick-on-Tweed to Bruges in Flanders, the centre of the weaving industry, and imported back again in the form of cloth. In 1370, Edward III, ' the Merchant King', doubled the value of wool by luring Flemish weavers to settle in East Anglia, Yorkshire and southern Scotland. As a result, the nascent domestic cloth industry was transformed and a lucrative export market in woven goods established. It was during this period that the Woolsack, upon which the Lord Chancellor sits in the House of Lords, was introduced in recognition of the vital importance of the wool trade and as a symbol of the nation's prosperity.

For all except the wealthy, clothing was made from coarse, undyed 'homespun' yarn. Every country home and many urban ones had a drop-spindle, distaff

spinning wheel for making yarn and often a small weaving loom as well, which catered for most of the family's needs. The first step in turning raw wool, either from a fleece or from bits and pieces collected from the ground or hedgerows, was to straighten the wool and get rid of dust, dirt or daggings. It was then combed with a carding brush into 'rolags' – rolls of combed wool ready for spinning. The next step was to tease and twist strands of wool from the rolag into a continous thread – the 'leader' – and attach them to one or other of the spinning devices. As the spindle, distaff or spinning wheel was rotated, the thread of wool got longer until the rolag was used up and the process repeated. In its very basic form, the yarn would be made from greasy unwashed fleeces, containing all the natural lanolin and suint – sweat salt. Whilst this had marvellous waterproofing qualities, it was impossible to dye and smelt overpoweringly of ammonia when warm. Until the invention of synthetic detergents, wool was 'scoured' (cleaned) by putting fleeces in tubs of rainwater on warm days. As the suint dissolved, it took a percentage of the dirt and grease with it. A more effective way, but one which required considerable after-treatment to get rid of the smell, was to soak the fleece in human or pig urine.

In the seventeenth century, scouring, carding, hand spinning and weaving became vibrant cottage industries in many parts of the country, providing employment for thousands of women and children. The wool combers passed carded wool to the spinners, who spun it into skeins; the skeins were then passed on to the winders, who prepared them for the weavers. Mechanization in the late 1800s created a dreadful upheaval in the lives of rural people as many families followed

employment to the dark, satanic textile mills of the industrial revolution. However, despite these changes, spinning wheels were still common in many households in the early part of the twentieth century, and in remote parts of Scotland and Ireland for much longer. Spinning became perceived as an occupation for an unmarried daughter (hence the word spinster) and women sitting at a spinning wheel or holding a spindle or distaff had long been a popular subject for artists, particularly by Victorians such as Marianne Stokes, William-Adolphe Bouguereau and Elizabeth Piper, who tended to glamorise an occupation which was drudgery for many women. The origin of 'pop goes the weasel', the cheerful rhyme known to every child, refers to the monotonous sound of the 'spinner's weasel', a mechanical yarn-measuring device that was attached to a spinning wheel. This had an internal ratcheting mechanism that clicked every two revolutions and made a 'pop' sound after the desired length of yarn was measured.

> SPINNING BECAME PERCEIVED AS AN OCCUPATION FOR AN UNMARRIED DAUGHTER (HENCE THE WORD SPINSTER) AND WOMEN SITTING AT A SPINNING WHEEL OR HOLDING A SPINDLE OR DISTAFF HAD LONG BEEN A POPULAR SUBJECT FOR ARTISTS, PARTICULARLY BY VICTORIANS SUCH AS MARIANNE STOKES, WILLIAM-ADOLPHE BOUGUEREAU AND ELIZABETH PIPER ...

What may have been a chore to women of previous generations has become possibly the most enthusiastically followed pasttime worldwide among hobbyists and small-scale artisan craftspeople. The International List of Weaving and Spinning Organisations, Guilds and Associations is a directory which includes literally hundreds of addresses and telephone numbers in Canada, America, Asia, Australasia and Europe – which of course includes Britain. There are more courses, lectures, demonstrations and literature on wool working than any other heritage craft, and behind it is a substantial industry supplying a vast range of equipment. This includes all the different wool types – from coarse Herdwick to superfine Merino and multi-coloured Shetland, Cashmere, Mohair, Angora, Alpaca or Vicuna – spindles, distaffs, hedgehogs, carding brushes and every sort of spinning wheel and weaving apparatus, from simple table looms to sophisticated floor looms.

Working with wool attracts people at any stage of proficiency; I know those who are quite content to spin their own knitting wool on a drop spindle from a rolag ordered online from a supplier, and equally I know others who keep small flocks of sheep and scour, card, dye, spin and weave their own cloth. At any level, wool working gives a marvellous feeling of accomplishment as well as a sense of connection to history and the land.

DYEING WOOL

Some of the most attractive woollen products are those that have been coloured with natural dyes, and a vast range of colour sources are there for the asking, growing wild in our woods and hedgerows. Bee propolis and a variety of plants, including the bark of apple, pear, rowan (wild cherry), ash, bog myrtle and St John's Wort produced a yellow dye. Red colouring is made from rue, blaeberry or the bark of alder and dogwood trees. Green comes from alder catkins, broom bark, privet berries, iris leaves, and heather before it flowers. Orange derives from ragweed, barberry root and bramble; magenta from dandelion; mauve from blueberry; purple from bilberries and sloes; violet from wild cress and bitter vetch; blue from blackberries and elderberries; brown from blackthorn and oak bark, water lily roots, walnut roots and dog dung. At one time, hound dung was one of a hunt servant's perks, and barrels of the stuff were sent from all over Britain to Bradford for dyeing corduroy. Many other dyes can also be made from lichens.

Originally, wool was dyed by boiling a whole washed fleece in a solution of plant extract – usually crushed berries – which tended to last until the first heavy shower of rain washed it out. Eventually, the knowledge of using ammonia as a mordant or fixing agent to hold the dye (a process discovered by the ancient Persians) found its way to Britain. For many centuries the process for dyeing involved steeping thread in urine or, when dovecotes became popular, pigeon dung and then boiling it in the chosen colour. By the beginning of the seventeenth century, ammonia was replaced by alum, a form of potash derived from burning shale, which remained the principal fixing agent until it was replaced by modern chemicals. Alum, potassium aluminium sulphate, can be easily procured and is the recommended fixing agent for the home dyer.

A considerable amount of experimentation is involved in home dyeing, and the depth of colour depends on the quantity used. A rule of thumb is to use a kilogram of vegetable matter to every 500g skein of yarn, steeped in 18 litres of water. The vegetable matter is cut into small chunks or berries are mashed up and placed in an 18-litre stainless steel or aluminium vessel, covered with water and left overnight. The following day, the mixture is boiled for one hour.

Meanwhile, the mordant is made by mixing together 114g alum and 28g cream of tartar with a little water to form a smooth paste. This is then added to an 18-litre stainless steel or aluminium vessel that is filled with water into which the yarn is immersed. After simmering for one hour the yarn is removed and the excess fluid gently pressed out. The mordanted wool is then immersed in the dye, off the heat, and left for one hour. After that, the wool is lifted out and allowed to drain.

TWEED – THE TAILOR'S TEXTILE

There is no comparison between hand-woven and machine-made cloth, and with practice it is perfectly possible to produce a considerable quantity of material. I know a hand weaver on the Isle of Lewis who started wool working as a hobby and now sells lightweight, hand-woven tweed to Saville Row tailors and the great couture houses.

The origin of the word 'tweed' is of historical interest: in the early eighteenth century a cottage industry that centred around spun wool, hand-knitted hose (stockings) and a rough cloth known as hodden grey existed in the Borders. As demand grew, small factories became established in the towns of Melrose, Selkirk, Jedburgh, Galashiels and Hawick. By 1800, 3,000 people were employed in Hawick alone, making carpets, hosiery, cloth, and other woollen goods, in mills powered by water. This water was transported through the town from the river Teviot, a tributary of the Tweed, by a complex system of sluices and culverts. Among the new textile businesses that sprung up in Hawick at the beginning of the century was a factory owned by William Lindsay Watson. Watson's Mill manufactured hosiery and twill or 'tweel', a hard-wearing patterned cloth, from premises on Commercial Road.

In 1820, Sir Walter Scott, the famous novelist, astonished London society by wearing trousers made of black and white checked tweel. The pattern was a copy of plaids worn by Border shepherds and in which they were traditionally buried. Overnight, checked trousers became fashionable and the Border mills were swamped with orders for patterned tweel. In 1826, a consignment marked 'Scotch

Tweels' was delivered from Watson's Mill to James Locke & Co., the leading woollen cloth merchant in London. A ledger clerk writing the word 'tweel' in his entry book pressed too hard with his quill pen, releasing a blob of ink, transforming the word 'tweel' to 'tweed'. Assuming the mistake to be intentional, James Locke placed his next order with Watson's Mill for 'tweeds'. With a stroke of genius, William Watson adopted the word as descriptive of his product, and Commercial Road, Hawick, became recognised as the home of tweed: a term which was to become synonymous with brilliance of design and quality of fabric across the world.

THE HOME OF TWEED

Watson's Mill is long gone, but the home of tweed is still Commercial Road, Hawick. Lovat Mill, named after one of the oldest tweeds which was created for the thirteenth Lord Lovat of Beauly, is one of the few surviving mills specialising in the design and weaving of Sporting and Estate tweeds, and is keeping part of Scotland's textile heritage vibrantly alive in its location of origin. Lovat Mill manufacture around 150 Estate Tweeds for clients that range from the great historic ducal estates such as Devonshire, Buccleuch, Westminster and Roxburghe, to more recently established sporting properties; several Regimental Tweeds, including the oldest regiment in the British Army, the Scots Guards, and a number of House Tweeds, amongst which are Hackett, Purdey and E.J. Churchill's shooting ground.

Stephen Rendle and Alan Cumming, the directors, are continually recreating old Estate Tweeds and creating new ones as sporting estates change hands. Traditionally, weight meant warmth, weatherproofing and durability, and Estate Tweeds were woven accordingly. Modern technology has enabled weavers to produce hard-wearing, lightweight, rain-resistant fabrics, containing Lycra, Teflon or nylon filaments. Lovat Mill focuses on producing personalised contemporary tweeds, whilst retaining the colour richness and appearance of traditional cloths.

Tweed was catapulted to further prominence thirty years later when there was a massive demand for 'Estate' tweeds. These are as uniquely Scottish as the tartan and like the tartan they are a uniform or livery that associates the wearer with a person or place. Estate tweeds evolved out of the great changes which occurred in the Highlands from the mid-nineteenth century. Scotland was beginning to become appreciated as a sporting paradise when Queen Victoria bought the Balmoral Estate in 1848. There were salmon in the rivers, pheasant and partridge on low ground, grouse on the moors and red deer on the high hills. Stalkers require clothing that blends with the landscape, and one of the first Estate tweeds, which is still worn by the Balmoral stalkers, ghillies and gamekeepers to this day, was designed by Prince Albert. The Balmoral Tweed is a dark blue design sprinkled with white and red, creating an overall grey effect that replicates the colours of the heather and granite mountains of Aberdeenshire.

> TWEED WAS CATAPULTED TO FURTHER PROMINENCE THIRTY YEARS LATER WHEN THERE WAS A MASSIVE DEMAND FOR 'ESTATE' TWEEDS. THESE ARE AS UNIQUELY SCOTTISH AS THE TARTAN AND LIKE THE TARTAN THEY ARE A UNIFORM OR LIVERY THAT ASSOCIATES THE WEARER WITH A PERSON OR PLACE.

The purchase of Balmoral led to a flood of wealthy Victorians wishing to follow the example of the monarchy, and there was no shortage of penniless Highland lairds willing to sell or lease their estates. The new landlords emulated royalty in commissioning tweed for themselves and their retainers, which were created uniquely for each estate as the exclusive property of the owner. The complex colour combinations and patterns were designed as camouflage, replicating the different scenery of individual localities. One of the earliest Estate tweeds, often used as a base upon which other designs are superimposed, is the famous Lovat Mixture. The inspiration for the blend of blues, yellows, browns and whites that create this tweed came from the colours that merge into the hillside above Loch Morar, in Invernesshire: the primroses and bluebells, birch trees and bracken, the dark waters of the loch and white sand of the shore.

The fashion for clothing estate staff in matching tweeds spread over the Border to the great sporting properties in England. In the early part of the twentieth century, private tweeds ceased to be solely connected to land ownership and the idea of an exclusive tweed for officers was soon adopted by many regiments, each commissioning their own design. A more recent progression from Regimental Tweeds has been House Tweeds. These are brand-related cloths, created for businesses aspiring to a unique distinction. Of the many that have their own tweeds are Hackett, the stylish menswear chain, Purdey, the famous London gunmakers, and several well-known shooting grounds, such as West Wycombe in Buckinghamshire. Indeed, anyone who wishes to do so can design, or have designed for them, their own bespoke tweed, and if they know how to they could even make it themselves.

WEAVING WOOL AT HOME

The easiest way to learn the fundamentals of weaving is to buy or make a square weaver loom and weave your own wool at home.

Make a 30 x 4 centimetre square frame and insert 3 x 30-millimetre brass screws at 6-millimetre intervals all the way round. Tie the yarn to the first screw on one side and zigzag your way from side to side, wrapping the yarn round the screws and tying off when you arrive at the end. This is your 'warp'. Next, thread a weaving needle with 45 centimetres of yarn, tie one end to the first screw of the next side and weave under one warp and over the next and so on until you reach the other end. This is the 'weft'. Re-thread the needle, tie onto the next screw and weave back again, going over the warp you went under the first time. Press the needle down between each pair of warp periodically to keep the weft tight.

In no time a piece of cloth begins to take shape and you are well on the way to being hooked. The next step is to enroll on one of the many hand-weaving class that are available around Britain through the Association of Guilds of Weavers, Spinners and Dyers and be taught by a professional. Then it's time to get a nice little second-hand four-shaft Louet W70 table loom at a cost of about £200 and, who knows, in a year or two you might be building an extension to the house and laying out several thousand pounds on a massive 16-shaft Dobby.

MAKING FELT

Felt is the earliest material known to man. It is windproof, waterproof, light, and can be made gossamer thin or a metre thick. Chinese historical records refer to felt as early as 2300 BC, when it was used as clothing, to make shields, armour, helmets, boats and yurts (the felt tents which the Mongolians have lived in for thousands of years). Felt caps dating from 3,500 years ago were found at prehistoric burial mounds in Denmark, and other felt artefacts have been discovered in Bronze Age barrows in several parts of Germany. The northern Europeans have a long tradition of commercial felt making; the Austrians and Bavarians have clothes made from Walkloden cloth, which is a type of felt, similar to the famous Swandri of New Zealand. The Scandanavians, Canadians and Russians have felt boots, boot liners and leggings. Although I had a British-made felt saddle on my first pony, there has never been a felt-making industry of any scale in Britain. It is, however, one of the quickest and easiest methods of making material and very popular with craft enthusiasts.

Felt is created when the scales which cover every fibre of wool are forced to adhere to each other – something that happens when a woollen garment gets accidently put into too hot a wash. It is delightfully easy to make and is as masculine an occupation as spinning is feminine.

To make felt, take a 1 square metre piece of bubble wrap and place it on a flat surface, such as a kitchen table. Spread an old linen sheet (cut to 2.5 square metres)

A Book of Britain

on top, set to one edge as you will fold it back on itself later. Gently pull thin segments, about 1m long, off a substantial rolag of wool (merino is the easiest wool for felting), laying them closely side by side over the area of bubble wrap, but back from the edge. Continue until there is a strip 6m long.

Start another line of wool segments making sure they slightly overlap the first ones. Continue until you have a fluffy mat 6m square. Repeat, laying the next layer at right angles, then repeat again. (The purpose is to have alternate vertical and horizontal layers, to bind and strengthen the cloth.)

Mix some soap flakes with water in a plastic squeezy bottle and squirt suds liberally over the mat of wool. Fold the sheet over the mat so that it forms a 6m square envelope. Massage the soapy water vigorously into the wool through the sheet, adding more if necessary – it wants to be good and wet. Keep working away at the wool with your fingertips and then, after about ten minutes of this, lay a stout 1.5-metre stick along the bottom of the envelope and roll it up tightly.

Remove the rolled wool to a hard surface and roll it backwards and forwards about 100 times, pressing down hard, making sure there is a full revolution each time. Unroll, wrap again from the other side and repeat.

Do this twice and then unroll it again and squirt more suds on. Roll and repeat as before. Whilst this is going on, heat 9 litres of water to boiling point and fill a sink with boiling water. Remove the stick and plunge in the envelope, making sure it is completely immersed (this expands the fibres), then plunge it into a bucket of cold water (this contracts the fibres). Repeat, adding more boiling water, then unwrap and discard the linen sheet. The felt will still be quite loose, and to make it firmer, scrunch it, squash it, ball it, bash it, even put it in a tumble drier for a bit. The harder it is treated, the tighter it becomes.

Finally, wash the felt in cold water with a little vinegar to dispel any residual soap suds, drain and, when dry, roll flat with a kitchen roller or, better still, an old mangle if you have one.

You now have a sheet of felt big enough for a bag, a hat or a pair of slippers!

> FELT IS THE EARLIEST MATERIAL KNOWN TO MAN. IT IS WINDPROOF, WATERPROOF, LIGHT, AND CAN BE MADE GOSSAMER THIN OR A METRE THICK... IT IS ONE OF THE QUICKEST AND EASIEST METHODS OF MAKING MATERIAL AND VERY POPULAR WITH CRAFT ENTHUSIASTS.

LAYING HEDGES

Hedgerows are the most charming, ancient and quintessential feature of the lowland British countryside. They are the aesthetically pleasing, distinguishing characteristic of many rural landscapes, reflecting the cultural history of local communities as well as providing habitat and corridors of safety for a wide range of birdlife, insects, small mammals and reptiles.

Hedging was first used during the later Neolithic period, 4,000 years ago, when prehistoric people developed a primitive form of crop cultivation, gradually becoming less dependent on hunting and scavenging. 'Dead hedges', walls of cut thorn bushes, were built to protect the little hand-cultivated fields from predation. As settlements became established, low banks of earth were thrown up round field margins, with cut thorn bushes and brambles pegged on top by wooden stakes. In time, blackthorn and bramble would self-seed and grow naturally, eventually creating a permanent barrier.

Hedges were common during the Bronze and Iron Ages, when much of the traditional chequerwork pattern of our lowland landscape began to take shape – among the oldest still in use are on the Land's End Peninsula in Cornwall. The Romans brought with them a long and sophisticated tradition of hedge management, examples of which have been found in the excavations in Oxfordshire and as far north as Dunbartonshire. The Anglo-Saxons planted hedgerows extensively across England, south of the river Humber, marking property boundaries and protecting fields, small woodlands and spinneys.

Young trees are easily damaged by livestock, and timber of all kinds was at a premium. Spinneys (from the old French *espinei*, meaning a thorny place) were an especially valuable source of material for temporary hedging. Although there were subsequent plantings during the ensuing centuries, particularly the enclosures of the medieval period, the general network and distribution of hedges remained more or less unchanged until the Enclosure Acts of the eighteenth and nineteenth centuries. During the Agricultural Revolution the 200,000 miles of quickset hedging planted between 1760 and 1820 probably equalled the total of all those planted in the previous 500 years, transforming the landscape of large parts of lowland Ireland and Britain. These new hedges were established by pushing live hazel and whitethorn cuttings directly into the soil (the word 'quick', means alive, as in 'the quick and the dead') to which holly, blackthorn, briar, dog rose, field maple, ash, elm or scrub oak were subsequently added. Alternatively, the seeds of oak, ash and thorn, etc., were scattered along a length of loose straw rope and buried where the hedge was required. A ditch-and-hedge was formed by throwing earth from the ditch onto the owner's side, forming a bank, and the hedging was planted below the top of the bank, which provided shelter to the growing plants.

Unless a hedge is cut and laid regularly it quickly becomes overgrown, the overmantle inhibits growth that makes up the body of the hedge and so it ceases to act as a barrier against stock. Hedge laying as we know it developed during the main period of the Enclosures and was always carried out in the winter months after the leaves have fallen and when the sap is down. To start with, the hedge layer cleared the hedge of all rubbish, such as deadwood, ivy and brambles, opening the bottom

of the hedge to allow the sun in to encourage the growth of new shoots. Each individual holly, ash, beech or hazel sapling, known as a pleacher, was then pruned of any large side branches and top-heavy material. The base of their trunk was then cut through until flexible enough to pull down, and as the hedger worked along the line of hedge the pleachers were laid on top of each other at an angle of 45 degrees. To support the newly laid hedge, coppiced hazel stakes are hammered into the ground at 45-centimetre intervals and the pleachers threaded through them. To finish the hedge, binders or hethers made from split hazel rods were woven along the top of the stakes to keep the hedgerow solid and to prevent wind damage.

A HEDGE FOR EVERY PURPOSE

There are more than thirty different styles of hedge laying across the UK and each has been developed over many years to cope with the climate of the area, the farming practices and the type of trees or shrubs that grow in the hedge.

Farms with large animals, such as cattle or horses, needed hedges able to withstand the weight of the animal pushing against them, so the Sussex Bullock and Midland Bullock were developed for this purpose. With a finished height of 1.37 metres, the stakes are driven into the ground 50 centimetres apart behind the 'stool' (stem) line towards the 'brush' (bushy) side. Hazel binders are then woven along the top to give maximum strength. The livestock are kept in the field behind the brush side of the hedge with a crop on the other side (the 'face' or plough side).

The Welsh Border hedge, predominantly a sheep barrier, is a double brush hedge with stakes driven in at 35-degree slant, 80 centimetres apart. Dead wood is

used in the hedge to protect the regrowth from being browsed by stock. The dead wood and live layers are bound down the centre line, with the top and side of the hedge being trimmed.

In Derbyshire, brush or bushy growth is placed on the livestock side and sawn timber stakes instead of hazel ones are driven in on the brush side of the 'stools', 4 metres apart. There are no bindings, but the hedge is trimmed to give a finished height of 1.25 metres. The base of the hedge around the stools is dug over to remove intrusive weeds and to encourage the bottom growth that is needed to restrain sheep.

In Kent and Sussex, the hedge is cut and laid over to create a double brush. A single line of stakes are placed 50 centimetres apart in the centre of the hedge with the top bound and both sides trimmed.

In Devon and Cornwall, where many of the hedges are of great antiquity, they are laid on top of a stone faced bank, which forms the main barrier against livestock, with densely planted hawthorn, blackthorn, hazel and guilder rose to keep sheep and lambs secure. This style uses crooked hazel sticks to secure the hedge, with binders along the tops. In other parts of the West Country, a row of stakes placed alternately on either side of the hedge keeps the stems in place, with hedge plants being woven around the stakes.

Up in the arable districts of Yorkshire, a very thin hedge is planted, finished with stakes and rails. No stock is held in fields against the hedge for up to five years, and it would then be cut close to the ground, giving plenty of growth thickness in the bottom, before the arable land is rotated to stock grazing.

THE DECLINING ART OF HEDGE LAYING

Hedge layers were a familiar sight during the winter months, cutting and laying, one hand covered in a thick, thornproof leather glove and wielding a mortise axe, long-handled slasher or curved billhook in the other. I remember hedges being laid on my father's farm in the fifties: the sweet smell of bramble smoke as the hedgerow trash was burnt, and the farm men trudging home in the gloaming, carrying bundles of firewood, faggots or hazel and ash rods, for which there was a wide range of uses.

There was a rapid decline in hedge laying from the early 1950s as machinery replaced manpower and many thousands of miles of hedgerows were bulldozed out to create large arable field units. Between 1950 and 1970, around 4,200 kilometres of hedgerow were being destroyed every year, which gradually increased until 8,500 kilometres were lost annually from 1980 to 1990. Others were neglected, and through deterioration or loss the single most important resource for small wildlife and their vital corridors of safety disappeared. Roadside hedgerows were controlled by tractor-mounted flails, which shattered rather than cut them into shape, leaving an unattractive perspective until regrowth disguised the damage.

In the early 1970s, three hedge layers, Fred Whitefoot, Clive Matthew and Valerie Greaves, realised that soon the valuable art of hedgerow management that had been acquired over hundreds of years would be lost forever. This trio conceived the idea of setting up a National Hedgelaying Society in order to enable the ancient skills to be documented and passed on to others. The founder members organised

demonstrations at agricultural and county shows, gradually attracting a membership of enthusiasts in sufficient numbers to hold competitions in various parts of the country.

As a result of pressure by conservation groups, government policy on hedgerows was forced to change. Subsidies to remove hedgerows were phased out and in 1992 a Hedgerow Incentive Scheme (HIS) was introduced to fund the replacement and restoration of hedgerows if they were considered to be long-established landscape features, important wildlife habitats, if they occurred on degraded landscapes or were of particular amenity value.

The 1997 Hedgerow Regulations in England and Wales were another important development. These aimed to protect hedgerows in the countryside and they apply to any hedgerow growing 'in, or adjacent to, any common land, protected land, or land used for agriculture, forestry, or the breeding or keeping of horses, ponies or donkeys'. Hedges in these situations (which in effect include most hedges in the countryside) are covered by the Regulations provided they are more than 20 metres in length or form part of a longer stretch of hedgerow. The Regulations particularly seek to protect hedgerows of archaeological, wildlife and landscape importance. Removal of these hedgerows is generally prohibited, although in certain circumstances local authorities may issue a 'removal notice'. There is currently no such protection for hedges in Scotland and Northern Ireland, where the retention of a mature hedgerow will sometimes be a condition of planning consent.

By 2008, over 6,000 kilometres of hedgerow had been replanted and almost 10,000 kilometres restored across the UK. Hedge laying has recently become one of the most popular recreational pastimes, offering aficionados the satisfaction of being involved in an important conservation and landscape project which also provides habitat for an immensely diverse range of flora and fauna. There are numerous local hedge-laying associations affiliated to the National Hedgelaying Society, of which the oldest is the Cottesmore Hunt Hedge-cutting Society. These and most of the agricultural colleges offer training, hold demonstrations, lectures and events on the art of hedge laying.

BILLHOOKS

The design of billhooks differed from county to county: in the hill country of the north of England and Scotland, the local blacksmiths made thick heavy ones which were also used for cutting heather for making heather 'besoms' – brooms. In the grass-rich Midlands, one side had a wide cutting edge for clearing dead grass and a straight blade on the other, for heavier work. Oxfordshire billhooks had a deep hook for clearing thick bramble growth; Kentish ones, designed for coppice work, were a compromise between the bills of the Midlands and the heavy North Country versions. The Suffolk was made for cutting roots, and the Norfolk bill had a longer handle for clearing reeds.

DRY STONE WALLING

If hedgerows are the defining characteristic of our lowland landscape, dry stone walls, or 'dykes', are the distinguishing feature of our pastoral hills and uplands, with a history which is equally ancient. The roots of dry stone walling ('dry' means made without using mortar) lie at least as far back as the Bronze Age. Early communities protected their crops and livestock by building barriers with whatever material was close to hand; whether with cut thorns which eventually self-seeded to a form of hedge, or by using the stones cleared from fields as they were ploughed or gleaned from the landscape in areas too harsh for trees or shrubs to grow. Neolithic man was an obsessive builder, constructing henges, monoliths, causeway camps, passage graves and tumuli, traces of which are scattered all over Britain from Cornwall to the Orkneys. The Iron Age Celts in particular fortified their hill settlements with stone and built walls to enclose stock or protect their crops. There is the site of a Celtic hill fort on part of my farm here in the Scottish Borders, one of many in the area, and the foundations of the little walls that marked the field boundaries are clearly visible when snow covers the ground. The Romans were, of course, great wall builders and left many legacies, of which Hadrian's Wall, the London wall and the Antonine Wall Mare are the most famous.

> THERE IS THE SITE OF A CELTIC HILL FORT ON PART OF MY FARM HERE IN THE SCOTTISH BORDERS, ONE OF MANY IN THE AREA, AND THE FOUNDATIONS OF THE LITTLE WALLS THAT MARKED THE FIELD BOUNDARIES ARE CLEARLY VISIBLE WHEN SNOW COVERS THE GROUND.

There followed a considerable gap in the history of wall building during the Anglo-Saxon period, as these sea-based Norse invaders tended to settle in the coastal lowlands. After the Norman Conquest, the Cistercians used dry stone walls to enclose their moorland sheep granges, and miles more were built throughout the medieval period as settlement increased in rocky upland areas such as the Lake District, the Pennines, the Dales, the Cotswolds, the south-west and north-east of England, Scotland and Ireland. These were mainly short, haphazard stretches of wall, built to enclose the small field systems of the time – many examples of these can be seen on the lower slopes of the Yorkshire Dales, the Cumbrian Fells and Highlands of Scotland. The vast majority of the dry stone walls stretching out over the hills of upland Britain were built during the main thrust of the Acts of Enclosure, during the eighteenth and nineenth centuries.

Thousands of miles of dry stone walls were built during this period by armies of itinerant dykers to establish boundaries for the newly created moorland hill farms. Many wall builders were fleeing poverty in Ireland, coming over with their families in the early spring and leaving with the first frosts or winter snows; others were soldiers from the European wars. It was brutal work; a good dyker would be expected to dig the foundations and build three metres of wall a day, which involved handling five tonnes of material. A small proportion of stone would be quarried locally and hauled onwards by horse and cart, but most had to be collected from the surrounding area and dragged on sledges to the site. Some places would have been so steep that the stone was carried up by basket or passed from hand to hand.

THE CRAFT OF CONSTRUCTING DRY STONE WALLS

There are several methods of constructing dry stone walls, depending on the quantity and geophysical composition of available stones.

Boulder walls, found in parts of Ireland or south-west Scotland, are single walls consisting primarily of large boulders that are laboriously rolled into position, around which smaller stones are placed. The beautiful dry stone walls of the Cotswolds, which have 'the trick of keeping the lost sunlight of centuries glimmering upon them', are made of tightly packed Oolitic limestone. The dykers of Derbyshire and North Yorkshire use sandstone, a more tricky material to handle, being coarse and difficult to shape into even blocks – hence the characteristic irregular pattern compared to the more even walls in South Yorkshire. Cornish walls are formed with slate in a herringbone pattern or a stone-clad earth bank topped by turf, scrub or trees and is characterised by a strict inward-curved 'batter' – the slope of the hedge. In Cumberland and Wales, slate, granite or carboniferous limestone are used, whilst in Scotland double walls of whinstone are most common.

'Double walls' are constructed by building two rows of stones along the boundary to be walled and packing the middle with smaller stones, known as 'heartings'. As with other dry stone walls, the stones are built up to the desired height layer by layer, and at intervals large tie-stones are placed spanning both faces of the wall. These have the effect of bonding what would otherwise be two thin walls leaning against each other, greatly increasing the overall strength of the structure. The final layer on the top of the wall consists of large stones called cope stones, with the long rectangular side of each cope stone perpendicular to the wall alignment. As with the tie stones, the cope stones span the entire width of the wall and prevent it breaking apart. In addition to gates, these walls may contain smaller, purpose-built gaps, half a metre high, called 'smoots' or 'lonky holes', to allow sheep through to lower ground in times of snow. Different regions have minor modifications to the general method of construction, sometimes because of limitations of building material available, but mainly to create a look that is distinctive to that particular area. Whichever method is used to build a dry stone wall, the basic principle remains the same for all of them: the height should be equal to the width of the base and the top be half the base width.

There are an estimated 125,000 kilometres of dry stone walling in England and probably the same amount in Scotland, Ireland and Wales, with 8,000 kilometres in Northern Ireland, including the famous 35-kilometre Mourne Wall in County Down, which passes over the summits of fifteen mountains. A well-made dry stone wall should last at least 200 years – and with proper maintenance, for many centuries. Most estates and farms employed a dyker solely to repair the walls and keep them in good condition, but many fell into disrepair during the two World Wars due to lack of available labour. This was to accelerate after World War II as hill farm incomes declined with falling wool prices and the numbers of agricultural workers employed in the uplands became substantially reduced. Gaps in walls were patched with pieces of tin, posts and railing – even old iron bedsteads – and where whole sections of wall collapsed they were replaced with lengths of wire fencing. Not only was the beauty and character that dry stone walls give to the

countryside rapidly being lost, so too was the habitat of many species of fauna and flora, such as lichens, mosses, ferns and various rare navelworts and spleenworts.

A diverse range of animals make use of walls. Some are permanent wall-dwellers, while nocturnal animals, such as voles and hedgehogs, use the crannies in dry stone walls as daytime resting places. Dry stone walls are especially valuable habitats for a variety of beetles, woodlice and spiders; limestone walls support many types of snails and slugs, and in the south the larvae of the glow-worm which feed on them. Reptiles, particularly adders, lizards and toads use them for hibernation, spring feeding, autumn nesting and as migration routes between dry wintering sites and wetter feeding areas. A number of birds will find nesting sites in walls – wrens, robins, pied and grey wagtails, spotted flycatchers, nuthatches and wheatears, blue tits, great tits and redstarts are among those that favour dry stone walls. Many of the small mammals which use earth banks and hedgerows as their habitat also live in dry stone walls. Voles, field mice, rats near farm buildings, rabbits and hares may all seek safety in walls, while red squirrels have been known to store nuts under the stones of walls adjacent to woodland. Bank voles are particularly fond of the double protection offered by old ivy-covered walls. Rabbits wreak havoc in walls by dislodging the smaller pinning stones, which lead to the collapse of larger ones and the eventual disintegration of that section of wall. Weasels and stoats breed and hunt among the stones, and in the Highlands polecats sometimes winter in walls.

As with hedgerows, walls provide 'corridors of safety' for small animals to move between areas of favourable habitat or feeding areas and, like hedges, they support the maximum amount of wildlife at the stage when the wall is mature or beginning to deteriorate but before it becomes derelict. Walls decrease significantly in the species they can support when they drop below 60 centimetres in height, and although a pile of stones is a valuable habitat, it will eventually become overgrown by weeds, brambles, ivy or other plants and the stones themselves subside into the ground. A derelict dry stone wall does not offer the diversity of specialised habitats provided by one in good condition, and although rebuilding is initially destructive, within a few years the wall starts to be recolonised by both animals and plant life.

Colonel Frederic Rainsford-Hannay of Kirkland, in Kircudbrightshire, was one of the landowners concerned at the deterioration of dry stone walls in south-west Scotland and the possibility that the art of dyking might be lost. In 1938, he formed the Stewartry of Kirkcudbright Drystone Dyking Committee to preserve the knowledge and to raise enthusiasm for wall building. Unfortunately the war intervened, but the Colonel's determination was still undaunted and in 1957 he published *Dry Stone Walling*, considered by many to be the definitive work on the subject.

The Colonel died in 1959 and the mantle of continuing the efforts of the Committee fell to Mrs Elizabeth Murray-Usher of Cally. In 1968, the Committee founded a national organisation called the Dry Stone Walling Association of Great Britain, which gradually established branches across Britain. The DSWA, now a registered charity based at the National Agricultural Centre at Kenilworth, was among the conservation bodies which lobbied government in the late 1980s to provide grants for repairing or replacing derelict walls. Since then, ongoing grants have been available for farms within Environmentally Sensitive Areas, National Parks or

Sites of Special Scientific Interest and funding for land managers may be available through Stewardship Schemes operated by Defra. Grants for dry stone work other than farm walling may also be obtainable. For example, dry stone features in community gardens, in restoration schemes, alongside cycle paths or other projects which benefit the community may attract sources of funding from other organisations which sponsor the arts, community action, urban renewal, and so on.

I used an early agri-environmental scheme to have one of the circular stone sheep enclosures on the farm rebuilt. Sheep 'stells', as they are called, were built adjacent to the various hefts on hill farms and were used during the year for clipping, for seasonal veterinary treatment and for feeding ewes in bad weather. As chemical dips were developed in the twentieth century to protect sheep from blowflies and the mites that cause sheep scab, large handling units were built centred round a dipper and the stells became redundant. Since they were no longer of any use, except occasionally at lambing time, the stells quickly collapsed through neglect and the stones often taken away to be used for other purposes. The uplands are littered with derelict stells; the one I had rebuilt was visible from the road leading to the farm, a

> THE STELLS QUICKLY COLLAPSED THROUGH NEGLECT ... THE UPLANDS ARE LITTERED WITH DERELICT STELLS; THE ONE I HAD REBUILT WAS VISIBLE FROM THE ROAD LEADING TO THE FARM, A SAD REMINDER OF THE TIME WHEN MANY MORE SHEPHERD FAMILIES LIVED IN THE HILLS.

sad reminder of the time when many more shepherd families lived in the hills. An old dyker called Bill Smith from Duns, in Berwickshire, rebuilt mine and the few weeks he worked for me were among the most enjoyable and fascinating periods I have spent with anyone.

Already past retirement age and burnt dark mahogany by the weather, Bill had been dyking for over fifty years and unlike most people I have known – apart from my father – he was able to talk and work at the same time. His hands seemed to operate independently as the remains of the stell walls were stripped to their foundations, whilst he chatted happily about the dykes he had built, the farms he had worked on, the shepherds he had known and the changes among hill communities since the War. Watching Bill work became mesmerising when rebuilding began. The conversation continued to flow as he stooped and bent, plucking large stones known as 'ribs' or 'doubles' from the piles of rubble and building up the side walls. He seemed to know instinctively which one to pick up and where it would fit into the construction, never handling the same stone twice and rarely using the little mason's club hammer, which appeared to be his only tool. Once restored to its former glory, the stell was a magnificent reminder of a bygone age and a monument to Bill's skill as a craftsman.

Dry stone walling has attracted an enormous following among people wishing to learn the ancient craft, either because they have walls on their land, would like to become involved in the conservation of an iconic countryside feature, or be taught how to build garden features out of a wonderful natural material. The website of the Dry Stone Walling Association of Great Britain lists the courses available across Britain from basic walling to the most complicated sculpturing.

THE SKILL OF THE SMITHS

Of all the tradesman who were required to make a village self-sufficient – the carpenter, cobbler, butcher, publican and shopkeeper – the most important was the blacksmith. From the earliest periods there would have been one smith to every handful of people and he was, without doubt, the most indispensable member of the community and usually the strongest, too.

Under the spreading chestnut tree
The village smithy stands,
The smith, a mighty man is he
With large and sinewy hands.
And the muscles of his brawny arms
Stand out like bands of iron.
Week in, week out, from morn till night
You can hear his bellows blow;
You can hear him swing his heavy sledge,
With measured beat and slow,
Like a sexton ringing a village bell,
When the evening sun is low.
HENRY WADSWORTH LONGFELLOW 1841
(The smith in the poem was Longfellow's neighbour in Cambridge, Dexter Pratt)

A village blacksmith was a highly accomplished and versatile craftsman who would be able to forge metal into an incredibly diverse range of objects. He made all the edged tools required for the local farm and woodland work, such as axe heads, the blades for scythes, sickles, brushing hooks, bill-hooks and wedges for splitting wood, steel plough spuds and coulters, hammer heads, harrow drills. He would also make the whole complicated range of different of hoes, spades and shovels, of which there were nearly 200, from bottoming spades and tile scoops for ditching, to ferreting grafts, rutters and fauchters for cutting peat, and sod edgers and loys for lifting turf. He was also responsible for the metal work on different types of agricultural and domestic horse-drawn vehicles and the hooks and lugs for shafts, swingle trees, bearer bands and bracing straps for carthorse harnesses. The blacksmith was usually an expert in wrought-iron work, too, turning out decorative gates and quantities of beautifully curved and matching iron palings for private houses and estates in the area. Increasingly during the nineteenth century, smiths would have adapted to making repairs to the new cultivating, reaping and thrashing machinery and early traction engines. In districts which were off the route of travelling tinkers, a blacksmith would use brazing to repair broken metal teapots, buckets, kettles and pans. The historical mainstay of any blacksmith's work, however, was shoeing horses.

Horses were domesticated in Eurasia by about 4000 BC and once people discovered their utilitarian value they realised the necessity of protecting the horse's hooves to maximise their use. The earliest form of protection was in the form of bootees made of hide or woven plant material. Crude iron horseshoes found in

graves of Celtic chieftains buried with their horses indicate that the Celts were the first to use metal nailed-on shoes, although these would have been the exception rather than the norm. Nailed horseshoes were known but rarely used by the Romans; much more common were iron 'hipposandals', a form of temporary shoe that could be fastened to the hoof for use on roads and easily removed when not required.

Iron shoes were commonplace by the time the Normans arrived and they, with their usual efficiency, introduced improved shoeing methods and the term 'farrier' from the Latin *ferrum*, meaning iron. The function of the horse had become increasingly important, and a farrier combined the role of shoesmith, blacksmith and horse doctor. He would be expected to diagnose and treat the vast range of equine ailments – from bowel bots, farcy, gripe and saddle or harness sores, to vives, pollevil, strangury and strangles. His specialist field was the complicated anatomy of the fetlock and hock, and being able to cure lameness caused by corns, splints, thrushes, bogspavins, throughpins, wind-galls, chipped hocks, curb, cracked heels, grease, founder, hoof bound, mallenders, sand crack, ring bone and quittors.

This situation remained unchanged until 1887, when the Court of the Worshipful Company of Farriers appointed a Committee to consider the establishment of a register of farriers and the setting up of practical examinations in the art of making shoes for and shoeing horses. In 1889, the Court provided funds to a special Registration Account, together with the setting up of the Institute of Horse Shoeing and an organisation under the auspices of the Company of a Register of qualified farriers throughout the country. In 1890, the Court invoked the assistance of the Lord Mayor, the Royal Agricultural Society, the Royal College of Veterinary Surgeons and others interested in the welfare of the horse to create a scheme for the training, examination and registration of farriers. Mindful of the need to improve quality, in 1907 the Company introduced further tests, which gave rise to the AFCL

qualification (Associate of the Farriers Company of London), followed by an even more difficult examination in 1923 to give holders the title Fellow of the Worshipful Company of Farriers. In 1975 the Farriers (Registration) Act, amended 1977, was passed 'To prevent and avoid suffering by cruelty to horses arising from the shoeing of horses by unskilled persons; to promote the training of farriers and shoeing smiths; to provide for the establishment of a Farriers' Registration Council to register persons engaged in farriery and to prohibit the shoeing of horses by unqualified persons'. As a result, blacksmithing and farriery are now recognised as separate skills, although the old term is often used to describe both.

THE FORGOTTEN FORGES

In 1900, despite the extensive network of railways, there still were over 3.5 million working and pleasure horses in Britain – hacks, hunters, tradesman's dray horses, vanners, cobs, heavy working horses, carthorses, ponies, carriage horses and racehorses. All of these required shoeing on a regular basis and, as the twentieth century dawned, there were at least 150,000 blacksmiths-cum-farriers throughout the country. These figures began a steady decline as mechanisation replaced horse power and gradually the old-fashioned blacksmith's forge and the familiar sound of a heavy hammer ringing on an anvil ceased to be part of the life of most villages.

My father used a pair of Suffolk Punchs for the heavy work on the farm in the fifties, and I can remember Matt Akehurst, my father's horseman, walking them down to the village to be shod. From a small boy's perspective, the forge with the coals glowing dully in the fire pit of the raised brick hearth, big leather bellows, anvils set in blocks of wood, assorted hammers and long-handled tongs was a place full of wonder and fascination. Fixed to one of the big double doors was a faded enamelled poster from the First World War of a ferociously moustachioed Lord Kitchener pointing an accusing finger with the caption: ' Your country needs you'. Along one wall was a rusty trough of water for cooling and tempering hot metal – which was believed to be a sovereign cure for warts. My memory of the smith is of a tall, grey-skinned man with his arms covered in little scars, wearing an old black army beret, a woollen singlet, hobnailed boots, high-backed Derby tweed trousers held up by a broad leather belt and a worn leather apron. His apprentice and 'doorman' was his son, a dark-haired, taciturn youth whose job was to tether the horses when they arrived and act as his father's assistant and general dogsbody when the shoeing process began.

First, four bars of steel were placed in the fire pit and the coals brought back to life with a roar when the son pumped the bellows. As these heated, the blacksmith carried his box of farriery tools – the rasp, breaking clinch, hammer, hoof knife, paring knife, buffer, hoof clippers, shoe and nail pullers – outside to the waiting carthorses. Whilst Matt held the first by its head collar the blacksmith tapped one of the hind legs to indicate which hoof he wanted and ran his hand down the fetlock. The horse obediently lifted his hoof and placed it on the blacksmith's bent knees, allowing him to study the old shoe for position, wear, tear, and the foot for hoof growth. These horses were part of his regular clientele and he knew the idiosyncrasies in the shape of each hoof. In the event of a problem he discussed this

with Matt and decided on a solution. He then broke off the clinched ends of the nails holding the old shoe with his hammer and buffer, and gently pulled it free with his pliers. The foot was then cleaned with a hoof pick, closely examined and trimmed with hoof clippers, paring knife and rasp. When this had been repeated on all four feet, the smith went back into the forge where his son had the bars red hot and shimmering with heat.

The next stage was thrilling to watch. The bar was hammered into shape around the curved horn of the anvil; bending the bar automatically thickened the inner edge and this had to be corrected by hammering it level with a heavy sledgehammer. As the glowing shoe was held on the flat part of the anvil with tongs, the smith would tap the uneven area with his light hammer and his son would swing the 9-kilogram hammer over his shoulder to land with a great thump. This would continue – tap, tap, thump; tap, tap, thump – until the shoe was 'true'. It was then taken outside and measured against the relevant hoof; brought in again, reheated and any necessary adjustments made. When the smith was happy that the shoe would be a perfect fit, the ends were rounded with a heel cropper and the eight rectangular nail holes were punched through. Finally, the hot shoe was placed briefly on the foot in a cloud of pungent smoke, to sear a pattern onto which it would be nailed. It was then thrown with a loud hiss into the tempering bath to cool.

> THE HORSE OBEDIENTLY LIFTED HIS HOOF AND PLACED IT ON THE BLACKSMITH'S BENT KNEES, ALLOWING HIM TO STUDY THE OLD SHOE FOR POSITION, WEAR, TEAR, AND THE FOOT FOR HOOF GROWTH. THESE HORSES WERE PART OF HIS REGULAR CLIENTELE AND HE KNEW THE IDIOSYNCRASIES IN THE SHAPE OF EACH HOOF.

Our village forge eventually closed in the mid-fifties, and a travelling farrier came every six weeks or so with ready-made shoes and cold-shod the horses. A poor compromise: hot shoeing fits the shoe to the foot; cold shoeing fits the foot to the shoe. Nowadays, many travelling farriers have portable gas-fired kilns, which enable them to hot shoe on site.

Village forges may have disappeared from much of rural Britain, except in places like Newmarket, Lambourn and the hunting shires, but both farriery and blacksmithing are now growth industries. By 2008, there were over 1.5 milllion horses and ponies in Britain, with several agricultural colleges such as Oatridge and Barony, in Scotland, Myerscough in Lancashire, Moreton Morrell in Warwickshire, Harper Adams in Shropshire, and the Hereford School of Farriery providing Farriery Training Agency approved apprenticeships for those seeking careers in shoeing. Similarly, there are any number of courses available in the ancient art of decorative blacksmithing – making weather vanes, signs, pokers, wall brackets, sculpturing, garden furniture, gates and railings – for both professionals and amateurs.

WORKING WITH LEATHER

It is difficult to comprehend the importance of leather from the earliest times until well into the twentieth century unless one remembers that rubber, plastics and cardboard are relatively recent inventions. The waterproof and heat-retentive properties of leather made the skins of all animals extremely valuable. The hides of larger beasts, red deer, cattle, pigs and horses were all used for saddle, bridle and harness making, drinking vessels, known as 'blackjacks' or 'bombards', armour, shields, shoes, boots, boats, tents and tarpaulins. (The skins of smaller animals, roe and fallow deer, calves, sheep, goats, roe and fallow, dogs, cats, rabbits, moles, foxes, badgers, martins, weasels, stoats, polecats, eels and red squirrels, sheep, calf and goatskins were made into parchment, vellum and book bindings (in 2008, William Cowley & Co., of Newport Pagnell, contractors to HM Stationery Office, were the last vellum and parchment makers in Britain). Fortunes were once made from breeding rabbits in warrens for their skins, which were used to make bed covers, linings, trimmings, caps and gloves, as were dog and cat skins. Martin, polecat and fox skins, the white winter coats of weasels and stoats, known as *miniver* and *ermine,* and the skin of red squirrels, called *vair*, were used as trimmings, only worn by those entitled to do so under the sumptuary laws, which forbade commoners from imitating aristocrats by copying their dress. For example, wearing ermine was and still is the prerogative of peers, and only Royalty could wear *vair*. Curiously, in the original story of Cinderella, the slipper was made of red squirrel

skin and not glass. In 1729, when Charles Perrault's enchanting fairy tale was translated from French to English, the translator misinterpreted *vair* for *verre*, the French for glass. Eel skin, known as *shagreen*, was made into fine shoes or book bindings and, because it shed moisture, was used to cover the handles of swords and daggers.

The leather industry was a large-scale nationwide employer. There were white-tawyers, who made white leather using alum; curriers, who dressed leather; saddlers, bridle makers and girdlers; cobblers, shoe and boot makers; furriers; cordwainers, who worked with fine leather; and thongers, who made straps and laces. There were also glove makers, purse makers, sheathers and, of course, tanners.

In the Middle Ages, every settlement had a tannery to cure the hides of animals slaughtered for consumption or hunted for their skins. In the early days these were soaked in pits containing an acidic mixture of human or animal dung and urine – pigeon dung, with its high phosphate content, a by-product of dovecotes, was often used. The dung and urine solution caused the pores and skin fibres to swell, lifting the fat and loosening the hairs in a process called 'bating'. The skins were then scraped to remove the fat and hair, before being immersed for many months in a pit filled with a mixture of water and the bark of oak, willow, alder, chestnut or birch, or any of the range of trees and plants containing tannin. Tannic acid, which protects plants from bacteria, acts on hides by removing fluid from the interstices between protein fibres, causing them to shrink and bind together. By the sixteenth century, slake lime, made from burning chalk and mixing it with water to create calcium hydroxide, had replaced dung and urine for bating hides, but the tanning process remained unchanged until modern tanning methods, using chromium sulphate, became widespread in the mid-1900s. J. & F. J. Baker, in Colyton, Devon, are the last tannery in Britain to use the old, traditional, oak bark tanning methods, in premises that have been on the same site since before the Roman occupation.

> THE LEATHER INDUSTRY WAS A LARGE-SCALE NATIONWIDE EMPLOYER. THERE WERE WHITE-TAWYERS, WHO MADE WHITE LEATHER USING ALUM; CURRIERS, WHO DRESSED LEATHER; SADDLERS, BRIDLE MAKERS AND GIRDLERS; COBBLERS, SHOE AND BOOT MAKERS; FURRIERS; CORDWAINERS, WHO WORKED WITH FINE LEATHER; AND THONGERS, WHO MADE STRAPS AND LACES.

TANNING

At one time there were tan yards in every market town and several in all the larger cities supporting the ancillary leather trades. London was the centre of leather work in the 1700s, due to the volume of beasts slaughtered every day at London's Smithfield Market, with dozens of tanneries in the adjacent streets. Nottingham had forty-seven, even a small town like Tewkesbury had four tanneries, and Colyton in Devon had two, providing employment to three bridle makers and thirty boot makers. However, in the middle of the nineteenth century the town of Walsall, near Birmingham, usurped London as the hub of the leather trade. Since the Middle Ages, Walsall had been the heart of the linery industry: loriners were saddlers' ironmongers and made bits, stirrups, buckles, spurs, harness mounts and the decorations that traditionally adorned carthorse harnesses. The chief requirement for loriners was access to high-grade charcoal and iron, and the countryside around Birmingham provided both these materials. A number of curriers (leather curers) established themselves in the city in the early eighteenth century, importing high-quality hides from tanneries such as Bakers, and with the opening of the Walsall canal in 1799 it was only natural that bridle makers and saddlers should move to the area.

By 1880, there were three large tanneries, employing 450 tanners, and curriers providing leather to 3,500 bridle and saddle makers. Twenty years later this number had doubled and Walsall was making military and civilian harnesses for every nation in the world – one company alone produced over 100,000 saddles between 1914 and 1916. There was a steady decline in output between 1920 and 1980, but now, with the ever-increasing growth in popularity for all equestrian sports and the demand for high-quality leather goods, Walsall has the highest concentration of leather workers worldwide. In the area there are over sixty-five saddle and bridle making firms and several thousand people employed in the leather goods trade, creating an enormous range of saddles and bridles, heavy horse harnesses, handbags, briefcases, cartridge bags, gun sleeves, luggage, gloves and menu covers.

> UNTIL THE DECLINE IN HORSEPOWER IN THE 1950S, THERE WAS SOMEONE IN MOST RURAL HOUSEHOLDS WHO COULD WORK WITH LEATHER. PEOPLE WERE NATURALLY SELF-SUFFICIENT, AND DESPITE SADDLERS' SHOPS IN VIRTUALLY EVERY MARKET TOWN AND MANY VILLAGE, GROOMS, HORSEMEN AND CARTERS WERE EXPECTED TO BE ABLE TO KEEP SADDLES, BRIDLES AND HARNESS IN GOOD REPAIR.

Until the decline in horsepower in the 1950s, there was someone in most rural households who could work with leather. People were naturally self-sufficient, and despite saddlers' shops in virtually every market town and many village, grooms, horsemen and carters were expected to be able to keep saddles, bridles and harness in good repair. If my father needed a new hunting saddle, the local saddler came to the stables, measured the hunter and made a template of the saddle area using strip lead – a piece of lead piping beaten flat – which could be moulded to the shape and curvature of the spine. Thereafter, my father did all his own saddlery repairs, largely because working with leather was one of his principal recreational pastimes. I can see him now on a cold winter's night in the tack room, with its saddle racks, bridle

hooks and wooden saddle horse, painstakingly stitching a lap seam along the edge of a girth held in a wooden clamp. On the bench would be his awls, punches, harness hammers, bevellers, crescent-shaped and straight paring knives, pricking irons, harness needles, thread and beeswax. My son, who has inherited his grandfather's gift of being able to turn his hand to anything, still uses these old tools and gains the same sense of satisfaction from repairing saddlery, making belts, leads, dog collars, cases, bags, sheaths and wallets.

Leather is a beautiful material to work with, and with the increasing interest in utilising natural products and heritage crafts all kinds of leather work have become extremely popular, both as a career option and as a hobby for amateurs. There are a host of day and residential courses available across Britain, as well as apprenticeships and a degree course in leather technology, supported by the Worshipful Company of Leathersellers, at the University of Northampton.

HANDMADE BOOTS

When I was sixteen, my father took me to Tom Hill, the famous military and sporting boot maker in Knightsbridge Green, to be measured for my first pair of hunting boots. This was a rite of passage for any young man keen on hunting and I vividly remember the fitter, Mr Ball, on his hands and knees, fussing round me with his measuring tape and order book, in a room steeped in the smell of leather. Examples of the boot maker's craft gleamed on shelves all around: wax calf hunting boots with mahogany, patent leather or champagne tops, butcher boots, polo boots in brown box calf, officer's field boots, greenly boots, Wellington boots, Newmarket and Briar boots with canvas uppers and the tall, thigh-length top boots worn by the Horse Guards.

In the nineteenth century virtually everyone rode, and in the provinces every market town would have a riding-boot maker, with dozens in London, including Hoby, who made boots for George III, the Prince Regent, the Royal Dukes and the Duke of Wellington; Maxwell, who made boots for George IV and the Kings of Spain; Peal and Co. and John Lobb, both of whom held Royal Warrants; Tom Hill, Foster, Corn, or Polsen, to name only a few of the more famous ones.

> EXAMPLES OF THE BOOT MAKER'S CRAFT GLEAMED ON SHELVES ALL AROUND; WAX CALF HUNTING BOOTS WITH MAHOGANY, PATENT LEATHER OR CHAMPAGNE TOPS, BUTCHER BOOTS, POLO BOOTS IN BROWN BOX CALF, OFFICER'S FIELD BOOTS, GREENLY BOOTS, WELLINGTON BOOTS, NEWMARKET AND BRIAR BOOTS WITH CANVAS UPPERS AND THE TALL, THIGH-LENGTH TOP BOOTS WORN BY THE HORSE GUARDS.

Until World War II, every officer in the British Army was required to have at least three pairs of boots (field boots, polo boots and brown riding boots) and hundreds of the different outworking craftsmen were employed in a thriving industry. Amongst these were fitters, who measure the exact shape of foot and leg; last makers and tree makers, who replicated the measurements onto wood; pattern cutters and clickers, who cut leather into the various components that go into making a riding boot; closers, who stitched the pieces together; makers, who added the sole; sockers, who made and inserted the innersole; and polishers, who painstakingly brought

the finished article to pristine glory. Since the 1950s, riding boot makers have gradually dwindled away to a mere handful; Lobb and Maxwell survive in London, there is also Davies Riding Boots in Wales (a relative newcomer), and Horace Batten Ltd of Ravensthorpe, Northamptonshire. The Battens have been making riding boots since 1660 and are now into the tenth generation, with grandfather, father and granddaughter currently working together.

The two crucial elements for good riding boots are the quality of the leather and the shape of the boots. Leather is a natural product and its condition is determined by the food an animal eats; Batten buys reverse calf, which is similar to suede, for hunting boots from J. & F. J. Baker, whilst the calf for ordinary riding boots comes from a tannery in France. A boot is shaped by soaking the leather and allowing it to dry onto a wooden tree blocked out with leather to the exact shape of the client's leg. The lengthy process of making a pair of riding boots takes around six weeks – polishing alone takes over two hours. Properly looked after, a good pair of leather boots will last a lifetime.

* * *

Accelerating social change after the Second World War transformed the rural economies, and with it the traditional crafts. The gradual loss of family firms ended the pattern by which traditional skills once passed from generation to generation. In this way many ancient crafts have been lost, or barely survive, and the same is true for local styles of workmanship, which helped give landscapes and communities their distinctiveness. Thankfully, the pendulum of time is now swinging back the other way and a resurgence of interest in preserving our heritage has created a new type of craftsperson. This new breed are often from urban backgrounds, for whom craftwork provides either an absorbing hobby or an occupation which combines country living with freedom from the rat-race as well as job satisfaction. The recent demand for these traditional crafts is being fuelled by the increasing rural in-migration of a new genus of country dweller, by the heritage sector, and by the lifestyle demands of green consumers. This timely resurgence of interest has meant that many skills are now being preserved that would otherwise be lost, and ensures they will carry forward to the next generation – and hopefully beyond.

CHAPTER EIGHT

COUNTRY SPORTS

For twenty-five years, from 1963 until 1981, when advances in agricultural technology led to 50 per cent of farm workers leaving the land, Southern Television made over 1,000 programmes of the hugely successful series *Out of Town*, presented by Jack Hargreaves. These were later broadcast on ITV and provided a wider audience with a fascinating insight into a rural life which was fast disappearing, as well as the dwindling traditions and values of the people who inhabited a world free of technology and who gratefully distanced themselves from the increasing tempo of modern life. Hargreaves had the extraordinary ability to comment without nostalgia or sentimentality on the accelerating distortions in relations between urban and rural values, whilst subliminally rebutting metropolitan assumptions about the character and function of the countryside. The ethos behind the programmes and the choice of both title and original signature tune, sung by Max Bygraves, reminded viewers that simply by making the effort to come 'out of town' and into the countryside they could be part of a priceless environment that is meant to be enjoyed and appreciated by everyone.

As I remember them, each programme began in Hargreaves's shed — the sort of glory hole filled with tools that everyone dreams of possessing — where he would produce some obscure, antique agricultural implement or curious device connected to field sports. He would then describe, in a very easygoing and unscripted manner, what the piece of ephemera was, who had made it and the sort of life the maker would have led, such as a set of heavy lead cups connected by leather straps that stock men fitted over the horns of young cattle to make the horns grow away from their cheeks, before the days of cauterising horn buds to prevent growth; metal digging shoes which drainers and ditch diggers buckled to the bottom of their hob-nailed boots to help force the spade into the ground, when every ditch and drain was laboriously dug by hand; a minnow trap for catching pike bait; a set of coursing greyhound couples (the double collars which simultaneously released the two competing greyhounds at a coursing event); the complicated piece of equipment used for hand-loading shotgun cartridges; a farriers' fleam (the triangular-bladed knife for opening a vein), from the days when bleeding both animals and humans was the medical cure-all; and a sailmakers' palm that fitted round the thumb, with a George III cartwheel penny sewn into the middle, used by sailors, tentmakers and saddlers to force a needle through canvas or leather.

I particularly recall his description of a lark twirler made by a bird catcher, a piece of wood studded with fragments of mirror glass, mounted on a spigot. This could be made to spin when a string was pulled and the flickering glass attracted larks to it. Hargreaves theorised that thirsty larks, whose habitat is open down and moorland, thought they were seeing water glinting in the sunlight. When enough had gathered, a spring-loaded clap net closed and the trapped birds were then put in cages to be sold in places such as Leadenhall Market, where they were in demand for their cheerful, warbling song.

There was always some connection between the artefact and the body of the programme that followed the discourse in the shed. These were often in two parts: lambing with a downland shepherd and fishing during the Mayfly hatch; a bee-skip maker and a driven pheasant shoot; an eel fisherman and a morning's goose

flighting with a wild fowler; a charcoal burner and pigeon shooting over decoys; a visit to a livestock market and a day with a lobster fisherman; the meet of a local pack of foxhounds and a point-to-point; Appleby Horse Fair followed by a visit to a shepherd at ramming time, to explain the reason for the different colour marks on a ewe's tail end. Every aspect of rural life was covered and explained: thatching, trug making, coarse fishing, beach and sea fishing, beagling, hound shows, terrier shows, harvesting, hunter trials, the annual round-up of New Forest ponies, pannage, mole catching, deer stalking, horse and greyhound racing, a day with an apprentice keeper or a young Hunt Servant, snipe shooting on the Romney Marshes, cider making, falconry, sheep shearing, a bodger at work, a tannery and a saddle maker, to mention only a fraction of the material filmed over twenty-five years.

Hargreaves's language was completely devoid of polemic when he described the links between farming, rural traditions, field sports and man's essential role in the management of wildlife. The series appealed to all ages and across a broad social spectrum – even my father, who disapproved of television and refused to allow us to have one until 1960, was known to sometimes watch *Out of Town*. Needless to say, I and all my contemporaries were avid fans and one of the great highlights of my life was when Jack Hargreaves borrowed my ferrets for part of a programme that was being made in our area of Sussex. I was at boarding school at the time and missed the opportunity to meet him, but the very fact that my ferrets were used by the great man himself did my street cred at the time an enormous amount of good.

> HARGREAVES'S LANGUAGE WAS COMPLETELY DEVOID OF POLEMIC WHEN HE DESCRIBED THE LINKS BETWEEN FARMING, RURAL TRADITIONS, FIELD SPORTS AND MAN'S ESSENTIAL ROLE IN THE MANAGEMENT OF WILDLIFE. THE SERIES APPEALED TO ALL AGES AND ACROSS A BROAD SOCIAL SPECTRUM – EVEN MY FATHER, WHO DISAPPROVED OF TELEVISION ... WAS KNOWN TO SOMETIMES WATCH OUT OF TOWN.

The popularity of the *Out of Town* series made Jack Hargreaves a household name, earned him the OBE and led, with support from the Inner London Education Authority and Southern Television, to the Out of Town Centre being established in 1974. This twenty-five-hectare farm, on Lord Montagu of Beaulieu's estate in Hampshire, was set up to give inner-city children the opportunity to stay on a working farm and learn about rural traditions and life in the British countryside, and is still a thriving residential educational centre for children of all ages and backgrounds.

Out of Town was a classic example of how television, the most powerful communication vehicle of the twentieth century, was able to maintain an increasingly urbanised population's appreciation and understanding of its rural heritage, and it is alarming how quickly this became lost in the years following the end of the series. So great had the perceived urban–rural divide become by the general election of 1997 that 'Nu Labour' believed supporting a backbenchers' Bill to ban hunting with hounds would be a populist vote winner. Their claim that animal welfare was at the heart of the proposed ban quickly lost credibility when it became public knowledge that Nu Labour had accepted a million-pound donation to party funds

from the Political Animal Lobby. This shadowy, single-issue, anti-hunting group was run by the sister of Anthony Banks, the MP for West Ham and vice-president of the League Against Cruel Sports.

From the perspective of the vast number of people who enjoyed a range of country sports, and the rural population for whom they were part of a traditional way of life, the proposed Parliamentary Bill to make hunting illegal raised a number of alarming issues. There were the obvious immediate concerns for Hunt Servants and grooms, whose livelihoods depended on their employment by the 320 Foxhound, Beagle, Basset, Harrier, Stag hound and Mink hound packs; the trainers of coursing greyhounds, salukis and whippets; and the humanitarian issue of what would happen to the 15,000 hounds. Added to which were the ancillary businesses dependent on hunting: horse breeders, livery yards, blacksmiths, boot makers, tailors, hoteliers, feed merchants, saddlers, veterinaries, and so on. Of equal anxiety was the wider consequence of the ban being successful: leaving donations from animal rights organisations aside, the rationale for the Protection of Wild Mammals Bill was the cruelty element of a dog chasing a wild mammal. If the Bill was to be debated on grounds of cruelty, it would be completely hypocritical for the government not to subsequently ban other country sports, such as shooting and fishing. The animal rights activists had no intention of allowing the government to be selective, and were jubilant in their certainty that a ban on shooting and fishing would immediately follow that for hunting. Paradoxically, the initial private

members' Bill was published by Michael Foster, the MP for Worcester and a keen competition angler, which led to some wag composing:

My anger simply knows no bounds,
At wicked Tories who ride to hounds,
I'd rather watch a live fish dangling,
When kindly socialists go angling.

There was very little laughter, however, in the dark days of 1997 when Nu Labour swaggered into office with an overwhelming majority of urban seats. Rural Britain was clearly a political irrelevance and it really seemed possible that centuries of custom, tradition and knowledge of wildlife, that had previously passed from generation to generation, would be callously destroyed on a spiteful political whim. There is hunting with hounds in France, Italy, Portugal, India, South Africa, Kenya, Ireland, Australia, New Zealand, Canada and the United States; match coursing is a popular spectator sport in Portugal, Ireland, Pakistan, the old USSR countries and the western states of America. Shooting and fishing are important contributors to the economies of so many nations there is little point in trying to list them all. Most of these countries have animal rights organisations, but only here had they become powerful enough to influence politics, and only in Britain were socialist MPs queuing up to vote on a bill to ban hunting.

Like many other rural people, I was baffled by the speed with which the majority of the population had become so distanced from the land that they were, at best, unconcerned with and, at worst, had become supportive of a government policy which discriminated against a minority of their fellow countrymen.

An incredible 700 hours of parliamentary time were devoted to the Hunting Act before Michael Martin, the then Speaker of the House of Commons, invoked the Parliamentary Act (normally only used in times of war or national emergency) to force the Bill through on 18 November 2004. The ban took effect in England and Wales on 18 February 2005, with a similar ban passed two years previously through the devolved Scottish Parliament.

It was, nevertheless, to be a pyrrhic victory in every sense of the word; for one thing, the contradictory wording of the Act simply demonstrated Labour's complete ignorance of wildlife and included such gems of wisdom as making it an offence to allow a dog to chase a mouse, but not a rat. A rabbit could legally be hunted with a dog, but not a hare. A fox, hare or deer could be legally flushed to guns with two dogs, but not with three, and any number of them could flush a fox to a bird of prey. There were reams of similar inconsistencies, and the Act, subsequently described by the Shadow Foreign Secretary William Hague in 2009 as '*a piece of legislation so deeply prejudiced and so ridiculously unworkable that its existence weakens and discredits the laws of the land*', proved to be legally unenforceable. More to the point, though, was the massive support for country sports from the public and media, as people began to question Labour's motivation in devoting so much time to a Bill which, apart from anything else, would criminalise law-abiding citizens if Bonzo failed to differentiate between a mouse and a rat.

Moreover, the claim that the law was based on preventing cruelty could not be substantiated. The press were quick to point out that only fifty years before, the Labour government under Clement Atlee had commissioned the Scott Henderson Inquiry to investigate all forms of hunting. In 1949, the Inquiry reported that: *'Fox hunting makes a very important contribution to the control of foxes, and involves less cruelty than most other methods of controlling them. It should therefore be allowed to continue.'* The other methods of control referred to were shooting, poisoning, snaring and gassing vixens with cubs whilst in their earths. Labour responded by commissioning their own report, appointing the economist Lord Burns as chairman. Lord Burns is an honourable man, but under the circumstances he was only able to reach a conclusion which will go down in history as a quite staggering piece of verisimilitude: 'hunting with dogs', he solemnly pronounced *'seriously compromises the welfare of the quarry species'*. When asked, during a subsequent debate in the House of Lords, whether he could perhaps be a little more explicit, Lord Burns replied, *'Naturally, people ask whether we were implying that hunting is cruel. The short answer to that question is no.'*

The perception of rural Britain changed drastically during Nu Labour's term of office. The values of rural and urban households became, in many ways, much more synchronised. Technology which enabled more and more people with urban-based employment to live in rural areas played a large part, as did growing conservation awareness, the increasing demand for traditional, natural, traceable, home-grown food and the Game to Eat initiative. The countryside is now seen as a force for good and the communities that live there, their customs and traditions, worth supporting. It is strange to reflect how much truth lies in the old adage: 'that even moral evil is also generative of good'. Since Labour began legislating against country sports, game fair attendance figures have gone up, more people are now fishing, shooting and participating in all forms of hunting, and by 2009 seven new hound packs had been formed since the Hunting Act, one of which, the North Pennine Hunt, I am extremely proud to be a Joint Master.

SPORTING DAYS BY THE RIVER

Of all the country pursuits in Britain angling is by far the most popular, with over 5 million devoted coarse, sea or game fishermen. It is one of the most accessible of sports and can be enjoyed by people with any form of physical and mental disability. At least 60,000 disabled people go fishing, and increasingly fisheries or the beats on game rivers are providing easily accessible, safe, comfortable, bank-side facilities with, in some cases, wheelyboats developed by the Wheelyboat Trust which enable handicapped fishermen access to boat fishing.

As with all other field sports, angling is a vital contributor to the economy and a key part of the socio-economic fabric. Around 19,000 full-time jobs and 6,000 part-time ones are dependent on an industry that generates in the region of £4 billion annually. It is the most popular global recreational pastime, encompassing the whole spectrum of social backgrounds and people of every age, especially children. Europe has 30 million anglers who spend 30 billion Euros each year and America has over 45 million recreational fishermen, supporting some one million jobs and creating an economic activity of $120 billion. Worldwide, these figures must escalate into hundreds of billions and involve enthusiasts of every nation.

Possibly no other sport induces such passion, fascination and determination among aficionados. I know any number of otherwise sedentary and unadventurous people who think nothing of disappearing to the north of Norway in pursuit of Arctic char, sea trout in the Falklands, enormous brown trout in New Zealand, bone fish in the Bahamas, wild rainbow trout in Alaska, steelhead salmon in Patagonia, the famous fighting mayheer in India, taimen in Siberia, or the silver goddess herself, the Arctic salmon, in Iceland. Equally, I have friends who are in seventh heaven sitting on the edge of a flooded quarry or beside a canal, mouths filled with maggots to keep them active, waiting for their float to bob as they bait fish for any coarse fish species – roach, perch, crucians, tench, bream, gudgeon, ruffe or carp. Others lure pike and zander, or troll for Arctic char in the Lake District; shore fish for whiting, surf bass, flounder, dab, rough ground codling, mullet and plaice. Some anglers cast from piers for pout, rockling and dogfish. Still more sea fish for conger eel, ling, pollack, gurnard, wrasse, deep water cod, sea bass, skate, mackerel, black bream or Porbeagle shark, happily sharing a boat with buckets of 'rubby-dubby' shark bait made from rotten fish. There are some who regard eels as the ultimate piscatorial challenge, while others have spent a lifetime perfecting the virtuoso art of casting a fly for salmon, sea or brown trout.

The ancient pastime of flounder tramping – feeling for flat fish with bare feet – is still performed in the muddy shallows of tidal estuaries of the rivers that run into Morecambe Bay, in Lancashire, and the bays round south-west Scotland – Luce, Wigtown and the Solway. Until 2007, the village of Palnackie, on the River Urr, in Kirkudbrighshire, hosted the Grande Internationale World Flounder Championships, an annual July event which attracts more than 350 competitors from Britain, as well as Russia, China, Japan, Europe, Canada and the United States. On the neighbouring River Nith, a small number of fisherman still Haaf net under licence over a summer season restricted to weekdays, for salmon, sea trout, flounder, dab and mullet as they swim upriver on the flood tide and back on the ebb.

HAAF NETTING

A Haaf net is Viking in origin – *haaf* is the old Norse word for heave – and consists of a 'poke' net mounted on a rectangular cedarwood frame 5 1/2 metres long by 1 1/2 metres high. Fishermen carry the frame over their shoulders as they wade into the flat, shallow waters and place the Haaf net in front of them, facing either the incoming or outgoing tides. The net is held by a central wooden pillar in one hand, whilst a few rungs of the net, which billows round the netter like an enormous brassiere, are held loosely in the fingers of the other hand.

Haaf netting is a very social form of fishing, with two, three, four or perhaps five netters forming a line and changing position as the flood tide rises. As soon as a netter feels the net jerk the legs of the frame are allowed to float to the surface and the whole thing is heaved upright by the central pillar, trapping the fish. This is disabled by a blow from a wooden club called a nep, or priest, hanging from a rope round the fisherman's waste and transferred to a fishing bag.

On the lower reaches of the Nith, where I have netted, the Haaf netting has for many centuries been preserved by the riparian owners, the lairds of Lantonside Estate, for the benefit of the estate employees and the people living in the coterminous villages. They now offer a limited number of licences to people living within a certain radius of the estate to ensure the art of this historic fishing method is not lost, and encourage people to go out on day licences with the estate keeper.

THE PERILOUS PAST TIME OF SHRIMP FISHING

Further down the coast, at Morecambe Bay, a few hardy souls risk their lives to bring us the ingredients for one of our great national delicacies – Morecambe Bay potted shrimps.

Fishing for brown shrimps is not exactly a recreational sport, more a cottage industry, but the experience is so utterly unique that it is worth going to the trouble of persuading a local fisherman to take you out. Morecambe Bay is broad, shallow, beautiful and deadly; a place of quicksands and terrible tidal bores that travel faster than a galloping horse. There the sea recedes an incredible distance of 12 kilometres to expose a vast 'wet Sahara' of sand and mudflats, divided by ever-changing patterns of water-filled channels and gullies, meandering into the hazy distance. It is an area so treacherous that there are still Queen's Guides there – a Royal Appointment dating back to 1536, when those with intimate knowledge of the sands were officially appointed to guide travellers across the bay at low tide.

> MORECAMBE BAY IS BROAD, SHALLOW, BEAUTIFUL AND DEADLY; A PLACE OF QUICKSANDS AND TERRIBLE TIDAL BORES THAT TRAVEL FASTER THAN A GALLOPING HORSE. THERE THE SEA RECEDES AN INCREDIBLE DISTANCE OF 12 KILOMETRES TO EXPOSE A VAST 'WET SAHARA' OF SAND AND MUDFLATS, DIVIDED BY EVER-CHANGING PATTERNS OF WATER-FILLED CHANNELS AND GULLIES, MEANDERING INTO THE HAZY DISTANCE.

For centuries, fishermen from the little villages round the coast have fished the bay for flounder, bass, cod and whitebait. When the tide goes out, the sea exposes a treasure trove of cockles and mussels, and in the deeper channels, brown shrimps. Until about 1850, shrimps preserved by potting in butter were a delicacy exclusive to the area around Morecambe Bay. Local fishermen trudged miles across the sands at low tide carrying 2-metre-wide hand nets mounted on poles to catch shrimps trapped in shallow gullies and gutters. These were potted and sold from handcarts round the Bay villages. When the railway from Lancaster reached Grange-over-Sands in 1857, Morecambe Bay suddenly became the holiday destination for wealthy Victorians. Demand for potted shrimps rocketed, not just in the smart hotels and villas being built all round the coast, but in London as well. To keep up supply, fishermen had to find a way of accessing deeper channels. The solution was nets pulled behind a horse and high-seated cart, and I have seen old photographs of fishermen perched on the seat of a completely submerged cart with the horse's head just visible above the water.

By the 1950s, the right sort of aquatic carthorse was becoming difficult to find and they were gradually replaced by tractors. Les Salisbury, owner of the award-winning Furness Fish, Poultry and Game Supplies, who pots shrimps under the brand name *Morecambe Bay Potted Shrimps,* kindly took me out a couple of years ago from Bardsea near Ulverston, where he keeps his shrimping rig. Here on the shingle beach were a collection of narrow, four-wheeled wooden trailers piled with nets and fish boxes, and three almost unidentifiable vintage tractors, black with rust and stripped of mudguards, headlamps and engine cowlings. 'Wonderful machine,' said Les, giving one an affectionate pat: 'A 1969 Leyland. We have to use

tractors of this age. Modern ones would never put up with the abuse these get.' With a series of tortured groans, the Leyland wheezed into life and, hitching on one of the trailers, we chugged down the shingle onto the sands. The inconsistency of the ground means that speed is of the essence and we bucketed along in top gear with the throttle lever pulled right back. The shoreline soon disappeared and we were in a weird world of vague horizons, screaming gulls, rippled sand and shallow pools of water. The shrimpers never go out alone in case of breakdown or someone getting stuck, and more tractors started appearing from other beaches along the Bay; some with their cowlings and superstructures removed or boxed in by curious wooden platforms. All were going flat out, weaving their way between soft and hard sand or bouncing through water-filled gullies in clouds of spray. It was like a scene from George Miller's 1981 film *Mad Max 2*. Three miles into this vast damp wilderness, where tractors and trailers have been known to disappear without trace, we arrived at the Ulverston Channel, a deep, fast-flowing tidal river that divides the sands. Here, trailers were unhitched and the nets, called shrimp trawls, hooked on behind them. Trailers were then re-attached by a 200-metre rope and the tractors drove off parallel to the channel, dragging the trailers at right angles into deep water. It is surreal, churning along in a line of these extraordinary vehicles, water pouring over the footplates and trailers submerged from view.

After a long drag, the tractors came out onto the sand and nets were emptied, a writhing, heaving mass of crabs, tiny jellyfish, whitebait, flukes and hundreds of translucent brown shrimps which were shaken through riddles until only the correct size remained. It is vital these are cooked whilst still fresh, so with the threat of an incoming tide the calvalcade careered back to shore where someone had a boiler ready and waiting.

FISHING FOR EELS

A much older form of piscine cottage industry is fishing for eels. Because of their ease of drawing to a bait, eels were probably the first freshwater fish hunted by Neolithic coastal communities, who caught them in wicker fish traps placed at the edge of reed beds on lakes and ponds, or with primitive wooden leinsters (eel spears).

The extraordinary lifecycle of our freshwater eels, about which there is still some uncertainty among marine scientists, has always fascinated me. Mature eels of about fourteen years of age gradually begin to change colour from olive-brown to silvery-grey in the autumn and, during the winter months, vacate their freshwater habitat to head for the sea, travelling overland if necessary. At this stage they are at least 50 centimetres long and very fat. When they reach saltwater, their gut dissolves and body fat alone must sustain them for the 6,000-mile ocean crossing to their breeding grounds, believed to be in the Sargasso Sea. Here in the vast, floating reed beds south of Bermuda, eels that have survived the journey mate, spawn and die. Over the course of the following one to two years, billions of tiny, 5-centimetre, leaf-shaped, translucent, larval eels are carried by currents across the Atlantic, arriving at European rivers such as the Gironne, the Severn or the River Bann in Northern Ireland, between March and May. By now they will have grown another couple of centimetres, are the shape of a pencil and, because of their translucence,

are known as glass eels or elvers. These migrate inland to find freshwater habitats, and once their destination has been reached the elvers become golden brown and the cycle begins again.

Bait fishing for eels is enormous fun, particularly by the light of a full moon in the autumn, and they are some of the best eating of any fish. The demand for fresh eels fuelled a considerable niche market industry at one time, which escalated when jellied eels became popular fairground and racetrack fare. Eels have rather fallen from favour here, whilst continuing to be enormously popular in Europe, with the main supplier of eels to the Continent being the Lough Neagh Fishermen's Co-operative Society, of Toome Bridge in Northern Ireland, one of the last remaining commercial wild eel fisheries in Europe. For many centuries, generation after generation of the same families, mainly from the scattered rural parish of Duneane, traditionally fished the lough for brown eels with long lines during the summer and autumn months.

Eels become active and start searching for food – carrion or anything smaller and slower than themselves – at night. In the early afternoon, long-liners, working in pairs from deep-keeled open boats, start setting the three long lines, each with 500 hooks laboriously baited with mealworms, earthworms or pollen fry. These are then attached to buoys until four o'clock the following morning, when the fishermen are allowed, under the strict eel-fishing rules on the lough, 'to take the catch'. The eels are deposited live in cages at landing quays round the lough for collection later in the day, whilst the fishermen begin the painstaking process of baiting 1,500 hooks and coiling the long lines on setting boards ready for the afternoon.

> IT IS A HARD BUT IDYLLIC LIFE OF LONG HOURS AND PERIODS OF UNREMITTING LABOUR, WITH A HISTORY OF GRADUALLY ESCALATING CONFLICT BETWEEN THE 350 FISHING FAMILIES DEPENDENT ON BROWN EELS FOR A SUBSISTENCE LIVING AND THE OWNERS OF THE SILVER EEL WEIRS AT THE MOUTH OF THE LOUGH.

It is a hard but idyllic life of long hours and periods of unremitting labour, with a history of gradually escalating conflict between the 350 fishing families dependent on brown eels for a subsistence living and the owners of the silver eel weirs at the mouth of the lough. In 1605, James I granted the ownership of the bed, water and fishing rights contained within the 400 square kilometres of Lough Neagh to Sir Arthur Chichester, the Lord Deputy of Ireland. These ancestral rights passed to his descendants, the Earls of Donegal, and subsequently by marriage in 1857 to the Earls of Shaftesbury, the current owners. The commercial fishing rights to the different species were let to interested parties, and as long as supply exceeded demand there was little cause for hostility between the weir owners who leased the eel fishing and the fishing families who believed they had a moral right to continue their historic way of life. The trouble started when the value of silver eels rocketed in the mid-nineteenth century when those with the fishing rights felt the activities of the long liners was a threat to the potential catch at the weirs.

For decades, efforts were made to restrict the eel fishermen, through either litigation or violence, until 1963 when the High Court of Northern Ireland conferred the absolute right to the eel fishing on the then leaseholders, a consortium

of Dutch and Billingsgate fish wholesalers. The fishermen could now only operate with the leaseholders' permission and subject to whatever restrictions they chose to impose. At this low point in the lives of the eel fishermen, Father Oliver Kennedy stepped into the ring. As curate of Duneane, where many of the fishing families lived, Father Kennedy was very aware and deeply concerned at the hardship visited upon his already disadvantaged parishioners. With his guidance and advice, the fishermen formed themselves into a cohesive body that bought the fifth share of the leaseholders' consortium in 1965, when one of the wholesalers put his share on the market. By 1971, with Father Kennedy as managing director, the Eel Fishermen's Co-operative had acquired, in a series of astonishing corporate moves, the entire eel-fishing rights on Lough Neagh and established lucrative new markets on the Continent. In under ten years they had achieved the forlorn hopes of previous generations.

From the outset, the object of the Society has been to safeguard the local community and preserve eel stocks for the future, and here Father Kennedy was ahead of anyone else. Well aware that European wild eel fisheries were overfishing to cash in on demand, and sensitive to the first indication of a drop in returning elver numbers, Father Kennedy introduced fishing restrictions and began buying elvers from the Severn Estuary to maintain stocking levels. Now, in 2009, when a shift in the course of the Gulf Stream or the effect of global warming has seriously affected the numbers of elvers returning to European waters, Lough Neagh has the only productive and sustainable wild eel fishery in Europe.

ROD FISHING

I rather agree with Jack Hargreaves, who urged fishermen to break with the tribalism of simply pursuing only one form of fishing and experience many different methods. 'What do they know of fishing', he wrote in *Fishing for a Year,* published in 1951, 'who know only one fish and one way to fish for him?' What I love as much as anything is the cathartic experience of going to a little tributary of the Teviot near here, where the banks are covered in mature alder and willow trees. These used to be coppiced 100 years ago, with clogs for woollen mill workers made from alder wood and baskets from willow rods for carrying the hanks of woollen thread. It is an enchanting place where the water's motion is as soothing as the mumbling sound it makes, tumbling over the shallows. Little black dippers scud along the surface of the water, mallard and ducklings creep under the overhanging banks, iridescent dragonflies dart here and there and bees drone among the cow parsley, yellow iris, pink campion and flowering wild garlic. I bring my old Sharpes Parabolic, a split cane rod designed by Carl Ritz, the hotelier, and try roll casting for the elusive little brown trout that lurk in the pools. I know my chances of catching anything are pretty remote, but it's peaceful and, like all the other fishermen in this country alone, I do love trying.

Rod fishing is a relatively recent pastime in the history of British country sports. The need for food was such that recreational angling scarcely occurred to anyone until well into the fourteenth century, although it had evidently become popular on the Continent before that period. In the days when there were few domestic animals and the main food source derived from everything that swam, flew or ran, fish were a vital component in the survival chain and everything from a porpoise to a minnow was eaten. Coastal communities, with their little inshore fishing boats and estuary netting, kept themselves supplied with fresh fish and traded salted fish with inland settlements. Upriver, freshwater fish were netted, trapped, speared and guddled. Wherever there was any sort of principal building – be it palace, castle, manor or monastery – moats were stocked and stew ponds dug.

Carp, introduced by the Normans, were the most popular stocking fish. They are hardy, prolific and fertile. The monastic houses specialized in carp husbandry and considerable effort went into selectively breeding bigger and better strains, some of which, with careful feeding, could grow to as much as 14 kilograms. There is nothing new about fish farming; protecting fish in the inland waterways was of enormous importance, and otters, the principal predator, were kept under control by otter hound packs. Their role was sufficiently significant to be recorded by a charter of Henry II when he appointed one Roger Follo as the King's Otter Hunter, in 1175, and a Royal pack of otter hounds to protect the monarch's fish reserves existed until the English Civil War.

Fishing was considered important enough to merit a book on it in the fifteenth century, with possibly the earliest publication on fishing being the *Treatyse of Fysshynge wyth an Angle,* printed by Wykynd de Worde in 1496 and supposedly written by a certain Dame Juliana Barnes, Prioress of the Nunnery at Sopwell, St Albans. Her prolific authorship included a treatise on hunting and hawking entitled the *Boke of St Albans* and a *Boke on Kervynge,* which contained advice for the

newly wealthy Tudors on manners and deportment. The *Treatyse* contains wonderful descriptions of the great cumbersome medieval rods made of willow or hazel and tipped with blackthorn, to which a line of nine-strand plaited horsehair was attached, leaving one wondering how anything was ever caught.

Bait fishing is more credible than the descriptions of suggested flies for trout and grayling, and yet the same patterns were still in use 100 years later, when line and rod were both finer and lighter. The first real advances in fishing as a recreation came in the late seventeenth century. Commercial fishing was still of enormous economic importance; fishing fleets were busier than ever, and estuary fishing was particularly lucrative, with licencees on rivers such as the Bann in Northern Ireland, the Tweed, Tamar, Tay, Tyne – in fact, any of the salmon-spawning rivers – netting, salting and exporting hundreds of tons of salted salmon each year to the West Indies as slave food. The massive growth in the popularity of rod fishing had much to do, I suspect, with Cromwell's Commonwealth. Hunting and hawking were frowned on by the Puritans as smacking of monarchist Roman Catholic activities, and the flood of seventeenth-century angling literature (for example, Walton's *Compleat Angler* of 1653) was written during or shortly after that period. Rods and tackle were now becoming sophisticated enough for casting of a sort; lines were down to three strands of horsehair, and by the end of the century reels became commonplace for heavier fish. Fly making had become more scientific, varied and realistic in attempts to imitate insects that attracted fish to rise.

The majority of fish were still caught with bait, and the fertile imagination of determined anglers was applied to improving bait recipes. Nicholas Cox, writing in the *Gentleman's Recreation* of 1697, devotes a considerable part of his book to the subject. For carp and tench he recommends feeding for a day or two by '*casting in garbage, chicken guts, pellets of honey and sugar mixed, livers of beasts, worms chopped in pieces, cow dung or grains steeped in blood and dried*'. Then for the fishing itself he recommends bait in the form of paste made from bean flour, cat's flesh and honey. Cox has a different recipe for each fish: cheese and honey for barbel; grasshoppers with their legs cut off for bream; chunks of congealed sheep's blood for dace; Parmesan cheese mixed with saffron for chub; wasp larvae with their heads dipped in blood for roach; wireworms for trout; and earthworms kept in moss for twenty days, minnows or lobworms scented with oil of ivy berries for salmon.

Special ingenuity was reserved for pike, for whom all anglers had a morbid admiration, based on stories of monster fish attacking cattle as they went to drink, and also otters, dogs and small children as they paddled in the shallows. Attacks on humans were well documented; Cox knew of someone's maid who had been bitten, as he coyly puts it, '*as she washed herself*'. A fish capable of such ungentlemanly behaviour needed spectacular bait. A young duckling or a live frog (preferably the

yellow variety) were Cox's and Walton's suggestions. Walton gave advice on the welfare of the frog prior to use: *'Use him as though you loved him, that is, harm him as little as you may possibly, that he may live the longer.'* Others favoured a small, active, newborn puppy or kitten tied to a bladder to keep them afloat. All recommended the heaviest tackle for these prehistoric creatures, which, until fly fishing for salmon became the vogue in the nineteenth century, were indisputably the most exciting fishing experience available.

Immense changes in fishing took place during the nineteenth century, particularly in Scotland during the early half of the century. Rods were now being made in greenheart or lancewood, flexible and exotic woods from Guyana and Cuba, the last section of which was sometimes made of split Calcutta or Tonkin bamboo. Dry flies came into use and oil-dressed silk floating lines replaced horsehair. Reels even had adjustable ratchet systems, which assisted playing a fish. There was another surge of fishing literature, amongst which was William Scrope's *Days and Nights of Salmon Fishing on the Tweed,* published in 1843. The salmon rivers of England, except in the south-west, had become victims of industrial pollution and both commercial and rod fishing were but a fond memory. Scrope wrote mouthwateringly of fishing on the Tweed and his book coincided with the sporting tourism revolution which was about to sweep Scotland. Fishing the northern rivers became, initially, a component of the whole 'Glorious Twelfth' grouse shooting and stalking adventure, before becoming part of the annual migration to Scotland

Country Sports 519

in its own right, with fishermen making pilgrimages to the Tweed, Tay, Dee, Spey, Naver and Helmsdale, to name only some of the wonderful northern salmon rivers. The geography of many of these game fish rivers brought incomes and employment to remote regions, particularly the Highlands, enabling other tourist industries, such as golf, to develop in the area.

Despite experimentation with split cane by rod makers such as Ustonson, Aldred, Blacker and Bernards, greenheart and lancewood were still the most commonly used material until 1880, when Allcocks, Hardy's and Farlow's began adopting a system perfected in America by Phillippe and Murphy, for making superior split cane hexagonal rods. This was the glorious age of game fishing, with riparian owners making lucrative incomes from their rights on the salmon beats in Scotland and trout streams in England such as the Kennet in Berkshire and the Itchen in Hampshire. It fuelled an industry that is still expanding to this day and gave us the names of the famous rod and tackle makers such as Hardy, Farlow, Allcock, Playfair, Sharpe and Grant. Alexander Grant was a great exponent of greenheart rods and invented the famous Grant Vibration, a rod of immense power with spliced joints that created flexibility along the entire length. In 1895, when demonstrating his rod to London retailers on the Thames at Kingston, Grant made a cast a distance of 61 metres. These rods were so superbly made that my grandmother was still using one on the Spey in the 1960s. A ladies' five-metre greenheart salmon rod with 'Drop-Down' rod rings and overlapping joins secured by oiled deerskin straps, it weighed over 4 kilograms, complete with reel. Considered a light rod compared with some in use at the time, it is hard to believe that fifty years later the modern equivalent in high modulus graphite – an Orvis Shooting Star, for example, plus a Battenkill Large Arbor reel – now weighs little more than half a kilogram.

Since the Second World War, the history of our game rivers seems to have been one long battle to conserve fish stocks. Agricultural pollution and acidity from massive forestry plantations have done enormous damage, so too have the fish farms, although both agriculture and fish farming are now making concerted efforts to reduce pollutant risk. Nothing can be done about the forestry, sadly. Klondikers drift-net fishing off Ireland and up in the salmon feeding grounds around Iceland had a devastating effect on wild salmon numbers, but international fishing agreements will now, hopefully, correct the balance. Conservation bodies such as the Tyne Rivers Trust, Tweed River Authority, the Westcountry Rivers Trust and the Countryside Alliance Campaign for Angling are only four of the many that work to improve spawning grounds on the main river tributaries and improve coarse fishing sites. We are winning the battle, which is just as well as a rod-caught salmon or sea trout is worth £10,000 to the Highland local economy (when you add in things such as hotels, golf and revenge spending from wives who don't fish); £73 million across rural Scotland alone in an average season. Scottish coarse fishermen and sea anglers contribute a further £50 million. Today, conservation is the central issue and fishermen have become guardians of the world's waterways.

PIGEON RACING

We are a nation of sportsmen, more sporting, I like to think, than any other, and there is nothing we love more than a challenge, particularly where animals are concerned; racehorses, greyhounds, trail hounds, trotting ponies, terriers, ferrets or – the working man's favourite – racing pigeons. 'A flat cap, greyhound shit and pigeon dung,' was a music hall reference to the principal components in the life of an urban sportsman, depicted so succinctly in the cartoon character, Andy Capp.

Pigeon racing was a natural progression from the centuries-old practice of using domesticated Rock Pigeons, which have an innate ability to find their way home over long distances, to carry messages. Until the development of the telegraph system, carrier pigeons were the swiftest method of communication and their use continued throughout both World Wars, when over 200,000 carrier pigeons were in use, thirty-two of which were subsequently awarded the Dickin Medal for bravery, the animal equivalent of the VC. Pigeon racing as a sport began in Belgium in the early nineteenth century, with the first organised race, held over one 160 kilometres, in 1818. This was followed in 1820 by a race of almost double the distance, from Paris to Liège, and in 1823, from London to Antwerp. In Britain at that time the sport was largely confined to private matches between the sporting gentry and endurance races, with the record for the longest journey ever flown still held by a pigeon belonging to the Duke of Wellington. This bird was released from a sailing ship on 8 April 1845, near the Ichabo Islands off the west coast of Africa, dropping dead 55 days later on 1 June, only a mile from its loft at Nine Elms, Wandsworth, having flown a distance of 11,225 miles, including a 3,500-mile detour over the Sahara Desert.

Keeping pigeons soon became a popular urban backyard hobby that could involve the whole family; this and the expansion of the rail network in the mid-nineteenth century meant that the sport of racing took off in Britain, as it was now possible to transport pigeons to the start point of a race practically anywhere in Britain or on the Continent. The sport received another upsurge in popularity in 1886 when King Leopold II of Belgium gave a pair of racing pigeons to Queen Victoria, who established a racing loft at Sandringham. Both Edward VII and George V were keen fanciers and had success with the royal pigeons, including first prizes in the national race from Lerwick in the Shetland Isles. Pigeons from the Royal Loft were used as carrier pigeons during the First and Second World Wars, one of which won a Dickin Medal for its role in carrying a message reporting a lost aircraft in 1940. After the war, the pigeons returned to racing, winning further national and international races.

Queen Elizabeth II takes an active interest in the royal pigeons and regularly visits the lofts when she is at Sandringham,

where 160 mature birds and 80 juveniles have been managed since 1992 by Carlo Napolitano, the official Loft Manager for Her Majesty the Queen. Carlo enters pigeons into one or two club races each week and all national races during the season, which runs from April to September. At various times over the years, the Queen's racing pigeons, with their distinctive leg rings bearing the royal insignia, have won every major race in the calendar. In July 2008, Her Majesty donated three birds from the Royal Loft to the Wetherby Young Offenders Institute, to give prisoners the opportunity of learning a constructive hobby in the hope that some might continue it on release and reduce the likelihood of re-offending. As with all country sports, pigeon racing has an eclectic following and the six regulatory organisations in Britain have memberships that range from peers to the sport's traditional urban heartland members, and everyone in between.

Young birds are trained by taking them further and further away from their lofts until they are ready to compete in novice races of 100 kilometres, which increase to 1,000 as they mature, with big international races covering distances of 1,600 kilometres. A race is won by the bird that flies the fastest number of metres per minute, with the exact distance from the race point to the competing member's loft calculated by computer. Birds will reach speeds of 130 kilometres an hour at stages over a race if the wind is behind them, and about 80 kilometres an hour on a calm day.

The size of the average pigeon loft is between 50 and 100 birds, although some fanciers, such as the Masserella family, who are market leaders in breeding and selling racing pigeons, will have several thousand birds, some of which will be extremely valuable. A racing pigeon can sell for anything from £50 to £150,000, depending on blood lines, and in the Far East, where millions of dollars are bet on the outcome of pigeon races, immense sums exchange hands over successful birds.

There are around 50,000 people in Britain devoted to pigeon racing, with one-loft racing gaining popularity. This is the process of training birds bred by many different breeders in the same loft, under the same trainer and in the same conditions – as opposed to trainer against trainer in their own lofts and usually with their own birds. It is thought to be the fairest method of proving which bloodline or breeder is best and usually provides the highest amount of prize money. Pigeons are recorded by electronic timing systems scanning the birds as they enter the home loft, with winners decided by as little as 100th of a second. The birds are all taken to the same release point and they return to the same home loft, so the winner is the fastest bird to complete the journey from A to B. One-loft racing is now becoming very popular all over the world.

Pigeon racing is not without heartbreak; vagaries of the weather, electricity pylons and, increasingly, birds of prey will see an end to birds – it is estimated that 70,000 pigeons racing every year are killed by raptors.

> A RACE IS WON BY THE BIRD THAT FLIES THE FASTEST NUMBER OF METRES PER MINUTE, WITH THE EXACT DISTANCE FROM THE RACE POINT TO THE COMPETING MEMBER'S LOFT CALCULATED BY COMPUTER. BIRDS WILL REACH SPEEDS OF 130 KILOMETRES AN HOUR ... IF THE WIND IS BEHIND THEM, AND ABOUT 80 KILOMETRES AN HOUR ON A CALM DAY.

HOUND TRAILING

A sport that, although synonymous to Cumbria, also takes place in the Western Borders of Scotland, Southern Ireland and, to a lesser extent, North Yorkshire, is hound trailing. In simplistic terms, hound trailing is a speed and endurance test during which specially bred hounds follow an aniseed trail of around ten miles over ground varying from the steepest rock-strewn fell to boggy mosses, in every sort of weather from sleet to blistering heat.

Hound trailing originated among the walkers of trencher-fed hounds from local Fell packs, looking for a bit of out-of-season fun. At the end of the hunting season, the hounds from the Fell hound packs would be dispersed amongst the farming community who would look after a hound or maybe a couple of hounds until the beginning of the next season.

Quite when the idea started of laying a trail and betting on the outcome of two or more hounds racing round it is anyone's guess. John Coughlan, who reported hound-trailing events for many years in the *Whitehaven News*, mentions in his fascinating book on trailing that an entry in a Wensleydale parish record, dated 1750, refers to a villager being paid to lay a trail using dead cat, but I suspect the sport had been on the go long before then. Its popularity spread, particularly among the traditionally hard-betting West Cumberland mining communities during the nineteenth century, and hounds began to be selected for speed and stamina purely for racing. Soon trailing was a regular feature of life in north-west England and the Borders north of Carlisle from early spring until late autumn.

As the sport became more competitive, some outcrossing to pointer, harrier and greyhound (even collie) was tried, in order to reduce weight and improve speed. A modern trail hound stands between 50 and 65 centimetres at the shoulder and weighs 13 to 25 kilograms, depending on whether they are a dog or a bitch. They are recognised as a true breed with the vital characteristic for any trail hound – drive, dash, nose and stamina – deriving their Fell hound ancestry. To preserve these qualities, an outcross to a foxhound dog is still allowed under HTA rules.

> IN SIMPLISTIC TERMS, HOUND TRAILING IS A SPEED AND ENDURANCE TEST DURING WHICH SPECIALLY BRED HOUNDS FOLLOW AN ANISEED TRAIL OF AROUND TEN MILES OVER GROUND VARYING FROM THE STEEPEST ROCK-STREWN FELL TO BOGGY MOSSES, IN EVERY SORT OF WEATHER FROM SLEET TO BLISTERING HEAT.

By 1900 there were a number of hound-trailing associations and no clear rules. To survive, the sport obviously needed regulating and in 1905 the situation came to a head when a hound that had been clipped down to the skin appeared for the first time. The extra advantage in having been clipped allowed the hound to win its race, causing a riot among competitors and spectators as opposing factions argued over whether this was cheating.

Robert Jefferson from Whitehaven, a man of considerable stature and local reputation, is credited with forming the Cumberland Hound Trailing Association in 1906, which continues as the governing body for the seven area committees in Cumbria. The Borders, Southern Ireland and North Yorkshire have their own governing bodies, but they all race under the same rules at international meetings. The

HTA, with around 1,000 members, hold meetings every day of the week, the Border, with a membership of 150, has five or so a week, and in North Yorkshire, one. There are different grades of trail at each meeting: 'Senior', for hounds over two years old; 'Puppy', for those over one year but under two; 'Maiden', for hounds that have never won a championship trail; and 'Restricted', for hounds that have not won more than three trails in the current and preceding season. There are also 'Veteran' trails for hounds over six. Entry fees are a tiny £1 per hound – and the prize money is correspondingly small – but all associations donate their proceeds after expenses to local charities, and with the economy of scale this mounts up.

The HTA have various main events through the season: the May Day Borrowdale trails, the Bitch and Dog Produce trails in June, the Festival of Hound Trailing in July, the August Premier and October HTA trails. All four associations are a feature of agricultural, game and county shows in their areas as well as, for the HTA, the famous Grasmere and Ambleside Sports, and for the Borders, the Langholm Common Riding. The four associations meet annually to hold an International trail and all information is available through the internet or the *Whitehaven News*, West Cumberland's famous weekly newspaper, which devotes an entire page to the winners of the previous week's Hound Trailing Association meetings, hound form and the forthcoming fixture lists.

Nearly all hounds are owner trained and a close affinity between hound and trainer is vital. Although hound trailing is essentially a betting sport, with bookies

Country Sports

present at every meeting, competitors give the impression of running hounds for the sheer pleasure of watching what is virtually the family pet racing. This is reciprocated by the hounds and it is quite obvious at any meeting that the fundamental reason they race with such uninhibited enthusiasm is to please their owner. Most people probably have three hounds at different ages in training and, whilst exercise is crucial, infinite care goes into their diets, with many people possessing jealously guarded recipes passed down from generation to generation. A hound might be trailing three times a week, so getting the balance right between carbohydrates for stamina, protein for an energy boost and red or white meat to control the hound's temperature, depending on hot or cold weather, is a highly skilled art.

The trails are laid by two extremely fit trailers who clamber out to the halfway point of the designated route, carrying the trail cloths and a quantity of the scent mixture in which they are soaked (a blend of paraffin and aniseed made up by an officially appointed chemist). The trailers then walk away from each other, dragging the soaked rags, one going towards the start and the other towards the finish, so in effect the trail is more or less circular, with the start and finish always near the actual trail field where everybody parks their vehicles. There are scenes of high excitement when the trailers come tottering in and entries for first race, baying with excitement and straining at their leashes, are taken to the start line. Coats are stripped off to reveal incredibly lean fox-hound types, most of whom have been trace-clipped down to the skin, all except the last 10 centimetres of tail, which is left to protect the tip. An official dabs then each hound on the shoulder with a coloured marker to thwart any attempt at race fixing by introducing a fresh hound halfway round – a dodge not unheard of in the bad old days. Handlers remove collars and grip a fistful of loose skin at the scruff; the start judge drops his white flag and the hounds are slipped, moving off in a pack which quickly changes shape as lead hounds pull ahead.

A senior trail must last a minimum of 25 minutes, or it is deemed that hounds have cut the trail, to a maximum of 45; puppy trails are roughly half the distance and half the time. The pack is often quickly lost from sight as it disappears over the skyline and spectators eagerly scan the horizon through binoculars as they wait for the hounds to come back into view. There is a buzz of excitement as the leaders are identified and a flurry of activity round the bookies' stalls as punters adjust bets, which can be taken throughout the trail. A distant line of trail hounds moving inexorably towards you down a distant fell side is an incredibly thrilling sight, particularly when you've got a fiver on the favourite, but it takes an aficionado to know one hound from another while they are still a long way off. With minutes to

go, a video camera is set up to record the winner and owners carrying plastic or metal buckets containing titbits move down to the finish line. When hounds become clearly visible, a terrific cacophony of noise starts as owners call hounds in, shouting their name, blowing whistles and waving or banging feed buckets. Hounds are caught as they cross the finish line – an easy enough task as their heads are straight into the buckets – rugged up and checked for injury. Winners receive their 'ticket' and organisers immediately prepare for the next race.

Most of the hound trailers whom I know have inherited their passion for the sport, and it is this that gives hound-trailing meetings such a delightful 'family outing' atmosphere. Membership spans the ages and there are any number of extremely healthy-looking septuagenarians – which is not surprising, considering a hound in training needs exercising about five miles a day – who have been trailing since they were at school. Their children have followed them into the sport and their grandchildren can be seen happily kicking a football round the car park field whilst the family pet is racing.

> A DISTANT LINE OF TRAIL HOUNDS MOVING INEXORABLY TOWARDS YOU DOWN A DISTANT FELL SIDE IS AN INCREDIBLY THRILLING SIGHT ... BUT IT TAKES AN AFICIONADO TO KNOW ONE HOUND FROM ANOTHER WHILE THEY ARE STILL A LONG WAY OFF.

Hound trailing quickly gets under the skin; the scenery, whether Solway coast, Dumfriesshire hill or Cumbrian fell, is stunning, and as John Jacklin of the North Yorkshire HTA observed, 'Like hunting, it takes you to places you wouldn't otherwise have gone to.' Even as a spectator, you become entranced after only a couple of meetings, and I could listen to the craic of the older members all night long, stories of laying trails with the effluent of road kills rotted down in an old milk churn, before aniseed came in during the fifties, or of young enthusiasts skiving off school to walk hounds miles to trail meetings back in the thirties; tales of the hound nobbling and skullduggery that used to go on, or finding out where a trail was going to run and sneaking a hound round it before the meeting so that it was familiarized with the route; getting a mate to lie out on the fell and signal where a particular hound was at a certain point in the race to swindle the bookies; or the enterprising chap who soaked the tip of a hound's tail in the urine of a bitch on heat to stop others passing it in a dog-hound-only race. Old countrymen reminiscing is part of our vanishing countryside, and for that alone a trail hound meet is worth a visit.

FERRETING

Late autumn sliding into winter is always a nostalgic time of year: the stark eeriness of leafless trees against a slate grey sky, a burst of colour as a shaft of thin sunlight strikes a patch of dead bracken and the staccato song of a mistle thrush, noisily defending the last berries on a rowan tree. In weather like this, when there is enough frost in the air to turn one's breath into clouds of condensation and the earth has a musty, ancient smell, I can sometimes see in my mind's eye a man and boy making their way down from a grassy cleugh below the heather line: the man with a ferret box on a leather strap round his shoulder; the boy with a spade from which a brace of rabbits are hung by their hind legs. This enchanting imagery of an almost timeless pastoral scene always brings a flood of evocative memories. This could be me and my son returning from an afternoon's ferreting, when he was very small, or any number of the generation after generation of adults who had spent the day introducing a child to his first experience of country sports.

I was first taken ferreting by Joe Botting, our gardener, when I was six years old and I remember the occasion with absolute clarity: the red-eyed, yellow-skinned Jill ferret and the larger, darker, polecat Hob weaving backwards and forwards against the wire front of their oblong cage; the two-compartment wooden box into which they were lifted; the purse nets and wooden pegs being taken down from the hooks they hung on and being put into the deep, ex-Royal Mail canvas bag; the spade with its short narrow blade. I can even remember the pungent smell

of Airman Light, the coarse black cigarette tobacco Joe smoked. I can see the place, approaching a bank where we could expect to find Ishmaelites, as Joe called rabbits, when he put out his cigarette and whispered, 'Now we must be very quiet.' He sat on the mailbag as he deftly set the nets, before slipping the yellow Jill into a burrow. There was an anxious wait when nothing seemed to happen, and then the rapid, muffled thumping below ground and thrilling, sudden rush as a rabbit bolted, the net jerked tight and a grey-brown body bounced in the tangled mesh.

Within a short space of time I had a ferret of my own, when Joe's pair bred producing a litter of kits in the early spring and he gave me an eight-week-old Jill in the middle of May. I kept the little ferret in a disused loose box in the stables, where she had a raised hutch filled with hay reached by a ramp and I can still feel a sense of the exquisite pleasure of running down to see her every morning. The sound of my footsteps on the cobbles always alerted her, and by the time I arrived she was already weaving backwards and forwards at the loose-box door. I had the whole summer to play with her before going back to school in the autumn and spent hours following her round the garden, through the flower beds or in and out of the shrubbery as she pursued her erratic scent-driven explorations. When these palled, she would play endlessly with a rubber ball, pushing it about with her nose or dancing round it, giving little cheeps of excitement. I was the happiest child alive, and to advertise my delight I christened her Diana, after my mother. Later on I was given a Hob by Herb Bathgate, a noted local ferreter, which I called Joe, thinking it would please him. (The word *Hob,* by the way, is Middle English for goblin or fiend. *Jill* was a commonly used female appellation, as in a Jill donkey.)

I often went ferreting with Joe, and each expedition was a lesson in field craft. He taught me to kill a rabbit with a blow to the back of the neck and how to paunch one, making sure the bladder had been squeezed empty before the stomach cavity was opened with a cut from the brisket to the pelvis. The liver was extracted and fed to the ferrets in their box as a reward for their hard work, and to avoid attracting carrion the steaming, grey-green intestines were always buried. From Joe I learnt to watch for the natural factors that might affect the way rabbits bolted and increase the likelihood of the ferrets killing below ground; a darkening sky presaging rain or the tell-tale signs of a fox in the neighbourhood; the prolonged alarm call of a jay in woodland, sheep in a field suddenly flocking together; or, the most obvious of all, the pungent smell of fox urine.

> I KEPT THE LITTLE FERRET IN A DISUSED LOOSE BOX IN THE STABLES, WHERE SHE HAD A RAISED HUTCH FILLED WITH HAY REACHED BY A RAMP AND I CAN STILL FEEL A SENSE OF THE EXQUISITE PLEASURE OF RUNNING DOWN TO SEE HER EVERY MORNING. THE SOUND OF MY FOOTSTEPS ON THE COBBLES ALWAYS ALERTED HER, AND BY THE TIME I ARRIVED SHE WAS ALREADY WEAVING BACKWARDS AND FORWARDS AT THE LOOSE-BOX DOOR.

When I was a little older, I ferreted on my own with only Tiger, my first terrier, for company. Tiger was one of several generations of terrier bred by my father from a line which went back to a Sealyham dog belonging to Jack Champion, the famous Huntsman of the Old Surrey and Burstow, and a bitch owned by Frank

Chilman, who had been my grandfather's gamekeeper before the Second World War. I taught Tiger to overcome his natural instinct to bite ferrets, and once he was 'steady', as the expression goes, I would always leave one hole open when netting burrows. Tiger would sit above the unnetted hole, trembling with anticipation, his head cocked to one side as he listened to the ferret moving stealthily round the tunnels below him. Then, as the rapid thumping of a bolting rabbit grew louder, he would rise to a quivering half crouch and, at the moment when a rabbit pauses at the mouth of a burrow for that microsecond while they decide which way to run, Tiger would strike like a bolt of lightning.

Ferreting has long been recognised as one of the best ways to introduce a child to country sports and the basics of field craft. Owning a ferret teaches them the responsibilities, common sense and intuition that are all essential components of looking after a working animal and, just as importantly, after a little initial tuition ferreting provides the opportunity to discover our vanishing countryside unsupervised and to learn about wildlife from their mistakes. Success depends on silence, interpreting wind direction, proper care of equipment and sensible treatment of a creature that will bite hard if handled stupidly. Best of all, when they get it right a child experiences that wonderful sense of achievement in bringing something home for the pot. Ferrets are also wonderfully versatile; over the years I have had enormous fun bolting rabbits to nets, Harris hawks or whippets, and there is no finer training in handling a gun. To shoot bolting rabbits, a novice must be quick getting his gun up and shoot fast. The mistake common to all shooting – being behind or below – is quickly identified by the tell-tale puff of dust on the heels of a departing bunny.

A true ferret, the descendant of either a Steppe polecat, a European polecat or a hybridisation of both, is yellowish in colour and has the red eyes of a genuine albino. Quite when and where the first polecat was domesticated has been lost in the mists of antiquity, but their sporting lineage must be as old as hawk or hound. The nomadic Black Sea tribes used nicotine-coloured Steppe polecats to bolt their staple diet of sousliks and marmots at least 3,000 years ago. Ferrets were well known to the ancient Greeks and were used by the Romans to hunt rabbits in Spain and the Balearic Islands. Although the tradition continued in Europe, the exact date of the introduction of rabbits and, by association, ferrets to Britain is uncertain. Rabbits were among the species in the living larders imported by the Romans (rabbit embryos, *laurices*, were considered great delicacies) but none appear to have survived the collapse of the Empire. There is apparently no native name for rabbit in the Anglo-Saxon language, nor any mention of them in the Domesday Book. Most historians agree that they were brought across from Europe around the middle of the twelfth century, as part of the existing and highly lucrative Norman culture of rabbit farming.

Warrens, or coney garths (enclosures surrounded by banks topped with gorse and with pillow mounds to encourage burrowing), became established all over Britain wherever there was suitable free-draining soil. The rights to establish a warren were franchised or gifted by the King to the nobility and the Church, with some of them being huge places such as Lakenheath in the Brecklands of Suffolk,

set up by the Bishops of Ely, which was surrounded by a bank ten miles long topped with furze. The neighbouring warrens of Brandon, also belonging to the Bishops of Ely; Thetford, belonging to the Prior of Thetford; and Mildenhall, belonging to the Abbot of Bury, were all of roughly the same size.

Rabbit farming was a very valuable part of the medieval economy, as the flesh was a delicacy and the skins worth proportionately as much as a bullock's, being used for bed covers, caps and gloves, waistcoats, linings and trimmings – their uses and the demand for them were endless. Warrens were fiercely protected, with the meat and salted skins stored in fortified lodges, similar to the ruins of those that can be seen at Thetford and Mildeham, and the perimeters were patrolled by warreners.

The beauty of warrens was the speed with which they could be up and running. Once the earth banks had been built a warren was in production almost immediately; a doe will breed at six months and, depending on the weather, produce six litters a season. Half of these will be does, reproducing within the same year. Linnaeus, the Swedish zoologist and father of modern ecology, once worked out that a pair of rabbits could potential multiply to 18,000 in four years.

Warreners were highly respected stockmen of equal social standing as falconers or huntsmen, as the considerable art history of ferreting from the late Middle Ages until the seventeenth century demonstrates. Pope Clement VI's bedroom in the Palace of the Popes at Avignon, where the Holy See was located for much of the early Rennaissance period, is decorated with a huge fresco depicting a ferreting scene, which was painted in 1343 by Matteo Giovanetti. The aptly named John the Fearless, Duke of Burgundy, was painted by an unknown artist in the early fifteenth century with a live ferret wrapped round his neck. One of the finest pieces of ferreting art is the magnificent Ferreting Tapestry, made in Burgundy during the fifteenth century, which hangs in the Burrell Collection, Glasgow.

Inevitably, some rabbits escaped and established themselves in the surrounding countryside. At some stage, peasants observing the warreners at work would have caught and tamed their own polecats and ferreting became the poacher's bread and butter. It was a risky business, though, as the Game Laws of 1390 imposed a year's imprisonment on anyone possessing ferrets who did not have '*in lands 40 shillings per annum*'. Despite the gradual spread of wild rabbits and the damage they caused to arable crops, ferreting was still worthy of inclusion by Cox in *The Gentleman's Recreation*. He recommended bolting them to 'tumblers' – small lurchers. During the agricultural improvements of the eighteenth and nineteenth centuries, the rabbit population expanded enormously and ferreting became a necessary form of vermin control. At the same time, with the shift in population from country to town during the industrial revolution, ferret keeping became a link to their rural background for many urban people and thousands are still kept in the backyards of Britain's housing estates.

Ferrets seemed to lose their status during this period and tended to be poorly treated. Johnson scarcely mentions them in his *Sportsman's Cyclopedia* of 1831, other than to observe that they were hunted with their 'mouths sewed up' to prevent them killing underground. Even 150 years later, most people, like Joe, kept ferrets in hutches that were far too short for active animals and fed them on an unnatural

diet of bread and milk, believing this made them easier to handle. I remember how disapproving he was that mine were kept in an old loose box with plenty of space to run around.

Curiously, the introduction of myxomatosis in the 1950s, which temporarily wiped out the rabbit population, was the catalyst that eventually led to enormous advances in ferret welfare. The majority of owners hung on to their ferrets regardless of the shortage of rabbits, to discover that ferrets, like all mustelidae – otters, badgers, stoats and so on – are highly intelligent, natural comics which make delightful pets. Improvements in housing, diet and veterinary care were all driven by an increase in pet ferret ownership now so large (2 million at the last count) that nine years ago ferrets were voted the pet of the millennium.

Like other pets, ferrets sometimes become victims of abuse and neglect or are simply dumped when they cease to amuse, and over fifty ferret rescue centres have become established across the country, devoted to the welfare and rehabilitation of ferrets that have become injured or been abandoned by unscrupulous owners. Many of these are part-funded by breed shows and enormously popular ferret racing events: competing ferrets, vociferously encouraged by their owners, gallop down 10-metre plastic tubes over a series of eliminator heats. At least, that is the theory. Some repay the months of training and complete the course, others perversely turn round halfway down the tube and rush back to the start line, or curl up and go to sleep. Occasionally one exceeds expectations, like the ferret owned by an elderly lady from Belford, in Northumberland, which covered the distance at the North of England Ferret Racing Championships a few years ago in a scorching 11.3/4 seconds, seeing off the other 200 competitors (including my ferret, Fido) and rocketing to national prominence as the Guinness World Records' Fastest Ferret. All of which was to benefit working ferrets when the rabbit population recovered and the interest in ferreting returned.

In my day, a sporting child had to rely on someone like Joe to get them started; nowadays there are hundreds of ferreting clubs eager for new members, and with the emphasis on educating the young of all backgrounds about their rural heritage there is no shortage of experts in BASC or the Countryside Alliance willing and eager to help get them started. Furthermore, there are over 140 game and country fairs up and down the country every year from April to October, each with its own ferret display and someone on hand from one of the many ferret organisations offering advice on welfare, housing and the practicalities of ferreting.

One of the most entertaining days ferreting I have had in recent years was bolting rabbits to Harris Hawks. A party of falconers from the North Wales region of the Welsh Hawking Club came up to our part of the world and stayed at the local dog- and hawk-friendly pub in the village for a week, flying their hawks on various farms in the neighbourhood. On the day they came to me, I took them to a high point on the farm where there was a thriving rabbit population in the grassy cleughs and gullies below a crag once used as a Roman lookout post. This was an ideal place for the falconers: there was a big expanse of open hill ground which sloped down from the burrows to a stone wall bordering an improved grass field, where the rabbits grazed at dawn and dusk.

It was a glorious, bright, early November day with a brisk, prevailing northerly breeze, which meant we would be bolting into the wind and any noise from my movements as I entered the ferrets would be minimised. The falconers intended to fly the Harris Hawks in relays of four, and once they had removed the hoods and allowed the hawks to winnow for a few minutes, the first four were cast off to hang on the wind in a line covering the face of the rabbit bank. Within minutes of entering one of the ferrets, the first rabbit bolted and the nearest hawk dropped like a stone to make the first kill. Thereafter, rabbits popped out thick and fast and the afternoon became absolutely riveting. With an enemy within and an enemy without, rabbits were exerting every ounce of speed as they bolted and, once clear, used their intimate knowledge of the ground and phenomenal ability to jinx from side to side. This really stretched the hawks' strength, velocity, persistence and footing to the maximum, as they poured their energy levels and courage into the chase, stooping and rebounding frantically with amazing aerial dexterity.

FALCONRY – BRITAIN'S ANCIENT SPORT

Falconry is an incredibly ancient field sport, probably as old as coursing. The first hunting birds of prey are believed to have been trained at around the same time in both the Mongolian steppes and in Persia. In documented Iranian history there are records proving that falconry existed during the Pishdadidian Dynasty of Persia, around 8,000 BC. The knowledge gradually moved westwards across Asia and into Europe; the Ancient Greeks trained and flew birds of prey, as did the Romans, Celts, Anglo-Saxons and Normans. The crusading knights met falconers in the Middle East who had taken the art to a level of sophistication far beyond that which existed in Britain, bringing back entirely new methods of husbandry and elegant falconry techniques, as well as exotic new breeds.

In this Age of Chivalry, the pursuit of wild animals was seen as a knightly occupation; this chivalry and good manners were extended to hunted prey and the correct ritual, ceremony and terminology of the chase became sacrosanct. For over two and a half centuries, from roughly 1100 to 1350, it was customary for the sons of gentlemen to be sent as squires to the households of nobles, to learn the sophistication, manners and behaviour of court via the hunting field. This education was very rigid; not only was most art and music inspired by hunting but the encyclopaedic terminology of the chase had to be learnt perfectly, including the complicated dictionary of hawking and the complexities of conduct in the respectful handling of dead quarry.

> TO MAKE A MISTAKE IN CARVING, AN ERROR IN THE TERMS OF THE ART OF VENERY, OR TO USE THE WRONG WORD IN THE LANGUAGE OF FALCONRY, WAS TO INCUR SEVERE PENALTIES. NO ONE, NO MATTER HOW BRAVE, WOULD BE GRANTED THE GOLDEN SPURS OF KNIGHTHOOD UNLESS THEY WERE PROFICIENT IN ALL OF THESE.

Every single creature, fur, fish or fowl, was given the courtesy of being carved in its own exclusive way, and to make a mistake in carving, an error in the Terms of the Art of Venery, or to use the wrong word in the language of falconry, was to

incur severe penalties. No one, no matter how brave, would be granted the golden spurs of knighthood unless they were proficient in all of these, including spending a successful period as a carving esquire. Most important of all was remembering the exact dates of the 'fence months' or closed seasons of all the different quarry species, which allowed them to breed undisturbed.

During this time the contribution of falconry to the food chain led to a rigid stratification of the different breeds based on their hunting ability, which became linked to social rank. Thus, owning peregrines or gyrfalcons was reserved for the great and the good, goshawks for yeomen, sparrow hawks for clerks and priests, merlins (principally lark hawkers) for ladies, and kestrels, which are only capable of catching mice, for knaves, children and servants.

LANGUAGE OF FALCONRY

Falconry developed a whimsical language and terminology of its own, equally as complicated as that for venery or carving, and a thorough knowledge of every aspect of falconry was considered an essential part of a gentleman's education. Some of the words once exclusive to falconry (of which *Mews* is the most obvious), found their way into every day usage: *Cadge,* as in to cadge a lift, stems from the name of the wooden perching frame on which a number of hawks were carried on a day's hawking. The 'Cadger', a person who carried the frame and kept the birds calm, was always an old, retired falconer, hence 'Codger'. A 'Callow' is a nestling raptor whose feathers are in the blood-quill stage, a phrase still used to describe someone who is young or naive, as in callow youth. A 'Haggard' is a young hawk that has been caught for training after it had acquired adult plumage and was consequently difficult to tame. It was only in the late sixteenth century that the word was applied to describe an unkempt or wild-looking person and has subsequently come to mean gaunt or careworn. When raptors drink, it is called *bowsing*. A bird that drinks heavily is a *bowser*, hence the term 'boozer'. Mantling, the attitude which a bird of prey adopts when it huddles protectively over a kill with wings and tail spread, has given us both mantel, as in cloak, and mantelpiece.

Falconry was much more than merely an amusement or method of providing food (hawking was, after all, the only means of catching birds on the wing); it became a very prominent expression of social and political authority. For the monarch and nobility it was a deadly serious pastime, considered among the finest of all earthly pursuits, and was, for many centuries, an important means of cultural communication. The passion for falconry was shared between most cultures of the known world and falcons made ideal diplomatic gifts.

Dealing in hawks was big business, with traders making fortunes with birds from Flanders, Germany, Russia, Switzerland, Norway, Iceland, Sicily, Corsica,

Sardinia, the Balearic Islands, Spain, Turkey, Alexandria, the Barbary States, India and even China. Marco Polo left a fantastic and no doubt exaggerated account of the great Kubla Khan embarking on a hunting expedition in 1276, with a vast army of retainers and Huntsmen, including 10,000 falconers and a multitude of peregrine falcons, gyrfalcons, sakers, goshawks and eagles. Even a modest late medieval or Tudor gentleman's establishment would have an elaborate south-facing mews to house the big Norwegian or Icelandic gyrfalcons for casting at cranes and herons. Peregrines, from Hungary or any of the other Central European countries, were the most important hawk to any falconer flown at grouse, pheasants, partridges, ducks, rabbits and hares. Little Lanner falcons, imported from Italy, Greece and North Africa, were flown at partridges, and the larger Sakers, from Central Europe and South Asia, at larger birds and hares. Added to these were domestic hobbies, merlins, goshawks and sparrowhawks; the last two commonly followed on horseback with brachets, a type of small hound used to drive game out of cover to them.

> *'The bratchet's bay*
> *From the dark covert drove the prey'*
> WALTER SCOTT, 'Marmion'

Kestrels, traditionally considered a lowly bird in the hierarchy of hawks, were used for the hawking education of the son of the house. Hawks required long hours of infinite patience, kindness, cleanliness and delicate treatment of damaged feathers, and a falconer was as highly regarded as a huntsman. He would have a pharmacopoeia of different medicines and perhaps his own herb garth attached to the mews; a workshop of delicate tools for making and repairing the bells, swivels, varvels, jesses, leashes, gloves and the ornate plume-crowned hoods in the colours of the owners heraldic livery. Master falconers in royal or noble households were in great demand and able to command fantastic salaries. The post was dignified by elevation to part of the royal households both here and on the Continent, with the first Duke of St Albans being created Hereditary Master Falconer of England. The wording of the title has changed slightly over the centuries, and today the Queen's Grand Falconer is Murray De Vere Beauclerk, the 14th Duke of St Albans.

By the time of the English Civil War in 1641, falconry had become the elegant diversion of a diminishing minority, although hawks continued to be used for many years to flush game into nets or keep them held to the ground whilst a net was drawn over them. The sport went into a total decline during the troubled years of the Commonwealth, and with the Restoration, as returning cavaliers brought back lighter, more manoeuvrable Continental shotguns, shooting became the fashion and the skilled mystery of falconry was kept alive by only a handful of enthusiasts. There was a resurgence of interest in the mid-eighteenth century when that great sportsman, Lord Orford, established a mews at Houghton Hall in Norfolk with the aid of Dutch falconers.

In 1771 Lord Orford's establishment of hawks was passed to the Falconers Society, which later became the British Falconers Club, under the management of the wonderfully eccentric and immensely wealthy Colonel Thomas Thornton, of Thornville Royal in Yorkshire. Thornton is a notable figure in the history of racing, hunting, shooting, fishing, falconry and sporting literature, having written two highly entertaining books on his sporting travels in Scotland and France: *A Sporting Tour through the Northern Parts of England and a great part of the Highlands of Scotland* (1804), and *A Sporting Tour Through France* (1806). He established magnificent hawk-houses on his estate and hawked on a scale not seen for several centuries, employing the artist Sawrey Gilpin (1733–1807) to record many of the hawking and other sporting events in his action-packed calendar. Henry Hall Dixon (1822–70), the sporting journalist known by his nom de plume, 'The Druid', described the Colonel setting out for a day's sport. *'Fourteen men servants with hawks on their wrists, ten hunters, a pack of stag hounds, lap-dog beagles and a brace of wolves formed the advance guard. Two brace of pointers, and thrice as many greyhounds in rich buff and blue sheets, with armorial bearings, followed in their train.'* Thus equipped, he was ready for virtually anything that moved, his pointers and hawks for all manner of birds on the ground or on the wing. The beagles, greyhounds and hawks were for rabbits and hares, with staghounds and, presumably, the wolves for deer. If all else failed, the Colonel invariably carried a massive multi-barrelled shotgun, made to his own design.

In those days, the Falconers Club held meetings every April for kite, heron and crow hawking on the great rabbit warrens of Norfolk and Suffolk and at Alconbury Hill in Huntingdonshire. Management of the club passed to Lord Orford in 1780 and in 1792 to Lord Berners, who held office until 1838. By 1839, with both kites and herons becoming scarce on open ground in East Anglia, the Falconers Club were invited by the Dutch Royal Family to hawk in Holland, becoming renamed the Loo Hawking Club. Under the management of the English-controlled club and the falconers of the King of Holland, the members enjoyed unsurpassable sport flying hawks, mainly at herons. In 1853 the club came to an end, and hawking has never since been carried on in Holland on a large scale. After a brief period of abeyance, the famous 'Old Hawking Club' was formed, managed by Mr E. Clough Newcome, who had for many years been the guiding spirit of the Loo Hawking Club, showing fine sport in rook hawking on the Wiltshire downs – the best substitute for heron hawking – and also at game of all kinds in Scotland and England. A number of private establishments were formed about this time; when the Duke of Leeds rented Mar Lodge on Deeside from the Earl of Fife, he built up a magnificent team of hawks to fly at grouse, blackcock, capercaille, snipe and woodcocks, employing John Pells and Peter Ballantyne as his falconers. John Anderson, another famous

KESTRELS, TRADITIONALLY CONSIDERED A LOWLY BIRD IN THE HIERARCHY OF HAWKS, WERE USED FOR THE HAWKING EDUCATION OF THE SON OF THE HOUSE. HAWKS REQUIRED LONG HOURS OF INFINITE PATIENCE, KINDNESS, CLEANLINESS AND DELICATE TREATMENT OF DAMAGED FEATHERS, AND A FALCONER WAS AS HIGHLY REGARDED AS A HUNTSMAN.

name in the history of hawking, ran the Renfrewshire Subscription Hawks solely for game hawking on the Flemings' estate at Barochan Castle. Amongst others were Major Fisher, T. J. Mann and W. H. St Quintin, who trained peregrines to fly at seagulls, the Hon. C. W. Mills, Arthur Newall and the famous naturalist Sir Henry Boynton Bt of Burton Agnes, who mainly favoured goshawks, F. Salvin, the Rev. W. Willmott and the Rev. G. E. Freeman, the well-known writer on falconry. Added to which there would also have been any number of general countrymen, game keepers, wildfowlers and, no doubt, poachers who had a knowledge of falconry and kept a few hawks.

Following the death of Mr Newcome in 1871, the Old Hawking Club was re-organised on a larger basis by Lord Lilford and the Hon. Cecil Duncombe, with the Hon. Gerald Lascelles as manager. Under his management, the ethos of the club expanded beyond providing sport for its members to include training for young falconers and making hawks available to beginners whose efforts with an untrained bird could only result in failure. By 1927, the increased interest in falconry led to the Old Hawking Club evolving into the British Falconers Club.

Today, falconry is one of the fastest-growing country pursuits, with over 25,000 people (5,000 of whom hunt with hawks) involved, who keep between them around 75,000 birds of prey. There are twenty-three falconry clubs whose interests are represented to the government by the Hawk Board and the Campaign for Falconry, a subcommittee of the Countryside Alliance. Some 2,000 people breed birds of prey in the UK and more than 3,000 full-time equivalent jobs are dependent on falconry. Twenty-one pest-control businesses use raptors to scare off bird infestations, particularly of seagulls, pigeons and starlings from civil and military airfields, landfill sites and prominent city centre buildings such as the Houses of Parliament and the Cardiff Millennium Dome.

Education is a major part of falconry in the twenty-first century, with falconers regularly visiting schools, and it has been estimated that annual displays at county and agricultural shows, game fairs and corporate hospitality days are watched by more than 45 million people. No one who has studied a wild hawk in flight or stooping to kill could fail to be fascinated by the notion of taming one, and over thirty-five centres provide tuition in mastering the ancient art. The modern falconer is required to learn a variety of different skills: immense patience and sensitivity to his birds' moods, well-being and ailments; knowledge of leather working sufficient to make and repair the various pieces of furniture required for hawking; the ability to skin and butcher fresh food for the birds; and an understanding of game and other wildlife. Above all, they must have absolute commitment and dedication to creatures that are probably more temperamental and demanding than any other, but the rewards outweigh the long hours of training and devoted attention. There are sixty or so different species which are allowed to be hunted and a wide range of different types of hawking: game hawking for partridge, pheasants, grouse, blackcock, rabbits, hares, snipe, woodcock and a host of wildfowl.

SPORTING SHOOTING

The environmental, social and economic benefits of shooting have long been recognised, but not until 2006 had all the evidence been collated under one statistical report. To achieve an accurate statement of the different financial, conservation and human elements involved, the British Association of Shooting and Conservation, the Countryside Alliance and the Country Land and Business Association, supported by the Game Conservancy Trust, commissioned an independent study by Public and Corporate Economic Consultants in 2004. The main objectives were to research and define the principal components of sporting shooting and their associated interests; to assess the economic contribution to the UK economy; and to evaluate the conservation and habitat management activities from game, deer and wildfowl shooting.

Statistics are only relevant when used to illustrate a point or defend a position, and it was important during Nu Labour's term of office to demonstrate the extent to which country sports provide opportunities for people of all ages and sexes to enjoy their rural heritage, whilst making a positive contribution to the environment, economic and social fabric. The PACEC report showed that nearly half a million people shoot live quarry every year, made available by 61,000 landowners or 'shooting providers' over 15 million hectares of land. This equates to 'shooting providers' having management responsibilities across two-thirds of the British rural land mass and within that area 2 million hectares are actively conserved for

game habitat, creating an enhanced biodiversity in which other species flourish, and dwarfing the total acreage of land managed by Natural Nature Reserves, Wildlife Trusts or the RSPB.

It is an undisputed fact that, except for in areas of blanket Forestry Commission planting, the cherished landscape of Britain has been created by field sports and the natural beauty of the countryside is largely maintained by the estimated £250 million per annum spent by 'shooting providers' on habitat and wildlife management. A key finding of the report was that shooting supports the equivalent of 70,000 full-time jobs: 31,000 directly, with a further 39,000 jobs in ancillary businesses dependent on shooting, such as gun and cartridge manufacturers. Hotels, bed and breakfast establishments, game seed businesses, game farms, sporting clothing manufacturers, tailors, tweed mills, game dealers, taxidermists, tree nurseries (several million pounds are spent each year on replanting) and, with over 1 million shotgun certificate holders, the police firearms departments.

Of the 61,000 providers of shooting, at least three-quarters offer rabbit and pigeon shooting, making pest control the most accessible form of shooting. Although there is obviously a recreational element to pigeon and rabbit shooting, the economic importance should not be overlooked; it has been estimated that each week 1,000 pigeons eat one ton of food intended for human consumption. Multiply this by a British pigeon population calculated at well over 10 million, plus some winter migrants, and you have nearly 400,000 tons vanishing out of the food chain. An infestation of rabbits can cause an equivalent amount of damage, so control of both species plays an important role in crop protection. They also have the virtue of providing superb sporting challenges and being extremely good to eat. Pigeons and rabbits rank with driven lowland game as the most popular in terms of number participation, followed by walked-up lowland game, deer stalking, inland and coastal wildfowling, and driven and walked-up grouse over dogs. As well as more formal days, many driven lowland shoots offer rabbit and pigeon shooting, duck flighting and walked-up rough days on the edges of the estate or late in the season.

OUR GAME HERITAGE

Game is as organic and free ranging a food as you could possibly get. It is healthy, high in protein, low in fat and full of flavour. Game is inexpensive, easy to cook, versatile and very available. Curiously, a large percentage of our quarry species is not indigenous to these islands and was originally introduced from other countries – hares, rabbits, fallow deer, Sika deer, Muntjac, Chinese water deer, red-legged partridges and, of course, the bird that is more synonymous with the British countryside than any other, the pheasant.

PHEASANTS

Phasianus colchicus, the species known as the Old English black-neck, with their gold, russet, purple, green and white plumage, originated from the marshy, rush-covered delta of the river Phasis – the Rioni of modern-day Georgia. Greek mythology would have us believe that it was Jason and the Argonauts who brought

these magnificent birds to Greece from the ancient kingdom of Colchis. Be that as it may, the historian Aeschylus refers to pheasants being kept to adorn the aviaries of wealthy Athenians. They remained rare exotics for the next 400 years until Greece was absorbed into the Roman Empire.

Pheasants were brought to Britain by the Romans as part of the luxuries that travelled with them, and for the next 500 years the ancestors of our Old English black-neck lived a pampered life of cosseted domesticity. How any of these vain, quarrelsome, spoilt creatures managed to fend for themselves, when the Empire collapsed and they were abandoned, is truly miraculous, but somehow enough survived, particularly in East Anglia, to form the nucleus of a feral stock.

> PHEASANTS WERE BROUGHT TO BRITAIN BY THE ROMANS AS PART OF THE LUXURIES THAT TRAVELLED WITH THEM, AND FOR THE NEXT 500 YEARS THE ANCESTORS OF OUR OLD ENGLISH BLACK-NECK LIVED A PAMPERED LIFE OF COSSETED DOMESTICITY. HOW ANY OF THESE VAIN, QUARRELSOME, SPOILT CREATURES MANAGED TO FEND FOR THEMSELVES ... IS TRULY MIRACULOUS.

Invaders who followed the Romans were poor historians and the first recorded evidence of the naturalisation of pheasants is in 1059, where they are mentioned in documents belonging to Waltham Abbey in Essex. The Normans introduced more pheasants, semi-domesticated birds that were part of their 'living larders' – a highly sophisticated form of game farming. Thereafter, pheasants appear regularly in historical records, either in the statistics of the nobility and clergy who were granted

544 ⚔ *A Book of Britain*

the royal favour of being allowed to keep and kill them, or as highly prized delicacies in the detailed accounts of elaborate medieval feasting. The Norman system of game farming gradually became redundant and pheasants established themselves as wild birds. The feral population remained relatively small and localised to the grain counties of East Anglia, until agricultural improvements in the early nineteenth century provided the ideal habitat and food source for them. Under these conditions, the population expanded rapidly and by the end of the century pheasants had become our principal game bird.

PARTRIDGES

There are two species of partridge found in the British Isles: the little chubby Grey or English partridge, which is indigenous, and the larger, red-legged or French partridge. Until the late 1900s, Grey partridges were our principal game bird. They were prolific, territorial, and in the days when most wild birds were netted their behavioural pattern of scuttling together when alarmed and crouching immobile until danger has passed made them obligingly easy to catch. The same trait made them easy to shoot, when progress in gun-making technology produced a shotgun light enough to be carried with relative ease. All agricultural progress seemed to suit them, particularly the enclosures and improvements of the eighteenth and early nineteenth centuries. Even when pheasants became the popular quarry species, there was no competition for habitat or food and Grey partridges continued to thrive.

French partridges were first introduced to Britain in 1673, when Charles II sent his French gamekeeper, Favennes de Mouchant, to bring a considerable number of pairs back from France. These were introduced to Windsor and Richmond parks but failed to survive. About 100 years later a group of landowners – Lords Hertford, Rendlesham and Rochford and the Duke of Northumberland – made a concerted effort to establish red-legged partridges by importing thousands of eggs and hatching them under broody hens. Although some of these did become established and the population increased, with more introduced over the next 100 years, French partridges remained the minority species. This situation changed dramatically during the agricultural reclamations of the 1960s and 70s, when the destruction of thousands of miles of hedgerows removed the Grey partridges' habitat and the indiscriminate use of pesticides destroyed much of their food source. By the 1990s the Grey partridge population had dropped from an estimated 1 million to 145,000, and despite the exertions of the Game Conservancy Trust and numerous individual landlords, who have had some localised successes, the overall number has since halved. French partridges proved hardy and adaptable to conditions which made Grey partridges almost extinct, and although a few Grey partridges come into the food chain early in the season, red-legs are now the most commonly eaten bird.

Adult Grey partridges have grey legs, a grey beak and white bellies with a distinctive, chestnut-brown horseshoe marking. Young birds have less distinct colouring on their under parts, yellowish feet and brown beaks. Young red-legs are identifiable by their flexible beaks and the wing primaries will be pointed and have a white tip.

DEER

Britain has six wild deer species: red, roe, fallow, sika, muntjac and Chinese water deer. Red and roe deer are indigenous, fallow have been here since the Norman Conquest and the last three are descendants of deer introduced in the late nineteenth century, who made successful bids for freedom. The numbers of red deer managed by professional stalkers on the Highland deer forests remains fairly constant at about 350,000, but in the rest of the country the population of the other species has been relentlessly increasing year after year. A combination of climate change, agricultural improvements, winter-sown crops, spread of small woodland planting and even the Forestry Commission's hideous conifer plantations created the perfect lowland habitat for deer numbers to expand. Roe deer, which were virtually extinct in the 1850s, numbered 500,000 in 2008. Descendants of the two pairs of muntjac which escaped from Woburn Abbey in 1920 had multiplied to 128,000, and these became the most widely distributed of all deer in England, even predating into the suburbs of London. The story of increasing numbers was the same for fallow, sika and the curiously tusked Chinese water deer, producing a combined UK deer population of over 1,500,000.

A BRIEF HISTORY OF SHOOTING AND SHOTGUNS

Driven lowland shooting evolved as a result of the agricultural revolution of the eighteenth and nineteenth centuries. The partridge and pheasant populations expanded rapidly as miles of quick-set hedging and shelterbelts were planted and thousands of acres of poor-quality land were enclosed and reclaimed. Agricultural improvers such as Lord Townsend and Lord Leicester in Norfolk and Robert Bakewell in Leicestershire pioneered the idea of planting turnips as winter feed for sheep, rotating turnips, cereals and grass leys to maximise land use. These practices were adopted by farmers in general, particularly in East Anglia and the Midlands, as more and more land went under the plough to meet demands for grain. The hedges, ditches, wide grassy headlands and small woodland shelterbelts, tall, hand-scythed corn stubbles and broad-leafed root crops were all perfect habitat, providing deep cover, roosts and a plentiful food source in which partridges and pheasants flourished.

By the late eighteenth century, gun makers such as Durs Egg and Joseph Manton were producing quality shotguns built on Continental lines that were lighter, shorter and more manoeuvrable than anything previously made. Partridges were now shot immediately after harvest, with the aid of pointers originally imported from Spain. These large, heavy, slow-working dogs had phenomenal noses, ideal for the deep-scythed stubbles and, later on, the turnip fields. Trained to quarter the ground searching for coveys, they stand 'on point' as soon as one is scented and a covey of partridges (in those days they were all the indigenous Grey partridge) scuttle together at the first sign of danger, crouching immobile until it passes or until they are forced into the air. This enabled sportsmen, usually no more than two of them shooting together, to cock their flintlocks, check the powder in the flash pan and creep forward, ready to fire at the very moment the covey took to the air.

The popularity and spread of this walked-up shooting is reflected in the quantity of late-eighteenth-century sporting art depicting sporting gents in top hats and high-buttoned leggings, calf-deep in golden stubble or dark green root crops firing at departing coveys, their black and white pointers in classic three-legged poise, head and tail rigid and one leg raised. Others are of Guns firing at pheasants or woodcock flushed from woodland by cocker or springer spaniels. These paintings always show the shotgun held well back down the barrel, almost at the trigger guard. Gun making may have improved, but muzzle loaders of the period were still prone to finger-obliterating barrel bursts, most frequently where the barrel joined the breech.

The flintlock had many limitations; the open firing mechanism was sensitive to wet or windy weather and there was a long delay before the priming powder in the pan ignite the main charge. The greatest drawback was restrictions in the angle at which a gun could be fired without the powder falling out of the pan, which marginalized shooting to birds that were either taking to the wing or landing. All these problems were solved by the Reverend Alexander Forsyth, the Presbyterian minister of Balhelvie, in Aberdeenshire. Forsyth was a keen wildfowler and was constantly frustrated by, among other things, missing birds that altered course as soon as they saw the priming powder of his flintlock ignite. In 1807, after painstaking experimentation, he came up with the idea of replacing gunpowder with small quantities of shock-sensitive fulminate of mercury wrapped in sheep's gut, which exploded when struck by the gun's hammer, igniting the main charge. Gunsmiths such as Joseph Manton and Joseph Egg, and inventive amateur sportsmen such as Colonel Peter Hawker, applied themselves to developing Forsyth's concept, and by 1830 flint and steel had been replaced by fulminate of mercury encased in a small brass cap which fitted over a nipple protruding from the breech. So, after 500 years, a gun could be fired in any weather and at any angle. At the same time, the old Game Laws restricting the right of shooting to those who could show a certain level of income or landowners and their eldest sons had been repealed. For the first time, landlords could invite whom they liked and even let their land to shooting tenants.

Into the sporting utopia created by agricultural improvements, and made increasingly accessible by ever-improving roads and railways, stepped parties of seven or eight Guns shooting together. Initially, Guns continued to walk in line abreast, shooting forward at partridge on stubbles and at pheasants in woodland, with frequent pauses to allow the new percussion muzzle loaders to be charged. In some areas of East Anglia and the adjoining counties, there was an early experiment in planting circular woods which encouraged pheasants to fly round and back over the walking guns.

Driven shooting of both partridges and pheasants probably occurred at much the same time, in about 1840; by now, mechanical reapers were cutting stubbles shorter, which allowed partridges to see a line of Guns and dogs approaching and to scuttle away ahead of them, only taking to the wing when they met an obstacle such as a hedge. Someone, presumably out of sheer frustration, suggested that a party of Guns split, with half hiding behind a hedge whilst the others drive the

birds towards them. At much the same time, it was noticed that pheasants driven ahead of walking Guns always made a beeline for the next wood and that Guns placed between the two would have a sporting shot.

The novelty caught on and the concept of driving coveys of partridges over forward-standing Guns concealed behind high hedges or pheasants over Guns strategically placed between woods was experimented with on a number of estates. The first organised driven partridge shoot took place in 1845 at Heveningham Hall, in Suffolk, the seat of Lord Huntingfield (who is reputed to have practised for weeks on potatoes lobbed to him over the high walls of the kitchen gardens), whilst driven pheasant shooting was pioneered by Lord Leicester at Holkham Hall, in Norfolk. The previously sparse grouse populations on the Yorkshire moors, the Pennines and the uplands of southern Scotland had increased dramatically in areas where sheep graziers burnt the heather on an annual basis. So much so that by 1840, driving grouse over Guns had become a regular occurrence on the moors owned by the Stanhopes of Cotton Hall, near Barnsley.

There was one drawback to driven shooting in those early days: guns were still loaded at the muzzle, and keeping pace with the volume of driven game could necessitate as many as four double-barrelled shotguns per person and as many loaders. The whole performance of trying to pour powder and shot into a muzzle loader in the heat of the moment and fit the fiddly little percussion caps in place with birds whizzing over and an impatient employer yelling for a fresh gun was a recipe for disaster. (One of the most frequent accidents among loaders was caused by glowing smuts lining the barrels from the previous shot igniting a fresh powder charge as it was being rammed home.)

> THE FIRST ORGANISED DRIVEN PARTRIDGE SHOOT TOOK PLACE IN 1845 AT HEVENINGHAM HALL, IN SUFFOLK, THE SEAT OF LORD HUNTINGFIELD (WHO IS REPUTED TO HAVE PRACTISED FOR WEEKS ON POTATOES LOBBED TO HIM OVER THE HIGH WALLS OF THE KITCHEN GARDENS).

Mercifully for all concerned, gunsmiths here and on the Continent were working on the development of a shotgun that hinged open at the breech and fired a cartridge containing powder, shot and its own integral ignition. By 1860, British gun makers had improved breech loaders to the extent that sportsmen were able to shoot as fast as they could load Eley's new composite cartridge. The breech loader heralded a shooting bonanza here and, until the First World War, in Europe. It was the era of the great shooting house parties with landowners creating habitat for game cover which not only became a defining feature of the landscape, but provided us with a conservation legacy that benefits all wildlife species. Royalty led the way with Queen Victoria developing the shoot at Windsor and the future Edward VII purchasing Sandringham in 1860. His pioneering example in game management was followed on many other great estates and names such as Merton Hall, the seat of Lord Walsingham. Elveden, made famous for its shoot by Prince Dhuleep Singh, Lord Albermarle's Quidenham, Chatsworth, Blenheim, Crichel in Dorset, Wellbeck, Combe Abbey, Highclere, Wilton House and, of course, Holkham, where driven shooting started, are only a few of the names that resound through the history of shooting and conservation.

Country Sports

There was equal enthusiasm for shooting in Europe, with exchanges of invitations and ideas among British and European landowners. Bohemia and Hungary were the main attractions, with the estates of Baron Hirsch at St Johann, where Lord Ripon once shot 7,000 partridges in a week, Count Karolyi's estate at Totmagyar, and Count Trautmansdorf's at Jemniste in Bohemia being the plumb invitations, where game swarmed in a landscape of maize strips, arable stubbles and oak woodlands. Baron Hirsch advised Prince Edward on partridge rearing and, after a series of disastrous wet springs towards the end of the 1870s, sent crates of partridges from Hungary to replace the losses at Sandringham. Ever helpful, Baron Hirsch also supplied plans of the enormous game larders at St Johann, on which the ones at Sandringham are based.

Shooting began on the Glorious Twelfth of August, the start of the grouse season, with the great shots of the day shooting on moors such as Dallowgill, Wemmergill, Gunnerside and Blubberhouse in the North of England, Byrecleugh, Priestlaw, Mayshiel, the Hopes, Tollishill, Leadhills and Langholm in the Scottish Borders, or those in Angus and Aberdeenshire. Queen Victoria had put Scotland on the map as a much-sought-after sporting destination when she bought Balmoral in 1850. This could not have happened at a more opportune moment for the Highlands; the era of the Golden Hoof, when flock masters were happy to pay huge rents for sheep grazings on land previously occupied by red deer, came to an abrupt end when wool began to be imported from Australia and the bottom dropped out of the domestic market. In the latter part of the eighteenth century, the red deer population had been rigorously culled to make way for sheep to such an extent that by 1810 only a handful of the today's 450 productive deer forests had any quantity of beasts. Even T.B. Johnson, in his *Sportsman's Cyclopedia* of 1831, referred to red deer as scarce and localised. As sheep left the Highlands, the red deer re-established themselves remarkably quickly on land that would otherwise have been worthless, and stalking developed as a necessary method of wildlife management. With wealthy Victorians wishing to emulate royalty, a railway system covering a journey in hours which had previously taken days, and improvements in rifle making, deer forests became prime land use across the Highlands. By the end of the nineteenth century, the area covered by deer forests had risen to 2 million hectares and shooting lodges had been built all over the Highlands. Today, 37 per cent of Scotland's land mass supports a red deer breeding population of over 350,000, with stalking playing a vital part in the economy and rural infrastructure.

During the late Victorian and Edwardian era, gun making made huge strides forward, as competing gun makers employed all their versatility and creativity in precision engineering to meet the challenge of multiple shots at streams of fast-

> WITH WEALTHY VICTORIANS WISHING TO EMULATE ROYALTY, A RAILWAY SYSTEM COVERING A JOURNEY IN HOURS WHICH HAD PREVIOUSLY TAKEN DAYS, AND IMPROVEMENTS IN RIFLE MAKING, DEER FORESTS BECAME PRIME LAND USE ACROSS THE HIGHLANDS. BY THE END OF THE NINETEENTH CENTURY, THE AREA COVERED BY DEER FORESTS HAD RISEN TO 2 MILLION HECTARES.

flying, driven birds. Hammers, which had previously been on the outside of guns, became housed within the action casing; ejectors were developed which speeded up loading. Smokeless nitro powder replaced the old, smelly black powder which had left clouds of sulphurous smoke. Barrel lengths and choke were a topic endlessly debated. It was a period of ceaseless experimentation and technological improvement, and by 1900 the shotgun had reached a peak of perfection in design and craftsmanship that has remained more or less unaltered to this day. There was a worldwide demand for English-made guns during this period and hundreds of gun makers set up businesses in London and Birmingham. The finest guns were works of art, built by London gun makers such as Purdey, Boss, Lancaster, Evans, Lang, Grant, Atkin, Holland and Holland, Watson, Woodward, Beesley and, later, Churchill; or Dickson and McNaughton in Edinburgh. A Gun on a big driven day would require two guns and a loader, and it quickly became the fashion to have a matched pair made with identical engraving on the actions.

Hundreds of hours of painstaking craftsmanship went into making and fitting a gun, but the engravers' work would double its value. The intricate fine or bold bouquet, rose or acanthus scrollwork, or vignettes of game scenes, some with delicate gold inlays, were laboriously gouged out of the action with tiny hand-held chisels. Many of the best London guns made in the late nineteenth century are still in use today, their value increased by 500 times their original price. During the years of post-war austerity in the 1950s and 60s, many of the great London gun makers ceased trading, with only Holland and Holland, Purdey and Boss continuing to make a limited number of guns, mainly for the overseas market. Since the 1980s, there has been a resurgence of demand for handmade guns both here and abroad. Prices for a pair of new 12-bore game guns from Purdey start at £132,000, to which can be added various levels of engraving. This starts at about £3,000 per gun, rising to as much as £70,000 for engraving by one of the three world-famous engravers: Phil Coggan, Alan Brown or Ken Hunt. A number of different craftsmen are involved in making a bespoke gun; actioners, barrellers, stockists, finishers, ejector makers, trigger makers and engravers. Purdeys make around sixty bespoke guns a year, of which perhaps four will be at the top end of the market, and although these may be bought by collectors simply as investments the others will be used in the field.

Shotguns for game shooting are traditionally made in 12-bore calibre with two and a half inch chambers. Some people prefer 16-bore – I shot with one for many years, and more recently the lighter 20-bore has become very popular with the increasing number of lady shots. In the nineteenth century, Birmingham gun makers such as Tolley, Reilly and Greener made big-bore shotguns specifically for wildfowling, in 10-, 8- or colossal 4-bore calibre.

WILDFOWLING

If I had to choose one category of shooting above all others I would unhesitatingly pick wildfowling. To me, it offers everything that I love about nature and wildlife; it takes place at a time of day when the rest of the nation are still abed and in areas that are unspoilt, remote and uncivilised. Even the north Kent marshes, which run beside the Thames and are surrounded on all sides by urban development and industrialisation, become isolated and very lonely when light begins to fade and a bone-chilling river mist creeps over the sea wall, obliterating every landmark.

The fascination with wildfowling started in my childhood when my father packed to go north, 'fowling on the Tay. The excitement and sense of adventure were infectious and I would watch mesmerised as he assembled the oiled wool seaman's socks, string vests, jerseys, long johns with buttons up the ankle, Balaclava helmet, leather jerkin, corduroy breeches and long, camouflaged canvas smock with breast pockets, deep hood and curious strap that buckled between the legs, black rubber thigh waders, game bag, compass and otter hunting pole, and lastly, and best of all, the massive, double-barreled, Reilly 8-bore hammer gun in its leg o' mutton leather gun case and the boxes of fat dark-red cartridges. Bustling around his dressing room, he described the flat, snow-covered fields of the Carse of Gowrie running down to vast reed beds beside the Tay; crouching on the edge of them with his black Labrador, Pilot, in the darkness of a freezing early morning, listening to the reeds rustling in the wind and the murmuring of geese out on the mud as he waited for the dawn; the first glints of daylight on the sluggish black water and the sudden clamour and 'whoosh' of wings as geese lifted from their roosts and turned to fly inland, the heart-pumping anticipation as a skein came within range, and the boom and kick of the big gun.

> **MY FATHER HAD A WONDERFUL ABILITY TO CREATE EVOCATIVE PICTURES OF THE MARSHES HE LOVED: THE HUGE LAPIS LAZULI SKIES AS THE DAWN CAME UP, THE EARLY MORNING CRIES OF WATER FOWL AND WADERS, THE IODINE SMELL OF THE SEA AND RUMBLE OF SURF, SUDDEN SEA MISTS AND BITTER COLD. I WOULD LISTEN SPELLBOUND AS HE TOOK ME BACK TO A TIME WHEN A QUARTER OF BRITAIN WAS MARSH, BOG OR WETLAND; A PLACE TEEMING WITH EVERY CONCEIVABLE WILDFOWL.**

My father had a wonderful ability to create evocative pictures of the marshes he loved: the huge lapis lazuli skies as the dawn came up, the early morning cries of water fowl and waders, the iodine smell of the sea and rumble of surf, sudden sea mists and bitter cold. I would listen spellbound as he took me back to a time when a quarter of Britain was marsh, bog or wetland; a place teeming with every conceivable wildfowl, all of which migrated south every winter to escape the freezing temperatures in Iceland, Greenland or northern Europe. He would explain how the tide, weather and the phases of the moon influence the movement of wildfowl and the way in which the wetlands had been harvested for centuries with nets, decoys and hawks. He told me about the invention of firearms and the solitary men in sealskin caps and leather waders, stinking of the goose grease they used as protection against the cold, who struggled to make a living from the salt marshes or out in the estuaries

with their big-bore guns, supplying the growing towns with wildfowl. He described the pressure on these wildfowlers to meet the demands of the escalating urban populations and their efforts to increase the number of birds shot. One of these was attempting to approach rafts of duck roosting on water in a small boat similar to a canoe, with what amounted to a small cannon attached to the front. The danger in operating a shallow draft boat at sea was extreme and the chance of a successful shot remote, but necessity is the mother of invention and poor market gunners regularly risked their lives trying to earn a living.

> THE DANGER IN OPERATING A SHALLOW DRAFT BOAT AT SEA WAS EXTREME AND THE CHANCE OF A SUCCESSFUL SHOT REMOTE, BUT NECESSITY IS THE MOTHER OF INVENTION AND POOR MARKET GUNNERS REGULARLY RISKED THEIR LIVES TRYING TO EARN A LIVING.

In the early nineteenth century, the mystique of wildfowling began to attract the attention of sporting naturalists, and among the first was Colonel Peter Hawker, author of *Instructions to Young Sportsmen in All That Relates to Guns and Shooting* (1814). Hawker was also the first person to import Newfoundland dogs from Canada and train them as retrievers. These dogs, and the lesser Newfoundland or St John's Dog, were used by fishermen to haul in nets on the Canadian cod banks. At about the same time, the Earl of Malmesbury acquired a breeding foundation of St John's Dogs, which were the ancestors of our ubiquitous and ever-popular Labrador retriever. For the next fifty years, Hawker's book, which achieved its tenth reprint just before his death in 1852, was unrivalled as the authority on wildfowling and responsible for capturing the imagination of people such as Sir Ralph Payne-Gallwey, Lewis Clement, John Guille Millais, the Rev. Hely Hutchinson and Abel Chapman. These are only a fraction of those who found the lure of the marshes irresistible and found kindred spirits among the puntsmen or longshore gunners, and who wrote vividly of their experiences.

Towards the end of the century, marsh habitat was becoming endangered through escalating agricultural reclamations and the wildfowl endangered from indiscriminate shooting on the foreshore. Most foreshores, the area of land between high and low tide on which there is a right of free shooting, belong to the Crown – a concession intended to give the working man access to fish and a few wildfowl. This was increasingly abused, particularly on marshes anywhere near large cities. With the arrival of the railways, few marshes were far away and there was no one to control the numbers of people shooting or stop the unscrupulous digging hides on the shore and indiscriminately shooting geese as they came in to roost.

In 1908 concerned wildfowlers, led by Stanley Duncan, an engineer who hunted the marshes around Sunk Island on the Humber, founded the Wildfowlers' Association of Great Britain and Ireland, with Sir Ralph Payne-Gallwey as President. Wildfowlers were encouraged to form clubs and acquire the shooting rights on the Crown foreshore and any neighbouring marshes. Their aim was to bring the foreshore and the marshes under the control of responsible people, whose love of wildfowl would ensure the conservation of bird life whilst enabling a traditional pot hunting sport to continue. From the first meeting in Stanley Duncan's black hut at Patrington Haven, which he used for his wildfowling trips, WAGBI

grew into an organisation which set standards for wetland conservation that have since been emulated in Europe, America, Canada, Australia and New Zealand. In 1981, WAGBI expanded to encompass all shooting and conservation issues, changing its name to the British Association for Shooting and Conservation. BASC now (2009) has a membership of 130,000, with over 1,600 affiliated clubs and shooting syndicates, of which 200 are wildfowling clubs. The Association is represented on, or works in partnership with, all other major conservation bodies here and in Europe. It has been thanks to the efforts of WAGBI that an ancient part of our sporting heritage has been preserved. Through them I, and hundreds of others, have game books full of treasured memories. More importantly, wildfowling is accessible to anyone interested, with all the help and advice needed to make a start available from BASC and individual wildfowling clubs.

BEATING

It is not necessary to shoot to be part of the enjoyment of a shooting day, and one of the ways of becoming involved in a rural community is by offering one's services as a beater on the local shoot. There are driven shoots of one sort or another in practically every part of Britain and all of them need beaters during the season. It is a delightful way for people of either sex and any background to spend a day in the countryside. Manoeuvring quantities of game birds to fly over guns is a fascinating exercise, particularly with grouse, where the topography of the landscape and wind direction are all complicated determining factors.

Beating is a wonderful method of educating boys and girls in the ways of wildlife management. For many, it will be their first opportunity to earn some pocket money in a healthy and wholesome occupation, in the company of responsible adults whose ambition is to introduce a new generation to their rural heritage. An extension of beating is picking up; every shoot needs pickers up who stand behind the line of guns, mark where birds have fallen and use their dogs to retrieve all the shot game. There is an enormous amount of pleasure and satisfaction to be gained from training and working a retriever, and many newcomers to the countryside have graduated from the beating line to picker up to enjoy a greater sense of involvement on a shooting day.

> BEATING IS A WONDERFUL METHOD OF EDUCATING BOYS AND GIRLS IN THE WAYS OF WILDLIFE MANAGEMENT. FOR MANY, IT WILL BE THEIR FIRST OPPORTUNITY TO EARN SOME POCKET MONEY IN A HEALTHY AND WHOLESOME OCCUPATION, IN THE COMPANY OF RESPONSIBLE ADULTS WHOSE AMBITION IS TO INTRODUCE A NEW GENERATION TO THEIR RURAL HERITAGE.

Some of the bigger lowland and moorland days will be 'double gun' days, in which case a Gun will require a loader. To 'load and exchange' to a Gun on a big day is a highly accomplished art. For example, as a covey of driven grouse approaches a butt, the Gun takes two shots in front, passing the empty gun with his right hand to the loader who simultaneously places the fore end of the second gun into the Gun's left hand, enabling him to turn and take two shots behind the butt as the covey flies past. To appreciate what a highly skilled accomplishment loading is, one must envisage a rapid succession of these manoeuvres synchronised to the phenomenal speed at which grouse are capable of flying. A Gun who shoots regularly on double gun days will usually have the same loader, and the symbiosis between the two, when birds are coming thick and fast is riveting to watch. (Most of the thirty or so shooting schools teach loading, and there are over 500 clay pigeon clubs affiliated to the Clay Pigeon Society who offer advice.) My first job after leaving school was loading for the grouse season on two moors in Perthshire, Farleyer and Foss, owned by Major Neil Ramsay; before I went I spent a day with Mr Gage, the famous shooting instructor at the Holland and Holland shooting ground.

In 2006, the National Organisation of Beaters and Pickers Up was formed to help people become involved with beating and picking up, regardless of whether they had participated before or were complete novices. NOBS operate a registry of available beaters, pickers up and loaders, acting as a link between them and gamekeepers or shoot captains requiring staff on shooting days.

EQUESTRIAN SPORTS

Most people who enjoy country sports are either directly involved or take an active interest in many others in the broad spectrum of rural pursuits. The various different equine disciplines have an enormous following among participants or spectators, of all ages and backgrounds.

By the end of the Second World War it began to look as if we were about to lose our equine heritage and that many of the different breeds which had made British horses famous throughout the world were likely to die out or become endangered species. Except for the ceremonial duties of the Queen's Household Cavalry and the King's Troop Royal Horse Artillery, our cavalry regiments were all mechanised. The day of the heavy horse for farm, dray and forestry work was over, as these wonderful animals were replaced by tractors and lorries. There was no place for the elegant driving breeds, the Cleveland Bays, Yorkshire Coach Horses, the Hackneys and Norfolk Trotters or the hundreds of different types of sturdy vanner, the light draught horses that were once driven by tradesmen in every village, town and city.

It was only among those who hunted or raced and through the amalgamation in 1947 of the Institute of the Horse, the Pony Club and the National Horse Association of Great Britain, to form the British Horse Society, that an interest in equitation was preserved. Through their combined efforts, there has been a progressive growth in equine sports and it is incredible to think that equiculture has become one of the fastest-growing global industries. At least 3 million people in Britain of all ages now ride every year, and 25 per cent of the population – nearly 15.5 million – have some interest in horses. In 2009, the number of horses in the UK exceeded 1 million, with 730,000 households having responsibility for the daily upkeep of a horse – this is an increase of 20 per cent on 1999 figures. Around 250,000 people are employed in an industry which covers equine products, blacksmiths, clothing businesses, veterinaries, horse box manufacturers, corporate event organisers, builders, riding schools, saddlers and feed merchants. Among them, they generate an income of £3.5 billion per annum.

Every discipline in the history of equitation, and several new ones, have their devoted following. There is the complicated and ancient art form of Haute Ecole, as well as eventing (the triathlon of the equestrian world, which combines show jumping, cross-country and dressage), polo and polocrosse, long-distance endurance riding and, among the young, the increasingly trendy Mounted Gymkhana Games. Carriage driving is enjoying a huge resurgence of interest; heavy horses are now being used again for timber extraction and, since it was banned under the Hunting Act 2004, foxhunting, the bedrock of racing, has attracted bigger mounted fields than ever before. Riding holidays, ranging from basic pony trekking in beautiful parts of the British countryside to mounted adventures in Africa, South America, Mongolia and unexplored parts of the old Eastern Bloc countries, are increasingly popular.

In the 1960s, a number of independent bodies began to provide riding as a form of therapy for disabled people, particularly those from urban backgrounds. My mother, among many other volunteers, was much involved in this movement, and in 1969 the charity Riding for the Disabled was formed. This and the sister charity, Driving for the Disabled, now have more than 500 member groups run by

18,000 volunteers who provide more than 25,000 disabled adults and children with the opportunity to enjoy riding or carriage driving.

There are hundreds of spectator events throughout the year: point-to-point meetings, cross-country team chases, hunter trials and Pony Club gymkhanas organized by the 200 or so foxhound packs, one-, two- and three-day events, the magnificent international spectacles of the Badminton and Burghley horse trials, polo or polo-cross tournaments and carriage driving competitions.

THE ANNUAL APPLEBY FAIR

Among the great historical equine spectacles are the few remaining gypsy horse fairs of which Appleby in Westmoreland is the largest in Europe and best known. This is held every year in early June and has taken place since the reign of James II, who granted a Royal charter in 1685 allowing a horse fair *'near to the River Eden'*.

The fair starts on the first Thursday in June and ends on the second Wednesday with around 10,000 gypsies from all over Britain and Ireland, and many hundreds of coloured horses, converging on Gallows Hill outside the town. Here they establish a sprawling camp of traditional wooden, horse-drawn 'vardos' and gleaming modern caravans, with every shape and size of horse and pony (even the odd donkey) tethered along roadside verges or to the back of cars and lorries. A horse worth thousands could be tied up next to one that will sell for less than a hundred, and through the wheeling and dealing that goes on day and night the same horse might be sold several times.

From early morning, droves of horses are ridden down from Gallows Hill, weaving their way through the traffic to the centre of Appleby where they are swum in the River Eden, then have their legs rubbed with sawdust to make the hair stand out, before being 'flashed' along Flashing Lane. Here, a constant stream of horses, some driven in trotting rigs, others ridden bareback, are hammered up and down the lane in front of crowds of potential buyers. Elsewhere stalls sell junk food, gawdy crockery and every conceivable type of horse accoutrements from driving whips to horse brasses, with, of course, no shortage of fortune-tellers and palm-readers. At night, the Hill is lit by the flickering lights of hundreds of camp fires as the community parties. With so many gypsies in one place and a historical culture of machoism among the young bucks, an electric atmosphere dominates, with a flavour of the riotous indiscipline that attended the horse fairs in the Georgian and Victorian era.

There are other horse fairs at places such as Lee Gap near West Ardsley, in Yorkshire, which claims to be the oldest, protected under a Royal Charter dating from 1136. There are also one day bi-annual horse fairs at Stow-in-the-Wold, Yarm Horse Fair, Llanbydder in Carmarthenshire, Ballyclare and Mounthill in Northern Ireland or Brigg in Lincolnshire, which dates from a Royal Charter of 1235:

> *It was on the fifth of August, the weather hot and fair,*
> *Unto Brigg Fair I did-e-repair, for love I was inclined.*
> *I got up with the lark in the morning with my heart full of glee,*
> *Expecting there to meet-e-my dear, long time I wished to see.*
> Old Folksong

THE PONY CLUB

Any parent of a child wishing to learn to ride can do no better than contact their local branch of the Pony Club. On 1 November 1929, the Institute of the Horse started a Junior Branch of their organisation, known as the Pony Club, 'for the purpose of interesting young people in riding and sport and at the same time offering the opportunity of higher instruction in this direction than many of them can obtain individually'. Under the new scheme, the country was divided into districts based on the hunting country of each Hunt and affiliated to them. The first to be formed was the North and South Shropshire Hunt branch, and this was quickly followed by the Belvoir, Cottesmore, Craven, Essex Union and Essex, Fernie, Grafton, Ludlow, Surrey and Burstow, Vale of White Horse and Wynstay.

Today (2010) the Pony Club is an international organization with a worldwide membership responsible for encouraging the ever-growing interest in riding among the young. Members have the opportunity to learn the learn equine welfare and the broad spectrum of equine skills, from hunting, tetrathlon, show jumping, polo, polocrosse, mounted gymkhana games, eventing and dressage. In Britain alone there are around 350 branches organising programmes of competitions, training days, paper trails, gymkhanas and the annual Pony Club camps.

The beauty of the Pony Club is that it encompasses children from urban as well as rural backgrounds and you do not necessarily need to own your own pony to be a member. Apart from gaining riding skills and a sound knowledge of horses from experts in the field, the Pony Club has provided generations of young people with a very special social experience, based on competitive fun, education, friendship and the priceless responsibility of looking after the well-being of an animal. Nearly all the members of the British Olympic equestrian team over the last fifty years started their careers as Pony Club members. There are just as many opportunities for adults to learn to ride and become involved in equine sports, from hunting to carriage driving, as there are for children. The British Horse Society is dedicated to pointing anyone interested in the right direction, offering lists of recommended riding schools and livery yards, and where to seek the best advice on how to set about buying a suitable mount.

BREEDING HUNTERS

It is astonishing to think that each of the 5,000 Thoroughbred foals born in Great Britain every year, and over 11,000 worldwide, can trace its ancestry back, through the sire's line, to one of three horses imported during the wave of enthusiasm for racing which gripped Britain in the years following the Restoration of Charles II. Eastern horses were acknowledged as having all the qualities of speed and stamina needed to improve the existing British racehorses, and buyers were sent to the Middle East to acquire Syrian and Turkish stallions. Some of these were to become quite famous as sires: the Alcock Arabian, D'Arcy's White Turk, Leedes Arabian, Curwen's Bay Barb and the Brownlow Turk were all credited with being responsible for the grey coat colour in Thoroughbreds. However, the three recognised as being the foundation stock of all modern Thoroughbred racehorses are the Byerley Turk, captured from the Turks by Captain Robert Byerley in 1686 at the Battle of Buda; the Darley Arabian, bought by Thomas Darley of Aldby Park, in Aleppo, Syria, in 1704 and brought back to the family seat in North Yorkshire; and the Godolphin Arabian, bought in 1729 by the Earl of Godolphin.

> IT IS ASTONISHING TO THINK THAT EACH OF THE 5,000 THOROUGHBRED FOALS BORN IN GREAT BRITAIN EVERY YEAR AND OVER 11,000 WORLDWIDE, CAN TRACE THEIR ANCESTRY BACK, THROUGH THE SIRE'S LINE, TO ONE OF THREE HORSES IMPORTED DURING THE WAVE OF ENTHUSIASM FOR RACING WHICH GRIPPED BRITAIN IN THE YEARS FOLLOWING THE RESTORATION OF CHARLES II.

There are dozens of different hunter types bred to suit the topography of different hunting countries, whether in Britain or abroad. A glance through *Baily's Hunting Directory* – the annual registry since 1895 of Hunts and hunting worldwide – gives an indication of what type of hunter is likely to go well and where: a three-quarter-bred or clever hill pony is needed for hunting in the hills of Northumberland with the Border, College Valley and North Tyne, or on Exmoor with the Devon and Somerset Staghounds; a good, breedy jumper for the Shropshire clay, woodland and trappy obstacles in the Wheatland country, but less blood and more sense when hunting on the Devon moors with the Lamerton; a bold blood horse for the Pytchely, a seven-eighths breed that can jump for the Bedale; and a short-legged, active, sure-footed, clever animal for the rocky dingles and wet hill going with the Goathland. Should one be hunting with the Arapahoe Hunt in America or the Equipagem De Santo Huberto in Portugal, a strong Thoroughbred-type horse with speed and endurance is recommended.

My father bred lightweight hunters and eventers by putting Welsh cob mares to Thoroughbred stallions and crossing their progeny back to Thoroughbred, to produce three-quarter breds. He was a big man and also bred heavy hunters for himself, taking brood mares to the Royal Mews in the late sixties, when the magnificent Cleveland Bay stallion, Mulgrave Supreme, was standing at stud. I have six oil paintings of hunters that belonged to my grandparents just before the war, painted by the equestrian artist Frances Mabel Hollams on her favourite material, wooden tea chest tops. Three are bays which my grandfather hunted, big horses

standing seventeen hands (the measurement for a hand is four inches, so called from the width of a palm); while the others are finer and lighter, sixteen hands or a little over which my grandmother hunted side-saddle. Hollams painted them standing poised, on sound open feet, tacked up and ready to go, their ears cocked forward and bright intelligent eyes searching the distance. They are classic examples of their type, possessing the substance of their draught forebears with enough Thoroughbred blood to give quality. Their withers are well developed, with broad, muscular backs and that little arch at the loins that suggests a first-rate fencer. The shoulders are long and sloping with just a hint of shoulder blade showing through the skin, suggesting a long galloping stride; well-hooped ribs, deep, powerful quarters and large, clean hocks. Any of these would be recognisable as the sort bred by my father, or the hundreds of those bred by hunter breeders today.

HUNTING

My sister and I were very privileged to have had an upbringing where horses were part of everyday life; in fact one of the earliest photographs of me is seated in a sort of wicker basket on a pony aged, I suppose, about one year old. The next in the equestrian series was of my first day hunting with the Old Surrey and Burstow, aged four, when I was blooded by that great Huntsman, Jack Champion.

We still had heavy horses on the farm in the early fifties, both my parents hunted and my father bred hunters and eventers. A hunter combines the best qualities of other breeds to produce a horse for a specific purpose. The most common foundation stock for several centuries has been Irish Draught or something of similar type, which provides bone, substance and an honest, steady nature, crossed with a Thoroughbred to impart that breed's easy riding action, refinement, greater endurance and better shoulder conformation.

In 2009 there were 320 hound packs in England, Wales and Scotland registered with their regulatory bodies, the Masters of Foxhounds Association, the Association of Masters of Harriers and Beagles, the Masters of Deer Hounds Association, the Association of Masters of Harriers and Beagles, the Masters of Basset Hounds Association, the Masters of Mink Hounds Association and the Central Committee of Fell Packs. Of these, the three Staghound packs, twenty Harrier packs and 185 Foxhound packs own around 850 horses, which are provided for Hunt staff. Over the course of the season, the total annual 'attendance' at all meets of hounds amounts to 1,300,000 people, of which 550,000 will be mounted.

WE HAVE A DEEPLY ENTRENCHED CULTURAL HERITAGE OF HUNTING WITH HOUNDS THAT GOES BACK TO CLASSICAL TIMES.

We have a deeply entrenched cultural heritage of hunting with hounds that goes back to Classical times. Many people believe the Normans introduced hunting as we know it today, forgetting that the Celts hunted deer, fox and hare with their little Segusian hounds, the ancestor of the beagle, that the Romans brought with them greyhounds for coursing brown hares, and the Britons and Romano-British bred the celebrated rough-coated Agassaean, from which both the Welsh and Breton Hounds descend. New, superior hound breeds, the manners and language of hunting and chivalric respect for the quarry which persists to this day were a result of the Norman Conquest when, for 300 years, Britain became an integral part of Europe and largely indistinguishable from other countries. The Normans also introduced the system of Royal Forests and a codification of the principal Beasts of Venery – the Hart, the Hare, the Boar and the Wolf; these remained the 'Noble' quarry species and the prerogative of the monarch, his nobles and the clergy. Vermin such as foxes were smoked from their earths or bolted with terriers either into nets or, if there was open ground, to lurchers.

Changes in hunting came as a result of the Black Death in 1349, which halved the population and freed the serf from land tenure by servitude, putting him in a seller's market for his labour. The late fourteenth and fifteenth centuries saw the rise of the yeoman, the squire and the wealthy merchant setting himself up as a country gentleman. The new landowners used their power in Parliament to change

the game laws from the old Forest Laws protecting the rights of the King to laws protecting the rights of the gentry. From 1390, the hunting and the taking of game was restricted '*to any layman having in lands forty shillings per annum or any priest or clerk with ten pounds living per annum*'. The right to hunt was now qualified simply by income and created the special character and defining feature of British field sports: there was no class distinction. In theory and in practice, an affluent yeoman could hunt as freely as his armigerous neighbour and there was nothing to stop a man not wealthy enough to own his own hounds from riding to someone else's. A small tenant farmer or tradesman with sufficient income could, and did, follow hounds on equal terms with the rest of the field – except, of course, the Master of Hounds.

Some of the new landowners were socially ambitious and established deer parks, indulging in the pomp, ceremony and expense of keeping an establishment of deer hounds. Most were without pretensions and, except in areas such as the West Country and parts of Cumberland where red deer were naturally plentiful, quite content to hunt hare with deep-scenting Gascon hounds, and occasionally fox, with small, active brachets. Hare coursing with greyhounds, freed from the medieval limitations of previous generations, was increasingly popular, and most squirearchal kennels had a leash of gaze hounds. Otters were assiduously hunted to protect fish stocks as they had been since long before Roger Follo was created King's Otter Hunter by Henry II in 1175.

There was a resurgence of popularity in the stylised ritual of deer hunting among royalty, nobility and the wealthy during the Tudor period, but unlike the Continent, where it was restricted to the aristocracy, hunting in Britain was as much a sport of the squire and yeoman as it was of King and noble. Hare hunting and coursing remained the popular sport of squires, but by the mid-sixteenth century, as foxes became an increasing agricultural pest, hounds began to be bred specifically for them. They also began to appear in literature for the first time as a respected quarry species. George Tuberville devotes some literary space to foxes in *The Noble Art* (1576), as does Sir Thomas Cockaine in *A Short Treatise of Hunting* (1591) and Gervase Markham in *Country Contentments* (1611).

Park deer had been released during the Civil War, and with the beginnings of agricultural improvement and enclosures after the Restoration, the herds of fallow, red and roe deer began to lose their status as quarry species and were rigorously culled as pests. Towards the end of the seventeenth century, the fox population expanded and hunting them became an increasingly popular and necessary method of management. The Duke of Monmouth and Lord Grey were hunting solely the fox by 1670, at Charlton in Sussex. Mr Monson of Burton was hunting them in 1672 and Mr Pelham of Brocklesby at about the same time. In 1680 George Villiers, the

> IN THEORY AND IN PRACTICE, AN AFFLUENT YEOMAN COULD HUNT AS FREELY AS HIS ARMIGEROUS NEIGHBOUR AND THERE WAS NOTHING TO STOP A MAN NOT WEALTHY ENOUGH TO OWN HIS OWN HOUNDS FROM RIDING TO SOMEONE ELSE'S. A SMALL TENANT FARMER OR TRADESMAN WITH SUFFICIENT INCOME COULD, AND DID, FOLLOW HOUNDS ON EQUAL TERMS WITH THE REST OF THE FIELD.

2nd Duke of Villiers, was finally expelled from court and passed his exile hunting fox with his tenants on his Yorkshire estates, in what is now the Bilsdale Hunt country. Lord Arundell had Foxhounds at Wardour Castle, Wiltshire, from 1696, Mr Boothby of Tooley Park, Leicestershire, from 1697, and Mr Orlebar of Hilnwick Park, Northamptonshire, by 1702. Except in the open hill country of the north, where a small fast 'Ribble' hound developed, hounds were slow, deep-scenting creatures, not fast enough to catch a fox above ground, and were used in conjunction with lurchers, much as they are in parts of Wales today, or they 'unkennelled' the fox early in the morning when he was still torpid from his night's feed and hunted him slowly and methodically from covert to covert. The red deer herds were managed with hounds in the West Country; hare hunting and coursing remained popular, otters were controlled as before and on the fells of Cumberland farmers in different districts kept a couple of fox hounds each which were packed together on the day and hunted on foot.

> HOUNDS WERE SLOW, DEEP-SCENTING CREATURES, NOT FAST ENOUGH TO CATCH A FOX ABOVE GROUND AND WERE USED IN CONJUNCTION WITH LURCHERS, MUCH AS THEY ARE IN PARTS OF WALES TODAY, OR THEY 'UNKENNELLED' THE FOX EARLY IN THE MORNING WHEN HE WAS STILL TORPID FROM HIS NIGHT'S FEED AND HUNTED HIM SLOWLY AND METHODICALLY.

Fox hunting recruited steadily all over Britain during the eighteenth century, attracting great nobles such as the Dukes of Rutland, Richmond and Grafton, as well as the Earls of Craven, Spencer, Fitzwilliam, Scarborough, Coventry, Carlisle and Gainsborough, to name only a few. There was no shortage of wealthy hunting squires: Noel in Rutland, Chaworth in Nottinghamshire, Evelyn in Hampshire, Fownes in Dorset, Calvert in Hertfordshire, Slingsby, Darley, Fox Lane, Bright and Draper in Yorkshire. At the same time, more packs of Foxhounds were sent to America, most notably for Lord Fairfax, George Washington and Thomas Jefferson. Great sporting artists such as James Seymour, John Wootton, Peter Tilleman, Sawrey Gilpin and George Stubbs found inspiration in the pageantry of hunting, as did George Morland, Philip Reinagle, Benjamin Marshall and J. F. Herring. These are only a fraction of the artists, in the encyclopedia of sporting art, which includes people such as Cecil Alden, Lionel Edwards, Sir Alfred Munnings, Elizabeth Sharp and Tania Still who have been inspired by horse, hound and hunting.

By the middle of the eighteenth century the landscape, especially in East Anglia and the Midlands, was being transformed by enclosures and agricultural improvements, hedge and shelterbelt planting. This created an environment where a fox could travel fast across country, and although the influence of Eastern stallions imported fifty years earlier had produced stronger, faster horses, hounds were still the slow, steady line hunters of old. Much time and effort was devoted to improved hound breeding, but two people in particular were responsible for introducing changes which created fox hunting as it is known today: Hugo Meynell of Quorndon Hall, in Leicestershire, and Peter Beckford of Stapleton, in Dorset. Meynell started the practice of drawing in the middle of the morning rather than at daybreak, and both selectively bred hounds for drive and dash. The rolling

Leicestershire country that Meynell hunted was all grass and hedges in those days, and sporting pilgrims came from all over the country to enjoy this new, fast hunting with all the thrill of plenty of jumping and to study Meynell's science in hunting the new breed of hounds. From this grew the special character of hunting in the Shires and the development of the archetypal Leicestershire Hunter – a bold blood horse, with plenty of stamina, which could jump well. In 1796 Peter Beckford, equally as famous for his hound breeding, wrote what was to become the bible for all Masters of Foxhounds, *Thoughts Upon Hare and Fox Hunting,* starting a flood of hunting literature which continues to this day.

The popularity of hunting spread during the nineteenth century, thanks largely to the railways, which increased the volume of urban people either hunting or following hounds on foot. For the first time, hare, fox, stag and otter hunting enjoyed the participation of urban visitors as much as country residents. This was a very welcome addition to hunting finances; maintaining a pack of hounds is an expensive business and by the middle of the century all but a very few packs were dependent on the annual subscriptions of their followers. The ability to travel about the country with unprecedented ease led to a massive growth of interest in match coursing, with clubs coursing under National Coursing Club rules springing up all over the country.

HARE COURSING

In this sport, under National Coursing Club rules, two greyhounds – the fastest breed of dog – are matched against a hare – the fastest and most agile animal in the natural world.

The ethos of match coursing has remained unaltered since long before Arrian, a Roman living in the first century AD, observed that *'the aim of true sportsmen with hounds is not to take the hare, but to engage her in a racing contest, or duel, and he is pleased if she escapes'*. Hares are driven from a wide area of land towards a large field known as the 'running ground'. This has a number of 'soughs' – stone-built underground chambers into which the hare can escape if it feels hard pressed. Hares are driven into a field adjacent to the running ground where they sit quietly until a sufficient number have built up. A line of beaters moves slowly forward, pushing hares singly onto the running field. Positioned fifty metres into the field is a shy, containing the slipper, a trained official licensed by the NCC with the two greyhounds.

Match coursing is essentially a betting sport, and the slipper has the responsibility of deciding whether the hare is fit to course and must study her closely as she approaches the shy. As she passes the shy he must make his decision – only about one in three of the hares that come onto the running field would be coursed – and if he is satisfied the hare is fit and not carrying excess mud, he runs forward with the greyhounds joined by double collars which can be released simultaneously. The hare is given never less than a 75-metre lead – 'the law' – and once both greyhounds are properly sighted, the double collar is released.

The course probably lasts less than a minute before the hare disappears into a sough or leaves the running field, and is an incredible display of speed and agility; a hare has 80 per cent rear vision and is capable of turning in its own length without losing momentum. A mounted judge awards points for, in very simplistic terms, speed and the ability to make the hare turn. The Blue Riband of coursing, from 1837 until it was banned under the Hunting Act 2004, was the 64-dog Waterloo Cup, held on the marshes at Altcar near Liverpool over three days. This was attended by over 100,000 people every year; a railway line was laid from Liverpool to Altcar specifically for the benefit of spectators, and a steeplechase circuit was built at Aintree where the Grand National is run, to provide the crowd with another day's entertainment once the Cup was over. At the turn of the century, prize money for the Waterloo Cup was equal to the winner of the Derby.

Country Sports

THE IMPORTANCE OF HUNTING FOR THE WIDER COMMUNITY

The veterinary opinion, supported by 500 members of the Royal College of Veterinary Surgeons, confirmed that hunting by hounds was the natural, balanced, biological method of controlling wildlife, proven over the centuries and the most humane way of managing the population of deer, fox, hare and mink. Hunts employ Hunt staff to provide this service to the rural community, and on a hunting day the Huntsman and his whippers-in are the only people hunting the quarry species. Beyond this vermin control service, Hunts provide a vital role as a social communicant in rural areas and are responsible for large areas habitat conservation.

> THE VETERINARY OPINION, SUPPORTED BY 500 MEMBERS OF THE ROYAL COLLEGE OF VETERINARY SURGEONS, CONFIRMED THAT HUNTING BY HOUNDS WAS THE NATURAL, BALANCED, BIOLOGICAL METHOD OF CONTROLLING WILDLIFE, PROVEN OVER THE CENTURIES AND THE MOST HUMANE WAY OF MANAGING THE POPULATION OF DEER, FOX, HARE AND MINK.

The advent of the motor car made all types of hunting even more accessible to townspeople and led to the formation of Hunt Supporter Clubs. The members of these clubs are actively involved in organising many of the social events that have always been such a vital part of rural life and now have an important role in educating the general public. Hunts provide over 4,000 social and equestrian functions every year, attended by more than 1.5 million people, raising in the region of £5 million, a considerable proportion of which is donated to charity.

Over 200 Hunts offer a dead stock removal service, which is of enormous value to the farmers in their country who would otherwise have to pay for their disposal, collecting around 400,000 carcasses a year. Hunting generates some £15 million directly to the economy and provides employment to around 10,000 people. Of the 320 hound backs recognised by their various regulatory bodies, 187 are foxhound packs and twenty are harrier packs – hare hounds which have a mounted following. Three are deer packs, seventy-two are beagle and ten are basset packs. There are nine fell packs, which hunt fox on foot in the Cumbrian Fells and twenty packs of mink hounds.

In 1977, the Masters of Otter Hounds Association passed a voluntary moratorium on hunting otters after the population was decimated by agricultural pesticides, particularly Dieldrin, which accumulated in the tissues of freshwater fish. Otter habitat was quickly colonised by American Mink, most of which had been released from fur farms by animal activists. Unlike otters, mink predate a considerable distance from water and can climb trees. They have a varied diet which includes anything smaller than themselves and have been largely contributory to water voles being virtually wiped out. Controlling mink with hounds has proved to be the most effective method of damage limitation to bankside wildlife.

Between them, Hunts have a total registered hunting country amounting to 1,400 square miles. Perhaps a quarter of this is not hunted for reasons of safety – motorways, roads, railways and development; only 3 per cent is not hunted because

permission is denied. The majority own their property, some of which are of great architectural merit. These include 200 kennels and stabling, 152 slaughterhouses, 150 incinerators, 310 houses and sixty-five flats to provide accommodation for employees. Added to which, they own about 700 hectares of paddocking, 3,000 acres of covert and are involved in the conservation management of several thousand more.

❋ ❋ ❋

Man has had a responsibility for wildlife since the days when the principal predators became extinct, and controlling vermin by selective culling with hounds has long been accepted as the most compassionate way of dealing with a necessity. Furthermore, it is the only method which gives species the consideration of a closed season, to breed and rear their young undisturbed. Using an Act of Parliament to impose unacceptable alternatives was inhumane, prejudicial and socially divisive.

Acknowledgements

My grateful thanks to Jenny Heller for commissioning this book and to Helena Caldon, for making our months of editing such a pleasure. Cristian Barnett for his superb photography and Martin Reftel his assistant. Chris Wormell for his magnificent illustrations and Simon Gerratt, Myfanwy Vernon-Hunt and Lizzy Gray at HarperCollins.

I owe an immense debt of gratitude to the many individuals and organisations up and down Britain who generously contributed their time to making this book possible.

Walter Jeffrey
Willie and Marita Jeffrey
Tom Lloyd
Jean Allen
P. H. Coate & Son
Andrew Parr
J. & F. J. Baker & Co. Ltd
William Dickson
Maureen Day
The Dorset Buttons
Nick Denyer
Nick Parkes
Holkham Hall Estate
Horace and Tim Batten (Bootmaker Ltd)
Emma Humphreys
Rupert Inglesant MFH
Belvoir Hunt (Duke of Rutland's)
Peter Dent
Helen Goodwin
Hugo and Stanley Wurst
Nigel Beaumont
James Purdey and Sons
Father Kennedy
Lough Neagh Fishermen's
 Cooperative Society

Simon Whitehead
Pakefield Ferrets
George Bowyer MFH
Fitzwilliam Hunt
Kirsten Scheuerl
Speyside Cooperage
T. Tyhurst & Son
David Barber and Nada Jankovic
Dr Luke Dixon
The Hawick Common
 Riding Committee
Angus Laing MFH
Norman Laing MFH
Liddesdale Hunt
Andrew Cartwright
Robbie Cowan
Lantonside Estate
Glynn Cook
Steven Woodhall
Kate and Robert Elliot
Stephen Rendle
Alan Cumming
Lovat Mill
John Mease

Associations

Association of Masters of Harriers and Beagles
Tel: 01242 602564
www.amhb.org.uk

The Basketmakers' Association
www.basketassoc.org

Bat Conservation Trust
Tel: 0845 1300 228
www.bats.org.uk

Border Stick Dressers Association
www.bsda.eu

British Association of Shooting and Conservation
Tel: 01244 573000
www.basc.org.uk

The British Beekeepers' Association
Tel: 02476 696 679
www.britishbee.org.uk

The British Falconers Club
Tel: 01692 404057
www.britishfalconersclub.co.uk

The British Horse Society
Tel: 0844 848 1666
www.bhs.org.uk

British Mycological Society
www.britmycolsoc.org.uk

Clay Pigeon Society
Tel: 01483 485 400
www.cpsa.co.uk

Country & Land Business Association
Tel: 020 7235 0511
www.cla.org.uk

The Countryside Alliance
Tel: 020 7840 9200
www.countryside-alliance.org.uk

Countryside Alliance Campaign for Angling
Tel: 020 7840 9200
www.countryside-alliance.org.uk/the-alliance/our-campaigns/our-angling-campaign

Dry Stone Walling Association of Great Britain
Tel: 015395 67953
www.dswa.org.uk

European Squirrel Initiative
Tel: 01394 386919
www.europeansquirrelinitiative

Federation of City Farms & Community Gardens
Tel: 0117 923 1800
www.farmgarden.org.uk

Federation of Welsh Packs
Tel: 01437 710453

The Field Studies Council
Tel: 0845 3454071
www.field-studies-council.org

Game & Wildlife Conservation Trust
www.gwct.org.uk

Gamekeepers Welfare Trust
Tel: 01677 470180
www.thegamekeeperswelfaretrust.com

Guild of Straw Craftsmen
www.strawcraftsmen.co.uk

The Heather Trust
Tel: 01387 723201
www.heathertrust.co.uk

Hound Trailing Association Ltd
www.houndtrailing.org.uk

Hunt Staff Benefit Society
Tel: 01285 653001
www.mfha.org.uk

London Natural History Society
www.lnhs.org.uk

**National Council of
Master Thatchers Association**
www.ncmta.co.uk

National Coursing Club
www.nationalcoursingclub.org

National Gamekeepers Organisation
Tel: 01833 660869
www.nationalgamekeepers.org.uk

National Hedgelaying Society
www.hedgelaying.org.uk

**National Organisation
of Beaters and Pickers Up**
Tel: 08456 345014
www.nobs.org.uk

National Working Terrier Federation
www.terrierwork.com

The Pony Club
Tel: 02476 698300
www.pcuk.org

Royal Agricultural Benevolent Institution
Tel: 01865 724931
www.rabi.org.uk

Royal Forestry Society
Tel: 01442 822028
www.rfs.org.uk

**Royal Scottish Agricultural
Benevolent Institution**
Tel: 0131 333 1023 or 0131 472 4166
www.rsabi.org.uk

RSPB
Tel: 01767 680551 (office hours)
www.rspb.org.uk

Scottish Crookmakers Association
www.onlineborders.org.uk

Scottish Gamekeepers Association
Tel: 01738 587515
www.scottishgamekeepers.co.uk

The Scout Association
Tel: 0845 300 1818
scouts.org.uk

Slow Food® UK
Tel: 020 7099 1132
www.slowfood.org.uk

Sporting Lucas Terrier Association
www.sportinglucasterrierassociation.co.uk

Tyne Rivers Trust
www.tyneriverstrust.org

Union of Country Sports Workers
Tel: 01295 712719
www.ucsw.org

The Vintners' Company
Tel: 020 7236 1863
www.vintnershall.co.uk

Westcountry Rivers Trust
Tel: 01579 372140
www.tamarconsulting.org/wrt

Wildlife Ark Trust
www.wildlifearktrust.org

The Wildlife Trusts
Tel: 01636 677711
www.wildlifetrusts.org

Woodland Trust
Tel: 01476 581135
www.woodlandtrust.org.uk

The Worshipful Company of Dyers
Tel: 020 7236 7197
www.dyerscompany.co.uk

Worshipful Company of Farriers
Tel: 01923 260747
www.wcf.org.uk

Index

A

abbeys 65–6, 112, 464
Abbot, George 430
Abbots Bromley Horn Dance 400–5
Act for the Preservation of Grain (1566) 281
Act of Elizabethan Religious Settlement 419
Act of Supremacy (1534) 418, 419
Acts of Enclosure
 see Enclosure Acts
adder catchers 285
adders 102, 103, 242, 283–5, 484
 bites 159, 183, 285
 and hedgehogs 281, 285
Aeschylus 544
Aesop's Fables 250
Aethelbert, King 244
Africa 82, 96, 272
Age of Chivalry 535
Agisters 132–3, 137
agistment 132–3
agricultural improvers 75–7, 83, 86, 549
Agricultural Revolution 51, 82, 94, 252, 261, 370, 476, 549
agricultural shows 90–1
agriculture see farming
agri-enviroment schemes 264–6, 320, 485
agrimony (*Agrimonia eupatoria*) 317
Akehurst, Billy 16
Akehurst, Jim 174, 206, 211, 220, 221, 222, 228, 234
Akehurst, Matt 16, 489, 490
Albemarle, Lord 551
Albert, Prince 472
Alden, Cecil 574
alder 106, 113, 442
 timber 118
Alexanders (*Smyrnium olusatrum*) 339–42
alien introductions 253, 308–9
All Hallows Eve 175
All Saints' Day (All Hallows Day) 174, 176
All Souls College, Oxford 429–31
Allendale Tar Barrel Ceremony 425–6
almshouses 413–14
altocumulus clouds 219
alum 4688
Amadou fusees 364
Americas 82, 91, 95–6, 148, 272, 291, 319, 320, 349, 350, 441, 467, 560
ammonia 325, 468
Ancient Tree Hunt 163
Anderson, Jon 539–40
Andrews, F. W. 258
Anglo-Saxon period 480, 535

'black dykes' 40
deer parks 130
enclosures 128
farming 51, 62–4, 112, 128, 137
hedge planting 476
swan eating 406
wool production 464
animal welfare 255–6
Anne, Queen 164
ants 230
apple orchards 96, 156, 194
Appleby Fair 564
April 188–9, 204
arable farming 51, 54, 58–9, 61, 62, 65, 72–4, 111, 252
 commons 71–2
 crops grown 55, 56, 58, 90, 107, 108
 futures contracts 66
 monoculture 272, 293
 Neolithic 107
 set aside 264, 293
Arbor Day, Aston-on-Clum 378–9
ards 55
Argyll, 8th Duke 151
Arrian 579
Arundel, Lord 574
ash 106, 108, 139, 278, 295, 476
 coppice 102, 103, 106, 112, 113, 120
 drawing lightning 218–19
 hedging 477
 in mythology 153–4
 timber 119–20
 woodland 106, 119, 458
Ashdown Forest 54, 71, 102–4, 108, 130, 275
Association of Guilds of Weavers, Spinners and Dyers 473
Athelstan, King 413
Atholl, Dukes of 139
Atlee, Clement 506
atmospheric pressure 211–12
Atropos 298
Aubrey, John 228
August 197, 205
Augustine, St 150, 244, 418, 447
Augustinians 464
aurochs 106
Australia 28, 91, 291, 297, 320, 349, 554, 560
Autumn Equinox 171, 199
Aylesford, Lord 460

B

Bacon, Francis 351, 352
badgers 23, 24, 103, 245, 249, 282–3, 288, 297, 364, 491
 tracks and signs 23, 24, 262
Badger Protection Act (1992) 282
Bagot goat 401
Baily's Hunting Directory 568
Bakewell, Robert 83, 86–7, 142, 549
Balfour, Lady Eve 320
Ballantyne, Peter 539
Balmoral Tweed 472
Ban 242
Bands of Mercy 256
Banks, Anthony 504
barn owls 227, 267
Barnes, Dame Juliana 517–18
barometers 211
Barons' Revolt 134
barrel-making 116–17
Barrymore, Lord 'Hellgate' 86
basil, wild (*Clinopodium vulgare*) 355
basketry 452, 454
Basketmakers' Association 457
Bat Conservation Trust 279, 280
bat detectors 279
Bat Groups 279
Bathgate, Herb 529
bats 226, 242, 245, 277–80
 urban 303
Battle of Britain 283
Bayeux Tapestry 206
beacons 115
Beaker People 107, 437
beating 561
beating the borders 432–3
beavers 242, 252, 309
Beckford, Peter 574, 578
Bedford, Duchess of 20
Bedford, Dukes of 45, 90, 253
Bedford, Earl of 77, 80
Bedfordshire 305
beech 106, 131, 138–9, 147
 coppice 113, 120, 144
 hedging 357, 477
 timber 120–3
bee-friendly gardening 445
beehives 441–2
bee keeping 437–45
bees 157, 204, 205, 230, 242, 296–8, 327
 importance to man 445
beeswax 438–9
Beggar's Bush, Northumberland 50
Beltane 154, 168, 191, 371, 446
Belvoir Oak 164
Benedictines 35, 65–6, 346, 409, 438, 464
Beney, George 253

Bentley family 400
Bentley World Toe Wrestling
 Competition 433
Berkley, Colonel 86
Berlepsch, Baron von 441
Berners, 14th Lord 46–7
Biddenden Dole 414
Biggar, Strathclyde 424–5
bilberries/blaeberries (*Vaccinium myrtillus*)
 317, 350
billhooks 479
birch 106, 137
 timber 123–6
birch polypore 364
birds 266–77
 caged 252
 egg collecting 23, 258, 263
 folklore and myth 242–4
 nesting habits 267–9
 protection 306
 providing nesting sites 268
 taxidermy 257–8
 threats from 305, 306–7
 and weather 212, 225–9, 237, 272–4
 woodland 102
birrus (woollen cloaks) 59
bistort (*Polygonum bistorta*) 344
Black Death 67, 70, 128, 411, 571
black horehound (*Ballota nigra*) 317
blackberries (*Rubus fructicosus*) 20, 199,
 315, 318, 319, 356–7
blackbirds (ouzels) 228
blackcocks 539, 540
black-dykes (devil's dykes, Grim's dykes) 40
blacksmiths 115, 177, 486–90
blackthorn (*Prunus spinosa*) 234, 319, 357,
 442, 476
Blake, William 255
Blue Moons 173
blue tits 268
Boadicea 292
boar 106, 242, 252, 308
 beasts of the Forest 131, 245, 293
'bodgers' 120–3, 144
bog myrtle (*Myrica gale*) 354
Bog Snorkelling Championships,
 Waen Rhydd 433
Bohemia 554
Boke of St Albans 250
Boleyn, Anne 418
boot and shoe trees 123
Boothby, Mr 574
boots, handmade 497–8
Border Stick Dressers Association 461
Boreham, Thomas 250
Boscabel House oak 377
Bothwell, James Hepburn, Earl of 34

Botting, Joe 16, 23, 104, 212, 325–6, 528,
 529, 533–4
Bouguereau, William-Adolphe 467
bovine tuberculosis 282
Boy Scout movement 262
Boynton, Sir Henry, Bt 540
bracken (*Pteridium*) 349–50, 451
brambles 442, 452
Bran 242
Braughing, Hertfordshire 417
bread-wheat farming 60
Brendan, St 148
breweries 116
Bridgeman, Charles 44
Bridgewater Canal 84–5
Bridgewater, Duke of 84–5
Brighton Burning the Clocks festival 433
Brigit 446
Brindley, James 84–5
British Association for Shooting and
 Conservation (BASC) 541, 560
British Beekeepers Association 443
British Falconers Club 539, 540
British Horse Society 563, 567
British National Standard hive 441
British Stickmakers Guild 460
British Trust for Ornithology 308
Broads 35, 451
Broadway Hill Castle 43
bronze 107
Bronze Age 51, 107, 371
 farming 55–6
 felt making 474
 hazel 157
 hedges 476
 hill figures 35, 36, 39, 242
 stone barriers 480
Brooke, Lady Margaret 306
broom (*Cytisus scoparius*) 344–5
Broughton Carr, William 441
Brown, Alan 555
Brown, Lancelot 'Capability' 44–5
Brown, Thomas 269
brown rats 301–3
Buccleuch, Duke of 91
Buchanan, R. 267
Buck Stone 32
Buckfast bees 442
Buckinghamshire 306
Buckstone Moss 32
buildings, timber use 112–13
'Bumblebee Paradox' 298
bumblebees 296–8
Burghead, Murray Forth 425
burial sites 157
burnet (*Poterium sanguisorba*) 352

Burning the Clavie 425
Burning the Old Year Old Out 424
Burns, Bill 256
Burns, Lord 506
bustards 245, 252
butterflies 102, 242, 346
butterfly collecting 23, 258, 263
Byerley Turk 568
Byron, Lord 255

C
Cage, Lyme Park 42
Cailleach 151
Caius, Dr 253
calcium 318, 323, 324, 325, 333, 339
Cambridgeshire 72, 428, 448
 see also Fens
Canada 91, 143, 290, 467, 560
canals 84–5
Candlemas Day 174, 184–5
capercaillie 539
Carless, William 377
Carnarvon, Lord 460
carp 517
carrier pigeons 522
Carr-Lewty, R. A. 271
Carroll, Lewis 291
Carta de Foresta 134
Carter, Mary 379
Carus, Emperor 191
carving 535–6
castles 112
Castro, Fidel 319
Catesby, Robert 419
Catherine of Aragon 372, 418
Catholicism *see* Roman Catholicism
catnip (*Nepeta cataria*) 353
Catrail, Scotland 40
cats 224, 244, 245, 491
cattle 34, 55, 56, 59, 61, 62, 65, 107, 108, 111,
 126, 128, 491
 as weather meters 237
 and wild garlic 312
 Celtic breeds 59
 gorse fodder 346
 hedgehog accusations 281, 295
 new breeds 87
 shrew superstitions 295
cauls 16
causeway camps 55, 107
Celtic calendar 154, 168, 175, 176, 184, 191,
 197, 371, 446–7
Celtic Dyke, Nithsdale 40
Celts 32, 111, 148, 535
 barrel making 116
 bee keeping 437–8
 farming 58–60, 108, 446

586 ⚜ *A Book of Britain*

holly superstitions 151
horseshoes 488
hunting 571
metallurgy 108
nature worship 148, 446
sacred animals 242, 292
sacred trees 126, 148, 151, 358
stone fortifications 480
war chariots 59, 120
woollen industry 464
ceorls 62
ceps (*Boletus edulis*) 362, 366
Cerne Abbas Giant 36
Cernunnos 242, 400, 446
Cerridwen 447
chalk, as top dressing 58–9
Chambers, Sir William 43
Champion, Jack 16, 19, 529, 571
chanterelle (*Cantherella cibarius*) 362, 366–7
Chapman, Abel 559
charcoal 107, 108, 111, 115, 116, 126, 127, 138, 143, 494
charcoal burners 20, 103–4
Charlemagne, Emperor 464
Charles, Prince of Wales 461
Charles I 44, 77, 80, 134, 372, 397
Charles II 81, 82, 118, 138, 304, 352, 374, 377–8, 379, 545, 568
Charles III of France 130
chases 132, 147
Chelsea Pensioners 378
Cheshire 107, 111, 112, 412, 454
Cheviot Hills 20, 35, 464
Chichele, Henry 429
Chichester, Sir Arthur 513
chicken of the woods (*Laetiporus sulphurous*) 362, 367
chickens, and rain 224
chickweed (*Stellaria media*) 328–9, 318
children
 beating (on shoot) 561
 connecting with nature 20–4, 261–3
 ferreting 23, 534
 foraging 19–20, 319
 health 153, 317
 Pony Club 567
 protection 256
children's books 250–1
Chilman, Frank 19, 236, 529–30
Chilterns 120–3, 138–9
Chinese water deer 549
Christian persecutions 177, 180, 183, 189, 192
Christianity
 charity tradition 413
 church weather vanes 206
 conversion of Britain 148, 150, 154, 168, 244–5, 413, 447

Christie, Mr 142
Christmas Day 174, 180
Chulkhurst (Chalkers), Eliza and Mary 414
Church 41, 62, 64, 112, 244, 342, 530
 antagonism to fungi 362
 and bees 438
 classification of animals 245
 and pagan festivals 174, 175, 180, 189, 191, 244, 370, 372, 376, 378
 see also saint's days
Churchill, Winston 283, 304
churchyards 150
'circle of life' 447
cirrus ice clouds 219
Cistercians 29, 51, 65–6, 112, 438, 464, 480
Civil War 80, 134, 138, 156, 397, 400, 517, 538, 573
Clare, John 176, 203, 229, 234, 276
Claudius II, Emperor 186
Clay Pigeon Society 561
Clearwing moths 300
Clement, Lewis 559
Clement VI, Pope 533
climate, historical 55–6, 64, 65, 66, 107
climate change 169, 183, 237–9
clouds 215–20
Clough Newcome, Mr E. 539
clover 81, 90
Clydesdale horses 83
Coachbuilders' associations 120
coaches and carriages 86, 151, 454
Coate family 457
Cockaine, Sir Thomas 573
cockerels 224
 weather vanes 206
Coggan, Phil 555
Coke, Thomas, 1st Earl of Leicester 90, 142, 549, 551
Coleridge, Samuel Taylor 255
collective nouns for animals 249
Collin, Abbe 441
Colony Collapse Disorder (CCD) 445
Columba, St 148, 452
Columella, Lucius 111
comfrey (*Symphytum uplandicax*) 314
Common Agricultural Policy 97
common ink cap (*Coprinus atramentarius*) 364, 367
common mallow, (*Malva sylvestris*) 343
Common Ridings 380–95
commoners' rights 71–2, 77, 128, 135
Company of Distillers 82–3
conifer plantations 28, 99, 139, 143, 144, 264, 279, 521, 549
Connla's Well 157
conservation 99, 144, 147, 266
 fish stocks 521

groups and bodies 266, 308, 320, 479
vs. stewardship 306–9
Constable, John 118, 255
Cooling Marshes, Kent 237
coopers 115, 116–17
copper, dietary 330
copper mines 107, 108
coppice woodland 20, 102, 111, 112, 113, 115, 127, 138
coppicing 55, 103, 106, 107, 108, 111, 112, 134, 143, 144, 157, 277, 458
coprine 364
corn dollies 447, 449
corn mint (*Mentha arvensis*) 353
corn 'necks' 448
Cornhill maypole 372
Cornwall 56, 107, 112, 320–2, 374, 446, 476, 480
 hedges 478
Cotswolds 70, 72, 480, 483
Cotton, Sir St Vincent 86
cotton industry 126
Coughlan, John 524
Country Land and Business Association 541
Countryside Alliance 540, 541
Countryside Council for Wales 147, 266
Countryside and Rights of Way Act (2000) 266
Court of Attachment (Forty Days' Court) 133
Court of Swanimote 133
Coventry, Countess of 43
Cowan, T. W. 441
Cox, Nicholas 518, 533
coypu 309
crab apple (*Malus sylvestris*) 106, 113, 156, 318, 357–8, 442
craft guilds 62–4, 66
crafts 144, 434–99
crickets 230–2
Cromwell, Oliver 80, 151, 156
Cromwell's Commonwealth 81, 138, 193, 370, 372, 377, 397, 420, 518, 538
cross-quarter days 174, 191
Cryer, Samuel 378
'Crying the Neck' 448
Cuban Missile Crisis (1962) 319
cuckoo bumblebees 297
Cuckoo Day 225
cuckoos 188, 225–6, 228, 242–4, 275
Culloden, Battle of 123
Culpepper, Nicholas 120
Cumberland 20, 252, 344, 460, 483, 573, 574
Cumberland Hound Trailing Association (HTA) 524–5
Cumberland, Duke of 123
Cumbria 20, 107, 450, 524

Index 587

Cumming, Alan 471
cumulonimbus clouds 218
cumulus clouds 215
'cundies' 34
'curriers' 494

D
Da Vinci, Leonardo 290
Dahl, Roald 282
dandelion (*Taraxacum officinale*) 318, 326–8
Darley Arabian 568
Dartmoor 20, 56, 59, 134
Darwin, Charles 257
Davies Riding Boots 498
Davis, John 75–6
Day of the Transfiguration 197
de Mauduit, Vicomte 317–18
de Multon, Thomas 156
de Soules, Sir Nicholas 34
de St Croix, Reverend W. 39
De Vere Beauclerk, Murray 538
deal 113
Dean Forest Act (1838) 135
December 180, 202
deer 24, 127, 549
 tracks 262
 see also specific species
deer balls 364
deer forests 91, 261, 554
deer hunting 252, 573, 578
deer parks 34, 41, 72, 128, 130, 252, 573
Defoe, Daniel 82–3
Department for Environment, Food and Rural Affairs (DEFRA) 137, 266, 306, 485
Derbyshire 112, 286, 412, 483
 hedges 478
Derbyshire Peak District 119
 well dressing 410, 411–12
Devil/Satan 160, 199, 245, 356, 372, 424
Devil's Dyke, Cambridgeshire 40
Devil's Stone, Shebbear 424
Devon 96, 107, 252, 568
 hedges 478
Devonshire, Dowager Duchess of 460
Devonshire, Duke of 39
'dew point' 212–14
Dickin Medal for Bravery 522
Dieldrin 319, 580
'Dig for Victory' 317
Diocletian, Emperor 183, 189, 192
Dissolution of the Monasteries 51
distilling of spirits 82–3, 116
divining rods 157
Dockwray, Bill 237
Dog (wild) rose (*Rosa canina*) 357, 476
dogs 224, 244, 491
Dolbear's Law 232

Doles and Charities 413–17
Domesday Book 132, 530
Donegal, Earls of 513
drainage 16, 28, 34, 77–80, 261
drisheens 355
Druids 191, 228, 242, 371, 438
 sacred birds and animals 228, 244
 sacred plants 354
 sacred trees 148, 150, 156, 157
dry stone walling 34, 480–5
Dry Stone Walling Association (DSWA) 484, 485
ducks
 domestic 59, 224
 hawking 538
 wildfowling 559
Dunbar, battle of 151
Dunca, Stanley 559
Duncombe, Cecil 540
dung 24, 249, 262
Dunmore House 'pineapple' 43
Dutch Elm Disease 118, 119
dyeing 468

E
Eadgifu 130
earthworks 39–40
East Anglia 51, 80, 138, 144, 159, 229, 309, 324, 428, 447–8, 464, 544, 545, 549, 574, 550
 Brecklands 107, 142
East India Company 82
Easter food 355
Easter Ledge Pudding 344
Easter Sunday 189
Eckingon Manor, Ripe 20
economy 66, 72, 96, 333
 benefits of field sports 542, 580
 demand-led 60
 rural 498
Edgar, King 410
Edinburgh 65, 198, 257, 365, 372
 gun makers 555
Edmond, King 64
Edmonstone, John 257
Edmund I 130
Edward I 113, 163, 406
Edward III 464
Edward VI 74, 163
Edward VII 409, 522, 551, 554
Edward the Confessor 164
Edwards, Lionel 574
eel fishing 511–14
eel skin (*shagreen*) 493
Egrement Crab Fair 156, 433
Egremont, Lord 90

Einstein, Albert 445
elder (*Sambucas nigra*) 322, 334–7
elderberry schnapps 337
elderberry wine 335–7
Elizabeth I 76, 199, 351, 354, 372, 409, 414, 419
Elizabeth II 409, 414, 522–3
Elizabethan period 42, 51–4, 75–7
 use of wild plants 323, 324, 326, 338, 354–5
elk 106
Ellman, John 87
elm 139, 476
 coppice 112, 113
 timber 118–19
Ely Cathedral 'Lantern Tower' 113
enclosure 71–4
Enclosure Acts (1603–1860) 34, 51–4, 72, 91, 96–7, 135, 139, 252, 322, 357, 370, 476, 480
Endsleigh, Devon 20, 45
England 85, 93, 134, 143, 144, 189, 252
 Black Death 70
 conifer plantations 28, 264
 dry stone walling 483
 enclosures 72, 91
 folklore 159, 160, 177
 House Tweeds 472
 Roman sites 61
 trees and woodland 113, 115, 126, 147
 truce with Netherlands 82
 wild plants 349, 352, 355
England Hedgerow Regulations 479
Eostre 189, 242
Epona 242
Epping Forest 130, 131, 135
equestrian sports 562–78
equinox; vernal equinox
equinoxes 168, 170, 191 *see also* autumn
ergotism 66–7
ermine 290, 491
Essex 51, 60, 448
'Estate' tweeds 471, 472
estovers 71, 132, 379–80
EU/EEC 97, 99, 293
European Bat Weekends 280
Evangelist symbols 175
Evelyn, John 138–9, 143, 157, 324, 331–3, 361, 415
eventers 20, 24, 568
'Evil May Day' riots (1517) 372
Exmoor 20, 54, 134, 252, 568
Exodus 437

F
Fabulous Histories (*The History of Robins*) 251
Fairfax,. Lord 574

fairy tales 250
falconry 535–41
　language 536
fallow deer 198, 249, 364, 491, 549, 573
　beasts of Chase 131, 245
famine years 66–70
Faringdon Folly Tower 46–7
farm buildings 34, 54
farming
　Anglo-Saxon 51, 62–4, 112, 128, 137
　animal welfare 255
　birth of modern farms 71–4
　Bronze Age 55–6, 108
　Celtic 58–60, 108, 446
　eighteenth and nineteenth century
　　improvements 90–1, 94–6, 428, 545
　fluctuation in methods 51–4
　intensive 28, 279, 442
　and landscape alteration 58–64
　Middle Ages 64–71
　Norman period 64–7
　over-production 99, 264, 320
　post-war to 1980s 28, 96–9, 143, 264, 293, 319–20, 545
　post-1990 29, 99, 264–5, 443
　Roman period 60–1, 111
　sixteenth and seventeenth century
　　progress 75–82
　subsidies 29, 99, 320, 443
　see also agricultural improvers;
　agricultural Revolution; agri-
　environment schemes; arable farming;
　hill farming; livestock farming
farming calendar 168
　'entry' into new farms 188
　and lunar cycle 170–1
Farrier (Registration) Act (1975) 489
farriery 488–9, 490
fat hen (*Chenopodium album*) 55, 58, 322–3
Fawkes, Guy 419
February 184–6, 203, 312
Federation of City Farms and Community
　Gardens 303
Fellowes, Anne 352
felt making 474–5
fennel (*Foenicum vulgare*) 342–3
Fens 457
　drainage 16, 77–80, 151
ferret rescue centres 534
ferreting 23, 528–35
Ferreting Tapestry 533
feudalism 64, 245
feverfew (*Tancetum parthenium*) 314
fiddleheads 350
field maple 106, 113, 476
field mushroom (*Agaricus campestris*)
　362, 366

field and country sports 24–8, 500–81
　books on 251
　economic, social and environmental
　　benefits 24, 541–2, 580–1
fieldfares 229
Firle Corn 36
first-footing 424–5
'First Fruits' festival 197
fish farms 517, 521
fish fertility icon 244
Fisher, Major 540
fishing 20, 505, 507–21
Fitzherbert, John 75
Flamsteed, John 304
flax 71, 91
fleabane (*Inula dysenterica*) 353
Flemish farming 81, 142
Flemish weavers 72, 464
flint 39
Flintcroft, Henry 42–3
Flodden Field, Battle of (1513) 382
Flora 371
flounder tramping 507
fly agaric 362, 365
Flyboats 85
fog 212–14
Folijambe, Joseph 83
folklore and customs 173, 368–433
　trees 148–60
'follies' 41–3, 46–7
Follo, Roger 245, 517, 573
Folly Tower, Pontypool 43
Food Lovers Fairs 320
foraging 19–20, 261, 318–19, 320, 322
'forest' 130
Forest Laws 128–33, 134, 245, 293, 573
Forest of Dean 108, 109, 112, 131, 134, 135, 137, 138
Foresters 132
Forestry Commission 28, 137, 143, 144, 264, 349, 542, 549
Forestry Act (1919) 143
forges 489–90
Forsyth, Alexander 550
Fortingall Yew 163
Foster, Michael 505
four-field rotation 81, 83
Fowell family, Abbots Bromley 400
fowl 65
　as weather meters 224–5
fox hunting 252, 563, 573–8
fox hounds 16–19, 573
foxes 24, 202, 242, 249, 491
　beasts of Chase 131, 245
　tracks and signs 23, 24, 262
　urban 301, 303

France 61, 66, 67, 82, 130, 277, 343, 539, 545
Freeman, Rev G. E. 540
freemen 62
Freston Tower, Suffolk 41
Freya 244
Frogline 287
frogs 23, 204, 230, 245
　edible 253
Fuller, Mad Jack 46
fungi 102, 322, 362–7
furniture making 120–3, 138–9, 364, 454

G

Gage, Mr 561
gale mead 354
Gallerami, Cecilia 290
game 543–9
Game and Wildlife Conservation Trust 274
Game Conservancy Trust 541, 545
Game Laws 533, 550
Game to Eat initiative 506
Garland Day, Castleton 378
garlic, wild (*Allium ursinum*) 102, 184, 312, 314, 318, 330–1
garlic mustard (*Alliaria petiolata*) 331–3
Garm 244
geese, domestic 59, 186, 187, 199, 202, 224, 409
geese, wild 173, 229, 242, 275, 306
Geoffrey of Anjou 344
geology 51
George I 164, 301
George III 497
George IV 352, 494
George V 522
George VI 290, 309
Gerard, John 312, 364
German bands 399
giant puffball (*Langermannia gigantean*) 364–5, 366
Gilpin, Sawrey 539, 574
Giovanetti, Matteo 533
Glanville, William 415
glass-making 338, 349
Glastonbury Lake Village 324, 452
Glastonbury Thorn 156
global warming 237, 514
'Glorious Twelfth' 519, 554
Gloucestershire 96, 194, 457
goats 55, 56, 59, 62, 65, 107, 108, 128
　Bagot 401
　fertility symbols 244
　Satanic symbols 245
goatskin 491
Godolphin Arabian 568
gold mining 108
Good Friday 189

Good King Henry (*Chenopodium bonus-henricus*) 55, 324
Gooding, Thomas 41
Googe, Barnaby 76–7
gorse (*Ulex europaeus*) 322, 345–6
goshawks 250, 536, 538, 540
Gould, John 257
Graham, Kenneth 251, 282
Graham, Mr 142
Grand Tour 42
Grant, Alexander 521
Grant Vibration 521
Gray, Thomas 159
Great Alarm (1804) 115
great spotted woodpeckers 228
Great Spitalfields Pancake Race 433
Great Storm (1987) 236
Greaves, Valerie 478
Greece/Greeks, ancient 42, 437, 530, 535, 544
green laver (*Ulva lactuca*) 339
green parakeets 253
green wood-cup 364
green woodpecker 228
Green, Henrietta 320
Green, John and Benjamin 46
Greenwood, James 370
Gregory I, Pope 150, 187, 244–5, 447
Gregory XVI, Pope 186
Grey, Lord 573
grey partridges 545
grey squirrels 253, 308–9
greyhounds 571, 579
Gripe Water 342
ground elder (*Aegopodium podagraria*) 330
Ground Game Act (1880) 293
grouse 24, 261
 hawking 538, 539, 540
 shooting 551, 554, 561
grouse moors 94–5, 264, 306, 472, 551, 554
Groveley Woods 379–80
guano 95–6
Guild of Straw Craftsmen 449
gun engravers 555
gunpowder manufacture 116, 138
gunsmiths 549, 550, 551, 555
gurning 156
Guy Fawkes night 418–23
gyrfalcons 250, 536, 538

H
Hadrian's Wall 20, 111, 480
Haaf netting 508–9
Hague, William 505
Hall Dixon, Henry 539
Hallowe'en 274, 275
halos, sun or moon 215

Hamilton, Duke of 83
Hampshire 135, 144, 415, 503
Hampton Court Chase 128
Hampton Court maze 120
Hamsland Holt farm 16
Hanbury, John 43
hare coursing 293, 573, 574, 579
hares 291–3, 242, 245
 blue 290, 291
 brown 291, 292, 293
 hawking 540
 hunting 573, 574, 578
 in hunting hierarchy 131, 245, 293
 prints 262
Hare Preservation Act (1892) 293
Hargreaves, Jack 52–3, 517
Harris Hawks ferreting with 534–5
Harvest Festival 446, 447
Hatfield Chase 77, 134
Hawick Common Riding 382–95
Hawick tweed mills 469–71
hawk classification 250
Hawker, Peter 251, 550, 559
Hawker, Robert 446
hawthorn (whitethorn) 154–6
 'beggar's bush' 50
 hedging 357, 442, 476
hazel (*Corylus avellana*) 106, 108, 361
 basketry 452
 coppice 20, 103, 113, 144, 157, 458
 hedging 357, 361, 442, 476, 477
 myth and folklore 157–60
 walking sticks 458–9
hazel nuts 157, 159, 160, 193, 198–9, 318, 361
heather burning 94–5, 551
heaths 54
Heber, Reginald 430
hedge laying 476–9
hedge woundwort (*Stachys sylvatica*) 314
hedgehog fungus 364
hedgehogs 24, 102, 103, 252, 262, 280–2, 295, 484
 and adders 285
 urban 303
hedgerow harvest 19–20, 318, 319, 356–61
Hedgerow Incentive Scheme (HIS) 479
Hedgerow Regulations (1997) 479
hedgerows 23, 442
 destruction 28, 96–9, 264, 279, 357, 442, 545
 planting 252, 322, 357
hedging trees 119, 120, 123, 139–42
hefting 92–3
'Helston Furry Dance' 374–5
henges 55, 56, 168
Henry II 134, 245, 344, 415, 573
Henry III 156

Henry VI 429
Henry VIII 113, 128, 205, 345, 370, 411, 414, 418, 419, 447
Henry of Knighton 70
herb gatherers 315–17, 318, 325, 345
herbal remedies 313–17
 see also specific plants
herbicides 28, 319, 442
Herefordshire 96
Hermitage Castle 34
Herod 193
Herod Agrippa 194
Herring, J. F. 574
Hertfordshire 305, 417
Hevingham Hall, Suffolk 551
hibernation 236, 277–87
Highland Clearances 91–3
highways 85–6
Hill, Charles 327
hill/upland farming 29, 51, 56, 92–3, 95, 97, 108, 197, 222, 239, 305, 460–1, 483, 485
hill figures 35–9
hill forts 32, 36, 46, 58, 59, 108, 480
Hind, Richard 397
Hirsch, Baron 554
Hoare, Sir Richard 42
hobby horses 375–6, 426–7
Hogg, James 93, 385
hogweed (*Heracleum sphondylium*) 330
Hokitika Wild Food Festival 320
Holkham Hall, Norfolk 90, 142, 551
Hollams, Mabel 568–9
Holland 16, 142, 539
Holland and Holland 555, 561
holly 106, 147, 150–1, 476
 hedging 357, 442, 477
Holy-Rood (Holy-Cross) Day (Nutting Day) 160, 198–9, 361
honey 204, 205, 242, 296, 358
 see also bee keeping
honey fairs 439
Hoo Peninsula, Kent 236–7
hops (*Humulus lupulus*) 319, 334
Horace Batten Ltd 498
hornbeam 106, 108, 139, 147
 coppice 20, 102, 103, 106, 113
 timber 120
Horne, Matthew 325
horse chestnut (*Aesculus hippocastrum*) 317
horse fairs 564
horse mushroom (*Agaricus arvensis*) 362, 366
horse shoeing 486–9
horseradish (*Armorica rusticana*) 322, 333–4
horses 491
 draught 83, 563
 fodder 346
 herbal remedies 333

hide 491
holly whips 151
nettle fodder 326
ploughing 65, 71
reverence for 242
war chariots 59
as weather meters 222
see also equestrian sports; riding festivals
Houblon, Archer 160
hounds 571, 574, 580 see also fox hounds; greyhounds; otter hounds
hound trailing 524–7
house martins 198, 228, 275
House Tweeds 471, 472
Humphries, W j 168
Hundred Years War 71, 72
Hungary 554
Hunt Supporter Clubs 580
Hunt, Ken 555
hunters (horses) 16, 20, 24, 568–9
hunting 16–19, 62, 252, 570–8
 importance for wider community 580–1
 and Nu Labour 503–6
 our heritage 249
 regulatory bodies 571
 see also Forest Laws
Hunting Act (2004) 293, 505–6, 563, 579, 581
Hunting the Mallard 429–31
Huntingfield, Lord 551
hurling 120
Hutchinson, Rev Hely 559

I
Ilchester estate swannery 409
Imbolc 168, 184, 446
Improved Langstroth beehive 441
Industrial Revolution 143, 253–5, 374, 397, 465–7
industry 138, 261
 dawn of 82–3
insect-repelling plants 353–4, 355
Insectline 298
insects 296–300
 and weather 226, 230–3
inulin 327
iodine 339
Iona 452
Ireland 93, 184, 191, 298, 355, 480, 521
 conifer plantations 139
 copper mining 107
 dry stone walls 483
 folklore 154, 157, 177
 grey squirrels 253
 hedging 476
 holy wells 411
 hound trailing 524
 hurling 120

spinning 467
trees and woodland 119, 143, 164
use of wild plants 325, 339
see also Northern Ireland
Irish hare 291
Irish moss (*Chondrus crispus*) 314, 339
iron, dietary 318, 323, 324, 325, 330, 331, 339
Iron Age 32, 51, 108, 244, 446
 hedges 476
 hill figures 35, 36, 39
 significant trees 153, 157
 woollen garments 59
iron industry 108, 111, 138
iron ore 102, 108, 120, 218
Italy 42, 150, 277

J
J & J. F. Baker, Coylton 493, 498
Jacklin, John 527
Jacobean period 42
jam making 315
James I/VI 84, 156, 252, 364, 380, 419, 513
James II 344, 564
James IV of Scotland 382
James the Apostle 194
James, Warren 135
January 183, 203
Jedburgh Jethart Ba' 432–3
Jefferson, Robert 524
Jefferson, Thomas 574
Jeffrey, Walter 389, 390
Jeffries, Richard 251–2
Jekyll, Gertrude 314
Jesus Christ 169, 193, 197, 334
jet trails 220
John, King 134, 163
John the Fearless 533
Johns, Rev. C. A. 276
Johnson, Samuel 164
Johnson, T. B. 292, 533, 554
Judas Iscariot 183, 334
July 194, 205
June 192–3, 205

K
Karolyi, Count 554
Kay, Professor M. E. 282
Keats, John 255
Kehrle, Brother Adam 442
Kennedy, Father Oliver 514
Kennedy, John 319
Kent, William 42, 44, 96
Kent 51, 59, 60, 144, 194, 278, 414, 479
 hedges 478 see also Weald
Kent marshes 556
kestrels 227, 250, 536, 538
Kettlewell Scarecrow festival 433

Kett's Rebellion 74
Kielder Forest 28, 144, 264
King Alfred's Tower, Stourhead 43
King Edward's Chair (Coronation Chair) 113
Kings Evil 163–4
Kipling, Rudyard 313–14
Kitchen Front 317
Knights Templar 164, 193
Knour, Sir Richard, Sheriff of Northumberland 34
Knowles, Miss 103, 104
Kubla Khan 538

L
Lade, Sir John 86
Lady Day 174, 188, 415–16
Lady's Knowe 32
Lady's Well 32
ladybirds 232–3
Lake District 112, 480
Lakenheath, Brecklands 62, 530
Lambert, Joyce 35
Lammas 174, 197, 205, 447
Lammermuirs 29
Lancashire 118, 126, 344, 397
landscape 32–4
 changing 109–13
 evolution 51–64
 heritage 35–40
landscape designers 41–7
landscape gardeners 44–5
Landseer, E. H. 255
Lang, Cosmo 431
Langstroth, Lorenzo 440
Lanner falcons 250, 538
lark twirlers 502
Lascelles, Gerald 540
Last Supper 197, 206, 413
lavender 351
Lavenham, Suffolk 72
laverbread 339
lead mining 108
League Against Cruel Sports 504
leather work 491–8
Lee Gap horse fair 564
Leicestershire 65, 70, 74
Leicestershire Hunter 578
Leoni, Giacomo 42
Leopold II of Belgium 522
leprosy 70
Lewes Bonfire Night 420–3
Lewis, C. S. 282
Lilford, Lord 540
lime burning 76
lime 106, 442
 coppice 106, 113
 historical 164

Index 591

woodland 106
Lincolnshire 51, 56, 72, 113, 338, 428
 see also Fens
Linnaeus 533
little owls 253
livestock farming 56, 59, 60–1, 62, 65, 108, 252
 benefits of four-field rotation 81–2
 new breeds 86–7
Lloyd George, David 317
Lobb and Maxwell 498
Locke, James 471
London 60, 112, 118, 257, 322, 351, 370, 494
 bee keeping 443
 Black Death 70
 gun makers 555
 May Day festivities 372, 374
 Tower ravens 304
 transportation 84, 85–6, 147
 wildlife 301, 303, 549
London Bat group 303
London Zoological Society 257
long barrows 55, 107
Long Man of Wilmington 36–9
Longfellow, Henry Wadsworth 29, 486
Loo Hawking Club 539
lorinery 494
Lough Neagh Fisherman's Co-operative Society 513–14
Louis IV of France 130
Lovat Mill, Hawick 471
Lovat Mixture 472
Lowland Clearances 91
lowland shooting 549
lowlands 54, 56, 60, 107, 112, 126, 261, 476
Lowry, Malcolm 436
Lucianus, governor of Damascus 183
Lucozade 317
Lughnasadh 168, 197, 446–7
lunacy 173
Lunacy Act (1842) 173
lunar cycle 168, 170–3
Luprecalia 186
Luther, Martin 418
lynchets 54, 59
Lynedoch, Lord 91

M

Mabey, Richard 320
Magna Carta 134
magnesium 331, 339
magpies 306
Major Oak 163
mallow *see* common mallow; marsh mallow
Malmesbury, Earl of 559
manganese 330, 331

Mann, J. T. 540
Manson-Bahr, Sir P. 271
March 187–8, 203
Marco Polo 538
Mari Lwyd (Grey Mare) festivals 426–7
marigold (*Calendula arvensis*) 314
marjoram (*Origanum vulgare*) 355
Markham, Gervase 250, 573
marl 76–7
Marlowe, Christopher 304
marsh mallow (*Althea officinalis*) 343
marsh samphire (*Salicorna europaea*) 338–9
Marshall, Benjamin 574
Marsham Nettle Eating Contest 433
martens 131, 245
Martin, John 255
Martin, Michael 505
Martin, Richard 255–6
Martin's Act (1822) 255–6
Martinmas 174, 176–7
Marvin, Lady Elizabeth 414
Mary, Virgin 32, 156, 232, 410, 438
Mary I 420
Mary Queen of Scots 34
Maryculter sweet chestnut 164
Masserella family 523
match coursing 505
Matthew the Evangelist 175, 199
Matthew, Clive 478
'Maundy' 413
Maundy Thursday 414
Maxentius, Emperor 177
May 191, 204
May customs 377–80
May Day 154, 174
May Day celebrations 371–6
May dew 372
May Fair, London 374
maypoles 371, 372, 374
mead 157, 242, 354, 358, 437, 438
Meade-Waldo, Colonel 253
meadowsweet (*Filipendula ulmaria*) 317, 351, 354
meat production 61, 87, 96, 255
Meek, Albert 258
megaliths 32, 56
Mehring, Johannes 441
Meikelour hedge 123
Meikle's threshing machine 90
Mercier, Jean 123
merlins 250, 536, 538
Mesopotamia 67
metallurgy 107, 108
meteorology, modern 169, 239
Michael, Archangel 199
Michaelmas Day 174, 199
Middle Ages 127, 184, 193, 194, 206,

245, 250, 249, 305
 almshouses 413
 bee keeping 439
 farming 64–71
 folklore and customs 156, 225, 371
 hedgehog eating 281
 hunting 130, 249
 monastic peat extraction 25
 tanneries 493
 use of wild plants 323, 333, 342, 354–5, 357
 value of ermine 290
 value of swans 406
Middle Eastern horses 568, 574
Middleton, Thomas 175
midges 226
Midlands 51, 54, 65, 72, 113, 137, 138, 144, 180, 448, 479, 549, 574
Midsummer's Day 174, 193
Midsummer's Eve 193, 342
migration, toads 287
migration myths 242–3, 275
migratory birds 29, 225–6, 228–9, 242–4
Millais, John Guille 559
Mills, Hon C. W. 540
Mills, Harry 'Brusher' 285
Minehead May Day celebrations 376
mining 107, 108, 109, 111
Ministry of Agriculture 28, 264, 309, 317
Ministry of Food 315, 317, 416
mink 290, 308, 309, 580
Mischief Night 424
mistle thrushes 227–8, 528
mistletoe 148, 156
Moccus 242
moles 282, 491
 as weather meters 224
monasteries 64
 bee keeping 438–9
 peat extraction 35
 sheep farming 29, 51, 65–6, 464
Monmouth, Duke of 573
monoliths 107, 168
Monsoon, Mr. 573
Montagu of Beaulieu, Lord 503
Monte Cassino 187
moon, and weather prediction 220
 see also lunar cycle
More, Sir Thomas 338
Morecambe Bay potted shrimps 510–11
Morland, George 574
Morris dancing 399, 428
moths 298–300
 luring 299
Mulgrave Supreme 568
Munnings, Sir Alfred 574
Muntjac deer 301, 549
murrains 66, 281, 295

Murray, John, 4th Earl of Dunmore 43
Murray-Usher, Elizabeth 484
muscimol 365
mustard growing 80
mustelidae 288, 290
mute swans 406 *see also* Swan Upping
Mynell, Hugo 574–8
Mytholmroyd World Championship Dock Pudding Contest 344
myxomatosis 534

N
Nairne, Robert Murray 123
Napoleonic Wars 115, 142, 253
Napolitano, Carlo 523
NASA 169
National Coursing Club rules 293, 578, 579
National Hedgelaying Society 478–9
National Moth Nights 298–9
National Organisation of Beaters and Pickers Up (NOBS) 561
National Park Authority 137
National Priory Species 303
National Society for the Prevention of Cruelty to Children 256
Natural England 137, 147, 266
Natural History Museum 258
Nature Conservancy Council 147
nature
 connecting with 261–3
 weather messages 212–20
 wild weather warnings 236–7
navvies 85
Neill of Bladen, Lord 431
Neolithic era 32, 39, 157, 242, 446, 480
 eel fishing 511
 farming 54–5, 107
 hedging 476
 use of wild foods 55, 323, 324
 weatherlore 168
 woodland 106–7
Nerners, Lord 539
Nero 197
nettles (*Ursica dioica*) 55, 184, 318–19, 322, 325–6
New Book of Knowledge 233
New Forest 71, 130, 134
New Forest Act (1877) 135–6
New (Nu) Labour 266, 503–4, 505, 506, 541
New Naturalist Series (Collins) 264
New Year's Eve 180
 festivities 424–6
New Zealand 28, 291, 297, 320, 349, 474, 560
Newall, Arthur 540
Newberry, John 250
Newton, Isaac 374
night sky 220

Nightingale, Florence 253
nightingales 188, 225, 275–7
'Nine Stone Rig' (dirge) 32–4
nitrogen-fixation 81
Noctule bats 278
Norfolk 51, 71, 74, 90, 338–9, 428, 448, 454, 479, 539 *see also* Broads; Fens
Norman Conquest 51, 64, 130, 464, 549
Normans/Normans era 41, 517, 535
 bee keeping 438
 deer parks 72
 farming 41, 64–6
 Forest laws 128–33, 245, 293
 game farming 544–5
 horse shoeing 488
 Royal Forests 134, 571
 rabbit farming 530
 wool production 464
 use of wild plants 330, 342
Norse mythology 153, 244
North of England 34, 65, 94, 119, 346, 396, 460, 479, 554
North Pennine Hunt 506
North Sea flood (1953) 236–7
North Yorkshire 65–6, 483
 hound trailing 524, 525
Northampton oak service 378
Northamptonshire 56
Northern Ireland 242, 272
 conservation bodies 266
 dry stone walling 483
 eel fishing 513–14
 megaliths 56
 woodland 147
Northern Ireland Environment Agency 147
Northumberland 20, 28, 50, 144, 264, 344, 425, 460, 568
Northumberland, Dukes of 40, 545
Norwich Cathedral 35
Nottinghamshire 65, 72, 428
November 176–7, 202
Nutting Day 20, 160, 198–9, 361

O
O'Brien, Phillippa 445
oak 106, 108, 131, 135, 147, 156, 228
 ancient 148
 bark 111
 barrels 116
 basketry 452
 coppice 20, 103, 106, 115
 drawing lightning 218–19
 historical 163–4, 377
 standards 102
 timber 112, 113–15, 364
 woodland 106, 139, 150, 458
 see also sessile oak

Oak Apple Day 377–8, 379
October 175, 202
Odin 244
Offa's Dyke 40
'Old Hawking Club' 539, 540
Old Man's Day, Braughing 417
'Old Song' 390–1
one-loft racing 523
open-field/strip systems 51–4, 62, 65, 71–2
orache, common (*Atriplex patula*) 55, 318, 324–5
orache, spear (*Atriplex bastata*) 324
orchards 60, 127, 156, 194
Orford, Lord 538, 539
Orlebar, Mr 574
organic foods 99, 320, 543
Orton, Arthur 416
osier beds 452, 454, 457
otter hounds 517
otter hunting 573, 574, 578, 580
otter skin 242
otters 242, 249, 288
 prints 262
 spraints 24, 262
 urban 301
Out of Town 502–3
Out of Town Centre 503
owl pellets 24, 262
Oxford-Burcot Commission 84
Oxfordshire 65, 479
oyster mushrooms (*Pleurotus ostreatus*) 367
oysters 194

P
Padstow Hobby Horses 375–6
Palladius, Rutilius 111
Palm Sunday 189
Palnackie World Flounder Championships 506
pannage 71, 128, 132, 133
Paracelsus 173
parasol mushroom (*Lepiota procera*) 366
Parent Larch, Blair Atholl 139
Parker, Eric 271
parliament 66
Parliament Oak 163
Parr, William, 1st Marquess of Northampton 74
partridges 24, 472, 545
 beasts of Warren 131, 245
 hawking 538, 540
 shooting 549, 550–1, 554
pastoral farming 54, 58, 71, 108
Patten, Marguerite 317
Paul, Apostle 183
Payne-Gallwey, Sir Ralph 251, 559

Pearl-bordered fritillary 346
peat extraction 35
Pelham, Mr. 573
Pells, John 539
Pembroke, Earls of 380
Pennant, Thomas 286
Pennines 480, 551
Penshaw Monument, Tyne and Wear 46
Pepys, Samuel 372
Percy, Robert 'Boy' Heber 47
peregrine falcons 250, 306, 536, 538, 540
 urban 301
Perrault, Charles 250, 493
pesticides 28, 279, 293, 301, 319, 445, 545, 580
Peter, St 197, 206
Petrini, Carlo 320
pheasants (*Phasianus colchichus*) 24, 102, 202, 227, 472, 543–5
 beasts of Warren 131, 245
 hawking 538, 540
 shooting 142, 549, 550–1
 tracks 23
Philips, Roger 320
phosphate 325
phosphorous 323, 330
Pick your Own 320
Picts Work Ditch 40
'picturesque' vogue 42–3
pied wagtails 226
pigeon racing 522–3
pigeon shooting 543
pigs 55, 56, 59, 62, 107, 108, 128, 491
 and lunar cycle 173
 as weather meters 222
pike fishing 518–19
piling 116
pine martens 242, 288, 290
'Pinch Bum Day' 377–8
pinecones 221
Piper, Elizabeth 467
pipistrelle bats 277–8
Pishdadidian Dynasty 535
place names 50, 70, 128, 159, 331, 346
plaiting straw figurines 446–9
plane trees 164
Plantagenet kings 344
plantation movement 138–9, 143
 see also conifer plantations
Plat, Sir Hugh 76–7
Plato 413
Plautus 413
Pliny the Elder 58–9, 334
Plough Light 428
Plough Monday 427–8
ploughs and ploughing 55, 56, 59, 60, 65, 83

Pluteus cervinus 364
Plymouth Hoe Giants 36
Poem on the Evil Times of Edward II 70
pointers 549
polecats 242, 249, 288, 290, 484, 491, 530, 533
Political Animal Lobby 504
pollarding 128, 452
Pontack sauce 335
Pony Club 24, 567
Pope, Alexander 275
poplar 106, 139, 378–9
population
 decline 51, 61, 70–1, 112
 growth 51, 54, 55, 59, 61, 66, 74, 75, 79, 86, 95
'porry' 323
potassium 323, 333, 339, 349
Potter, Beatrix 251, 282
poultry 59, 409
'Powte's Complaint' 77–80
Pratt, Nanny 16, 19, 102, 103, 104, 318, 319
Price, James 269
Protection of Birds Act (1954) 263, 306
Protestants 372, 418–19, 420
Public and Corporate Economic Consultants (PACEC) report on shooting 541
Purdey and Boss 472, 555
Puritanism and Puritans 80, 193, 370, 372, 397, 420, 518
purple laver (*Porphyra umbilicalis*) 339
Pytheas of Massilia 60

Q

quarter-days 174
Quinby, Moses 441

R

rabbit skin 491
rabbits 23, 364, 484
 beasts of Warren 131, 245
 farming 65, 530–3
 hawking 538, 540
 kidney fat 236
 shooting 543
 tracks and signs 23, 261–2
 as stoats' prey 289
 see also ferreting; warrens
Rackham, Oliver 111, 138, 144
Raffles, Sir Stamford 257
ragged robin (*Lychnis flos-cuculi*) 192
railways 85, 95, 115, 255, 370, 522, 554, 578
rainbows 215
Rainsford-Hannay, Frederic 484
Ramsay, Major Neil 561
Rann, 'Sixteen String Jack' 86
raptors 306

Rare Breeds Survival Trust 83
rationing 19, 261, 317, 318, 442
ravens 227, 242, 245, 304–5, 306
 Tower of London 304
red deer 24, 91, 106, 131, 203, 245, 249, 252, 261, 472, 491, 549, 554, 573, 574
 beasts of Forest 131, 245, 293
red squirrel skin (*vair*) 491–3
red squirrels 137, 244, 364, 484
red-legged (French) partridges 252, 545
redwings 229
Redwood, John 431
reeves 54, 56, 59
Reformation 370, 379, 400, 411, 418, 428
Reformation Oak 74
Regents Park 257
Regimental tweeds 471, 472
Reguarders 132
Reinagle, Philip 574
reiver families 380
Remiguis, St 164
Rendle, Stephen 471
Repton, Humphrey 45, 46
Restoration 81, 193, 370, 374, 377–8, 379, 397, 420, 538, 568
retrievers 559
Retting Tapestry 533
Reynard the Fox 250
rheumatism ('screws') 212, 319, 325–6
ribbon dancing 371
Richard I 134, 344
Richard II 401
Richmond Park 198, 545
Richter, Paul 335–7
ridge and furrow 65
Ridgeway 56
riding festivals 380–95
Riding for the Disabled 24, 563–4
Ridler, Major Horace 436
Right of Estovers, Wishford Magna 379–80
Ripe and Chalvington 20, 36, 436–7
Ripon Wakeman's curfew horn 370
river navigation 84
Ritz, Carl 517
Robin Hood 163
robins 228, 269, 303
 in literature 251
rock samphire (*Crithmum maritimum*) 338
rod fishing 517–21
roe deer 24, 102, 131, 249, 491, 549, 573
 beasts of Chase 131, 245
Roman Catholicism and Roman Catholics 41–2, 164, 342, 362, 372, 418–20, 447
Roman Empire 51, 61, 111, 371, 530, 544
Romans/Roman Occupation 35, 108, 168, 437, 535
 animal and plant introductions 281, 330,

594 *A Book of Britain*

342, 361, 530, 544
apple orchards 156
bee keeping 438
farming 51, 60–1
festivals 151, 186, 370, 371
hedge management 476
'hipposandals' 488
hunting 571
oak crowns 148
swan eating 406
timber requirements 109–11
use of wild plants 334, 354, 361
wall building 480
Romanticism 255
Rooke, Major Hayman 163
Rosehill, Brightling 46
rosehips 20, 317, 318, 319, 357
rosin 127
Rothschild, Walter, 2nd Baron 258
Rousham, Oxfordshire 44
rowan (mountain ash) (*Sorbus aucuparia*)
106, 153–4, 358–61, 442, 528
Rowley, John 39
Royal African Company 82
Royal Forests 130–3, 134–7, 147
Royal Herb Strewers 352
Royal Pigeon Loft 522–3
Royal Remedy Oak 163–4
Royal Society for the Prevention
of Cruelty to Animals 256
Royal Society for the Protection of Birds 306
rue (*Ruta graveolens*) 353
Rumney, Bridget 352
rushes 351, 396
Rushton's Lodge, Northamptonshire 41–2
Ruskin, John 371

S
saddlery 494–6
sage (*Salvia officinalis*) 204, 351
saints days 168, 169, 174–99, 245,
396, 410, 447
saker falcons 250, 538
salads (sallets) 324
Salisbury, Les 510–11
Salisbury Cathedral 380
salmon 157, 242, 306, 472, 521
fishing 518, 519
Salome 193
salt pans 111
Salvin, F. 540
Samber, Robert 250
Samhain 168, 175, 176, 446
Sandringham 522–3, 551, 554
Satan's boletus (*Boletus satanus*) 366
Saturnalia 151, 180
Saxon mercenaries 111–12

Saxon month names 184, 191, 192, 271
scarlet pimpernel 234
Scarletts Farm, Cowden 16
scoparin 345
Scotland 51, 67, 85, 93, 112, 134, 191, 358, 539
Black Death 70
'black dykes' 40
boulder walls 483
climate change 183
conservation bodies 266
distilleries 116
dry stone walls 34, 483, 484
enclosures 91
fishing 506
folklore 151, 154, 159, 193, 198
Forestry Commission 143, 144
grouse moors 551
heather burning 94
holy wells 411, 412
monastic sheep farms 65–6
New Year's Eve festivities 424–5
place names 159, 346
quarter days 174
rod fishing 519–21
spinning 467
sporting destination 554
St John's nuts 193
Stone of Destiny 113
timber use 118, 119
trees and woodland 115, 123, 138, 147, 150
turnpikes 86
walking stick making 460–1
wetlands 452
wild plants and uses 317, 325, 346, 349,
352, 354, 355, 358, 364
wildlife 252, 294, 305
Scots pine 135, 142, 278
timber 126–7
Scott, Sir Walter 469, 538
Scott Henderson Inquiry 506
Scott's of Beauclerc Arms and crest 437
Scottish Borders 32–4, 371, 480
grouse moors 554
hound trailing 524, 525
monastic wool production 464
riding festivals 380–95
rowan trees 154
scrub oak 115
wild plants 312
wildlife 278, 301, 305
Scottish Crookmakers Association 461
Scottish Highlands 20, 35
birch 123, 126
conifer plantations 28, 139, 264
deer forests 91, 549, 554
dry stone walls 480
Estate tweeds 472

fishing 521
ravens 305
red deer 91, 252, 261, 554
Scots pine 126–7
thatching 451
Scottish National Heritage 147, 266, 309
Scottish Parliament 505
Scout movement 23
Scrope, William 251, 519
scrub oak *see* sessile oak
scurvy 322, 326
sea beet (*Beta vulgaris* subsp. *maritima*) 339
sea purslane (*Halimione portulacoides*) 339
sea trout 521
Sefton, Lord 86
September 198–9, 205
sessile/scrub oak 106, 113, 115, 137, 147, 476
Seward, Anna 135
Sewell, Anna 251
Seymour, James 574
Shaftesbury, Earls of 513
shaggy ink caps (*Coprinus comatus*) 326, 367
shaggy parasol (*Lepiota rhacodes*) 366
Shakespeare 220, 333, 338
Sharp, Elixabeth 574
Sheard, Virna 175
Shebbear stone turning ceremony 424
sheep 50, 55, 56, 62, 71, 72, 107, 108,
111, 115, 127, 128
Celtic breeds 59
Church classification 245
'dressing' ram's horns 460
gorse fodder 346
and grouse 94, 95
hefting 92–3
hill/upland farming 9, 29, 51, 92–3,
261, 460–1, 485
impact of climate change 239
monastic 29, 51, 65–6, 464
new breeds 86–7, 90
Romney Marsh 60–1
'stells' 485
Suffolk 90
walks 54, 65
as weather meters 222, 237
sheepdogs 93, 285
trialling 93
sheepskin 491
Shell Hermitage, Pontypool 43
Shelley, Percy Bysshe 255, 362
shepherd's purse (*Capsella bursa-pastoris*)
314, 318
Sherwood Forest 135, 163
Shields, Alexander 258
ship-building 115, 127, 138
Shire horses 83, 174
shooting sports 16, 94, 95, 142, 505, 530,

Index 595

 541–61
 history 549–60
 Hunter's Moon 173
 snipe 272
shotguns 549, 550, 551, 554–5
shrews 293–5
shrimp fishing 510–11
Shropshire 412, 568
Shrove Tuesday 186
Sika deer 253, 549
Silbury Hill 39–40
silver mining 108
Singh, Prince Duleep 551
skull cap (*Scutellaria galericulata*) 317
slave trade 82
sloe gin 357
sloes 357
Slow Food Movement 320
Smirke, Robert 46
Smith, Bill 485
Smith, J. T. 328
Smithies, Catherine 256
snake stones 242
snipe 188, 271–2
 hawking 539, 540
soap-making 349
sodium 338
soil fertility and fertilisation 51, 54, 58–9,
 61, 66, 72, 75–7, 81, 90, 95–6, 108, 349
soil tillage 54 *see also* ploughs and ploughing
solar cycle 168, 173
solstices 191
 see also summer solstice; winter solstice
Somerset 96, 119
Somerset levels 106, 107, 454, 457
sorrel (*Rumex acetosa*) 326
South Yorkshire 412, 428, 483
Sowerby Bridge Wakes festival 399
Spain 61, 277, 530
Spanish Armada 199
sparrow hawks 250, 536
sparteine 345
sphagnum moss 314
spiders 230
spinneys 476
spinning 464–7
Spital 70
sporting artists 574
Spratt, Father John 186
squirrels 103, 153
 see also grey squirrels; red squirrels
St Albans, Dukes of 538
St Ananias' Day 183
St Anne's Well, Buxton 411
St Barnabas' Day 174, 192
St Bartholomew's Day 197
St Bartholomew's the Great, Smithfield 415

St Benedict's Day 187–8
St Bride's Day 184
St Catherine's Day 177
St Chad's Day 174, 187
St Clement's Day 177
St David's Day 187
St George's Day 189, 329
St Giles' Day 198
St Gregory the Great's Day 187
St Helen's swan pit, Norwich 406
St James's Day 194
St John, Charles 251
St John's Day 193
St John's Wort 193
St Luke's Day (Dog-Whip Day) 175
St Mary's chapel, Aberdeen 164
St Matthew's Day 199
St Matthias' Day 186
St Olcan's Well, Lough Neagh 411
St Quintin, W. H. 540
St Peter in Fetters Day 197
St Peter's Church Pig Bell, Sandwich 370
St Simon and St Jude's Day 175
St Swithin's Day 194
St Thomas Didymus' Day 180
St Urban's Day 191
St Valentine's Day 186
St Vincent's Day 183
'St Vitus' Dance' 192
St Vitus' Day 192
stag-antler thumb sticks 458–60
Staffordshire 64, 412, 413, 448
standard trees 102, 134, 143
standing stones 371, 424
Stanhopes of Cotton Hall 551
Statute of Merton 72, 74
Stevenson, Harry 86
stewardship 24, 306–9
Still, Tania 574
Stilton Cheese Rolling Competition 433
stoats 242, 245, 249, 288–90, 484, 491
Stokes, Marianne 467
stone circles 168
Stone of Destiny 113
Stonehaven Fireball Ceremony 425
Stonehenge 55, 56, 107
Strabo 60
Strand maypole 372, 374
straw crafts 446–9
straw work industry 448–9
strewing herbs 351–2
Stuart period 354–5
Stubbes, Philip 372
Stubbs, George 574
Suffolk 71, 448, 479, 539 *see also* Broads
sugar 439, 442
sugar beet 442

Sugar Loaf, Dallington 46
sulphur 331, 333
summer solstice 168, 171, 193
supermarkets 320
Surrey 76, 415
Sussex 76, 276, 305, 420
 hedges 478
Sussex Downs 36–9
Sutton Hoo 64
swallows 188, 198, 226, 228, 275
Swan Upping 406–10
swans 244
'swarm bee keeping' 438
Sweet, Ray 106
sweet chestnut (*Castanae sativa*) 164, 361
 coppice 20, 102, 103, 111, 144
 sweet chestnuts 318, 361, 442
Sweet Track 106
swifts 198, 225
sycamore 139

T

tannic acid 493
tanning 111, 197, 349, 493, 494–6
tansy (*Chrysanthemum vulgare*) 351, 354–5
tar 127
taxation 66, 82–3
taxidermy 257–8
Teltruth, T. 250
Temperance Movement 376
Temple of Ancient Virtue, Stowe 42
Temple of Apollo, Stourhead 42–3
teraxicin 327
'Teribus' 385–6, 395
terriers 19, 529–30
Thames 84, 236–7, 352
 Swan Upping 409–10
thanes 62
thatching 450–1
Thor 148, 218, 244, 245
Thornton, Colonel Thomas 539
Thoroughbreds 568–9
three-field system 61, 65
thunder and lightning 218
thyme, wild (*Thymus drucei*) 352
Tichborne, Lady Mabella 415, 416
Tichborne, Sir Edward 416
Tichborne Claimant 416
Tichborne Dole 415
Tilleman, Peter 574
timber 113–27, 134, 138
 and full moon 173
 imported 143
 Roman requirement 109–11
tin mining 107, 108
Tissington well dressing 411
toads 230, 245, 286–7, 484

midwife 253
toadstone 286
Tolley, Reilly and Greener 555
Tom Hill, Knightsbridge Green 497
Townsend, Viscount 'Turnip' 83, 549
tracks and signs 23–4, 249, 261–2
trade 56, 62, 66, 82, 96, 107
Tradescant, John and son 44
Trajan, Emperor 177
transportation 84–6
Trautmansdorf, Count 554
Treason Act 419
trees
 ancient 54, 148, 163–4
 mysterious and mythical 148–60
 remarkable 163–4
Tremains 19
Tresham, Sir Thomas 41–2
trimethylamine 154
Trimmer, Sarah 250
Tuberville, George 573
Tudor period
 enclosures 72–4
 falconry 538
 monarch's hereditary swan rights 406
 obligatory woollen cap 400
 timber requirements 113
 tree planting 127
 use of wild foods 323, 326, 338
Tull, Jethro 83
turbary 71, 132
Turner, J. W. M. 255
turnips 81, 83, 90, 549
Turnpike (Toll Pike) Trusts 84, 85–6
turpentine 127
Tusser, Thomas 75, 209, 351
tweed 469–71
two-field rotation 59, 62, 446

U
Uffington Castle 36
Ufton Court Maundy distributions 414
UK Biodiversity Plan 281, 285
underwood 102, 111, 113, 127
uplands 54, 252, 261, 267, 480
 see also hill/upland farming
Urban I, Pope 191
urtication 325–6

V
vagrants 50, 74
valerian root 314
Valvona and Crolla, Edinburgh 365
Van Tilborgh, Gillis 416
Vaughan, Roland 75–6
Vegetable Drugs Committee 315
Verderers 41, 132

Verderers' Court, New Forest 135–7
Vermuyden, Cornelius 77, 80
vernal equinox 170, 188
Victoria, Queen 256, 351, 472, 522, 551, 554
Victorian era
 Highland shooting 554
 Morecambe Bay 510
 sentimentalization of rural past 374, 399, 446, 467
 taxidermy 257–8
 Wakes holidays 397–9
 wildlife protection 306
Vikings (Norsemen) 156, 244, 371, 508
Villiers, George, 2nd Duke 573–4
Vinelands Dandelion Festival 328
vitamins
 A 323, 333, 339
 B 318, 323, 324, 333, 339
 C 317, 322, 323, 333, 339, 357
 D 283, 339
 E 333
 K 333
voles 484
Vortigern 111

W
Wakefield World Coal Carrying Competition 433
Wakes Day festivals 396–9
Waldegrave, William 431
Wales 43, 51, 85, 93, 112, 134, 187, 448, 450, 574
 bracken 349
 conifer plantations 28, 264
 conservation bodies 266
 dry stone walling 483
 folklore 154, 159
 Forestry Commission 143, 144
 Hedgerow Regulations 479
 laverbread 339
 Mari Lwyd festivals 426–7
 megaliths 56
 mining 107, 108, 138
 ravens 305
 Roman sites 61
 trees and woodland 119, 137, 147
 turnpikes 86
 wetlands 452
walking sticks 458–63
Wall, Matthew 417
Walpurgis Night 371
Walsall leather trade 494
Walsh, John Henry 251
Walsingham, Lord 251, 258
Walton, Isaac 275, 518, 519
War Women's Association 315
Ward, James 255
warrens (coney garths) 530–3

Warwick, Earl of 74
Warwickshire 65, 112, 443
Washington, George 574
wassailing 156, 358
water meadows 75–6
water mint (*Mentha aquatica*) 352–3
water voles 309
watercress 318
Waterloo Cup 579
Watkins, Kenneth 147
Watling, Roy 365
Watson's Mill, Hawick 469, 471
Waugh, Benjamin 256
'waxwing winters' 229
Wayfarer's Dole, Winchester 415
Weald 16, 102, 108, 109, 111, 112, 138
weasel skin (miniver) 491
weasels 242, 245, 484
weatherlore 166–239
 ancient art 206–34
 calendar 202–5
 credibility 169
 and saints' days 174–99
weather vanes 206
weaving 56, 72, 91, 464, 465
 at home 473
wedding customs 160
well dressing 410–12
Well of Segais 157
Wellesley, Lord Gerald 47
Wellington, Duke of 522
Welsh Border hedge 477–8
West, Martin 431
West Country 20, 35, 72, 107, 108, 156, 159, 252, 276, 358, 374–6, 448, 573
 hedges 478
Weston, Sir Richard 84
wetlands 35, 261, 271–2, 452, 457, 556–9
Wey navigation 84
whisky barrels 116, 126
White Dyke 34
White Horse of Uffington 35–6, 242
White, Gilbert 251, 276, 295
White, Captain Samuel 258
whitebeam 113, 442
Whitefoot, Fred 478
Whitelands College, London 371
Whitlock, Melanie 445
Whitstable Oyster Festival 194
Whitsunday 174, 189, 191
whorled mint (*Mentha x verticillata*) 353
wicker 452, 454
Wilbraham, Randle 43
wild flowers
 May display 191
 woodland 102
wild plants 55, 311–67

autumn harvest 356–61
coastal 338–43
dyes 468
hillside 344–50
nature's harvest 313–20
non-culinary 351–5
poisonous 19, 319
return to 320–2
using 322–37
and weather 234
wildfowl 24, 540
Wildfowlers' Association of Great Britain (WAGBI) 559–60
wildfowling 556–60
wildlife 19, 240–309
changing attitudes 252–6
in the city 301–3
collective nouns 249
hibernating 277–87
hunters and hunted in winter 288–95
hunting hierarchy 131, 245, 293
impact of modern landscaping policies 264–7
importance of fungi 364
in literature 250–2, 282
preparation for winter 236
protection vs. stewardship 306–9
use of dry stone walls 484
and weather 225–9
whiling away the hours with 267
woodland 102
see also birds; insects
Wildlife and Countryside Act (1981) 279, 285, 305, 306, 338
wildwood 54, 55, 58, 106, 107, 109, 111, 127
William III of Orange 82, 134
William Cowley & Co 491
William the Conqueror 64, 112, 130, 132
William the Conqueror Oak 163
Willmott, Rev W. 540
willow work 452–7
Wiltshire 39, 107, 112
Wiltshire downs 539
Wilweorthunga 410
windmills 80
winds 206–11
Windsor Castle 113
Windsor Forest 135
Windsor Park 164, 252, 545, 551
Wingates, Northumberland 50
winter solstice 150–1, 168, 173, 424
witch protection 153–4, 193, 342, 358
witches 245, 275
withies 452, 454
Woburn Abbey 45, 301
Wolsey, Cardinal 120
wolves 127, 131, 242, 245, 252, 539

beasts of the Forest 131, 245, 293
Wolf Moon 173
wood fuel 111, 120, 126
wood pasture 54, 128, 135, 137, 138
wood sorrel (*Oxalis acetosella*) 326
Wood, Rev. J. G. 251
Woodbury, Thomas 441
Woodchester 61
woodcock 242, 272–4, 275
hawking 539, 540
shooting 550
woodland 100–65
and bees 442
changing landscape 109–13
'improving' 138–44
clearance 54, 55, 56, 60, 74, 97, 107, 109, 111, 127, 138, 143, 252
conservation 261
management 111, 277
preservation 147
squirrel damage 308
working British 106–8
see also Forest Laws; Royal Forests; timber; trees
Woodland Trust 147, 163
wool churches 72
wool crafts 464–75
wool industry 51, 54, 56, 59, 71, 72, 91, 96, 97, 464
Charles II's regeneration scheme 377
monastic 51, 65–6, 464
obligatory woollen caps 400
Scottish demise 554
Woolsack 464
Woolton Pie 317
Woolwich 'Gentleman's Vulcan' 177
Wootton, John 574
Worcester, Lord 86
Worcester Oak Apple Day pageant 378
Worcestershire 96, 112
Wordsworth, William 255
World War I 16, 143, 303, 337, 376, 436, 454, 489
carrier pigeons 522
use of wild plants 314–15
World War II 96, 143, 261, 283, 325, 345, 442, 483, 498, 563
carrier pigeons 522
Tower ravens 304
use of wild plants 315–18, 327
wormwood (*Artemesia absinthium*) 353–4
Worshipful Company of Basket Makers 454
Worshipful Company of Dyers 409, 410
Worshipful Company of Farriers 488–9
Worshipful Company of Leathersellers 497
Worshipful Company of Vintners 409, 410
Wotton Dole 415

wrens 244, 268
Wyatt, James 43
Wyatt, Sir Francis 45
Wych (Scotch) elm 106, 119, 139

Y

yellow hammer 346
yeomen 71, 571, 573
yew 106, 150
ancient 163
Yggdrasi 244
York Minster 175
Yorkshire 20, 72, 344, 350, 397, 448, 464
hedges 478
Yorkshire moors 551
Yule 180

First published in 2010 by Collins

HarperCollinsPublishers
77–85 Fulham Palace Road
London W6 8JB

www.harpercollins.co.uk

13 5 7 9 10 8 6 4 2

Text © Johnny Scott 2010

Images © Cristian Barnett 2010 with the following exceptions:
p94 © Terry Whittaker/FLPA; p243 © Phil McLean/FLPA; p273 © Erica Olsen/FLPA; p274 © Paul Hobson/FLPA; p280 © Gary K. Smith/FLPA; p288 © Roger Tidman/FLPA; p295 © Derek Middleton/FLPA; p284 © Kim Taylor/naturepl.com; p302 © Laurent Geslin/naturepl.com; p441 © Laurie Campbell/naturepl.com; p537 © Nick Garbutt/naturepl.com; pp541, 544 © Kirsten Scheurl; p307 © Mike Lane/Photoshot; p477 © Ernie Janes/Photoshot; p296 © Paul Sterry; pp487, 525 © Photolibrary.com

Illustrations © Chris Wormell/The Artworks

While every effort has been made to trace and acknowledge copyright holders, we would like to apologise should there be any errors or omissions.

The author asserts his moral right to be identified as the author of this work.
A catalogue record for this book is available from the British Library.

ISBN: 978-0-00-728815-1

All rights reserved. No parts of this publication may be reproduced, stored in a retrieval system or transmitted, in any form or by any means, electronic, mechanical, photocopying, recording or otherwise, without the prior permission of the publishers.

SIR JOHN SCOTT

Sir John Scott (Johnny to his friends) is a historian, broadcaster, columnist, countryside campaigner and farmer. He wrote and co-presented the BBC2 series *Clarissa and the Countryman* and writes for a variety of magazines and periodicals on field sports, food, farming, travel, natural history and rural issues.

Johnny's family farmed in Northumberland and East Sussex, where he was brought up in a long tradition of rural stewardship. He acquired his love and knowledge of the country from the Hunt servants, gamekeepers, ghillies, stalkers and shepherds he knew as a child. Johnny studied agriculture on three continents, was a lumberjack, miner, cook, Lloyds' broker and brakeman in the British bobsleigh team, before returning to farm hefted hill sheep in the Scottish Borders.

A lifetime devotee of the countryside and its sports, Johnny is an excellent horseman, a keen shot and passionate supporter of country issues, maintaining links to numerous organisations as President of the Union of Country Sports Workers; Vice President of The Heather Trust; Board Member of the European Squirrel Initiative; Patron of the National Organisation of Beaters and Pickers Up; Patron of the Sporting Lucas Terrier Association; President of the Gamekeepers Welfare Trust; Patron of the Wildlife Ark Trust; Centenary Patron of BASC; President of the Tay Valley Wildfowler's Association; President of the Newcastle-upon-Tyne Wildfowlers Association; founder member of the Cholmondeley Coursing Club, and Chairman and Joint Master of the North Pennine Hunt.